P9-CKQ-529

Nineteenth-Century
Painters and Painting:
a Dictionary

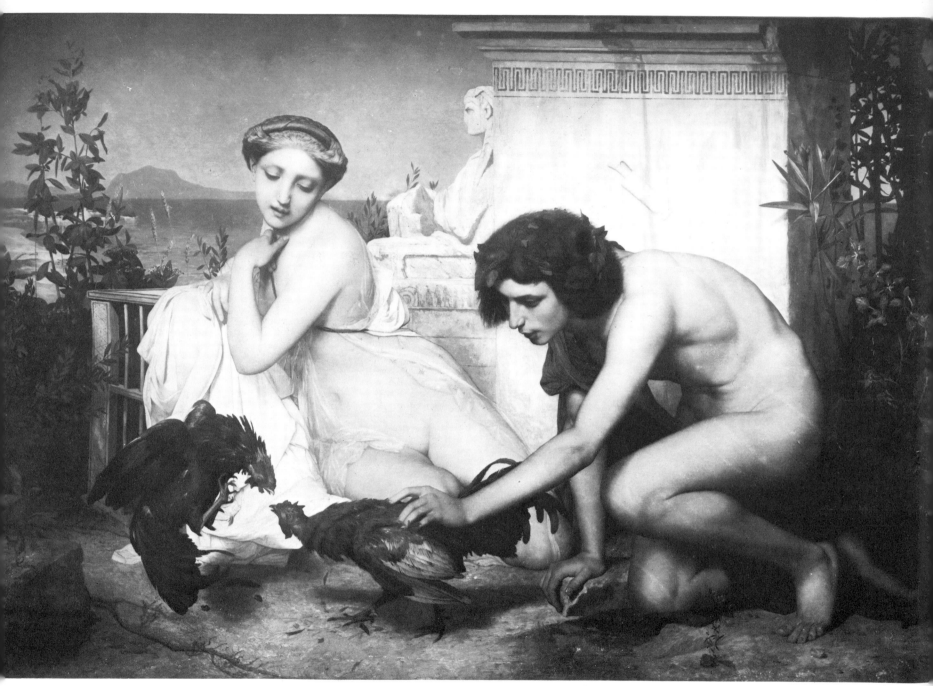

J.-L. Gérôme *The Cock Fight* 1847

GERALDINE NORMAN

Nineteenth-Century Painters and Painting: a Dictionary

with 469 illustrations, 32 in color

UNIVERSITY OF CALIFORNIA PRESS

Berkeley and Los Angeles 1977

For my father

Acknowledgments

I should like to thank Mrs Susan Schonfield for
her invaluable research assistance and Professor
Gerald M. Ackerman, both for his letters of
advice on source books and ideas and for
contributing a foreword to this volume. I should
also like to thank Dr Ulrich Finke, Mr Ronald
Parkinson and Professor Norman D. Ziff for
reading the proofs and making suggestions for
which I am enormously grateful.

UNIVERSITY OF CALIFORNIA PRESS
Berkeley and Los Angeles, California

ISBN: 0-520-03328-0
Library of Congress Catalog Card
Number: 76-24594

Foreword

This book is more than a handy reference work in which to look up painters of the nineteenth century. It is the first modern book to attempt to cover almost all the artistic schools of that period without any bias as to their assumed importance in 'mainstream art history' or their alleged contributions to the development of contemporary art. Geraldine Norman takes the reasonable position that in a dictionary of nineteenth-century painting artists considered important in their own time should be included together with those whom we *now* think important. As a result, this work is the first step towards forming an unprejudiced and non-partisan history of nineteenth-century painting. Geraldine Norman, in her succinct biographies, delights in pointing out the relationships between artists – as teachers and students, as friends and associates – that transcend the currently accepted divisions of art history. Artists who have usually been seen either in heroic isolation or in dramatic conflict with one another become, in this dictionary, integrated participants in the international artistic activity of the century. The boundaries of national schools and the dogmatic definitions of movements dissolve in our minds as we see how artists moved – independently, curiously, without prejudice – through artistic circles and from one country to another. Even just browsing in this dictionary is not only rewarding but has unexpected results: in reading, for instance, a series of related entries, one's conception of artistic life in the nineteenth century will seem more unified, precise and vivid.

A dictionary like this is largely a compilation of facts, but in looking up unknown artists we need more than facts: we require some critical information about the style and quality of their work. It is quite easy to look elsewhere for more substantial articles on, say, Delacroix and Gauguin than this book offers; and because we are already familiar with the character of such well-known artists' work, we may only use the entries on them to ascertain a date or a fact. The special usefulness of this dictionary, however, rests in the entries about artists whom we either do not know very well, or do not know at all. In telling us about the works of these lesser-known artists, Geraldine Norman is generous and trustworthy. Her critical ability has been informed not just by extensive travelling and research, but also by following, for many seasons, the salesrooms of London. This somewhat unorthodox and on-the-spot art-historical training has exposed her to an enviable and very wide range of nineteenth-century painting, far greater than that which is presently on view in public collections. Her experience has, at the same time, protected her from the occasional constraints of the established categories of art history.

Gerald M. Ackerman

Professor of Art History, Pomona College

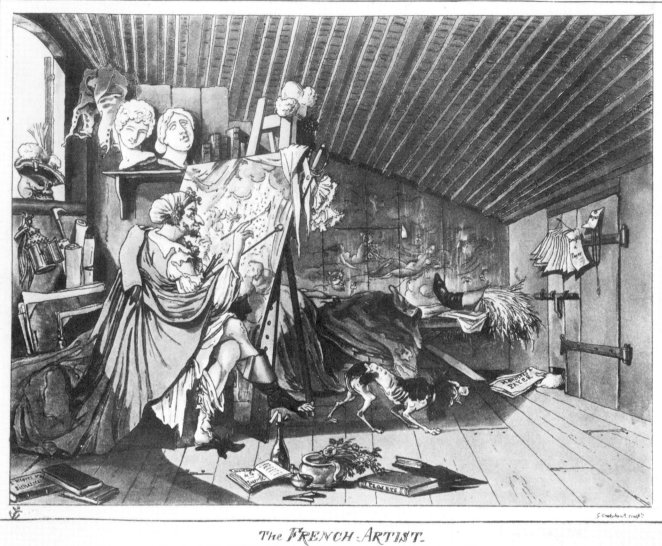

G. Cruikshank *The French Artist* 1819, aquatint

The ragged Bohemian-looking artist is
painting in his garret studio a grandiose subject picture
typical of the early years of the century.
Cruikshank never visited Paris but it seems
possible that, even in London, he had heard stories
of the *Primitifs* – a group of Jacques Louis David's
pupils who wore Greek dress, long beards and cloaks
in order to demonstrate their commitment to the
'primitive' purity of early Greek art.

This dictionary is based on the assumption that the broad outlines of nineteenth-century art history have not yet been definitively mapped. The struggle for recognition of the Impressionists and Post-Impressionists during their own lifetimes, and the posthumous acclaim of their work as the crowning achievement of the century, has introduced a special bias into most twentieth-century studies of the period. The story of nineteenth-century art is generally traced through the series of French *avant-garde* movements that led up to the Impressionist achievement, from Delacroix and the Romantics to Courbet, Barbizon and the Realists, the Impressionists themselves, and the great succeeding generation of Post-Impressionists (Gauguin, van Gogh, Cézanne, Seurat) who prepared the way for the major artistic developments of the twentieth century. The foundations for this now conventional view of nineteenth-century art were laid with the publication of Meier-Graefe's *Entwicklungs-geschichte der modernen Kunst* in 1904.

Most of the artists who were honoured as artistic leaders in their own lifetime and accorded, as was the practice of the century, a range of high-sounding titles and decorations have been cast into oblivion. They are dismissed with that same contempt with which they themselves dismissed the artistic innovations of the Impressionists. In my view this picture of the period is just as unbalanced and misleading as that accepted by the nineteenth-century art establishment. The achievement of Poussin does not invalidate the achievement of Rubens; they were contemporaries but they were different. There were many fine painters among the artists whose careers were crowned with academic honours, just as there were many fine artists among the rebels; both groups influenced each other and the dividing line between them is often far from clear.

Furthermore, artistic activity was not confined to France. There were distinguished national schools throughout Europe and America, not isolated but constantly interacting with each other. To some extent the story of art outside France has survived with less distortion; with some exceptions, national schools have retained a national popularity and have been studied in some depth. The longstanding battle between the *avant-garde* and the establishment is peculiar to France. The only consistent distortion that creeps into national art history is an attempt to draw parallels with contemporary French painting; there is hardly a nation which does not claim to have invented Impressionism before the French.

This again reflects the conventional assumption that the succession of *avant-garde* movements in France lies at the centre of nineteenth-century artistic development. In fact, there were individual artists and schools elsewhere in Europe and America of great importance in their own right. There are no frontiers in art and artists travelled widely, learning from each other. Many artists of all nations studied for a period in Rome, and many foreign artists were attracted at various times to Paris, London, Munich, Düsseldorf and Antwerp. In the second half of the century, the great international exhibitions offered opportunities to compare the achievements of different national schools.

Thus, in my view, an approximately true outline of the course of artistic development in the nineteenth century can only become clear when the national pieces of the jigsaw puzzle have been fitted together, when the dominance of

France is no longer assumed and, within the French school, when rebels and academicians are appreciated without prejudice as interacting parts of the whole.

I have, therefore, aimed with this dictionary to cover the major figures of all the national schools, the established artists as well as the *avant-garde*, and to stress their studies abroad and their interaction with foreign schools. No doubt in the course of the current reassessment new artists will become prominent whose significance I have not appreciated. Nevertheless, I hope that this dictionary will remain a useful tool for all those interested in the period.

The dictionary covers some seven hundred artists, artistic movements and institutions, and I have constantly been faced with the problem of whom to include and whom to leave out. The extent and quality of recent publications varies greatly from country to country. I have tried to base my assessment of an artist's importance on the judgments of more qualified scholars; since the publication dates of my source material have varied from 1830 to 1975 this has required a wary eye for fashionable prejudices. The emphasis of my selection has been on those artists who were highly regarded in their own lifetime, but I have also tried to include artists whose distinction has been demonstrated by more recent studies.

At the beginning of each entry I have tried to indicate the nature of the artist's work and its historical context within the century's art. Next I record where and with whom the artist studied, together with any other significant influences on his work; where appropriate I have also mentioned his own influence on others. This is followed by a summary of the main features of his career. Details of academic and other honours which he received are generally fully recorded, as an indication of the prominence that the artist enjoyed in his own time.

In describing an artist's work I have given considerable emphasis to subject matter, much more than is currently fashionable among art historians. I make no apology for this, for I believe it to be in line with the spirit of the century I am discussing. There was a clear-cut hierarchy of subject matter in the nineteenth century, accepted by artists and critics alike, and according to which the 'greatness' of a painting could be judged: history painting (religious, historical, classical), genre, portrait, landscape, still life – in that order. Part of the Impressionists' struggle lay in reversing this attitude. Furthermore, subject matter was an important concern for artists who expected to be judged on the poignancy of the scene depicted and its message for the viewer – whether moral, political, philosophical, poetic or humorous.

This is a dictionary of nineteenth-century artists, but there are inevitably a large number of borderline cases who belong partly to the eighteenth or twentieth centuries. My bias has been towards the beginning of the century. I have included a number of eighteenth-century artists who survived only a few years into the nineteenth, because of the influence they exerted on their successors; important twentieth-century artists who began their careers in the last years of the nineteenth have not generally been included, unless they produced work of special significance before 1900 – significant, that is, for the contemporary art world rather than for their own subsequent careers.

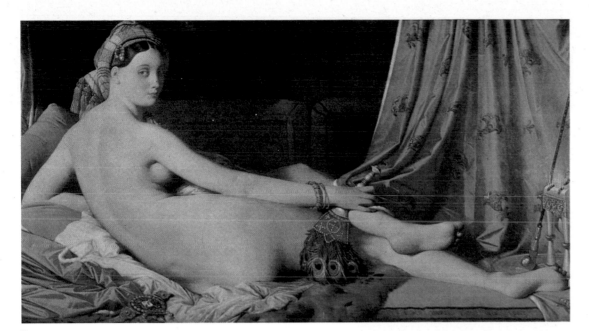

1

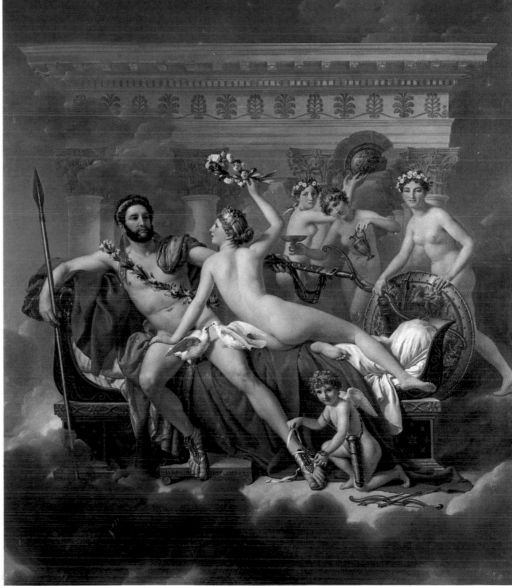

1 JEAN AUGUSTE DOMINIQUE INGRES
Odalisque 1814

2 JACQUES LOUIS DAVID *Mars Disarmed by
Venus and the Graces* 1822-4

Two alternative traditions of painting were inherited
by the nineteenth century, that of Poussin, with his
cool, clear-cut outlines and classical idealism, and
that of Rubens, with his emotive use of rich colour
and strong, approximative brushstrokes. In their
names many of the great battles between nine-
teenth-century artists were fought, most notably
the battle of line against colour, of Ingres against
Delacroix, which has often been described as the
clash of classicism and Romanticism.

The torch of classicism was carried into the
nineteenth century by David. In iconographic terms
it was perhaps his smoothly modelled, clean-limbed
nudes of idealized beauty – reflecting the classicists'
endeavour to combine in their canvases the most
perfect proportions to be found in nature – that left
the most lasting mark on the new century. His
Mars Disarmed by Venus and the Graces (2) provides
a fine example.

In the hands of his pupil Ingres, one of the most
influential geniuses of the nineteenth century, the
clean outlines and idealized beauty of the classical
nude evolves a sensuous realism. His *Odalisque* (1)
was among the earliest of a long series of female
nudes, a theme to which he was still returning in
old age. Their influence can be traced in the work
of many later artists including that of the Néo-
Grecques, Gérôme and his friends in Paris, and of
English limners of classical scenes, such as Leighton
and Poynter. It can also be traced among the
Symbolists (Moreau) and the Impressionists
(Renoir, Degas).

2

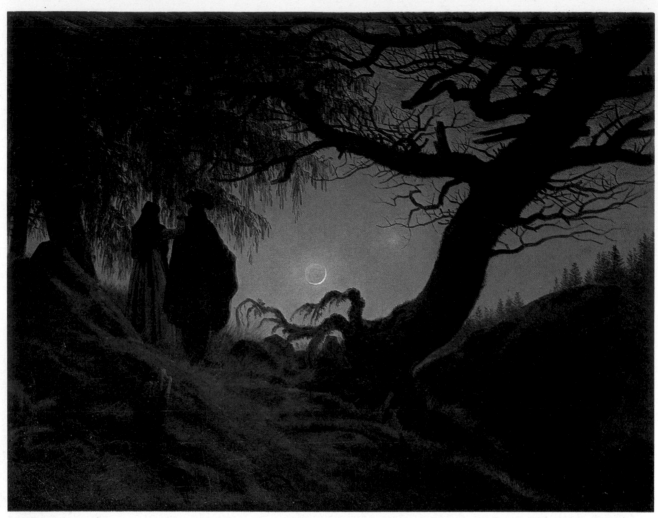

3

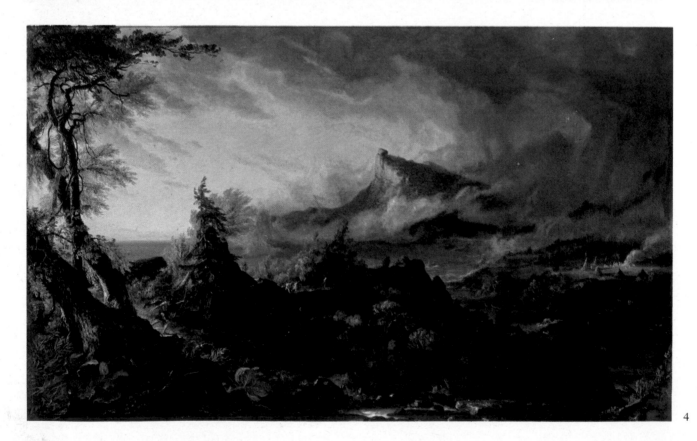

4

While the Neoclassicists had sought an ideal, both physical and moral, of universal validity for all countries and all times, the Romantics gloried in differences. They searched out the exotic, the deviant and the unique, both through the exploration of the subconscious and in the cults and cultures of distant eras or climes.

An intensely personal religious perception finds outward form in the landscapes of the German artist, Caspar David Friedrich, as in his *Man and Woman Gazing at the Moon* (3). The American Thomas Cole's four-part *Course of Empire* steals some of its theatrical effects from the example of his English forerunner John Martin, using them to unfold the birth, flowering and destruction of a civilization; it is an allegory built on the example of Rome. *The Savage State* or *Commencement of Empire* (4) is the first of the series and indicates also Cole's powers as a naturalistic landscape painter, the first great limner of untamed nature in North America.

Delacroix, whose name is almost synonymous with Romanticism in France, has sought out the most exotic scene of Eastern horror in *The Death of Sardanapalus* (5): as the potentate dies his concubines are put to the sword. Out of this he builds a brilliantly balanced pattern of mass and colour.

Henry Fuseli, the Swiss artist who settled in England and thus provided a curious link between German classicism and English Romanticism, often took his subjects from Shakespeare. *Titania and Bottom* (6) is an early example of the connections between painting and the theatre in the Romantic age. It is also a forerunner of the fairy pictures to which several English and German artists were to turn their hands.

3 CASPAR DAVID FRIEDRICH *Man and Woman Gazing at the Moon* c. 1830–5

4 THOMAS COLE *The Savage State* or *Commencement of Empire* 1833–6

5 FERDINAND VICTOR EUGÈNE DELACROIX *The Death of Sardanapalus* 1827

6 HENRY FUSELI *Titania and Bottom* c. 1790

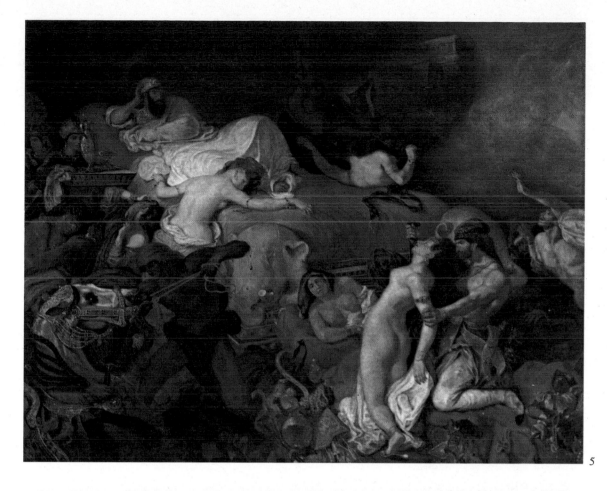

5

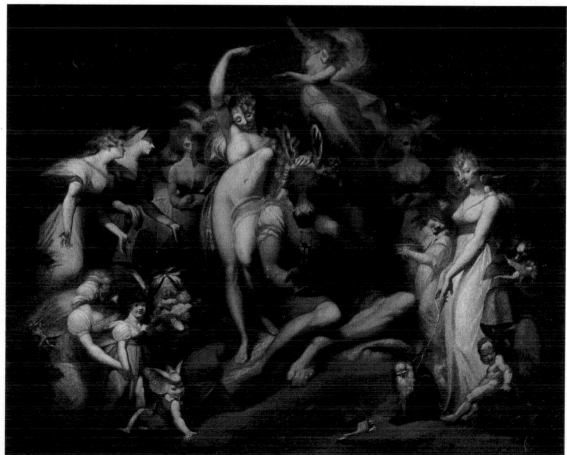

6

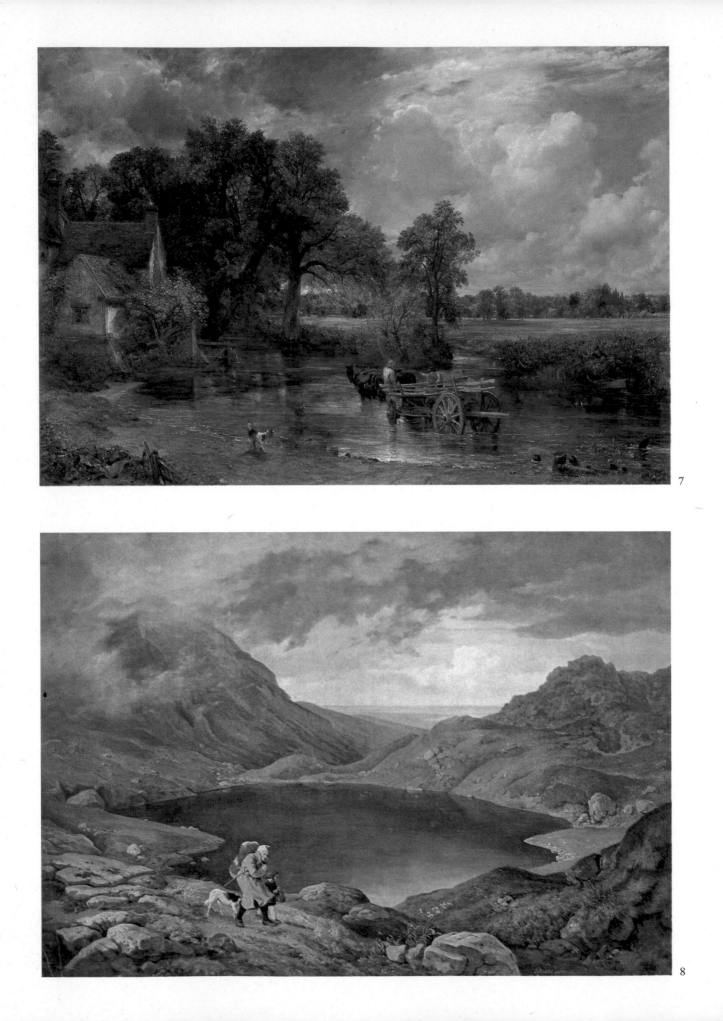

7

8

Romantic Landscape

Landscape in the Romantic age was seen from the inside out; artists strove not merely to depict a view but to express in their painting their own feelings for nature and its poetry. Yet the greatest achievements of the age lay in naturalistic landscape painting. Constable, Rousseau and their followers distilled the intimate poetry of everyday nature, a limited horizon within which Romanticism mingles with Realism.

Constable's *The Hay Wain* (7) was shown at the famous Paris Salon of 1824, helping to spread a knowledge of his work and the influence of the English 'colourists' in France. This influence can be traced particularly among the landscape painters of the French Barbizon School, of which Théodore Rousseau was the founder and father-figure, though Rousseau's *Marshy Landscape* (10) was painted nearly twenty years after the exhibition of Constable's painting.

The same period saw a growing interest in naturalistic landscape painting in Germany, the Biedermeier landscapists differing from their French and English counterparts in adopting a more linear and highly finished style. The essence of German Biedermeier *Gemütlichkeit* (cosiness) is realized in the work of Ludwig Richter, for example in *The Little Lake* (8), the hard finish of his paintings relieved by the sweet naïvety of their content.

Turner, perhaps the greatest of Romantic landscapists, is also essentially a naturalist. But the feelings he has to express about nature are in a higher, more passionate key; *Rain, Steam and Speed* (9) impressionistically suggests the clash of battling elements. But his work, however impressionistic, begins and ends in poetry; the parallel with the optical Realism of the French Impressionists is deceptive.

7 JOHN CONSTABLE *The Hay Wain* 1821

8 ADRIAN LUDWIG RICHTER *The Little Lake* 1839

9 JOSEPH MALLORD WILLIAM TURNER *Rain, Steam and Speed – The Great Western Railway* 1844

10 PIERRE ETIENNE THÉODORE ROUSSEAU *Marshy Landscape* 1842

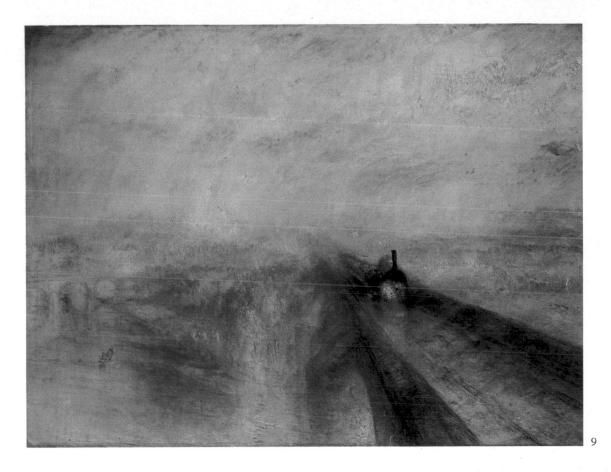

9

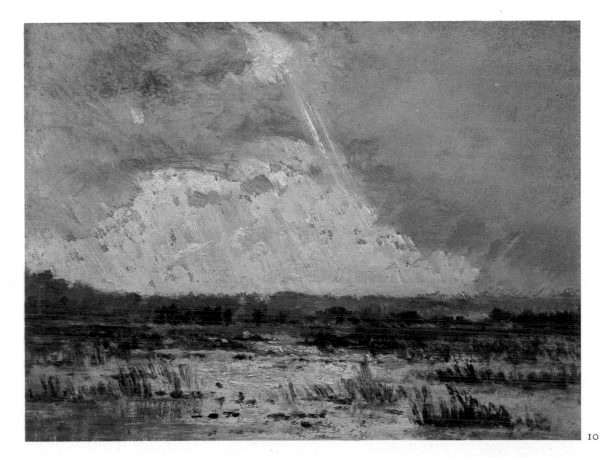

10

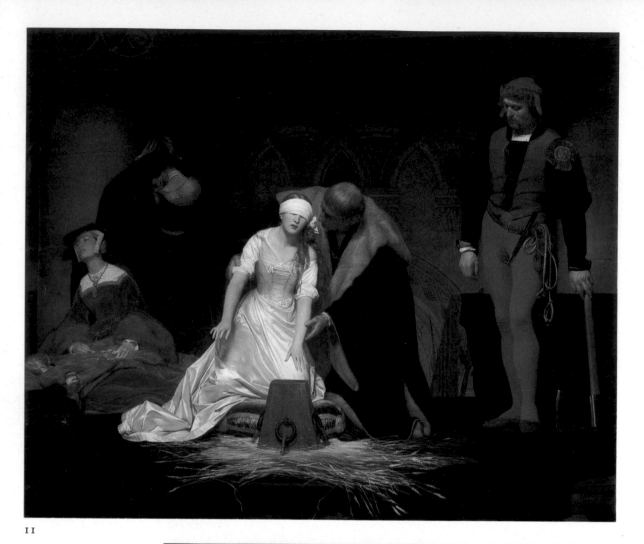

History Painting

'Great' painting tended in the nineteenth century to be equated with the delineation of great deeds, ideals, allegories or morals. This explains the continuing popularity of history painting. The inspiration of American history, especially the American War of Independence, virtually gave birth to the genre in the work of Benjamin West (*Penn's Treaty with the Indians*, 13). Paul Delaroche, whose influence was felt throughout Europe, turned it towards the lachrymose contemplation of human tragedy (*The Execution of Lady Jane Grey*, 11). Nationalists recreated their countries' noblest hours, as in the work of the Polish patriot Jan Matejko (*Stephen Batory at Pskov*, 12). In France two Napoleons were briefly emperors within a hundred years; Jean Louis Meissonier hymned the victories of both (*Napoleon III at Solferino*, 14).

11 PAUL DELAROCHE *The Execution of Lady Jane Grey* 1833

12 JAN MATEJKO *Stephen Batory at Pskov* 1872

13 BENJAMIN WEST *Penn's Treaty with the Indians* 1771

14 JEAN LOUIS ERNEST MEISSONIER *Napoleon III at Solferino* 1863

11

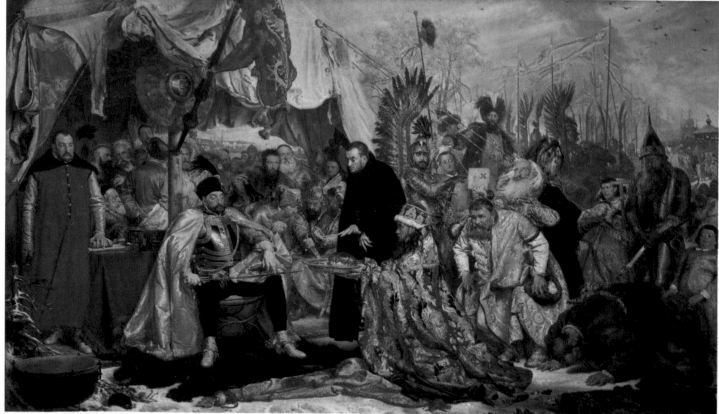

12

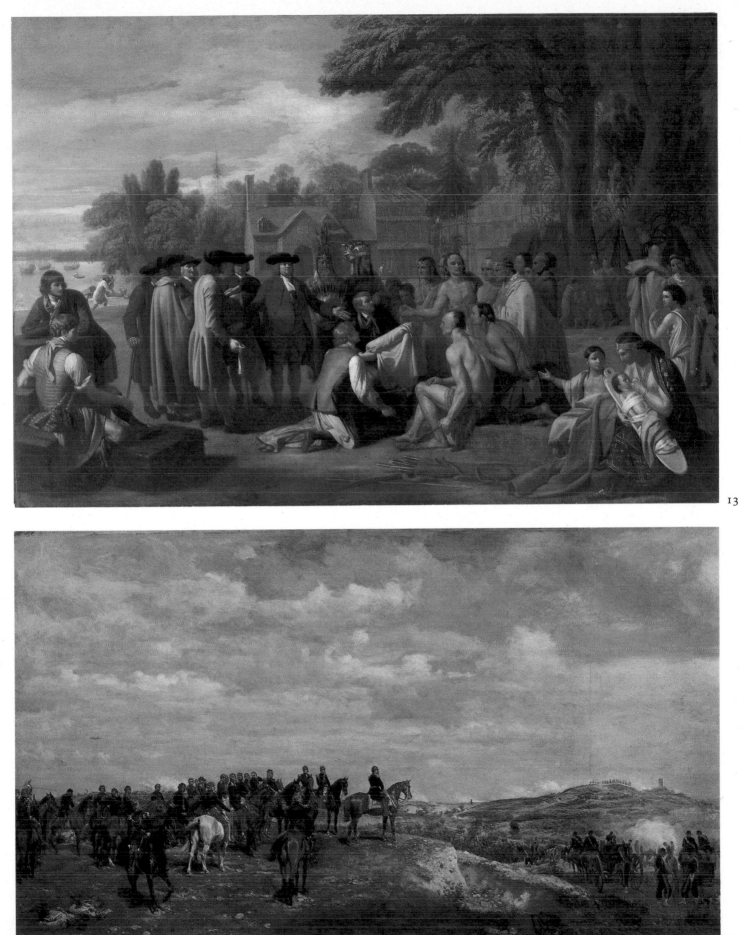

13

14

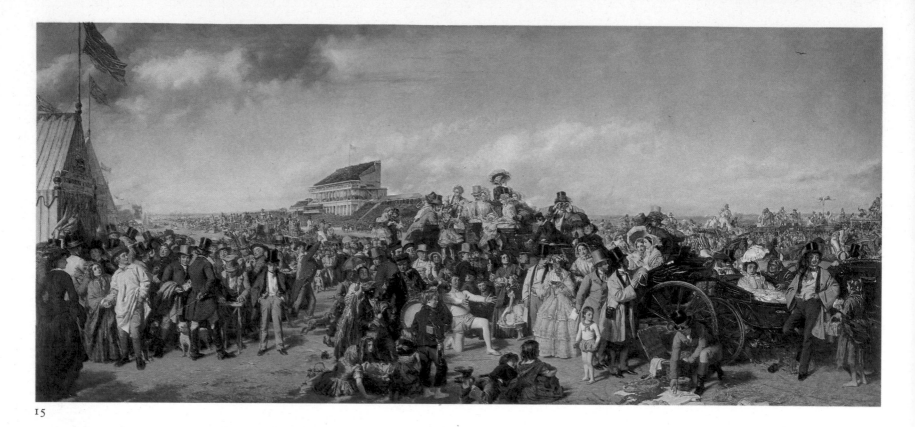

15

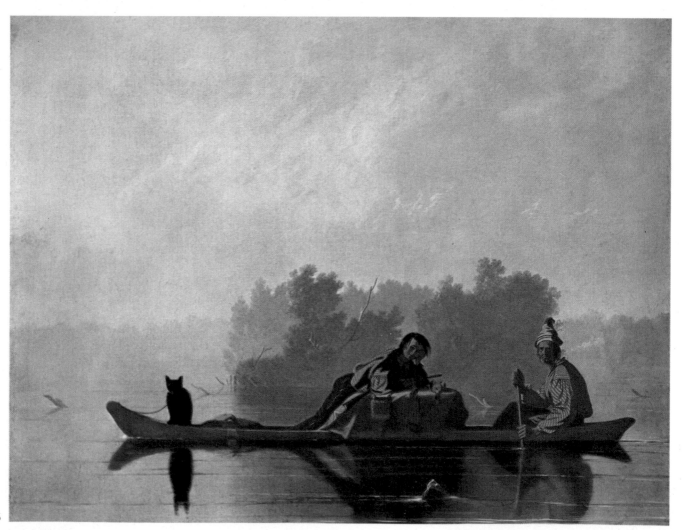

16

17

Scenes of contemporary life had a wide popular appeal in mid-nineteenth-century Europe and America, continuing a tradition begun by Dutch artists of the seventeenth century. The Realist spirit of the age, however, dictated the instant recognizability of contemporary 'types', giving paintings from different countries an interesting national flavour. Frith's *Derby Day* (15) is definitively English, Spitzweg's *The Hypochondriac* (17) could come from nowhere but Munich, Fedotov's *Little Widow* (18) has a whiff of Tolstoy, while Bingham's *Fur Traders Descending the Missouri* (16) speaks of the American outback. Nevertheless they are all to an extent mirrors in which the new middle-class collectors could recognize their world.

15 WILLIAM POWELL FRITH *Derby Day* 1856–8

16 GEORGE CALEB BINGHAM *Fur Traders Descending the Missouri* *c.* 1845

17 CARL SPITZWEG *The Hypochondriac* 1866

18 PAUL ANDREYEVICH FEDOTOV *Little Widow* 1851

18

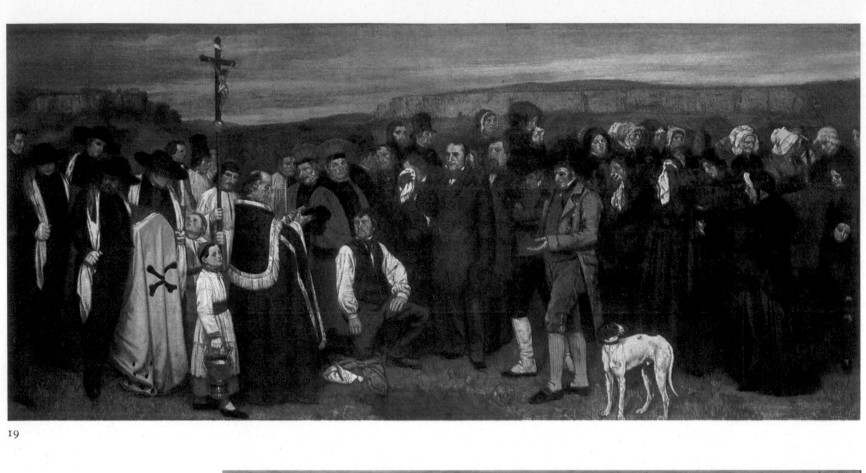

19

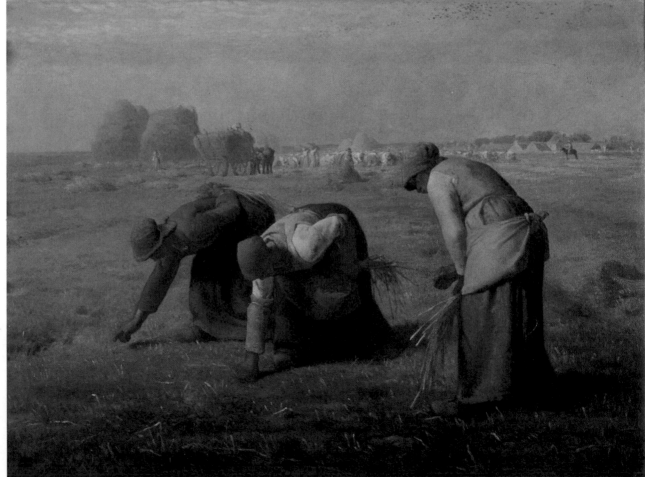

20

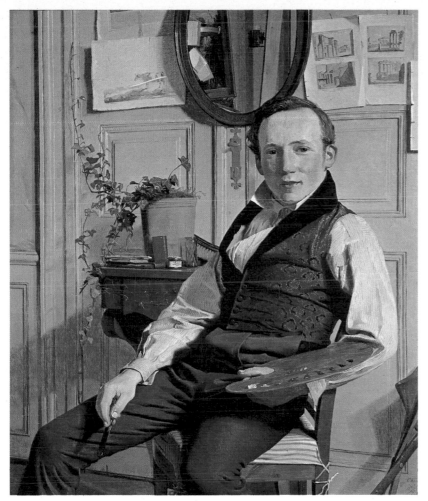

21

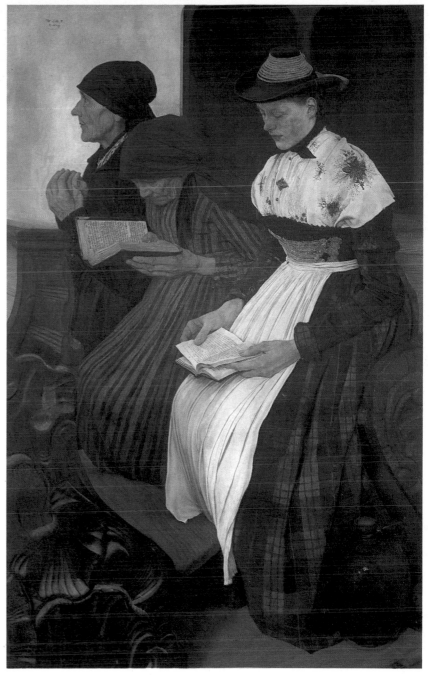

22

It is characteristic of the twentieth-century's critical reassessment of nineteenth-century painting that the artists now considered of greatest stature received scant recognition in their day. This is well illustrated in the field of Realist genre painting where the outsiders attempted to reconstruct a deeper level of reality than their popular contemporaries, less obviously pretty but with more psychological depth.

Both Courbet and Millet were criticized for treating the ignoble lives of the peasantry as suitable subjects for high art; now Courbet's *Funeral at Ornans* (19) and Millet's *The Gleaners* (20) are among the best-known paintings of the century. In fact, recognition of the stature of these two artists came in time to profoundly influence late nineteenth-century painting.

In Germany Wilhelm Leibl, a friend and admirer of Courbet, is now perhaps the most highly considered artist of the Realist generation and his *Three Women in Church* (22) a well-known image. Yet the criticism with which his work was received in the Munich of his day led him to work in semi-isolation in the country villages of Bavaria. The golden age of Danish painting, around the mid-century, is now often referred to as 'the age of Købke' and his portrait of *The Landscape Painter Frederik Sødring* (21) is widely known. His failure to achieve full membership of the Copenhagen Academy clouded his last years with resentment.

Avant-Garde Realist Genre

19 GUSTAVE COURBET *Funeral at Ornans* 1849

20 JEAN FRANÇOIS MILLET *The Gleaners* 1857

21 CHRISTEN SCHJELLERUP KØBKE *The Landscape Painter Frederik Sødring*

22 WILHELM MARIA HUBERTUS LEIBL *Three Women in Church* 1882

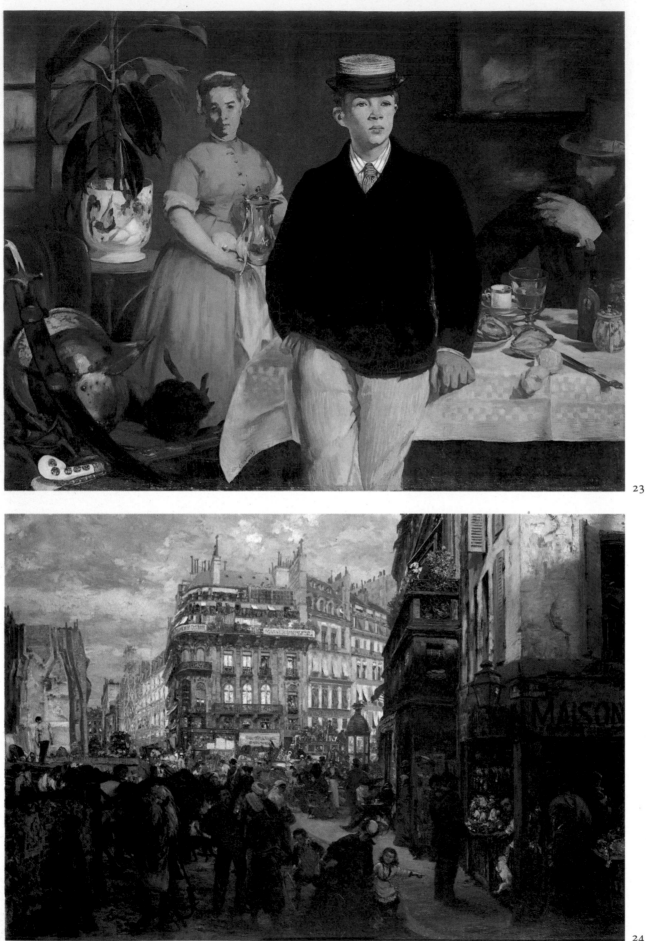

23

24

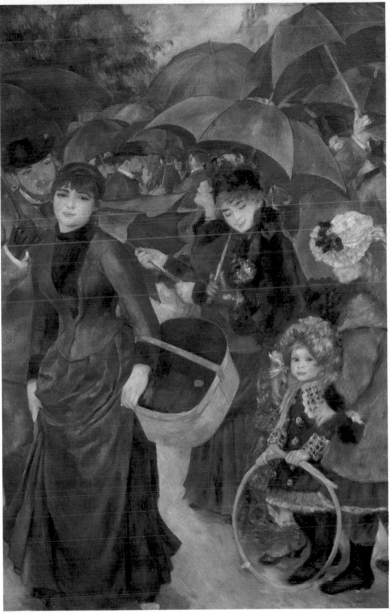

25

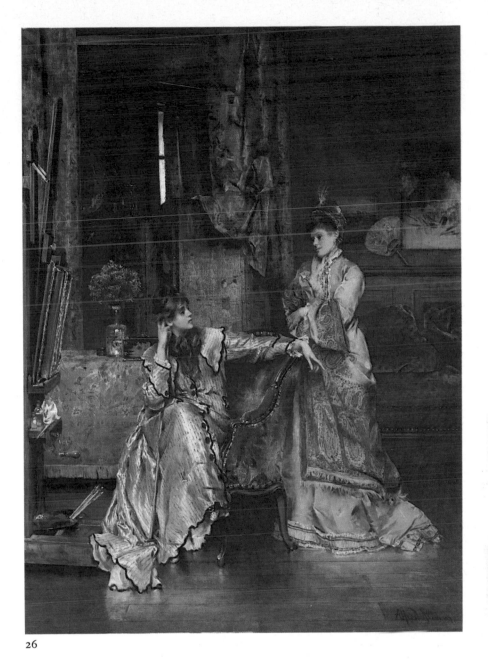

26

Impressionism

23 EDOUARD MANET *Lunch in the Studio* 1869

24 ADOLF FRIEDRICH ERDMANN VON MENZEL
Weekday in Paris 1869

25 PIERRE AUGUSTE RENOIR *The Umbrellas*
1884

26 ALFRED EMILE LÉOPOLD STEVENS
The Visit

While the optical theories and experiments of the Impressionists were unique to the group and their well-recorded struggle for recognition has often led them to be seen as an isolated phenomenon within the context of nineteenth-century art, their work is very much a product of the age. In literature this was the era of the great Naturalist writers; they used words to create a faithful, unromanticized image of the society within which they lived and this endeavour was echoed by many artists of the time.

Their influence can be seen in Manet's *Lunch in the Studio* (23) and Renoir's *The Umbrellas* (25). Alfred Stevens, a Belgian painter and friend of Manet's whose work took Paris by storm, was working in the same vein though he limited himself almost exclusively to depicting the lives of society ladies, as in *The Visit* (26).

In Germany Adolf von Menzel was the artist *par excellence* of the Prussian court. Having achieved fame with his historical illustrations of the life of Frederick the Great, he turned his attention to contemporary life. His images, free of artificial overtone or storytelling, often parallel those of the Impressionists. This is particularly underlined by his French paintings, such as *Weekday in Paris* (24).

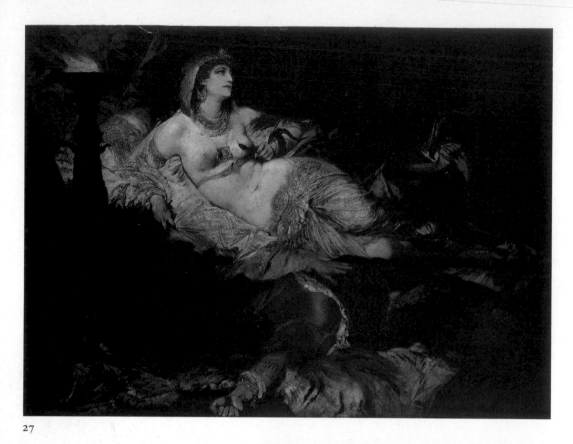

27

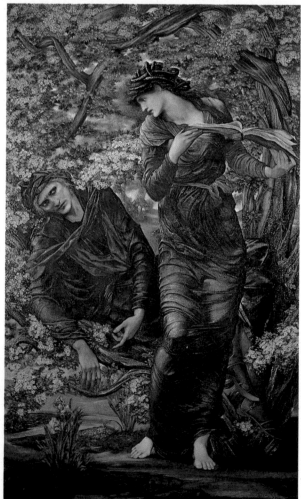

28

Nineteenth-century art history is littered with '-isms' and Symbolism has recently become the vogue word to describe the groundswell of imaginative reaction against Realism. Its stricter definition within the realm of literature makes it in many ways unsatisfactory. The artistic reaction set in more than a decade before the Symbolist movement in literature, though the work of these artists was often extolled by the Symbolist writers.

The term 'New Idealism' was coined to describe this reaction within the nineteenth century, while the little used 'Neo-Romanticism' is perhaps the most accurate. This underlines the link between the first Romantic age and the late-century resurgence of imaginative art. Neo-Romantic painting took many forms, its principal feature being a renewed interest in the spiritual content of subject matter.

Particularly characteristic of the period, however, is the use of a richly ornamental style to create a world of decadence, death, myth and magic. Gustave Moreau in France created jewelled palaces of decadence, as in his *Orpheus* (29); Burne-Jones in England wove magical tapestries from Arthurian legend in such paintings as *The Beguiling of Merlin* (28); Hans Makart in Vienna built, on the Rubens tradition, a world of richly costumed dreams as, for example, in his *Death of Cleopatra* (27); Arnold Böcklin, the most influential artist of his age in the German-speaking world, having begun life as a Realist landscape painter, adopted or evolved his own myths to symbolize the forces of nature, as in *The War* (30).

27 HANS MAKART *Death of Cleopatra* 1874-5

28 SIR EDWARD BURNE-JONES *The Beguiling of Merlin* 1874

29 GUSTAVE MOREAU *Orpheus* 1865

30 ARNOLD BÖCKLIN *The War* 1896

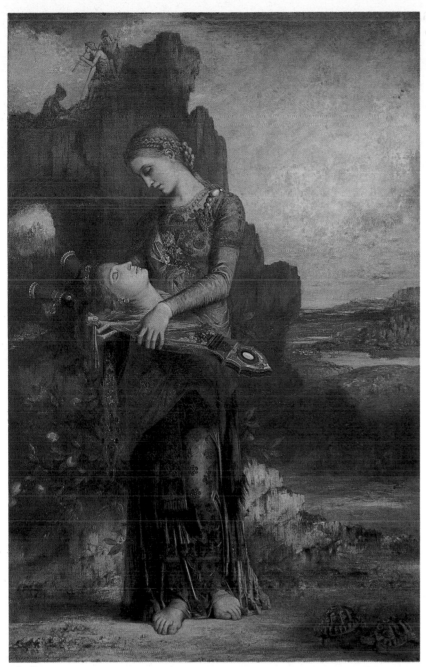

29

30

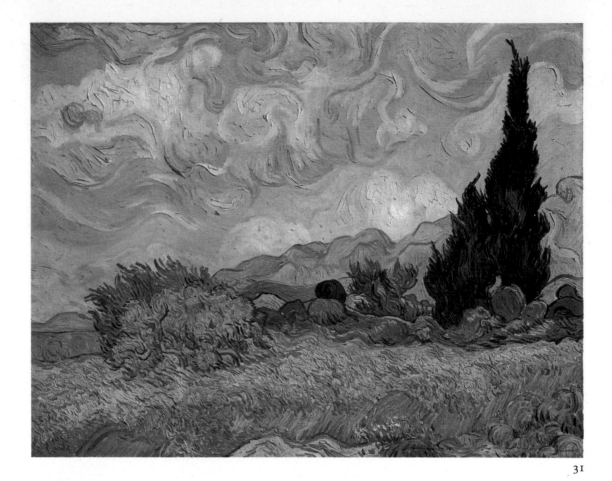

31

Expressionism is a term normally only applied to twentieth-century artists, but it has its roots in the nineteenth century among those painters who sought to externalize their inner emotions on canvas. Virtually ignored in their own century, the work of Van Gogh and Munch has provided a starting point for many twentieth-century artists.

Van Gogh's violent inner vision finds outlet in flaming landscapes such as *A Cornfield with Cypresses* (31). In Munch's later work the pent up psychological strain of his traumatic early life is expressed in the wild and lonely images of such a painting as *The Cry* (32).

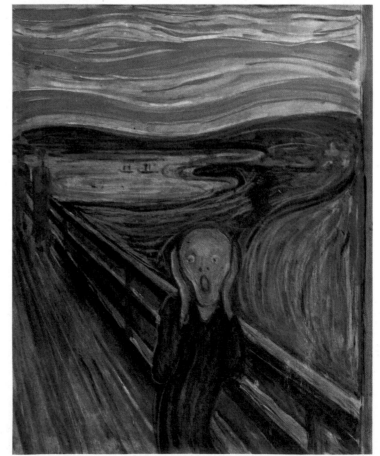

31 VINCENT WILLEM VAN GOGH *A Cornfield with Cypresses* 1889

32 EDVARD MUNCH *The Cry* 1893

32

I have relied entirely on published material and more on general works than individual biographies. The dictionaries of Bénézit and Thieme-Becker have been very useful, the latter being more reliable.

The listing of museums in this book is, inevitably, not exhaustive and should serve only as a starting-point for further scholarly research. Paintings by those academic artists whom twentieth-century art historians have tended to ignore are often in store, the accessibility of reserve collections varying from museum to museum. In national capitals with more than one gallery containing nineteenth-century paintings, I have indicated, when printed catalogues were available, where an artist's work is located. Many museums, however, only have catalogues of paintings on view. In some cases paintings are shifted from time to time between a city's museums. In Amsterdam the whole of the Fodor collection of nineteenth-century paintings, once housed in the Fodor Museum, is now in store, while the Stedelijk collection is only occasionally exhibited. In Brussels the paintings shown in the Modern Art Museum and those shown in the Ancient Art Museum are interchangeable; I have referred to both as 'Musées Royaux'.

American museums present special problems: through quite frequent buying and selling of paintings their collections are continually changing and consequently few catalogues are published. Sixteen museums have kindly checked through my list of artists and indicated whether they have examples in their collections: Baltimore Museum of Art; Walters Art Gallery, Baltimore; Boston Museum of Fine Arts; Albright-Knox Art Gallery, Buffalo; Fogg Museum, Cambridge Mass.; Art Institute of Chicago; Cincinnati Art Museum; Cleveland Museum of Art; Detroit Institute of Arts; Minneapolis Institute of Arts; Metropolitan Museum, New York; Brooklyn Museum, New York; Philadelphia Museum of Art (including the John G. Johnson loan collection); National Gallery of Art, Washington; Corcoran Gallery, Washington; Sterling and Francine Clark Art Institute, Williamstown Mass.

The bibliographies I have given for individual artists include only books entirely or almost entirely concerned with the painter in question. I have not given references to periodicals; for fashionable artists these can be found in a recent biography – for the unfashionable I would advise recourse to Thieme-Becker. Where much has been written about a single artist I have generally given only the more recent publications.

While this is primarily a dictionary with entries on artists and schools arranged in normal alphabetical order, the pages of colour illustrations which follow have been designed as a visual guide to the major artistic movements of the century. In general, painting, whether academic or *avant-garde*, French, European or American, followed a similar evolutionary pattern, from Neoclassicism, to Romanticism, to Realism to Neo-Romantic reaction or Symbolism.

Abbreviations

Acad.	Academy	Mo.	Missouri
Accad.	Accademia	Mod. Art	Modern Art
ARA	Associate Member of the Royal Academy of Arts, London	MOMA	Museum of Modern Art, New York
		Mus.	Museum
BM	British Museum, London	Nat.	National
C	century	NG	National Gallery
c.	*circa*	N.H.	New Hampshire
Ca.	California	N.J.	New Jersey
Conn.	Connecticut	Northumb.	Northumberland
		NPG	National Portrait Gallery, London
Dec. Art	Museum of Decorative Arts, Paris	N. Pin.	Neue Pinakothek, Munich
Fitzwm	Fitzwilliam Museum, Cambridge	N.Y.	New York
Fla.	Florida	Oxon.	Oxfordshire
Frankfurt/M.	Frankfurt-am-Main	Pa.	Pennsylvania
Hist. Soc.	Historical Society	Pub. Lib.	Public Library
Ind.	Indiana	RA	Member of the Royal Academy of Arts, London
Inst.	Institute		
Ky.	Kentucky	R.I.	Rhode Island
Lancs.	Lancashire	S.C.	South Carolina
Leics.	Leicestershire	Univ.	University
Lincs.	Lincolnshire		
Mass.	Massachusetts	Va.	Virginia
Md.	Maryland	V&A	Victoria and Albert Museum, London
Me.	Maine	Vt.	Vermont
Met.	Metropolitan Museum, New York	Yorks.	Yorkshire

Cross-references are indicated by SMALL CAPITALS

A

Academician. The major national and provincial academies of art generally have at any one time a fixed number of elected members known as 'academicians'. When a member dies or resigns a new member is elected. During the 19C this highly regarded honour gave the member certain executive responsibilities in organizing exhibitions and art teaching. The number of members varied widely: London's ROYAL ACADEMY had forty members and thirty associates from whom new members were elected; the holders of the fourteen chairs of painting in the French ACADÉMIE DES BEAUX-ARTS were automatically members of the INSTITUT. *See* FRENCH ART ESTABLISHMENT for a list of 19C academicians.

Academic Realism *see* REALISM

Académie des Beaux-Arts *see* FRENCH ART ESTABLISHMENT

Académie Julian. In 1873 Rodolphe Julian, a minor genre and portrait painter, started a painting school which proved so successful that he opened several branches in different parts of Paris. There was little formal teaching; he hired models and once a week a well-established artist, usually an ACADEMICIAN, would visit to criticize the students' work. These 'académies' were immensely popular with foreign artists who could not pass the stiff French language examination for the ECOLE DES BEAUX-ARTS, but they were also attended by many French artists. Among the foreign pupils were CORINTH, VALLOTTON and ZULOAGA. It was at the academy of the faubourg Saint-Denis that SERUSIER passed on his new-found enthusiasm for the SYNTHETISM of GAUGUIN to his NABI friends BONNARD, VUILLARD, DENIS and VALLOTTON. Among the visiting teachers were BOUGUEREAU and LEFEBVRE.

Academy (Academic). Academies of art are primarily educational institutions providing training in painting, sculpture, printmaking and – to lesser or greater extents – the applied arts. At the beginning of the 18C there were nineteen academies in existence, by the beginning of the 19C two hundred and by its end some two thousand. There are three main reasons for this proliferation: an idealistic belief in the value of raising standards of taste among the public at large; national and civic pride; and commercial competition which required high standards of artistic design. The major national academies were often supported by the state (notably in France) while provincial academies were willingly supported by the local community to whose prestige they added. The academies played a crucial role in 19C artistic development through their virtual monopoly of art teaching, their responsibility for or influence over major exhibitions (SALON, ROYAL ACADEMY Exhibitions) and the prestige that membership accorded to successful artists.

The first academies of art were founded in Italy in the 16C (Florence, Rome, Perugia, Turin). The French Académie Royale de Peinture et de Sculpture was founded in 1648 on the model of the Italian academies, and most of the 18C and 19C foundations were in their turn based on the French academy. Thus the academic system was grounded in Renaissance classicism; academic teaching in the 19C remained basically classical in its orientation and the differences in practice between the various national institutions were generally of a minor nature. The art student began by copying engravings, moved on to drawing from plaster casts of classical sculptures, and then to drawing from the live model. There was generally no formal instruction in painting, though students were expected to make extensive copies from Old Masters.

Among the academies most influential during the 19C must be numbered Antwerp, Brussels, Copenhagen, Dresden, Düsseldorf, London, Munich and Paris; other major institutions included Amsterdam, Berlin, Florence, Frankfurt (Städelsches Kunstinstitut), The Hague, Madrid, Milan, Naples, New York, Philadelphia, Rome, St Petersburg (where students were enrolled as young children) and Vienna. *See also*: ACADEMICIAN, AMERICAN ACADEMY OF FINE ARTS, DÜSSELDORF SCHOOL, FRENCH ART ESTABLISHMENT, NATIONAL ACADEMY OF DESIGN, ROYAL ACADEMY.
Lit. N. Pevsner: *Academies of Art* (1940)

Achenbach Andreas, b. Kassel 1815, d. Düsseldorf 1910. One of the pioneers of REALIST landscape painting in Germany, he was a leading light of the DÜSSELDORF SCHOOL at the height of its influence both in northern Europe and in America. He entered the Düsseldorf Academy at twelve and first exhibited at the KUNSTVEREIN at fourteen; he studied under SCHADOW and SCHIRMER. A visit to Holland in 1832–3 established his interest in naturalistic landscape, in which he was further encouraged by his friend GURLITT. In 1835, with RETHEL, he left Düsseldorf for Munich and Frankfurt. From this period date his first popular successes, *The Wreck of the President* and *Hardanger Fjord*. Between 1835 and 1845 he travelled widely, most importantly to Norway, Denmark and Sweden and to Italy. From 1846 he lived in Düsseldorf, allying himself politically with the revolutionary socialism of the Düsseldorf Realists, but he often revisited Norway and Italy. While he portrayed the landscape of many parts of Europe, his favourite subjects were stormy views of the North Sea and the windmills of Holland. His early works were tightly painted with careful detail; from the 1840s his brushwork became broader and he adopted a strong impasto. His work won international recognition; he was made a knight of the Order of Leopold of Belgium, chevalier of the French Legion of Honour and a member of the academies of Amsterdam, Antwerp and Berlin. Nevertheless he outlived his fame; his later work degenerated into mechanical repetition. OSWALD ACHENBACH was his brother and pupil. He is represented in most German museums and especially well in Düsseldorf, Frankfurt/M. and Munich. There are works

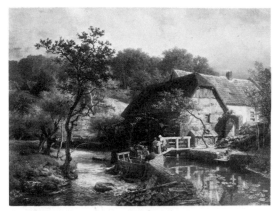

A. Achenbach *Westphalian Watermill* 1863

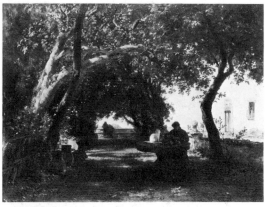

O. Achenbach *Italian Monastery Garden c.* 1857

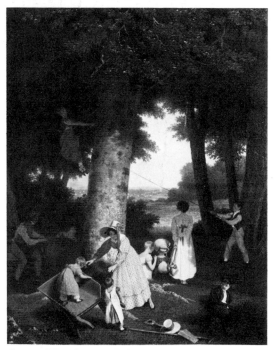

Agasse *The Playground* 1830

in Baltimore (Walters), London (Wallace) and New York (Met.).
Lit. B. Lasch: *A. Achenbach* (1934)

Achenbach Oswald, b. Düsseldorf 1827, d. Düsseldorf 1905. The younger brother of ANDREAS ACHENBACH, he also played an important part in the spread of REALIST landscape painting in Germany. His subject matter is chiefly drawn from Italy, where he spent much time; it gave him a taste for strong colour effects which he caught with loosely flowing brushwork. The inclusion of processions, village festivals and public gatherings sometimes gives his work an anecdotic flavour. He entered the Düsseldorf Academy at the age of twelve, leaving after two years to study in his brother Andreas's studio, and showed an early interest in painting directly from nature. Travels in Bavaria, Switzerland and northern Italy crystallized his style; the work of GURLITT was also a formative influence. He taught at the Düsseldorf Academy (1863–72). There are works in many German museums, including Berlin, Düsseldorf and Munich; he is also represented in Baltimore (Walters), New York (Met.) and Philadelphia (Mus. of Art).
Lit. C. Achenbach: *O. Achenbach in Kunst und Leben* (1912); J. H. Schmidt: *O. Achenbach* (2nd ed. 1946)

Adam Albrecht, b. Nördlingen 1786, d. Munich 1862. Adam belongs to the group of Bavarian 'little masters' of landscape and genre (W. KOBELL, WAGENBAUER, DORNER) who flourished at the opening of the 19C, combining a carefully finished style in the classical tradition with unaffected naturalism in composition. He took part in many of the military campaigns of his time and was highly regarded as a battle painter. His first studies were with C. Zwinger in Nuremberg; he moved to Augsburg (1806) where he studied with Rugendas, and to Munich in 1807. In 1809 he accompanied the Bavarian army in Napoleon's campaign against Austria and was appointed court painter by Eugène Beauharnais (*Battle of St Michael, Battle of Raab*). From sketches he made when he accompanied Beauharnais on the 1812 Russian campaign, he later executed a series of a hundred lithographs, assisted by his sons Franz and Benno, under the title *Voyage pittoresque et militaire de Willenberg en*

Prusse jusqu'à Moscou, fait en 1812 etc. (1827). In 1848, already in his sixties, he was back with the Austrian army in Italy painting the battles of Vicenza and Novara for Kaiser Franz Josef and those of Custozza and Novara for Ludwig I of Bavaria. His campaigns gave him a special fascination with horse painting; in times of peace he was highly regarded for his equestrian portraits and sporting groups, and he also painted farm-horses at work in the Bavarian landscape. Franz Adam was a faithful assistant until his father's death, after which he made a personal reputation with genre and military pictures, especially those depicting the Franco-Prussian War. Benno made a name as an animal and sporting painter. There are works in Berlin, Cologne, Darmstadt, Hamburg, Hanover, Kaliningrad, Munich, Stuttgart, Vienna and Weimar.
Lit. A. Adam: *Aus dem Leben eines Schlachtenmalers* (autobiography 1886); H. Holland: *Schlachtenmaler A. Adam und seine Familie* (1915)

Aesthetic Movement. A literary and artistic reaction to the prosperous middle-class morality of Victorian England. Its guiding principle, 'art for art's sake', was imported from the Bohemian world of French artists and poets dominated by Charles Baudelaire, as was the decadent fascination with the pursuit of sensation. Among the chief literary figures of the movement were Wilde, Swinburne and Pater. In art the period is characterized by the lush poetic imagery of ROSSETTI and BURNE-JONES, the 'Nocturnes' and 'Symphonies' of WHISTLER, emphasizing his search for a musical harmony of tone and colour, and the decadent arabesques of the drawings of BEARDSLEY.
Lit. W. Gaunt: *The Aesthetic Adventure* (1945); E. Aslin: *The Aesthetic Movement* (1969)

Agasse Jacques Laurent, b. Geneva 1767, d. London 1849. Swiss genre, landscape and animal painter. He lived extensively in England and the influence of the SPORTING SCHOOL is reflected in his works of intimate charm and careful finish. He studied in Paris (1786–9) with DAVID and C. VERNET, and was a close friend of TÖPFFER, with whom he collaborated on some paintings. He visited London (1790) on the invitation of Lord

Rivers, and settled there in 1800. His work is best represented in Geneva.
Lit. D. Baud-Bovy: *Peintres genèvois*, Vol. II, '1766–1849: Töpffer, Massot, Agasse' (1904)

Aivazovsky (Ayvazovsky, Ajvazowski) Ivan Constantinovich, b. Feodosia 1817, d. Feodosia 1900. Marine painter, a forerunner of REALIST landscape painting in Russia, who achieved an international reputation. He studied at the St Petersburg Academy (1833) under Vorobyov and the French marine painter P. Tanneur, but formed his style by copying Claude Lorrain and J. Vernet at the Hermitage. He travelled through Europe to Rome (1839) on a state grant, also visiting Germany, Austria, Spain, Portugal, England and Holland. In 1844 he returned to St Petersburg, where he was appointed court marine painter and executed a series of views of Russian ports commissioned by Tsar Nicholas I. He visited Asia Minor in 1846 and became professor at St Petersburg in 1847. *Four Seasons*, exhibited in Paris in 1857, earned him the Legion of Honour. He paid an extended visit to Constantinople in 1875, receiving several commissions from the Sultan Abdul-Aziz. A member of the Amsterdam Academy (1844) and the Florence Academy (1875), he claimed to have painted over four thousand canvases. There are works in Feodosia, Helsinki, Leningrad (Russian Mus.) and Moscow (Pushkin, Tretiakov).
Lit. T. I. Bulgakov: *I. K. Aivazovsky and his Works* (1901, in Russian)

Aligny Claude Félix Théodore (called Caruelle d'Aligny), b. Chaumes 1798, d. Lyons 1871. A classical landscapist in the tradition of VALENCIENNES, he was the friend and instructor of COROT in Rome. With careful draughtsmanship and cool colours, his paintings set scenes from ancient history and mythology, the Bible and European history in reconstructed historical landscape settings. He studied with REGNAULT, paid a lengthy student visit to Rome and first exhibited in Lyons in 1822 (*Daphnis and Chloe*). He won the Legion of Honour in 1837 and was appointed director of the Lyons Ecole des Beaux-Arts in 1860. There are several works in Paris (Louvre) and he is represented in a number of French provincial museums, notably Lyons, and in Boston.

Allston Washington, b. Georgetown (S.C.) 1779, d. Cambridgeport (Mass.) 1843. History and landscape painter, considered the inaugurator of ROMANTIC landscape in America. After studying at the ROYAL ACADEMY with WEST (1801–3), he visited Paris (1803–4) and Italy (1804–8), where he formed close friendships with S. T. Coleridge, Washington Irving and THORWALDSEN. He was in the U.S. from 1808 to 1811, when he returned to London with MORSE, his pupil. His first major painting, showing his taste for the fantastic, was *Dead Man Revived by Touching the Bones of Elisha* (1811–13); it won him two hundred guineas from the British Institution. In his landscapes, Poussin and Claude were formative influences, but he also admired FUSELI, TURNER and J. MARTIN. *The Deluge* (1804), *Diana in the Chase* (1805) and *Elijah in the Desert* (1818) are seen as the first important achievements of American landscape, all in dramatic vein. In 1818 he returned to America, settling first in Boston and then (1830) in Cambridgeport. His fantasy turned to a gentler mood of mystery with *Moonlit Landscape* (1819) and *The Flight of Florimell* (1819). A huge canvas of *Belshazzar's Feast* (1817–43) marred his later career; it was to be his masterpiece but, after bringing it unfinished from London, he worked on it 1820–8 and from 1839 to his death, never achieving the effect he desired. There are works in many American museums, including Baltimore (Mus. of Art), Boston, New York (Met., Brooklyn) and Washington (Corcoran). There is a portrait of Coleridge in London (NPG).
Lit. W. Allston: *Lectures on Art and Poems* (1850); J. B. Flagg: *Life and Letters of W. Allston* (1892); E. P. Richardson: *W. Allston* (1948)

Alma-Tadema Sir Lawrence, b. Dronrijp 1836, d. Wiesbaden 1912. A painter of scenes of daily life in ancient Greece, Rome and Egypt; he paid particular attention to the rendering of surfaces and textures, marbles, bronze, flowers, rich silks, etc. The scenes are often anecdotal, generally concerning beautiful women (*A Silent Greeting, A Favourite Custom, A Foregone Conclusion*). His work, which was popular in America, helped to form the Hollywood vision of life in ancient times. He was born in Holland but forged his success in England, becoming a

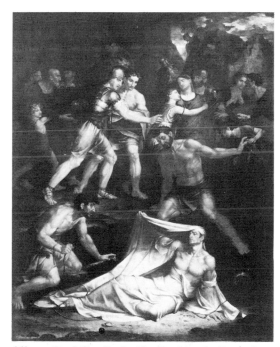

Allston *Dead Man Revived by Touching the Bones of Elisha* 1811–13

Alma-Tadema *A Favourite Custom* 1909

naturalized British subject in 1873. He studied at the Antwerp Academy (1852-8) with WAPPERS and LEYS, assisting the latter with his Antwerp Stadhuis frescoes in 1859. His early work shows him a close follower of Leys, painting carefully finished scenes of medieval life. A visit to Italy and Pompeii in 1863 began his interest in Roman, Greek and Egyptian antiquity. He exhibited *Pyrrhic Dance* in 1869 at the ROYAL ACADEMY and moved to London the following year. His style, immensely popular in Britain, changed little over the years. ARA in 1876, RA in 1879, he was knighted in 1899. He numbered his paintings with Roman numerals after 1850, the last being CCCCVIII. There are works in Baltimore (Walters), Boston, Cardiff, Cincinnati, Cambridge Mass. (Fogg), Dordrecht, London (Tate, V&A, Guildhall), Philadelphia, The Hague (Mesdag) and Washington (Corcoran).
Lit. G. Ebers: *Alma-Tadema* (1885); P. Cross-Standing: *Sir L. Alma-Tadema* (1905)

Alt Rudolf von, b. Vienna 1812, d. Vienna 1905. Oil and watercolour landscape, architectural and interior painter, 'the leading virtuoso of landscape watercolours on the European Continent' (Novotny). A fine naturalist painter, he has been hailed as inventing IMPRESSIONISM before the Impressionists. From careful linear draughtsmanship, the legacy of his artist father Jakob, he evolved *c.* 1840 towards free sparkling brushwork. After long years of struggle and hard work, he began to achieve fame and honours in the late 1870s. He studied with his father, who influenced his early style, and at the 'historical school' of the Vienna Academy (1826). His style matured during extensive travels in Austria, Italy, Bohemia, Germany and Belgium, while Prague, in particular, inspired his favourite and often repeated architectural views. He earned a regular income by depicting in watercolour the interiors of noble residences, and became president of the Vienna Kunstler-Genossenschaft (1874) and a member of the Berlin Academy. He won a gold medal at the Philadelphia Centennial Exhibition (1876), and became a professor at the Vienna Academy in 1879. In 1892 he was knighted ('von') and elected a member of the Vienna Academy and the Société Royale Belge des Aquarellistes. For his ninetieth birthday the

Vienna SECESSION, of which he became honorary president in 1898, held a special exhibition. His brother Franz was also a landscape and architectural painter. There are works in Baltimore (Walters), Hamburg, Leipzig, Venice and Vienna.
Lit. L. von Hevesi: *R. von Alt, sein Leben und sein Werk* (1911); L. Münz: *R. von Alt, 24 Aquarelle* (1954); F. Hennings: *Fast hundert Jahre Wien: R. von Alt, 1812-1905* (1967)

Aman-Jean Edmond François, b. Chevry-Cossigny 1860, d. Paris 1936. French painter, pastellist and lithographer. His simple intimate paintings, often female studies, are informed with a slightly mysterious poetry which reflects on the one hand his admiration for ROSSETTI and BURNE-JONES, on the other his involvement with French SYMBOLIST artists and writers. In his later work he turned to an INTIMISTE style much influenced by BONNARD. He studied under LEHMANN at the ECOLE DES BEAUX-ARTS (1880) where he met SEURAT, with whom he shared a studio for several years. He exhibited first at the official SALON (*St Genevieve* 1886), at the first two SALONS DE LA ROSE+CROIX (1892 and 1893), and regularly at the Salon de la Société Nationale (*Alone* 1896). In 1924 he was co-founder with BESNARD of the Salon des Tuileries. There are works in Dijon, Douai, Lyons, Metz, Paris (Dec. Art, Louvre), Reims and Stuttgart.

American Academy of Fine Arts. Originally named the New York Academy of Fine Arts, it was founded in 1802 by a group of connoisseur-amateurs and a few painters to be 'a germ of those arts so highly cultivated in Europe, but not yet planted here'. The classical casts in its first exhibition (1803) were soon stored away unseen and, though renamed the American Academy of Fine Arts, it remained 'an expiring taper' until VANDERLYN returned from Europe with the casts and copies of Old Masters which he had collected for the Academy (1815). The same year TRUMBULL was elected president, and annual exhibitions were launched at which modern American pictures were exhibited among the Old Master copies and casts. After a few years of success, however, its popularity waned and the institution was dissolved in 1839.
Lit. B. Cowdrey (ed.): *American Academy and Art-Union Exhibition Record* (1953)

American Art-Union. Based on the principle of the provincial German KUNST-VEREIN, the immensely successful Art-Union came into existence in 1839. Raffle tickets were sold all over the U.S., and with the proceeds paintings were purchased as prizes for the winning tickets. The losers each received a large engraving. At the Art-Union gallery in New York, open from April to October, aspiring artists showed paintings which they hoped to sell to the Union; the number of paintings purchased increased from 36 in the first year to 395 in 1851. The Union purchased only works by living American artists working at home or abroad. It spread the taste for picture-collecting throughout the country and financially underpinned the flowering of the native school of landscape and genre. Among the artists whose reputation it made were BINGHAM, INNESS, JOHNSON, MOUNT and WOODVILLE. In 1848 a series of four paintings by COLE, *The Voyage of Life*, was offered and membership rose from 9,666 to 16,475. In the following year the Union paid its highest ever prices for three historical works – $1,500 for Gray's *The Wages of War*, $1,200 for Huntington's *St Mary and Other Holy Women at the Sepulchre*, $1,000 for *The Attainder of Strafford* by LEUTZE – to the chagrin of landscape and genre painters; the average price paid was around $100. The Union was run by merchant-amateurs who in the later years fought with both the artists and the NATIONAL ACADEMY OF DESIGN. A legal battle ended in 1852 with the closure of the Union as an illegal lottery. Its success had brought about the establishment of the Western Art-Union in Cincinnati in 1847, the Philadelphia Art-Union in 1848, Trenton's New Jersey Art-Union in 1850 and Boston's New England Art-Union in 1850. The *Bulletin of the American Art-Union*, America's first art magazine, was inaugurated in 1848.
Lit. B. Cowdrey (ed.): *American Academy and Art-Union Exhibition Record* (1953)

Amerling Friedrich von, b. Vienna 1803, d. Vienna 1887. Austria's most acclaimed portraitist of the 19C, he combined BIEDERMEIER naturalism with flowing brushwork and elegant composition, reflecting his schooling with LAWRENCE and the influence of the English school; his female portraits

and occasional groups (*The Arthaber Family* 1837) were particularly admired. After studying at the Vienna Academy (1816–23/4) and at the Prague Academy, he worked under Lawrence in London (1827) and under H. VERNET in Paris (1828). His portraits became popular in the 1830s (*Kaiser Franz in the Uniform of a Prussian General* 1834). He spent 1831–2, 1836 and 1840–3 in Italy; during his last visit he developed a secondary speciality in romantic single figure subjects. He also painted landscapes, which he did not sell, for his own pleasure. There are works in Berlin, Graz, Munich and Vienna (Belvedere).
Lit. L. A. Frankl: *F. von Amerling, ein Lebensbild* (1889); G. Probszt: *F. von Amerling: Der Altmeister der Wiener Porträtmalerei* (1927)

Ancher Anna Kirstine (née Brondum), b. Skagen 1859, d. Skagen 1935. Painter of interiors and genre, combining the influences of the IMPRESSIONISTS and the Dutch school. 'She was one of those rare colouristic geniuses – a Danish Berthe Morisot' (Poulsen). She studied in Copenhagen (1875–9), and after her marriage to MICHAEL ANCHER in 1880 lived a simple life in the fishing village of Skagen, her birthplace, which in the 1880s became a centre for Denmark's *plein air* painters. Her gentle intimate scenes of village life have led some to name her as the most original painter of the group. She became a member of the Copenhagen Academy in 1904. Her work is represented in Copenhagen (Hirschsprung, Ny Carlsberg Glyptotek, State).

Ancher Michael Peter, b. Rutsker 1849, d. Skagen 1927. Painter of fishermen and the sea, with a REALIST accent on the harsh life of the weatherbeaten men. He was one of the Danish *plein air* painters who gathered in the fishing village of Skagen during the 1880s. He studied at Copenhagen Academy (1871–5) before moving to Skagen, where he married Anna Brondum (ANCHER). His impressionistic brushwork probably developed under the influence of KRØYER, who spent much time in Paris; Ancher's first visit to France was in 1889–90. He acknowledged a debt to Dutch painting, especially Vermeer. He became a member of the Copenhagen Academy in 1889. There are works in

Alt *Peasant's Room in Seebenstein* 1853

Amerling *The Lute Player* 1838

A. K. Ancher *Interior with a Young Girl Plaiting her Hair* 1901

Aarhus, Budapest, Copenhagen (Hirschsprung, State) and Oslo (NG).

Lit. J. J. Jensen: *Jydske Folkelivsmalere, Dalsgaard, M. Ancher, Hans Smidth* (1937)

Ancients, The. A student group formed around 1824 by PALMER and his friends, who considered BLAKE their prophet and inspiration. In addition to Palmer, the group was composed of the painters Edward Calvert and George Richmond, the sculptor and miniaturist Frederick Tatham and his brother Arthur, an undergraduate later to become a prebendary, the watercolourists Henry Walter and Francis Oliver Finch, the draughtsman and engraver Welby Sherman, and John Giles, a future stockbroker. Giles had a special passion for the Middle Ages and it was his constant references to the superiority of 'the ancients' that led to the adoption of the name. During Palmer's Shoreham years the friends were constant visitors, making music, reading poetry, acting scenes from Mrs Radcliffe's novels, walking the hills in the moonlight and amazing the local peasantry. Blake's woodcuts illustrating Virgil's *Eclogues* inspired works of pastoral magic from Palmer, Calvert and Richmond at this period. By 1830 the members of the group were beginning to grow apart.

Angrand Charles, b. Criquetot-sur-Ouville 1854, d. Rouen 1926. A close associate of SEURAT and SIGNAC, whom he met in 1884 during the discussions over the founding of the SALON DES INDÉPENDANTS. He painted scenes of rustic life, orchards, farmyards and harvest scenes, first in an IMPRESSIONIST style but later adopting the DIVISIONIST technique under the influence of Seurat. He experimented with the use of large dashes of colour in place of Seurat's small dots and also worked extensively in pastel and charcoal. There are works in Copenhagen (Ny Carlsberg Glyptotek), Geneva, Paris (Louvre) and Tournai.

Lit. R. Welsh-Oucharou: *The Early Works of C. Angrand* (1971)

Anker Albert, b. Ins (Berne) 1831, d. Ins 1910. Genre painter whose carefully painted scenes of peasant life in the region round Berne appealed to Swiss nationalism in the 1860s so that public collections competed to commission and buy his work. *Afternoon Prayer* (1861) launched his fame and was bought by the city council of Neuchâtel; a large canvas of *The Village School* was commissioned for Berne in 1864 and widely exhibited. He often painted children and these works achieved considerable popularity outside Switzerland, winning him a gold medal at the 1867 EXPOSITION UNIVERSELLE. He studied theology in Berne before taking up painting in Paris, working with GLEYRE and at the ECOLE DES BEAUX-ARTS. He first exhibited in the SALON of 1859. He spent winters in Paris and summers in Switzerland, settling again at Ins only in 1890. There are works in Basle (Kunstmuseum), Berne, Geneva (Rath), Lille, Neuchâtel and Sheffield.

Lit. M. Quinche-Anker: *Le Peintre A. Anker 1831–1910, d'après sa correspondance* (1924); C. von Mandach: *A. Anker* (1941); H. Zbinden: *A. Anker in neuer Sicht* (1961)

Anquetin Louis, b. Etrépagny 1861, d. Paris 1932. French painter who collaborated with BERNARD in the development of CLOISONNISM and was credited by several of his contemporaries as the pioneer of the style; GAUGUIN greatly resented the suggestion that he had been influenced by Anquetin. In Paris (*c.* 1882) he entered Cormon's studio, where he became a friend of TOULOUSE-LAUTREC and VAN GOGH, who introduced him to Japanese prints. His early work showed the influence of DELACROIX and Michelangelo; this was succeeded by the influence of DEGAS, MONET and Japanese prints. In 1886 the exhibition of the *Grande Jatte* of SEURAT persuaded him to experiment with POINTILLISM; he was influenced away from this style by Bernard and the friends began to develop the Cloisonnist technique (*The Mower* 1887). He exhibited in the SALON DES INDÉPENDANTS, and with the Société Nationale. In the mid-1890s he turned to a more traditional style, based primarily on the example of Rubens (*The Combat* 1896). There are works in La Rochelle, London (Tate) and Paris (Mod. Art).

Appiani Andrea, b. Milan 1754, d. Milan 1817. One of the most celebrated of Italy's NEOCLASSICAL painters, he worked mainly in fresco. Born and bred in Milan, he had no direct contact with the Roman classicism of Winckelmann and MENGS; his work shows an independent study of nature combined with grace and colour inherited from the 15C Lombard school. The debt to Luini and Correggio is particularly marked. After studying under C. M. Giudici, who had in turn learnt his classicism in Rome, he assisted Trabellesi and Knoller with frescoes in Milan and Monza, the *Amor and Psyche* (1789) frescoes at Monza being among his first independent work. His reputation was confirmed by the frescoes for S. Maria sopra S. Celso in Milan (1792–5). Upon the arrival of the French in Milan (1796), he was appointed Napoleon's court painter in Italy. He executed several fresco cycles for the Royal Palace in Milan, the most notable being a frieze of Napoleon's victories in chiaroscuro, imitating bas-reliefs. The first Italian artist to tackle contemporary history, he achieved a realism unknown to his contemporaries. His portraits combine classical simplicity with Renaissance grace (*Napoleon, General Desaix, Signora Angiolini*). In addition to his frescoes in Milan and Monza, there are works in Baltimore (Walters), Brescia, Florence (Uffizi), Milan (Brera), Rome (Mod. Art) and Versailles.

Lit. G. Marangoni: *La rotonda dell'Appiani nella villa reale di Monza* (1923); A. Zappa: *A. Appiani e l'arte neoclassica nel suo spirito e nella sua derivazione litteraria* (1921); M. Borghi: *I disegni di A. Appiani nell'Accademia di Brera* (1948)

Art Nouveau. A decorative style which flourished throughout Europe and America *c.* 1880–1910. Its central feature is the exaggerated ornamental use of the curved line, inspired both by vegetable forms and Japanese prints. The origins of the movement seem to be mainly English: the later paintings of ROSSETTI, the designs of MORRIS, the drawings of BEARDSLEY. The style quickly spread across Europe and was applied to architecture, ceramics, glass, furniture, silver, book illustration, bookbinding – every field of the applied arts. Among the most significant exponents can be counted KLIMT and the SECESSION group in Austria, a parallel group in Munich with their magazine *Jugend*, Gallé and his glassworks in Nancy, the Spanish architect Gaudi and his followers in Barcelona, Tiffany in America, and the Belgian painter turned designer VAN DE VELDE and his followers. In Paris it reached a high point in the art of the poster, to which TOULOUSE-LAUTREC,

STEINLE, CHÉRET and MUCHA notably contributed. Art Nouveau was the name of a shop opened in Paris by Samuel Bing in 1895. The style is known under many different names in different countries: Jugendstil (from the Munich magazine), Stile Liberty (from the London shop which promoted Art Nouveau design), Style Nouille, Style Metro (the French undergrounds were so designed), Sezessionstil.
Lit. P. Selz and M. Constantine (eds.): *Art Nouveau: Art and Design at the Turn of the Century* (1960); M. Amaya: *Art Nouveau* (1966); S. T. Madsen: *Art Nouveau* (1967)

Arts and Crafts. A movement which began in Britain where Ruskin, MORRIS and others, disgusted by the shoddy products of industrial mass production, sponsored a return to hand craftsmanship. They aimed at 'recovering for decoration . . . its place among the fine arts', and also at a social revolution with design by the people for the people. Artists in England and all over Europe became involved in the applied arts, in designing stained glass, ceramics, bookbindings and illuminations. The Arts and Crafts Exhibition Society was founded in 1888 under the presidency of CRANE, and the movement flourished well into the 20C.
Lit. T. J. Cobden-Sanderson: *The Arts and Crafts Movement* (1905); H. Read: *Art and Industry* (1934); G. Naylor: *The Arts and Crafts Movement* (1971)

Audubon John James, b. Les Cayes (Haiti) 1785, d. New York 1851. American artist-ornithologist and painter of wild life in its natural setting. He spent his youth in France and studied for a short period with DAVID. In 1803 he went to the U.S., where he discovered a taste for hunting and natural history; he took up taxidermy, and travelled extensively, making notes and drawings. After visiting England in 1826 to arrange for the publication of *Birds of North America* (1827–39), containing 435 colour plates, he divided his life between the U.S. and Britain. He became an honorary member of the NATIONAL ACADEMY OF DESIGN in 1833. His original drawings are in New York (Hist. Soc.).
Lit. A. Ford: *J. J. Audubon* (1964); A. B. Adams: *J. J. Audubon, A Biography* (1967)

Appiani *General Desaix* 1800

B

Backer Harriet, b. Holmestrand 1845, d. Oslo 1932. With KROHG, one of the leading Norwegian painters at the turn of the 19C, a social REALIST specializing in peasant interiors. Trained in Munich and Paris, she was strongly influenced by the HAGUE SCHOOL. She ran a private painting school in Oslo (1890–1909) and had much influence on the succeeding generation of Norwegian painters. There are works in Drontheim, Oslo (NG) and Stavanger.
Lit. E. C. Kielland: *H. Backer, 1845–1932* (1958)

Bakker-Korff Alexander Hugo, b. The Hague 1824, d. Leiden 1882. Painter of small cabinet genre scenes, known in his day as 'the Dutch Meissonier'. His favourite theme was vivacious aging spinsters, chatting in their drawingroom, admiring a plant or vase, sewing, playing the piano, etc. He lived with his sisters who often modelled for him; their furnishings are depicted with the sharp eye of a still-life painter. He studied with KRUSEMAN and at the Hague Academy under J. E. J. van den Berg; in Antwerp he studied with WAPPERS and DE KEYSER. His early works are biblical and historical canvases in the manner of his masters, and he also executed pen drawings in the manner of FLAXMAN and RETHEL. In 1848 he retired to Oegstgeest, where he developed his own style of painting in miniature, before settling in Leiden (1856). There are works in Amsterdam (Rijksmuseum, Stedelijk), The Hague, Haarlem (Teyler) and Leiden (Lakenhal).

Barabás Miklós, b. Markusfalva 1810, d. Budapest 1898. Popular Hungarian portrait and genre painter of the mid-century who painted the first genre scenes of daily life in

Barabás *The Arrival of the Bride* 1856

33

Hungary, works which achieved wide popularity through reproduction. A largely self-taught and immensely prolific artist, his later work tended to lapse into well-worn formulas. His portrait drawings were already appreciated in Hungary when he entered the Vienna Academy (1830) for a year, before moving on to Bucharest where his portraits earned him a considerable fortune, allowing him to make an extended visit to Italy (1833-40), where he conscientiously copied Old Masters. In 1840 he settled in Budapest, where society doted on him and showered him with commissions. The good public reception of his studies of street-sweepers, tinkers and gypsies encouraged him to paint larger and more ambitious scenes of Hungarian life (*Family Travelling in Transylvania* 1843). He exhibited successfully in Vienna and became the first president of the Budapest School of Fine Arts. He helped to stimulate active interest in the arts in Hungary and had many imitators and followers. There are works in Budapest (NG).
Lit. M. Barabás: *Barabás Miklós emlékiratai* (memoirs, 1902)

Barbizon School. Mid-19C French school of naturalistic landscape painting which takes its name from Barbizon, a village thirty miles south-east of Paris in the Fontainebleau forest, which became a centre for *plein air* painting. T. ROUSSEAU, the central figure of the school, first visited Barbizon in 1833 and paid frequent visits before settling there in 1848. He was joined by MILLET in 1849, and a colony of artists settled or visited there for shorter or longer periods. These included DUPRÉ, DIAZ DE LA PEÑA, TROYON, HARPIGNIES, COROT, HUET, DAUBIGNY and COURBET. An early ROMANTIC orientation, best exemplified by Huet's and Dupré's stormy landscapes, gave way to a REALIST endeavour to paint landscape and peasant life directly from nature with unprettified simplicity. Most typical are Rousseau's forest interiors. The principal influences on the school were the Dutch 17C masters, especially Ruysdael and Hobbema, and the English painters CONSTABLE and BONINGTON. The Barbizon painters were essentially colourists; they had learned with the help of CONSTABLE and DELACROIX that the manifold dappled and shimmering details of nature defied the academic ideal of high finish and could only

be caught with loose summary brushstrokes of contrasting colour. This is exemplified by the work of Rousseau, Diaz and Dupré and was taken to the threshold of true IMPRESSIONISM in Daubigny's later paintings. The Barbizon painters were initially rejected by the SALON and persecuted by the ACADEMICIANS; their acceptance by the art establishment began around the mid-1850s. Their popularity rose so steeply that a succeeding generation, including BRETON, LHERMITTE and BASTIEN-LEPAGE, could make dazzling academic careers with paintings of rural life that closely imitated the Barbizon masters. Many Impressionists also found their early inspiration in the *plein air* painting of the Barbizon School; MONET, RENOIR, SISLEY, SEURAT, CÉZANNE and BAZILLE all worked there for a time. The school also exerted a powerful international influence; the HAGUE SCHOOL, including J. ISRAËLS, the MARIS brothers and MAUVE, were their closest followers, while STIMMUNGSLANDSCHAFT had direct roots in Barbizon. INNESS is the most distinguished of the many Barbizon-influenced American landscapists; the school also had many followers in Russia, most notably LEVITAN. The MACCHIAIOLI in Italy owed an important debt to it. SEGANTINI and VAN GOGH are only two among the many copyists of Millet's peasants. By the turn of the century Barbizon was the most fashionable 'modern' school in the international art market.
Lit. J. W. Mollet: *The Painters of Barbizon* (1890); J. Bouret: *The Barbizon School* (1973); G. Pillement: *Les Pré-Impressionistes* (1973)

Barye Antoine Louis, b. Paris 1796, d. Paris 1875. French sculptor best known for his animal subjects (*Lion Crushing a Serpent* 1833, *Jaguar Devouring a Hare* 1850). His bronze groups became very popular with collectors. He studied with GROS, was a close friend of DELACROIX and shared the early struggles of the ROMANTICS; he frequently visited Fontainebleau and rented a house in Barbizon, where he made many landscape drawings, paintings and watercolours, often including figures of stags and other wild animals. He was made a chevalier of the Legion of Honour in 1833, an officer in 1855 and a member of the INSTITUT in 1865. There is a large collection of his work in the Louvre and others in Baltimore (Walters,

Maryland Inst.) and Washington (Corcoran).
Lit. C. O. Zienseniss: *Les Aquarelles de Barye* (1954); G. F. Benge: *The Sculpture of A. L. Barye in American Collections* (1969); S. Pivar: *Barye Bronzes* (1974)

Bastien-Lepage Jules, b. Damvilliers 1848, d. Paris 1884. Painter of peasant life, who used a palette and style close to those of the IMPRESSIONISTS. He owed his subject matter to MILLET, his technique to MANET. Zola called his art 'Impressionism corrected, sweetened and adapted to the taste of the crowd', and his popular success hastened the acceptance of Impressionism and spread its influence abroad. He also painted small portraits, hailed for their psychological depth. In 1867 he went to study in Paris at the ECOLE DES BEAUX-ARTS and with CABANEL, and first exhibited in the SALON of 1870. After being wounded in the siege of Paris, he spent two years convalescing at Damvilliers, painting country scenes. *Song of Spring*, exhibited in the Salon of 1874, was bought by the state, thus establishing his fame and fortune. One of his many pupils was Marie Baskirtscheff, an ardent romantic admirer, who died of consumption one month before he did; his last sketch was of her funeral. There are works in Dublin, Grenoble, The Hague, Lille, Montpellier, New York (Met.) and Paris (Louvre, Mod. Art).
Lit. A. Theuriet: *J. Bastien-Lepage, l'homme et l'artiste* (1885); A. de Fourcaud: *J. Bastien-Lepage, sa vie et ses œuvres* (1888); M. Baskirtscheff: *Journal intime* (1890)

Baudry Paul, b. La Roche-sur-Yon 1828, d. Paris 1886. Second Empire classicist, immensely admired and now best remembered for his frescoes, notably the decoration of the Paris Opéra. His inspiration was primarily drawn from the Italian 16C, Michelangelo, Raphael, Correggio and the Venetian colourists, though he added a Parisian sensuality to his nymphs, goddesses and muses: 'You can see that Music or Poetry's waist was laced up in a close-fitting corset before she sat for the picture' (Muther). He also painted portraits, and was influenced slightly by IMPRESSIONISM in later life, but his Renoiresque nudes were disdained by ACADEMICIANS and innovators alike. In 1844 he went to Paris, where he was a pupil of DROLLING at the ECOLE DES BEAUX-ARTS. After

winning the first Rome prize in 1850, he steeped himself in the 16C in Italy. He first exhibited in the SALON of 1852, and carried out his first fresco decorations in 1857. The Opéra frescoes were commissioned in 1866; he spent a year studying the Sistine Chapel and visited the Raphael cartoons in London in preparation. The frescoes were unveiled in 1874. He was commissioned to decorate the Panthéon with a Joan of Arc series, but died before carrying it out. There are works in Angers, Baltimore (Walters), Bayonne, Chantilly, Grenoble, Lille, Mulhouse, Nantes, Paris (Louvre), Rochefort, La Roche-sur-Yon, Rouen and Troyes.
Lit. C. Ephrussi: *P. Baudry, sa vie et son œuvre* (1878) and *P. J. A. Baudry* (1883); P. Bonnefon: *Les Etapes de la vie d'un peintre : P. Baudry d'après des lettres inédites* (1902)

Bazille Jean Frédéric, b. Montpellier 1841, d. Beaune-la-Rolande 1870. Short-lived companion and collaborator of the IMPRESSIONISTS in their early struggles. He came of a wealthy Languedoc family and was an important financial prop for both MONET and RENOIR. He arrived in Paris in 1862 with his father's permission to divide his time between studies of medicine and painting, and entered the studio of GLEYRE, where he formed a close friendship with Monet, Renoir and SISLEY. In 1864 he painted in Honfleur with Monet while waiting for the results of his medical examinations; after his poor results he was allowed to devote himself wholly to painting. In 1865 he shared his studio with Monet, in 1866 with Renoir and in 1867–8 with both. His work paralleled that of his friends, including landscape, still life and figure subjects. His most famous work is a painting of his family on the terrace of their country home, *The Artist's Family*; he painted a first version, later destroyed, in 1866 and a second which was exhibited at the SALON of 1868. *The Artist's Studio* (1870) gives a relaxed view of his friends in the rue de la Condamine studio, including Renoir, Zola, MANET, Monet and himself – a likeness painted in by Manet. He enlisted in a Zouave regiment in August 1870 and was killed on 28 November. Most of his works are in Montpellier and Paris (Musée de l'Impressionisme).
Lit. G. Poulain: *Bazille et ses amis* (1932); F. Daulte: *F. Bazille et son temps* (1952)

Beardsley Aubrey Vincent, b. Brighton 1872, d. Menton 1898. In his black and white drawings the spirit of *fin de siècle* 'decadence' was crystallized. His ornamental combination of sinuous line and dark masses was a formative influence on ART NOUVEAU; the drawings, which include a substantial series of erotica, tend to hold sinister undertones of corruption. They combine the contrasting influences of rococo, Botticelli and Japanese prints. He started drawing in his schooldays; his work came early to the notice of BURNE-JONES, who persuaded him to leave his job in a City insurance office and attend Westminster School of Art (1891). The five hundred or so illustrations for Dent's edition of Malory's *Morte d'Arthur* (1893–4) established his reputation; in 1894 he provided illustrations for Oscar Wilde's *Salomé* and *The Yellow Book*. A victim of the social purge of those connected with Wilde after the 1895 trial, he was rescued by publisher Leonard Smithers who in 1896 commissioned illustrations for Pope's *Rape of the Lock* and *Lysistrata*. He also provided illustrations for the *Savoy Magazine* and his own romance *Under the Hill*. In December 1897 he went to the South of France for the sake of his health, and died there of tuberculosis in March 1898. His drawings had an important influence on Art Nouveau designers in Germany, Austria and Belgium, and are echoed by many 20C artists. There are drawings in London (Tate, V&A).
Lit. A. E. Gallatin: *A. Beardsley : A Catalogue of Drawings and Bibliography* (1945); B. S. Harris (ed.): *Collected Drawings of A. Beardsley* (1967); B. Reade: *Beardsley* (1967); B. Brophy: *Black and White : A Portrait of A. Beardsley* (1968); H. Maas, J. L. Duncan, W. G. Good (eds.): *The Letters of A. Beardsley* (1971); M. Easton: *Aubrey and the Dying Lady* (1972); B. Brophy: *A. Beardsley and his World* (1976)

Begas Karl Joseph, b. Hainsberg (nr Aachen) 1794, d. Berlin 1854. Berlin historical painter and portraitist. His highly finished portraits owe a debt to INGRES and French classicism; his historical works echo the literary-theatrical preoccupations of the contemporary DÜSSELDORF SCHOOL. He studied in Bonn and with GROS in Paris (1813–21), where he painted several religious works, attracting the interest and patronage of King Friedrich Wilhelm III of Prussia. In Italy (1822–4), his

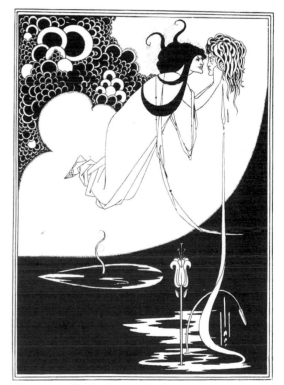

Bastien-Lepage *Harvesters* 1877

Beardsley *J'ai baisé ta bouche, Iokanaan* 1894

Bendemann *The Jews in Exile* 1832

Bendixen *River Landscape* 1815–32

interest in medieval painting, stimulated by the Boisserée collection in Stuttgart and Giotto's work in Padua, was extended by association with the NAZARENES in Rome. He settled in 1824 in Berlin, where he was appointed professor at the academy (1826) and was made an ACADEMICIAN (1829). He was much in demand as a portraitist and his historical paintings (*Lorelei* 1835) enjoyed great popular success. Around 1840 he turned to painting scenes from contemporary life under the influence of the BIEDERMEIER REALISTS. He was an influential teacher, contributing to the French orientation of the Berlin school. His son Rheinhold was one of the leading German sculptors of his day; his three other sons Karl, Oscar and Adalbert were also artists. There are works in most German museums, notably Berlin and Cologne.
Lit. L. Pietsch: *Die Künstlerfamilie Begas*

Belgian Colourists. A group of Belgian history painters who (*c.* 1830–40), reacting against the NEOCLASSICISM of DAVID, sought to infuse their paintings with the rich colour of Rubens and van Dyck, their Flemish predecessors. They had a wide international influence. WAPPERS, the pioneer of the movement, achieved immediate acclaim with his patriotic *Burgomaster van der Werff* (1830), followed by *Episode in the Belgian Revolution of 1830* (1834). The twenty-foot *Abdication of Charles V* by GALLAIT and the *Treaty of the Nobles* by BIÈFVE first achieved sensational success in 1841 and thereafter toured the capitals of Europe. DE KEYSER was also associated with the movement. The exhibition of Gallait's and Bièfve's paintings in Munich (1843) contributed to the establishment of the PILOTY school of German colourists. FORD MADOX BROWN studied with Wappers at Antwerp.
Lit. C. Lemonnier: *Histoire des Beaux-Arts en Belgique* (1881); H. Hijmans: *Belgische Kunst des 19 Jahrhunderts* (1906)

Bellangé Joseph Louis Hippolyte, b. Paris 1800, d. Paris 1866. A military painter and lithographer, highly regarded in his day, he studied with GROS (1816) and became a close friend of CHARLET. He first exhibited at the SALON in 1822; *Napoleon's Return from the Island of Elba* (1834) established his fame. He worked extensively for the Galerie des

Batailles at Versailles, and in 1836 was appointed curator of Rouen Museum. He became a chevalier of the Legion of Honour (1834) and an officer (1861). There are works in Amiens, Baltimore (Walters), Bordeaux, Chantilly, Compiègne, Leipzig, Lille, London (Wallace), Nantes, Paris (Louvre), Rouen and Versailles.
Lit. J. Adeline: *H. Bellangé et son œuvre* (1880)

Bendemann Eduard Julius Friedrich, b. Berlin 1811, d. Düsseldorf 1889. History painter and portraitist who realized in his work, more completely than any other artist, the poetry of romantic resignation so characteristic of the early DÜSSELDORF SCHOOL. He was a close friend of SCHADOW, whose sister he married; stylistically he inherited Schadow's NAZARENE reliance on line and highly articulated form, but his power as a colourist outdistanced his contemporaries. He studied with Schadow in Berlin, followed him (1827) to Düsseldorf when he was appointed academy director, and visited Italy with him (1829–31). *The Jews in Exile* (1832) brought him immediate fame, its static melancholy reflecting the influence of the *Sorrowing Royal Couple* of LESSING (1829). He shared with his generation the vision of a rebirth of German art through monumental painting; hoping to attract commissions, he executed a fresco depicting *The Arts at the Fount of Poetry* in his father-in-law's Berlin home. His ambitions in this direction were only achieved when he moved to Dresden (1839–55) as a professor at the academy. He decorated the throne room of the castle with kings and lawgivers, and with a frieze depicting the evolution of culture; in the ballroom and concert-hall he painted scenes from Greek history. He also executed portraits and book illustrations (*Nibelungenlied*). He succeeded Schadow as director of the Düsseldorf Academy (1859–67). Among his major historical works are *Jeremiah among the Ruins of Jerusalem* (1836), *The Jews Taken into Babylonian Captivity* (1872) and *Penelope* (1877). There are works in Antwerp, Baltimore (Walters), Berlin, Cologne, Düsseldorf and Leipzig.
Lit. J. Schrattenholz: *E. Bendemann* (1891)

Bendixen Siegfried Detlev, b. Kiel 1786, d. London after 1864. German landscape

painter who followed the tradition of the Dutch 17C masters but worked extensively from nature. Cornelius Gurlitt underlines the similarity of his approach and style to CROME and the NORWICH SCHOOL. He established a parallel school in Hamburg where he taught several of Germany's earliest naturalistic landscape painters, MORGENSTERN and GURLITT among them. He came to Hamburg in his youth and after extensive travels (Italy, Paris, Munich, Dresden 1808–13) settled there in 1813. In 1815 he opened an art school, where his pupils helped him with commissioned decorations, studied his distinguished collection of Dutch paintings and sketched from nature in the countryside under his guidance. He was also an enthusiastic art dealer. He moved to London (1832) where he is recorded as an exhibitor at the ROYAL ACADEMY until 1864. There are works in Hamburg.

Bendz Wilhelm Ferdinand, b. Odense 1804, d. Vicenza 1832. BIEDERMEIER genre and portrait painter. He painted simple unromanticized interiors from everyday life and showed a particular interest in effects of artificial light. *The Blue Room* (c. 1830) is perhaps the most famous genre scene of the Danish Biedermeier period. He studied at the Copenhagen Academy under ECKERSBERG, and had his first success with a portrait of the clergyman *Hornsyld* (1825); several state purchases of his work followed. After winning a travel scholarship (1831) he went to Munich via Dresden and Berlin, but on his way to Rome he died at Vicenza. There are works in Copenhagen (State, Hirschsprung).
Lit. A. Roder: *W. Bendz* (1905)

Benvenuti Pietro, b. Arezzo 1769, d. Florence 1844. Tuscany's leading NEOCLASSICAL painter and teacher, a close friend of CANOVA and follower of DAVID. He painted historical, mythological and religious subjects, as well as portraits, and carried his paintings to an advanced stage in chiaroscuro before embellishing them with colour. He studied in Rome before visiting Paris (1810), where David was a decisive influence. He was appointed professor at the Florence Academy (1803) and elected its director in 1807. Among his many pupils was MUSSINI. There are works in Arezzo, Florence (Mod. Art, Corsini), Naples (Capodimonte), Nice,

Paris (Versailles), Pisa, Ravenna and Venice. *Lit.* L. Palmerini: *Pitture di P. Benvenuti* (1821); G. Faleni: *Ceni biografici del pittore P. Benvenuti* (1826); Saint Maurice-Cabany: *P. Benvenuti d'Arezzo* (1845)

Béraud Jean, b. St Petersburg 1849, d. Paris 1936. He painted scenes of daily life in Paris with considerable attention to detail, though his flowing brushwork indicates the influence of the IMPRESSIONISTS. A well-born dandy, he moved freely in aristocratic society and was a gay chronicler of Parisian life *c.* 1880–1900. Titles such as *The Post Office, Dancers at the Opera, The Moulin-Rouge, Varnishing Day at the Salon, Out of School* and *Return from the Funeral* indicate the wide social spectrum of his chosen scenes. He studied in the studio of BONNAT, first exhibiting at the SALON of 1873. He was a founder member of the breakaway salon of MEISSONIER, the SOCIÉTÉ NATIONALE DES BEAUX-ARTS (1890), and became an officer of the Legion of Honour. His scenes from the life of Christ in modern dress (*c.*1890) achieved a *succès de scandale*. There are works in Baltimore (Walters), Liège, Lille, Paris (Carnavalet), Tours and Troyes.

Bergh Sven Richard, b. Stockholm 1858, d. Stockholm 1919. Portraitist who also painted some landscape and genre. His work belongs to the generation between REALISM and IMPRESSIONISM, typified by BASTIEN-LEPAGE in France. With ZORN, he was one of the founders of the Swedish SECESSION movement, Konstnärsförbundet, in 1886; in 1893 he joined the Varberg school of *plein air* landscape painters. The son of a landscape painter, Johan Edvard, he studied at the Stockholm Academy (1877–81) and worked in Paris with LAURENS. His psychologically sensitive portraits were highly regarded by his contemporaries and he was also an influential teacher in Stockholm. There are works in Copenhagen, Göteborg, Oslo (NG) and Stockholm (Nat. Mus.).
Lit. T. Hedberg: *R. Bergh* (1903)

Bernard Emile, b. Lille 1868, d. Paris 1941. Painter of precocious talent whose development of CLOISSONISM and SYNTHETISM fundamentally changed the course of the art of GAUGUIN; indeed, Gauguin has often been credited with the invention of these styles.

Bendz *The Blue Room, or Interior in the Amaliegade c.* 1830

Béraud *Interior of a Patisserie* 1889

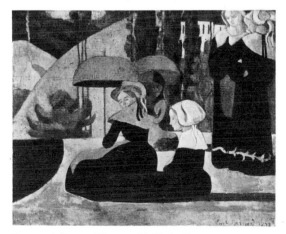

Bernard *Breton Women with Umbrellas* 1892

F. E. Bertin *View of a Hermitage in an Ancient Etruscan Excavation c.* 1837

Besnard *The Happy Island* 1900

Bidauld *François I at the Fountain of Vaucluse* 1803-25

He studied with Cormon at the ECOLE DES BEAUX-ARTS, where he became a close friend of TOULOUSE-LAUTREC. He experimented with POINTILLISM (*c.* 1886-7) but destroyed his canvases in this style after quarrelling with SIGNAC. He met VAN GOGH in 1887 and they worked together at Asnières. Although he met Gauguin briefly in 1886, their close friendship dates from 1888 when they were at PONT-AVEN exploring and developing the Synthetist approach. He suffered a religious crisis in 1890 and broke with Gauguin in 1891 over the latter's determination to take all credit as the creator of Synthetism. In 1893 he left Paris for Italy, went on to Constantinople and, eventually, to Egypt where he spent the next ten years. In Italy he was deeply impressed by the painters of the Venetian Renaissance and his later work, formed on their model, has never been highly regarded. He wrote for several magazines and periodicals in the 1890s and devoted an increasing amount of his time to writing in later years. There are works in Paris (Mod. Art).
Lit. P. Mornand: *E. Bernard et ses amis* (1957)

Bertin François Edouard, b. Paris 1797, d. Paris 1871. French landscape painter, an early associate of COROT and ALIGNY. They painted together in the Roman countryside (*c.* 1826) and later (*c.* 1829-30) in the forest of Fontainebleau (*Forest Interior* 1831, *Forest of Fontainebleau* 1833). Having worked extensively from nature, he developed a naturalistic handling of light, mass and distance, but his exhibition works remained generally in the classical tradition. He studied with GIRODET-TRIOSON and INGRES, and first exhibited in the SALON of 1827. In 1854 he succeeded his brother Armand as editor of the *Journal des Débats* founded by their father. He left many studies made on his travels in Italy, Greece, Spain and Switzerland. There are works in Bourges, Montpellier, Narbonne and Orleans.
Lit. C. Clerment: *E. Bertin* (1872)

Bertin Jean Victor, b. Paris 1775, d. Paris 1842. Landscapist, a faithful pupil and follower of VALENCIENNES. In the classical tradition he depicted heroic scenes from history and mythology in landscape settings; the landscapes were composed in the studio from innumerable outdoor sketches. He

'made fine studies as a basis for bad pictures' (Charles Blanc), and achieved a considerable reputation in the early decades of the 19C (Legion of Honour 1817) and was, with MICHALLON, the early instructor of COROT. There are works in many French provincial museums and in Paris (Louvre).

Besnard Paul Albert, b. Paris 1849, d. Paris 1934. Trained in the Ingresque tradition, Besnard added to this inheritance influences of most of the major movements of his time: the linear arabesque of the PRE-RAPHAELITES and ART NOUVEAU, the vivid colour and approximate brushwork of the IMPRESSIONISTS, the poetic suggestion of the SYMBOLISTS. He developed into a brilliant colourist with a penchant for subtle effects and reflections of light. He executed many major mural decorations (Ecole de Pharmacie 1883, Mairie du 1er arrondissement 1887, ceiling at Hôtel de Ville 1890, cupola of Petit-Palais 1907-10, ceiling at Comédie Française 1905-13). In addition to historical, allegorical and Symbolist decorations (*The Happy Island* 1900), he painted society portraits (with a debt to SARGENT), landscapes (especially on travels), Renoiresque nudes and scenes of daily life. He studied at the ECOLE DES BEAUX-ARTS and with CABANEL. After winning the first Rome prize in 1874 (*Death of Timophane, Tyrant of Corinth*), he went to Rome (1874-8). In London (1881-3) he took up etching under the influence of LEGROS and ZORN and came in contact with the Pre-Raphaelites. On his return to Paris he became friendly with the Impressionists. He was a founder member of the SOCIÉTÉ NATIONALE DES BEAUX-ARTS in 1890 and achieved almost every honour available to an artist. Director of the French Academy in Rome (1913-21) and of the Ecole des Beaux-Arts (1922), he became a member of the INSTITUT (1912) and of the Académie Française (1924); he received the grand cross of the Legion of Honour, and was the first artist to be accorded a state funeral at the Louvre. There are works in Paris (Louvre, Dec. Art), several French provincial museums, Brussels, Copenhagen, Düsseldorf and Venice, and also in Boston, Chicago, New York (Met., Brooklyn), Philadelphia and Washington (NG).
Lit. Roger-Marx: *The Painter A. Besnard* (1893); G. Mourey: *A. Besnard* (1906);

C. Mauclair: *A. Besnard, l'homme et l'œuvre* (1914)

Bezzuoli Giuseppe, b. Florence 1784, d. Florence 1855. History painter and portraitist who taught at the Florence Academy from 1814, taking over the senior professorship of painting after the death of BENVENUTI in 1844. He studied with SABATELLI and at the Florence Academy. The influence of Raphael is marked in his best portraits, while his strong use of colour resembles that of the French ROMANTICS. His most famous work, *Entry of Charles VIII into Florence* (1829), took him seven years to complete. He painted fresco decorations for several Florentine villas and palaces, including the Pitti; there are also works in Ajaccio, Florence (Mod. Art) and Pisa.
Lit. Della vita e delle opere del cav. prof. Giuseppe Bezzuoli maestro di pittura nell'-Accademia delle belle arti di Firenze (1855)

Bidauld Jean Joseph Xavier, b. Carpentras 1758, d. Montmorency 1846. Classical landscapist who left Provence for Paris in 1783, sketched in the Fontainebleau forest and attended the studio of C. VERNET; he worked in Rome from 1785 to 1791. His work was highly regarded in the early decades of the 19C. A SALON gold medallist (1812), he received the Legion of Honour (1823) and was the first landscape painter to be named a member of the INSTITUT (1823). His reputation helped to prolong the popularity of classical landscape to the detriment of the BARBIZON SCHOOL, for as president of the Salon hanging committee in the late 1830s he consistently rejected the work of the new school. There are works in Paris (Louvre), Versailles (Trianon) and many French provincial museums.
Lit. R. Rochette: *Notice historique sur la vie de M. Bidauld, paysagiste* (1849)

Biedermeier. The term has its origin in the names of two caricature Philistines featured in the Munich humorous magazine, *Fliegende Blätter*, and is now used to describe the styles of the period *c.* 1815–48, in Austria, Germany and Scandinavia, dominated by the taste of the newly prosperous middle classes. In the applied arts, the style of the period is essentially a simplified and popularized version of French Empire; in painting, the new middle classes of northern Europe, like the Dutch burghers of the 17C, preferred simple landscape, genre and portrait to the grandiloquence of history and allegory. They liked their paintings to be, as well as carefully finished, a faithful reflection of the world about them; for this reason the painters of the period are often called Biedermeier REALISTS. The style derives in part from French NEOCLASSICISM; the pioneers of the school, KRAFFT in Austria and ECKERSBERG in Denmark, had both studied with DAVID and applied his linear clarity to their genre and landscape paintings. Among other artists accounted the chief exponents of the style are WALDMÜLLER in Austria, SPITZWEG in Munich, KRÜGER and BLECHEN in Berlin, and KØBKE in Copenhagen. The movement coincides with the first burgeoning of Realism all over Europe; there are clear parallels with the work of CONSTABLE and WILKIE in England and with PALIZZI in Naples.
Lit. E. Kalkschmidt: *Biedermeiers Glück und Ende* (1957); R. Feuchtmüller: *Biedermeier in Österreich* (1963); W. Geismeier: *Malerei des Biedermeiers* (1970); I. Wirth: *Berliner Biedermeier* (1972)

Bièfve Edouard de, b. Brussels 1808, d. Brussels 1882. Second only to GALLAIT in the influential Belgian school of history painting of the 1840s. *Treaty of the Nobles* formed the natural complement to Gallait's *Abdication of Charles V*, and their exhibition together in Munich (1843) established the influence of the BELGIAN COLOURISTS over the PILOTY school of history painting. He studied at the Brussels Academy, with the NEOCLASSICAL painter Paelinck (1828–30), and in Paris with David d'Angers (1834–41). His career was at its peak during the 1840s, and after 1853 he virtually gave up painting. There are works in Antwerp and Brussels (Musées Royaux).

Bierstadt Albert, b. Solingen (nr Düsseldorf) 1830, d. New York 1902. The first American artist to paint panoramic Western landscapes, he has been called the founder of the Rocky Mountain School. He maintained the attention to detail of the DÜSSELDORF SCHOOL and expanded the panoramic sweep favoured by the HUDSON RIVER SCHOOL to a Wagnerian scale. His large canvases, with beetling crags, waterfalls, forests, lakes, often

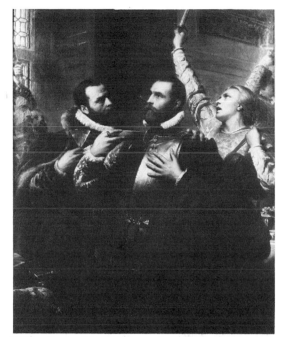
Bièfve *Scene of the Banquet at the Hôtel Cuylenborg 1566*

Bierstadt *The Rocky Mountains* 1863

Bingham *Stump Speaking* 1854

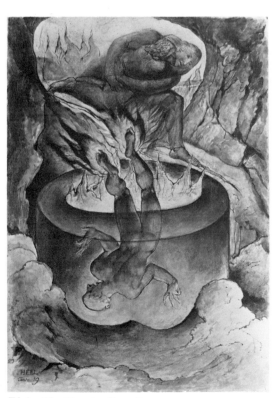

Blake *The Simoniac Pope* 1824–7

an Indian encampment in the foreground, and theatrical effects of light, were immensely successful in America and Europe. A cousin of the genre painter HASENCLEVER, his family migrated to America in 1831. He took up painting in 1851 and went to Düsseldorf (1853) to study with LESSING, A. ACHENBACH and LEUTZE. In 1856–7 he visited Rome before returning to America, where he joined the Shoshone Mountain expedition (1858) and travelled again to the West in 1863. His first major success was *The Rocky Mountains* (1863); he exhibited in London, Paris, Berlin and Munich, receiving many European honours. He was a member of the NATIONAL ACADEMY OF DESIGN, New York (1860), and a chevalier of the Legion of Honour. There are works in many American museums, including Baltimore (Walters), Boston, Buffalo, Cambridge Mass. (Fogg), Chicago, Cincinnati, Cleveland, New York (Met., Brooklyn) and Washington (Corcoran).
Lit. G. Hendricks: *A. Bierstadt: Painter of the American West* (1974)

Bingham George Caleb, b. Augusta County (Va.) 1811, d. Kansas City (Mo.) 1879. Genre, landscape and portrait painter, whose scenes of boatmen on the Missouri River and the early days of the Midwest were among the most highly regarded of the native genre school of the mid-century. The simple REALIST works of his early years are now the most admired; the technical sophistication he later learnt in Düsseldorf led him towards conventional artificiality. Apprenticed to a Missouri cabinetmaker (1827–8), he gravitated quickly to sign-painting, and from *c.* 1833 became an itinerant portraitist. He studied in Philadelphia, visited New York in 1838, and set up as a portraitist in Washington (1840–4). However, after unsuccessfully campaigning in the 1844 presidential election, he returned to Missouri. Looking for a new outlet, he tried his hand at genre, sending his paintings to the AMERICAN ART-UNION in New York, where they were immediately successful; engravings of his *Jolly Flatboatmen* (1847) were distributed by the thousand. He translated his electioneering experiences into paint, beginning with *County Election* (1851). In the following years, he worked mainly in Philadelphia and New York, though he visited Düsseldorf in 1856–8 and again in 1859. The Civil War diverted his

energies and he painted less in later life. There are works in Boston, Cambridge Mass. (Fogg), Chicago, Cincinnati, Columbia, New York (Met., Brooklyn) and Washington (Corcoran). (*see colour illustration 16*)
Lit. A. Christ-Janer: *G. C. Bingham* (1940); J. F. McDermott: *G. C. Bingham* (1959); E. M. Bloch: *G. C. Bingham: The Evolution of an Artist and a Catalogue Raisonné* (2 vols 1967)

Blake William, b. London 1757, d. London 1827. Visionary artist and poet, largely ignored in his own lifetime, who is now accorded an important though highly individualistic place in the early development of ROMANTICISM. He is best known for his graphic work, linear drawings lightly coloured in wash, engravings and etchings, but he also executed paintings in a form of tempera, his so-called 'frescoes'. Much of his work is strictly illustrative, of his own poems, the Bible, Milton or Shakespeare. His elongated figures, eccentricities of composition and religious symbolism take life from his hallucinatory visions, visions which he claimed to 'see' rather than imagine. The linearity and flat perspective of his work reflects the influence of NEOCLASSICISM; FLAXMAN, FUSELI and Stothard were friends of his student years. Other formative influences can be traced in the elongated simplicity of Gothic sculpture, linear Gothic prints, medieval illustration, and the mannerism of engravings after Michelangelo. At ten he entered Henry Pars's drawing school in the Strand, and was later apprenticed to the engraver Basire (1772–9). He entered the ROYAL ACADEMY Schools for a short period, but it was as a publisher's engraver, mainly of other men's works, that he continued to scrape a living. In the 1780s he developed an etching technique to print text and illuminated border in one block and through the 1790s printed many of his own works in this way (*Songs of Innocence* 1789, *Songs of Experience* 1794, prophetic books 1783–1804). He moved to Felpham (1800–3) to execute illustrations for the poet William Hayley. His main patron of the next decade was Thomas Butts, for whom Blake painted his first temperas and many watercolours; his financial problems were acute. In 1818 he met LINNELL, the friend and patron of his last years, and was introduced by him to VARLEY, PALMER and

others who held him in deep affection and veneration. *Illustrations to the Book of Job* (1821) was financed by Linnell. His woodcuts illustrating Virgil's *Pastorals* inspired the visionary landscapes of Palmer and the ANCIENTS. There is an important collection of his work in the Tate Gallery, London, but he is also represented in Baltimore (Mus. of Art), Cambridge (Fitzwm), Cambridge Mass. (Fogg), London (BM, V&A), Manchester, Melbourne, New York (Met., Morgan Lib., Brooklyn) and San Marino (Huntington).
Lit. A. Gilchrist: *Life of W. Blake* (1863); G. Keynes: *A Bibliography of W. Blake* (1921); A. Blunt: *The Art of W. Blake* (1959); G. Keynes: *W. Blake, Poet, Printer, Prophet* (1964); K. Raine: *Blake and Tradition* (2 vols 1968) and *W. Blake* (1970); D. G. Gillham: *W. Blake* (1973)

Blechen Karl, b. Cottbus 1798, d. Berlin 1840. One of the founders of naturalistic landscape painting in Germany, he worked principally in Berlin and was an important early influence on MENZEL. His oil sketches are particularly admired for their free and sparkling use of colour, relating his work to that of Menzel and the development of IMPRESSIONISM, but his ROMANTIC vision also allies him to FRIEDRICH, DAHL and BÖCKLIN in German landscape painting. He started life as a banker, drawing and painting in his spare time, and only fully dedicated himself to art at twenty-five. He entered the Berlin Academy under Lütke (1822) and visited Dresden (1823) where he met Dahl and Friedrich. In Berlin he attracted the interest of SCHINKEL, who secured him an appointment as scene painter at the Royal Theatre (1824-7). His landscapes of this period were romantic, somewhat theatrical, and strongly influenced by Schinkel (*Mountain Gorge in Winter* 1825). A visit to Italy (1828-9) crystallized his inclination towards naturalistic landscape, and his studies, sketches and finished paintings of Italian views brought him immediate success on his return to Berlin (*Gulf of Spezia* 1829-30). He became professor of landscape painting at the Berlin Academy (1831) and a member of the academy (1835). He continued to work from nature, and even in composed landscapes he retained the loose brushwork of his Italian period. *Rolling Mill near Neustadt-Eberswalde* (c. 1834) is one of the first examples

of an industrial motif in German landscape painting. He became mentally ill in 1836 and died in 1840. Most of his work is in Berlin, but he is also represented in Hamburg, Hanover, Kaliningrad and Vienna (Kunsthistorisches Mus.).
Lit. P. O. Rave: *K. Blechen* (1940); H. Scurla and V. Ruthenberg: *Der Maler K. Blechen, 1798-1840* (1963); G. Heider: *C. Blechen* (1970)

Bles David Joseph, b. The Hague 1821, d. The Hague 1899. Genre painter, whose small-scale works generally depict humorous anecdotes borrowed from *la vie galante*, with pretty, roguish young girls, often in 18C dress, painted in warm colours with careful attention to detail. Collectors would 'discuss the qualities and expression and, magnifying glass in hand, smack their lips over the piquancy of the anecdote represented' (Marius). He studied at the Hague Drawing Academy (from 1834), with KRUSEMAN (1838-41) and in Paris with ROBERT-FLEURY (1841-3). Back in The Hague, he developed his own brand of miniature genre painting. The 1850s and 1860s saw the apogee of his popularity, but his work gradually fell from favour as the younger generation of REALIST-oriented artists of the HAGUE SCHOOL made their mark. There are works in Amsterdam (Rijksmuseum, Stedelijk), The Hague and Rotterdam (Boymans).

Bloch Carl Heinrich, b. Copenhagen 1834, d. Copenhagen 1890. History and genre painter whose work is highly finished and somewhat mannered. After entering the Copenhagen Academy at fifteen, he exhibited portraits and realistically painted scenes of Danish life from 1854. He won a scholarship to visit Italy and was there 1859-65, turning to more ambitious historical subjects; *Prometheus*, sent back from Rome in 1864, met the highest critical acclaim in Denmark. A succession of scenes from Danish history followed (*Christian II in Prison*) and he was commissioned to paint a cycle of twenty-three scenes from the life of Christ for the chapel at Fredericksborg Castle. In later years he turned to humorous scenes of monastic life in the manner of GRÜTZNER. In 1883 he became a member of the Copenhagen Academy, where he also had a post as professor. He was accorded the French Legion

Blechen *Interior of the Palm House on the Peacock Island* 1832

Bles *The Conversation*

Böcklin *Villa by the Sea* 1877

Boilly *Gathering of Artists in Isabey's Studio* 1798

Boldini *Princess Marthe Bibesco* 1911

of Honour in 1878. There are works in Copenhagen (Hirschsprung, State), Helsinki and Stockholm.
Lit. C. H. Bloch: *C. Bloch* (1913)

Böcklin Arnold, b. Basle 1827, d. Fiesole 1901. Swiss painter who achieved reputation and outstanding influence in the German-speaking world, but whose spiritual home was Italy where he spent much of his time. His art developed out of naturalistic landscape painting, in which he showed himself a notable colourist; his early Roman landscapes parallel those of COROT (*Landscape in the Apennines* 1851). His aim next was to people his landscapes with figures in keeping with the landscape mood, and this led him further, towards the integration into his landscape canvases of mythological figures symbolizing the mood of nature; the rumble of a mountain storm is translated into the great god Pan, a waterspout at sea becomes Venus rising from the waves. Study of the Pompeii frescoes inspired him towards a more monumental art (frescoes for Basle Museum); the figures begin to dominate the composition (*Triton and Nereids* 1873). Gradually his poetic fantasy and the invention of symbolic figures led him away from naturalism; the dramatic content of his later work was heightened by strident colour contrasts. He studied in Düsseldorf with SCHIRMER (1845–7) and paid student visits to Brussels and Antwerp. For a brief period he worked with CALAME in Geneva (1847), and was in Paris in 1848. He painted Alpine landscapes in Basle (1848–50) and spent most of the period 1850–7 in Rome, where he became friendly with FEUERBACH. *Pan among the Reeds*, exhibited in Munich in 1859, established his reputation. He received his first commissions from Count Schack in 1859, worked at the newly founded Weimar Art School (1860–2) with LENBACH and BEGAS, and back in Rome (1862–6) he paid a formative visit to Pompeii. His Basle frescoes date from 1868–70. In Munich (1871–4) he painted sea pictures and the first of his 'Battle of the Centaurs' series. From 1874 to 1885 he was in Florence (first version of *The Island of the Dead*) where MAREES and Hildebrandt were his friends; in Zurich (1885–92) he simplified his palette, using brighter colours, and from 1892 he was again based in Florence. He had many admirers and

followers among the SYMBOLIST generation in Germany, including THOMA, STUCK and KLINGER. His work is best represented in Basle (Kunstmuseum), Berlin, Munich (N. Pin., Schack) and Zurich, but there are works elsewhere in Germany and the Metropolitan Museum in New York has one version of *The Island of the Dead. (see colour illustration 30)*
Lit. F. Runkel: *Böcklin Memoiren* (1910); J. Meier-Graefe: *Der Fall Böcklin* (1911); O. Fischer: *A. Böcklin* (1940); R. Andree: *A. Böcklin* (1962); G. Schmidt: *A. Böcklin* (1963); E. Fuchs: *Böcklin* (1976)

Boilly Louis Léopold, b. La Bassée 1761, d. Paris 1845. Prolific painter of small genre scenes and portraits of the Revolution, Empire and Restoration periods in France, with close attention to detail and a smooth, high finish; his cheerful bourgeois· scenes are often critically linked with the BIEDERMEIER genre of northern Europe. He received his only formal instruction from his father, a woodcarver, and his paintings enjoyed a modest popularity from the 1890s onwards. Financial prosperity eluded him in spite of the wide sale of engravings after his paintings; he was one of the first French artists to experiment with lithography. He received a first class gold medal (1803) and the Legion of Honour (1833). There are works in Paris (Louvre) and many French provincial museums; he is also represented in Berlin, Budapest, Cambridge Mass. (Fogg), Copenhagen (State), London (Wallace, NG) and Washington (NG).
Lit. H. Harrisse: *L.-L. Boilly, peintre, dessinateur et lithographe: sa vie et son œuvre* (1898)

Boldini Giovanni, b. Ferrara 1845, d. Paris 1931. Fashionable Parisian portraitist, as well as a distinguished townscapist, landscapist and genre painter. Trained among the REALIST-oriented MACCHIAIOLI school in Florence, he gravitated towards the IMPRESSIONISTS on his arrival in Paris and became a lifelong friend of DEGAS. His mature work is supremely stylish; he exaggerates elegance and movement with a dashing sweep of brushstrokes leaving each stroke clearly visible on the canvas, its impact undiluted by finish. His feminine portraits were extremely fashionable in turn-of-the-century Paris.

His artist–copyist father gave him his first instruction before he went to Florence (1862), where he entered the academy and frequented the Caffè Michelangelo, meeting-place of the Macchiaioli. In London (1870), the portrait commissions he received from the English aristocracy launched his success. In 1871 he settled in Paris, where he was taken up and fêted by the *beau monde*. There are works in Berlin, Dijon, Florence (Mod. Art), Milan (Mod. Art, Grassi, Scala), Palermo (Mod. Art), Paris (Louvre), Rome (Mod. Art) and Turin (Mod. Art).
Lit. E. Cardona: *G. Boldini, parisien d'Italie* (1952); R. de Grada: *Boldini* (1963); E. Cardona, R. de Grada, E. Piceni: *Boldini* (1964); D. Prandi: *G. Boldini: L'opera incisa* (1970); C. L. Ragghianti: *L'opera completa di Boldini* (1970)

Bonheur Rosa, b. Bordeaux 1822, d. Château By (Fontainebleau) 1899. The most famous French animal painter of the 19C; Pierpont Morgan paid £12,000 for her *Horse Fair* in the 1880s and presented it to the Metropolitan Museum, New York. She painted domestic, farm and wild animals with an unsentimental naturalism born of close observation and study, though the detailed and highly finished style of her first period later gave way to a broader impressionistic treatment. She studied in the drawing school of her father, landscape painter Raymond Bonheur, as well as copying in the Louvre and drawing from nature. She first exhibited in the SALON of 1841, and achieved her first major success in 1848; *Labourage nivernais* (1849) established her international reputation. A great eccentric, she kept sheep in her Paris apartment and travelled the countryside dressed as a man to study stables and cattle markets. In 1859 she purchased the Château By, near Fontainebleau, which she turned into a combination of studio and zoo; the Empress Eugénie herself brought the cross of the Legion of Honour there in 1865, and during the 1870 war Crown-Prince Friedrich of Prussia gave strict orders that her château should not be disturbed. She was the first woman to become an officer of the Legion of Honour (1894). Her finest work dates from the 1850s and 1860s, and was especially popular in England and America. There are works in Baltimore (Walters), Bordeaux, Boulogne, Buffalo, Chantilly (Condé), Chi-

cago, Cincinnati, Grenoble, Langres, Lille, London (Wallace, NG), New York (Met., Brooklyn), Paris (Louvre), Philadelphia, Rouen and Washington (Corcoran).
Lit. Roger-Millès: *Rosa Bonheur, sa vie et son œuvre* (1900); A. Klumpke: *Rosa Bonheur, sa vie et son œuvre* (1908)

Bonington Richard Parkes, b. Arnold (Notts.) 1802, d. London 1828. English painter and watercolourist who was trained in France, where he spent most of his short life and exerted an important influence on French ROMANTIC painting. His landscapes, reflecting the English watercolour tradition, were a novelty in France and a formative influence on the BARBIZON SCHOOL; he was an intimate friend of DELACROIX, and their early experiments in history painting have a similarity based on close collaboration (*Henry IV and the Spanish Ambassador* 1827). He studied briefly with Louis Francia, a watercolourist of the Girtin school, who had returned to Calais after some twenty years in England. Against parental opposition he left for Paris; though armed with an introduction to Delacroix from Francia, they met accidentally in the Louvre where Bonington copied from Dutch and Flemish paintings. The two became friends and, encouraged by GÉRICAULT, made a careful study of Rubens. He entered the ECOLE DES BEAUX-ARTS and the studio of GROS (1820). His brightly coloured watercolours sold well and financed sketching tours in northern France during 1821–3 (*Market Tower at Bergues* 1822, *Abbey of Saint Bertin* 1823). He first exhibited in the SALON of 1822, and won a medal at the famous Salon of 1824 where CONSTABLE, LAWRENCE and others were represented. He and Delacroix greatly admired Constable and visited England together in 1825, bringing back an engrossing interest in history painting for which they leant heavily on the example of the Flemish and Venetian colourists. He visited Venice in 1826, and exhibited in London (British Institution 1826, ROYAL ACADEMY 1828). His influence on English watercolour painting is reflected particularly by T. S. Boys and W. Callow. He is best represented in London (Wallace) and Paris (Louvre) but there are also good examples in the national galleries of London, Scotland and Canada and in the Nottingham Castle Museum. There are

Bonheur *The Horse Fair* 1853-5 (detail below)

Bonington *Henry IV and the Spanish Ambassador* 1827

further works in Berlin, Boston, Cambridge Mass. (Fogg), Cardiff, Chicago, Hamburg, Montreal (Learmont), New York (Met.), Philadelphia, Victoria and Washington (Corcoran).
Lit. H. Stokes: *Girtin and Bonington* (1922); A. Dubuisson: *Bonington, his Life and Work* (1924); A. Curtis: *Catalogue de l'œuvre lithographié et gravé de R. P. Bonington* (1939); A. Shirley: *Bonington* (1940)

Bonnard Pierre, b. Fontenay-aux-Roses 1867, d. Le Cannet 1947. A distinguished member of the NABIS in the last years of the 19C, he became a leader of the French INTIMISTE school of painting in the 20C. He was also a prolific book illustrator, lithographer and etcher. He began to study law in Paris *c.* 1885, but spent much of his time at the ACADÉMIE JULIAN, where he met VUILLARD, SERUSIER, DENIS and others who were to form the Nabi group. The sale of a poster design for *Champagne-France* in 1889 persuaded his father that he should study painting seriously. His early work was strongly influenced both by GAUGUIN and by Japanese prints; flat planes of warm colour were shaped by dark arabesque outlines in compositions of Japanese asymmetry (*Terrasse Family c.* 1893, *The Parade* 1890). From 1890 he shared a studio with Vuillard and Denis which became a meeting-place for the Nabis, and he exhibited with them at the SALON DES INDÉPENDANTS. He executed many lithographs in the 1890s, had his first one-man show at Durand-Ruel's in 1896, worked on costumes and décor for the Théâtre de l'Oeuvre, and illustrated his first book in 1898. Around 1900 his style changed; his brushwork became looser, his palette brighter, and he gave up decorative stylization in favour of naturalistic modelling and an almost IMPRESSIONIST technique. His subject matter varied little: sunlit interiors, often with a woman bathing, dressing or sleeping (*La Toilette*), or a family group gathered round a table (*Luncheon*), or occasional landscapes and still lifes (*View Over Le Cannet*). They share an atmosphere of domestic serenity, though his treatment of colour and light intensified with the years. He lived at Saint-Germain-en-Laye during the 1914–18 war and in 1925 bought a villa at Le Cannet, near Cannes, where he spent much of his time. There are works in Baltimore (Mus. of Art),

London (Tate), Paris (Mod. Art), New York (Brooklyn, Met.) and most galleries of modern art.
Lit. J. Rewald: *P. Bonnard* (1948); J. and H. Dauberville: *Bonnard : Catalogue raisonné de l'œuvre peint*, Vol. I 1888–1905, Vol. II 1906–19 (1965), Vol. IV and supplement (1974); A. Terrasse: *P. Bonnard* (1967); A. Fermigier: *P. Bonnard* (1970); J. Clair: *Bonnard* (1975)

Bonnat Léon Joseph Florentin, b. Bayonne 1833, d. Monchy-Saint-Eloi (Oise) 1923. French portrait and history painter, the formative influences on whose work were Caravaggio and Ribera, leading him to an ACADEMIC REALISM, dark in tone. In the mid-1870s he took up portrait painting, which brought him outstanding success. He painted most of the great men of his day, including Thiers, Victor Hugo, Carnot, Taine and Pasteur. His portraits were generally simple half-lengths or three-quarter-lengths against a plain background, the strength of the work lying in the accuracy of the likeness. He became one of the pillars of the artistic establishment. Chevalier of the Legion of Honour (1867), he climbed through the successive grades to reach the grand cross in 1900. He became a member of the INSTITUT (1881) and was a member of the jury of the EXPOSITIONS UNIVERSELLES of 1889 and 1900. A professor at the ECOLE DES BEAUX-ARTS in 1888, he became its director in 1905. He was a lifelong friend of DEGAS and the revered master of many distinguished artists, including TOULOUSE-LAUTREC, Dufy and Friesz as well as BÉRAUD and ROLL. Brought up in Spain and imbued with deep admiration for Ribera, Velasquez and the Spanish school, he studied with MADRAZO before moving to Paris, where he studied with COGNIET. In Italy (1858–60), he was influenced by Caravaggio and the 17C Bolognese. He painted many religious works in the 1860s (*Ascension of the Virgin Mary* 1869), as well as landscapes and history pieces, but his portrait of *Léon Cogniet* (1875) launched his success. He executed frescoes for the Panthéon (*Martyrdom of St Denis* 1885), the Palais de Justice and many French churches. He was a passionate and discerning collector, and left his superb collection to Bayonne. He is best represented in Paris (Louvre) and Bayonne (Bonnat), but

there are also works in Amsterdam, Baltimore (Walters), Berlin, Boston, Cambridge Mass. (Fogg), Chicago, Grenoble, London (NPG) and New York (Met.).
Lit. A. L. Fouquier: *L. Bonnat : première partie de sa vie et de ses œuvres* (1879); R. Cuzacq: *L. Bonnat, l'homme et l'artiste* (1940)

Bonvin François, b. Vaugirard 1817, d. Saint-Germain-en-Laye 1887. Genre and still-life painter. His quiet observation was combined with strong dark-toned brushwork, and his subjects were of the simplest – a man or woman at work, a kitchen, a pair of old shoes. He was admired and encouraged by COURBET and seen by contemporaries as the 19C reincarnation of Chardin. He attended the Académie Suisse and evening classes at the drawing school of LECOQ DE BOISBAUDRAN (*c.* 1843), as well as becoming the friend and pupil of GRANET (*c.* 1845). More importantly, he taught himself by studying Chardin and the Dutch genre painters of the 17C. He exhibited in the SALON from 1847, and received the Legion of Honour in 1870. There are works in Amsterdam (Rijksmuseum), Arras, Baltimore (Walters), Bayonne, Limoges, London (NG, V&A), Paris (Louvre) and several French provincial museums.

Borovikovsky Vladimir Lukich, b. Mirgorod 1757, d. St Petersburg 1825. With LEVITSKY the leader of the Russian portrait school of the late 18C and early 19C; like the 18C portrait school in England, this was a first flowering of indigenous art. Most typical are his large-eyed, languidly posed young women, imbued with a sentimental classicism transported to Russia by VIGÉE-LEBRUN. He worked with his father, a Cossack icon-painter, and after a short career in the army took up icon-painting himself. He met Catherine II during her Crimean progress (1787); her life had inspired the subjects for his icon allegories in a local church, and her influence took him to St Petersburg the same year, where he studied under Levitsky and painted miniatures on ivory after Levitsky's portraits. His first full-scale portraits were influenced by LAMPI, who befriended him, helped him to academy membership (1795) and left his studio to him

(1796). He was favoured at court, and painted state portraits of the imperial family and Russian nobility in which he abandoned rigid conventional poses for natural grouping. Infected with religious mysticism in his last years, he returned to icon-painting and was planning to become a monk when he died. His best-known icons are at Kazan Cathedral, Leningrad. His many pupils included VENETSIANOV. There are works in Moscow (Pushkin, Tretiakov).
Lit. D. Roche: *Un peintre petit-russien* (1906); N. Mashkovets: *V. Borovikovsky* (1950, in Russian)

Borrani Odoardo, b. Pisa 1833, d. Florence 1905. Landscape and genre painter, one of the Florentine MACCHIAIOLI. He combined strong formal composition, derived from his studies of early Italian painting, with a *plein air* REALISM that catches the luminous effect of southern sunlight in the Tuscan countryside. The son of a painter, he studied with Gaetano Bianchi, a picture restorer, who encouraged him to copy from Uccello and other Renaissance masters. He became a friend of SIGNORINI (*c.* 1854), took part in the discussions of the Macchiaioli group at the Caffè Michelangelo in the later 1850s, and worked from nature in the nearby countryside with other members of the group. He lived a withdrawn life in the country (1865-73) and later ran an art school in Florence. There are works in the galleries of modern art of Florence, Rome and Turin.

Bosboom Johannes, b. The Hague 1817, d. The Hague 1891. The most conservative of the HAGUE SCHOOL artists, he specialized in painting church interiors, usually in warm brown-gold tones, as often in watercolour as in oil. In early works the architectural details were rendered precisely but his touch became gradually looser and more summary. His own claim that he had known 'no other master than Rembrandt' is reflected in his use of light. He studied with HOVE from 1831, and travelled extensively in Germany, France and the Netherlands, showing from the first his penchant for Gothic interiors. In his later years he turned increasingly to watercolour. There are works in Amsterdam (Rijksmuseum, Stedelijk), Groningen, Glasgow,

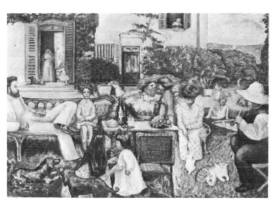

Bonnard *The Terrasse Family, or the Bourgeois Afternoon* c. 1893

Bonvin *Servant Drawing Water* 1861

Bonnat *Robert-Fleury* 1865

Borrani *Il Mugnone* 1865-8

Bosboom *Vestry at Nijmegen*

Boudin *Jetty and Wharf at Trouville* 1863

Hanover, The Hague (Mesdag, Communal), Montreal, Munich, Paris (Louvre) and Rotterdam (Boymans).
Lit. H. L. Berckenhoff: *J. Bosboom en A. L. Bosboom* (1891); Zilcken: *Peintres hollandais modernes* (1893); M. F. Hennus: *J. Bosboom* (1947)

Boudin Eugène, b. Honfleur 1824, d. Paris 1898. French painter of seascapes and beach scenes. He is seen as a direct precursor of IMPRESSIONISM; it was he who persuaded the eighteen-year-old MONET, the author so far of charcoal caricatures, to paint out of doors 'nature truly seen in all its variety and freshness' (Boudin). His seascapes are dominated by luminous skies full of fleeting movement; COROT called him the 'king of skies'. The son of a seaman, in 1844 he opened a stationery and framing shop in Le Havre, where COUTURE, TROYON, E. ISABEY and MILLET were among his clients. With Millet's encouragement he decided to become a painter, leaving in 1847 for Paris, where he copied in the Louvre. In 1850 the city of Le Havre bought two of his paintings and accorded him a three-year scholarship to study in Paris. Although he lived for short periods in Paris and paid several visits to Belgium and Holland, he spent most of his working life around Le Havre, Honfleur and Trouville. He was in constant contact with other artists who came to the coast to paint; E. Isabey was a formative influence on his early work, as was JONGKIND in later years. Other visitors to the coast included COURBET, Corot, DAUBIGNY and DIAZ. He exhibited at the SALON from 1859, participated in the first Impressionist Group Show (1874) and was accorded the Legion of Honour (1892). He is well represented in Paris (M. de l'Impressionisme) and Honfleur (Boudin), while he left over six thousand sketches, pastels and watercolours to the Louvre Cabinet des Dessins. A prolific artist, there are examples of his work in most museums where Impressionism is represented.
Lit. G. Cahen: *E. Boudin, sa vie et son œuvre* (1900); L. Cario: *E. Boudin* (1928); G. Jean-Aubry: *La Vie et l'œuvre d'après les lettres et les documents inédits d'E. Boudin* (1968); R. Schmit: *E. Boudin, 1824–1898* (3 vols 1973)

Bouguereau Adolphe William, b. La Rochelle 1825, d. La Rochelle 1905. French painter of mythological, religious and historic subjects as well as portraits and the occasional scene of contemporary genre. A pupil of the classicist PICOT, himself a pupil of DAVID, Bouguereau continued the tradition of academic classicism down to the end of the 19C. His carefully structured compositions, emphasizing the idealized human figure, are worked through half-tones to the highest degree of finish. He was a pillar of the FRENCH ART ESTABLISHMENT and as president of the SOCIÉTÉ DES ARTISTES FRANÇAIS was influential in discouraging the IMPRESSIONISTS and other innovators. After MEISSONIER formed the breakaway SOCIÉTÉ NATIONALE DES BEAUX-ARTS in 1890, the official SALON was known as 'le salon Bouguereau'. He studied at the ECOLE DES BEAUX-ARTS as well as with Picot. After winning the first Rome prize (1850) he went to Italy (1850–4), where he copied from Raphael, del Sarto and Reni. *The Body of St Cecilia Borne to the Catacombs* (1854) established his reputation; *The Triumph of Venus* and *Charity* were among his many paintings to achieve popularity through engravings. He painted ceiling decorations for the Grand Théâtre in Bordeaux (1869) and murals for La Rochelle Cathedral (1883) as well as several Paris churches. Professor at the Ecole des Beaux-Arts (1875), member of the INSTITUT (1876), member of the jury for the EXPOSITIONS UNIVERSELLES (1889 and 1900) and a chevalier of the Legion of Honour (1859), he reached the grade of grand officer in 1903. There are works in Paris (Louvre), Bordeaux, Dijon and La Rochelle; he is represented in many U.S. museums, and particularly well in Williamstown Mass.
Lit. R. Ménard: *Bouguereau* (1885); M. Vachon: *W. Bouguereau* (1900)

Boulanger Louis, b. Vercelli 1806, d. Dijon 1867. ROMANTIC painter, '*the* artist' of the group around HUGO, according to Hugo himself, sharing the poet's fascination with medieval melodrama and black magic (*Witches' Sabbath* 1828). He entered the ECOLE DES BEAUX-ARTS (1821) and studied with Lethière, though he was more influenced by DEVÉRIA. He received accolades for his *Mazeppa* (1827), but by the mid-1830s he had turned to quieter academicism and his reputation declined, though he continued to exhibit and became director of the Dijon

Ecole des Beaux-Arts (1860). He illustrated several of Hugo's works (*Phantoms* 1829) and many of his paintings were inspired by Hugo's themes (*Scene of an Orgy* 1866). There are works in Béziers, Cambrai, Dijon, Le Mans, Montpellier, Paris (Louvre), Pontoise, Rouen, Troyes and Versailles.
Lit. A. Marie: *Le Peintre poète L. Boulanger* (1925)

Boulenger Hyppolyte Emmanuel, b. Tournai 1837, d. Brussels 1874. Landscape painter, the leader of the Belgian REALIST school of the 1860s and 1870s. His works display a lyrical sensitivity to the mood of landscape (*Spring at Boitsfort* 1873). He studied at the Brussels Academy with NAVEZ, but extreme poverty forced him to settle at Tervueren (1863), where he was followed by several young artists. He became the undisputed leader of the school of Tervueren, the Belgian equivalent of the BARBIZON SCHOOL; the group first made its mark at the Brussels Salon of 1866 where it was fiercely criticized. Acceptance came in 1872 when Boulenger's *Avenue of Elm Trees* won a SALON gold medal. At his suggestion, the Société Libre des Beaux-Arts was formed in Brussels (1868), bringing together the young anti-academic painters; Barbizon and HAGUE SCHOOL artists were invited to show in their exhibitions during the 1870s. There are works in Antwerp, Brussels (Musées Royaux) and Mons.
Lit. P. Colin: *H. Boulenger* (1934)

Bracquemond Félix Henri, b. Paris 1833, d. Paris 1914. Artist-engraver. A friend of the IMPRESSIONISTS and powerfully influenced by Japanese prints, he was a guiding force behind the 1860s revival of original engravings by artists. Engravings had come to be almost exclusively a method of reproducing paintings; with Bracquemond and the Société des Aquafortistes (founded 1862) it was again used as a creative medium in its own right. He also worked for the porcelain manufactory at Sèvres and the Haviland porcelain company in Paris. He exhibited some fine portraits in his early years but gave up oil painting in the 1860s.

Braekeleer Ferdinand de (the Elder), b. Antwerp 1792, d. Antwerp 1883. History and genre painter who studied with VAN

Bouguereau *Nymphs and a Satyr* 1873

Boulanger *Mazeppa* 1827

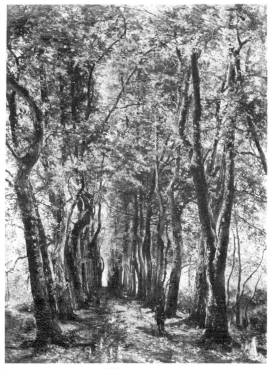

Boulenger *Avenue of Elm Trees* 1871

47

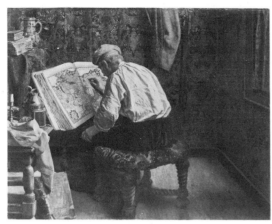

H. de Braekeleer *The Geographer* 1871

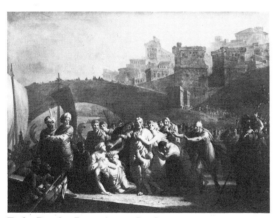

Brée *Regulus Returning to Carthage*

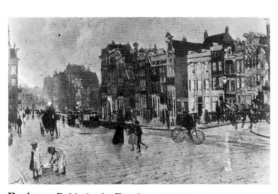

Breitner *Rokin in the Evening c.* 1900

BREE but turned (*c.* 1836) to genre painting in the manner of Teniers and de Steen. He achieved an international reputation, was keeper of Antwerp Museum, member of the Antwerp Academy and an influential teacher. His nephew LEYS was among his pupils. His sons Ferdinand the Younger (1828–57) and HENRI were both painters. There are works in Amsterdam (Rijksmuseum), Antwerp, Berlin, Brussels (Musées Royaux), Cologne, Montreal, Munich and Washington (Corcoran).

Braekeleer Henry de, b. Antwerp 1840, d. Antwerp 1888. Painter of genre, townscape and landscape, an individualistic exponent of REALISM. He painted quiet interiors and intimate landscapes; their atmosphere of provincial peace and order echoes the Dutch little masters of the 17C whom he greatly admired (*The Geographer* 1871, *The Picture Restorer* 1878). From his cousin LEYS he inherited a still-life painter's attention to decorative detail, but he replaced Leys's smooth finish by a flickering crowd of short brushstrokes. The old quarter of Antwerp provided his recurrent subject matter. He studied with his father FERDINAND and Leys at the Antwerp Academy; his early work closely follows Leys, but he soon abandoned history painting for scenes of contemporary life. He first exhibited in Antwerp in 1861, but his first critical success was in exhibitions in Brussels and Vienna (1872–3). A profound melancholy turned in his last years to mental illness but the few paintings of this period (*Strawberries and Champagne* 1884, *The Card Players* 1887) show a nervous, almost IMPRESSIONIST brushwork, which may reflect the influence of LES VINGT. There are works in Antwerp and Brussels (Musées Royaux).
Lit. C. Lemonnier: *H. de Braekeleer et son œuvre* (1905); P. Haesaerts: *H. de Braekeleer* (1943)

Braith Anton, b. Biberach 1836, d. Biberach 1905. Munich animal painter strongly influenced by TROYON. He studied with Pflug in Biberach and at the Stuttgart Art School (1851); in Munich (1860) he was influenced by the colour and broad brushwork of PILOTY. Troyon's influence dates from a visit to Paris (1867). There are works in Berlin, Biberach, Cologne, Hamburg, Melbourne and Sydney.

Brascassat Jacques Raymond, b. Bordeaux 1804, d. Paris 1867. Animal painter and landscapist, influenced by Paul Potter and the Dutch. He painted with careful attention to detail and an enamel finish, and his work was highly regarded in the 1830s and 1840s. He received the Legion of Honour (1837) and became a member of the INSTITUT (1846). In later years he was eclipsed by TROYON and BONHEUR. He is well represented in Paris (Louvre) and Nantes; there are works in many French provincial museums, and also in Amsterdam, Brussels (Musées Royaux), Leipzig, Leningrad, London (Wallace), Munich and Philadelphia.

Brée Mathieu Ignace van, b. Antwerp 1773, d. Antwerp 1839. NEOCLASSICAL painter and portraitist, more important as a teacher and an administrator than as an artist. 'He tempered the rigour of DAVID with a certain grace and freedom of brushwork' (Hymans). He studied at the Antwerp Academy with van Regemorter and in Paris with Vincent, and was favoured by the Empress Joséphine, who commissioned many works from him. He became a professor of the Antwerp Academy (1804) and director (1827). He passed on his own passionate admiration of Rubens and van Dyck to his pupils, who included WAPPERS, DE KEYSER, F. DE BRAEKE-LEER and WIERTZ, and who were credited with 'the revolution of the BELGIAN COLOURISTS'. There are works in Amsterdam (Rijksmuseum), Antwerp, Brussels (Musées Royaux), Cambrai, Leyden, Pontoise, Tournai and Versailles.
Lit. Levensbeschryving van M. J. van Brée (1852)

Breitner Georg Hendrik, b. Rotterdam 1857, d. Amsterdam 1923. Holland's most admired painter of the generation influenced by IMPRESSIONISM. He is best known for his views of Amsterdam; his fascination with the movement and bustle of the busy city is depicted in broad brushstrokes of sharply contrasting colours, with deep brown usually the dominant tone. He studied at the Hague Academy from 1875 under Koelman, and worked with W. MARIS (1880). He supported himself by teaching drawing in Leiden and Rotterdam. In 1884 he went to Paris, where he studied with Cormon, and where his interest in *plein air* painting was encouraged

by the Impressionists. In Amsterdam (1886), he studied at the academy with Allebé. His early military scenes already show his feeling for movement and light, but he found in Amsterdam the subject matter and style which gave his talents their full expression (*Lauriegracht* 1894–5). There are works in Amsterdam (Rijksmuseum, Stedelijk), Groningen and The Hague (Mesdag).
Lit. Steenhoff, Veth, Vogelsang: *G. H. Breitner, Indrukken en Biographische Aanteek* (1902); A. van Schendel: *G. H. Breitner* (1947); P. H. Hefting: *G. H. Breitner in zijn Haagse Tijd* (1970)

Bresdin Rodolphe, b. Ingrandes 1822, d. Sèvres 1885. French draughtsman, etcher and lithographer. His prints were generally tiny and executed with meticulous detail; biblical scenes are set in fantastic landscapes, densely enclosed with vegetation, with mysterious, slightly macabre overtones. He was much admired by the SYMBOLIST writers; his personality inspired Champfleury's novel *Chien-Caillou* and his prints (*Good Samaritan, Comedy of Death*) are described in Huysman's *A Rebours*. REDON was his pupil. He lived in obscurity and poverty; he dreamed of visiting the untamed backwoods of America and after winning a competition for a banknote design (c. 1871) he travelled there, to return penniless in 1876. His work is represented in most print rooms.
Lit. C. R. de Montesquiou: *L'Inextricable Graveur, R. Bresdin* (1908); K. G. Boon: *R. Bresdin. Etsen in lithografieën* (1955)

Breton Jules Adolphe Aimé Louis, b. Courrières 1827, d. Paris 1905. Painter of peasant landscapes, highly regarded in late-19C Paris. He was strongly influenced by MILLET and the BARBIZON SCHOOL, but romanticized the peasants and concentrated on pretty compositions, influenced by ROBERT. He studied with Felix de Vigne in Ghent, WAPPERS in Antwerp and DROLLING in Paris. He first attempted genre, but later took to landscape, scoring his first major success with *The Return of the Harvesters* (1853). Chevalier of the Legion of Honour (1861) and officer (1867), he became a member of the INSTITUT (1886) and was a member of the jury for the EXPOSITIONS UNIVERSELLES of 1889 and 1900. He was also a poet and the

Bresdin *The Comedy of Death* 1854

Breton *Calling the Gleaners Home* 1859

author of two volumes of reminiscences. There are works in Antwerp, Arras, Bagnères, Baltimore (Mus. of Art, Walters), Boulogne, Calais, The Hague, Lille, New York (Brooklyn, Met.) and Paris (Louvre).
Lit. M. Vachon: *J. Breton* (1899)

Brett John, b. Bletchingley 1831, d. Putney 1902. Landscape painter. Under the influence of the PRE-RAPHAELITES, he exhibited at the ROYAL ACADEMY in 1858 *The Stonebreaker*, a rustic scene painted with meticulous detail. It was highly praised by Ruskin, who adopted Brett as a protégé, driving him to paint the extraordinarily detailed view of the *Val d'Aosta* (1858). He continued to exhibit at the Royal Academy but did not repeat his early success; his interests turned towards astronomy, botany and geology and he painted many very detailed coastal views. There are works in Liverpool (Walker) and London (Tate).

Brodowski Anton, b. Warsaw 1784, d. Warsaw 1832. Painter of historical and religious subjects, much influenced by DAVID; he also painted portraits, particularly of Polish bishops and ministers. He first studied in Warsaw, and later in Paris (1805–8) under the miniaturist Augustin. Awarded a state grant on his return to Poland, he went again to Paris and studied under GÉRARD (1809–15). His large work *Saul and David* was exhibited in Warsaw (1819) and won him a state gold medal and a lasting reputation. He became a professor of Warsaw Art School the year before his death. There are works in Warsaw (Nat. Mus.).

Brown Ford Madox, b. Calais 1821, d. London 1893. Closely associated with the PRE-RAPHAELITES, he represents the most important link between their work and that of the NAZARENES and Continental history painting. His most important works, executed under the influence of the Pre-Raphaelites, were scenes from contemporary life, *Work* (1852–65), *The Last of England* (1852–5) and *Pretty Baa-Lambs* (1851–2), one of the first *plein air* figure subjects of the century. He studied in Bruges and Ghent and then (1837–9) in Antwerp with WAPPERS. He spent 1840–4 in Paris; his early history paintings

Brown *Work* 1852–65

Brüllov *Last Days of Pompeii* 1833

Buchser *Negro Hut in Charlottesville* 1870

reflect the influence of Wappers and DELA-ROCHE (*Execution of Mary Queen of Scots* 1842, *Prisoner of Chillon* 1843). He visited Rome (1845–6), where he met OVERBECK and the Nazarenes; he was strongly influenced by their medievalism and clear colour. Admiration of his most Nazarene work, *Wyckliffe* (1847–8), made ROSSETTI ask to be taken as a pupil (1848). This carried Brown into the Pre-Raphaelite orbit; he worked from nature with HUNT and MILLAIS, lightening his palette and experimenting with contemporary genre. Also through Rossetti he met MORRIS, for whom he executed book illustrations and designed stained-glass windows. In his later work he returned to a literary-historical style. He executed murals for Manchester Town Hall and there are also works in Birmingham, Liverpool, London (Tate, V&A), Manchester, Melbourne and Sydney.
Lit. F. M. Hueffer: *F. M. Brown* (1896); H. M. M. Rossetti: *F. M. Brown* (1902)

Brüllov (Brüloff, Briuloff, Bryullov) Karl Pavlovich, b. St Petersburg 1799, d. nr Rome 1852. The first Russian artist to gain an international reputation as a history painter with his monumental *Last Days of Pompeii*. He entered the St Petersburg Academy at ten; after winning a gold medal and a scholarship for foreign travel (1822), he went via Germany to Rome, where he copied Raphael and also executed portraits and genre paintings. In Naples, Pacini's opera *Ultimo giorno di Pompeia* inspired his masterwork, which was exhibited in Rome and Milan (1833) and had a triumphant reception. Sir Walter Scott called it 'an epic'; Gogol and Pushkin added paeans of praise, and Bulwer Lytton was inspired by it to write his famous novel *The Last Days of Pompeii*. Though Paris gave the painting only restrained praise, it caused a sensation in Russia and encouraged other painters to produce a multitude of enormous historical canvases. He visited Greece and Asia Minor (1835) before returning to St Petersburg (1841), where he was appointed a professor at the academy and painted scenes from Russian history, religious canvases and frescoes, though without repeating his first success. Back in Italy (1849), he painted some fine portraits and watercolours. The influence of his work on Russian academic art lasted throughout the century. There are

works in Leningrad (Russian Mus.) and Moscow (Pushkin, Tretiakov).
Lit. O. Lyaskovskaya: *K. Briullov* (1940, in Russian)

Bruni Feodor (Fidelio) Antonovich, b. Moscow 1800, d. St Petersburg 1875. History and religious painter, a follower of BRÜLLOV and influenced by the German NAZARENES. Son of an Italian artist, he studied at the St Petersburg Academy and was sent to Rome by his father (1818). *Death of Camilla* (1834) won him membership of the Academy of St Luke (Rome) and the title of ACADEMICIAN at St Petersburg. After returning to Russia, he went back to Rome (1838) to prepare a huge canvas, *The Bronze Serpent*, inspired by the recent triumph of Brüllov's *Last Days of Pompeii*, and its great success brought him many commissions for church decoration. He became director of the Hermitage (1849–54) and director of painting and sculpture at the St Petersburg Academy (1855). There are works in Leningrad (Russian Mus.), Milan (Ambrosiana) and Moscow (Pushkin, Tretiakov).

Buchser Frank, b. Feldbrunnen 1828, d. Feldbrunnen 1890. Much travelled Swiss landscape, genre and portrait painter. He belonged to the REALIST-oriented generation and took a special delight in effects of light; his sketches tend now to be more highly regarded than the smoother, more anecdotal, exhibition pictures. He studied theology before a visit to France and Italy (1847) decided him to take up painting and to study at the Academy of St Luke (Rome). He joined the Pope's Swiss Guards, fought with Garibaldi and fled to Paris (1849–50), where he worked with J. V. Schnetz. After studying at the Antwerp Academy (1850–1), he travelled to Paris, London, Morocco, Belgium, Holland, the U.S., Italy, Corfu, Albania, Montenegro and Dalmatia. He played a central role in the organization of artistic life in Switzerland, founding the Gesellschaft Schweizer Maler und Bildhauer (1866), campaigning for state financial support and inspiring the foundation of a National Salon (1890). His American sketches and portraits are particularly admired. There are works in Basle (Kunstmuseum), Berne, Neuchâtel and Zurich.

Lit. T. Röffler: *F. Buchser* (1928); W. Ueberwasser: *F. Buchser, der Maler* (1940); G. Wälchli: *F. Buchser* (1941)

Bürkel Heinrich, b. Pirmasens 1802, d. Munich 1869. One of Munich's first naturalistic landscape and genre painters, his broad views of South German or Italian country life allow neither landscape nor figures to dominate. He painted contemporary life without anecdote, the painterly technique echoing his studies of Dutch 17C masters. He took up painting seriously in 1822, and after being refused by the Munich Academy he studied with W. KOBELL and taught himself by copying Dutch paintings in Munich galleries. He exhibited at the Munich KUNSTVEREIN and soon found patrons. After a visit to Italy (1830–2), where he ignored the NAZARENES but was slightly influenced by ROBERT, he settled again in Munich, though he made constant sketching tours in the Bavarian mountains. He was an honorary member of the Dresden, Munich and Vienna Academies. There are works in Berlin, Bremen, Darmstadt, Hamburg, Kaliningrad, Leipzig, Munich and Stuttgart.
Lit. L. von Buerkel: *H. von Bürkel* (1940)

Burne-Jones Sir Edward Coley, b. Birmingham 1833, d. London 1898. A follower of the PRE-RAPHAELITES, though not one of the original Brotherhood, he painted subjects derived from Arthurian legends, fairy tales, myths and the Bible, in a richly decorative style influenced by Botticelli, Mantegna and, most importantly, his early master ROSSETTI. Greatly admired by the French SYMBOLISTS, he was invited to exhibit at the SALON DE LA ROSE + CROIX. He designed stained glass, tapestries, ceramics, illustrated books, etc. for his lifelong friend MORRIS, and had many followers both in England and Continental Europe, including F. Sandys, S. Solomon, E. de Morgan, KHNOPFF and L. A. Rosenkrantz. He went up to Oxford in 1853 intending to enter the Church, but with his fellow student Morris he discovered a new dedication to the beauty and romance of the Middle Ages. He visited French Gothic cathedrals with Morris (1855), before discovering his own dream in Rossetti's illustration to *The Maids of Elfenmere*. He left Oxford to work in Rossetti's studio, though he returned to paint frescoes for the Oxford Union with Rossetti and Morris (1857). In 1859 he paid his first visit to Italy, where he was profoundly influenced by the work of Botticelli. With his wife Georgiana Macdonald, whom he married in 1860, and John Ruskin, he went again to Italy in 1862. Until 1870 he worked mainly in watercolours. He first exhibited in the Grosvenor Gallery (1877), which thereafter became a shrine of the Burne-Jones cult and a focus of the AESTHETIC MOVEMENT. He became an ARA in 1885; he exhibited once (1886) and withdrew from membership in 1893. He received the French Legion of Honour (1889) and an English baronetcy (1894). There are works in Birmingham, Dublin, Glasgow, Liverpool, London (Tate, V&A) and Manchester. (*see colour illustration 28*)
Lit. Lady Burne-Jones: *Memorials of E. Burne-Jones* (1904); Lord David Cecil: *Visionary and Dreamer* (1969); M. Harrison and B. Waters: *Burne-Jones* (1973); P. Fitzgerald: *E. Burne-Jones* (1975)

Busch Wilhelm, b. Wiedensahl 1832, d. Mechtshausen 1908. Painter, poet and illustrator, his fame rests on his caricatures for the Munich *Fliegende Blätter* and his humorous poem-picture books poking fun at the bourgeoisie; the first of a long line of successes was *Max und Moritz* (1865). His place in German art is somewhat parallel to that of DAUMIER in France. He studied at the Düsseldorf Academy (1851), in Antwerp (1852–3), where he steeped himself in 17C Dutch art, and at the Munich Academy (1854) under KAULBACH; there he became a friend of DIEZ and LENBACH. His first caricatures for *Fliegende Blätter* appeared in 1858. His genre, portrait and still-life painting remained close to the Dutch and Flemish schools, especially Teniers, Brouwer, Rubens and Hals.
Lit. F. Novotny: *W. Busch als Zeichner und Maler* (1949); F. Bohns: *W. Busch: Leben, Werk, Schicksal* (1958); R. Hochhuth (ed.): *W. Busch, Sämtliche Werke und eine Auswahl der Skizzen und Gemälde* (1959); R. Behrens: *W. Busch: Zauber des Unvollendeten: Das unbekannte malerische Werk* (1963)

Bürkel *Gang of Robbers in the Abruzzi c.* 1832

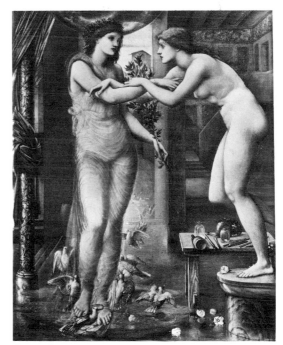

Burne-Jones *Pygmalion and the Image (III), The Godhead Fires* 1878

C

Cabanel *Birth of Venus* 1862

Caillebotte *Paris, A Rainy Day (Intersection of the Rue de Turin and the Rue de Moscou)* 1877

Calame *The Lake of Thun* 1854

Cabanel Alexandre, b. Montpellier 1823, d. Paris 1889. Painter who achieved great popularity under the Second Empire with both his society portraits and his mythological paintings. In the latter he follows INGRES in his persistent and slightly erotic treatment of the female nude (*Birth of Venus* 1862), though he departs from Ingres in treating nudes with the REALISM characteristic of his generation; they are denizens of Paris, not of Olympus. He studied at the ECOLE DES BEAUX-ARTS from 1840 under PICOT, winning the first Rome prize in 1845 and spending 1845-50 in Italy. His early works are conventional history paintings (*Death of Moses* 1855), but in the mid-1850s he turned to portrait painting. His elegant depiction of society ladies brought him immediate favour, and the success of *Venus* in 1862 inaugurated a series of mythological paintings which brought him the highest official honours. Chevalier of the Legion of Honour in 1863, he became an officer in 1864 and a commander in 1884. He was a member of the INSTITUT (1863) and a professor at the Ecole des Beaux-Arts. He formed many pupils, who imitated his mythological style, and was one of the most determined opponents of IMPRESSIONISM. There are works in Amiens, Antwerp, Baltimore (Mus. of Art, Walters), Cette, Graz, Lille, Montpellier, Moscow (Tretiakov), Paris (Louvre, Panthéon), Pontoise and Valenciennes.
Lit. V. de Sabligny: *Venus etc. de Cabanel* (1875)

Caffi Ippolito, b. Belluno 1809, d. Lissa 1866. Venetian view painter, distinguished also for his drawings and watercolours. He studied at the Venice Academy, moving in 1832 to Rome. In 1843 he embarked on a long journey round the Middle East returning with an important series of paintings and drawings. He took part in the Venetian uprisings of 1848-9 and has left many paintings of the military events of the time. He drowned at the naval battle of Lissa which he hoped to immortalize in paint. There are works in Belluno, Rome (Mod. Art), Turin (Mod. Art) and Venice (Ca' Pesaro, Correr, Mod. Art).
Lit. A. Caffi: *La vita di I. Caffi* (1967)

Caillebotte Gustave, b. Paris 1848, d. Gennevilliers 1894. IMPRESSIONIST painter, strongly influenced by MONET, and an important patron of his more famous Impressionist friends. He studied under BONNAT and exhibited at five of the Impressionist Group Shows, from 1876 to 1882. His large private income freed him from the necessity of selling his pictures, which are still mostly owned by his family. He bequeathed a large collection of paintings by his friends to the Luxembourg, destined for the Louvre, but his executor RENOIR had difficulty in persuading the administration to accept even a part of the collection. His work is represented in Paris (Louvre) and Chicago.
Lit. M. Berhaut: *G. Caillebotte* (1951); *Caillebotte l'impressioniste* (1968)

Calame Alexandre, b. Vevey 1810, d. Menton 1864. Successful Swiss painter of Alpine scenery, jagged mountains, glaciers and torrential waterfalls. His emphasis on the wild drama of nature was internationally acclaimed and gained him many followers in Switzerland and Germany. His formal study of painting began in 1829 under DIDAY, the pioneer of Alpine painting, whom he later outshone. He visited France (1836 and 1837), Germany, where he met A. ACHENBACH and SCHIRMER (1838), and Holland, where he studied the work of Ruysdael and Hobbema. *Orage à la Handeck*, exhibited in the Paris SALON of 1839, brought him major success which was followed by a gold medal (1841) and the Legion of Honour (1842). He visited Italy (1844-5), but the Swiss Alps remained his favourite subject matter. He repeated his successful compositions in several versions, for which he was criticized: 'Un Calame, deux Calames, trois Calames – que de calamités,' Muther records as a later Parisian comment, and BÖCKLIN, his pupil for a period, reiterated this criticism. There are works in Amsterdam, Antwerp,

Baltimore (Walters), Basle (Kunstmuseum), Berlin, Boston, Cincinnati, Cologne, Dresden, Frankfurt/M., London (NG, Wallace), Moscow (Tretiakov) and Philadelphia.
Lit. E. Rambert: *A. Calame, sa vie et son œuvre d'après les sources originaires* (1884); A. Schreiber-Favre: *A. Calame* (1934)

Callcot Sir Augustus Wall, b. London 1779, d. London 1844. Painter of landscapes, seascapes and historical genre. A pupil of Hoppner, in the 1820s and 1830s he was one of England's most highly regarded painters. He became an ARA (1806) and an RA (1810), and was for many years Keeper of the Royal Collections, for which he was knighted in 1837. There are works in Hamburg, Leeds, London (Tate, V&A), Manchester and Nottingham.
Lit. J. Dafforne: *Pictures by Sir A. W. Callcot* (1878)

Cals Adolphe Félix, b. Paris 1810, d. Honfleur 1880. Painter of landscapes and peasant life, a close friend of JONGKIND and others of the BARBIZON SCHOOL generation. A painter of great poetic sensitivity, he is counted among the forerunners of IMPRESSIONISM, and participated in five of the Impressionist Group Shows (1874–81). He trained first as an engraver before entering the ECOLE DES BEAUX-ARTS under COGNIET. After initial struggles, he found an enthusiastic patron and protector in Count Doria (*c.* 1859), and from 1870 he divided his time between Paris and Honfleur. There are works in Honfleur, Paris (Louvre) and Reims.
Lit. A. Alexandre: *A. F. Cals, ou le bonheur de peindre* (1900); V. Jannesson: *Le Peintre A. F. Cals (1810–1880) et son élève J. A. E. Bataille (1828–1911)* (1913)

Cammarano Michele, b. Naples 1835, d. Naples 1920. Italian painter of genre, portraits and battle scenes. His work flowered in the MACCHIAIOLI generation, but his particular strength lay in narrative painting, treating patriotic themes (*Battaglia di Dogali*), often on a large scale, and in social comment, depicting life in the poor quarters of Rome or the Neapolitan countryside. He entered Naples Academy (1853) under Smargiassi and Mancinelli, but was more influenced by the *plein air* painting of PALIZZI and his school. He moved to Rome (1865) and

visited Paris (1870), meeting COURBET and falling under the spell of GÉRICAULT. After the unification of Italy, he received many commissions to record the great events of Garibaldi's campaigns. His frequent visits to Venice carried his influence to the Venetian school, particularly ZANDOMENEGHI. He spent five years (1888–93) at Massaua studying the countryside to ensure accuracy in his *Battaglia di Dogali* (1893), and took over from Palizzi as professor of landscape painting at Naples Academy in 1900. There are works in Naples (Belle Arti, San Martino, Capodimonte) and in the galleries of modern art in Florence, Milan and Rome.
Lit. F. Girosi: *Cammarano* (1934); M. Biancale: *Cammarano* (1936)

Cammarano *The Battle of Dogali* 1889–93

Camuccini Vincenzo, b. Rome 1771, d. Rome 1844. Italy's leading exponent of the DAVID school of NEOCLASSICISM. His first major work, *The Death of Caesar* (1798), conceived possibly to outdo David's *Horatii*, borrows its composition from the antique; the accent is on drawing rather than on colour. In his many religious works he tended to follow Raphael; he was also a distinguished portraitist. He studied with Domenico Corvi and spent two years copying from Raphael and Michelangelo in the Vatican. His *Caesar*, followed by *Death of Virginia* (1804), brought him immediate success. Elected to the Academy of St Luke in Rome (1802), he became its director in 1806. For more than thirty years he was the overlord of Roman painting, and during the French occupation of Rome he was given a royal reception when he visited Paris and Munich. Pius VIII created him Baron in 1830, and he was an associate member of the INSTITUT. There are works in Naples, Prague, Rome and many Italian churches.
Lit. P. Filotico: *Su tre quadri dipinti per Napoli da V. Camuccini* (1841); P. E. Visconti: *Notizie intorno alla vita del Barone Camuccini pittore* (1845); C. Falconieri: *Vita di V. Camuccini e pochi studi sulla pittura contemporanea* (1875)

Camuccini *The Death of Caesar* 1798

Canon Hans (born Johann von Straschiripka), b. Währing (Vienna) 1829, d. Vienna 1885. Austrian history, genre and portrait painter, a leading light of late-19C Viennese painting with RAHL and MAKART. His painterly technique was modelled on Rubens, Jordaens

Canon *Page* 1870

and their school, almost slavishly in some of his historical and religious works. His portraits are distinguished by their freshness and psychological insight. He entered the Vienna Academy (1845) as a pupil of WALDMÜLLER and Rahl. He was an officer in the Austrian army (1848–55) and travelled extensively in the Orient, England, France and Italy. In Karlsruhe (1860–9) he taught TRÜBNER before moving to Stuttgart. The success of *Loge Johannes* at the Vienna Weltaustellung (1873) decided him to return to Austria (1874), where he received commissions for frescoes, altarpieces and portraits. There are works in Cologne, Hamburg, Stuttgart and Vienna (Belvedere).

Canova Antonio, b. Possagno 1757, d. Venice 1822. Italian NEOCLASSICAL sculptor, one of the most influential artists of his time. Among his most famous sculptures are *Napoleon* as a Roman hero, naked but for the toga over his arm (1811), *Pauline Bonaparte Borghese as Venus* (1808), and *Cupid and Psyche* (1787–93) in the Louvre. Painters frequently borrowed from his compositions. He studied in Venice and his early work is much in the French 18C tradition. In 1780 he visited Rome and Pompeii, settling in Rome (1781) where he became involved in the Neoclassical currents of the time. He visited London in 1815 after being sent by the Pope to Paris to secure the return of treasures looted by Napoleon. There is a large collection of casts of his works at Possagno, near Treviso, his birthplace. There are also works in Bergamo, Berlin, Florence, Genoa, London (V&A), Munich, Naples (Nazionale), Ottawa, Padua, Paris (Louvre), Rome (Borghese, Vatican, Capitolino, many churches), Turin, Venice (Accad., Correr, Querini-Stampalia) and Vienna.
Lit. E. Bassi: *Canova* (1952); A. Munoz: *A. Canova* (1957)

Carnovali Giovanni (called 'Il Piccio'), b. Montegrino Valtravia 1804, d. nr Cremona 1873. Solitary and individualistic innovator of the Lombard ROMANTIC school. He treated religious subjects, history, landscape and portraits, combining the influences of careful and eclectic study of Old Masters (Correggio, Luini, Titian, Rembrandt, Guardi, Tiepolo) with constant studies from nature. The result was a subtle lyricism whose salient features were a rich impressionistic colourism and a penchant for the *bozzetto* or 'unfinished' picture (*Hagar Driven Away by Abraham* 1863, *Bacchus Consoling Ariadne*). 'In his solitary meditations, he discovered that pictorial design consists of the relation of tones and the incidence of areas of shade and light, and for this reason the main efforts of the artist must be concentrated on colour' (Caversazzi). More admired than understood in his lifetime, his work was a powerful influence on the SCAPIGLIATURA colourists and such later painters as PREVIATI. He entered the Accademia Carrara at Bergamo to study under the classicist Giuseppe Diotti (1815) and in 1831 went to Rome, pausing at Parma to study Correggio. After visiting Cremona (1832) he settled in Milan (1836). He travelled in Switzerland and France with his painter friend Giacomo Trécourt (1845) and returned to Rome in 1847–8 and again in 1855. He studied the work of Old Masters in galleries throughout Italy. A large exhibition of his work in Milan (1909) established his reputation. There are works in Bergamo (Carrara, Donizettiano), Cremona (Civico), Florence (Uffizi), Milan (Mod. Art, Brera), Naples (Capodimonte), Rome (Mod. Art) and Turin (Mod. Art).
Lit. C. Caversazzi: *G. Carnovali detto ill Piccio* (1933); G. Nicodemi: *Paesaggi padani* (1954); P. Chiara: *Disegni di G. Carnovali* (1968)

Carolus-Duran Emile Auguste (born Charles Emile Auguste Durand), b. Lille 1838, d. Paris 1917. Immensely successful *fin de siècle* portraitist. In his early years, he was considered a REALIST with COURBET and RIBOT; he was also a friend of MANET, with whom he shared a passion for Velasquez. He added a chic prettiness to an IMPRESSIONIST style of painting which made his work acceptable to the public. He studied at the Académie Suisse and spent four years (1862–6) in Italy. *L'Assassiné*, a dramatic peasant scene with NAZARENE overtones, was a success in the SALON of 1866 and was sold to the Musée de Lille. With the proceeds he travelled to Spain where, overwhelmed by Velasquez, he spent an entire year copying his work. On his return to Paris, where he adopted the more sonorous name 'Carolus-Duran', *La Dame au Gant*, a portrait of his wife strongly influenced by Velasquez, brought him major success in the Salon of 1869 and launched him as a portrait painter, though he continued to paint landscapes and subject pictures. He became a chevalier of the Legion of Honour in 1872, an officer in 1878, a commander in 1889 and a grand officer in 1900. He was a founder, with MEISSONIER and PUVIS DE CHAVANNES, of the SOCIÉTÉ NATIONALE DES BEAUX-ARTS (1889), and became its president in 1898. He was a member of the jury for the EXPOSITIONS UNIVERSELLES of 1889 and 1900, a member of the INSTITUT and director of the French Academy in Rome (1905). There are works in Amiens, Baltimore (Mus. of Art), Lille, Paris (Louvre) and Versailles.
Lit. A. Alexandre: *Carolus-Duran* (1902)

Carrière Eugène, b. Gournay 1849, d. Paris 1906. Often considered a SYMBOLIST, Carrière found the mystery and emotion which inform his painting in his own family. Faces and figures emerge from his misty paintings, disengaged by the soft light that falls on them; children and maternity were his favourite themes, and at the turn of the century he was considered one of France's leading painters. The pastels of Quentin de la Tour inspired his dedication to painting. He was taken prisoner during the Franco-Prussian War, and his enforced stay in Dresden introduced him to Rubens, an important influence on his early work. In Paris, he studied under CABANEL (1872–6). He married in 1877, and his wife became the favourite model for his paintings, while the death of a son was the source of the melancholy in his later work. He was a friend of Daudet, Anatole France, the Goncourts and Verlaine (*Edmond de Goncourt on his Death Bed* 1896, *Verlaine* 1891). There are works in Avignon, Boston, Brussels (Musées Royaux), Cambridge Mass. (Fogg), Chicago, Cleveland, Douai, Geneva, Nantes, New York (Met.), Paris (Louvre), Philadelphia and Toulon.
Lit. G. Geffroy: *L'Oeuvre d'E. Carrière* (1901); J. and E. de Goncourt: *Künstlerköpfe* (1911); J. P. Dubray: *E. Carrière: essai critique* (1931); J. R. Carrière: *De la vie d'E. Carrière: souvenirs, lettres, pensées, documents* (1966)

Carus Carl Gustav, b. Leipzig 1789, d. Dresden 1869. Doctor and amateur painter,

the friend and biographer of FRIEDRICH. Influenced by Friedrich, he painted land- scapes, combining a mood of melancholy with careful observation of natural detail. He was also influential as an art theorist (*Letters on Landscape Painting* 1831). He studied medicine in Leipzig and in 1814 went to Dresden, where he met Friedrich. There are works in Berlin, Dresden, Düssel- dorf, Oslo (NG) and Weimar.
Lit. C. G. Carus: *Lebenserinnerungen und Denkwürdigkeiten* (1865–6, new ed. 1966); W. Goldschmidt: *Die Landschaftsbriefe des C. G. Carus, ihre Bedeutung für die Theorie der romantischen Landschaftsmalerei* (1935); M. Prause: *C. G. Carus, Leben und Werk* (1968)

Cassatt Mary, b. Pittsburgh (Pa.) 1845, d. Mesnil-Beaufresne 1926. American IMPRES- SIONIST, a close friend of DEGAS and strongly influenced by RENOIR. Mothers and children were her favourite subject matter. After studies at Pennsylvania Academy (1861–5), she went to Europe (1866) and visited Italy, the Low Countries and Spain, where she was profoundly influenced by Velasquez. She settled in Paris (1874), exhibiting in the 'SALON; Degas admired her work, they were introduced, and she became a friend and associate of the Impressionist group. She exhibited with the Impressionists in 1877, 1879, 1880, 1881 and 1886, but the first exhibition dedicated wholly to her work was at Durand-Ruel's (1891). She was influenced by an 1890 exhibition of Japanese prints in Paris (*Young Women Picking Fruit* 1891) and executed many coloured etchings, mainly of domestic scenes. She was accorded the Legion of Honour in 1904. Through her influential friends, particularly the Haver- meyers, she did much to spread the apprecia- tion and stimulate the collection of Impressionist paintings in America. Her works are included in many American galleries, including Baltimore (Mus. of Art, Walters), New York (Met.) and Philadelphia.
Lit. A. D. Breeskin: *The Graphic Work of M. Cassatt* (1948); J. M. H. Carson: *M. Cassatt* (1966); A. D. Breeskin: *M. Cassatt: A Catalogue Raisonné of the Oils, Posters, Watercolours and Drawings* (1970)

Catel Franz Ludwig, b. Berlin 1778, d. Rome 1856. Landscape and genre painter who moved to Rome in 1812, his home

Carnovali *Landscape c.* 1844–6

Carrière *Motherhood*

Carus *Allegory on the Death of Goethe c.* 1832

Carolus-Duran *The Woman with the Glove: Madame Carolus-Duran* 1869

Cassatt *A Cup of Tea c.* 1880

Cazin *Hagar and Ishmael c.* 1880

Cézanne *Mont Sainte-Victoire with a Large Fir Tree* 1885-7

becoming a centre for the German artist colony from the NAZARENES onwards. His Italian views painted in the tradition of KOCH were popular alike with German, English and Russian visitors. He became a member of the Berlin Academy in 1806, and an honorary professor there in 1841. There are works in Bergamo, Berlin, Copenhagen (Thorwaldsen), Hamburg, Hanover, Munich (N. Pin., Schack), Poznań and Stuttgart.

Catlin George, b. Wilkes-Barre (Penn.) 1796, d. Jersey City 1872. American artist, self-taught in the galleries of Philadelphia, who spent many years painting among the American Indian tribes. After holding a popular exhibition in New York in 1837, he toured Europe with his 'Gallery of Indians' from 1839. The collection was offered to the Smithsonian Institute in 1846 but not accepted until 1879. He is represented in many other American museums.
Lit. G. Catlin: *Episodes from Life among the Indians and Last Rambles* (ed. M. C. Ross 1959); H. Cracken: *G. Catlin and the Old Frontier* (1959); M. C. Roehm (ed.): *The Letters of G. Catlin and his Family* (1966)

Cazin Jean Charles, b. Samer 1841, d. Lavandou 1901. French landscape and history painter, highly esteemed in the last decades of the 19C; he was also an etcher and ceramic artist. His landscapes were strongly influenced by MILLET and COROT but he aimed at a heightened mood of poetry, often painting at dawn and dusk. In the 1860s he accompanied LEGROS to London, where he designed for the Fulham pottery and came under the influence of the PRE-RAPHAELITES. In the 1890s he turned increasingly to subject pictures, placing biblical or historical events in a landscape setting. He was a founder member of the SOCIÉTÉ NATIONALE DES BEAUX-ARTS (1890), and became a chevalier of the Legion of Honour (1882), an officer (1889) and a commander (1900). There are works in Baltimore (Walters), Berlin, Boston, Cambridge Mass. (Fogg), Chicago, Cincinnati, Lille, Lyons, Montreal, New York (Met., Brooklyn), Paris (Louvre), Philadelphia and Washington (NG, Corcoran).
Lit. L. Bénédite: *Cazin* (1902)

Cézanne Paul, b. Aix-en-Provence 1839, d. Aix-en-Provence 1906. While Cézanne's work was known only to a small group of sympathizers in the 19C, it became one of the central influences on 20C painting. From the large retrospective exhibition at the Salon d'Automne (1907), he became known to a wider public and his influence can be traced among the Fauves, the Cubists and artists of many other nationalities, including Mondrian and the early masters of a completely abstract art. In the solitude of his family home at Aix (*c.* 1885-95), he realized his ambitions 'to do Poussin again from Nature', 'to make of IMPRESSIONISM something durable and solid like the art of the museums'. He applied Poussin's classical geometry to the simple subject matter of the Impressionists, portrait, still life and landscape, reducing the complexity of nature to a formal synthesis of lines and planes, given three-dimensional volume by modelling in colour where traditionally painters had used tone. He stressed the construction of volume in space in terms of the cone, the sphere and the cylinder, an approach to be taken further by the Cubists. Cézanne's story is of a passionate and sensual nature finally repressed and controlled by his own act of will. His father was a wealthy banker and tradesman and he was educated at the Collège Bourbon where began his long friendship with Zola, broken only in 1886 with the publication of Zola's *L'Oeuvre*, in which Cézanne believed he saw himself wholly misrepresented. First constrained by his father to study law, he was allowed to take up painting in 1861 when he moved to Paris. He studied at the Académie Suisse where he met GUILLAUMIN and through him PISSARRO. At the Café Guerbois he met frequently with his friend Zola and the Impressionists MANET, RENOIR and SISLEY. His first style, however, owed more to DELACROIX, and through him to Rubens and Tintoretto; he saw himself as an imaginative painter, affecting dramatic and often erotic themes – *The Assassins*, *The Autopsy*, *The Temptation of St Anthony* – crudely painted with a violent impasto. In 1869 he met Marie Hortense Fiquet, a young model, who bore him a son in 1872 and whom he eventually married in 1886. In 1870 he fled to L'Estaque to avoid the Franco-Prussian War and in 1872 joined Pissarro and Guillaumin in Pontoise. His style became less violent and he began to paint in an Impressionist vein;

he learned to study nature, the world of atmospheric colour was revealed to him, and his power to organize form began to become apparent. His work was constantly refused by the SALON but he exhibited with the first Impressionist Group Show of 1874 and again in 1877 when he showed sixteen canvases. His work attracted little attention and, never at home in the big city, he retired to Aix, seldom re-emerging from his sanctuary. Here his mature style began gradually to evolve in portraits – he often painted Hortense Fiquet – in landscapes, especially Mont Sainte-Victoire, and in still lifes. For flower pieces he worked frequently from artificial flowers, the life of natural ones not being long enough to accommodate his laborious synthesis of planes articulated by innumerable slight modulations of colour. At his father's death in 1886 he inherited the Jas de Bouffan estate and an independent fortune. He worked increasingly in water-colour and the discipline of coloration in this medium probably affected his oils; he left many works unfinished in both media. In his last years there was a reappearance of his early romantic tendencies; his large canvases of nude *Bathers* in a landscape setting show this in terms of theme while the execution is more highly charged and agitated. There are several works in Basle (Kunstmuseum), Berlin, Budapest (Fine Arts), Chicago, The Hague, Leningrad (Hermitage), London (Tate), Paris (Louvre), Merion Pa. (Barnes Foundation), Moscow, Munich, New York (Met., MOMA), Oslo (NG), Providence R.I., Vienna (Kunst-historisches Mus.), Washington (NG) and Zurich.
Lit. A. Vollard: *P. Cézanne* (1924); A. Vollard: *P. Cézanne. His Life and Art* (1926); J. Rewald: *Cézanne et Zola* (1936); F. Novotny: *Cézanne* (1937); G. Mack: *P. Cézanne* (1938); R. Fry: *Cézanne* (1952); K. Badt: *The Art of Cézanne* (1965); J. Lindsay: *Cézanne, his Life and Art* (1969); F. Elgar: *Cézanne* (1969); A. Chappuis: *The Drawings of P. Cézanne* (catalogue raisonné 1973); J. Wechsler: *Cézanne in Perspective* (1975)

Chantrey Bequest. Sir Francis Chantrey (1781–1841), a very successful woodcarver and portrait painter who became a sculptor, directed in his will that his personal fortune should be turned into a fund, the income from which should be used for the purchase of paintings and sculpture of 'the highest merit' created within 'the shores of Great Britain'. The selection was left to the Council of the ROYAL ACADEMY. The purchases began in 1877 and reflect the taste of the art establishment; artists whose work was purchased include LEIGHTON, MILLAIS, G. F. WATTS, RIVIERE, ORCHARDSON, HERKOMER, STONE and a number of landscapists of the WALKER school. In 1904 a Select Committee of the House of Lords strongly criticized the administration of the fund and selection of paintings as 'incomplete and in a large degree unrepresentative'. Most of the Chantrey Bequest purchases are in the Tate Gallery, London. The academy continues to buy modern British works, mainly from their summer exhibition, which are then offered to the Tate.

Chaplin Charles, b. Les Andelys 1825, d. Paris 1891. Painter, etcher and lithographer. His success was due particularly to his portraits of women and children, but he also painted genre, landscape and some mythological and allegorical works. A pupil of DROLLING (1840) and the ECOLE DES BEAUX-ARTS, he exhibited in the SALON from 1845. His early genre scenes are modelled on Chardin and Fragonard (*Loto* 1865). In the 1880s, when the IMPRESSIONISTS were beginning to affect French painting, his brushwork became much freer and more sensuous. He heightened the effect of female charm by using pastel shades, particularly pink and silver grey, and venturing at times into déshabillé (*Memories in Pink* 1885). Empress Eugénie said of him: 'M. Chaplin, I admire you. Your pictures are not merely indecorous, they are more.' He executed several mural decorations for the Elysée Palace, including the Empress's bathroom, and also for the Tuileries and the Théâtre Français. With an English father and French mother, he became a naturalized Frenchman in 1886. He became a chevalier of the Legion of Honour (1865) and an officer (1887). There are works in Baltimore (Walters), Bayeux, Bayonne, Bordeaux, Bourges, Mulhouse, Paris (Dec. Art), Reims, Rouen and Saintes.

Charlet Nicolas Toussaint, b. Paris 1792, d. Paris 1845. Painter, draughtsman and lithographer dedicated to the depiction of

Chaplin *Loto* 1865

Charlet *Retreat from Moscow* 1836

Chase *A Friendly Call* 1895

Chassériau *Chaste Susanna* 1839

Chełmónski *On a Farm* 1875

the Napoleonic campaigns. A friend of GÉRICAULT, with whom he travelled to England in 1820, he was one of the first artists to contribute to the ROMANTIC generation's mastery of lithographic art. He worked under GROS from 1817. His army pictures helped to spread Napoleonic nostalgia and are said to have contributed to the July revolution; *The Retreat from Moscow*, exhibited in 1836, was his greatest artistic triumph. In 1839 he was appointed professor of drawing at the Ecole Polytechnique. There are works in Avignon, Baltimore (Walters), Bayonne, Chantilly, Geneva, Lyons, Nancy, Paris (Louvre), Pontoise, Reims, Rouen, Valenciennes and Versailles.
Lit. de Lacombe: *Charlet, sa vie, ses lettres suivi d'une description raisonné de son œuvre lithographique* (1856); H. de Saint-Georges: *Charlet, peint par lui-même* (1862) and *L'Homme Charlet* (1892)

Chase William Merritt, b. Williamsburg (Ind.) 1849, d. New York 1916. American painter of portraits, genre, still life and landscape; one of the leaders of European-oriented painting in the late 19C and particularly influential as a teacher. 'His work at various times is close to DUVENECK, to FORTUNY, to BOUDIN, to MANET, or to SARGENT' (Richardson). He studied in Munich under PILOTY (1872-8), opened a painting class at the New York Art Students League (1878), and exhibited at the Society of American Artists. There are works in Boston, Buffalo, Cambridge Mass. (Fogg), Chicago, Cincinnati, Cleveland, Florence (Uffizi), New York (Brooklyn), Philadelphia and Washington (NG, Corcoran).
Lit. K. M. Roof: *The Life and Art of W. M. Chase* (1917)

Chassériau Théodore, b. Samana (San Domingo) 1819, d. Paris 1856. Short-lived painter whose work combined NEOCLASSICAL and ROMANTIC elements: the Neoclassical linearity and ideal beauty of INGRES, the emotive use of colour of DELACROIX. The result was a somewhat exotic and melancholy dream world. Focillon saw his art as imbued with the reveries of the Creole, 'nostalgia for a far-off people, gentle but savage women, and forgotten treasures'. His art was an inspiration for the SYMBOLISTS, PUVIS DE CHAVANNES inheriting the emotive simplicity of his composition and MOREAU the exoticism

of his dream world. The son of a French consul in San Domingo, he showed a precocious talent for art. He entered Ingres's studio (1833) and followed him to Rome when he became director of the French Academy there (1834). Ingres, on whom his early work leans heavily, predicted that he would be 'the Napoleon of painting'. On a visit to Algeria (1846) the colour of the Orient was revealed to him; his Oriental scenes were frequently compared to those of Delacroix. He executed an important fresco cycle for the Salles des Comptes in the Palais d'Orsay (1844-8). Immensely popular, he threw himself with abandon into the gaiety of Parisian life; his health broke down and he died at the age of thirty-six. He is well represented in Paris (Louvre) and there are works in Avignon, Bagnères, Bayonne, Cambridge Mass. (Fogg), Chicago, La Rochelle, Le Havre, Nantes, New York (Met.), Poitiers and Versailles.
Lit. A. Bouvenne: *T. Chassériau, souvenirs et indiscretions* (1884); L. Bénédite: *T. Chassériau, sa vie et son œuvre* (1931); P. Jamot: *T. Chassériau* (1933); M. Sandoz: *T. Chassériau, catalogue raisonné* (1976)

Chełmónski Josef, b. Boczki (Warsaw) 1849, d. Kuklowska 1914. REALIST genre and landscape painter whose paintings of Polish peasant life are often anecdotic and sometimes sentimental. His early work was influenced by LENBACH and the Realist-oriented Munich painters. He was always fascinated by horses, and his later, more impressionistic work holds echoes of BONHEUR. He studied in Warsaw under GERSON, and at the Munich Academy (1872-4), spending some time in the Ukraine. *Cossacks in Line* received an honourable mention in the SALON of 1882, and his reputation was further enhanced when reproductions of his Polish genre scenes were published by Goupil. On his return to Poland (1887), he became an influential figure, and in 1897 joined the 'Young Poland' artistic group. *Horse Market – Sunday in Poland* gained a *grand prix* at the EXPOSITION UNIVERSELLE in Paris (1900). There are works in Baltimore (Walters), Bytom, Cracow, Danzig, Łódź, Lublin, Lvov, Poznań, Warsaw (Nat. Mus.), Wrocław and Zyrardów.
Lit. J. Wegner (ed.): *J. Chełmónski in the Light of his Correspondence* (1953, in Polish)

Chéret *Pantomimes Lumineuses au Musée Grévin* 1892

Church *The Heart of the Andes* 1859

Chéret Jules, b. Paris 1836, d. Nice 1932. Poster designer and illustrator. He pioneered poster design as an art form full of movement and colour, first gaining recognition with his three-colour poster for *Orpheus in the Underworld* (1858). He lived in London from 1859 to 1866. In the 1890s he briefly followed TOULOUSE-LAUTREC in using broad areas of flat colour, but soon returned to his natural impressionistic vigour. There is a large collection of his work at the Musée Chéret in Nice.
Lit. C. Mauclair: *J. Chéret* (1930)

Chintreuil Antoine, b. Pont-de-Vaux 1814, d. Septeuil 1873. Sensitive landscape painter of the pre-IMPRESSIONIST generation. A pupil of COROT, he first exhibited in the SALON of 1847, and later (1850) settled in Igny with his own pupil Jean Desbrosses. Seven years later he moved with Desbrosses to Septeuil, where he painted for sixteen years while battling against illness. His work was little appreciated in his lifetime. There are works in Paris (Louvre), many French provincial museums, Boston, Frankfurt/M., London (NG) and Philadelphia.
Lit. La Fizelière, Champfleury, Henriet: *La vie et l'œuvre de Chintreuil* (1874)

Church Frederick Edwin, b. Hartford (Conn.) 1826, d. New York 1900. Landscapist, particularly famed for his large canvases depicting wild South American scenery, and the only pupil (1844–6) of T. COLE, whose panoramic approach to landscape he followed. Dramatic effects of light were of particular fascination to him, but his approach was analytic, combining them with meticulous realistic detail in an attempt to achieve 'organic unity'. He first exhibited at the NATIONAL ACADEMY OF DESIGN (New York) in 1845, and set up his own studio in New York in 1848. After a trip with Cyrus W. Field to Columbia and Ecuador (1853), he painted South American views which were very successful at the National Academy; his greatest success, however, came with *Niagara* (1857) and *The Heart of the Andes* (1859). He travelled extensively in search of exotic scenery, returning to South America (1857) and sailing from Boston to Halifax. The success of *Niagara* at the EXPOSITION UNIVERSELLE in Paris (1867) took him to Europe and the Middle East. Both his hands became crippled by inflammatory rheuma-

tism in 1877, putting an end to his career at the height of his powers. There are works in Baltimore (Walters), Boston, Cambridge Mass. (Fogg), Chicago, Cincinnati, New York (Brooklyn), Reading Pa. and Washington (NG, Corcoran).
Lit. L. L. Noble: *The Heart of the Andes* (1859) and *After Icebergs with a Painter* (1861); D. C. Huntingdon: *The Landscapes of F. E. Church* (1966)

Ciardi Guglielmo, b. Venice 1842, d. Venice 1917. Venetian landscape painter of the REALIST generation. He studied at the Venice Academy with Moja and Bresolin. In 1868 he travelled round Italy, visiting Florence, Rome and Naples and making contact with the MACCHIAIOLI and other groups of Realist painters; some of his finest landscapes date from this period. His landscapes and seascapes explore every corner of the Veneto region and in 1894 he succeeded Bresolin as professor of 'vedute' (view painting) at the Venice Academy. A special exhibition was devoted to his work at the Venice Biennale of 1909. There are works in the modern art galleries of Florence, Milan, Palermo, Rome, Turin, Venice and also Naples (Capodimonte), Trieste (Revoltella) and Udine (Marangoni).
Lit. M. and P. Pospisil: *G. Ciardi* (1946)

Clairin Jules Georges Victor, b. Paris 1843, d. Belle-Ile-en-Mer 1919. History painter, a pupil of PILS and PICOT. At the end of the century he attempted ambitious dramatic pictures in the style of GROS and DELACROIX. He frequently painted his intimate friend Sarah Bernhardt, and the link with the theatre provided many commissions for theatre frescoes, including the staircase and two ceilings of the Paris Opéra. He became a chevalier of the Legion of Honour in 1887 and an officer in 1897. There are works in Agen, Baltimore (Walters), Dieppe, Louviers (Roussel), Nevers, Paris (Petit Palais) and Rouen.

Clique, The. A sketching club formed by a group of young artists around 1840 including FRITH, DADD, EGG, O'NEIL and PHILLIP, and modelled on the SKETCHING SOCIETY. They met one evening a week and sketched a subject generally taken from Byron or

Cloisonnism

Shakespeare; an adjudication of the best drawing of the week was followed by bread, cheese and beer. The friends were also involved in an attempt to form a rival exhibiting society to the ROYAL ACADEMY. It should not be confused with the ST JOHN'S WOOD CLIQUE.

Cloisonnism (Cloisonnist) *see* SYNTHETISM

Cogniet Léon, b. Paris 1794, d. Paris 1880. History painter of the DELAROCHE era; he was one of the most conservative members of the INSTITUT and an influential teacher, numbering many German as well as French artists among his pupils. He emphasized the aesthetics of the compositional sketch (a freely painted preparation for a picture), a method which was later to influence IMPRESSIONISM; his interest in this stemmed from his own master GUÉRIN and he passed it on to his pupil BONNAT. He won the Rome prize in 1817, and established his fame with *Marius on the Ruins of Carthage* (1824), though his greatest success was with *Tintoretto Painting his Dead Daughter* (1845). He became an officer of the Legion of Honour in 1846 and a member of the Institut in 1849. There are works in Aix, Angers, Bayonne, Bordeaux, Lille, London (Wallace), Montpellier, Nantes, Paris (Louvre), Reims, Toulouse and Versailles.
Lit. H. Delaborde: *Notice sur la vie de L. Cogniet* (1881); E. Vinet: *L. Cogniet* (n.d.)

Cole Thomas, b. Bolton-le-Moor (Lancs.) 1801, d. Catskill (N.Y.) 1848. The first highly successful American landscapist and a founder of the HUDSON RIVER SCHOOL. He painted wide vistas of mountain country untamed by settlers, principally in the Catskills. In parallel he developed a personal brand of historical landscape imbued with noble ideas, as in *The Course of Empire* (1833–6), four paintings depicting *The Savage State*, *The Arcadian State*, *The Consummation of Empire* and *The Destruction of Empire*. This aspect of Cole's output was influenced by the prints of J. MARTIN, with their theatrical exaggeration of light, immense vistas, and piling of level upon level of architectural detail. Born in England, he emigrated to America with his family in 1819. Poverty drove him to become an itinerant portraitist;

his meeting with the landscape painters Birch and DOUGHTY (1823) changed the direction of his art. He worked up sketches made in the Catskills (1825) into landscape paintings; these greatly impressed TRUMBULL, whose influence catapulted Cole to fame. He was co-founder of the New York NATIONAL ACADEMY OF DESIGN (1826). After travelling in England, France and Italy, where he was most impressed by Raphael, Claude and TURNER, he settled in the Catskills, making occasional forays to New York and alternating naturalistic landscape with historical painting. He completed two versions of the four-part *Voyage of Life* series (1839 and 1841–2), which became immensely popular after his death through AMERICAN ART-UNION reproductions. His work stimulated a high regard for landscape in America. CHURCH was his only pupil, but he strongly influenced DURAND and many other painters. There are works in Baltimore (Mus. of Art), Chicago, New York (Met., Hist. Soc.) and Washington (Corcoran, NG). *(see colour illustration 4)*
Lit. L. L. Noble: *The Course of Empire . . . and Other Pictures of T. Cole, NA, with Selections of his Letters and Miscellaneous Writings* (1853, reissued 1964); E. I. Seaver: *T. Cole* (1949)

Collins William, b. London 1788, d. London 1847. Rustic genre and landscape painter whose coastal views and slightly sentimental childhood scenes were particularly admired. He was a pupil of Morland and friend of WILKIE. He became an ARA in 1814, an RA in 1820, and travelled to France, Belgium, Holland, Germany and Italy. He was the father of the novelist Wilkie Collins. There are works in Birmingham, Brighton, Dublin, Edinburgh, Leeds, London (V&A), Manchester, Nottingham, Preston and Victoria (Australia).
Lit. Wilkie Collins: *Memoirs of the Life of W. Collins* (1848)

Conder Charles, b. London 1868, d. Virginia Water 1909. He is best known for his watercolours on silk and his painted fans, realized in soft, slightly mysterious tones, sometimes with courtly scenes that echo Watteau, sometimes with nymphs disporting. He also painted landscapes and portraits in oils. At the age of fifteen he went to Australia,

where he worked for the *Illustrated Sydney News* and exhibited in Melbourne before going to Paris (1890); there he studied at the ACADÉMIE JULIAN and in Cormon's studio, and became friendly with TOULOUSE-LAUTREC and the NABIS (*Moulin Rouge*). After 1894 he lived mainly in England, where he contributed illustrations to *The Savoy*, *The Studio* and *The Yellow Book*, and exhibited with the NEW ENGLISH ART CLUB. There are works in Boston, Cambridge Mass. (Fogg), Chicago, Dublin, Johannesburg, London (Tate), Melbourne, New York (Brooklyn), Paris and Sydney.
Lit. F. G. Gibson: *C. Conder* (1914); J. Rothenstein: *The Life and Death of Conder* (1938)

Constable John, b. East Bergholt 1776, d. London 1837. With TURNER, one of the two greatest English landscape painters of the 19C. The son of a Suffolk merchant, his naturalistic approach to landscape was primarily inspired by close study of the countryside he loved, with all its moods and fleeting effects of light; he also owed an important debt to the Dutch landscape painters of the 17C. His informal country views, full of lovingly observed detail, together with the broad impressionistic brushwork of his later work, helped to free French landscape painting from the classical tradition; his work was greatly admired by the ROMANTICS, particularly DELACROIX, and was an important influence on the BARBIZON SCHOOL. He was already sketching as a schoolboy; the collection of the amateur painter and patron of the arts, Sir George Beaumont, which included drawings by Girtin and Claude Lorrain's *Hagar and the Angel*, fired his enthusiasm. In 1796 he visited Edmonton and met the etcher John Thomas Smith, before returning to Suffolk to work with his father. He entered the ROYAL ACADEMY Schools only in 1799, and in 1802 exhibited his first landscape. In spite of help from WEST and other artists, he taught himself largely from the study of older pictures, particularly those of Jakob van Ruisdael, Claude, Richard Wilson and Gainsborough. Besides copying he earned a modest living from portraits until 1814. His first major work was *Dedham Vale*, exhibited in 1811. In 1809 he fell in love with Maria Bicknell whom he courted against much family opposition and finally married in

1816. He spent 1811–26 in independent study and exploration to which the three hundred or so spontaneous oil sketches of the Victoria and Albert Museum bear witness; major achievements include *The Hay Wain* (1821), cloud studies (1821–2) and *Salisbury Cathedral* (1823). He exhibited three paintings, including *The Hay Wain*, at the Paris SALON of 1824, winning an enthusiastic reception. In 1829 he become an RA, but the death of Maria Bicknell darkened his life. In his last ten years he attempted to carry the broad treatment of his sketches into his finished work (*Waterloo Bridge from Whitehall Stairs* 1832). His daughter bequeathed a large collection of his work to London's Victoria and Albert Museum but he is also represented in the Tate and the National Gallery. There are also works in Berlin, Boston, Cambridge Mass. (Fogg), Cardiff, Kassel, Chicago, Cincinnati, Detroit, Dublin, Edinburgh (NG), Hartford Conn., Leeds, Liverpool, Manchester, Montreal, Munich, New York (Met., Frick), Ottawa, Oxford, Paris (Louvre), Philadelphia, San Marino Ca., Toledo Ohio and Washington (NG, Corcoran). *(see colour illustration 7)*
Lit. C. R. Leslie: *Memoirs of the Life of J. Constable* (1843, new ed. 1951); S. J. Key: *J. Constable, His Life and Work* (1948); G. Reynolds: *Constable* (1965); J. Baskett: *Constable Oil Sketches* (1966); R. B. Beckett: *J. Constable's Correspondence* (6 vols 1962–8); R. B. Beckett: *J. Constable's Discourses* (1970); L. Parris, C. Shields, I. Fleming-Williams: *J. Constable, Further Documents and Correspondence* (1975)

Constant Benjamin, b. Paris 1845, d. Paris 1902. He achieved fame with his 'Oriental' pictures inspired by DELACROIX, and in the 1880s became a fashionable portraitist, much favoured in England and France. He worked with CABANEL (1867) and later travelled to Morocco (1871). He was a member of the INSTITUT (1893) and a commander of the Legion of Honour. There are works in Lille, Montreal, Mulhouse, Paris (Petit Palais), Perpignan and Toulouse.

Cooke William Edward, b. London 1811, d. Groombridge (Kent) 1880. Painter of river and coastal scenes, who was trained by his engraver father and worked with

STANFIELD. He was a distinguished botanist as well as a popular painter. He became an ARA in 1851 and an RA in 1863. There are works in Hamburg, Liverpool, London (V&A), Manchester, Salford, Sheffield and Sydney.

Cope Charles West, b. Leeds 1811, d. Bournemouth 1890. History painter, highly regarded by his contemporaries, who executed several frescoes for the Houses of Parliament in London and also painted small contemporary genre scenes. He became an ARA in 1843 and an RA in 1848. There are works in Leicester, Liverpool, London (Tate), Melbourne and Preston.
Lit. C. H. Cope: *Reminiscences of C. W. Cope* (1891)

Copley John Singleton, b. in or nr Boston (Mass.) 1737, d. London 1815. American portraitist and historical painter. The portraits of his early American period, before he left for Europe in 1774, follow the contemporary English school in composition but are distinguished by the uncompromising realism of the faces and a linear solidity of treatment. In England the influence of Reynolds led him to a freer, more fluent brushwork; with his compatriot WEST he started to paint large canvases realistically depicting contemporary events which were to exert considerable influence on the French school (DAVID, GROS, GÉRICAULT, DELACROIX) and later European history painting. He received his first instruction from his engraver stepfather Peter Pelham; otherwise he was largely self-taught, studying from such European engravings as were available. By 1760 he was beginning to enjoy a flourishing career as a portraitist in Boston. He sent portraits for exhibition at the London Society of Artists in 1765 and 1767 and was urged by West to come to London. He left America in 1774, travelling on from London to Italy where he visited Rome, Florence, Naples and Paestum. The double portrait *Ralph Izard and his Wife* (1774), painted in Rome, shows a strong NEOCLASSICAL influence. Settling in London he worked with West; *Watson and the Shark* (1778) is a contemporary event painted with direct realism. He also painted portraits and became an RA in 1779. His *Death of Chatham* (1779–80) caused a sensa-

Cogniet *Tintoretto Painting his Dead Daughter* 1845

Cole *The Oxbow (The Connecticut River near Northampton)* 1846

Constable *Dedham Lock and Mill* 1820

Corinth

tion; he hired a hall to exhibit it and collected some £5,000 in entrance fees. From the turn of the century his powers declined; he lost his patrons and suffered financial difficulties. There are works in London (NG, Tate) and many early works in Boston. He is also represented in Baltimore (Mus. of Art), Cambridge Mass. (Fogg), Cleveland, New York (Met., Brooklyn), Philadelphia, Washington (NG, Corcoran) and Yale.
Lit. M. B. Amory: *Domestic and Artistic Life of J. S. Copley* (1882, reissued 1969); J. T. Flexner: *J. S. Copley* (1948); J. K. Prown: *J. S. Copley* (1966); A. Frankenstein: *The World of Copley 1737–1815* (1970)

Corinth Lovis, b. Tapiau (E. Prussia) 1858, d. Zandvoort (Holland) 1925. Corinth is accounted, with LIEBERMANN and SLEVOGT, one of the leading German Impressionists; the accent is rather on German than IMPRESSIONIST, for their work had only loose links with the French movement. He used a rapid summary brushwork but a darker palette than the French pioneers and was not involved in similar optical experiment. His art is essentially REALIST, ranging over landscape, portrait, nudes and still life and even attempting to imbue mythological and religious subjects with the same factual objectivity. He depicted reality with a brutal and impetuous force. In the 1890s he was closely involved with the SECESSION movements of Munich and Berlin. He began his studies at Königsberg Academy (1876), moving to Munich in 1880 where he studied under LÖFFTZ and DEFREGGER. In 1884 he visited Antwerp and went on to study in Paris at the ACADÉMIE JULIAN under BOUGUEREAU and T. ROBERT-FLEURY (1884–7). He was influenced here by the work of Rubens and the modified Impressionism of BASTIEN-LEPAGE. From 1891 to 1900 he lived in Munich, exhibiting with the Secession artists, and in 1900 settled in Berlin where he joined the Berlin Secession. Crippled by a stroke in 1911, he taught himself to paint again; much of his later work is pessimistic and violent, establishing a link with Expressionism. There is a Corinth Museum at Tapiau, his birthplace, and he is represented in most German museums; there are also works in Baltimore, Basle (Kunstmuseum), Belgrade, Buffalo, Cambridge Mass. (Fogg), Chicago, Cincinnati, London (Tate), New York (MOMA),

Pittsburgh, Vienna (Kunsthistorisches Mus.) and Zurich.
Lit. G. von der Osten: *L. Corinth* (1955); C. Berend-Corinth: *Die Gemälde von L. Corinth* (1958); B. F. Schnieder: *L. Corinth* (1959); H. Mueller: *Die späte Graphik von L. Corinth* (1960); J. Streubel: *L. Corinth* (1969)

Cornelius Peter, b. Düsseldorf 1783, d. Berlin 1867. Most of his life was dedicated to fresco painting which, through his influence, came to be considered in Germany as the highest of artistic endeavours. His influence can also be traced in the revival of fresco painting elsewhere in Europe; his advice was sought on the British Houses of Parliament decorations. In Rome he was, with OVERBECK, the leader of the NAZARENES (1811–19). He shared at this time their devotion to early Italian painting, particularly Signorelli and the young Raphael. A thoroughgoing eclectic, in his later fresco cycles he leant on the examples of the Raphael Stanze, Michelangelo and Dürer, combining them in almost baroque ornamental compositions. The accent in his work was always on line and modelling; he used colour only to ornament the composition. His schooling at the Düsseldorf Academy was NEOCLASSICAL, but under the influence of the ROMANTIC writers (Tieck, Wackenroder, Schlegel) he turned back for inspiration to Dürer and 16C German engravings. His illustrations to Goethe's *Faust* (1811–16), combining a classical accent on line with bizarre Gothic distortion, met with the author's approval though he advised Cornelius to study Italian masters. In Rome (1811) he was welcomed by Overbeck and the Nazarenes. He was the guiding spirit in their group frescoes, first at the Casa Bartholdy, then at the Casino Massimo, inspiring them with his vision of a renewal of German art through monumental painting. In 1819 he was summoned to Munich by the future Ludwig I to execute fresco decorations for the Glyptothek (completed 1830); his use of scenes from Greek mythology as allegories of man's life and passions reflects the influence of F. Schelling: that painting should give form to metaphysical ideas. His cartoons and frescoes became ever more dense treatises on philosophy and theology. Director of the Düsseldorf Academy (1821–4), he organized

it on the Renaissance model of a master and his assistants, busying his students in the winter months on preparations for Munich frescoes to be executed in the summer. From 1824 he was director of the Munich Academy, and a generation of Munich artists found their talents channelled into the preparation of cartoons and the execution of sections of the master's fresco designs; some went on to execute their own fresco cycles. From 1836 to 1839 he worked on a *Last Judgment* mural to fill the whole east wall of the new Ludwigskirche. Its reception was unfavourable and in 1841 he left Munich for Berlin to work for Frederick William IV. He devoted most of the following years to cartoons for a major cycle of frescoes (never executed) to decorate a proposed extension of Berlin Cathedral modelled on the Campo Santo at Pisa. Most of his work is in Munich but he is also represented in Antwerp, Basle (Kunstmuseum), Berlin (Bartholdy Frescoes), Darmstadt, Dresden, Düsseldorf, Frankfurt/M., Leipzig and Weimar.
Lit. A. Kuhn: *P. Cornelius und die geistigen Strömungen einer Zeit* (1921); K. Koetschau: *P. Cornelius in seiner Vollendung* (1934); K. Andrews: *The Nazarenes* (1964)

Corot Jean Baptiste Camille, b. Paris 1796, d. Paris 1875. One of the great French landscapists of the 19C, an associate of the BARBIZON SCHOOL. His first Italian oil sketches are typical of the preparatory work of contemporary classical landscapists, but remarkable for their grasp of tonal values and composition, simply but strongly defined by southern sunlight. As he travelled round France and worked constantly from nature, his later work caught the northern light in tones of grey and silver, shimmering with movement. In parallel with his generation, he did not think of exhibiting his sketches but worked up exhibition landscapes in his studio, adding figures from the Bible, literature or mythology. At first he aimed at fashionable finish, but from the late 1840s he added his dancing nymphs to naturalistically treated landscapes painted with considerable freedom of brushwork. These works won him popular success, the Legion of Honour (1846), state purchases and a place on the SALON juries. His last years are marked by a series of portraits and figure pieces, not intended for exhibition, whose strength and

simplicity shows the influence of COURBET and MANET. The son of a draper, he followed his father's trade until 1822 when he was allowed to take up painting, and studied with the classical landscapists MICHALLON and V. BERTIN. In Rome (1825–8) he painted in the Roman Campagna with ALIGNY and E. BERTIN, sending *Bridge at Narni* and *Roman Landscape* to the Salon of 1827. Back in France he painted in the Fontainebleau forest, on the Normandy coast and elsewhere; he travelled constantly, revisiting Italy in 1834 and 1843. He had many followers (CHINTREUIL, Lépine, HARPIGNIES, DAUBIGNY) and aided the IMPRESSIONISTS in their early struggles. There are many works in the Louvre but he is also well represented in Baltimore (Mus. of Art, Walters), London (NG, V&A), New York (Met., Brooklyn), Washington (NG, Corcoran) and most museums where there are works of this period.

Lit. A. Robaut, E. Moreau-Nélaton: *L'Oeuvre de Corot: catalogue raisonné* (1904–6); E. Moreau-Nélaton: *Corot raconté par lui-même* (1924); G. Bazin: *Corot* (1951); J. Leymarie: *Corot* (1962); L. Saint-Michel: *L'Univers de Corot* (1974)

Costa Giovanni, b. Rome 1826, d. Marina di Pisa 1903. One of the pioneers of realistic landscape painting in Italy, a precursor and important influence on the MACCHIAIOLI movement. Cosmopolitan in outlook, a life-long friend of LEIGHTON, he helped to make Italian painters more aware of contemporary trends in England, France and Germany. In his later work he moved towards a SYMBOLISM influenced by the PRE-RAPHAELITES. His working life was frequently interrupted by his involvement with Garibaldi and the wars for the unification of Italy. He began his studies in Rome (1846) under CAMUCCINI and others. The 1850s were formative years; he spent much time painting from nature in the countryside round Rome, meeting like-minded foreigners including Leighton, BÖCKLIN and Emile David, from whom he probably learnt of COROT and the experiments of the BARBIZON SCHOOL. The first version of his famous *Women on the Beach at Anzio* dates from 1852; the definitive version was exhibited in Florence in 1861 and Paris in 1862. Forced for political reasons to move to Florence in 1859, he stayed there until 1870;

Copley *Watson and the Shark* 1778

Corinth *Walchensee Panorama* 1924

Costa *Women on the Beach at Anzio* 1852

Cornelius *Wise and Foolish Virgins* 1815–19

Corot *Morning, the Dance of the Nymphs* 1850 (detail right)

Cotman *Greta Bridge* 1810

Courbet *Bonjour M. Courbet!* 1854

Couture *Romans of the Decadence* 1847

it was during this period that his work influenced the Macchiaioli, especially FATTORI. He visited Paris and London in 1862 and after 1870 divided his time between Rome and England. He organized several exhibitions of foreign painting in Rome, including the work of Leighton, BURNE-JONES, Corot, DAUBIGNY, HÉBERT, LENBACH, Böcklin and ALMA-TADEMA. There are works in London (NG), Milan (Mod. Art, Grassi) and Rome (Mod. Art).
Lit. Rossetti-Agresti: *G. Costa, his Life, Work and Times* (1904); F. Sapori: *G. Costa* (1919); N. Costa: *Quel che vidi e quel che intesi* (autobiography 1927)

Cotman John Sell, b. Norwich 1782, d. London 1842. Watercolourist, one of the leading figures of the NORWICH SCHOOL, who worked with geometric clarity using flat planes of coloured wash. He worked as a colourist for Ackermann in London from about 1798 and studied at the informal academy of Dr Thomas Monro, where he was influenced by Girtin; *Chirk Aqueduct* (*c.* 1804) shows him already a master of his medium. On his return to Norwich (1806) he exhibited regularly with the Norwich Society of Artists. In Yarmouth (1812–23) he was primarily engaged in etching architectural antiquities for publication. He returned to Norwich (*c.* 1823) where he remained until he was appointed drawing-master at King's College, London, in 1834. In his later years he mixed paste with his watercolour to achieve a rich impasto which entirely changed his style. There are many works in the Castle Museum, Norwich, and he is also represented in Birmingham, Cambridge Mass. (Fogg), Dublin, Edinburgh, Leicester, Liverpool, London (Tate, V&A), Manchester, New York (Met.), Nottingham and Philadelphia.
Lit. L. Binyon: *J. Crome and J. S. Cotman* (1906); S. D. Kitson: *Life of J. S. Cotman* (1937); V. G. R. Rienaecker: *J. S. Cotman* (1953)

Courbet Gustave, b. Ornans 1819, d. La Tour de Peilz (Switzerland) 1877. An incomparable self-publicist, Courbet appointed himself the champion of REALISM and fought a long and successful campaign with the art establishment for its acceptance. This identification was crystallized by his private pavilion outside the 1855 EXPOSITION UNIVERSELLE, advertised with the placard 'Le Réalisme. G. Courbet'; in it he exhibited forty paintings, his offerings for the exhibition proper having been refused by the jury. A similar pavilion outside the 1867 Exposition Universelle contained 120 works. He rejected all idealization in art, painting what he saw with dark-toned realism which reflected his studies of Velasquez and Hals; this included landscapes, portraits, hunting scenes, nudes and, most controversial of all, huge canvases depicting the life of the poor with unromanticized brutality (*The Stonebreakers* 1849, *Funeral at Ornans* 1849). This scale of painting had hitherto been reserved for 'noble' classical and historical compositions. Courbet, under the influence of the socialist philosopher Pierre Joseph Proudhon, proclaimed that the noblest subject for art was the worker and the peasant. His father was a prosperous farmer at Ornans, near the Swiss border, and the local countryside and people constantly reappear in Courbet's work. Arriving in Paris in 1840, he quickly turned against academic teaching; he studied from the works of Rembrandt, Hals and Velasquez in the Louvre and attended life classes at the Académie Suisse. His *Stonebreakers* (destroyed in the Second World War) was hailed by Proudhon as 'the first socialist painting', and *Funeral at Ornans*, containing fifty lifesize figures, confirmed him as the leader of the Realist movement (championed by Champfleury and Baudelaire). *The Winnowers* and *Bonjour M. Courbet!* followed in 1854 and the centrepiece of his 1855 pavilion was *The Artist's Studio*, a Realist allegory of his own life and beliefs. In the 1850s his work was enthusiastically received in Germany and Belgium; a hunt held in his honour in Munich sparked off his series of hunting and snow scenes. A visit to Honfleur and Trouville with BOUDIN resulted in sea paintings (*Cliffs at Entretat after a Storm* 1870). In the 1860s he brightened his palette and his work became more relaxed and sensuous (*The Sleepers* 1866) with nudes, portraits, flower and fruit pieces taking the place of social comment. This brought him acceptance in Paris; he refused the Legion of Honour. However, his socialist leanings were rekindled in 1870 when he fought for the Commune and, designated 'curator of fine arts', was responsible for the

destruction of Napoleon's column in the Place Vendôme. After the fall of the Commune he was imprisoned for this and spent his last years in Switzerland trying to pay off his indemnity for it by the mass production of Swiss views with the help of assistants. His work was an important influence on MANET, MONET, RENOIR and CÉZANNE, as was his determined battle with the academic establishment. He is well represented in the Louvre and his work can also be found in most museums with 19C collections, including Baltimore (Mus. of Art, Walters), Berlin, Brussels (Musées Royaux), London (Tate, V&A), New York (Met.) and Stockholm (Nat. Mus.). (see colour illustration 19)
Lit. G. Boas: *Courbet and the Naturalistic Movement* (1938); G. Mack: *Courbet* (1952); A. Fermigier: *Courbet* (1971); A. Pinto: *Courbet: The Life and Work of the Artist* (1971); B. Nicholson: *The Studio of the Painter* (1973); T. C. Clark: *Image of the People* (1973); R. Bonniot: *G. Courbet en Saintonge 1862-1863* (1973); L. Nochlin: *G. Courbet. A Study of Style and Society* (1976)

Couture Thomas, b. Senlis 1815, d. Villers-le-Bel 1879. French history and portrait painter and a distinguished teacher. As a history painter he belongs among the ACADEMIC REALISTS, but his freedom of handling and strong tonal contrasts link his work with that of his pupil MANET. His best-known painting, *Romans of the Decadence* (1847) combines classical composition with a free colour treatment. He studied under GROS (1833) and DELAROCHE, won a second Rome prize in 1837 and began to exhibit in the SALON in 1840. Following the sensational success of his *Romans*, he founded an art school to which his fame attracted pupils from all over the world, including Manet, PUVIS DE CHAVANNES, FEUERBACH from Germany, W. M. HUNT and LA FARGE from America. In the 1860s his reputation declined and his publication of two books on painting caused little reaction. He retired to Villers-le-Bel, where he reverted to a peasant life, gardening and growing fruit. There are works in Antwerp, Baltimore (Mus. of Art, Walters), Berlin, Boston, Buffalo, Cambridge Mass. (Fogg), Chicago, Cincinnati, Cleveland, The Hague, London (Wallace), Madrid, Milan, Moscow (Pushkin),

New York (Met., Brooklyn), Paris (Louvre), Philadelphia and Washington (Corcoran).
Lit. T. Couture: *Méthodes et entretiens d'atelier* (1868) and *Paysage* (1869); Paul Leroi: *T. Couture* (1880); *Th. Couture 1815-1879. Sa vie, son œuvre, son caractère, ses idées, sa méthode, par lui-même et son petit-fils*, preface by C. Mauclair (1932)

Cox David, b. nr Birmingham 1783, d. Harborne 1859. English watercolourist whose fresh sparkling landscapes have much in common with DAUBIGNY and BOUDIN. He studied with VARLEY and was influenced by BONINGTON. His favourite painting ground was North Wales (*Rhyl Sands c.* 1854) but he also travelled in Belgium, Holland and France. He published several books on painting, the most famous being his *Treatise on Landscape Painting and Effect in Water Colours* (1813-14). He worked on a type of rather porous wrapping paper, now known commercially as 'Cox paper'. He took lessons in oil painting from W. J. MÜLLER in 1840 and painted several landscapes in this medium after settling at Harborne, near Birmingham, in 1841. He is best represented in Birmingham but there are also works in Cambridge Mass. (Fogg), Cardiff, Chicago, Cincinnati, Dublin, Edinburgh, Glasgow, London (Tate, V&A), Manchester, Melbourne, New York (Met., Brooklyn), Norwich, Nottingham, Philadelphia and Sydney.
Lit. A. P. Oppé: *Watercolours of Turner, Cox and de Wint* (1925); F. Gordon Roe: *Cox, the Master* (1946); T. Cox: *D. Cox* (1947)

Cranbrook Colony. A group of mid-century English genre painters who settled in the village of Cranbrook in Kent. Their work, generally devoted to everyday life, shared a strong element of narrative humour. The group included WEBSTER, J. C. Horsley, F. D. Hardy, G. B. O'Neill, G. Hardy and A. E. Mulready.

Crane Walter, b. Liverpool 1845, d. Horsham 1915. With MORRIS, a leading designer and book illustrator of the ARTS AND CRAFTS movement. His occasional paintings were inspired by the PRE-RAPHAELITISM of BURNE-JONES. There are works in London (Tate, V&A) and Manchester.

Lit. P. G. Konody: *The Art of W. Crane* (1902); W. Crane: *An Artist's Reminiscences* (1907); I. Spencer: *W. Crane* (1975)

Cremona Tranquillo, b. Pavia 1837, d. Milan 1878. One of the leaders of the SCAPIGLIATURA group, with RANZONI and the sculptor Giuseppe Grandi. Reacting against the careful draughtsmanship taught by Bertini and HAYEZ at the Accademia di Brera, Cremona abandoned outline, virtually dissolving figures into their background in a vibrant chromatic haze. Beautiful women are chosen to embody the poetic suggestion of titles such as *Loving, Silence, Attraction, Melody, Listening*. He studied at Pavia, where he became friendly with his fellow student FARUFFINI, before moving to the Venice Academy in 1852 and to Milan in 1860, studying at the Brera (1860-3). The works of this period reflect his academic instruction (*Marco Polo* 1863). His mature style began to evolve around 1866-8 under the influence of the Scapigliatura poets Rovani and Praga as well as his fellow artists Faruffini, Ranzoni and Grandi. Young artists alienated by the academic tradition began to gather round him and his work had an important influence on his Milanese contemporaries. There are works in Milan (Mod. Art, Brera, Grassi), Rome (Mod. Art), Trieste (Revoltella), Turin (Mod. Art), Udine (Mod. Art) and Venice (Mod. Art). *See illustration p. 66*
Lit. A. Neppi: *T. Cremona* (1931); G. Nicodemi: *T. Cremona* (1933); U. Ojetti: *T. Cremona e gli artisti lombardi del suo tempo* (1938)

Crome John (Old Crome), b. Norwich 1768, d. Norwich 1821. Landscape painter and the founder of the NORWICH SCHOOL, in quality and quantity of work the most important English regional school of the century. He interpreted the East Anglian landscape in an idiom close to Hobbema and the Dutch 17C masters. The collection of Thomas Harvey, a local amateur painter, which included Gainsborough, Wilson, Hobbema, Cuyp and other Dutch artists, was his basic source of study and inspiration, though around 1790 he received some help from Sir William Beechey. He painted landscapes while supporting himself by giving drawing lessons. He started an art school in his own house (1801) and founded the Norwich Society of Artists

Cremona *The Two Cousins* 1870

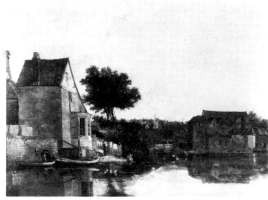

Crome *Back of the New Mills, Norwich c.* 1810-11

(1803), with whom he exhibited regularly for the rest of his life, though he sent occasional works to the ROYAL ACADEMY. Local patronage financed a visit to Paris (1814) to see the art treasures looted by Napoleon. His landscape etchings were published posthumously under the title *Norfolk Picturesque Scenery* (1834). His son John Berney Crome (Young Crome) was also a painter, following his father's style. There are works in Boston, Brussels (Musées Royaux), Cambridge Mass. (Fogg), Cincinnati, Edinburgh, London (Tate, V&A), Manchester, Montreal, New York (Met.), Norwich, Nottingham, Philadelphia, Sheffield, Sydney and Washington (Corcoran). *Lit.* C. H. C. Baker: *Crome* (1921); R. H. Mottram: *J. Crome of Norwich* (1931); D. and T. Clifford: *J. Crome* (1968)

Cropsey Jasper Francis, b. Rossville, Staten Island (N.Y.) 1823, d. Hastings-on-Hudson (N.Y.) 1900. American architect turned landscapist who painted, with great attention to detail, slightly theatrical views in the Catskills, White Mountains and Hudson River area which owe a debt to COLE – as do his occasional history pieces. In his later work he concentrated almost exclusively on autumn landscapes (*Autumn on the Hudson River* 1860). After visiting Europe (1847-50), he lived in London from 1856 to 1863. He was elected to the NATIONAL ACADEMY OF DESIGN (1851) and was a founder member of the American Watercolour Society (1865-6). There are works in Baltimore (Mus. of Art), Boston, Chicago, Cleveland, New York (Brooklyn) and Washington (NG, Corcoran).

Cross Henri Edmond, b. Douai 1856, d. Saint-Clair 1910. French painter who adopted the DIVISIONIST technique under the influence of SEURAT. He was born with the surname Delacroix, a difficult name for a French artist of the period; having an English mother he decided to anglicize his name in 1881. He studied in Lille and in Paris with BONVIN, who influenced his early dark-toned portraits and still lifes. He collaborated in the foundation of the SALON DES INDÉPENDANTS in 1884, coming under the influence of Seurat and SIGNAC, and turned then to bright-toned landscape painting in the Divisionist manner; he continued to work in this style, gradually enlarging and loosening his pattern of dots. There are works in Douai, Copenhagen (Ny Carlsberg Glyptotek), Frankfurt/ M. Grenoble, Houston, Munich, Otterloo (Kröller-Müller), Paris (Mod. Art, Dec. Art), Toledo and Zurich.

Cruikshank George, b. London 1792, d. London 1878. English caricaturist and illustrator. His earliest caricatures depict the close of the Napoleonic wars and he turned next to biting satire of the English court. In the Victorian era he began to satirize the foibles of society; his early style, firm, simple and pictorial, evolved towards densely crowded patterns of grotesque people. In the course of sixty years he produced well over 10,000 designs, ranging from drawings for *The Scourge* (1811-16) to illustrations to Charles Dickens (*Sketches by Boz* 1836-7, *Oliver Twist* 1838) and two series of etchings preaching against alcoholism (*The Bottle* 1847, *Drunkard's Children* 1848). He worked hard as a propagandist for temperance in later life, the most important among his rare oil paintings being a crowded narrative picture, *The Worship of Bacchus* (1860-2). He was the son of the caricaturist Isaac (1756-1811), while his younger brother Isaac Robert (1789-1856) entered the same field and worked on occasion as his assistant. There are works in London (Tate, V&A, BM) and many print rooms. (*see frontispiece p. 6*) *Lit.* A. M. Cohn: *G. Cruikshank, a catalogue raisonné* (1924); R. L. Patten (ed.): *G. Cruikshank, a Revaluation* (1976)

D

Dadd Richard, b. Chatham 1817, d. Broadmoor 1886. Painter of poetic fantasy whose mind became unhinged; after killing his father in 1843, he spent the rest of his life in Bethlem and Broadmoor, where he did his most important work. He painted in oil and watercolour with a miniaturist's precision, his poetic perception, heightened by madness and isolation, finding an outlet in densely detailed works. His subjects were often inspired by poetry and literature but he also painted landscapes and shipping scenes. Shakespeare's *Tempest* and *Midsummer Night's Dream* led him to the realm of fairy painting, to which his most famous work, *The Fairy Feller's Master Stroke*, belongs. In 1837 he entered the ROYAL ACADEMY Schools, where he met FRITH, PHILLIP, EGG, O'NEIL and others with whom he formed THE CLIQUE (c. 1840). In 1842 he embarked on a tour of the Middle East with Sir Thomas Phillips, from which he returned insane in 1843; Egyptian mythology apparently helped to tip the balance of his mind and he believed himself for the rest of his life subject to the arbitrary will of Osiris. Much of his work still belongs to the Bethlem Royal Hospital and Broadmoor but he is also well represented in London (Tate, V&A, BM) and there are works in Bedford, Cambridge (Fitzwm), Cambridge Mass. (Fogg), Liverpool, Manchester, Newport, Oxford, San Marino (Huntington) and York.
Lit. D. Greysmith: *R. Dadd, The Rock and Castle of Seclusion* (1973); P. Allderidge: *R. Dadd* (1974)

Daffinger Moritz Michael, b. Vienna 1790, d. Vienna 1849. Miniaturist and portrait painter whose elegant free-flowing style is an outstanding example of the influence of LAWRENCE on Viennese painting; he was also influenced by FÜGER. Like his father, he was a porcelain painter and worked at a Vienna factory until 1812, though he took time off to study at the Vienna Academy under H. Maurer from 1802. In 1841 he started a series of 415 paintings of Austrian wild flowers. There are works in Stockholm and Vienna (Belvedere).
Lit. L. Grünstein: *M. M. Daffinger und sein Kreis* (1923); E. Pirchan: *M. M. Daffinger : Miniaturmaler des Vormärz* (1943)

Dagnan-Bouveret Pascal Adolphe Jean, b. Paris 1852, d. Quincey (Haute-Saône) 1929. French genre painter, one of the group round BASTIEN-LEPAGE whose realistically painted scenes from contemporary life owe a debt to both MILLET and the IMPRESSIONISTS. He studied under GÉRÔME and COROT, winning a second Rome prize in 1876. His first major success was *Wedding at the Photographer's*, exhibited at the 1879 SALON. Under the influence of Bastien-Lepage he began (c. 1880) to concentrate on scenes from Breton life, its peasants and festivals. He became a chevalier of the Legion of Honour in 1885 and an officer in 1892, and was a member of the INSTITUT (1900). There are works in Baltimore (Walters), Cognac, Moscow (Tretiakov), Mulhouse, Munich and Paris (Louvre).

Dahl Johan Christian Clausen, b. Bergen 1788, d. Dresden 1857. Norwegian painter who studied in Denmark but spent most of his working life in Dresden. He was among the pioneers of naturalistic landscape painting in Germany, where he achieved considerable success and influence. He was a close friend of FRIEDRICH, with whom he shared a house for many years. His moonlit landscapes, rising mists and mountain torrents echo Friedrich but lack his inner vision. He worked constantly from nature; like CONSTABLE in England he painted many studies of clouds (*Study of Clouds* 1825). His first amateur efforts earned him entrance to the Copenhagen Academy (1811); he was influenced by ECKERSBERG and studied the Dutch 17C landscapists. In 1818 he moved to Dresden, where he was enthusiastically received by Friedrich and the younger landscapists, becoming a member of the academy in 1820. In Italy (1820-1) he was

Dadd *The Fairy Feller's Master Stroke* 1855-64

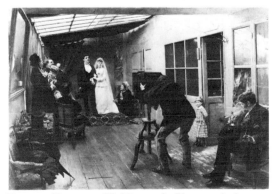

Dagnan-Bouveret *Wedding at the Photographer's* 1878-9

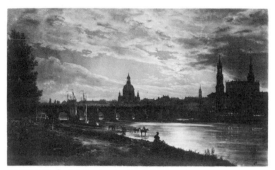

Dahl *View of Dresden by Full Moon* 1839

Danby *The Deluge* 1840

Danhauser *Liszt at the Grand Piano* 1840

a guest of the Danish Crown Prince Christian Frederick in Naples. Italy had an important impact on his mastery of colour and he brought back many freely painted studies. In 1824 he became a professor at the Dresden Academy and in 1826 paid his first return visit to Norway. Wild Norwegian scenery which he had often painted from memory now became his favourite subject matter (*Shipwreck on the Norwegian Coast* 1831). He paid further visits to Norway in 1834, 1839, 1844 and 1850. He was made a member of the Copenhagen Academy (1827), Stockholm Academy (1832) and Berlin Academy (1835). His work influenced MORGENSTERN in Munich, BLECHEN in Berlin and FEARNLEY in Norway; he was Norway's first important painter and a lasting influence on their landscape school. There are works in Bergen, Berlin, Kassel, Cologne, Copenhagen (State, Thorwaldsen), Hamburg, Munich (N. Pin.), New York (Met.) and Oslo (NG).
Lit. A. Aubert: *Prof. Dahl* (1893) and *Den nordiske Naturfölelse og Prof. Dahl* (1894); J. H. Langaard: *J. C. Dahl's Verk* (1937); A. Aubert: *Maleren J. Ch. Dahl* (1920); L. Østby: *J. Ch. Dahl, Tegninger og Akvareller* (1957)

Dalsgaard Christen, b. Krabbesholm 1824, d. Sorø 1907. Genre painter who depicted peasant life in Denmark with all its old costumes and customs, an approach championed at the time by the influential Professor Høyen as the road to a new and authentic Danish art. He belonged essentially to the REALIST generation, seeking a psychologically accurate presentation of the trials and struggles of the poor (*Dispossessed, The Mormons*). He studied at the Copenhagen Academy with ECKERSBERG and RØRBYE, and first exhibited at Charlottenborg in 1847; his work quickly became popular. From 1862 he lived at Sorø, where he taught at the academy. He was made a member of the Copenhagen Academy in 1872 and knighted in 1879. There are works in Copenhagen (State).
Lit. K. Søborg: *C. Dalsgaard* (1902)

Danby Francis, b. Wexford 1793, d. Exmouth 1861. Irish landscape painter. His early works are in a ROMANTIC realistic vein (*Clifton Rocks from Rownham Fields c.* 1822); after reaching London he painted dramatic landscapes and history pieces strongly influenced by J. MARTIN (*The Deluge* 1840) and others which echo TURNER. He studied at the Dublin Royal Society Schools and with landscapist James O'Connor before settling in Bristol (1813); he first exhibited at the ROYAL ACADEMY in 1820 and moved to London *c.* 1823-4. The sale of *Sunset at Sea* to LAWRENCE (1824) established his reputation; he became an ARA in 1825. A matrimonial scandal forced him to leave England in 1829; he lived mostly in Switzerland, also visiting Paris and Norway, and returned to England in 1840. From 1845 he lived at Exmouth. His sons James Francis and Thomas were also landscape painters. There are works in Bristol, Cambridge (Fitzwm), Cambridge Mass. (Fogg), Dublin, Edinburgh, Geneva (Rath), Leicester, London (Tate, V&A, Soane) and Sheffield.
Lit. A. Adams: *Francis Danby: Varieties of Poetic Landscape* (1973)

Danhauser Josef, b. Vienna 1805, d. Vienna 1845. BIEDERMEIER genre painter, one of the creators of the style. He painted both peasant life and Viennese society; Franz Liszt appears in several scenes. After studying at the Vienna Academy (1824-6) under KRAFFT, he visited Venice (1826), where he studied Bellini, Titian and Veronese. His first genre paintings were humorous atelier scenes (1828-9); later he painted large genre scenes drawn from Viennese society (1836-40). He was a professor at the Vienna Academy (1840-2), and visited the Netherlands (1842). The high finish he learnt from Krafft gave way to freer treatment under the influence of AMERLING and, at least from 1839, WILKIE, whose *Opening of the Will* inspired his work of the same name. There are works in Graz and Vienna (Belvedere).
Lit. A. Rössler: *J. Danhauser* (1911)

Daubigny Charles François, b. Paris 1817, d. Paris 1878. Landscape painter and graphic artist. A friend of COROT and the BARBIZON SCHOOL, he painted calm domestic landscapes, especially along the waterways of France. His study of graduated reflections of light and the broader brushwork of his later years link him with IMPRESSIONISM; he was a friend of both MONET and SISLEY. He studied with his father, the landscape painter Edmonde François Daubigny, worked

briefly with GRANET and entered the studio of DELAROCHE in 1838. He earned his living for a time with book illustrations, but in 1848 had his first success in the SALON with five landscapes from the Morvan district; in 1853 *Harvest* was bought by the government and *Spring* by the Emperor in 1857. His reputation was established and he even received commissions for landscapes, which was most unusual at the time. His studio-boat, 'Le Bottin', was launched in 1857, and in it he travelled and painted the waterways of France; the idea was later imitated by MANET. He became a chevalier of the Legion of Honour in 1857 and an officer in 1874. His son Karl was also a landscape painter. There are works in most museums where the 19C is represented, including many French provincial museums, as well as Baltimore (Mus. of Art, Walters), Boston, Edinburgh, Glasgow, London (NG, Tate), Montreal, New York (Met.), Paris (Louvre) and Washington (NG, Corcoran).
Lit. J. Laran: *Daubigny* (1913); L. Bourges: *Daubigny, souvenirs et croquis* (1900); E. Moreau-Nélaton: *Daubigny raconté par lui-même* (1925); M. Fidell-Beaufort, J. Bailly-Herzberg: *Daubigny. The Life and Work* (1975)

Daubigny *Cattle on a River Bank* 1874

Daumier Honoré, b. Marseilles 1808, d. Valmondois 1879. French caricaturist and lithographer, one of the greatest graphic artists of the 19C. The plastic fluency of his lithographic technique has often been compared to sculpture; 'There is something of Michelangelo in that fellow,' said Balzac. His 4,000 or so lithographs, mostly taken from contemporary Parisian life, are a penetrating critique of the human condition, its pretensions, corruption, cruelty and naïvety. He was a bookseller's assistant and messenger at the law courts before his gift for political cartooning was discovered by Charles Philipon, who employed him on *La Caricature* in 1830. His caricature of Louis-Philippe as Gargantua brought him six months' imprisonment (1832) and led shortly to the closure of *La Caricature*. He turned then to social satire, contributing to Philipon's *Le Charivari* for forty years. Among his most famous works are *The Legislative Belly*, *The Freedom of the Press*, *Lafayette's Funeral* and the *Rue Transnonain* (all 1834). He executed a brilliant series satirizing the legal profession and

Daumier *The Third Class Railway Carriage c.* 1865-70

1836 brought his *Robert Macaire* series, based on a contemporary melodrama. He habitually modelled his figures in clay before transferring them to the page; these models, cast in bronze after his death, are popular with collectors. Between 1855 and 1870 he took to painting in oils, executing a series of pictures on the *Don Quixote* theme and such famous works as *The Third Class Railway Carriage*, *The Melodrama* and *Crispin and Scapin*. In 1872 he began to go blind and, reduced to extreme poverty, he retired to a house at Valmondois bought for him by COROT. Most print rooms have examples of his lithographs, which were published in large editions. There are several paintings in the Louvre, and others in Baltimore (Walters), Berlin, London (NG), Lyons, Munich (N. Pin.), New York (Brooklyn, Met.) and Washington (NG, Corcoran).
Lit. N. A. Hazard, L. Delteil: *Catalogue raisonné de l'œuvre lithographié de H. Daumier* (1904); J. Lassaigne: *Daumier* (1947); O. Larkin: *Daumier, Man of his Time* (1966); K. E. Maison: *H. Daumier: Catalogue Raisonné of the Paintings, Watercolours and Drawings* (1968); R. Rey: *Daumier* (1968); A. Rossel: *H. Daumier prend parti* (1971); J. Cherpin: *L'homme Daumier: un visage qui sort de l'ombre* (1973)

David Jacques Louis, b. Paris 1748, d. Brussels 1825. The leading artist of the revolutionary and Napoleonic periods in France; he was the greatest painter of the NEOCLASSICAL movement and its continuing influence was ensured by the artists who flocked to his studio from all over France and Europe. INGRES, GROS, GÉRARD, J. B. ISABEY, KRAFFT, NAVEZ and ECKERSBERG were among his pupils. His style nonetheless contains contradictions; the stern simplicity of his history paintings with their accent on line, the human figure and the example of classical sculpture is belied by the charm and direct realism of his portraits, while his Napoleonic canvases show the influence of the Venetian colourists. He had his first instruction from Boucher who advised him to enter Vien's atelier; *Antiochus Dying for the Love of Stratonice* which won him the Rome prize in 1774 still has rococo elements. In Rome (1775-80) he wholeheartedly embraced the Neoclassicism of Winckelmann, Mengs and their associates. His series of large classical

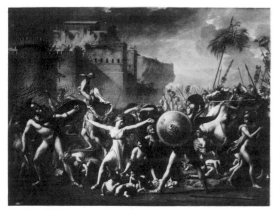

David *The Intervention of the Sabine Women* 1799
(detail below)

canvases followed: *Belisarius Asking for Alms* (1781), *Andromache Grieving over the Dead Hector* (1783), *The Oath of the Horatii* (1785), *The Lictors Bringing Home to Brutus the Bodies of his Dead Sons* (1789). These paintings celebrated the republican virtues of Rome and owed part of their enormous success to an identification with the ideals of the revolutionaries. David was a friend of the revolutionary leaders, especially Robespierre, was elected to the National Convention in 1792 and voted for the execution of Louis XVI. In painting he turned to more straightforward realism with the unfinished *Oath of the Tennis Court* (1791) and his portraits of revolutionary martyrs, *Marat* (1793), *Lepeletier* (1793; destroyed) and *Barra* (1794). He was a dominant member of the Committee of Public Instruction, securing the abolition of the Academy, the reorganization of the SALON and the establishment of the INSTITUT. With the fall of Robespierre he was denounced and imprisoned, painting his only landscape, *The Luxembourg Gardens* (1794), from the window of his cell. After his release he renounced politics; he established a teaching studio and in 1799 completed *The Intervention of the Sabine Women*, his most complete realization of Neoclassical principles with its accent on the naked human form and formal composition. He was named first painter to the Emperor in 1804 and returned to the celebration of contemporary events with the vast *Napoleon Crowning Josephine* (1805–7) and *The Distribution of the Eagles* (1810). With the fall of Napoleon he escaped to Switzerland and finally settled in Brussels, where he returned to classical themes and painted some portraits. He is well represented at the Louvre and in Versailles. There are works in many French provincial museums and also in Antwerp, Berlin, Boston, Brussels (Musées Royaux), Buffalo, Cambridge Mass. (Fogg), Chicago, Cincinnati, Cleveland, Cologne, Genoa, New York (Met.), Philadelphia and Washington (NG). *(see colour illustration 2)*

Lit. E. J. Delécluze: *L. David, son école et son temps* (1855); D. L. Dowd: *Pageant Master of the Republic. J. L. David and the French Revolution* (1948, new ed. 1969); R. L. Herbert: *David, Voltaire, Brutus and the French Revolution* (1972); R. Verbraeken: *J. L. David jugé par ses contemporains et par la posterité* (1973); D. Wildenstein: *Documents complementaires au catalogue de l'œuvre de L. David* (1973); A. Brookner: *J. L. David: A Personal Interpretation* (1975)

Decamps Alexandre Gabriel, b. Paris 1803, d. Fontainebleau 1860. French ROMANTIC painter of landscape, genre and Oriental scenes; he was the first among the Romantics to visit the Orient and the first to paint biblical scenes in their true local landscape (*Joseph Sold by his Brethren* 1835, *Moses Taken from the Nile* 1837). His naturalistic landscapes and genre scenes, bathed in tremulous golden light, were much admired; it was said that DELACROIX painted with colours and Decamps with light. He studied with Etienne Bouhot (1816) and PUJOL (1817) but, reacting against the academicism of this DAVID pupil, he preferred to teach himself, finding ready buyers for small landscapes with figures painted from nature. He first exhibited at the 1827 SALON with *The Plover Shoot* and his first Oriental scene *Soldiers of the Vizier's Guard*. A visit to Constantinople and the Near East (1827–9) set the future course of his art; he had a major success with Oriental scenes in the 1831 Salon. Several lithographs and caricatures date from around this period (*The Monkey Connoisseurs*). Despite the success of his small paintings, Decamps yearned to be a monumental history painter, resenting his lack of state commissions. He visited Italy in 1832–3 and exhibited a large *Defeat of the Cimbri* in the 1834 Salon without success. Around 1853 he gave up painting, but returned to it after the good reception of his sixty pictures in the 1855 EXPOSITION UNIVERSELLE. He is particularly well represented in the Louvre and the London Wallace Collection; there are works in many French provincial museums and in Amsterdam (Rijksmuseum), Baltimore (Mus. of Art, Walters), Boston, Brussels, Cambridge Mass. (Fogg), Chicago, The Hague, Moscow (Pushkin), New York (Met., Brooklyn) and Philadelphia.

Lit. M. Chaumelin: *Decamps, sa vie, son œuvre et ses imitateurs* (1861); C. Clément: *Decamps* (1886); P. du Colombier: *Decamps* (1928)

Defregger Franz von, b. Stronach 1835, d. Munich 1921. Genre painter who settled in Munich and won outstanding popularity

Decamps *Jesus on the Lake of Genesareth c.* 1853

Defregger *Speckbacher and his Son* 1869

Degas *The Dancing Class* 1874

c. 1880–1900 with his scenes of peasant life in the Tyrol. His name is often associated with KNAUS and VAUTIER, his contemporaries, and the two other outstanding German painters of peasant life. His early water-colours and oil sketches are distinguished by a fresh REALISM but from around 1880 he lapsed into anecdotal repetition. His early years were spent as a farm labourer. He then studied drawing and carving with the Innsbruck sculptor Michael Stolz. In 1860 he moved to Munich where he studied first with Dyks and Anschütz and then, after visiting Paris (1863–4), with PILOTY from 1864 to 1870. His first major success was *Scene from Speckbacher's Life* (1869). His scenes from the Tyrol's struggle for independence under Andreas Hofer in 1809 date mainly from the 1870s. He was a professor at the Munich Academy from 1878 to 1910, receiving a knighthood ('von') in 1883. There are works in Bremen, Berlin, Wrocław, Bucharest, Cologne, Frankfurt/M., Hamburg, Innsbruck, Leipzig, Munich, Stuttgart and Vienna.
Lit. A Rosenberg: *Defregger* (1911); H. Hammer: *F. von Defregger* (1940)

Degas Hilaire Germain Edgar (family name de Gas), b. Paris 1834, d. Paris 1917. One of the greatest figure painters of the 19C, he was closely involved in the IMPRESSIONIST movement, organizing many of the Group Shows. His work, however, sets him rather apart from MONET and the landscape painters; his Impressionism is characterized by the endeavour to catch the instantaneous character of movement and gesture (dancers, racehorses) rather than the retinal exploration of effects of light outdoors. He was the chronicler of contemporary life, the café, the concert-hall, a woman at her toilet, dancers rehearsing or on stage, the Longchamp races. His instantaneous approach was influenced by photography, while Japanese prints inspired his interest in novel perspective.. He was an admirer of INGRES, and had a thorough academic training, including intensive copying from Old Masters; but unlike his academic contemporaries he used the technical virtuosity gained by this training as a springboard for further experiment, in subject matter, composition and brushwork and also in media: oil paint thinned with spirit or water, pastel,

pastel combined with watercolour, tempera, gouache and every department of printmaking, etching, drypoint, monotype, lithography and aquatint. Born into a wealthy family, he entered the ECOLE DES BEAUX-ARTS under Louis Lamothe, a pupil of Ingres, in 1855. In 1856–7 he visited Rome, Florence and Naples, making an intensive study of Quattrocento painting. His early work comprised portraits and history subjects (*Young Spartans Exercising* 1860). In 1862 he met MANET, who became a close friend, and turned to subjects from contemporary life; the examples of COURBET, DAUMIER and GAVARNI were also influential at this period. The Longchamp races and ballet dancers were among his first contemporary subjects (*Mlle Fiocre in 'La Source'* 1867). In the 1870s he turned to more ambitious figure groups such as *Viscomte Lepic and his Daughters* and, on his 1872 visit to America, *Cotton Exchange in New Orleans*. He exhibited ten works in the first Impressionist exhibition (1874) and contributed to six of the subsequent exhibitions. In the 1880s women dressing, in the bath or at their toilet became dominant themes, as well as domestic scenes such as *Women Ironing* and the *Milliners*. He was beginning to go blind and worked increasingly in pastel, as well as modelling figures in wax which were subsequently cast in bronze (*Fourteen-Year-Old Dancer c.* 1880). For the last twenty years of his life he was almost completely blind, living a retired and solitary life. He is well represented in Paris (Louvre, Musée de l'Impressionisme) and there are works in most galleries where Impressionism is represented, including Baltimore (Mus. of Art, Walters), London (NG, Tate, V&A, Courtauld), New York (Met., Mod. Art, Brooklyn, Frick) and Washington (NG, Corcoran).
Lit. J. B. Manson: *The Life and Work of E. Degas* (1927); P. A. Lemoisne: *Degas et son œuvre* (1948); D. C. Rich: *E. H. G. Degas* (1951); J. Rewald: *Degas: Sculpture, the Complete Works* (1957); J. S. Boggs: *Portraits by Degas* (1962); E. P. Janis: *Degas Monotypes* (1968); A. Werner: *Degas Pastels* (1969); T. Reff (ed.): *The Notebooks of E. Degas* (2 vols 1975)

Delacroix Ferdinand Victor Eugène, b. Charenton-Saint-Maurice 1798, d. Paris 1863. The foremost artist of the French

Delacroix *The Death of Sardanapalus* 1827

Delaroche *The Princes in the Tower* 1831

ROMANTIC school, he combined an intensely poetic interpretation of subject matter with rich colour used to heighten the emotional impact of his work. He entered the studio of GUÉRIN in 1815; more influential than this classical master were his studies of Rubens and the Venetians in the Louvre. There he met BONINGTON, who became a close friend; he was also influenced by GÉRICAULT, who was working on his *Raft of Medusa*. He first exhibited in the 1822 SALON with *Dante and Virgil in Hell*, which was sharply criticized but purchased by the state. In 1824 he exhibited his *Massacre at Chios* in the famous Salon which included *The Hay Wain* by CONSTABLE; Delacroix is said to have completely repainted the background of the *Massacre* in rich broken colours after seeing Constable's painting. In 1825 he visited England with Bonington, where both greatly admired the free handling of colour of such artists as LAWRENCE, ETTY and WILKIE; inspired by the anecdotal medieval scenes then fashionable in England, both tried their hands at these (*The Execution of Marino Faliero* 1826). In 1830 he celebrated the victory of Louis-Philippe and the House of Orleans with *Liberty Leading the People*. While the battle within the artistic establishment between the NEOCLASSICISTS headed by INGRES and the Romantics headed by Delacroix was to deny him a chair at the INSTITUT until 1857 and bring many Salon refusals, he received important fresco commissions from the state, for the Palais Bourbon (1833–47), the Luxembourg library (1840–7), the Louvre Apollo gallery (1850–1), the Hôtel de Ville (1852–4) and the church of Saint-Sulpice (1853–61). In 1832 he was invited to accompany the Comte de Mornay on a mission to Morocco, also visiting Algiers and southern Spain. The vivid colour of the Orient and its exotic peoples profoundly influenced his work (*Women of Algiers* 1834, *Jewish Wedding in Morocco* 1839) providing subject matter to which he constantly returned. In his later work he alternated decorative cycles with paintings inspired by Byron, Shakespeare and Dante, Oriental scenes, and a famous series of lion hunts. Most of his major works are in the Louvre but he was immensely prolific and is also represented in Baltimore (Mus. of Art, Walters), Boston, Bristol, Buffalo, Chantilly, Chicago, Cincinnati, Cleveland, Copenhagen (Ny Carlsberg Glyptotek), Dublin, Edinburgh, The Hague, London (NG, Wallace), Los Angeles, Montreal, New York (Met., Brooklyn), Philadelphia, Toronto, Versailles, Washington (NG, Corcoran, Phillips) and elsewhere. *(see colour illustration 5)*

Lit. E. Delacroix: *Journals* (1893–5, English trans 1961) and *Oeuvres littéraires* (1923); C. Baudelaire: *Delacroix* (1927); Y. Deslandres: *Delacroix* (1963); L. Johnson: *Delacroix* (1963); G. P. Mras: *E. Delacroix's Theory of Art* (1966); F. H. Trapp: *The Attainment of Delacroix* (1971)

Delaroche Hippolyte (called Paul), b. Paris 1797, d. Paris 1856. Delaroche was probably the most successful history painter of the 19C; his influence was felt all over Europe, especially in Belgium, Germany and England, while his teaching studio was the most highly regarded in Paris under the July Monarchy. His art defies modern categorization; his careful drawing and high finish link him with the NEOCLASSICISTS, his subject matter – death, duels and drama set in medieval and Renaissance times – with the ROMANTICS. He owes to this middle-of-the-road-position – known even in his lifetime as *le juste milieu* – the honour of being the youngest artist elected to the 19C INSTITUT; the course of his art would, it was hoped, resolve the Classic–Romantic dilemma. He worked at a time when history and scientific historical research were burning new interests among the intelligentsia; his painstaking research to ensure the historical accuracy of costume, architecture and accessories link him with the scientific spirit of the REALIST era and the work of such ACADEMIC REALISTS as GÉRÔME (his pupil) and MEISSONIER. He was influenced by contemporary theatre; it was his practice to model figures in wax and arrange them as a theatrical tableau from which to study effects of light. He began his studies in Watelet's studio (1816), moving to that of GROS in 1818. He first exhibited at the SALON of 1819 and had his first success in 1822 with *Rescue of the Young Joas by his Aunt Joseba*. *The Death of Queen Elizabeth* (1827) launched his highly successful series of paintings from English history, including *The Princes in the Tower* (1831) and *The Execution of Lady Jane Grey* (1833). Elected a member of the Institut in 1832, he became a

professor at the ECOLE DES BEAUX-ARTS in 1833 and inherited Gros's studio on his death in 1835. He visited Italy in 1834–5 (marrying the daughter of H. VERNET), 1838 and 1843. In 1837 he received the commission for a 27-metre hemicycle mural in the Ecole des Beaux-Arts; completed in 1841 it depicted the history of art, and its grouping and formal composition are echoed in the work of many later artists. It was damaged by fire in 1855 and he was preparing to restore it at the time of his death. He turned increasingly to religious subjects after his wife's death in 1845, at the same time painting a number of scenes from the French Revolution. He painted many portraits, including a posthumous series of Napoleon. Engravings after his history subjects achieved wide popularity. He is well represented in London (Wallace), Nantes, Paris (Louvre) and Versailles, while there are also works in Baltimore (Walters), Cambridge Mass. (Fogg), many French provincial museums and other European centres. *(see colour illustration II)*
Lit. L. de Loménie: *M. Delaroche* (1844); E. de Mirecourt: *Les Contemporains: P. Delaroche* (1856); Halévy: *Notice sur la vie et les œuvres de M. P. Delaroche* (1858); L. Runtz-Rees: *H. Vernet and P. Delaroche* (1880); E. de Lalaing: *Les Vernet, Géricault et Delaroche* (1888)

Delaunay Jules Elie, b. Nantes 1828, d. Paris 1891. French history painter and portraitist who studied with FLANDRIN and Lamothe, entering the ECOLE DES BEAUX-ARTS in 1848. In his early work he closely followed INGRES but his visit to Italy, after winning the first Rome prize in 1856, introduced him to the 15C masters Uccello, Botticelli and Gozzoli, whose example dominated his later work (*The Plague in Rome* 1869, *Diana* 1872). He received many important mural commissions: for the Opéra (together with BAUDRY), for the Palais Royal, and *Scenes from the Life of St Genevieve* for the Panthéon, unfinished at his death. In his later years he became a popular portraitist. He was a chevalier of the Legion of Honour (1867), an officer (1878), a member of the INSTITUT (1879), and a professor at the Ecole des Beaux-Arts (1889). There are works in Bayonne, Bordeaux, Louviers (Roussel), Nantes, Paris (Louvre), Rouen and Tours.

Delville Jean, b. Louvain 1867, d. Forest (Brussels) 1953. Belgian SYMBOLIST, an enthusiastic follower of the Sâr Péladan; he exhibited at Péladan's first four SALONS DE LA ROSE + CROIX in Paris, and was leader of a parallel movement in Belgium. His 'poetic lyricism' is 'charged with mystical and occult overtones' (Milner). *The Treasures of Satan* and *Orpheus* (1893) are among his most famous works. After studying at the Brussels Academy, he first exhibited with *L'Essor* (1885). He was a member of LES VINGT, the Brussels *avant-garde* movement, but disliking its NATURALIST and IMPRESSIONIST orientation he led a breakaway group, Pour l'Art, in 1892. He founded the Cercle d'Art Idéaliste, which held three exhibitions (1896–8) and whose manifesto closely followed Péladan. After a period in Italy in the 1890s he was appointed lecturer at the Glasgow School of Art (1900–7), and later became professor at the Brussels Academy. There are works in Bruges, Brussels, Ixelles, Louvain and Paris (Louvre).

Denis Maurice, b. Granville 1870, d. Paris 1943. A member of the NABIS and their chief theorist. He studied at the ACADÉMIE JULIAN, where he met SERUSIER and was introduced by him to the work of GAUGUIN, whose influence is apparent in *The Muses* (1893); *Homage to Cézanne* (1900) is his most famous work. After visits to Italy in 1895 and 1897, he turned away from Gauguin's SYNTHETISM to a decorative style influenced by 15C Italian painting. Like Serusier, he later turned to religious painting, and in 1919 was co-founder of the Ateliers d'Art Sacré in Paris. He also designed stained glass and executed several large murals (Théâtre des Champs Elysées, Petit Palais). His important publications on art theory included *Théories: Du Symbolisme et de Gauguin vers un nouvel ordre classique* (1912) and *Nouvelles Théories sur l'art moderne et l'art sacré* (1922). There are works by him in Paris (Mod. Art, Dec. Art).
Lit. S. Barazzetti-Demoulin: *M. Denis* (1945)

Detaille Jean Baptiste Edouard, b. Paris 1848, d. Paris 1912. Painter of battles and military life, largely drawn from the Franco-Prussian War of 1870. His scenes are naturalistic but painted with close attention to detail. His popular success was outstanding;

Delaunay *The Plague in Rome* 1869

Delville *Orpheus* 1893

Detaille *The Dream* 1888

Devéria *The Birth of Henri IV* 1827

Diaz de la Peña *Jean de Paris Hill, Forest of Fontainebleau* 1867

he was received in the highest society and armies manoeuvred for him to sketch. MEISSONIER, impressed by his talent, took him as a pupil at seventeen; *A Corner of Meissonier's Studio* was his first SALON exhibit in 1867. He fought in the Franco-Prussian War; two huge battle panoramas followed – *Champigny* and *Rezonville* – painted in collaboration with DE NEUVILLE. He became a chevalier of the Legion of Honour (1872), an officer (1881) and a commander (1897); he was also a member of the INSTITUT (1892). There are works in Paris (Carnavalet, Petit Palais) and many French provincial museums, and also in Baltimore (Walters), Boston, Buffalo, Cambridge Mass. (Fogg), Chicago, New York (Met.), Philadelphia and Washington (Corcoran).

Devéria Eugène François Marie Joseph, b. Paris 1805, d. Pau 1865. The studio in the rue de l'Ouest which he shared with his elder brother Achille (1800–57) was a central meeting-point of the young French ROMANTICS in the 1820s. Notable among the group were Victor Hugo and his brother Abel, Musset, Sainte-Beuve and Fontanay; among the artists, David d'Angers, BONINGTON and BOULANGER. A pupil of GIRODET-TRIOSON, his first SALON exhibit, *The Birth of Henri IV* (1827) was rapturously received. Together with Boulanger's *Mazeppa* it was considered to outshine by far Delacroix's contributions. This success was not repeated; he painted some ceilings in the Louvre but during the 1850s his Salon offerings were systematically rejected. His brother Achille made a reputation as a lithographer and portraitist. There are works in Angers, Avignon, Bernay, Béziers, Florence (Uffizi), Le Havre, Montpellier, Neuchâtel, Orleans, Paris (Louvre), Rouen, Valence and Versailles.

Diaz de la Peña Narcisse Virgile, b. Bordeaux 1808, d. Menton 1876. A landscape painter of the BARBIZON SCHOOL, he specialized in the flickering nuances of light and shade in the deep forest (*Jean de Paris Hill, Forest of Fontainebleau* 1867). He also painted figure groups, often mythological, in landscape settings (*Sleeping Nymph* 1855, *Venus and Adonis* 1848). MILLET attempted to imitate these popular works in his youth; Diaz's work also had an important influence on MONTICELLI and FANTIN-LATOUR. After an apprenticeship in a printing works, he started to paint porcelain at Sèvres with DUPRÉ. He studied painting with Souchon but learnt more from his friends Dupré, RAFFET and Cabat and from copying in the Louvre. His first SALON exhibits of 1831, 1834 and 1835 were ROMANTIC figure subjects inspired by DELACROIX. From 1837 he was constantly with P.E.T. ROUSSEAU at Barbizon, where his mature style developed. Collectors were interested in his work from an early date but only around 1870 did he begin to enjoy an important international reputation. A prolific artist, his work is represented in most museums dealing with the 19C, including Baltimore (Walters), London (NG, V&A, Wallace), New York (Met., Brooklyn), Paris (Louvre) and Washington (NG, Corcoran).

Diday François, b. Geneva 1802, d. Geneva 1877. Pioneer of Alpine landscape painting in Switzerland, though later somewhat outshone by his pupil CALAME. He attended the drawing school of the Société des Arts in Geneva, but was largely self-taught. He was impoverished and struggling until 1830, when the Société gave him a travel scholarship. In Paris he received some help from GROS and on returning to Geneva he rapidly achieved wide popularity for his Alpine views (*The Giessbach Waterfall, The Wetterhorn, The Lake of Brientz*); he opened an art school and had many pupils. He won a gold medal in the SALON of 1841, and was accorded the Legion of Honour in 1842. He left a large fortune to create the Fondation Diday for the purchase of paintings and encouragement of arts in Switzerland, as well as prize money for a biannual Concours Diday for students of painting. There are works in Amsterdam (Stedelijk), Basle (Kunstmuseum), Bucharest (Simu), Geneva (Rath), Munich and Zurich.

Diez Wilhelm von, b. Bayreuth 1839, d. Munich 1907. Genre painter specializing in vagabonds and soldiers in scenes often set during the Thirty Years War; he was the most distinguished of the Munich painters of the 1870s who lovingly imitated Dutch and Flemish Old Masters. His scenes are painted realistically and are full of finely observed detail (*Plunderers of the Thirty Years War*). In 1855 he entered the Munich Academy,

Diez *Ambush* 1882

Dillis *View of the Quirinal* 1818

but left almost immediately to teach himself by copying in the galleries. He was particularly attached to Brouwer, Teniers and the Dutch school, but also studied Schongauer and Dürer. He became successful as an illustrator in the 1860s, while developing a personal style of small genre painting. A professor at the Munich Academy from 1870, he was a popular and influential teacher. There are works in Berlin, Hamburg, Kaliningrad, Leipzig and Munich.

Dillis Maximilian Johann Georg von, b. Grüngiebing 1759, d. Munich 1841. He combined landscape painting with teaching and museum administration but nevertheless can be counted among the founders of Munich's naturalistic landscape school (*The Tegernsee* 1825). His style owed much to the Dutch landscapists of the 17C, and a little to Claude and Poussin in his treatment of distance. Basically a draughtsman rather than a colourist, the careful detail and muted colour of his early work developed after 1800 towards looser brushwork and a brighter palette under the influence of his erstwhile pupil, W. VON KOBELL (*View of the Quirinal* 1818). He travelled widely, visiting Italy several times, either on museum business, with noble patrons or in charge of their sons. Inspector of the new Hofgarten Gallery in 1790, he was the Munich Academy's first professor of landscape painting (1808-13). He was employed by the Wittelsbachs to buy paintings for their collections and in 1815 was sent to Paris to secure the return of works of art removed by Napoleon. Given overall charge of the Munich galleries in 1822, he secured the purchase of the famous Boisserée collection of German and Flemish primitives in 1827. He was actively involved in the foundation of the Munich KUNSTVEREIN in 1824. Most of his paintings are in Munich (N. Pin., Schack). *Lit.* W. Lessing: *J. G. von Dillis als Künstler und Museumsmann* (1951)

Divisionism (Divisionist). A method of painting in small dots or commas of colour. It was pioneered by SEURAT, and derived from his interest in applying scientific theory to painting; the small dots of juxtaposed colour were to merge in the eye of the spectator. SIGNAC, the chief propagandist of the style, explained that Divisionism 'guaran-

tees all the benefits of luminosity, colour and harmony: (1) by the optical mixture of pure pigments (all the colours of the prism and all their tones); (2) by the separation of different elements such as local colour, the colour of the light, as well as the colours produced by their interactions; (3) by the balancing of these elements and their proportions (according to the laws of contrast, gradation and irradiation); (4) by the selection of a brushstroke proportionate to the size of the canvas.'

Seurat's first experiment with the method, *Bathing at Asnières*, exhibited at the SALON DES INDÉPENDANTS in 1884, brought about his subsequent collaboration with Signac. When his *Sunday Afternoon on the Island of La Grande Jatte* (in which the method is fully developed) was shown at the last Impressionist Group Show of 1886, it was exhibited in company with Divisionist works by Signac, PISSARRO and his son Lucien. Several other French artists also adopted the style (ANGRAND, Dubois-Pillet, Petitjean, LUCE) and they came to be known as the Neo-Impressionists. *Grande Jatte* was exhibited with LES VINGT in Brussels in 1887 and several Belgian artists adopted the Divisionist technique (VAN DE VELDE, VAN RYSSELBERGHE). Divisionism was introduced by the art dealer-painter GRUBICY to Italy, where it had many followers (SEGANTINI). The terms Pointillism and Chromatic Luminarism are often used to describe this style.
Lit. P. Signac: *D'Eugène Delacroix au Néo-Impressionisme* (1899); J. Rewald: *Post-Impressionism* (1962); F. Cachin (ed.): *F. Fénéon, au-delà de l'Impressionisme* (1966)

Doré Paul Gustave Louis Christophe, b. Strasbourg 1832, d. Paris 1883. Prolific and successful 19C book illustrator who in later years also executed some oil paintings and sculpture. His quirky and, on occasion, visionary imagination places him in an interesting intermediate position between the early ROMANTIC movement and the SYMBOLIST artists of the late century. Théophile Gautier said of him: 'If a publisher were to ask him to illustrate the influence of a flea on a woman's emotions, I feel sure he would find a means of doing it.' In 1848 he received a three-year contract for caricatures in *Journal pour rire* and exhibited his first drawings in the SALON. His illustrations of

Doré *The Wandering Jew Crossing a Cemetery* 1856

Drolling *Interior of a Kitchen* 1815

Rabelais and Balzac's *Contes drôlatiques* (1854–5) established his fame. His large-format illustrated books, of which the first was Sue's *Juif-Errant* (1856), are seen as the forerunners of modern illustrated books with original prints by famous artists. There are paintings in Baltimore (Walters), Bayonne, Etampes, Grenoble, La Rochelle, Leeds, Liverpool, Montpellier, Pontoise, Reims, Rouen, Sète, Troyes and Versailles.
Lit. H. Leblanc: *Catalogue d'œuvre complet de G. Doré* (1943); M. Rose: *G. Doré* (1946); E. de Maré: *The London Doré Saw* (1973); M. Henderson: *G. Doré : Selected Engravings* (1973); N. Gosling: *G. Doré* (1973); G. Forberg: *G. Doré. Das graphische Werk* (2 vols 1975)

Dorner Johann Jakob (the Younger), b. Munich 1775, d. Munich 1852. With W. VON KOBELL, DILLIS and WAGENBAUER, one of the founders of Munich's naturalistic landscape school. He specialized in mountains, waterfalls and forests, his paintings deriving on the one hand from his study of Claude, Ruisdael and Everdingen and on the other from studies from nature. After receiving his first instruction from his landscape painter father, Johann Jakob the Elder, he studied in Austria, Switzerland and France (1802–3) and in 1803 became official restorer to the Munich galleries; in 1808 he was a Munich gallery inspector. His best period was *c.* 1818 (*Village Street* 1817, *The Waterfall c.* 1818, *Rocky Gorge* 1822). Most of his work is in Munich or neighbouring Bavarian castles.

Doughty Thomas, b. Philadelphia (Pa.) 1793, d. New York 1856. Self-taught landscapist whose semi-topographical depictions of native scenery have what Richardson calls 'a very personal flavour compounded of their luminous skies and gentle solitude' (*View from Stacey Hill* 1830, *In Nature's Wonderland* 1835). Originally a leather currier, he began painting *c.* 1820 with encouragement from SULLY; he worked in Pennsylvania, Boston and New York, and visited Europe in 1837 and 1845–6. His work was an early influence on COLE; he has been seen as a forerunner of the HUDSON RIVER SCHOOL. There are works in Baltimore (Mus. of Art), Boston, Cambridge Mass. (Fogg), New York (Met., Brooklyn) and Washington (NG, Corcoran).

Doyle Richard, b. Dublin 1824, d. Dublin 1883. He was primarily an illustrator, designing in 1849 the famous cover of *Punch* which was in use for over a century. He painted landscapes in oil and watercolour but is better known for his fairy pictures, some large in scale including many hundreds of fairies (*Elves in a Forest*, *Home of Sorcerers*). This subject matter was suggested by contemporary literature; he illustrated Ruskin's *King of the Golden River* and W. Allingham's *The Fairy Land*. His father John Doyle (1797–1868) was a well-known caricaturist and his brother Charles (1832–93) also painted some fairy pictures. There are works in Dublin and London (V&A).
Lit. D. Hambourg: *R. Doyle* (1948)

Drolling Martin (signature Drölling or Drelling), b. Oberbergheim 1752, d. Paris 1817. Self-taught artist who came early to Paris where his small genre paintings and portraits found a ready market though little official recognition. His peaceful middle-class interiors are based on the Dutch and Flemish example, though the glossy, satin-smooth finish is his own. He exhibited in the SALON from 1793, and decorated Sèvres porcelain (1802–13). His son Michel Martin (1786–1851) had some success as a history painter and portraitist. There are works in Aix, Bordeaux, Graz, Le Puy, Orleans, Paris (Louvre, Carnavalet) and Soissons.

Dubois Paul, b. Nogent-sur-Seine 1829, d. Paris 1905. Sculptor and portraitist profoundly influenced by Italian 15C art. After studying with Toussaint (1856) and making a long visit to Italy (1859–62), he began exhibiting in the sculpture section of the 1863 SALON and had his first success with *Florentine Singer* (1865). He took up painting in the 1870s and had considerable success as a portraitist. He became a chevalier of the Legion of Honour (1867), an officer (1874), a commander (1886), achieving the grand cross (1896); he was also a member of the INSTITUT (1876). He was curator of the Luxembourg Museum (1873) before becoming director of the ECOLE DES BEAUX-ARTS in 1878. There are works in Baltimore (Walters), Bayonne, Bourges, Bucharest, Chalons-sur-Marne, La Roche-sur-Yon, Montpellier and Versailles.

Dupré Jules, b. Nantes 1811, d. L'Isle-Adam 1889. Landscapist of the BARBIZON SCHOOL, a pioneer of *paysage intime* when historical landscape was the accepted convention. He was a close friend and collaborator of T. ROUSSEAU and importantly influenced by CONSTABLE. His landscapes are distinguished by a particular interest in atmosphere, reflected in the study of skies, their moods and ever-changing cloud formations. The broad fluid treatment that he adopted first (c. 1835) under the influence of Constable became progressively bolder with the use of thick impasto. He started his career decorating porcelain at Sèvres (1823), where he met DIAZ, Cabat and RAFFET. He studied painting with J. M. Diébolt and first exhibited at the 1831 SALON, where his paintings were well received. He was invited to England by Lord Graves (1834), and the influence of Constable and English landscape painting was reflected in his *View of Southampton*, exhibited with success at the 1835 Salon; it was admired by DELACROIX and by LAMI, who invited him to paint the landscape background to his *Battle of Hondschoote* (1836 Salon). He met Rousseau in 1834; other friends included MILLET, COROT, DAUBIGNY, Delacroix, DECAMPS and DAUMIER. From 1839 to 1852 he did not exhibit at the Salon. After 1850 he lived in L'Isle-Adam, making occasional visits to Paris and the Normandy coast. He is well represented in the Louvre and there are works in many French museums, as well as in Amsterdam (Rijksmuseum), Baltimore (Mus. of Art), Boston, Cambridge Mass. (Fogg), Cardiff, Chicago, Cincinnati, Geneva, Glasgow, The Hague, London (Wallace, NG), New York (Met., Brooklyn), Stockholm and Washington (NG, Corcoran).
Lit. J. Claretie: *Dupré* (1879); J. W. Mollett: *Painters of Barbizon: Corot, Daubigny, Dupré* (1890); M. M. Aubrun: *J. Dupré, 1811–1889: catalogue raisonné de l'œuvre peint, dessiné et gravé* (1974)

Durand Asher Brown, b. Jefferson Village (N.J.) 1796, d. Jefferson Village 1886. Engraver turned landscapist, after the death of COLE the leader of the HUDSON RIVER SCHOOL. He painted both panoramic views and wildly tangled woodland interiors. After an apprenticeship with Peter Maverick, he engraved pictures for gift-book annuals, periodicals and banknotes, becoming America's leading engraver. He turned to painting c. 1834, starting with portraits and historical genre scenes, and became a close friend of Cole, with whom he made several sketching expeditions. In Europe (1840–1), he visited London, Paris, Italy, Belgium and Switzerland, and was deeply impressed by CONSTABLE and Claude. After trying a few Europeanized subjects, he turned to native landscape painting, and his home at Catskill Clove became a gathering place for the Hudson River artists (*Kindred Spirits* 1849). He helped found the NATIONAL ACADEMY OF DESIGN (1826) and was president 1845–61. His *Letters on Landscape Painting*, published in the 1850s, expressed the philosophy of the Hudson River group, who looked on painting God's creation as a religious endeavour. Nature, he wrote, 'in its wondrous structure and functions that minister to our wellbeing, is fraught with high and holy meaning, only surpassed by the light of Revelation.' There are works in Baltimore (Mus. of Art, Walters), Boston, Cambridge Mass. (Fogg), Cincinnati, Cleveland, Detroit and New York (Met., Hist. Soc.).
Lit. J. Durand: *Life and Times of A. B. Durand* (1894)

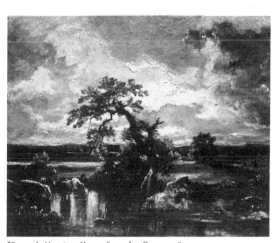
Dupré *Setting Sun after the Storm* 1851

Düsseldorf School. Between 1830 and 1870 Düsseldorf was one of the most highly regarded artistic centres of Germany. It attracted artists from all over the world, including a large group from the U.S. (LEUTZE, BIERSTADT, WHITTREDGE, BINGHAM). Artists from Scandinavia (TIDEMAND, GUDE), Russia and eastern Europe (MUNKÁCSY) often studied in Düsseldorf in preference to Paris. The reputation of the school was first established by SCHADOW, the Nazarene director of the academy appointed in 1825, and the pupils who followed him from Berlin, LESSING, SOHN, HILDEBRANDT and BENDEMANN. They painted literary-historical works with a debt to the NAZARENES and the theatre. Düsseldorf and the Rheinland was subject to the harsh feudal government of Prussia, and the artists became politicized. Under the initial leadership of Lessing, they painted historical scenes concerning the fight for freedom of individuals, groups or nations. Many artists were associated with the 1848 uprisings; the genre painters turned to contemporary scenes of injustice (HASENCLEVER, HÜBNER) painted

Durand *View Toward the Hudson Valley* 1851

Duveneck *Old Town Brook, Polling, Bavaria* c. 1878

Dyce *Titian's First Essay in Colour* 1856–7

with a new Realist concern. REALISM in landscape was initiated by A. and O. ACHENBACH, building on the more conventional tradition of Lessing and SCHIRMER. After 1848 the briefly full-blooded Realist trend was diluted to suit the taste of a newly prosperous middle-class clientele. This is apparent in the later landscapes of the Achenbachs and the immensely popular peasant genre scenes of KNAUS and VAUTIER. From 1835, when a group of artists left the academy (Achenbach, RETHEL, Hasenclever), there was a smouldering battle between the Nazarene-idealistic-oriented academy, which remained a faithful servant of the Prussian authorities, and the liberal-revolutionary Realists. Only in 1869, after a much publicized campaign, were the Realists allowed back into the academic hierarchy.
Lit. W. Hütt: *Düsseldorfer Malerschule* (1964)

Duveneck Frank, b. Covington (Ky.) 1848, d. Cincinnati (Ohio) 1919. Portrait, genre and landscape painter who introduced the style of the Munich REALISTS to America with great success. His work was 'realistic and atmospheric in vision, dark and warm in tonality, and dashing in its *bravura* displays of brushstroke' (Richardson). He worked as an interior decorator of churches and chapels before visiting Munich (1870), where he studied at the academy under DIEZ and was acquainted with LEIBL and his circle. On his return to America (1873), he exhibited at the Boston Art Club (1875), which brought him sudden fame. He started an art school in Munich in 1878, attracting some sixty pupils, mainly Americans; half of them moved with him to Florence in 1879. He remained in Italy until 1888, when he returned to Cincinnati, where he became closely involved with both the Museum and Academy of Art. He was a member of the NATIONAL ACADEMY OF DESIGN (1906). There are works in Baltimore (Mus. of Art), Boston, Bremen, Buffalo, Cambridge Mass. (Fogg), Chicago, Cincinnati, Cleveland, Indianapolis, New York (Brooklyn) and Washington (NG, Corcoran).
Lit. W. S. Siple: *F. Duveneck* (1936)

Dyce William, b. Aberdeen 1806, d. London 1864. Religious and historical painter, decisively influenced by the NAZARENES in Rome; his work, with its clear contours and simple colours, brought their influence to England. He was admired by the PRE-RAPHAELITES and under their influence painted *Pegwell Bay* (1859–60) and *Titian's First Essay in Colour* (1856–7), interpreting their aim of truth to nature through painstaking attention to detail. He studied medicine and theology in Aberdeen and at the ROYAL ACADEMY Schools under LAWRENCE. He visited Italy in 1825 and 1827, joining the Nazarene circle; *Madonna and Child* (1828) won the praise of OVERBECK and CORNELIUS and launched his international reputation. *Joash Shooting the Arrow of Deliverance* (1844) and *Jacob and Rachel* (1853) are the best-known examples of his later Nazarene-inspired work. He returned to Scotland and settled in Edinburgh (1830–7), where he devoted himself mainly to portrait painting. From 1838 he was based in London; he undertook extensive mural decorations, for the House of Lords, at Osborne House and a Buckingham Palace summerhouse (commissions from Prince Albert) and for several churches. He became an ARA in 1844, and an RA in 1848, but declined to be a candidate for the presidency in 1850. Painting shared his time with many other interests; he devoted much time to improving art education and industrial design, becoming the first director of the new school of design at Somerset House (1838). He was a leader of the High Church movement, a composer of church music and wrote on many subjects, including electro-magnetism. There are works in Aberdeen, Birmingham, Edinburgh, Hamburg, London (Tate, V&A), Manchester, Melbourne and Nottingham.

E

Eakins Thomas, b. Philadelphia (Pa.) 1844, d. Philadelphia 1916. Painter whose scientific interests were closely related to his art. He painted with careful REALISM, stylistically related to the ACADEMIC REALISM of BONNAT and GÉRÔME, under whom he studied in France. His studies of anatomy found an outlet in the carefully observed *Gross Clinic* (1875), an updated version of Rembrandt's *Anatomy Lesson*, and the similar *Agnew Clinic* (1889), and also in his studies of the male nude used in scenes of bathers and athletes (*Max Schmitt in a Single Scull* 1871, *Between Rounds* 1899); his landscapes and landscape backgrounds further reflect his studies of space and perspective. His later portraits are penetrating psychological studies of character, limited often to a head and by implication a state of mind. He studied at the Pennsylvania Academy (1861-6), concurrently following a course in anatomy at the medical college. He moved to Paris in 1866, studying under Bonnat and Gérôme, and visited Italy, Germany and Spain (1868-9). After returning to Philadelphia (1870), he taught at the Pennsylvania Academy from 1876, a professor of drawing and painting from 1879. He stressed to his students the importance of studies from the male nude, and his attempt to include women students in these classes forced his resignation in 1886. He became a member of the NATIONAL ACADEMY OF DESIGN in 1902. His work is best represented in Philadelphia, but there are also works in Baltimore (Mus. of Art), Boston, Buffalo, Cambridge Mass. (Fogg), Chicago, Cincinnati, Cleveland, New York (Brooklyn) and Washington (NG, Corcoran).
Lit. L. Goodrich: *T. Eakins* (1933); F. Porter: *T. Eakins* (1959)

Eastlake Sir Charles Lock, b. Plymouth 1793, d. Pisa 1865. Painter turned art historian and administrator; his years as director of the London National Gallery saw some of its most significant acquisitions. He dedicated himself to history painting under the influence of WEST and HAYDON; his Roman years are marked by the influence of the NAZARENES

and by genre scenes of peasants and *banditti* in the Roman *campagna* of the type popularized by ROBERT. He received his first instruction from Samuel Prout, studied with Haydon (1809) and at the ROYAL ACADEMY Schools. The proceeds of his successful *Bonaparte on Board the Bellerophon* (1815) took him to Rome in 1816 where he remained until 1830 (*Pilgrims arriving in Sight of Rome* 1827). He became an ARA in 1827 and an RA in 1830; he was secretary to the Royal Commission for the Decoration of the Houses of Parliament (1841-62), president of the Royal Academy (1850) and director of the National Gallery (1855). He was knighted in 1850. His leanings towards Nazarene historicism made him popular with Prince Albert and the court. There are works in London (Tate, V&A) and Manchester.
Lit. Lady Eastlake: *A Memoir of Sir C. L. Eastlake* (1869); W. C. Monkhouse: *Pictures by Sir C. L. Eastlake* (1875)

Eckersberg Christoffer Wilhelm, b. Sundeved 1783, d. Copenhagen 1853. The undisputed overlord of Danish painting in the great Danish BIEDERMEIER era (*c.* 1820-50). A NEOCLASSICIST by training, he found justification for his instinctive REALISM in the classicists' reverence for nature. He painted historical and religious subjects and portraits which echo the work of DAVID and INGRES (*Nude in Front of a Mirror c.* 1837), while the fresh landscapes and seascapes he painted for his own pleasure are outstanding examples of Biedermeier Realism (*View through the Arches of the Colosseum* 1815). After studying at the Copenhagen Academy under Abilgaard from 1803, he won a travel scholarship (1809); he became a pupil of David in Paris (1811-13), and spent 1813-16 in Rome, where he became a close friend of THORWALDSEN, met Ingres and painted his first notable portraits and landscapes. In 1816 he returned to Copenhagen, becoming a member of the academy (1817) and a professor (1818). In 1820 he introduced into the academy curriculum daylight painting from nature. Perspective was one of his

Eakins *Max Schmitt in a Single Scull* 1871

Eastlake *Escape of the Carrara Family from the Pursuit of the Duke of Milan, 1389* 1849

Eckersberg *View through the Arches of the Colosseum* 1815

Edelfelt *Women outside the Church at Ruokolahti* 1887

Egg *Travelling Companions* 1862

central interests and he found particular satisfaction in the study of the complex rigging on ships; much of his free time was devoted to painting ships and the sea. KØBKE and most of Denmark's Biedermeier Realists were his pupils. He also influenced DAHL and several German landscapists. His works are mainly in Copenhagen (State, Hirschsprung, Thorwaldsen).
Lit. P. C. Weilbach: *Eckersbergs Levned og Värker* (1872); E. Hannover: *Maleren C. W. Eckersberg* (1898); V. Jastrau: *C. W. Eckersberg* (1921)

Ecole des Beaux-Arts *see* FRENCH ART ESTABLISHMENT

Edelfelt Albert Gustav Aristides, b. Borgä 1854, d. Borgä 1905. Painter of rustic scenes, much influenced by BASTIEN-LEPAGE, and one of the first Finnish artists to study in Paris, thus helping to break the hold of the DÜSSELDORF SCHOOL over Finnish painting. The REALIST orientation of his peasant scenes gave way (*c.* 1900) to a more spiritual art, treating biblical subjects and old Norse sagas (*Christmas Morning* 1889, *Christ and Mary Magdalen* 1890). He studied in Helsinki, at the Antwerp Academy (1873) and in Paris under GÉRÔME (1874). He exhibited regularly at the SALON (1877–89) and from 1890 with the SOCIÉTÉ NATIONALE DES BEAUX-ARTS, dividing his life between Paris and his country villa at Borgä. Chevalier of the Legion of Honour in 1887, he became an officer in 1889 and a commander in 1901. There are works in Copenhagen, Helsinki (Athenaeum), Leningrad (Russian Mus.), Luxembourg, Mulhouse, Paris and Stockholm (Nat. Mus.).
Lit. B. Hintze: *A. Edelfelt* (1942)

Edlinger Josef Georg von, b. Graz 1741, d. Munich 1819. Munich's leading portraitist at the beginning of the 19C. His paintings of wealthy burghers were executed with solid realism softened by broad flowing brushwork derived from the baroque tradition. He was self-taught and spent most of his early years in Austria and Hungary. In 1770 he went to Munich, where he was appointed court painter in 1781. There are works in Augsburg, Berlin, Darmstadt, Graz, Munich and Nuremberg.

Egedius Halfdan, b. Drammen 1877, d. Oslo 1899. Painter who led the reaction against REALISM in Norway with works of rich fantasy and colour, summer landscapes shimmering with light and figure paintings full of wild movement. He studied in Oslo with BACKER and in Copenhagen with ZAHRTMANN, making summer sketching expeditions with student friends, and contributed an important series of illustrations to Sturlason's *Saga of Nordic Kings* (1899). There are works in Bergen and Oslo (NG).

Egg Augustus Leopold, b. London 1816, d. Algiers 1863. English genre painter. Following the early Victorian fashion, he drew his subject matter mainly from literature, particularly favouring Shakespeare, Scott and Le Sage. He was one of the few established painters to befriend the PRE-RAPHAELITES; under their influence he tried his hand at scenes from contemporary life, with great success (*Travelling Companions* 1862). He studied at Sass's Academy (1834) and at the ROYAL ACADEMY from 1835; he was a member of THE CLIQUE. He became an ARA (1848) and an RA (1860). There are works in Birmingham, Leicester, London (Tate, V&A, Guildhall), Preston and Sheffield.

Enhuber Karl von, b. Hof 1811, d. Munich 1867. Munich's most renowned mid-century genre painter. He depicted peasant and small-town life with anecdotal humour reminiscent of WILKIE, whose *Opening of the Will* hung in Munich from 1826 and was the cornerstone of a new school of genre painting. His most successful work dates from the last decades of his life, when his brushwork became broader and more fluent under the influence of SPITZWEG. He briefly attended the Munich Academy (1832) and studied Metzu, Terborg and the Dutch 17C masters in the Munich galleries. His genre scenes, exhibited at the KUNSTVEREIN from around 1833, soon gained popularity. He became a member of the Munich Academy in 1858. There are works in Bamberg, Berlin, Danzig, Darmstadt, Leipzig, Munich, Schleissheim and Strasbourg.

Ensor James, b. Ostend 1860, d. Ostend 1949. An important figure in the Belgian *avant-garde* of *c.* 1880–1900. His work has been described as a 'hallucinated kind of IMPRESSIONISM' (Haftmann) and was an influence on both Expressionism and Surrealism in the 20C. His paintings are crowded

Ensor *Christ's Entry into Brussels* 1888

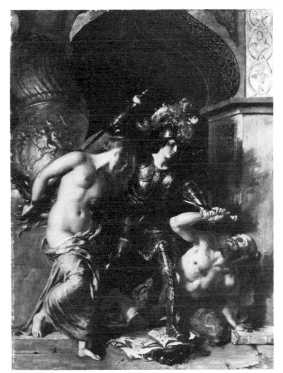

Etty *Britomart Redeems Fair Amoret* 1833

with skeletons, masks and ghosts, their bright colours echoing TURNER and the Impressionists; a hallucinatory treatment of space contributes to the surreal effect. He studied at the Brussels Academy (1877–9) under PORTAELS, where he met ROPS. From 1879 he lived a lonely life in Ostend. He helped to found LES VINGT, a group of independent artists (1883), but left them in 1889 when his masterpiece, *Christ's Entry into Brussels*, was rejected for exhibition. His best work was done by 1900, though his fame post-dates the First World War. He became a baron in 1929. There are works in Antwerp, Boston, Brussels (Musées Royaux), Buffalo, Cambridge Mass. (Fogg), Chicago, Cleveland, Detroit, London (Tate), New York (Met., Mod. Art), Paris (Mod. Art) and Philadelphia.
Lit. L. Tannenbaum: *J. Ensor* (1951); J. Damase: *L'Oeuvre gravé de J. Ensor* (1967); R. Croquez: *Ensor en son temps* (1970); P. Haesaerts: *J. Ensor* (1973); R. Van Gindertael: *Ensor* (1976)

Esquivel Antonio Maria, b. Seville 1806, d. Madrid 1857. Painter of religious and genre scenes, based almost slavishly on the example of Murillo, as well as many portraits of the royal family and leading Spanish figures of his day; he also did illustrations and caricatures. He studied in Seville and in Madrid, where he was an honorary member of the S. Fernando Academy (1832) and exhibited religious, genre and history paintings (1835–8). He was struck by blindness but recovered in 1841, returning busily to work. There are works in Madrid (Mod. Art, Liceo); he is also represented in Chicago.
Lit. J. Guerrero Lovillo: *A. M. Esquivel* (1957)

Etty William, b. York 1787, d. York 1849. His lifelong, all-consuming interest was the female nude; he used classical mythology and allegory as vehicles to translate his studies into exhibition works, painting rapidly in rich colour and chiaroscuro derived from Titian and the Venetians. Admired by DELACROIX, he had an important influence on the following generation in England, especially MILLAIS and G. F. WATTS. He settled in London in 1805 and entered the ROYAL ACADEMY Schools (1807) where he studied under LAWRENCE; he first exhibited at the academy in 1811. A visit to Italy (1816) was cut short by illness, but in 1821 he had his first resounding success with *Cleopatra's Arrival in Cilicia*, he returned to Italy (1822–4), where he spent nine profoundly influential months in Venice copying Titian and Veronese. He became an ARA in 1824 and an RA in 1828. He continued throughout his career to attend the academy life classes to draw from the nude, and thus influenced Millais and other students who watched him at work. He visited Belgium in 1840 and 1842 to study Rubens and moved to York on account of his failing health the year before his death. There are works in Aberdeen, Boston, Cambridge, Cambridge Mass. (Fogg), Dublin, Edinburgh, Glasgow, Leicester, Liverpool, London (NPG, V&A), Montreal, New York (Met., Brooklyn), Nottingham, Paris (Louvre), Philadelphia, Preston, Sheffield and Sunderland.
Lit. A. Gilchrist: *Life of W. Etty* (1855); W. C. Monkhouse: *Pictures by W. Etty* (1874); W. Gaunt: *Etty and the Nude* (1943); D. Farr: *W. Etty* (1958)

Evenpoel Henri, b. Nice 1872, d. Paris 1899. Short-lived Belgian IMPRESSIONIST painter. His portraits, townscapes and genre scenes are informed by a spiritual insight and gentle melancholy which also links his work with the SYMBOLISTS. After studying at the Brussels Academy, he went to Paris (1892) where he studied at the ECOLE DES BEAUX-ARTS with MOREAU. He was strongly influenced by MANET and a friend of Matisse, Rouault and DENIS. There are works in Brussels (Musées Royaux), Ghent and Liège.
Lit. P. Lambotte: *H. Evenpoel* (1908); P. Haesaerts: *Les Dessins d'Evenpoel* (1943); F. E. Hyslop (ed.): *H. Evenpoel à Paris: Lettres choisies 1892–99* (1971)

Exhibitions, International. London's Great Exhibition of 1851 launched a fashion for prestige international exhibitions in both Europe and America. The selection of paintings for an exhibition, the medals awarded, and indeed a place on the jury that awarded medals were all sources of prestige for the artists of the time. The 1851 exhibition in London was devoted entirely to industrial products, though a small international exhibition of painting and sculpture was held in Brussels in the same year. The Paris *Exposi-*

tion Universelle of 1855 included a fine arts section in addition to industrial exhibits, and from then on this became the practice with all major exhibitions. The most important exhibitions were, in chronological order: London (1851), New York World's Fair (1853), Paris (1855), London (1862), Paris (1867), Vienna (1873), Philadelphia Centennial (1876), Paris (1878), Paris (1889), Chicago World's Columbian (1893), Paris (1900)..
Lit. K. W. Luckhurst: *The Story of Exhibitions* (1951); R. D. Mandell: *Paris 1900 : The Great World's Fair* (1967)

Exner Johann Julius, b. Copenhagen 1825, d. Copenhagen 1910. Painter of traditional peasant life in Denmark, the genre encouraged as a National Art by the influential Professor Høyen around the mid-century. 'He often comes perilously near the line where what is child-like becomes childish and what is sweet becomes sugary' (Muther). He studied at the Copenhagen Academy from 1839 with ECKERSBERG and J. L. Lund, and first exhibited in the late 1840s. He became a member of the Copenhagen Academy (1864) and a professor (1872–93). His work was popular among his contemporaries. There are works in Copenhagen (State).

Exposition Universelle see EXHIBITIONS, INTERNATIONAL

Eysen Louis, b. Manchester 1843, d. Munich 1899. German naturalistic landscape painter. Influenced by THOMA, LEIBL and the BARBIZON SCHOOL, his central interest lay in effects of light. He studied at Frankfurt Städelsches Institut and in Berlin and Munich, before becoming a pupil of BONNAT in Paris (1869–70). After 1879 he lived a retired life with his family near Merano. His reputation was established after his death, especially by the freely painted Taunus and Tyrol landscapes of his later period. There are works in Berlin, Kassel, Frankfurt, Innsbruck, Merano and Stuttgart.
Lit. W. Zimmermann: *Der Maler L. Eysen* (1963)

F

Faed Thomas, b. Burley Mill (Kirkcudbrightshire) 1826, d. London 1900. Painter of Scottish peasant genre in the tradition of WILKIE. *The Mitherless Bairn* (1855) became well-known through engravings. He became an ARA in 1859 and an RA in 1864. There are works in Aberdeen, Blackburn, Glasgow, Hamburg, Leicester, Liverpool, London (Tate, V&A), Melbourne, Montreal, Sheffield and Sunderland.

Fantin-Latour Ignace Henri Jean Théodore, b. Grenoble 1836, d. Buré 1904. His copious still lifes, mainly of flowers, and his portraits were painted with intimate REALISM and careful finish. A friend of the IMPRESSIONISTS, though less experimental, he was particularly close to WHISTLER, who introduced him to England where his flower pieces were enthusiastically received. The son of a painter (Théodore 1805–72), he studied with LECOQ DE BOISBAUDRAN and COURBET. He also formed himself by copying in the Louvre, an activity which he continued throughout his career, meeting his artist wife Victoria there (*m.* 1878). He first exhibited in the SALON in 1861 but was relegated to the Salon des Refusés in 1863, along with MANET, Whistler and others. His group portraits of fellow artists and writers have become famous documents of the period: *Homage to*

Delacroix (1864), *Atelier in the Batignolles* (1870), *Table Corner* (1872), *Round the Piano* (1885). Baudelaire, Champfleury, Whistler, Manet, MONET, RENOIR, Zola and others are depicted. His enthusiasm for the music of Wagner and Berlioz inspired a series of ROMANTIC mythological canvases in which nude figures emerge from a mysterious haze of paint (*The Dance* 1891). There are works in the Louvre and several French provincial museums, and in Antwerp, Baltimore (Mus. of Art), Berlin, Birmingham, Boston, Brussels, Cambridge (Fitzwm), Cleveland, Dublin, Glasgow, Kansas City, London (NG, Tate, V&A), Manchester, New York (Met.), Ottawa, Oxford, Toledo, St Louis and Washington (NG, Phillips).
Lit. L. Bénédite: *Fantin-Latour* (1902); V. Fantin-Latour: *Catalogue de l'œuvre complète de Fantin-Latour* (1911)

Faruffini Federico, b. Sesto San Giovanni (Milan) 1831, d. Perugia 1869. REALIST painter of historical scenes. After studying with Trécourt in Pavia, he accompanied his friend CREMONA to Milan and Venice and went with CARNOVALI to Rome in 1855. His studies on the use of colour to convey effects of light provide a link between Carnovali and the SCAPIGLIATURA school of Cremona. Lack of recognition and financial difficulties drove

him to suicide at the age of thirty-eight. There are works in Milan (Mod. Art, Grassi), Novara (Giannoni) and Rome (Mod. Art).
Lit. P. M. Bardi: *F. Faruffini* (1930)

Fattori Giovanni, b. Livorno 1825, d. Florence 1908. A close associate of the MACCHIAIOLI, Fattori first adapted their approximative brushwork (quick spots of colour or *macchia*) to historical canvases (*Mary Stuart* 1859), then to contemporary 'history', the military campaigns of the Risorgimento (*The Italian Camp after the Battle of Magenta* 1861), and finally to other contemporary subjects, portrait, landscape and rural life (*The Palm Leaf Rotunda* 1866). He aimed to combine an element of outline and chiaroscuro with the *macchia* technique, his outlines being defined by quick brushstrokes of colour; his work also retained an emphasis on formal composition. He studied at the Florence Academy under BEZZUOLI from 1846, breaking off his studies to travel through Italy (1848–9) as a messenger for patriotic conspirators. From 1850 he painted from nature in the countryside with SIGNORINI, BORRANI, SERNESI and the other Macchiaioli, but also spent time studying the frescoes of Filippo Lippi and Ghirlandaio. He was importantly influenced (*c.* 1860) by the ability of COSTA to combine poetic content and elements of

classical composition with REALIST painting. On Costa's advice he embarked on his first heroic military painting, *The Battle of Magenta*, and moved away from the Macchiaioli group. He pursued his own individual line and, teaching at the Florence Academy from 1886, exerted much influence on his contemporaries. In later life he executed many fine etchings. There are works in Florence (Mod. Art), Livorno (Fattoriano), Milan (Mod. Art, Grassi, Brera), Rome (Mod. Art), Trieste (Revoltella) and Turin (Mod. Art).
Lit. R. de Grada: *G. Fattori* (1965); M. Borgiotti, P. Nicholls: *La lezione pittorica di G. Fattori* (1968); L. Blanciardi: *L'opera completa di Fattori* (1970)

Fearnley Thomas, b. Frederikshald 1802, d. Munich 1842. ROMANTIC landscapist, a follower of DAHL and FRIEDRICH and later also influenced by CONSTABLE. A wide traveller and a quick and keen worker, he helped to found the Norwegian landscape school. He studied in Oslo (1819), Copenhagen (1821–3) and Stockholm (1823–7). After his first meeting with Dahl in 1826, he became his pupil in 1829, which marked a great change in his career and style. In the 1830s he travelled to Italy, Sicily, Switzerland, Paris and London, and in 1839 visited the Hardanger and Sogne fjords with A. ACHENBACH and Breslauer. His landscapes often include some elements of genre but his genuine enthusiasm and feeling for nature maintain their freshness. There are works in Bergen, Oslo (NG), Copenhagen (Thorwaldsen) and Stockholm.
Lit. S. Willoch: *Maleren Thomas Fearnley* (1932)

Fedotov Paul Andreyevich, b. Moscow 1815, d. St Petersburg 1852. Satirical genre painter of city and army life. His work was an important influence on the socially reformist painting of the following generation in Russia, and provides a unique record of Russian *petit bourgeois* life in the 1840s. Self-taught in art, he attended the Moscow Cadet School and painted watercolours of army life until he was offered an allowance to study at the St Petersburg Academy by Archduke Michail Pavlovich and left the army in 1844. He studied under Sauerweid and BRÜLLOV, and first exhibited in 1847. He found his personal *métier* through the

Fantin-Latour *The Rhine Maidens* 1876

Fearnley *From Labrofossen* 1836

Faruffini *The Reader* 1864

Fattori *The Italian Camp after the Battle of Magenta* 1861

Fedotov *The Major's Courtship* 1851 version

inspiration of the Dutch genre painters and the prints of Hogarth and WILKIE. Although elected ACADEMICIAN on the strength of *The Major's Courtship* (1848), a second painting, satirizing an army officer, brought censorship and enmity, and his melancholy, unsatirical *Little Widow* was not exhibited. Lack of patronage and fear of increasing neglect drove him to madness; he entered an asylum in 1851 and died five months later. There are works in Kiev, Leningrad (Russian Mus.) and Moscow (Ostroshov, Pushkin, Tretiakov, Tsviekov). *(see colour illustration 18)*
Lit. Y. Leshchinsky: *P. A. Fedotov* (1946, in Russian)

Fendi Peter, b. Vienna 1796, d. Vienna 1842. BIEDERMEIER genre, portrait and occasional landscape painter. He worked extensively in watercolour as well as in oils, enjoying great popularity with the Austrian aristocracy for his work in this medium; the sorrows of the poor and happy intimate scenes of mothers and children were his favourite themes. His sweeping brushwork and bright sparkling colours contain an echo of the baroque tradition as well as a foretaste of IMPRESSIONISM. He studied at the Imperial Drawing Academy (1810–13) under Fischer, Maurer and LAMPI, and in 1818 became official draughtsman to the Imperial Coin and Antiquity Cabinet; his careful drawings won him entry to imperial and aristocratic circles, where he later found patrons for his genre scenes and portraits and employment as a drawing master. In 1821 he went to Venice to study the Old Masters. *Mass by the Outer Burgtor* (1826) was his first major work, and he turned increasingly from official drawings to portraits and genre scenes. He became a member of the Vienna Academy in 1836. Teaching took up a considerable amount of his time in later years; the SCHINDLERS and Treml were among his pupils. He was a formative influence on the Austrian watercolour school. There are works in Riga and Vienna (Belvedere).
Lit. H. Adolph: *P. Fendi* (1951)

Ferneley John, b. Thrussington (Leics.) 1782, d. Melton Mowbray 1860. Painter of horses in landscapes, racehorses and hunting scenes. He studied with MARSHALL and settled at Melton Mowbray where he worked almost exclusively on commissions for the country gentry and nobility. His sons John Jr. and Claude Lorraine were also painters. There are works in London (Tate).
Lit. G. Paget: *The Melton Mowbray of John Ferneley* (1931)

Feuerbach Anselm, b. Speyer 1829, d. Venice 1880. Feuerbach, with his friends BÖCKLIN and MARÉES – known as the German Romans – was one of the major German exponents of idealistic painting in the later 19C. His aim was to translate into paint the classical ideal of humanity which, in common with contemporary German writers, he saw as embodied in the sculpture of antiquity. His treatment of figures and landscape was influenced by the REALISTS, but his monumentally composed canvases are peopled with antique characters whose air of deep reverie and inward suffering dictates the atmosphere of the work. This is stressed by a symbolically sombre palette, dominated by a violet-brown. He came of a family of scholars and politicians; it took him more than a decade of study to find the true direction of his art. He studied at Düsseldorf under SCHADOW (1845–8), at Munich with RAHL (1848–50), at Antwerp with WAPPERS (1850–1), and in Paris with COUTURE (1851–3). In Venice he copied from Veronese, Titian and Palma Vecchio (1855–6). In 1856 he arrived in Rome, his future home, and began gradually to develop his mature style. He painted a number of large figure subjects, their composition strongly influenced by Couture: *Plato's Symposium* (1869, second version 1873), *The Judgment of Paris* (1870), *The Battle of the Amazons* (1869–73) and several versions of *Medea* (1866–70). His *œuvre* further comprised a series of symbolic single figures (*Iphigenia* 1862) and portraits (*Nana in a White Cloak* 1861). The image of his Roman model Nana Risi haunted his work; she embodied his ideal of classical womanhood. Appointed a professor at the Vienna Academy in 1873, he resigned in 1876 and spent his last years in Venice. He is well represented in Berlin, Hamburg, Munich (N. Pin., Schack) and Stuttgart, and there are works in many other German galleries.
Lit. A. Feuerbach: *Vermächtnis* (1885, new ed. 1926); H. Uhde-Bernays: *Feuerbach, Beschreibender Katalog seiner sämtlichen Gemälde* (1929); E. Kühnemann: *Zu A. Feuerbachs reifem Stil* (1948); J. Lauts,

W. Zimmermann: *A. Feuerbach* (1961); M. Arndt: *Die Zeichnungen Anselm Feuerbachs* (1967)

Fildes Sir Samuel Luke, b. Liverpool 1844, d. 1927. He started his career as an illustrator, working for such magazines as *The Graphic* and *Once a Week*, and was chosen by Dickens to illustrate *The Mystery of Edwin Drood*. He turned to painting in the 1870s; *Applicants for Admission to a Casual Ward* (1874) with its combination of REALISM and social comment won him fame. He painted a few other works of this type (*The Widower* 1876, *The Doctor* 1891), a series of colourful Venetian scenes, and portraits which were the cornerstone of his successful career. He became an ARA in 1879 and an RA in 1887; he was knighted in 1906. There are works in Aberdeen, Hamburg, Liverpool (Walker), London (Tate, V&A), Manchester, Sydney and Warrington.
Lit. L. V. Fildes: *Luke Fildes R.A., A Victorian Painter* (1968)

Flandrin Hippolyte Jean, b. Lyons 1809, d. Rome 1864. Religious painter and portraitist, a faithful pupil and friend of INGRES. His religious painting is firmly grounded on 14C and 15C Italian art, which he discovered under the influence of the NAZARENES in Rome. His church frescoes have been considered the most important of the 19C. HOLMAN HUNT and ROSSETTI discovered those in Saint-Germain-des-Prés in 1849: 'The most perfect works taken *in toto* that we have seen in our lives ... Wonderful! Wonderful!! Wonderful!!!' His portraits closely followed the example of Ingres and earned him great popularity, especially as a delineator of women and young girls; he was official portraitist to Napoleon III. He studied in Lyons and in Paris with Ingres (1829); he went to Rome after winning the first Rome prize in 1832, and was joined there by Ingres, the new director of the Villa Medici, in 1835. Having begun with history painting, he discovered his vocation as a religious painter, and became a friend of OVERBECK and the Nazarenes. On his return to Paris, he executed several important church cycles, including Saint-Séverin (1840–1), Saint-Germain-des-Prés (1842–6), Saint-Paul at Nîmes (1847–9), Saint-Vincent-de-Paul (1849–53), Saint-Martin-d'Ainay at Lyons (1855) and Saint-

Germain-des-Prés (1856–61). The success of his portrait *Jeune Fille à l'œillet* in the SALON of 1859 brought him a flood of portrait commissions. He was a chevalier of the Legion of Honour (1841), an officer (1853) and a member of the INSTITUT (1853). His brothers Auguste and Jean Paul were also painters. There are works in Amiens, Angers, Bagnols, Calais, Florence (Uffizi), Lille, Lisieux, Lyons, Paris (Louvre), Montauban, Nantes, Rouen, Saint-Etienne and Versailles. *Lit.* H. Delaborde: *Lettres et pensées de H. Flandrin* (1865); L. H. Mouchot: *H. Flandrin, sa vie, son œuvre* (1872); L. Flandrin: *H. Flandrin, sa vie et son œuvre* (1902)

Flaxman John, b. York 1755, d. London 1826. NEOCLASSICAL sculptor. In addition to the 170 or so monuments he made between 1794 and 1826, he designed for Wedgwood's pottery and for several silversmiths. He achieved international reputation and influence through his outline drawings made as illustrations for the *Iliad* and *Odyssey* (1793), *Aeschylus* (1795) and *Dante* (1802); they are of archaic simplicity imitating classical reliefs and vase painting, and many 19C painters, including INGRES, used them as a compositional source. He entered the ROYAL ACADEMY Schools in 1770, where he was a friend of BLAKE and G. Romney. He began to work for Wedgwood in 1775 and visited Italy with his help (1787–94). He became an RA in 1800 and professor of sculpture in 1810. University College, London, has a large collection of his drawings and models, and there are also works in Bath, Chichester Cathedral, Copenhagen (Thorwaldsen), Edinburgh (NPG), Glasgow, Gloucester and London (NPG, V&A, Westminster Abbey, St Paul's).
Lit. W. G. Constable: *J. Flaxman* (1927)

Fohr Carl Philipp, b. Heidelberg 1795, d. Rome 1818. Primarily a landscape painter, he combined the influence of KOCH and the NAZARENES. His project of a group portrait of the German artists in Rome at the Caffé Greco was never achieved but the careful pencil studies for it remain an important record of the period. He studied at Heidelberg with F. Rottman, from 1810 in Darmstadt with G. W. Issel, and briefly from 1815 in Munich. He arrived in Rome in 1816 but was drowned in the Tiber two years later. His brother Daniel was also a

Fendi *The Poor Officer's Widow* 1836

Feuerbach *Iphigenia* 1862

Fildes *The Doctor* 1891

Flandrin *Tower of Babel* 1856–61

Flaxman *Achilles Lamenting the Death of Patroclus* 1793

landscape painter. There are works in Darmstadt and Frankfurt.

Lit. P. Dieffenbach: *Das Leben des Malers K. Fohr* (1823, new ed. 1918); A. von Schneider: *C. P. Fohrs Skizzenbuch* (1952); G. Poensgen: *C. P. Fohr und das Caffé Greco* (1957); J. C. Jensen: *C. P. Fohr in Heidelberg und im Neckartal* (1968)

Fontanesi Antonio, b. Reggio Emilia 1818, d. Turin 1882. Piedmontese landscape painter. COROT and T. ROUSSEAU were the most important influences on his work but he was not content with naturalistic landscape painting and sought to imbue his work with poetry and mood by stressing effects of light (dawn, dusk, etc.). His landscapes influenced several Italian painters of the SYMBOLIST generation as well as the 20C Futurist Carlo Carrà. He entered Reggio's art school at fourteen, under Minghetti. During 1848-50 he fought with Garibaldi. In Switzerland (1850) he was influenced by CALAME. In 1855 and 1858 he was in Paris where he met Corot, Rousseau and DAUBIGNY. He exhibited *The Ford* in Paris and *Quiet* in Florence (1861), both landscapes in his mature style. In London (1866) he was impressed by the poetry of landscapes by TURNER; the following year he met the MACCHIAIOLI in Florence. He was given a professorship at Lucca in 1868 and in 1869 at Turin's Accademia Albertina. He taught at the Tokyo Academy in Japan (1876-8) before returning to Turin. There are works in Bologna (Mod. Art), Florence (Uffizi), Milan (Brera, Mod. Art), Piacenza (Mod. Art), Reggio Emilia (Fontanesi), Rome (Mod. Art) and Turin (Mod. Art).

Lit. G. Faldella: *La vita popolare di A. Fontanesi* (1903); E. Celanza: *A. Fontanesi* (1911); C. Carrà: *A. Fontanesi* (1924); M. Calderini: *A. Fontanesi, pittore paesista* (1925); M. Bernardi: *Fontanesi* (1962); M. Carrà: *A. Fontanesi* (1966); M. Bernardi: *A. Fontanesi* (1968)

Forain Jean Louis, b. Reims 1852, d. Paris 1931. He was primarily an illustrator, caricaturist and graphic artist, treating bourgeois life, café society and the *demi-monde* with biting satirical humour. His paintings and watercolours were executed in the same spirit, with quick IMPRESSIONIST brushwork but muted colours. The most important influences on his work were DAUMIER and DEGAS. He exhibited four times with the Impressionists (1879-86) and was greatly admired by CÉZANNE, TOULOUSE-LAUTREC and VUILLARD. He contributed caricatures and drawings to almost all leading newspapers and magazines of his time, and published several collections of his graphic work. There are works in most galleries where Impressionists are represented, including Boston, Chicago, Dresden, London (Courtauld, Tate), Paris (Louvre) and Washington (NG, Corcoran).

Lit. M. Guérin: *J. L. Forain lithographe* (1910) and *Forain aquafortiste* (1912); C. Dodgson: *Forain* (1936); J. Pujet: *La Vie extraordinaire de Forain* (1957)

Fortuny y Carbo Mariano, b. Reus (Spain) 1838, d. Rome 1874. Spanish genre painter whose elegant scenes of daily life, often, like those of his contemporary MEISSONIER, in 18C costume and of small dimensions, achieved outstanding popularity in France, Italy and Spain. He had a penetrating eye for character and the characteristic in a scene and may be accounted an ACADEMIC REALIST. His fine draughtsmanship, brilliant palette and sparkling virtuoso brushwork had many imitators, notably in Italy and Spain. His visits to Morocco resulted in a series of Oriental scenes, while during his last months in Portici he turned towards a new IMPRESSIONIST style inspired by MANET. He was brought up by his grandfather, a sculptor and modeller, and began his formal studies at the age of twelve. He attended the Barcelona Academy from 1853, studying under C. Lorenzale and copying after the work of GAVARNI whom he greatly admired; he won the academy's Rome prize in 1857, arriving the following year in the city which he was to make his home. In 1859 he visited Morocco, following the campaigns of General Prim, exhibited his campaign sketches in Madrid and returned to Rome via Paris. In 1862 he spent several months in Morocco, gathering material for his vast *Battle of Tetuán*, and again visited Paris. In 1866-7 he was in Paris and Madrid where he married Cecilia, daughter of MADRAZO; this inspired his most famous work, *The Spanish Wedding* (*La Vicaria*), which won the praise of DORÉ, Dumas and Gautier among others and was sold prestigiously by Goupil in 1870. There are works in Baltimore (Walters), Barcelona, Boston, Buenos Aires, Cambridge Mass. (Fogg), Chicago, Cincinnati, Copenhagen, The Hague, Madrid (Prado), Mannheim, Milan, Moscow (Tretiakov), Munich, New York (Met.), Philadelphia and Washington (Corcoran).

Lit. J. C. Davillier: *Fortuny, sa vie, son œuvre* (1876); C. E. Yriarte: *Fortuny* (1886); A. Maseras, C. Fages de Climent: *Fortuny, la mitad de una vida* (1932); L. Gil Fillol: *Fortuny* (1952)

Foster Myles Birket, b. North Shields 1825, d. Weybridge 1899. Painter of idyllic rural scenes and hedgerow still lifes, primarily in watercolour and in the vein pioneered by W. HUNT. After working as an engraver and illustrator, he turned to watercolours *c.* 1859. In later years he achieved wide popular success. There are works in Aberdeen, Birmingham, Blackburn, Glasgow, Liverpool, London (V&A) and Sydney.

Lit. H. M. Cundall: *B. Foster* (1906)

Fourmois Théodore, b. Presles 1814, d. Ixelles 1871. Belgian naturalistic landscape painter. Strongly influenced by Hobbema, his paintings were based on sketches from nature in the Ardennes and elsewhere and gave him a pioneering place in Belgian *plein air* painting. From *c.* 1826-7 he worked with a Brussels lithographic firm, Dewasme-Ptelinx. He was self-taught as a painter, first exhibiting in Brussels (1835) with immediate success. There are works in Antwerp, Bruges, Brussels (Musées Royaux), Hamburg, Liège, Mons and Montreal.

Frédéric Baron Léon Henri Marie, b. Brussels 1856, d. Schaerbeek (Brussels) 1940. His work, largely devoted to the sufferings of the poor, has a strong political overtone. Deeply influenced by 15C Italian painting, he often used the format of a triptych and imbued the work with deeper meaning through a hieratic formalism of composition; the figures and their environment, however, were painted with highly finished REALISM. He studied at the Brussels Academy under PORTAELS and spent two years in Italy where he was particularly influenced by the work of Botticelli and Ghirlandaio. His first triptych, *The Legend of St Francis*, dates from the early 1880s; his most famous work, the *Chalk Sellers*

Fortuny y Carbo *The Spanish Wedding (La Vicaria)* 1870

Frédéric *Chalk Sellers* triptych, centre panel above, side panels below, 1882-3

triptych (Brussels), was painted 1882-3. He exhibited all over Europe, including the Berlin and Munich SECESSIONS; he achieved state purchases in France as well as Belgium. There are works in Antwerp, Brussels (Musées Royaux), Ghent and Paris.

French Art Establishment. A painter's road to fame and fortune in 19C France was strictly controlled by the machinery of the art establishment. Collectors were unlikely to buy the work of an artist who had not exhibited at the Salon; commissions for the decoration of state buildings and state museum purchases were also dictated largely by an artist's Salon performance. It should, however, be noted that the taste of those wielding state patronage did not always coincide with that of the ACADEMICIANS who ran the art establishment; DELACROIX, frequently rejected from the Salon and only accorded a chair at the Institut in old age, was constantly employed on mural decorations for the state, at the Louvre and elsewhere.

From its inception in 1648, with biannual Salons from 1667, the Académie Royal de Peinture et Sculpture played a central role in French art. During the 18C only academicians or those affiliated to the Académie could exhibit and the only role of the Salon jury, established in 1746, was to avoid the exhibition of politically scandalous works. The Académie was suppressed by the revolutionary government in 1793 but the Salon exhibitions continued, while a new system of recompenses was established.

In 1795, the Institut Nationale des Sciences et des Arts was founded to take the place of the old academies (Académie Française, Académie des Inscriptions et Belles-lettres, Académie des Sciences, Académie des Sciences Morales et Politiques, Académie des Beaux-Arts); initially the Institut had three classes (Sciences, Sciences Morales et Politiques, Littérature et Beaux-Arts) but in 1803 the fine arts were divided from literature to form a fourth class. With the restoration of the monarchy, the classes of the Institut were renamed 'Académies', but the Institut itself was retained, including the finest French intellects from every discipline.

The Académie des Beaux-Arts received its definitive organization in 1819. There were forty members (thus also members of the Institut) and five sections: painting, sculpture, architecture, engraving and music. There was a varying number of associates and foreign correspondents. Members collaborated in running the Ecole des Beaux-Arts competitions, deciding the winners of the Rome prize and presenting candidates for professorships at the Ecole. Nieuwerkerke instituted a major reform in 1863, removing much of the academicians' authority over the Ecole on account of its previous abuse and stultifying effect on the development of art. Some powers were returned to them in 1874.

The Ecole des Beaux-Arts was founded in 1648, partially suppressed in 1793, and re-established in 1795. Its organization was virtually unchanged from 1819 to 1863. There was daily instruction in life drawing and special courses in anatomy, perspective and history; painting as such was not taught. In 1863, the administration of the Ecole was transferred from the Académie to a new Conseil Supérieur, an *atelier* system was introduced within the Ecole, and painting added to the curriculum. In 1874 a system of prizes and diplomas was instituted.

The French Academy in Rome was founded by Colbert in 1666 to accommodate the winners of the Rome prize competitions. For most of the century there was one prize a year for painting, one for sculpture, a prize every two years for engraving, and one prize each, every four years, for historical landscape and medal engraving. The academicians in Paris prepared an annual report on progress in Rome, based partly on work sent back to France by the students for criticism and partly on an assessment by the director of the Rome academy.

The Salon exhibitions were the chief way of bringing an artist's work to the notice of the public. The exhibitions were held biannually from 1802-31, then annually (excluding 1832) to 1852, biannually to 1863, and annually thereafter (excluding 1871). The selection jury, who also distributed medals, wielded great power over the careers of other artists and used it to discourage in turn the ROMANTICS, the REALISTS and the IMPRESSIONISTS. From 1803 the jury was composed of six members (the director of museums, two collectors and three artists); academicians and medal winners could exhibit without submission to the jury. In

Friedrich

1830 all forty academicians were turned into the jury, introducing a strong conservative bias. In 1848 there was no jury; all comers could exhibit. The 1850 jury was elected by all previous exhibitors (excluding 1848); the medals and other recompenses were decided by a special jury, half taken from the elected jury and half appointed by the Minister of the Interior. In 1852 there was a single jury, half elected, half appointed. In 1857 the role of the jury was returned to the academicians. In 1863 a quarter of the jury was appointed and the rest elected by those artists who had already won medals or received Salon recompenses; the appointed proportion was expanded to a third in 1869. In 1870 the jury was wholly elected by previous exhibitors; in 1872 it was wholly elected but by medallists and Rome prize winners. In 1880 responsibility for the organization of the Salon was passed wholly to the Société des Artistes Français, membership of which was open to all previous Salon exhibitors. In 1890 an argument within the Société over the continuation of the distribution of recompenses (medals and honourable mentions) resulted in a split; MEISSONIER with PUVIS DE CHAVANNES, A. STEVENS, SARGENT, BOLDINI and others formed the Société Nationale des Beaux-Arts and a separate Salon, without prizes and run on slightly more liberal lines.

The system of recompenses was instituted in 1793, with the initial suppression of the academy, and continued through the 19C. In order of desirability, these were: an honourable mention, a third class, second class and first class medal (with a corresponding cash prize), travel scholarships or the Salon prize (an additional Rome prize instituted in 1874), and the grand medal of honour. In 1863 the three classes of medal were reduced to one, but were separated again in 1874.

Another source of honours, the EXPOSITIONS UNIVERSELLES of 1855, 1867, 1878, 1889 and 1900, distributed bronze, silver and gold medals. Membership of the jury which selected exhibitors and distributed medals was a further honour, while artists of special distinction were accorded personal exhibitions within the Exposition. The various grades of the Legion of Honour, chevalier, officer, commander, grand officer and grand cross, were also accorded to painters, Meis-

sonier being the first artist to receive the grand cross. The Beaux-Arts reform of 1863 stipulated that no artist was eligible for the Legion of Honour unless he had either won a first class Salon medal, a second class medal followed by a 'rappel', a third class medal followed by two 'rappels', or the new single class medal three times.

Academicians. There were fourteen chairs of painting within the Académie des Beaux-Arts (i.e. fourteen of the forty members were painters). They were held during the 19C by the following artists:

I
1795 Van Spaendonck
1822 Hersent
1860 Signol
1892 Merson

II
1795 Vincent
1816 Prud'hon
1823 Bidauld
1846 Brascassat
1867 Cabat
1893 Constant

III
1795 Regnault
1829 Heim
1865 Gérôme
1904 Carolus-Duran

IV
1795 Taunay
1830 Granet
1850 Robert-Fleury, J. N.
1890 Français
1897 Vollon

V
1803 Denon
1825 Ingres
1867 Hesse, A.
1879 Delaunay
1891 Lefebvre
1912 Besnard

VI
1803 Visconti
1818 Lethière
1832 Blondel
1853 Flandrin
1864 Muller, C.
1892 Detaille

VII
1795 Vien
1809 Menageot
1816 Garnier
1849 Cogniet
1881 Bonnat

VIII
1812 Gérard
1837 Schnetz
1870 Baudry
1886 Breton

IX
1815 Guérin
1833 Drölling
1851 Alaux
1864 Lehmann
1882 Boulanger
1888 Moreau
1898 Morot

X
1795 David
1816 Le Barbier
1826 Vernet, H.
1863 Cabanel
1889 Henner
1905 Lhermitte

XI
1815 Girodet-Trioson
1825 Thevenin
1838 Langlois, J. M.
1839 Couder
1874 Hébert
1909 Collin

XII
1815 Gros
1835 Abel de Pujol
1861 Meissonier
1891 Laurens

XIII
1815 Meynier
1832 Delaroche
1857 Delacroix
1863 Hesse, N. A.
1869 Lenepveu
1898 Cormon

XIV
1815 Vernet, C.
1836 Picot
1868 Pils
1876 Bouguereau
1905 Flamenc

Friedrich Caspar David, b. Greifswald 1774, d. Dresden 1840. Visionary landscape painter, an important exponent of German ROMANTICISM. A deeply spiritual vision of nature was expressed in his work, giving allegorical and symbolic meaning to his landscapes. He made particular use of the luminous quality of light at sunset and sunrise, and also stressed simple vertical or horizontal images (horizons, tall Gothic ruins, pines). His symbolism was often direct: spring flowers for youth, gnarled ancient trees for age, the transience of ruins, the eternity of evergreens. He first studied with the architect J. G. Quistorp in Greifswald, before attending the Copenhagen Academy (1794–8) where he was influenced by the Romantic landscapists Christian Lorentsen and Jens Juel. He moved to Dresden in 1798, meeting RUNGE in 1801 and the circle of Tieck and Novalis in 1802. He was awarded a prize for two sepia drawings in the Weimar exhibition (1805) organized by Goethe. His landscape altarpiece, *The Cross in the Mountains* (1807–8), the first major oil painting in his mature allegorical style, aroused great controversy, and his work was further criticized when *Monk by the Sea* and *Abbey in the Oak Wood* were exhibited in Berlin (1810). He was a member of the Berlin Academy (1810) and of the Dresden Academy (1816). The Wars of Liberation ended his brief period of fame; in the 1820s his work was eclipsed in public appreciation by the Düsseldorf Romantics. In 1820 he established a shared house and studio with DAHL. A severe illness (1825–6) was followed by a period of extreme poverty and he began to feel persecuted. In 1835 a stroke seriously affected his powers. His intensely personal vision precluded direct

imitators, although he was a strong influence on the Dresden landscapists, Dahl, CARUS, OEHME and KERSTING, and an indirect influence on F. OLIVIER and, later, MUNCH. Rediscovery of his work brought critical appreciation from 1900 on. There are works in Berlin, Bremen, Copenhagen, Dortmund, Dresden, Düsseldorf, Frankfurt/M., Gotha, Greifswald, Hamburg, Hanover, Kaliningrad, Leipzig, Mannheim, Munich (N. Pin.), Oslo (NG), Prague (NG), Riga, Schweinfurt, Stralsund, Vienna (Kunsthistorisches Mus.), Weimar and Zurich. *(see colour illustration 3)*
Lit. I. Emmrich: *C. D. Friedrich* (1964); L. D. Ettlinger: *C. D. Friedrich* (1967); S. Hinz (ed.): *C. D. Friedrich in Briefen und Bekenntnissen* (1968); W. Sumowski: *C. D. Friedrich – Studien* (1970); H. Börsch-Supan, K. W. Jähnig: *C. D. Friedrich, Gemälde, Druckgraphik und bildmässige Zeichnungen* (1973); H. Börsch-Supan: *C. D. Friedrich* (1974)

Fries Ernst, b. Heidelberg 1801, d. Karlsruhe 1833. Landscapist, influenced both by ROTT-MANN and the OLIVIER school. His instinctive feeling for nature and fine draughtsmanship encouraged a more realistic approach in German landscape painting. He studied at Heidelberg with F. Rottmann (1810–12), with Kuntz in Karlsruhe (from 1812) and for a year at the Munich Academy (1818). After 1821 he worked in Munich and made studies from nature in the Tyrol. In Rome (1823–7) he was influenced by KOCH. In 1829 he returned to Munich, where he became a friend of C. ROTTMANN, before becoming court painter in Karlsruhe (1831). His brothers Bernhard and Wilhelm were also painters. There are works in Berlin, Düsseldorf, Frankfurt/M., Halle, Hamburg, Heidelberg, Karlsruhe, Leipzig and Munich (N. Pin., Schack).

Frith William Powell, b. Aldfield (Yorks.) 1819, d. London 1909. Victorian genre painter, whose large panoramas such as *Derby Day*, painted with clear colours and minute attention to detail, often had to be protected from enthusiastic crowds by railings at the ROYAL ACADEMY. Among the first to take advantage of the new steel engraving reproduction technique, he was said to have made over £3,000 from reproductions of *Ramsgate Sands* (1854). Urged to take up

painting by his parents, he studied with H. Sass and from 1837 at the Royal Academy Schools. He began by painting scenes from history and literature, particularly from Scott, Goldsmith and Sterne, and first exhibited at the Royal Academy in 1840. He became an ARA (1845) and an RA (1852). The success of the PRE-RAPHAELITES encouraged his natural bent towards painting contemporary scenes; the very successful *Ramsgate Sands*, purchased by Queen Victoria, was followed by *Derby Day* (1858), *The Railway Station* (1862), *The Salon d'Or, Homburg* (1871) and *Private View at the Royal Academy* (1883). *Derby Day* and *Ramsgate Sands* won him further fame at the INTERNATIONAL EXHIBITIONS in Vienna (1873) and Paris (1878). In later years he returned to his early, rather sentimental, literary themes. He received the Legion of Honour (1878) and the Order of the Bath (1908), and became an honorary member of the Brussels, Antwerp, Vienna and Stockholm Academies. There are works in Aberdeen, Brussels, Cambridge, Leicester, London (Tate, V&A), Manchester, Preston, Sheffield and Wolverhampton. *(see colour illustration 15)*
Lit. W. P. Frith: *Autobiography* (1887) and *Reminiscences* (1888); N. Wallis (ed.): *A Victorian Canvas: The Memoirs of W. P. Frith* (1957)

Fröhlicher Otto, b. Solothurn 1840, d. Munich 1890. Painter of Alpine landscapes who worked mainly in Munich and became a highly regarded exponent of STIMMUNGS-LANDSCHAFT. He studied at the Munich Academy under STEFFAN from 1859, becoming a close friend of THOMA. He also studied under O. ACHENBACH in Düsseldorf (1864–5) and visited Paris and Barbizon (1876–7). There are works in Berne and Weimar.
Lit. H. Uhde-Bernays: *O. Fröhlicher* (1922)

Fromentin Eugène, b. La Rochelle 1820, d. Saint-Maurice 1876. French painter of Oriental scenes who also achieved distinction as an author. Muther calls him 'the Watteau of the East', emphasizing the grace and charm he brought to a genre of painting already richly worked by DELACROIX, DE-CAMPS and MARILHAT. He began by studying law and published his first book of essays

Friedrich *Abbey in the Oak Wood* 1809–10

Frith *Many Happy Returns of the Day* 1856

Fröhlicher *View near the Handeck c.* 1878

Fromentin *Hunting with Falcons in Algeria* 1863

Füger *Count Franz Josef Saurau* 1797

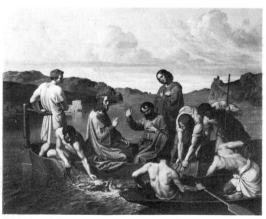

Führich *The Miraculous Draught of Fishes* 1848

in 1837. In 1840 he moved to Paris and turned to painting in 1843. He studied with J. C. J. Remond and with Louis Cabat, a landscapist highly regarded at the time, before Marilhat's Oriental scenes exhibited at the SALON of 1844 determined his vocation. He visited Algeria in 1846, 1848 and 1852–3. His early works, somewhat linear and formal, were profoundly influenced by Marilhat, but in his second period he applied the soft tones and lyrical brushwork of COROT to Eastern scenes, and from *c.* 1860 his work became more highly charged as he used the full range of the palette. He published several travel books, a much admired novel, *Dominique*, and a respected discussion of the Old Dutch Masters, *Les Maîtres d'autrefois*. He was a chevalier of the Legion of Honour (1859) and an officer (1869). There are works in Baltimore (Walters), Bayeux, Brussels (Musées Royaux), Chantilly, Douai, Geneva, Graz, La Rochelle, Montpellier, Moscow (Tretiakov), Nantes, Paris (Louvre), Reims and Rouen.
Lit. L. Gonse: *E. Fromentin, peintre et écrivain* (1881); P. Gaudin: *Essai sur E. Fromentin* (1877); A. Ollivier: *E. Fromentin, peintre et écrivain* (1903); E. Brard: *Nos Gloires nationales: E. Fromentin* (1902); P. Dorbec: *E. Fromentin* (1926); A. Lagrange: *L'Art de Fromentin* (1952); B. Wright, P. Moisy: *G. Moreau et E. Fromentin: documents inédits* (1972)

Füger Friedrich Heinrich, b. Heilbronn 1751, d. Vienna 1818. NEOCLASSICAL painter, the dominant influence at the Vienna Academy *c.* 1783–1818. He started as a miniaturist before becoming a portrait painter with a strong debt to the English school. Rome stimulated his interest in history painting in the Neoclassical manner but his fluid treatment of paint echoes the Austrian baroque tradition. He studied in Stuttgart, Leipzig (with A. F. Oeser, the instructor of Goethe and Winckelmann) and Dresden, where he achieved his first success as a miniaturist. In Vienna (1774), his portraits of the imperial family won him a scholarship to Rome (1776). His acquaintance with Mengs, Trippel and DAVID turned him towards historical painting. He returned to Vienna in 1783 as vice-director of the academy, was director from 1795 and director of the Imperial Painting Gallery from 1806.

It was against his teaching that the young NAZARENES, PFORR and OVERBECK, reacted when they left Vienna for Rome in 1809. There are works in Berlin, Braunschweig, Budapest, Graz, London (NPG), Munich, Prague, Stuttgart and Vienna (Belvedere).
Lit. J. de Bourgoing: *Miniaturen von H. Füger und anderen Meistern aus der Sammlung Bourgoing* (1925); A. Stix: *H. F. Füger* (1925)

Führich Josef von, b. Kratzau (N. Bohemia) 1800, d. Vienna 1876. The main propagandist of the NAZARENES in Austria, as a professor at the Vienna Academy. A sensitive draughtsman and uneven though prolific painter, he achieved an international reputation for his gentle religious works which echo the early Italian masters. The son of a village painter, Wenzel Führich, in 1819 he had two of his paintings accepted for a Prague exhibition and entered the Prague Academy. At this time he was strongly influenced by the writings of Schlegel, Novalis and Tieck, as well as studying the work of Dürer. He was sent by Metternich to Rome (1827–9), where he met the Nazarenes and completed the Tasso room frescoes begun by OVERBECK for the Casino Massimo. After returning to Prague (1829) he was summoned by Metternich to Vienna (1834), where he became professor at the academy (1840). During the 1848 revolution he escaped to Bohemia, returning to Vienna in 1851, when he was commissioned to carry out the frescoes in Alterchenfeld Church. His drawings and prints earned him the nickname 'the theologian with the pencil'. There are works in Bremen, Leipzig, Munich (Schack), Poznań, Prague and Vienna (Belvedere).
Lit. J. von Führich: *Briefe aus Italien an seine Eltern 1827–29* (1883); H. Wörndle: *J. Führichs Werke* (1914); J. von Führich: *Lebenserinnerungen* (1926)

Fuseli Henry (Füssli, Johann Heinrich), b. Zurich 1741, d. London 1825. Swiss painter who made his career in England; he was considered among the leading history painters of his time. His technical education in Rome was NEOCLASSICAL, informed by his admiration of Michelangelo; at the same time he was essentially a ROMANTIC, painting themes from literature (Homer, Dante, Shakespeare and Milton) and interpreting them with subjective emotion, an approach

that was recognized as a visual parallel to their own work by Goethe, Herder and the 'Sturm und Drang' poets. His work is often sensual and horrific; the fantastic coiffeurs of his elongated women have been related to fetishism by modern psychologists. He pioneered the visual interpretation of fairy mythology and folk superstition with his evil spirits, sprites and fairies (*The Nightmare, The Changeling*, various themes from *A Midsummer Night's Dream*). HAYDON, CONSTABLE, MULREADY and LANDSEER were among his many pupils, and he was the only successful painter who befriended BLAKE ('a damn good fellow to steal from'). The son of a Zurich court painter who destined him for the church, he was ordained in 1761 but had to leave Switzerland for Berlin in 1763 for political reasons. He moved to England in 1764, earning his way by translations, including Winckelmann's *Reflections on the*

Painting and Sculpture of the Greeks (1765). Encouraged by Reynolds, he left London for Rome to study painting (1770), returning in 1778 to England where he had his first success with *The Nightmare* (1782). He contributed to Boydell's Shakespeare gallery, and produced his own Milton gallery (over thirty illustrations of Milton). He was an ARA (1788), RA (1790), professor of painting at the ROYAL ACADEMY from 1799 and keeper from 1804. There are works in Auckland, Birmingham, Cambridge (Fitzwm), Frankfurt/M. (Goethe Mus.), London (Tate, Courtauld), Weimar and Zurich. (*see colour illustration 6*)
Lit. N. Powell: *The Drawings of H. Fuseli* (1951); F. Antal: *Fuseli Studies* (1956); G. Schiff: *J. H. Füssli: Ein Sommernachtstraum* (1961); P. Tomory: *The Life and Art of H. Fuseli* (1972); N. Powell: *Fuseli: The Nightmare* (1973)

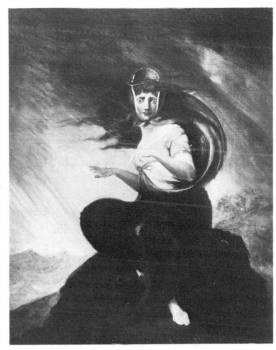

Fuseli *Mad Kathleen* 1806

G

Gallait Louis, b. Tournai 1810, d. Brussels 1887. One of the leaders of the Belgian school of history painting; he depicted incidents, often tragic, from European history using compositions reminiscent of the theatre and a careful finish. He achieved international renown in the 1840s and 1850s, and had considerable influence, especially in Germany on the Munich PILOTY school. He studied law, but abandoned it for painting in 1830, entering the Tournai Academy under Hennequin, a pupil of DAVID. In Antwerp (1832) he studied at the academy and from the work of Rubens and van Dyck, and won a scholarship from Tournai to study in Paris (1834), where he worked in the Louvre and established a close friendship with DELAROCHE. In 1836 *Tasso* was bought by King Leopold of Belgium, and several paintings were commissioned for the Salle des Batailles at Versailles (1837-40). *Abdication of Charles V* (1841) was hailed as a masterpiece and exhibited all over Europe. He returned to Brussels in 1843, hoping for major state commissions which never materialized. There are works in Amsterdam, Antwerp, Baltimore

(Walters), Berlin (NG), Brussels (Musées Royaux), Cologne, Frankfurt/M., Ghent, Hamburg, Leningrad (Hermitage), London (Wallace), Liège, Mannheim and Munich.
Lit. A. Teichlein: *L. Gallait und die Malerei in Deutschland* (1853); Sulzberger: *L. Gallait* (1889)

Gallén-Kallela Akseli Waldemar, b. Pori (Bjorneborg) 1865, d. Stockholm 1931. SYMBOLIST painter, graphic artist and designer whose favourite subject matter was Finnish myth and legend. The Kalevala cycle held a lifelong fascination for him and inspired his most important and dynamic works, which also use Finnish peasant designs and natural wool and wood textures. He was also a fine portraitist, using a flat formalized style. He studied at the Helsinki Art School and in Paris (1884), and made his debut in the SALON of 1888 with Finnish genre and landscape owing a strong debt to BASTIEN-LEPAGE. The *Aino Triptych* (1892) was based on Kalevala themes; in 1894 he settled in Ruovesi, where he saw the landscape and people as the natural heirs of the old heroic

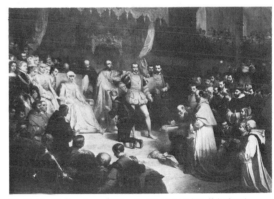

Gallait *Abdication of Charles V* 1841 (detail below)

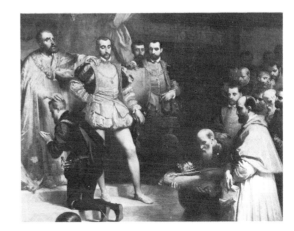

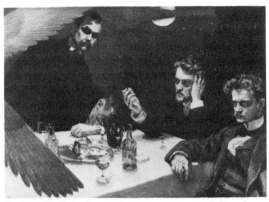

Gallén-Kallela *Symposion* 1894

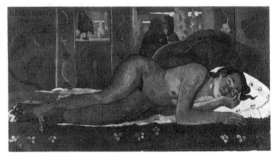

Gauguin *Nevermore* 1896

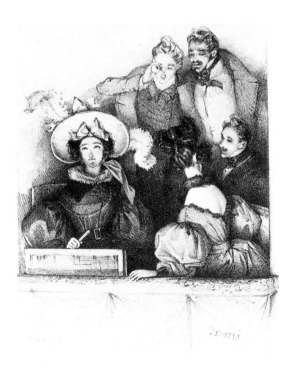

Gavarni *A Box at the Opera* 1831

days. He visited Germany (1895), Italy (1901-3) and East Africa (1909). His final monumental works emphasize the harsh, linear quality of his style; his art has been called a 'Finnish manifesto'. There are works in Wrocław, Budapest, Göteborg and Helsinki (Athenaeum, Gallén-Kallela).
Lit. A. Levinson: *A. Gallén* (1908); L. Wennervirta: *A. Gallén-Kallela* (1914); O. Okkonen: *A. Gallén-Kallela* (1948)

Gärtner Johann Philipp Eduard, b. Berlin 1801, d. Berlin 1877. BIEDERMEIER painter of landscape and town views. He was renowned particularly for his panoramas of Berlin, painted with almost mathematical exactitude, and was one of the earliest German artists to experiment with *plein air* painting. He studied with F. W. Müller in Kassel, was employed as a student decorator at the Berlin porcelain factory (1814-21), and worked with the theatre scene painter Gropius and at the Berlin Academy. He studied in Paris with BERTIN (1825-7). In 1834-5 he executed a six-part panorama of Berlin, which brought him an invitation from the Tsar to visit Russia (*Panorama of Moscow from the Kremlin*). He was a member of the Berlin Academy (1833). There are works in Berlin, Halle, Hamburg, Kaliningrad and Leningrad.
Lit. W. Kiewitz: *E. Gärtner 1801-1877: Beschreibendes Verzeichnis seiner Original-lithographien* (1928)

Gauguin Paul, b. Paris 1848, d. Atuana (Marquesas Islands) 1903. Gauguin took up painting under the influence of the IMPRESSIONISTS but it was with his decisive rejection of naturalism (*c.* 1888) that his art came into its own. He turned for inspiration to primitive art which 'proceeds from the spirit and makes use of nature'; the rest of his life was spent interpreting the interplay of superstition, myth and religion in the daily life of unsophisticated people, 'natural men' as he called them, first in Brittany, then Tahiti, then the Marquesas Islands. Stylistically he developed the flat planes of rich colour with dark outlines that he found in folk art and stained glass; the influence of Japanese prints can be seen in his use of arabesques, contributing to the sheer decorative appeal which is an outstanding feature of his work. From the 1890s he softened his flat planes of colour,

reintroducing some modelling and a more sinuous line. With a French father and Peruvian mother, his childhood was divided between their countries. At seventeen he went to sea where he worked for six years. In 1871 he joined a Paris stockbroking firm; he began to paint with his colleague E. Schuffenecker, exhibiting a landscape at the 1876 SALON and forming an impressive collection of Impressionist paintings. He also went on painting holidays with PISSARRO and CÉZANNE and exhibited at the Impressionist Group Shows of 1880, 1881 and 1882. In 1883 he lost his job and decided to dedicate his life wholly to painting, a decision which ensured a life of desperate financial struggle. He spent a year with his wife and children in Copenhagen at her parents' home, but the marriage broke up and he returned to Paris in 1885. In 1886 he paid his first visit to Brittany; he also met VAN GOGH, a passionate personality with whom he shared many ideas. In 1887 he visited Martinique and his imagination was fired by the rich tropical landscape. In Pont-Aven, Brittany, in 1888, together with BERNARD, he pioneered the SYNTHETIST approach as an alternative to naturalism (*Vision after the Sermon* 1888, *The Yellow Christ* 1889). He also spent two disastrous months of 1888 with van Gogh at Arles. He spent 1889-90 in Brittany (Pont-Aven and Le Pouldu); returning to Paris in 1890 he became closely associated with the SYMBOLIST writers. Disenchanted with civilization that left him short of both money and recognition, he left for Tahiti (1891-3) in search of a simple life and rich landscape (*Women on the Beach, The Spirit of the Dead is Watching*). After a brief stay in Paris he returned to Tahiti (1895-1901), painting *Nevermore, Where do we come from? What are we? Whither are we going?* and other masterpieces. In 1901 he settled on Dominica, one of the Marquesas Islands (*And the Gold of their Bodies, Riders on the Beach*). He aroused the bitter enmity of the colonial authorities and died in extreme poverty and privation. There are works in most museums of modern art, including London (Tate, Courtauld), New York (Met., MOMA), Paris (Louvre, Petit Palais) and Washington (NG, Phillips).
Lit. J. de Rotonchamp: *P. Gauguin* (1906); C. Morice: *P. Gauguin* (1920); M. Guérin: *L'Oeuvre gravé de Gauguin* (1927); M.

Malingue (ed.): *Lettres de Gauguin à sa femme et à ses amis* (1946); C. Chassé: *Gauguin et son temps* (1955); G. Wildenstein (ed.): *Gauguin, sa vie, son œuvre* (1958); H. R. Rookmaker: *Synthetist Art Theories* (1959); J. Rewald: *Post-Impressionism, from van Gogh to Gauguin* (1962); M. Bodelsen: *Gauguin's Ceramics* (1964); G. Wildenstein: *Gauguin* (1964); A. Bowness: *Gauguin* (1971); W. Jaworska: *Gauguin and the Pont-Aven School* (1972); L. Leprohon: *P. Gauguin* (1975)

Gavarni Paul (born Guillaume Sulpice Chevalier), b. Paris 1804, d. Auteuil 1866. French draughtsman and lithographer, the contemporary and nearest rival of DAUMIER. In the 1830s he became fashion-plate artist *par excellence* and caricaturist of the twinkling provocative grace of the French coquette. A year in prison for debt (1835) and other troubles brought a more serious political and social commitment to his art. His four years in London from 1847 were devoted not to dainty observations of society but a deeply sympathetic study of the vice and suffering of the urban poor. He adopted the pseudonym of Gavarni in 1828. His work is represented in most major collections of graphics.
Lit. E. and J. de Goncourt: *Gavarni: l'homme et l'œuvre* (1873); J. Armelhaut, E. Bocher: *L'Oeuvre de Gavarni* (complete catalogue 1873); P. A. Lemoisne: *Gavarni, peintre et lithographe* (1924)

Gay (Ge), Nikolai Nikolaievich, b. Voronyei 1831, d. Chutor Michailovski 1894. Religious painter and portraitist linked with PEREDVIZHNIKI group. His tortured, starkly Realist scenes from the life of Christ brought scandal as well as fame; the thinking of Tolstoi inspired the brutal REALISM of his later works. He studied at the St Petersburg Academy from 1850, winning a gold medal and travel scholarship in 1857, and travelled to Rome and Naples (1857-60) and Florence (1861-9). He turned to religious painting under the influence of IVANOV, whom he met in Rome. After becoming a member of the St Petersburg Academy (1872), he retired to his country estate in the Ukraine (1875), where he studied religion and philosophy, and became an intimate friend of Tolstoi, whom he met in 1882; he also embarked on a new series of paintings from the life of

Christ which combined mysticism with intense Realism. In 1890 his *What is Truth?* (Christ and Pilate) was considered blasphemous and removed from exhibition. *Golgotha* and *The Crucifixion* followed, showing a wasted, wretched and near-demented Christ-figure. There are works in Leningrad (Russian Mus.) and Moscow (Pushkin, Tretiakov).
Lit. L. N. Tolstoi, N. N. Ge: *Correspondence* (1930, in Russian); W. Stasov: *The Life, Works and Letters of N. N. Gay* (1904, in Russian)

Genelli Giovanni Bonaventura, b. Berlin 1798, d. Weimar 1868. German draughtsman, painter and engraver in the NEO-CLASSICAL tradition. His fame was founded on his outline drawings, which were strongly influenced by Carstens, but developed often with erotic fantasy; his three major cycles of drawings, *From the Life of a Rake* (1840), *From the Life of a Witch* (1841-3) and *From the Life of an Artist* (1850s), were subsequently published as engravings. He was the son of the landscape painter Janus Genelli, and studied in Berlin with HUMMEL and his uncle Hans Genelli, the architect. In Rome (1822-32), KOCH introduced him to the work of Carstens (d. 1798). He lived in Munich (1836-59) until he was summoned to Weimar by the Grossherzog Karl Alexander. In 1856 he met Graf Schack, the great Munich patron of the arts, for whom he painted a series of mythological oils. Most of his oil paintings are in the Schack Gallery in Munich. There are drawings in Berlin, Dresden, Frankfurt/M., Leipzig, Munich, Vienna and Weimar.
Lit. H. Marshall: *B. Genelli* (1912); B. Genelli: *Aus dem Leben eines Künstlers* (1922); H. Ebert: *B. Genelli: Leben und Werk* (1972)

Gérard Baron François Pascal Simon, b. Rome 1770, d. Paris 1837. French portraitist whose popularity rivalled that of DAVID in the first decades of the 19C. Napoleon employed him to paint many official portraits and he became court painter to the Bourbons after the Restoration. He was a pupil of David, who secured his election to the Revolutionary Tribunal, though the non-political Gérard was usually too 'ill' to attend. He had his first major success in the 1796 SALON with

Gay *Alexander Herzen*

Genelli *Mythological Subject*

Gérard *Madame Récamier* 1805 version

Géricault *The Raft of the Medusa* exhibited 1819

a portrait of the miniaturist J. B. ISABEY and his daughter. His flattering portrait of *Madame Récamier* (1802) was preferred by the sitter to that by David. He was accorded the Legion of Honour and membership of the INSTITUT in 1812, and created Baron by Louis XVIII in 1819. His NEOCLASSICAL subject pictures were also admired, painted with a mannered fantasy close to GIRODET-TRIOSON and a porcelain-smooth finish. Among his history paintings are an *Auster-litz* executed for Napoleon and the *Corona-tion of Charles X* for the Bourbons. There are works in Paris (Louvre), Versailles and many French provincial museums, and in Baltimore (Mus. of Art), Chicago, Dresden, Geneva, Madrid and Washington (NG).
Lit. C. Lenormant: *F. Gérard, peintre d'histoire: essai de biographie et critique* (1846); H. Gérard: *Oeuvre du Baron F. Gérard* (1852–7); H. Gérard (ed.): *Correspondance de F. Gérard avec les artistes et les personnages célèbres de son temps* (1867)

Géricault Jean Louis André Théodore, b. Rouen 1791, d. Paris 1824. Géricault's art represents the first great flowering of ROMAN-TICISM in France; the promise of his short career was continued and developed by DELACROIX, on whom his work was a fundamental influence. His only major subject picture, *The Raft of the Medusa*, treats a contemporary shipwreck on an epic scale. The formal pyramid composition still reflects the classical tradition, but the treatment of corpses, for which he had made studies in the Paris morgue, introduces a new REALIST preoccupation, while the survivors, mad with suffering, reflect his fascination with the darker reaches of the human spirit. Michelet called him the 'Correggio of suffering'. Beside art, horses were the passion of his life – a fall from a horse led to his death – and they recur frequently in his painting. In 1818 he entered the studio of C. VERNET, and moved to that of GUÉRIN in 1810. He made his debut at the SALON with *Cavalry Officer Charging* (1812), a dramatic unity of soldier and rearing horse with a debt to GROS; this was followed by the *Wounded Cuirassier* (1814). In 1816 he spent a year in Italy, studying the work of Michelangelo and Caravaggio; the carnival race down the Corso in Rome inspired his projected *Race of the Riderless Horses*, a huge frieze com-

position for which only studies were completed. Back in France he began work on the *Medusa*, which was exhibited in 1819; the critical reception was cool, though it was greeted enthusiastically by younger artists, especially Delacroix. He spent 1820–2 with CHARLET in England, where a travelling exhibition of the *Medusa* had been arranged. His *Epsom Derby* dates from this visit, as does a series of drawings and lithographs (some with Charlet's collaboration) of horses and scenes of poverty in the London streets, the latter influenced by the work of WILKIE, Rowlandson and CRUIKSHANK. In 1822–3 he painted a series of portraits of inmates of the Salpêtrière lunatic asylum with a powerfully realistic treatment. There are works in Aix, Avignon, Baltimore (Walters), Bayonne, Buffalo, Cambridge Mass. (Fogg), Chantilly, Chicago, Detroit, Dijon, Geneva, Ghent, Glasgow, London (NG), Munich, New York (Met., Brooklyn), Paris (Louvre), Rouen, Stockholm (Nat. Mus.) and Vienna (Kunsthistorisches Mus.).
Lit. C. Clement: *T. Géricault, étude bio-graphique et critique avec le catalogue raisonné* (1868, revised by L. Eitner 1973); K. Berger: *Géricault: Drawings and Watercolours* (1946); K. Berger: *Géricault and his Works* (1955); D. Aimé-Azam: *Mazeppa: Géricault et son temps* (1956); L. Eitner: *Géricault's Raft of the Medusa* (1972)

Gérôme Jean-Léon, b. Vesoul 1824, d. Paris 1904. Gérôme was a pillar of the FRENCH ART ESTABLISHMENT in the second half of the 19C. A brilliant draughtsman, his work is highly finished, modelled through a succession of *demi-teintes* in the academic manner; he showed exceptional originality in composition, often accentuating ideas by the arrangement of his figures. In his softly curved nudes he owed a substantial debt to INGRES, especially in his early NÉO-GRECQUE or Pompéiste works, scenes of life in Greece and Rome painted in clear colours with a frivolous touch of wit and eroticism. He turned to a more serious realism *c.* 1856; scenes of contemporary life in Egypt and the Middle East painted with a scrupulous eye for characteristic detail began to dominate his œuvre, though he continued to paint some works in the Néo-Grecque style and also genre scenes set in 17C dress. His care over historic and ethnographic accuracy

makes him an important exponent of ACADEMIC REALISM. Sculpture became his major interest *c.* 1878; following antique tradition, he tinted his marble figures and was an innovator in his combined use of materials, marble, ivory, bronze and precious stones. The son of a silversmith in Vesoul, he entered the Paris studio of DELAROCHE in 1839; he became a close friend of Delaroche and visited Italy with him in 1844. Studying with GLEYRE (1845), he imitated the classical compositions of his master without his serious intent in *The Cock Fight* (1847), which brought him the praise of Gautier and sudden fame. He led a group of young artists in Gleyre's studio who continued to paint in this manner and became known as the Néo-Grecques or Pompéistes; *The Cock Fight* also brought him several state commissions and a flourishing portrait practice. The large allegorical *Age of Augustus: The Birth of Christ*, commissioned by the state, was exhibited in 1855 together with his first Realist genre scene, *Recreation in a Russian Camp*. He paid his first visit to Egypt in 1856, returning many times afterwards. Among his most famous works are *Duel after the Masked Ball* (1857 and versions), *The Prisoner* (1863), *The Death of Caesar* (1867) and *The Eminence Grise* (1874). He was made a chevalier of the Legion of Honour in 1855, an officer in 1867, a commander in 1878 and a grand officer in 1900; appointed professor at the ECOLE DES BEAUX-ARTS in 1863, he became a member of the INSTITUT in 1865. He was an implacable enemy of IMPRESSIONISM; he fought against the MANET memorial exhibition in 1884 and the government acceptance of the CAILLE-BOTTE bequest of Impressionist pictures in 1895-7, but was nevertheless a lifelong friend of DEGAS. There are works in Paris (Louvre) and many French provincial museums, and in Amsterdam, Baltimore (Mus. of Art, Walters), Boston, Cleveland, Hamburg, London (Wallace), Minneapolis, New York (Met.), Ontario, Phoenix, Sheffield and Williamstown Mass. (Clark).
Lit. F. F. Hering: *Gérôme, his Life and Works* (1892); C. Moreau-Vauthier: *Gérôme, peintre et sculpteur* (1906); H. Roujon: *Gérôme* (1912)

Gerson Adalbert de Woicieck, b. Warsaw 1831, d. Warsaw 1901. Historical painter, newspaper illustrator and influential art teacher and critic in Warsaw. He studied in Warsaw, at the St Petersburg Academy and in Paris under L. COGNIET (1856). After settling in Warsaw (1858), he enjoyed a far-reaching influence on Polish art. Several of the leading Polish IMPRESSIONISTS were among his pupils. There are works in Cracow and Warsaw (Nat. Mus.).

Gervex Henri, b. Paris 1852, d. Paris 1929. History, portrait and genre painter. The success of his early history and genre paintings (*Satyr and Nymph* 1874, *Rolla* 1878) was assured by his sensuous treatment of the female nude; the SALON jury refused his *Rolla*, based on A. de Musset's novel, on moral grounds. His fluid brushwork owed a debt to his friends MONET and RENOIR. He was a successful portraitist, especially popular with ladies, and received several mural commissions (Hôtel de Ville, Opéra-Comique, Mairie of 19th arrondissement). His *Dr Péan at the Saint-Louis Hospital*, an updated version of Rembrandt's *Anatomy Lesson*, inspired a spate of hospital pictures. He was a pupil of Brisset, CABANEL and FROMENTIN and first exhibited in the Salon of 1873. A chevalier of the Legion of Honour (1882), an officer (1889) and a commander (1911), he was a founder member of the SOCIÉTÉ NATIONALE DES BEAUX-ARTS and a member of the INSTITUT (1913). There are works in Angers, Bayonne, Bordeaux, Brussels, Dijon, Limoges, Mulhouse, Paris (Louvre) and Versailles.

Gierymski Aleksander, b. Warsaw 1850, d. Rome 1901. Polish REALIST, fascinated by the visual challenge of *plein air* painting, but seeking to add to his work a further painterly realization of psychological mood. He lived in poverty, wandering between Poland, Germany, France and Italy, but is now hailed as the forerunner of 20C Polish IMPRESSIONISM. He progressed from history and tavern scenes in the academic Munich formula (1868-74) to *plein air* explorations of sunlight (1876-80), a taut Realist depiction of the alienation and poverty of Jewish life in Poland (1880-8), and finally an exploration of landscape and townscape mood, using a POINTILLIST technique inspired by SEURAT and his followers. After studying in Warsaw, he followed his brother MAX to Munich

Gérôme *Slave Market*

Gervex *The Box c.* 1880

A. Gierymski *Jewish Feast (Tasleq)* 1884

Gifford *Mount Mansfield*

Gigante *Storm on the Gulf of Amalfi*

(1868), where he worked under PILOTY and Anschütz. In Rome (1875–80) he made *plein air* studies for his sunlit conversation piece, *The Bower*. He spent most of the period 1880–9 in Poland painting Jewish scenes, culminating in the major success of his *Jewish Feast* in Munich and Berlin in 1888, his only moment of fame. He spent 1890–3 in Paris, where he was influenced by Seurat and the Impressionists. From Cracow (1893–5) he moved to Munich (1895–7) and then to Italy, with occasional visits to Paris and Germany. There are works in Bytom, Cracow, Łódź, Poznań, Warsaw (Nat. Mus.) and Wrocław
Lit. A. Sygietyński: *Album M. i A. Gierymskich* (1886); J. Wolff: *A. Gierymski* (1948); J. Starzynski: *A. Gierymski* (1967, English trans. 1971)

Gierymski Maximilian (Maks), b. Warsaw 1847, d. Reichenhall 1874. Pioneer of Polish REALISM, the brother of ALEKSANDER. He painted landscapes, scenes from Polish-Jewish and gypsy life, and many military episodes from the 1863 rising and Polish 18C history. He studied with KOSSAK in Warsaw and at the Munich Academy under PILOTY and Wagner, achieving a substantial reputation in both cities for his high artistic standards and genuine feeling for landscape. There are works in Cracow, Łódź and Warsaw (Nat. Mus.).
Lit. A. Sygietyński: *Album M. i A. Gierymskich* (1886)

Gifford Sanford Robinson, b. Greenfield (N.Y.) 1823, d. New York 1880. HUDSON RIVER SCHOOL landscapist. His concentration on effects of light and atmosphere gives him an intermediate position between COLE, who greatly influenced his early work, and INNESS, the later innovator. He graduated from Brown University in 1844 and studied with John Rubens Smith. He became a member of the NATIONAL ACADEMY OF DESIGN in 1854 and spent 1855–7 in Europe, where he admired the early works of TURNER and travelled with WHITTREDGE through Belgium, Holland and Switzerland to Italy. On his return to New York he set up a studio, and served briefly in the Civil War. In 1868 he travelled round the Mediterranean and in 1870 visited the American West with KENSETT and Whittredge. There are works in Baltimore (Mus.

of Art), Boston, Cambridge Mass. (Fogg), Chicago, Cleveland, Detroit, New York (Brooklyn, Pub. Lib.) and Washington (Corcoran).

Gigante Giacinto, b. Naples 1806, d. Naples 1876. Landscapist, a leading figure in the naturalistic SCHOOL OF POSILLIPO. He was most at home in watercolour or tempera, though he painted extensively in oils. He built up effects in rapid touches of colour, a ROMANTIC naturalism he is thought to owe to the influence of TURNER and BONINGTON, who visited Naples. After an initial period of instruction from his father, Gaetano Gigante, he studied watercolour painting with Huber and oils with PITLOO at the Naples Academy. He paid an extended visit to Rome in 1826 and enjoyed an important local reputation on his return to Naples. King Ferdinand II appointed him drawing master to his children and Francesco II made him court painter. He was also popular with the foreign colony; he accompanied the Empress of Russia to Sicily, preparing for her an album of Sicilian views. There are works in Milan (Mod. Art), Naples (Capodimonte, San Martino), Rome (Mod. Art), and Turin (Mod. Art).
Lit. R. Causa: *Aquarelli di G. Gigante* (1955); A. Schettini: *G. Gigante* (1956); S. Ortolani: *G. Gigante* (1967)

Gille Christian Friedrich, b. Ballenstedt 1805, d. Wahnsdorf (Dresden) 1899. Landscapist, a pupil and follower of DAHL; his oil sketches from nature have a freedom that prefigures IMPRESSIONISM. He entered the Dresden Academy (1825) to learn engraving, but two years later changed to painting under Dahl. From 1830 to 1850 he worked mostly as a lithographer, afterwards returning to oil painting; his landscapes show a ROMANTIC penchant for autumn or evening light. There are many works in Bremen and Dresden.

Girardet Karl, b. Locle 1813, d. Paris 1871. Swiss painter of genre and landscape, whose sketches have been compared to those of MENZEL as forerunners of the REALIST revolution; he also painted historical subjects, influenced by the DELAROCHE school. He moved with his father, the artist Charles Samuel Girardet, to Paris (1822), where he studied under L. COGNIET. He first exhibited

small genre scenes in the 1836 SALON, with immediate success, and was taken up by Louis-Philippe who sent him and his brother Eduard to Italy and Egypt (1842) to make studies for a painting for Versailles, and to Spain (1846) to paint Montpensier's marriage. After the 1848 revolution, he settled in Brienz. There are works in Algiers, Amsterdam, Basle (Kunstmuseum), Berne, Bourges, Chantilly, Lille, Nantes, Neuchâtel, Reims, Strasbourg and Versailles.
Lit. R. Burnand: *L'Etonnante Histoire des Girardet, artistes suisses* (1940) and *Les Girardet au Locle et dans le monde* (1957)

Girodet de Roucy Trioson Anne Louis, b. Montargis 1767, d. Paris 1824. A favourite pupil of DAVID, he was the mannerist of the turn-of-the-century NEOCLASSICAL school. He favoured more poetic and romantic themes than his master, but became the leader of the classical faction of artists after David's exile. After entering David's studio in 1785, he won the first Rome prize in 1789 and spent the following five years in Italy. His early works follow the accepted Neoclassical conventions, but in 1801 he painted for Napoleon the extraordinary *Ghosts of French Warriors Received by Ossian*, a mixture of mythological and modern dress in which the many floating figures defy the laws of gravity. His *Death of Atala* (1808) presages the troubadour style of the later ROMANTICS. He was a member of the INSTITUT (1815), and a chevalier of the Legion of Honour (1816); he was posthumously appointed officer in 1824. There are works in Ajaccio, Amiens, Angers, Avignon, Bernay, Bourges, Châteauroux, Cherbourg, Compiègne, Grenoble, Leipzig, Le Puy, Marseilles, Montpellier, Nice, Orleans, Paris (Louvre), Sémur and Versailles.
Lit. G. Levitine: *Girodet-Trioson: An Iconographical Study* (1952); G. Bernier: *A. L. Girodet 1767–1824* (1975)

Glasgow Boys. Nickname of a group of Scottish painters who achieved international renown in the 1890s for their naturalistic but poetic landscape paintings with a strong debt to the BARBIZON SCHOOL and BASTIEN-LEPAGE. LAVERY, GUTHRIE, HENRY, HORNEL and PATERSON were among the most distinguished. The influence of Barbizon and its Dutch counterpart, the HAGUE SCHOOL, was

felt in Scotland more strongly than in England on account of a number of enlightened collectors and dealers. As early as 1874 Craibe Angus, brother-in-law of the Dutch dealer van Wisselingh set up a gallery in Glasgow where he showed works by COROT, DIAZ, P. E. T. ROUSSEAU, BOSBOOM, the brothers MARIS, ISRAËLS and by MAUVE. Examples of the work of COURBET and MONTICELLI also found their way there. The Edinburgh International Exhibition of 1886 included French and Dutch sections and in 1889 Alexander Reid opened his influential Glasgow firm, the Société des Beaux-Arts. The Glasgow Boys had links with the NEW ENGLISH ART CLUB in London and exhibited as a group in Munich from 1890 with great success. Their work was seen as a close parallel to the Munich STIMMUNGSLANDSCHAFT.

Gleyre Marc Gabriel Charles, b. Chevilly 1808, d. Paris 1874. Painter of classical and historical subject pictures and portraits, with the high finish and idealized grace of the INGRES school, but with a personal, sometimes bizarre, visionary quality. He ran a highly regarded independent studio which he inherited from DELAROCHE in 1843 and closed in 1864. He taught MONET, RENOIR, SISLEY and BAZILLE, his instruction following the academic tradition but laying special emphasis on the sketch, outdoor landscape studies and, most important, originality and personal expression. He moved to Paris in 1825 and studied with Hersent. In Italy (1828–33) he met the NAZARENES and developed a lifelong veneration for Raphael; in 1834–7 he travelled in the Orient with an American patron. His first major success, *Evening, or Lost Illusions*, exhibited in the 1843 SALON, brought him several state commissions. After 1849 he lived a retired, brooding life, avoiding the Salon and turning down the Legion of Honour. There are works in Baltimore (Mus. of Art, Walters), Basle (Kunstmuseum), Cambridge Mass. (Fogg), Lausanne, Montpellier, Neuchâtel, Paris (Louvre) and Troyes.
Lit. C. Clement: *Gleyre, étude biographique et critique* (1878)

Gogh Vincent Willem van, b. Zundert 1853, d. Auvers-sur-Oise 1890. His career as an artist lasted only from 1880 to 1890; he sold one picture in his lifetime, and his fame and

Girardet *Haymaking in the Oberland*

Girodet de Roucy Trioson *Ghosts of French Warriors Received by Ossian* 1801

Gleyre *Evening, or Lost Illusions c.* 1843

97

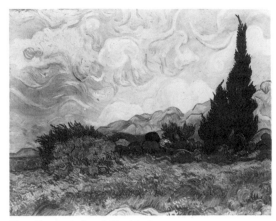

Van Gogh *A Cornfield with Cypresses* 1889

Goya *Executions of May 3, 1808* 1814

influence belong to the 20C. The son of a Dutch pastor, he worked for his uncle's art-dealing firm (Goupil) in The Hague, London and Paris, as a teacher and lay preacher in England and as a bookseller in Dordrecht. Next he studied theology and worked as a missionary among the coalminers in the Borinage. He began to draw seriously in August 1880, briefly attending the Brussels Academy and working from nature. He spent 1882–3 in The Hague, learning from MAUVE, BREITNER and other artists; he lived at his father's Nuenen parsonage painting peasant life during 1884–5. His early work is dark in tone, strongly influenced by MILLET and Mauve, and inspired by a missionary zeal to proclaim the harsh realities and suffering of peasant life (*The Potato Eaters* 1885, *Daughter of the People* 1885). He was in Antwerp from November 1885 to March 1886, making his first exploration of the expressive use of colour under the influence of Rubens and DELACROIX and 'discovering' Japanese prints. In March 1886 he moved to Paris to live with his brother Theo, who worked for Goupil's and was attempting as a sideline to sell the work of the IMPRESSIONISTS. Here his palette burgeoned with colour in a series of flower still lifes inspired by MONTICELLI. He enrolled in Cormon's studio, where he met TOULOUSE-LAUTREC and BERNARD (and, through him, GAUGUIN). Through Theo he met PISSARRO, SEURAT and the Impressionists. He began to paint views of Paris and its neighbourhood, experimenting with Impressionism and POINTILLISM. In 1887–8 he developed his own expressive Post-Impressionist style, a tapestry of rapid brushstrokes in powerfully emotive colour (interpretations of Hiroshige prints, *Père Tanguy*, *Self-Portrait in Front of an Easel*). Seeking the colouristic inspiration of a southern landscape, he left for Arles in February 1888, entering a frenzied time of painterly endeavour, his first great period. He painted landscapes, portraits and still lifes at great speed, using formal simplifications and blazing colour to convey the mood of his intense response to the subject before it faded (*Drawbridge at Arles*, *Sunflowers*, *L'Arlésienne*). Gauguin joined him in Arles in October 1888; their relationship became highly charged with emotion and on Christmas Eve he hit Gauguin, then cut off his own ear. After two weeks he resumed painting (*Self Portrait with a Bandaged Ear*) but was soon back in hospital. In April 1889 he was voluntarily admitted to the insane asylum at Saint-Remy-de-Provence where he painted intensely between attacks of madness (*Garden of the Asylum*, *Cypresses*). He left in May 1890 to live at Auvers-sur-Oise under the supervision of Dr Gachet, a friend of Pissarro and CÉZANNE. This started well (*Cornfield with Crows*, *Mlle Ravoux*) but he quarrelled with Gachet, his madness returned and in July 1890 he committed suicide. The writhing arabesques and intense emotive colour of his later work influenced many 20C artists, including MUNCH, the Fauves and the German Expressionists. There are important collections of his work in the Kröller-Müller Museum, Otterloo, and the Amsterdam Stedelijk. There are also works in Baltimore (Mus. of Art), Boston, Cambridge Mass. (Fogg), Chicago, Copenhagen (Ny Carlsberg Glyptotek), Edinburgh, Essen, Glasgow, London (Tate, Courtauld), Minneapolis, Moscow (Pushkin), New York (Met.), Paris (Louvre), Washington (NG) and most museums of modern art. *(see colour illustration 31)*
Lit. J. van Gogh-Bonger: *V. van Gogh: Brieven aan zijn Broeder* (1914); P. Gauguin: *Avant et après* (1918); J. B. de la Faille: *V. van Gogh* (catalogue raisonné 1928, 1939); C. M. Books: *V. van Gogh: A Bibliography* (1942); M. Buchmann: *Die Farbe bei V. van Gogh* (1948); W. Weisbach: *V. van Gogh: Kunst und Schicksal* (1949); *Verzamelde Brieven van V. van Gogh* (1952–4; English trans. 1958); J. Rewald: *Post-Impressionism from van Gogh to Gauguin* (1962)

Goodall Frederick, b. London 1822, d. London 1904. He achieved fame with Egyptian and biblical scenes, following a visit to Egypt in 1858–9, and painted in this vein for the rest of his life; his earlier works had included landscapes, peasant genre and a few historical canvases. He became an ARA (1852) and an RA (1863). There are works in Bristol, Cambridge (Fitzwm), Glasgow, Hamburg, Leicester, Liverpool, London (Tate, V&A), Melbourne, Preston, Salford, Sheffield, Sunderland and Sydney.
Lit. F. Goodall: *Reminiscences of F. Goodall* (1902)

Gottlieb Moritz (Maurycy), b. Drohobycz 1856, d. Cracow 1879. Polish painter of

expressive and highly personalized studies of Jewish life, especially portraits; he was the most successful pupil of MATEJKO. He studied in Lvov (1867), in Vienna (1872-4), under Matejko in Cracow (1874-5), in Munich under PILOTY (1875-6) and in Vienna (1876-8). He returned to Cracow in 1878 and paid a brief visit to Rome in 1878-9. Many of his works were destroyed by Hitler. His brother Leopold was also an artist and illustrator. There are works in Cracow and Warsaw (Nat. Mus.).

Goya y Lucientes Francisco José de, b. Fuendetodos (nr Saragossa) 1746, d. Bordeaux 1828. The greatest Spanish painter and graphic artist of the 19C. His first major works were baroque idylls echoing Tiepolo, notably the cartoons for royal tapestries such as *The Parasol* and *The Picnic*. The almost complete loss of his hearing in 1792 brought a more bitter and introspective note to his art. His court portraits are characterized by penetrating realism; *The Family of Charles IV* (1800) outstandingly depicts the vanity and ugliness of the ruling family. His first series of etchings, *Los Caprichos* (1796-8), savagely satirizes the foibles and brutalities of contemporary society. The atrocities of the Napoleonic wars led him even deeper into realms of savage fantasy, notably in his series of etchings *The Disasters of War* and the nightmarish frescoes in his own home (*Saturn Devouring his Children*). His work continued the rich painterly tradition of Velasquez, while his biting social comment looks forward to DAUMIER and the French REALISTS; his fantastic visions of witches and uncanny apparitions are among the outstanding achievements of the ROMANTIC era. He studied at Saragossa, moving *c*. 1766 to Madrid, where he worked with Francisco Bayeu, whose sister Josefa he married. He visited Italy in 1771. He executed cartoons for the royal tapestry manufactory (1775-81) and was made deputy director of the Madrid Academy S. Fernando in 1785, *pintor del rey* (1786), *pintor de camara* (1789) and *primer pintor de camara* (1799). In war-torn Spain his sympathies clearly lay with the liberals but he worked for each and every overlord, Charles IV, Ferdinand VII, Joseph Bonaparte and the Duke of Wellington. With the restoration, he was pardoned and re-employed by the court, but left Spain in

1824 to avoid reactionary persecution, briefly visiting Paris and settling in Bordeaux. His work is best represented in Madrid (Prado, S. Fernando Acad.). There are examples in most national collections, and in Agen, Baltimore (Mus. of Art), Barnard Castle, Bayonne, Besançon, Boston, Castres, Chicago, Cincinnati, Cleveland, Detroit, San Diego, Edinburgh, Hartford Conn., Houston, Kansas City, Lille, Minneapolis, Montreal, Munich, New York (Met., Frick, Brooklyn, Hispanic Soc.), Northampton Mass., Ottawa, St Louis, São Paolo, Seville, Toledo, Toledo Ohio, Valencia and Worcester Mass.
Lit. A. Malraux: *Dessins de Goya au Musée du Prado* (1947); F. D. Klingender: *Goya in the Democratic Tradition* (1948); J. Lopez-Rey: *Goya's Caprichos: Beauty, Reason and Caricature* (1953); E. L. Ferrari: *Goya, his Complete Etchings, Aquatints and Lithographs* (1962); T. Harris: *Goya: Engravings and Lithographs* (2 vols 1964); F. J. Sanchez-Canton: *F. Goya* (1965); E. Harris: *Goya* (1969); J. Gudiol, I. Ricart: *Goya* (4 vols 1971); P. O. Troutman: *F. Goya: Paintings, Drawings and Prints* (1971); J. Ortega y Gasset: *Velasquez, Goya and the Dehumanization of Art* (1972)

Graff Anton, b. Winterthur 1736, d. Dresden 1813. Swiss-born portraitist and miniaturist who worked in Germany. He adopted a simple, NEOCLASSICAL style, disdaining pose and ornament but displaying considerable psychological sensitivity. He was nicknamed the 'van Dyck of Germany'. He lived in Dresden from 1766, and painted most of Germany's great poets, artists and scholars of the time, as well as the aristocracy. There are works in Basle (Kunstmuseum), Berlin, Berne, Breslau, Cologne, Dresden, Hamburg, Leipzig, Munich (N. Pin.), Oslo (NG), Strasbourg and Weimar.
Lit. R. Muther: *A. Graff* (1881); J. Vogel: *A. Graff* (1898); O. Waser: *A. Graff 1736-1813* (1926); E. Berckenhagen: *A. Graff: Leben und Werk* (1967)

Granet François Marius, b. Aix 1775, d. Aix 1849. The most successful of the French genre and landscape painters of the early century. He particularly favoured church and convent interiors, to which his busy figures add an informal element of genre, often in a

Granet *The Capuchin Chapel* 1817

Graff *Frederick the Great* 1781

slanting play of sunlight. His watercolour and oil landscape sketches, made out of doors with a summary freedom, have been highly regarded since they were made known by a 1913 exhibition devoted to the pupils of DAVID. He studied at Aix with Constantin, and in Paris (1801) with David. It was of one of his sketches that David made the famous comment: 'Il sent la couleur.' He was in Rome 1802-19 and on his return to Paris scored a resounding success with *The Capuchin Chapel* in the SALON of 1819; he made sixteen copies with variations for the princes of Europe, and an enlarged version by SULLY toured America. He was conservator of the Louvre from 1826, member of the INSTITUT and director of the history galleries at Versailles (1830); he became an officer of the Legion of Honour (1837), and was a member of the Berlin, Rome and St Petersburg Academies. He retired to Aix following the 1848 revolution. He was a friend of INGRES, who painted a famous portrait of him with the Roman skyline as background. There are works in Aix, Ajaccio, Amiens, Antwerp, Avignon, Baltimore, Bayonne, Bourges, Cambridge Mass. (Fogg), Compiègne, Copenhagen (Thorwaldsen), Dijon, Dunkirk, Fontainebleau, La Fère, Leningrad (Hermitage), Lyons, Marseilles, Montauban, Montpellier, Munich, Neufchâtel, New York (Met.), Paris (Louvre), Reims and Versailles.
Lit. P. Silbert: *Notice historique sur la vie et l'œuvre de Granet* (1962)

Grant Sir Francis, b. Kilgraston (Scotland) 1803, d. Melton Mowbray 1878. A painter of sporting scenes and the most fashionable English portraitist of the mid-century. A well-born Scotsman, he rejected a career in law to study painting with FERNELEY at Melton Mowbray. Society connections brought him ready patronage for hunting scenes and equestrian portraits. He was an ARA (1842) and an RA (1851); he succeeded EASTLAKE as president of the ROYAL ACADEMY in 1866, thus earning a knighthood. There are works in Glasgow, London (NPG), Norwich and Victoria.

Gregorio Marco de, b. Resína 1829, d. Naples 1876. Italian *plein air* painter, one of the leaders with DE NITTIS of the SCHOOL OF RESÍNA. He was much influenced by F. PALIZZI, especially in his use of vivid con-trasting colours. Having fought with Garibaldi, he spent 1860-3 in Egypt. After returning to Naples he collaborated with de Nittis and other anti-academic painters who worked outdoors around Resína (1863-7). There are works in Florence (Mod. Art) and Naples (San Martino).

Grigorescu Nicolae Jon, b. Vacaresti 1838, d. Campina 1907. Rumania's most important 19C painter, he was recognized in his own lifetime as the founder of a new national art. He worked for several years in Barbizon and applied a spontaneous REALISM learned in France to the landscape and people of his own country: peasant and gypsy life, scenes in the Jewish communities, picturesque villages and dusty country roads. Of peasant stock, he was apprenticed in youth to an icon-painter, studied in Bucharest, and began by painting church murals (Zamfira 1856, Agapia 1858-61). Awarded a state travel scholarship in 1861, he went to Paris and briefly enrolled in Cornu's studio. In 1862-9 he lived mainly in Barbizon and Marlotte, where his mature style developed under the influence of COURBET, T. ROUSSEAU, DIAZ and COROT. In 1873 an exhibition of his work in Bucharest proved outstandingly successful and ensured his financial independence. He returned frequently to France, maintaining a Paris studio until 1887. He took part in the Rumanian war of independence (1877-8) and painted a number of patriotic battle scenes (*The Attack of Smardan*). From 1887 he lived in Bucharest. There are works in Bucharest (NG).
Lit. F. Sirato: *Grigorescu* (1938); I. Jianu: *Grigorescu* (1956); G. Oprescu: *Grigorescu, 1838-1907* (1961)

Grimshaw John Atkinson, b. Leeds 1836, d. Leeds 1893. A prolific artist chiefly noted for his night townscapes lit by moonlight or lamplight. He started painting when a clerk for the Great Northern Railway. His early landscapes were influenced by the PRE-RAPHAELITES and are conspicuous for their detail and almost lurid chromatic effects. He was one of the first artists to make use of photographs, on which his townscapes are often based. He was very popular with the public, though treated with suspicion by the academic establishment, and has been much copied and faked. His two sons Louis and Arthur painted in a similar style. There are works in Leeds, London (Tate) and Preston.
Lit. J. Abdy: *A. Grimshaw* (1970); G. R. Phillips: *The Biography of J. A. Grimshaw* (1972)

Gros Baron Antoine Jean, b. Paris 1771, d. Bas-Meudon 1835. A pupil of DAVID and a major influence on both GÉRICAULT and DELACROIX, he holds an important position in the development of the ROMANTIC movement in France. His highest achievements were three paintings of Napoleon, *The Bridge at Arcole* (1796), *Napoleon Visiting the Victims of the Plague at Jaffa* (1804) and *The Battle of Eylau* (1808). He departed from the conventions of NEOCLASSICAL history painting by combining a colouristic *bravura* with dramatically crowded compositions, both derived from his study of Rubens and the Venetians – an example that Géricault and Delacroix were to follow. The large-scale realistic depiction of contemporary events was also a departure from Neoclassical convention, while his heroic, almost godlike treatment of Napoleon is strongly Romantic in spirit. The son of a miniaturist, he entered David's studio in 1785, and left for Italy (1793) with David's help; in Genoa he attracted the interest of Joséphine, who presented him to Napoleon. He followed the army to Arcole, which led to his first Napoleonic epic, *The Bridge at Arcole* (1796). In 1801 he returned to Paris, where his work was highly regarded, and he received many portrait commissions; he was a chevalier of the Legion of Honour (1808) and an officer (1828), and was a member of the INSTITUT (1815). The exiled David bequeathed his studio to him, and a commission to decorate the Panthéon cupola occupied him intermittently between 1811 and 1824. Under the Restoration he executed some fine portraits (*Mme Récamier in Old Age*, *Girl with a Jet Necklace*) but, mindful of David's criticism of his colouristic experiments, he turned back to mythological paintings in a colder, more conventional, Neoclassical style. He was created Baron by Charles X but his work was derided by younger artists; for this and more personal reasons he committed suicide. There are major works in the Louvre and Versailles; he is also represented in many French provincial museums, and in Boston, Cambridge

Grigorescu *The Attack of Smardan* 1885

Gros *Napoleon Visiting the Victims of the Plague at Jaffa* 1804

Groux *The Coffee Mill c.* 1855

Mass (Fogg), Cleveland, Detroit, Moscow (Pushkin) and Washington (NG).
Lit. J. Tripier Le Franc: *Histoire de la vie et de la mort du Baron Gros* (1880); R. Escholier: *Gros, ses amis et ses élèves* (1936); G. Delestre: *A.-J. Gros* (1951)

Groux Charles Corneille Auguste de, b. Comines 1825, d. Brussels 1870. A pioneer of REALISM in Belgium, he was predominantly a painter of the poor and their sufferings. He was influenced by COURBET, whose *Stonebreakers* was exhibited in Brussels in 1852, and his work was often compared to that of MILLET, though his paintings retained a narrative element foreign to French Realism. He studied with NAVEZ at the Brussels Academy, and his early works were history subjects treated with carefully finished detail in the manner of LEYS. *Banc des Pauvres*, exhibited at Antwerp in 1849, was his first successful contemporary subject. His harshly moralizing scenes were much admired and brought him many imitators in the 1850s. He was a founder member in 1868 of the Société Libre des Beaux-Arts with ROPS and MEUNIER. There are works in Antwerp, Brussels (Musées Royaux) and Valenciennes.
Lit. E. Leclercq: *C. de Groux* (1871); M. E. Tralbaut: *V. van Gogh and C. de Groux* (1953)

Grubicy de Dragon Vittore, b. Milan 1851, d. Milan 1920. He painted delicate studies of landscape, inspired by MAUVE and the HAGUE SCHOOL, in a DIVISIONIST technique with a debt to SEURAT. He shared an art-dealing business with his brother Alberto and promoted Lombard artists in all the artistic centres of Europe, first the SCAPIGLIATI, and then the Divisionists SEGANTINI and PREVIATI. He also introduced European influences to Lombardy, notably those of the Hague School and the PRE-RAPHAELITES. He was an influential writer and critic. There are works in Milan (Sforzesco), Rome (Mod. Art), Paris (Mod. Art) and Venice (Mod. Art).
Lit. P. Levi: *Il fenomeno Grubicy nella vita e nell'arte* (1910)

Grützner Eduard, b. Grosskarlowitz (Neisse) 1846, d. Munich 1925. German genre painter specializing in humorous scenes of monks and peasants, as well as painting occasional flower pieces and portraits. A distinguished colourist, he was immensely popular in his day, especially in America. In 1864 he entered the Munich Academy, studying with Anschütz (1865) and PILOTY (1867). He turned from history to genre painting but still received every encouragement from Piloty. There are works in Baden-Baden, Bautzen, Wrocław, Karl-Marx-Stadt, Chicago, Cologne, Dresden, Frankfurt/M., Görlitz, Gothenburg, Kaliningrad, Leipzig, Mainz, Mannheim, Moscow, Munich, Nice and Würzburg.
Lit. F. von Ostini: *Grützner* (1902); R. Braungart: *Grützner* (1916)

Gude Hans Fredrik, b. Christiania (now Oslo) 1825, d. Berlin 1903. Popular landscapist whose paintings of wild Norwegian scenery and *plein air* approach brought fresh life to the Norwegian seascape and landscape school. He worked largely in Germany, where young Norwegian artists flocked to study with him. His national success was partly due to his reiteration of themes connected with the sea; Muther called him 'the CALAME of the North'. He also, in association with TIDEMAND, painted genre pictures of country ceremonies which were enormously popular. He studied in Christiania (1837-41) before moving to Düsseldorf where he studied with A. ACHENBACH and SCHIRMER (1846). He made sketching expeditions in the Norwegian countryside in the summers and lived briefly in Christiania (1848-50). He returned to Düsseldorf in 1850, taking over Schirmer's teaching post in 1854. After spending 1862 in Wales, he became director of the Karlsruhe Art School (1863-80), and ran a teaching studio in Berlin from 1880 to 1903. There are works in Berlin (NG), Bergen, Dresden, Hamburg (Kunsthalle), Hanover, Helsinki (Athenaeum), Karlsruhe, Leipzig, Mannheim, Melbourne, Oslo (NG), Prague, Stockholm, Stuttgart and Vienna. (*see illustration p. 102*).
Lit. L. Dietrichson: *Af Hans Gudes Liv og Vaerker, Kunstnerens Livserindringer* (1899)

Guérin Baron Pierre Narcisse, b. Paris 1774, d. Rome 1833. A leading NEOCLASSICAL painter of the Empire and Restoration periods. His compositions often have an air of theatrical *mise-en-scène*, for which he was reproached by his contemporaries. He sweet-

ened the heroic classicism of DAVID but continued to paint scenes from classical history and mythology (*Phedra and Hippolytus* 1802, *Andromache* 1810, *Aeneas Recounting to Dido the Troubles of Troy* 1817). Forced to take up art by his parents, he studied under REGNAULT and won the first Rome prize in 1797. Since no stipends for Rome students were available, he remained in Paris and achieved a sensational success with *The Return of Marcus Sextus* (1799), which was seen as symbolic of the return of *emigrés* to France. He then spent two years in Italy, returning to further success in 1802. He became a chevalier of the Legion of Honour (1803) and an officer (1831); he was appointed professor at the ECOLE DES BEAUX-ARTS in 1815. He refused the directorship of the Rome Academy in 1816 but accepted it in 1822, and was created Baron in 1829. The leading artists of the ROMANTIC movement studied in his atelier: GÉRICAULT, DELACROIX, HUET and SCHEFFER. He laid special emphasis on the painted sketch and was influential in establishing a sketch competition as a preliminary to the Rome prize in 1817. There are works in Angers, Berlin, Bordeaux, Caen, Compiègne, Dijon, Lille, Madrid (Mod. Art), Paris (Louvre), Pontoise, Rouen, Valenciennes and Versailles.

Guillaumet Gustave Achille, b. Paris 1840, d. Paris 1887. French painter of Oriental scenes. Fascinated by effects of light, he caught in his paintings the mysterious tones and the vast horizons of the East with the poor under the blazing sun. A pupil of PICOT and Barrias, he first exhibited in the SALON of 1861. He became a chevalier of the Legion of Honour in 1878. There are works in Algiers, Bucharest, Dijon, Lille, Limoges, Lyons, La Rochelle, Paris (Louvre) and Rouen.
Lit. G. Guillaumet: *Tableaux algériens* (1888)

Guillaumin Jean Baptiste Armand, b. Paris 1841, d. Paris 1927. IMPRESSIONIST landscape painter. His work has a lyrical quality while the strong brushwork and bright colours of his later period have affinities with the Fauves. He came to Paris at seventeen to work as a clerk in the city administration, and combined painting with his job until 1892, when he turned exclusively to art. He studied at the Académie Suisse, where he met CÉZANNE and PISSARRO, and exhibited in the Salon des Refusés in 1863; from 1874 he contributed to all the Impressionist Group Shows, with the exceptions of 1876 and 1879. He counted MONET, SIGNAC and VAN GOGH among his friends and often stayed at Auvers-sur-Oise with Dr Gachet, their friend and patron. There are works in the Louvre and most museums where Impressionism is represented.
Lit. E. des Courrières: *A. Guillaumin* (1924); G. Lecomte: *Guillaumin* (1926); G. Serret, D. Fabiani: *A. Guillaumin* (catalogue raisonné 1971); C. Gray: *A. Guillaumin* (1972)

Gude *Norwegian Mountain Landscape c.* 1860

Guillemet Jean Baptiste Antoine, b. Chantilly 1843, d. Dordogne 1918. Landscapist and marine painter, who studied with COROT (1862) and later with DAUBIGNY and VOLLON. He achieved considerable success with intimate but poetic landscapes which are strongly influenced by Corot. He became a chevalier of the Legion of Honour in 1880, an officer in 1896 and a commander in 1910. A friend of MANET, Zola and the IMPRESSIONISTS, he proved an invaluable ally in their battle for recognition, serving on the SALON jury from 1880. CÉZANNE was first represented in the Salon (1882) as his pupil. There are works in Amiens, Bordeaux, Cette, Dijon, Grenoble, Mulhouse, Paris (Louvre), Périgueux, Rochefort, Rouen, Toulon, Tourcoing and Troyes.

Guérin *The Return of Marcus Sextus* 1799

Gurlitt Heinrich Louis Theodor, b. Altona 1812, d. Naundorf bei Schmiedeberg 1897. German landscape painter. Himself profoundly influenced by ECKERSBERG and the REALIST tendencies of the Copenhagen Academy, he introduced a new objective naturalism to Düsseldorf. Through his influence on the ACHENBACH brothers in Düsseldorf, he helped to change the course of German landscape painting in the mid-century. He studied in Hamburg with Gensler and BENDIXEN, and was influenced towards landscape painting by his fellow students MORGENSTERN and DAHL. He worked at the Copenhagen Academy under Eckersberg (1832) and from there paid his first visits to Norway and Sweden. He travelled constantly, staying for longer periods in Munich, Copenhagen, Rome, Vienna, Berlin and Gotha, and also visiting Spain, Portugal, Greece, Dal-

Gurlitt *Trees in Italy* 1843–6

Guillaumin *The Fishermen* before 1891

Guys *The Champs-Elysées*

matia and Hungary. There are works in Berlin, Dresden, Düsseldorf, Gotha, Görlitz, Hamburg, Hanover, Kiel, Leipzig, Mannheim, Munich, Oldenburg and Vienna.
Lit. Ludwig Gurlitt: *L. Gurlitt, ein Künstlerleben des 19 Jahrhundert* (1912)

Gussow Karl, b. Havelberg 1843, d. Pasing (Munich) 1907. Genre and portrait painter who, from the late 1860s, dedicated himself to painting the life of the poor with almost photographic accuracy. His early work was in a ROMANTIC mythological vein. He was most influential as a teacher in Weimar and Berlin. He studied in Weimar (1860) under RAMBERG and Pauwels, and in Munich (1867) under PILOTY. He was a professor at Weimar (1870), at the Karlsruhe Academy (1874-6) and then at the Berlin Academy. He moved to Munich in 1892. There are works in Berlin, Dresden, Ghent, Halle, Liverpool, Sheffield and Weimar.
Lit. K. Pietschker: *K. Gussow und der Naturalismus* (1898)

Guthrie Sir James, b. Greenock 1859, d. Dunbarton 1930. Landscapist and portrait painter of the Glasgow school, one of the GLASGOW BOYS. He gave up law for painting in 1877, studying in London and Paris where he was much influenced by BASTIEN-LEPAGE. He was an associate of the Royal Scottish

Academy (1888), an academician (1892) and president (1902-19); he was knighted in 1902. He was also a member of the NEW ENGLISH ART CLUB and the Paris SOCIÉTÉ NATIONALE DES BEAUX-ARTS. There are works in Edinburgh, Glasgow and Victoria.

Guys Constantin Ernest Adolphe Hyacinthe, b. Vlissingen 1805, d. Paris 1892. Self-taught draughtsman and watercolourist, the most perceptive chronicler of French daily life under the Second Empire. He left home at eighteen to fight in the Greek war of independence, took up drawing in the 1840s and represented the *Illustrated London News* in the Crimea. In the 1860s he settled in Paris, where his scenes of café- and night-life provided inspiration for FORAIN and TOULOUSE-LAUTREC. Among his devoted friends and admirers were DAUMIER, GAVARNI, Baudelaire and the photographer Nadar. Carefully avoiding fame, he did not sign his drawings, and died penniless. He is represented in the print rooms of most important museums and notably in the Carnavalet, Paris.
Lit. G. Geffroy: *C. Guys, l'historien du Second Empire* (1904); A. d'Euguy: *Au temps de Baudelaire, Guys et Nadar* (1945); C. Hall: *C. Guys* (1945); C. P. Baudelaire: *The Painter of Modern Life (C. Guys) and Other Essays* (ed. J. Mayne 1964)

H

Habermann Hugo Freiherr von, b. Dillingen 1849, d. Munich 1929. Portrait and figure painter with a leaning towards the decadent, melancholy or slightly perverse; he played a central role in the Munich SECESSION, was vice-president in 1892 and president in 1904. From the rich palette of the PILOTY school he turned, in the late 1880s, to dark tones with touches of contrasting light. After participating in the 1870 war, he entered the Munich Academy (1871), where he studied with Piloty from 1873. He became a friend of the REALIST-oriented painters who gathered round LEIBL, and was influenced by VON UHDE. In 1892 he became involved in the

Secession movement. He was professor at the Munich Academy from 1905 to 1924. There are works in Bremen, Wrocław, Cologne, Elberfeld, Frankfurt/M., Hamburg, Hanover, Leipzig, Munich (N. Pin.), New York (Met.), Stuttgart, Troppau and Winterthur. *(see illustration p. 104)*
Lit. F. von Ostini: *H. von Habermann* (1912)

Haes Carlos de, b. Brussels 1829, d. Madrid 1898. Landscapist, who painted mainly naturalistic views of the Spanish coast, Andalusia and the Pyrenees. Of Dutch parents, he was brought up in Malaga, and after studying in Brussels with J. Quinaux he

Habermann *The Artist's Brother* 1888

Hammershøi *Nude Female Model* 1889

returned to Spain, where he exhibited landscapes in Madrid from 1856. He became professor of landscape painting at the S. Fernando Academy, Madrid, in 1857. He travelled widely and exhibited with success throughout Europe. There are works in Bayonne and Madrid (Mod. Art).

Hagn Ludwig von, b. Munich 1819, d. Munich 1898. Historical genre painter whose scenes were generally set in the 17C or 18C and painted on a small, intimate scale. He used a sparkling, almost impressionistic palette, and was considered the first colourist among Munich's genre painters. He entered the Munich Academy in 1841, moved to Antwerp in 1846, studying with WAPPERS and de Block, and studied in Berlin (1851-3) with MENZEL. In Paris (1853-5) he was much influenced by MEISSONIER, WILLEMS and A. STEVENS, and became a friend of PETTENKOFEN and V. MÜLLER. After returning to Munich (1855), he scored his first major success at the KUNSTVEREIN exhibition of 1858. He was a close associate of LENBACH and his circle. There are works in Frankfurt/M. and Munich.

Hague School, The. Dutch school of landscape and genre painting which flourished *c*. 1860-90, developing more or less directly out of the BARBIZON SCHOOL in France and achieving by the turn of the century a comparable international popularity. Its principal exponents comprised BOSBOOM, J. ISRAËLS, the MARIS brothers and MAUVE. They depicted the simple life of fisherfolk and peasants, sometimes in interiors, as in Israëls' most typical work, sometimes at work in the fields or on the dunes. Jacob Maris frequently painted Dutch townscapes and Willem corners of a field with grazing cows and sheep, while Bosboom was the master of church interiors. The keynotes of the school were a free spontaneous brushwork and a muted range of colour. All worked with equal success in watercolour and oil. The original group of artists had innumerable followers, including W. Roelofs, P. C. Gabriel, J. Weissenbruch and H. W. Mesdag. Their influence can be traced throughout Europe, notably in the work of the so-called German IMPRESSIONISTS (LIEBERMANN, CORINTH, SLEVOGT), in the GLASGOW BOYS and in Italy's SEGANTINI.

Lit. W. J. de Gruyler: *De Haagse School* (1968)

Haider Karl, b. Neuhausen (Munich) 1846, d. Schliersee 1912. Lyrical landscape painter, the heir of FRIEDRICH and SCHWIND and a friend of THOMA. One of the circle of Munich REALISTS round LEIBL, he studied at the Munich Academy from 1861 under Hiltensperger and Anschütz, becoming friendly with Leibl; both were deeply impressed by COURBET at the Munich INTERNATIONAL EXHIBITION of 1869. He spent 1875-6 in Florence with BÖCKLIN, and joined the SECESSION exhibitions after 1892. There are works in Berlin, Wrocław, Cologne, Dresden, Frankfurt/M., Hamburg, Karlsruhe, Leipzig, Munich (N. Pin.), Stuttgart and Würzburg.
Lit. E. Haider: *K. Haider, Leben und Werk eines Süddeutschen Malers* (1926)

Hammershøi Vilhelm, b. Copenhagen 1864, d. Copenhagen 1916. Leader of the Danish Den Frie Udstilling (Free Exhibition) group, an equivalent of the SECESSION movements elsewhere. He painted, in a limited range of subdued colours, deserted interiors, misty dreamlike architectural views and landscapes, and a considerable number of portraits. He studied at the Copenhagen Academy from 1879 and with KRØYER. The official Charlottenborg Salon's rejection of his *Portrait of a Girl Sewing* (1887) initiated a revolt of younger artists leading to the foundation of Den Frie Udstilling in 1891. There are works in Aarhus, Berlin, Copenhagen (Hirschsprung, Ny Carlsberg Glyptotek, State), Florence, Fredericksborg, Göteborg, Rome and Stockholm (Nat. Mus.).
Lit. A. Bramsen: *V. Hammershøi's Arbejder* (1900); Bramsen-Michaelis: *V. Hammershøi* (1918)

Hansen Carl Christian Constantin, b. Rome 1804, d. Copenhagen 1880. A pupil of ECKERSBERG in Copenhagen, he followed his master's unpretentious BIEDERMEIER REALISM in landscape, genre and portraits, but achieved contemporary fame with paintings of classical history and allegory. His views of Rome are claimed to rival those of COROT, while in his *Danish Artists in Rome* (1837) he left an intimate and realistic record of his friends. His later years were taken up mainly with portraits and frescoes. Son of

a portrait painter, Hans Hansen, he studied architecture and, from 1825, painting at the Copenhagen Academy. He spent 1835-44 in Italy, mainly in Rome, visiting Naples and Pompeii (1838-9). His classical frescoes (1844-53) for the vestibule of the Copenhagen University building were hailed as a high point of Danish art. He was a member of Copenhagen Academy (1864) and the vice-director (1873). There are works in Copenhagen (State, Hirschsprung, Thorwaldsen) and Fredericksborg.
Lit. E. Hannover: *Maleren C. Hansen* (1901); V. Jastrau: *C. Hansen* (1923)

Harburger Edmund, b. Eichstatt 1846, d. Munich 1906. Adept in humorous genre scenes drawn from contemporary life, but with a debt to Ostade and Teniers. His contributions to the humorous periodical *Fliegende Blätter* (some 1,500 drawings) from 1870 onwards made him famous throughout Germany. He studied at the Munich Academy under Lindenschmit, was a friend of DIEZ and his group, and lived in Munich. There are works in Danzig, Darmstadt, Leipzig, Mainz, Munich, Münster, Prague, Reichenberg and Zurich.

Harnett William Michael, b. Clonakilty (Eire) 1848, d. New York 1892. Still-life painter who combined everyday objects into canvases of brilliant *trompe l'œil* REALISM. His brief late-century popularity was such that dealers signed his name to works of many contemporaries; these confused attributions were only unravelled by Frankenstein in 1953. He left Ireland for Philadelphia with his parents in 1849 and worked as a silver engraver there and in New York, studying drawing at night at the Pennsylvania Academy and the NATIONAL ACADEMY OF DESIGN. He turned to oil painting in the Philadelphia still-life tradition (1875), and spent 1880-6 in Europe, mostly in Munich and Paris. In 1886 he settled in New York, making one further European visit in 1889. His success was genuinely 'popular', and he never earned the regard of the connoisseur-critics. There are works in Boston and San Francisco.
Lit. A. Frankenstein: *After the Hunt* (1953)

Harpignies Henri Joseph, b. Valenciennes 1819, d. Saint-Privé (Yonne) 1916. Landscapist, a follower of the BARBIZON SCHOOL,

who came late to painting, only dedicating himself definitively to art in 1848. He studied with Achard, but his style was formed from a close study of the Barbizon painters, especially COROT, and his extensive travels in Italy. He first exhibited in the SALON of 1853, and from the late 1860s achieved fame and success. He became a chevalier of the Legion of Honour (1875), an officer (1883) and a commander (1901). There are works in Paris (Louvre) and many French provincial museums, as well as in Baltimore (Walters), Boston, Cambridge (Fitzwm), Cambridge Mass. (Fogg), Chicago, Cleveland, Grenoble, London (NG), Minneapolis, New York (Met.), Philadelphia, Williamstown Mass. (Clark) and Washington (NG).

Hasenclever Johann Peter, b. Remschied 1810, d. Düsseldorf 1853. One of the founders of the DÜSSELDORF SCHOOL of genre painting. His work leant heavily on English example (Hogarth, Rowlandson, WILKIE, etc.), but his naturalistic treatment and *plein air* study of light, especially in the work of the 1840s, place him among the Düsseldorf REALISTS. He was involved in the 1848 revolution and his work of the 1840s has strong political overtones. He entered the Düsseldorf Academy under SCHADOW in 1827 but his liberal-realist approach soon antagonized his teacher, and he retired to Remschied where he painted portraits and his first humorous genre scenes which found immediate popularity (exhibited Berlin 1832, Düsseldorf 1833). He returned to Düsseldorf in 1833 and in 1836 painted his famous *Atelier*, a humorous view of himself and fellow artists in a studio painted with revolutionary Realism. His series of paintings illustrating C. A. Kortum's story of *Hieronymus Jobs*, the first *Jobs as a Student* exhibited in 1838, brought him fame. He moved to Munich in 1838 but after a visit to Italy returned to Düsseldorf in 1842. His most important Realist paintings date from the following years (*Wine Tasting*, *Reading Room*, both 1843, *The Town Council in 1848* 1849). After 1848 he turned to more conventional humorous narrative painting. He was a member of the Berlin Academy (1843). There are works in Amsterdam (Stedelijk), Berlin, Cologne, Düsseldorf, Elberfeld, Munich, Münster and Riga.
Lit. W. Cohen: *J. P. Hasenclever* (1925)

Hansen *Danish Artists in Rome* 1837

Harpignies *River Scene* 1887

Hasenclever *Atelier* 1836

Haydon *Christ's Entry into Jerusalem* 1820

Hayez *Sicilian Vespers* 1846 version

Heade *Storm over Narragansett Bay* 1868

Hassam Frederick Childe, b. Dorchester (Mass.) 1859, d. East Hampton 1935. American IMPRESSIONIST painter. Stylistically his work is closely related to MONET, with a high-keyed palette and rich treatment of sunlight. He studied in Boston where he was influenced towards painting by the BARBIZON SCHOOL pictures in the collection of W. M. HUNT. He visited Europe in 1883 and returned in 1886 to study under BOULANGER and LEFEBVRE in Paris. He began to work in the Impressionist style around 1890 (*Washington Arch in Spring* 1890) and in 1898 founded the Society of Ten American Painters with like-minded artists. His style changed little in later years and he achieved a wide popularity in America. His work is represented in most major American museums.
Lit. A. V. Adams: *Childe Hassam* (1938)

Haydon Benjamin Robert, b. Plymouth 1786, d. London 1846. English history and genre painter. A student of FUSELI, Northcote, Hoare and the ROYAL ACADEMY Schools, he dedicated his life to the ideal of history painting that would raise the standard of public taste, adopting the type of Raphaelesque style that had been advocated by Reynolds (*Dentatus* 1809, *Judgment of Solomon* 1814, *Christ's Entry into Jerusalem* 1820, *Raising of Lazarus* 1823). Lack of appreciation and financial troubles finally drove him to suicide, but the continuing importance attached to history painting in England owed him a debt. He was the first to advocate the fresco decoration of the Houses of Parliament (though shattered when not asked to contribute); the first artist to sketch the Elgin Marbles, he was influential in securing their purchase by the state; his views on the social role of art anticipated and influenced Ruskin and MORRIS. EASTLAKE was his pupil and devoted admirer. Several of his history paintings won contemporary acclaim, but their completion led him into debt for which he was four times imprisoned. To salvage the situation he turned his hand to genre paintings (*The Mock Election* 1827, *Chairing the Member* 1828) and portraits. His autobiography and journals, a lively record of his time, have earned him more lasting fame than his pictures. He counted among his friends Keats, Wordsworth, Scott, Hazlitt and, from student days,

WILKIE. There are works in Leeds, Leicester, London (NPG, V&A, Tate), Melbourne and Sunderland.
Lit. T. Taylor (ed.): *Life of B. R. Haydon, Historical Painter, from his Autobiography and Journals* (1853); E. George: *The Life and Death of B. R. Haydon* (1948, 1967); C. Olney: *B. R. Haydon, Historical Painter* (1952); W. B. Pope (ed.): *The Diary of B. R. Haydon* (5 vols 1960–3)

Hayez Francesco, b. Venice 1791, d. Milan 1882. Leading Italian artist of the ROMANTIC school. His student works are purely NEO-CLASSICAL but his mature history paintings use the rich colouristic treatment of the 17C Venetians while laying an accent on REALISM and verisimilitude. He spent his youth in Venice but was adopted by Milan where Italy's Romantic writers were congregated; they saw in his patriotic scenes from Italian history (*Pietro Rossi* 1820, *Sicilian Vespers* 1821) a painterly realization of their own aims. He became an influential teacher. He studied at the newly founded Venice Academy with Matteini (1808) and, after winning a Rome prize in 1809, spent the next seven years in Rome where he was helped by Canova and made the acquaintance of INGRES and the NAZARENES. He returned to Venice in 1817 but the exhibition of *Pietro Rossi* in Milan in 1820 led him to move there in 1822. He established a popular private school in 1825 and later became a professor at the Brera (1850–80). His portraits include most of the leading artistic and literary figures of his time in Italy. There are works in Florence (Mod. Art), Naples (Capodimonte, San Martino), Milan (Mod. Art, Brera), Rome (Mod. Art, S. Luca), Turin (Mod. Art), Trieste (Revoltella) and Venice (Mod. Art).
Lit. L. Archinti: *F. Hayez e la pittura romantica Italiana* (1880); F. Hayez: *Le mie memorie* (1890); G. Nicodemi: *I dipinti di F. Hayez* (1934) and *F. Hayez* (1962); C. Castellaneta: *L'opera completa di Hayez* (1971)

Heade Martin Johnson, b. Bucks County (Pa.) 1819, d. St Augustine (Fla.) 1904. With LANE he is accounted one of the main exponents of American LUMINISM. He was primarily a landscapist, but also painted a large series of hummingbirds perched amid

rich flowers and foliage (*Hummingbirds and Passionflowers c.* 1865). His landscapes are characterized by their poetic vision, interpreted with precise REALISM and particular attention to effects of atmosphere and light (*Spring Shower, Connecticut Valley* 1868). The son of a prosperous Pennsylvania farmer, he had an early training with Thomas Hicks and visited Europe *c.* 1837-40, spending two years in Rome. A compulsive wanderer, he lived in many American cities, travelled in Central America and visited Puerto Rico. In 1863 he accompanied the Rev. J. C. Fletcher to Brazil to illustrate his book on hummingbirds; the visit inspired many paintings but the book was never published. There are works in Boston, Cincinnati, Cleveland, Detroit, New York (Met., Brooklyn), Philadelphia and Washington (NG).
Lit. R. G. McIntyre: *M. J. Heade* (1948); T. E. Stebbins: *The Life and Works of M. J. Heade* (1975)

Hébert Antoine Auguste Ernest, b. Grenoble 1817, d. Grenoble 1908. His pale melancholy scenes from history or Italian peasant life were realistically painted with a sometimes sentimental literary accent. He studied under David d'Angers and DELAROCHE, won the first Rome prize in 1839 and was in Italy until 1846. His sensational success with *Malaria* in the 1850 SALON led to an important official career. Chevalier of the Legion of Honour (1853), officer (1867), commander (1874), grand officer (1900) and holder of the grand cross (1903), he was the director of the French Academy in Rome (1867-73) and a member of the INSTITUT (1874). There is a Musée Hébert at La Tronche (Isère) and there are works in Baltimore (Walters), Bayonne, Chantilly, Dijon, Grenoble, Luxembourg, Montpellier, Paris (Louvre) and Rouen.

Heim François Joseph, b. Belfort 1787, d. Paris 1865. History painter. Faithful to his master Vincent and turn of the century NEOCLASSICISM, he was highly successful under the Restoration but outlived his fame. He won the first Rome prize in 1807, became a chevalier of the Legion of Honour (1825) and an officer (1855); he was a member of the INSTITUT (1829). There are works in Amiens, Bayonne, Bordeaux, Compiègne, Montpellier, Paris (Louvre, Carnavalet), Lyons, Pontoise, Sémur and Versailles.

Heinrich August, b. Dresden 1794, d. Innsbruck 1822. ROMANTIC landscapist, a pupil of FRIEDRICH. He was absorbed by the intimate details of landscape, the foliage and the rocks, and shared the religious reverence for nature of the NAZARENES. After studying at the Dresden Academy (1810) with Lindner, he moved to Vienna (1812) under Mössmer; there he became a friend of the OLIVIER brothers and SCHNORR VON CAROLSFELD. Illness drove him back to Dresden; he re-entered the Dresden Academy in 1818 and enjoyed a close friendship with Friedrich and DAHL. There are works in Dresden.

Helleu Paul César, b. Vannes 1859, d. Paris 1927. Graphic artist who specialized in dry-point etchings of fashionable Paris life and Parisiennes. He worked rapidly, building an image from a multiplicity of flowing lines, and was dubbed 'le Watteau à vapeur'; Proust based his Elstir on a combination of Helleu and MONET. He also executed pastels, which achieved considerable popularity, and impressionistic landscapes. A close friend of Sargent, WHISTLER, A. STEVENS and BOLDINI, he was an honorary member of the International Society of Sculptors, Painters and Gravers in London and a member of the SOCIÉTÉ NATIONALE DES BEAUX-ARTS. He was accorded the Legion of Honour (1904). There are works in most print rooms, and also in Chicago, New York (Brooklyn), Paris (Petit Palais) and Sydney.
Lit. R. de Montesquiou: *Helleu, peintre et graveur* (1913); E. de Goncourt: *Catalogues de pointes sèches de Helleu* (1898)

Henner Jean Jacques, b. Bernweiler (Alsace) 1829, d. Paris 1905. His allegorical nudes melting mysteriously into a landscape background, as well as his sensitive portraits, made him one of the most fêted French painters of the last quarter of the 19C. Of peasant stock, he studied with Goutzwiller in Altkirch (1841), with G. Guérin in Strasbourg (1844) and at the ECOLE DES BEAUX-ARTS in Paris with DROLLING (1846). He won the first Rome prize (1858) and spent 1859-65 in Italy, where he made a careful study of Correggio and the Venetians. He first exhibited at the SALON in 1863 and became a member of the INSTITUT in 1889. There are works in Baltimore (Mus. of Art,

Hébert *Malaria c.* 1850

Helleu *Madame Helleu c.* 1905

Henner *Idyll, or The Fountain* exhibited 1873

Herkomer *On Strike* 1891

Hildebrandt *The Soldier and his Child* 1832

Walters), Boston, Cincinnati, Florence, New York (Met., Brooklyn), Paris (Musée Henner, Palais des Beaux-Arts, Louvre), Philadelphia and Washington (NG, Corcoran).
Lit. H. Devillers: *J. J. Henner* (1885); C. Grad: *J. J. Henner* (1887); A. Soubies: *J. J. Henner, notes biographiques* (1905); J. Henner: *En memoire de J. J. Henner, notes intimes* (1906); L. Loviot: *J. J. Henner et son œuvre* (1912)

Henry George, b. Ayrshire 1859(?), d. London 1943. Landscape and decorative painter, one of the original GLASGOW BOYS. He studied at Glasgow School of Art and became a close friend of HORNEL, with whom he collaborated on two large works (*The Druids, Star in the East*). They visited Japan together in 1892 and he subsequently painted many Japanese subjects. He was a founder member of the NEW ENGLISH ART CLUB, an associate of the Royal Scottish Academy in 1892, and an academician in 1902; he was an ARA (1907) and an RA (1920). There are works in Capetown, Edinburgh, Glasgow and Montreal.

Herkomer Sir Hubert von, b. Waal (Bavaria) 1849, d. Budleigh Salterton 1914. He started his career as an illustrator, contributing engraved scenes of contemporary life, full of social comment, to *The Graphic* magazine. Turning to oils he achieved his first successes with similar realistically painted subjects (*The Last Muster: Sunday at the Royal Hospital, Chelsea* 1875, *Hard Times* 1885, *On Strike* 1891). He also painted happy pastoral scenes under the influence of WALKER and established an international reputation as a portraitist (*Wagner, Ruskin, Lord Kitchener*); group portraits also became a speciality (*The Council of the RA* 1908, *The Firm of Friedrich Krupp* 1914). The son of a German woodcarver who settled in Southampton in 1857, he studied at the South Kensington Schools under FILDES (1866) and began to contribute engravings to *The Graphic* in 1869; his first major success was *The Last Muster*. He became a chevalier of the Legion of Honour (1878), an officer (1889) and a correspondent member of the INSTITUT (1896); he was an ARA (1879) and an RA (1890). He was raised to German nobility in 1899 and given an English knighthood in 1907. There are works in Berlin,

Boston, Bristol, Glasgow, Hamburg, The Hague (Mesdag), Leeds, Leipzig, Liverpool, London (Tate, NPG), Melbourne, Munich and Victoria.

Lit. A. L. Baldry: *H. von Herkomer, R.A.: A Study and a Biography* (1902); Sir H. von Herkomer: *My School and My Gospel* (1908); J. Saxon Mills: *Life and Letters of Sir H. von Herkomer: A Study in Struggle and Success* (1923)

Herring John Frederick, Senior, b. Surrey 1795, d. Meopham Bank (Kent) 1865. A popular racehorse painter who also executed sporting and farmyard scenes. For many years he painted the winners of the Derby and the St Leger, and was employed as an animal painter by the Duchess of Kent. His sons, Benjamin Jr and John Frederick Jr, were also sporting and animal painters, as was his brother Benjamin Sr. There are works in Baltimore (Mus. of Art), Blackburn, Dublin, Glasgow, Leeds, Leicester, London (Tate), Melbourne and Reading.

Hildebrandt Ferdinand Theodor, b. Stettin 1804, d. Düsseldorf 1874. History, genre and portrait painter, one of the founders of the DÜSSELDORF SCHOOL. Both his subject matter and composition owed a strong debt to the theatre, particularly to Shakespeare (*The Princes in the Tower* 1835, *Faust and Mephistopheles* 1824); he was a close friend of the actor Ludwig Devrient and the poet-playwright Immermann. Like others of the school, his paintings often contain veiled political protest; *The Robber* (1829) is a celebration of the man who steals from the rich to give to the poor. He was admired as a REALIST by his contemporaries for his careful detail and sympathetic treatment of human situations (*The Soldier and his Child* 1832). He studied at the Berlin Academy from 1823 and followed his professor, SCHADOW, to Düsseldorf in 1826. He visited Belgium (1829) and Italy (1830-1) with Schadow, was in St Petersburg in 1844 and Antwerp in 1849. He taught at the Düsseldorf Academy from 1832, becoming a professor in 1836 and retiring on account of illness in 1854. He painted a portrait of WAPPERS in 1849 and was one of the first German artists to feel the influence of the BELGIAN COLOURISTS. There are works in

Amsterdam, Berlin, Cologne, Düsseldorf and Leningrad.

Hill Carl Fredrick, b. Lund 1849, d. Lund 1911. Swedish painter. His early work was influenced by COROT and DAUBIGNY but after a mental breakdown in 1878 he began to paint apocalyptic visions of gloom and despair which have been likened to both Expressionism and Surrealism. During this period he also executed numerous drawings and watercolours. He studied at Stockholm Academy (1871) before moving to Paris (1873), where he discovered the BARBIZON SCHOOL and was taught briefly by Corot. He was hospitalized in Paris from 1878 to 1880, and on his return to Lund he worked in seclusion and in a state of semi-insanity for the next thirty years. There are works in Lund, Malmö and Stockholm (Nat. Mus.).
Lit. E. Blomberg: *C. F. Hill* (1949); A. Anderberg: *C. Hill, hans liv och hans Konst* (1951)

Hilleström Pehr (the Elder), b. Väddö 1732, d. Stockholm 1816. Swedish genre painter who depicted the life of peasants and early industrial conditions in an objective and realistic style. He used lighting effects such as torches and furnaces to heighten the drama of his compositions. A master weaver, he studied tapestry and carpet-making in Paris at the Savonnérie and Gobelin factories, and painting under Boucher (1757-8). He started painting in oils (c. 1770), inspired particularly by Chardin. He became an associate of the Stockholm Academy (1773), professor (1794) and director (1810). Later in life he developed an interest in smelting processes and factory interiors. He led the development of a national school in Swedish art, not only through his works but also through his influential career as a teacher. His son, Pehr the Younger, was a landscape painter. There are works in Göteborg, Linköping and Stockholm (Nat. Mus.).
Lit. O. Sirén: *Pehr Hilleström d.ä., Väfvaren och målaren* (1900); S. Rönnow: *Pehr Hilleström och hans bruks-och bergverksmålningar* (1929)

History Painting. The depiction of scenes from history was popular with 19C artists and is a genre particularly characteristic of

the period. In the second half of the 18C NEOCLASSICAL painters had turned for subject matter to classical history and mythology with a new aim: to find scenes illustrating human qualities of eternal significance, courage, patriotism, self-sacrifice, etc. They believed that great art should be ennobling and their paintings were partly to be read as visual sermons (DAVID's *Oath of the Horatii*). It was natural that artists should subsequently turn to other periods of history to illustrate the same eternal truths. The idealism of the American and French revolutions supplied contemporary subject matter (WEST's *Death of General Wolfe*, David's *Marat*) while the ROMANTICS' interest in the Middle Ages opened up another new era to painters (PFORR's *Entry of Emperor Rudolf into Basle in 1273*, INGRES' *The Dauphin Entering Paris in 1358*). The French domination of Europe under Napoleon stimulated an intense revival of nationalism among the conquered peoples, and artists turned to the celebration of great achievements in their nation's past (HAYEZ' *Sicilian Vespers*, WAPPERS' *Burgomaster van der Werff*).

In France itself the thunder of early Romantic history painting (DELACROIX's *Massacre at Chios*, DEVÉRIA's *Birth of Henri IV*, BOULANGER's *Mazeppa*) gave way under Louis-Philippe to the depiction of more gently affecting scenes (DELAROCHE's *Princes in the Tower*). The 1830s and 1840s saw the full flowering of this historical fashion, with the French school (Delaroche, COGNIET, ROBERT-FLEURY) exerting a wide international influence. Already apparent in their work was an element of the scientific attitude of the REALIST generation; their paintings were preceded by careful historical and archaeological researches to ensure the authenticity of costume, architecture and accessories. Their successors, now sometimes referred to as ACADEMIC REALISTS (LEYS, MEISSONIER, MENZEL) turned to painting imagined scenes from daily life in earlier times, with the same scientific attention to authenticity but without necessarily depicting any recorded event. In the latter years of the 19C costume genre of this type became universally popular, some artists turning to classical times (ALMA-TADEMA), others to cavaliers and roundheads, and others again to *fêtes galantes* of the 18C.

Recent criticism often dismisses these developments under the blanket heading of

Hodler *Night* 1890

Hoeckert *The Burning of Stockholm Castle* 1866

Homer *The Gulf Stream* 1899

Hübner *The Emigrants' Farewell* 1846

'historicism'. During the 19C itself, however, history painting was considered the highest form of artistic endeavour; there was a universally accepted hierarchy of importance in subject matter: history painting came first, followed by genre, portrait, landscape and still life – in that order. By history painting was understood the depiction of scenes from history, the Bible, classical mythology as well as allegorical works.

Hodler Ferdinand, b. Berne 1853, d. Geneva 1918. One of the most important Swiss painters of the 19C. Influenced in his early work by COROT and COURBET, and later by the tonal range of the IMPRESSIONISTS, his mature work (landscape, allegory, history) was part naturalistic, part SYMBOLIST. Its dominant characteristic was an emphasis on structure, symmetry, parallelism and rhythm; he used a formal structure with clear outlines to heighten the mystical and emotional impact of the work. He studied (1867–70) with Sommers in Thun, painted landscapes for the tourist trade, and moved to Geneva in 1871. Here he was befriended by MENN, who took him as his pupil (1871–6) and introduced him to the work of Corot and the BARBIZON SCHOOL. His first major allegorical work, *Night*, playing on the parallelism of sleeping forms, was exhibited at the Paris Salon des Champs-de-Mars in 1891. He became a member of the Société Nationale des Artistes Français and exhibited at the SALON DE LA ROSE + CROIX in 1892. He turned increasingly to monumental figurative compositions: *Weary of Life*, *Disappointed Souls* and *Eurythmy* (trilogy 1891–5), *Retreat from Marignano* (1896–1900), *Day* (1900), *William Tell* (1903) and others. In 1904 he was accorded the main room at the Vienna SECESSION exhibition and his own gallery at the Berlin Secession. There are works in the chief Swiss museums, including the Kunstmuseum in Basle, and in Cambridge Mass. (Fogg), Chicago, Cologne, Düsseldorf, Frankfurt/M., Hamburg, Hanover, Leipzig, Munich (N. Pin.), Stuttgart and Vienna (Kunsthistorisches Mus.).
Lit. H. Mühlestein, G. Schmidt: *F. Hodler 1853–1918: Sein Leben und sein Werk* (1942); W. Hügelshofer: *F. Hodler* (1952); J. Brüschweiler: *F. Hodler und sein Sohn Hector* (1966–7)

Hoeckert Johann Fredrik, b. Jönköping 1826, d. Göteborg 1866. Genre and historical painter whose lifesize scenes of peasant and Lapp life had a great influence on his Swedish contemporaries, as did his ROMANTIC historical works which combine the influences of DELAROCHE and DELACROIX. He studied with Boklund in Munich (1846–9) and visited Lapland in 1849. He studied with KNAUS in Paris from 1851, winning his first SALON success and a two-year pension from the King of Sweden with *Queen Christina Orders the Assassination of Monaldeschi* (1853). *Service in a Lapland Chapel*, with lifesize figures, won a gold medal at the 1855 EXPOSITION UNIVERSELLE. He returned to Stockholm to teach at the academy in 1857, but continued to travel widely. There are works in Göteborg, Lille and Stockholm (Nat. Mus.).
Lit. H. Wieselgren: *J. F. Hoeckert 1826–66* (1900)

Homer Winslow, b. Boston (Mass.) 1836, d. Prout's Neck (Me.) 1910. American naturalist painter and illustrator; apparently uninfluenced by the French IMPRESSIONISTS, he developed a similar technique with summary brushwork and a concentration on light. He was apprenticed to a Boston lithographer (1855–7) and worked as an illustrator for *Ballou's Pictorial* and *Harper's Weekly* (1857–75). His illustrations of sport and everyday life were very popular, as were his Civil War scenes from 1862. He worked for many years on wood-block techniques, and his methods of emphasizing light and dark masses and manipulating space drew close to Japanese prints – to which he may have been introduced by LA FARGE. He started painting in oils during the Civil War, and was elected associate of the NATIONAL ACADEMY OF DESIGN (1864) and academician (1865). He spent a year in Paris when his first oil, *Prisoners from the Front*, was selected for the EXPOSITION UNIVERSELLE (1867). The 1873 exhibition of English watercolours at the National Academy may have sparked his interest in this medium; he developed a loose flowing treatment which subsequently appears also in his oils. To the 1870s belong his paintings of rural life and children. In the 1880s he turned to large-scale works of fishermen and the sea, spending 1881–2 working from

nature on the English coast, exhibiting *Hark, Hark, The Lark* at the ROYAL ACADEMY in 1882. He settled at Prout's Neck on the coast of Maine in 1883; his sea pictures were combined with bright sunlit watercolours of Bermuda and the Bahamas. After 1890 he concentrated on seascapes, often without figures (*Cannon Rock* 1895, *North-Easter* 1895, *The Gulf Stream* 1899). In his last years he became a total recluse and was only partially understood by his contemporaries; his high reputation dates from the 20C. There are works in Baltimore (Mus. of Art), Boston, Chicago, Milwaukee, New York (Met., Brooklyn), Philadelphia, Washington (NG, Corcoran), Williamstown Mass. and Yale.
Lit. L. Goodrich: *W. Homer* (1959); A. T. Gardner: *W. Homer, American Artist: His World and his Work* (1961); D. F. Hoopes: *W. Homer Watercolours* (1969); S. Longstreet: *The Drawings of W. Homer* (1970); J. Wilmerding: *W. Homer* (1972)

Hornel Ernest Atkinson, b. Victoria 1864, d. Kirkcudbright 1933. Genre painter, one of the GLASGOW BOYS. He studied at the Trustees Academy, Edinburgh, and in Belgium under VERLAT. He was a close friend of HENRY, with whom he collaborated on two large paintings, and paid an influential visit to Japan in 1892. His Japanese paintings of 1893–4 are most highly regarded. There are works in Bradford, Glasgow, Leeds, Liverpool, Manchester, Montreal, Sunderland and Toronto.

Horny Franz Theobald, b. Weimar 1798, d. Olevano 1824. Landscapist, an associate of the NAZARENES in Rome. His landscape drawings and watercolours, influenced by OLIVIER and SCHNORR, are among the finest of this school. After studying at Weimar art school, he found a patron in the dilettante and art historian Karl Friedrich von Rumohr, who took him to Rome (1816). He worked with KOCH and with CORNELIUS on the Casino Massimo frescoes. From 1819 to his death he lived in the village of Olevano. There are works in Berlin, Dresden, Frankfurt/M., Nuremberg, Vienna and Weimar.
Lit. W. Scheidig: *F. Horny* (1954)

Hove Family of Artists. Dutch family of painters closely involved in the adaptation of the 17C tradition of landscape and genre painting to the ROMANTIC and REALIST eras.
Bartholomeus Johannes (b. The Hague 1790, d. The Hague 1880) was a scene painter and townscapist; the exteriors of massive Gothic churches constantly recur in his busy town scenes. He received many honours in his lifetime and was drawing instructor to the Princess of Orange. He and his son Hubertus trained many of the important mid-century artists of the HAGUE SCHOOL; Marius calls him 'the foundation upon which a whole generation of artists has built'. His own pupils included BOSBOOM and Weissenbruch. His three sons Hubertus, Johannes Hubertus and Willem were all artists; the sculptor Bart Vetter was his grandson, ANDREAS SCHELFHOUT his cousin, and Antonie Waldorp his brother-in-law.
Hubertus (b. The Hague 1814, d. Antwerp 1865) studied with his father and H. van de Sande Bakhuizen. Having experimented with landscape and church interiors, in the manner that Bosboom so successfully derived from his father's teaching, he devoted most of his artistic career to traditional Dutch interiors with a strong debt to Pieter de Hooch. J. MARIS and C. Bisschop were among his pupils. There are works by Bartholomeus Johannes in Amsterdam, The Hague (Communal) and Rotterdam; by Hubertus in Graz, The Hague, Leipzig, Munich, Rotterdam and Stuttgart.

Hübner Carl Wilhelm, b. Königsberg (now Kaliningrad) 1814, d. Düsseldorf 1879. Düsseldorf genre painter whose fame rests on his political paintings of the 1840s, highlighting the inhumanities of feudal overlords and the new middle classes; *The Weaver* (1844) underlines the pittance paid to weavers by profiteering wholesalers, while *Game Laws* (1845) shows a peasant shot by an overlord for hunting on his land. He studied at the Düsseldorf Academy with SCHADOW and SOHN (1837) and was an officer in the Düsseldorf city militia during the 1848 revolution. His later works depict the life of the poor in a more conventional manner, without political overtones. He became a professor at the Düsseldorf Academy in 1864 and influenced several younger artists, including KNAUS. He was accorded the order of Leopold of Belgium, and was a member of the Antwerp and Philadelphia Academies.

There are works in Berlin, Wrocław, Cincinnati, Dresden, Düsseldorf, Gotha, Hamburg, Hanover, Kaliningrad, Karlsruhe, New York (Met.), Oslo (NG) and Riga.

Hudson River School. American landscape school, the first indigenous movement to achieve wide popularity in America. The artists worked chiefly in the Catskill Mountains of New York, the White Mountains of New Hampshire, and along the banks of the Hudson River. The forerunner and founder of the school was COLE, in his naturalist mode; after Cole's death DURAND, recognized then as the 'greatest artist in America', became the pivot of the school and, in his writings, its chief theoretician. He believed that the 'general truths and spirit' of a landscape should be shown, rather than 'literal features of view'. He saw landscapes as 'visual sermons'. His followers ranged from self-taught itinerant artists, who provided primitive views for a popular market, to painters of great sophistication and power. Among the principal artists were WHITTREDGE, KENSETT, GIFFORD and DOUGHTY; they painted wide vistas of untamed American landscape with few figures, and hermetic forest interiors with wildly rampant vegetation. Their work combines careful naturalistic detail with dramatic effects of light and atmosphere; for this reason some members of the group (notably HEADE, LANE, Gifford and Kensett) are known also as LUMINISTS. Such effects were further developed and dramatized by the second generation of Hudson River artists, BIERSTADT, CHURCH and MORAN – also known as the Rocky Mountain School.
Lit. J. K. Howat: *The Hudson River and its Painters* (1972)

Huet Paul, b. Paris 1803, d. Paris 1869. ROMANTIC landscapist, a friend of DELACROIX and BONINGTON, and forerunner and associate of the BARBIZON SCHOOL. He worked constantly from nature, in his early years (*c.* 1816–26) in the rambling wilderness of the Ile de Seguin near Saint-Cloud, and later particularly in Normandy where he painted many seascapes. A spontaneous treatment of atmosphere and light was already apparent in his work before the famous SALON of 1824 where the English artists CONSTABLE, Bonington and the Field-

Huet *View of Rouen* 1831

Hughes *April Love* 1855–6

ings made their impact on French painting (*Elm Trees at Saint-Cloud* 1823). Influenced by the Romantic poets, his landscapes dwell on nature in its more dramatic moods, the flood, the storm, man battling with the elements (*Flood at Saint-Cloud* 1855). He studied with GUÉRIN (1818) and GROS (1820), in whose studio he met Bonington. His life-long friendship with Delacroix began in 1822. He was also a friend of HUGO, Dumas and many writers, and was considered by his contemporaries the founder of Romantic landscape. He was accorded the Legion of Honour in 1841, and after 1849 was often in Barbizon. He also did many etchings and lithographs. There are works in Paris (Louvre) and many French provincial museums.
Lit. R. P. Huet, M. G. Lafenestre (eds.): *P. Huet d'après ses écrits, sa correspondance, ses contemporains* (1911); P. Miguel: *P. Huet : De l'aube romantique à l'aube impressioniste* (1962)

Huggins William, b. Liverpool 1820, d. Christleton (nr Chester) 1884. Painter of animals, historical scenes (usually incorporating animals) and portraits. An associate of the Liverpool Academy (1847), and member (1850), he exhibited at the ROYAL ACADEMY from 1842 to 1875. There are works in Blackburn and Liverpool.

Hughes Arthur, b. London 1832, d. London 1915. One of the closest followers of the PRE-RAPHAELITES and particularly influenced by MILLAIS. The subjects of his paintings were predominantly personal dramas in lyrical rustic settings (*The Long Engagement* 1859, *Home from the Sea* 1863), though he also painted Arthurian legend and literary genre. His paintings declined in quality from the mid-1860s, but he was a prolific and distinguished illustrator. He studied with the English sculptor Stevens (1846) and at the ROYAL ACADEMY Schools from 1847, at the same time as W. H. HUNT and Millais; his friendship with the Pre-Raphaelites followed. He first exhibited at the Royal Academy in 1852, and won high praise from Ruskin for his *Ophelia* (1852) and *Eve of St Agnes* (1856). He collaborated on the Oxford Union frescoes (1857) with ROSSETTI, BURNE-JONES *et al.*, and the following year withdrew from public life. There are works

in Birmingham, Bradford, Liverpool, London (Tate, V&A), Manchester and Oxford.

Hugo Victor Marie, b. Besançon 1802, d. Paris 1885. The great French Romantic poet was also a distinguished graphic artist. His drawings parallel his writings, depicting the Gothic castle, the wild storm, the blasted tree, and also imaginative scenes from fairy legend. His drawings served 'as a more rapid and precise means than writing of fixing the vision which flitted through his mind' (M. Clouard). His drawings can be seen in the Musée Victor Hugo in Paris.
Lit. Dessins de V. Hugo, gravés par P. Chenay, texte par T. Gautier (1863); J. Sergent: *Dessins de V. Hugo* (1955); J. Delalande: *V. Hugo, dessinateur génial et halluciné* (1964); C. W. Thompson: *V. Hugo and the Graphic Arts, 1820–1833* (1970); P. Georgel: *Dessins de V. Hugo* (1971)

Hummel Johann Erdmann, b. Kassel 1769, d. Berlin 1852. Naïve BIEDERMEIER REALIST, specializing in architectural subjects. He studied at the Kassel Academy, first architecture and then painting from 1790. He spent 1792–9 in Rome where he met REINHART and KOCH. In Berlin (from 1800) he worked on theatrical designs and illustrations, and in 1809 became professor of perspective at the Berlin Academy, of which he was made a member in 1811. Curious effects of light and trick perspective were of special fascination for him; the four paintings devoted to reflections in a granite bowl set up in front of Altes Museum (1831) are the most famous examples. There are works in Berlin, Frankfurt/M. and Oslo (NG).
Lit. G. Hummel: *Der Maler J. E. Hummel : Leben und Werk* (1954)

Hunt William Henry, b. London 1790, d. London 1864. A painter of still life, landscape and rustic genre, most famous for his small, highly detailed watercolours of nature, a bird's nest among primroses, ferns, etc. These earned him the nickname of 'Birdsnest Hunt' or 'Hedgerow Hunt'. He studied with VARLEY and was a close friend of LINNELL. His work was highly praised by Ruskin and he had a host of imitators, including the successful later watercolourist FOSTER. There are works in Amsterdam,

Birmingham, Cardiff, Dublin, Glasgow, Leicester, Liverpool, London (NPG, V&A), Manchester and Preston.
Lit. Ruskin: *Notes on S. Prout and W. H. Hunt* (1879)

Hunt William Holman, b. London 1827, d. London 1910. Founder member of the PRE-RAPHAELITE Brotherhood with MILLAIS and ROSSETTI; he was a guiding spirit in the Brotherhood's early days and the only artist to remain in his later work true to its tenets, namely: 'truth to nature' – interpreted as a minute attention to detail – and a dedication to moral and social improvement, often symbolically expressed (*The Hireling Shepherd* 1853, *Awakening Conscience* 1854). His major biblical pictures took many years of painstaking work, with visits to the Holy Land to ensure verisimilitude; their popularity as steel engravings place them among the best-known images of the Victorian era (*The Light of the World* 1853, *Finding of Christ in the Temple* 1854-60, *Scapegoat* 1854, *Shadow of Death* 1870-3). In 1844 he entered the ROYAL ACADEMY Schools, where he met Millais and Rossetti with whom he formed the Pre-Raphaelite Brotherhood in 1848. He first exhibited at the academy in 1846; his first work signed with the initials P.R.B. was *Rienzi*, exhibited in 1849. In 1850 his *Druids* was sharply criticized but *Valentine and Sylvia* of 1851 brought Ruskin's enthusiastic championship and a Liverpool exhibition prize. He visited Egypt and Palestine in 1854-6, 1869-72 and 1875-8. He was the first to publish an account of the Pre-Raphaelite Brotherhood, an article in *Contemporary Review* of 1886 and a two-volume work, *Pre-Raphaelitism and the Pre-Raphaelite Brotherhood*, in 1905. There are works in Birmingham, Leeds, Liverpool, London (Tate, V&A), Oxford, Manchester, Melbourne and Preston.
Lit. A. C. Gissing: *W. H. Hunt, a Biography* (1936); D. H. Hunt: *My Grandfather, His Wives and Loves* (1969); G. H. Fleming: *That Ne'er Shall Meet Again: Rossetti, Millais, Hunt* (1971)

Hunt William Morris, b. Brattleboro (Vt.) 1824, d. Isle of Shoals (N.H.) 1879. American figure, portrait and, in later years, landscape painter. After studying in Düsseldorf and with COUTURE in Paris (1847), he discovered MILLET in 1850 and worked for two years at his side in Barbizon, helping him considerably by purchasing his works. He returned to America in 1856, settling at Newport and later in Boston (1862), where he became an artistic mentor. He introduced the BARBIZON SCHOOL to America and was an important influence on LA FARGE and HASSAM. In 1875 he was commissioned to execute two murals for the State Capitol, Albany. Only the sketches and studies for these now remain. He was drowned on the Isle of Shoals in 1879. There are works in New York (Met.) and Washington (Corcoran).
Lit. W. M. Hunt: *Talks on Art* (1877); H. C. Angell: *Records of W. M. Hunt* (1881); H. M. Knowlton: *Art-Life of W. M. Hunt* (1899)

Hugo *Tower of Rats* 1840

Holman Hunt *Shadow of Death* 1873

I

Impressionism (Impressionist). The final development of that strain of naturalistic painting, particularly landscape, which is a central feature of 19C art from CONSTABLE in England to PALIZZI in Naples, BLECHEN and others in Germany and the BARBIZON SCHOOL in France. It carried the REALIST landscape painting of COURBET, COROT and DAUBIGNY a stage further by concentrating on colour and light in rapid summary brush-strokes. 'They discovered that, if we look at nature in the open, we do not see individual objects each with its own colour but rather a bright medley of tones which blend in our eye or really in our mind' (Gombrich). Influenced by Chevreul's scientific treatises on colour harmonies, Impressionist artists did away with traditional chiaroscuro modelling in shades of grey, using instead juxtaposed dabs of complementary colour. The

central figures of Impressionism were MANET, MONET, RENOIR, SISLEY, PISSARRO and DEGAS, along with BAZILLE, GUILLAUMIN, MORISOT, CASSATT and CAILLEBOTTE. The great years of the movement were 1870–90. Even during this period, however, there were wide divergencies of attitude and technique between the various members of the group; what brought them together was the antagonism of the art establishment and constant rejections by the SALON jury. In 1874 they held their first Group Show; Monet's *Impression – Sunrise* was lampooned in the *Charivari* and the exhibitors were jeeringly referred to as 'impressionists'. The name was adopted by the group themselves and seven more Impressionist Group Shows were held before 1887. Public acceptance of their work came slowly, though many successful artists borrowed from them; in many countries, including Russia and America, the influence of Impressionism was first felt through the work of BASTIEN-LEPAGE.
Lit. J. Rewald: *The History of Impressionism* (1946); F. Mathey: *The World of the Impressionists* (1961)

Indépendants, Salon des. As a reaction against the official Paris SALON jury's exclusions, rejected artists organized a Groupe des Artistes Indépendants in 1884, and in May opened an exhibition in the Tuileries Gardens at which anyone could exhibit. There was no jury and no selection. REDON, SEURAT, SIGNAC and GUILLAUMIN were among the motley crew of exhibitors. The operation was highly disorganized and a more responsible group, including Redon, subsequently formed the Société des Artistes Indépendants. They continued to hold annual Salon exhibitions with no jury.

Induno Domenico, b. Milan 1815, d. Milan 1878. Pioneer and popularizer of narrative genre painting in Italy. In his early years he treated historical and religious subjects, changing in 1846 to contemporary scenes, especially patriotic themes and the everyday life of the poor. His brushwork became progressively more summary and from *c.* 1860 he adopted bright clear colours for his detailed canvases, which always express a touching sentiment or story. Born into a poor family, he was apprenticed to a goldsmith before entering the Milan Academy

under SABATELLI; *Alexander the Great* (1837) won him a prize and a pension to visit Rome. His first contemporary genre painting was *Vivanderia* (1846). He was involved in the revolution (1848) and afterwards lived in Switzerland and Tuscany until 1859, when he settled in Milan. His patriotic *Peace of Villafranca* (1860) won him fame throughout Italy and he painted many replicas. His brother Gerolamo (1827–90) was also a genre painter, more traditionalist in technique and REALIST in spirit. Closely involved in the Risorgimento campaigns, he painted many military scenes and followed the Italian forces to the Crimea in 1855. There are works in Florence (Uffizi), Milan (Brera, Mod. Art), Naples (Capodimonte), Padua (Civico), Rome (Mod. Art), Trieste (Revoltella) and Turin (Mod. Art).
Lit. G. Nicodemi: *D. and G. Induno* (1945)

Ingres Jean Auguste Dominique, b. Montauban 1780, d. Paris 1867. The most distinguished and influential exponent of mid-19C French classicism. His highly finished paintings combine an almost photographic REALISM with a new range of solutions to the problem of ideal beauty in composition and form. In this sphere his influence can be traced on DEGAS, RENOIR and even Picasso, though he exerted the most direct influence on the academic painters who were his pupils. He was a supreme draughtsman, using meticulously controlled line and fine cross-hatching to record the character and appearance of visitors to Rome, from whom he made a living in his early years. Later he became the champion of line against colour in the Classic-Romantic controversies of the 1820s and 1830s, in which DELACROIX represented the opposite polarity. A carefully orchestrated harmony of tones is, nevertheless, a powerful feature of his work, especially in the treatment of rich stuffs and surface textures. Portraits have often been seen as his crowning achievement, though he himself considered them a time-consuming interruption of his career as a history painter. An eclectic, he sought compositional prototypes in that art of the past most suited to his subject matter: antique sculpture, vase painting and medallions (also the outline drawings of FLAXMAN), in early Italian painting from Giotto to Perugino, most particularly in Raphael, in medieval illu-

minations and even Persian and Indian art. He received his first instruction from his father and studied at the Toulouse Academy. He entered the studio of DAVID in 1797 and in 1801 won the first Rome prize with his *Envoys of Agamemnon before Achilles*. The troubled political climate delayed his departure for Rome until 1806; he earned his living with portraits (*Bonaparte as First Consul* 1804, *Mlle Rivière* 1805), in which his combination of finely observed Realism and ornamental arrangement first becomes apparent. He lived in Italy from 1806 to 1824; the paintings that he was required, like other students, to send back to the Paris Académie were sharply criticized. In 1808 he sent *Oedipus and the Sphinx* and the *Bather of Valpinçon*, the first of his subtly erotic full-length nudes (half-length 1807); this was a theme to which he constantly returned, and which culminated in *The Turkish Bath* (1862). When his scholarship ran out he turned to portraits and portrait drawings for a living, also trying his hand at small narrative paintings (*Raphael and the Fornarina* 1814, *The Dauphin Entering Paris* 1821). In 1824 he returned to Paris where his *Vow of Louis XIII*, a mystical religious work heavily indebted to Raphael, was a SALON triumph; chevalier of the Legion of Honour in 1824 (officer 1826) and a member of the INSTITUT (1825), he was commissioned to paint the *Apotheosis of Homer* ceiling for the Louvre (completed 1827). Students flocked to his studio. From 1835 to 1841 he was director of the French Academy in Rome (*Odalisque with Slave* 1839, *Roger and Angelica* 1839, *Antiochus and Stratonice* 1840). After his return to Paris he worked on a fresco, *The Golden Age* (1843–50), for the Château de Dampierre, painted some of his most outstanding portraits (*Baronne de Rothschild* 1848, *Mme Moitessier*, versions 1851 and 1856) and returned to his exploration of the female nude (*Venus Anadyomene* 1848, *La Source* 1856, *Turkish Bath* 1862). He became a commander of the Legion of Honour in 1845 and grand officer in 1855 when the EXPOSITION UNIVERSELLE contained a triumphant retrospective exhibition of his work. In 1862 he was named a senator. There are works in Paris (Louvre), the Ingres Museum at Montauban and several French provincial museums, and also in Antwerp, Baltimore (Walters), Brussels (Musées

Induno *Peace of Villafranca* 1860

Ingres *Roger and Angelica* 1839

Inness *The Coming Storm* 1878

Royaux), Buffalo, Cambridge Mass. (Fogg), Chicago, Cincinnati, Cleveland, Cologne, Detroit, Düsseldorf, Florence (Uffizi), Hartford Conn., Kansas City, Leningrad (Hermitage), London (NG), New York (Met., Frick) and Washington (NG). *(see colour illustration 1)*
Lit. H. Lapauze: *Ingres, sa vie et son œuvre* (1911); J. Alazard: *Ingres et l'Ingrisme* (1950); G. Wildenstein: *Ingres* (1954); N. Schlenoff: *Ingres, ses sources littéraires* (1956); R. Rosenblum: *J. A. D. Ingres* (1967); P. Gaudibert: *Ingres: the Life and Work of the Artist* (1971)

Inness George, b. nr Newburgh (N.Y.) 1825, d. Bridge of Allan (Scotland) 1894. Landscapist who carried the HUDSON RIVER tradition from the mountains to the cultivated plains and rejected panoramic vistas for intimate views. He introduced the colouristic lessons of DELACROIX and the BARBIZON SCHOOL into American art, blurring the focus of both light and detail in a hazy softness. He was one of the most influential founders of Native American Impressionism, though he violently rejected any attempt by critics to link his work with the French school. An epileptic, he was apprenticed to a mapmaker in 1841 and studied from 1844 with the French landscape painter R. F. Gignoux in Brooklyn. The successful sale of his early Hudson River-style works, strongly influenced by COLE and DURAND, enabled him to visit Europe in 1850 and 1854, when he became intimately involved in the battles of Delacroix and the Barbizon painters. He settled in Medfield (Mass.) in 1859, moving to New Jersey in 1864 and spending 1870-4 in Rome and Paris. His mature style developed slowly but his final adoption of restricted views painted on small canvases in summary impressionistic style catapulted him to fame and fortune. CONSTANT stated that 'no greater landscapist had ever painted' (Flexner). A full member of the NATIONAL ACADEMY OF DESIGN in 1868, he was admired by the new generation of European-oriented artists and became co-founder of the Society of American Artists in 1877. Deeply religious, like the Hudson River artists he saw landscape painting as a form of religious expression, and found endorsement for his own subjective attitude in Swedenborgianism. There are works in most major American museums and also in Frankfurt/M. and Montreal.

Lit. G. Inness Jr: *Life, Art and Letters of G. Inness* (1917); E. McCausland: *G. Inness, an American Landscape Painter* (1946); L. R. Ireland: *The Works of G. Inness. An Illustrated Catalogue Raisonné* (1965); N. C. Rousky: *G. Inness* (1971)

Institut *see* FRENCH ART ESTABLISHMENT

Intimisme (Intimiste). A form of painting notably developed by VUILLARD and BONNARD in which scenes of daily family life are caught with a quiet but lyrical intimacy. Their brushwork broadly follows the IMPRESSIONISTS, though Vuillard and his brother-in-law ROUSSEL used a muted range of tones. In the work of other turn-of-the-century artists such as AMAN-JEAN and BESNARD, Intimiste studies are mixed with an element of SYMBOLIST mystery. In England similar intimate interiors were painted by SICKERT and STEER.

Isabey Jean Baptiste, b. Nancy 1767, d. Paris 1855. The most successful French portrait miniaturist of the early 19C. He studied with Dumont and DAVID, first exhibiting at the 1793 SALON. He was a favourite with Napoleon and Joséphine and the official organizer of their fêtes; thereafter he succeeded in working for Louis XVIII, Charles X, Louis-Philippe and Napoleon III. Chevalier of the Legion of Honour in 1817, he reached the rank of commander in 1853. There are works in Paris (Louvre, Carnavalet) and Versailles, and most museums with collections of miniatures have examples of his work.
Lit. Mme de Basily-Callimaki: *J. B. Isabey, sa vie et son temps* (1909); M. W. Osmond: *J. B. Isabey, the Fortunate Painter* (1947)

Isabey Louis Gabriel Eugène, b. Paris 1803, d. Lagny 1886. Marine, landscape and genre painter of the French ROMANTIC school. Strongly influenced by DELACROIX, he applied a summary brushwork and sparkling colour to his scenes, imbuing his seascapes with a powerful feeling of the drama of nature. His work was an important early influence on BOUDIN as well as on SPITZWEG and the Munich school, and was most successful on an intimate scale; his infrequent larger works for the court and his costume genre set in the reign of Louis XIII are generally

E. Isabey *Arrival of Queen Victoria at Treport* 1843

I. Israëls *The Shop Window*

J. Israëls *Maternal Bliss* 1890

more routine. Son of J. B. ISABEY, he intended to go to sea, but his first paintings of the sea around Le Havre started him on an artistic career; exhibiting seascapes and landscapes for the first time at the SALON of 1824, he won a critical success and a first-class medal. He continued to exhibit at the Paris Salon as well as in Berlin, Vienna and Munich, and was court painter to Louis-Philippe in company with LAMI and GRANET, depicting several important events (*Napoleon's Coffin Carried on Board Ship at St Helena* 1840, *The Departure of Queen Victoria's Yacht watched by the French Fleet* 1843, *Louis-Philippe Landing at Portsmouth* 1844). He worked from nature in Normandy and Brittany, often in watercolour which he had taken up under the influence of BONINGTON. He was one of the most distinguished early lithographers. He became a chevalier of the Legion of Honour in 1832 and an officer in 1852. There are works in Baltimore, Berlin, Boston, Cambridge Mass. (Fogg), Chicago, Cleveland, Detroit, Dieppe, Edinburgh, Hamburg, London (Wallace, NG), Moscow (Pushkin), New York (Met., Brooklyn), Philadelphia, Stockholm and Washington (Corcoran).
Lit. G. Hédiard: *E. Isabey, étude, suivie du catalogue de son œuvre* (1906); A. Curtis: *Catalogue de l'œuvre lithographié d'E. Isabey* (1939)

Israëls Isaac, b. Amsterdam 1865, d. The Hague 1934. With BREITNER, the leading exponent of IMPRESSIONISM in Holland. The son of J. ISRAËLS and largely self-taught, he began his career painting small highly finished portraits and then gained success with military pictures. From 1886 he lived with Breitner in Amsterdam, where he executed quick impressionistic sketches of low life, street and sea shore scenes. In Paris (1903-14) bright contrasting colours entered his palette. He settled in The Hague. There are works in Amsterdam (Rijksmuseum, Stedelijk), Baltimore (Mus. of Art), Groningen and The Hague.
Lit. J. H. Reisel: *I. Israëls: portret van een Hollandse impressionist* (1967); A. Wagner: *I. Israëls* (1969)

Israëls Josef, b. Groningen 1824, d. The Hague 1911. In his day considered the greatest Dutch artist of the century, he was the leader of the HAGUE SCHOOL. Fishermen and peasants provided his main subject matter. In his most admired period (*c.* 1870-90) he painted simple scenes from daily life with psychological insight; soft light is concentrated on a few figures while the background is in tones of grey. His power to convey character and emotion through the painting of hands was particularly praised. Scenes from working life became a characteristic of the Dutch school in the late century under his influence, which was also felt by VAN GOGH and LIEBERMANN. He studied in Amsterdam (1840) with the history painter KRUSEMAN and at the academy under PIENE-MAN, before moving to Paris where he studied with PICOT, H. VERNET and DELAROCHE, and felt a profound admiration for SCHEFFER and DECAMPS. On his return to Amsterdam (1847) he began to exhibit history paintings with Old Testament themes. Under the influence of the BELGIAN COLOURISTS he turned (*c.* 1852) to themes from Dutch history which, with his portraits, first showed the psychological leanings of his later work. A visit to Zandvoort (1855) inspired his interest in the lives of fishermen, and his first works in this vein are anecdotal and painted with attention to detail. In the 1860s his style became steadily looser and romantic overtones were replaced by poetic simplicity; his mature style developed after he settled in The Hague (1870). In the 1890s he turned to landscape painting and *c.* 1900 significantly lightened and brightened his palette under the influence of his IMPRESSIONIST son I. ISRAËLS. There are works in Amsterdam (Rijksmuseum, Stedelijk), Baltimore (Mus. of Art), Dordrecht, Glasgow, Groningen, The Hague (Communal, Mesdag), Leyden, London (NG), Montreal, Moscow (Tretiakov), Munich and Rotterdam.
Lit. J. E. Phythian: *J. Israëls* (1912); A. Plasschaert: *J. Israëls* (1924); H. E. van Gelder: *J. Israëls* (1945)

Ivanov Alexander Andreyevich, b. St Petersburg 1806, d. St Petersburg 1858. Russian painter who spent most of his life in Italy and some twenty years of it on one huge canvas, *Christ Appearing to the People*. Profoundly influenced by the NAZARENES, he saw a philosophical interpretation of religion as the highest aim of art. His preparation for *Christ Appearing to the People* involved

twenty-four compositional studies, some in oil and highly finished, together with over two hundred sketches of landscapes and figures whose spontaneous and sensitive realism led a later generation to compare him with the IMPRESSIONISTS. He laid special stress on verisimilitude, making figure studies in the Jewish quarter of Livorno, attempting to obtain a pension for travel to the Holy Land (in which he was supported by OVERBECK and THORWALDSEN) and, having failed, working constantly in parts of the Campagna which he believed to resemble Palestine. He entered St Petersburg Academy at the age of twelve, studying under his father. His early works treated classical and religious themes; in 1827 his *Joseph Inter-*

preting Dreams and sketches of the *Laocoön* and *Venus de Medici* won him a gold medal and travel scholarship. Leaving in 1830, he reached Rome in 1831. A *Noli Me Tangere* completed in Rome in 1835 was enthusiastically received in St Petersburg and he was named a member of the academy. He then devoted himself to his major work; the 1848 revolution sparked a crisis of religious doubt and he fell under the influence of the German theologian D. Strauss. In 1858 he decided to exhibit his *Christ* with no further work and accompanied it to St Petersburg, where he died. There are works in Leningrad (Russian Mus.) and Moscow (Tretiakov, Pushkin).
Lit. M. Alpatov: *A. Ivanov* (1956, in Russian)

Ivanov *Christ Appearing to the People* 1834

J

Jacque Charles Emile, b. Paris 1813, d. Paris 1894. Animal painter of the BARBIZON SCHOOL and a close friend of MILLET. His most frequent subjects were flocks of sheep and domestic farmyard scenes. He exhibited in the SALON between 1845 and 1870, and received the Legion of Honour in 1867. There are works in Paris (Louvre), many French provincial museums, and in Amsterdam (Stedelijk), Baltimore (Mus. of Art, Walters), Boston, Bucharest (Muzeul Toma-Stelian), Cincinnati, Cleveland, Glasgow, The Hague (Mesdag), Minneapolis, Montreal, New York (Met., Brooklyn), Philadelphia, Reims, Sheffield and Williamstown Mass. (Clark).

Janmot Anne François Louis (called Jean Louis), b. Lyons 1814, d. Lyons 1892. Religious painter of the Lyons school whose work is based on the example of the 14C and 15C Italian masters. Focillon calls his work a 'mystic marriage of a visionary and an Ingriste' and comments that he surpasses BLAKE and the English PRE-RAPHAELITES in poetic depth and enigmatic power of expression. He studied with Bonnefond in Lyons and INGRES, Orsel and FLANDRIN in Paris, exhibiting in both cities. He travelled widely and decorated many churches; his most

famous works are a cycle of vast paintings entitled *Poème de L'Ame*. There are works in Lyons, Périgueux and Versailles.

Jettel Eugen, b. Johnsdorf 1845, d. Lussingrande 1901. Austrian landscapist, long resident in Paris, and an important link between the BARBIZON SCHOOL and visiting artists from German-speaking countries. He painted the broad flat landscapes of northern France and Belgium in intimate, slightly dreamy mood, with fine colour sense. He studied from 1860 at the Vienna Academy under Zimmerman. While based in Paris (1873–95) he travelled in France, Hungary and Italy, and he settled in Vienna in 1895. He was accorded the Legion of Honour in 1889. There are works in Abbeville, Amsterdam, Berlin, Chicago, Leipzig, Munich, New York and Vienna (Belvedere).

Johnson Eastman, b. Lovell (Me.) 1824, d. New York 1906. Genre painter and portraitist who combined the lessons of the DÜSSELDORF SCHOOL with the study of Rembrandt and Dutch 17C genre to develop a technically distinguished style of narrative painting drawn from American life. His work tends to sentimentalize. Self-taught,

Janmot *Flower of the Fields*

Jettel *Fields near Auvers-sur-Oise* 1894

Johnson *Not at Home c.* 1872-80

Jongkind *Banks of a Canal in Holland* 1868

he began as a portraitist in crayon *c.* 1841, before travelling to Düsseldorf (1849), where he shared a studio with LEUTZE, and to The Hague, where he was offered a post as court painter. He studied briefly with COUTURE in Paris and returned to America in 1855. *Old Kentucky Home* (1859) made his reputation, and many genre scenes followed. His experimental outdoor genre sketches of the 1870s have a spontaneity that relates him to INNESS and HOMER; he was never commissioned to work them up into finished pictures and turned almost exclusively to portraiture in the 1880s. There are works in Baltimore (Mus. of Art, Walters), Boston, Buffalo, Cambridge Mass. (Fogg), Chicago, Cincinnati, Cleveland, Detroit, New York (Pub. Lib., Brooklyn), Philadelphia, Pittsburgh, Syracuse and Washington (NG, Corcoran). *Lit.* J. I. H. Baur: *An American Genre Painter: E. Johnson* (1940); E. U. Crosby: *E. Johnson at Nantucket: His Paintings and Sketches of Nantucket People and Scenes* (1944); P. Hills: *E. Johnson* (1972)

Jongkind Johann Barthold, b. Lattrop 1819, d. Côte-Saint-André 1891. Dutch landscape and marine painter, a precursor of IMPRESSIONISM. His naturalistic and freely painted landscapes were (with those of BOUDIN) a formative influence on MONET. He worked up his oil paintings in the studio from sketches and watercolours made on the spot, retaining much of the freedom of the watercolour original. He studied at the Hague Academy from *c.* 1840 under SCHELFHOUT, whose winter landscapes and naturalistic drawings were an important influence on his mature style. In 1845 he met E. ISABEY and went to Paris to work with him and with PICOT. After spending 1855-60 in Holland, he returned to France, meeting Boudin in 1862 and Monet in 1863, and exhibiting with the BARBIZON SCHOOL. In 1878 he settled at Côte-Saint-André, but ended his days in a lunatic asylum. There are works in Amiens, Amsterdam (Stedelijk), Bagnères-de-Bigorre, Baltimore (Mus. of Art), Bayonne, Boston, Brussels, Elberfeld, Le Havre, London (Tate), New York (Met., Brooklyn), Paris (Louvre), Philadelphia, Reims, Rotterdam, Saintes and Washington (Corcoran). *Lit.* E. Moreau-Nelaton: *Jongkind, raconté par lui-même* (1918); G. Besson: *J. B. Jongkind, 1819-1891* (1945); M. F. Hennus: *J. B. Jongkind* (1945); V. Hefting: *Jongkind d'après sa correspondance* (1969)

Josephson Ernst, b. Stockholm 1851, d. Stockholm 1906. Leader of the Swedish SECESSION movement, the Konstnärsförbundet, founded in 1886. He painted portraits, genre and landscape; starting as a conventional northern REALIST, he became a noted colourist with a debt to both the 17C Venetians and the IMPRESSIONISTS. From the early 1880s he moved away from Realism, adding to his landscapes an element of Nordic myth and fantasy (*The Water Sprite*, several versions, 1877-84). The strange works that followed his mental breakdown in 1888 were little known in his lifetime but were a strong influence on the Swedish Expressionists. After studying at the Stockholm Academy (1867-76) and briefly with GÉRÔME in Paris (1874), he won a travel scholarship (1876) and visited Holland, Italy (1877-80) and Spain (1881-2). He settled in Paris (1882-8), becoming the leader of a group of Swedish anti-academic artists there. After his mental illness in 1888 he lived in Sweden. There are works in Göteborg and Stockholm (Nat. Mus.). *Lit.* P. O. Zennstrom: *E. Josephson* (1946); S. L. Millner: *E. Josephson* (1948); I. Mesterton: *Vagen till fosoning* (1957)

K

Kaulbach Bernhard Wilhelm Eliodorus von, b. Arolsen 1805, d. Munich 1874. The most honoured German artist of his time, successor of CORNELIUS as leader of the Munich school and forerunner of PILOTY. Following Cornelius, his major works were frescoes and cartoons; he was primarily a draughtsman. His subjects were mainly historical, but his interest lay in the philosophical significance of the events depicted; *The Destruction of Jerusalem* was a generalized analysis of the end of a civilization. He occasionally provided printed notes on the proper interpretation of his pictures. Son of the unsuccessful painter Philipp Karl Friedrich Kaulbach, from whom he received his first instruction, he entered the Düsseldorf Academy in 1822, passing from the elementary to the most advanced class in one year. He moved with Cornelius to Munich in 1826 and started fresco work. His cartoon *Battle of the Huns* (1834-7) brought him instant fame; his finely observed drawings were also much admired and he had to make several versions of his famous *Madhouse* (1835). Several publishers then turned to him for illustrations and his wood engravings for *Renard the Fox* were very popular in Germany. He was acclaimed as a 'German Hogarth' for his mixture of satire and REALISM. His sensuous paintings of female characters from Goethe confirmed this reputation and achieved a wide market through oleograph reproduction. He visited Rome in 1837 and 1838-9, and in 1835 was appointed court painter to Ludwig I of Bavaria. He executed stairway frescoes for the Berlin New Museum (1845-65) and became director of the Munich Academy in 1849. He was appointed a member of the Berlin, Dresden and Brussels Academies. He received the Legion of Honour as well as a knighthood ('von'), and also became a correspondent member of the French INSTITUT. His son Hermann was also a successful painter. There are works in Antwerp, Berlin, Bremen, Hamburg, Munich, Stuttgart and Weimar.
Lit. H. Muller: *W. von Kaulbach* (1893); F. von Ostini: *W. von Kaulbach* (1906);

J. Durck-Kaulbach: *Erinnerungen an W. von Kaulbach und sein Haus* (1922)

Keller Albert von, b. Gais 1844, d. Munich 1920. His sparkling little paintings of Munich high society first brought him wide popularity, in both Germany and Paris; they are a German parallel to the work of A. STEVENS. From the 1880s he turned to mystic-religious works, which reflected the contemporary interest in spiritualism and the occult; echoes of his earlier style remained in his female portraits. Born into a distinguished Swiss family, he was taken up by Munich society, and under the influence of VON HAGN and VON RAMBERG turned to painting in 1865; his formal training was mostly with the latter. A supporter of the Munich SECESSION (1892), he helped it to a quick social acceptance. He was knighted ('von') in 1898. There are works in Basle (Kunstmuseum), Berlin, Bremen, Hamburg, Leipzig, Munich and Vienna.
Lit. H. Rosenhagen: *A. von Keller* (1912)

Kensett John Frederick, b. Cheshire (Conn.) 1816, d. New York 1872. Landscape painter of the HUDSON RIVER SCHOOL, immensely popular around the mid-century. He turned from the wild panoramas of COLE and DURAND to more intimate views. He took a poetic delight in atmosphere and light and is cited as an important exponent of LUMINIST painting, especially for 'the beautifully realized distances and skies that were the glory of his art' (Flexner). He worked largely along the eastern seaboard, adding coastal views and the sea to the school's repertoire. Son of an English engraver, he started work in this medium, painting landscapes in his spare time. In 1840 he sailed for Europe with DURAND, Casilear and Rossiter, steeping himself in the CONSTABLE tradition in England but admitting confusion at the variety of European styles; he also visited France, Italy and Germany. On his return to America (1847) he opened a studio in New York, and became a member of the NATIONAL ACADEMY OF DESIGN in 1849. He travelled widely in

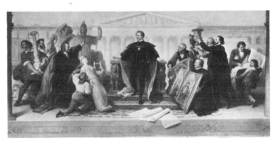
Kaulbach and pupils *Ludwig I Surrounded by Artists and Scholars* 1850-53

Keller *Portrait of a Woman* 1874

Kensett *Third Beach, Newport* 1869

Amcrica and visited Europe again in 1856 and 1861. He was very popular both with artists and with businessmen-connoisseurs; he was a member of the U.S. Capitol Art Commission (1859), and co-founder and trustee of the Metropolitan Museum. There are works in Baltimore (Mus. of Art), Boston, Buffalo, Cambridge Mass. (Fogg), Chicago, Cleveland, Detroit, New York (Brooklyn, Hist. Soc.) and Washington (NG, Corcoran). *Lit.* J. Kettlewell: *J. F. Kensett* (1967)

Kersting Georg Friedrich, b. Güstrow 1785, d. Meissen 1847. Portrait and genre painter, a close friend of FRIEDRICH in Dresden. His most distinguished works are portraits in interiors carefully selected to reflect the personality of the sitter, a genre popularly practised in Copenhagen where he spent his student years. He entered the Copenhagen Academy in 1805, moving on in 1808 to the Dresden Academy. In 1816 he was appointed drawing master to the Countess Sapieha in Warsaw, and in 1818 became head of the painting section at the Meissen porcelain factory, which allowed him little time for easel painting. His son Hermann was also an artist. There are works in Berlin, Dresden, Hamburg, Kiel, Mannheim, Rostock and Weimar. *Lit.* O. Gehrig: *G. F. Kersting* (1931); G. Vriesen: *Die Innenraumbilder G. F. Kerstings* (1935)

Keyser Nicaise de, b. Dorf Santvliet (Antwerp) 1813, d. Antwerp 1887. Belgian history painter. Like WAPPERS, he absorbed a deep veneration for Rubens from VAN BRÉE at the Antwerp Academy, and contributed to the international fame of the BELGIAN COLOURISTS. He began with religious paintings, and had his first success with a *Crucifixion* (1834) before turning to historical battle scenes of carefully researched accuracy; *Battle of the Golden Spurs* (1836) caused a sensation. In the 1840s he began painting literary genre (*Tasso and Isabella d'Este, Faust and Gretchen*). He was also a successful portraitist, working in a style modelled on van Dyck for the courts of Belgium, Sweden, Bavaria and Württemberg, and recording the appearance of several contemporary painters, including MEISSONIER, BONHEUR and MILLAIS. He became a knight of the Order of Leopold of Belgium and the Lion of the Netherlands, officer of the Legion of Honour and correspondent member of the INSTITUT, as well as being an associate member of many foreign academies. There are works in Amsterdam (Rijksmuseum, Stedelijk), Antwerp, Berlin, Brussels (Musées Royaux), Cologne, Courtrai, Douai, Ghent, The Hague, London (V&A), Munich and Nice. *Lit.* H. Hymans: *Notice sur la vie et les travaux de N. de Keyser* (1889)

Khnopff Fernand, b. Grembergen 1858, d. Brussels 1921. Belgian SYMBOLIST who exhibited in the ROSE + CROIX salons in Paris and was an admirer of MOREAU and the PRE-RAPHAELITES. His work is static, with an accent on beauty, and slightly sinister (*The Caress* 1896). He was obsessed by his sister's beauty and her image constantly reappears in his work. His house on the Avenue de Course, Brussels, mirrored his exotic and decadent fantasies and has been compared with that of Des Esseintes in Huysmans' *A Rebours*. He studied law before entering the Brussels Academy under MELLERY; in 1877 he went to Paris where he studied with LEFEBVRE and MOREAU. He was a founder member of LES VINGT (1883) and its successor La Libre Esthétique. Oscar Wilde admired his work; Péladan hailed him in 1893 as 'the equal of Gustave Moreau, of BURNE-JONES, of [PUVIS DE] CHAVANNES and of ROPS'. There are works in Brussels (Musées Royaux), Budapest, Florence (Pitti), Munich (N. Pin.), New York (Mod. Art), Venice (Mod. Art) and Vienna (Albertina). *Lit.* L. Dumont-Wilden: *F. Khnopff* (1907); N. Eemans: *F. Khnopff* (1950)

Kiprensky Orest Adamovich (also called Schwalbe), b. Korporia 1773, d. Rome 1836. Russian portrait and history painter. His early portraits have a psychological insight and colouristic power that parallels the work of GROS and GÉRICAULT; for this reason they are seen as initiators of ROMANTICISM in Russia (*Colonel Davydov* 1809). Domicile in Rome later turned him to a more conventional NEOCLASSICISM. He studied at the St Petersburg Academy with Levitski and Ugriumov and was influenced by the French artist G. Doyer. The source of his portrait style, however, was the study of Rubens, Rembrandt and van Dyck. In 1816 he went to Rome and began to associate with CANOVA, CAMUCCINI and THORWALDSEN. He returned to Russia in 1823 but settled again in Rome in 1827. There are works in Leningrad (Russian Mus.), Moscow (Pushkin, Tretiakov) and Florence (Uffizi). *Lit.* N. N. Vrangel: *O. Kiprensky in Private Collections* (1912, in Russian); G. Lebedev: *Kiprensky* (1937, in Russian); A. Atsarkina: *O. Kiprensky* (1948, in Russian)

Klimt Gustav, b. Vienna 1862, d. Vienna 1918. Leading Austrian SYMBOLIST, co-founder and first president of the Vienna SECESSION (1897). He was both decorator and painter, combining in his mature work starkly naturalist elements and rich ornamental patterns. He contributed to the Vienna craft revival and influenced later artists such as Schiele and Kokoschka. The son of an engraver, he studied at the Vienna School of Decorative Arts (1876–83), and shared a studio with his brother Ernst and F. Matsch (1883–92); they collaborated on fresco decorations (Karlsbad and Vienna theatres), mostly in an allegorical manner influenced by MAKART. After his brother's death in 1892, he ceased to paint for almost six years until he became involved with the Secession movement. Among the demonstrable influences on his work are ALMA-TADEMA, BURNE-JONES, MOREAU, KHNOPFF, TOOROP, Japanese prints and Byzantine mosaics. He withdrew from the Secession in 1903 but established close links with the Wiener Werkstette, or craft movement, executing many designs and decorations (designs for mosaics in the Palais Stoclet, Brussels, 1905). There are works in Brussels (Stoclet), Munich (Bayerische), Rome (Mod. Art), Venice (Mod. Art) and Vienna (Mod. Art). *Lit.* F. Novotny, J. Dubai: *G. Klimt* (1968); C. M. Nebhay: *G. 'Klimt: Dokumentation* (1969); W. Hofmann: *G. Klimt und die Wiener Jahrhunderterwende* (1970)

Klinger Max, b. Leipzig 1857, d. Grossjena (nr Naumburg) 1920. Painter, sculptor and graphic artist whose attempt 'to give visible artistic form to poetic perceptions' (Gurlitt) led him to classical myth, the Bible and gruesome fantasy with echoes of GOYA. His work is often associated with the SYMBOLISTS. His cycles of engravings linked by a narrative theme are among his best-known works

Khnopff *I Lock the Door upon Myself* 1891

Klimt *Music* 1895

Klinger *The Judgment of Paris* 1887

Knaus *The Cheat* 1851

(*Deliverances of Sacrificial Victims, A Life, Of Death*). He began his studies in Karlsruhe with GUSSOW in 1874, and moved with him to Berlin in 1875. He also studied briefly with BÖCKLIN, by whom he was much influenced; he made engravings after several of Böcklin's pictures. He first exhibited at the Berlin Academy in 1878 with two series of etched sketches, *Series Upon the Theme of Christ* and *Fantasies Upon the Finding of a Glove*, already combining strong realism with fantasy. He spent 1883–6 in Paris, 1886–8 in Berlin and 1888–93 in Rome with a fellow painter Karl Stauffer-Bern. From 1893 he lived in Leipzig with occasional lengthy visits abroad. He concentrated largely on graphic work until 1886, when he took increasingly to painting and sculpture, breaking new ground with polychrome sculpture. His first major painting, *The Judgment of Paris* (1887), in a specially designed sculptural frame, caused critical uproar; public acceptance grew rapidly after the exhibition of his *Beethoven* monument at the Vienna SECESSION in 1902. There are works in Berlin, Dresden, Hamburg, Leipzig and Melbourne.
Lit. F. H. Meissner: *M. Klinger* (1894); H. W. Singer: *M. Klingers Radierungen und Steindrucke* (1909); W. Pastor: *M. Klinger* (1918); A. Suhl: *M. Klinger und die Kunst* (1920); M. Klinger: *Briefe* (ed. H. W. Singer 1924); M. Schmid: *M. Klinger* (5th ed. 1926)

Knaus Ludwig, b. Wiesbaden 1829, d. Berlin 1910. Düsseldorf genre painter, his international renown was matched only by MENZEL among German painters of the later 19C. He was the heir of HASENCLEVER and the politically orientated REALISM of the DÜSSELDORF SCHOOL; peasant life was his almost exclusive theme. His art was anecdotal, emphasizing the psychology of his characters; he used a fluent brushwork and a bright palette with a dominant golden tone. The influence of his cheerful village tales can be traced throughout Europe from 1860 onwards. He entered the Düsseldorf Academy in 1846 under SCHADOW and SOHN, but soon allied himself with LESSING and his Realist faction. In 1848 he left Düsseldorf to paint from life in a small village, scoring his first major success with *Peasant Dance*, exhibited at the Düsseldorf KUNSTVEREIN in 1849 and at Berlin in 1850. He lived mainly in Paris

from 1852 to 1860, but travelled extensively (England 1856, Italy 1857). He returned to Germany and, after a lengthy stay in Berlin, settled in Düsseldorf from 1867 to 1874. An attempt by the Berlin Academy to set up a teaching atelier system modelled on Paris brought him back to Berlin (1874) where he remained, running an atelier until 1882. His freshest and most original work belongs to the early years, his greatest fame to the decades 1860–80. He was a member of the Berlin, Amsterdam, Antwerp, Munich, Vienna and Oslo Academies, and the only German member of the ROYAL ACADEMY from 1882 to 1896 when he was joined by Menzel; he became a chevalier of the Legion of Honour (1859) and an officer (1867). There are works in Aachen, Baltimore (Walters), Berlin, Cambridge Mass. (Fogg), Cologne, Düsseldorf, Hamburg, Kaliningrad, Leipzig, Liège, Mainz, Montpellier, Moscow (Tretiakov, Pushkin), New York (Met.), Paris (Louvre), Stuttgart and Washington (Corcoran).
Lit. L. Pietsch: *L. Knaus* (1896); W. Zils: *L. Knaus* (1919)

Kobell Johannes Baptist (Jan II), b. Delftshaven 1778, d. Amsterdam 1814. An influential forerunner of the Dutch 19C landscape school. He worked extensively from nature but his landscapes indicate a considerable debt to Paul Potter. Brought up in a Utrecht orphanage, he studied with W. R. van der Wall. His work was greatly admired and much sought after by collectors; one of his landscapes won a gold medal at the Paris SALON of 1810 and brought many commissions from France. Over-ambitious and always dissatisfied, he went insane in 1813 and died the following year. There are works in Amsterdam (Rijksmuseum), Antwerp, Bordeaux, Wrocław, Cambridge Mass. (Fogg), Dijon, Dunkirk, La Rochelle and Rotterdam.

Kobell Wilhelm Alexander Wolfgang von, b. Mannheim 1766, d. Munich 1855. Founder figure of the 19C Munich landscape school. His early works were close to the Dutch 17C masters, especially Wouvermanns. His interest in effects of light then led him to panoramic views with low linear horizons, great expanses of sky, and sunlit foreground figures caught with crystalline clarity. He studied with his

Kobke

W. A. W. von Kobell *Landscape near Munich* 1819

Kobke *Entrance to Castle* 1834

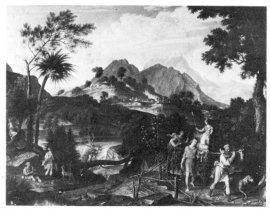

Koch *Italianate Landscape with the Messengers from the Promised Land* 1816

122

father, Ferdinand Kobell, and at the Mannheim Academy before being called to Munich (1792) as court painter. His mature style developed under the influence of DILLIS and the Bavarian landscape. In 1808 Crown Prince Ludwig commissioned a series of large paintings from him depicting Bavarian heroism in the Napoleonic campaigns. In Paris (1809-10) he was influenced by C. VERNET; he succeeded Dillis as professor of landscape painting at the Munich Academy (1814-26) and in 1817 received a knighthood ('von'). He was dismissed from the academy in 1828 when CORNELIUS discontinued the chair of landscape painting as too trivial an art form, but he retained his popularity with bourgeois patrons of the BIEDERMEIER period. There are works in Augsburg, Berlin, Kassel, Darmstadt, Frankfurt/M., Hamburg, Innsbruck, Munich (N. Pin.), Narbonne, Stuttgart and Weimar.
Lit. W. Lessing: *W. von Kobell* (1923, new ed. 1966); K. Sternelle: *W. von Kobell* (1965); S. Wichmann: *W. von Kobell. Monographie und Kritisches Verzeichnis der Werke* (1970)

Kobke Christen Schjellerup, b. Copenhagen 1810, d. Copenhagen 1848. The genius of Danish BIEDERMEIER painting; the golden age of Danish painting (*c.* 1820-50) is often known as 'the age of Kobke'. He painted almost exclusively landscapes and portraits, in which simple motifs, an almost crystalline clarity, luminous northern light and an affectionate delight in detail are the main features. He entered the Copenhagen Academy under Lorentzens in 1822 and studied from 1828 under Eckersberg; the latter's classically oriented REALISM was a formative influence, as were the expeditions to paint in the countryside with Eckersberg and his fellow pupils. His first masterpieces date from *c.* 1830 to 1834. He spent 1838-40 in Italy, visiting Rome, Naples and Capri, and in 1844-5 helped with frescoes for the THORWALDSEN Museum. An associate of the Copenhagen Academy in 1842, he was refused full membership and the disappointment darkened his last years. He continued to paint; the small *plein air* studies of this period, with their looser brushwork, are now particularly highly regarded. Most of his paintings are in Copenhagen (State, Hirschsprung, Industrial, Charlottenborg). (*see colour illustration 21*)

Lit. E. Hannover: *Maleren C. Kobkes* (1893); M. Krohn: *Maleren C. Kobkes* (1915); L. Swane: *C. Kobke* (1938)

Koch Joseph Anton, b. Obergibeln (Tirol) 1768, d. Rome 1839. The most influential early 19C German landscape artist. His first sketches from nature in the Tirol and the Swiss Alps gave him a taste for monumental scenery which was later combined with the influence of Poussin and Claude; his scenes of grand untrammelled nature are peopled with small-scale biblical or mythological characters. He lived most of his life in Rome, where he influenced many German artists. After studying in Stuttgart with Mettenleiter (1785) and training as an engraver, he spent 1792-4 exploring the Swiss landscape and making many studies from nature. On his arrival in Rome (1795) he fell heavily under the influence of Carstens and became a friend of THORWALDSEN, WÄCHTER and Wallis. He sold landscape drawings and watercolours to English tourists, but it was his illustrations to Dante's *Divine Comedy*, much influenced by Carstens, that established his reputation from 1802. He began (*c.* 1805) to paint landscapes; the enthusiastic reception in Munich of his *Subiaco* (1811) decided him to settle in Vienna (1812-15), the period during which his artistic fame reached its height. On his return to Rome (1815) he became friendly with the NAZARENES and in 1825-9 completed the Dante room frescoes begun by VEIT in the Casino Massimo. There are works in Basle (Kunstmuseum), Berlin, Darmstadt, Frankfurt, Hamburg, Hanover, Leipzig, Munich (N. Pin., Schack), Rome, Stuttgart and Vienna (Belvedere).
Lit. E. Jaffé: *J. A. Koch, sein Leben und sein Schaffen* (1905); O. R. Luterotti: *J. A. Koch* (1940); J. E. von Borries: *J. A. Koch, Heroische Landschaft mit Regenbogen* (1967)

Koekkoek Family of Artists. Extensive family of landscape painters active in Holland from the late 18C to the early 20C. They contributed importantly to the development of the Dutch ROMANTIC school. **Johannes Hermanus** (b. Veere 1778, d. Amsterdam 1851) was the father of the line, a self-taught painter of marine and river views which combine careful detail, clear colours and a satin smooth finish. His work was much admired in England and Germany as well

as Holland. **Barend Cornelis** (b. Middelburg 1803, d. Cleves 1862) was his son and the most important artist of the family in terms of contemporary reputation and influence. He is accounted one of the leading figures of the Dutch Romantic school. His subjects were generally wooded landscapes and snow scenes with characteristically luminous skies, the brushwork carefully finished and the composition showing a strong debt to Hobbema and Wijnants. He received his first instruction from his father and travelled extensively in Germany, Switzerland and Belgium, finally settling at Cleves (1841) where he started an art school. His exhibits at the Paris SALONS won him several medals; he was accorded the Legion of Honour, the Netherlands Order of the Lion, and the Belgian Order of Leopold; he was a member of the Amsterdam and St Petersburg Academies. **Marinus Adrianus** (b. Middelburg 1807, d. Hilversum 1870) was his younger brother and also a landscape painter of distinction. **Johannes** (b. Middelburg 1811, d. Breda 1831), a third but short-lived brother, was a marine painter. **Hermanus** (b. Middelburg 1815, d. Haarlem 1882) was the fourth brother and the most gifted after Barend Cornelis. He used a looser, more approximative brushwork to render scenes of daily life along the Dutch coast and became a member of the Amsterdam Academy in 1840. **Willem** (b. Amsterdam 1839, d. London 1895) was the son of Hermanus and a noted painter of townscapes. He moved to London in 1881. **Johannes Hermanus Barend** (b. Amsterdam 1840, d. Hilversum 1912), also a son of Hermanus, was a marine and landscape painter. There are works by Barend Cornelis in Amsterdam (Rijksmuseum, Stedelijk), Antwerp, Berlin (NG), Bremen (Kunsthalle), Wrocław, Chicago (Art Inst.), Cincinnati, Cologne, Dijon, Dordrecht, Haarlem (Teyler), Karlsruhe, Leipzig, Münster, Nantes, New York (Met., Pub. Lib., Hist. Soc.), Rotterdam (Boymans) and Sheffield; by Johannes Hermanus in Bristol, Hamburg, Mainz, Munich, Norwich and Sheffield; by Marinus Adrianus in Cincinnati, Courtrai and Sheffield; by Hermanus in Brussels, Courtrai, Glasgow, Karlsruhe, Le Havre, Melbourne and Sheffield. There is a painting by Willem in Montreal and one by Johannes Hermanus Barend in New York (Brooklyn).

Lit. B. C. Koekkoek: *Herinneringen en Mededeelingen eenen Landschapschilder* (1841); F. Gorissen: *B. C. Koekkoek, 1803–1862* (1962)

Koller Rudolf, b. Zurich 1828, d. Zurich 1905. Animal and landscape painter, a REALIST who sought to interpret the mood and mystery of nature. He studied in Zurich with Schweizer, Obrist and Ulrich, and at the Düsseldorf Academy in 1846; there he met BÖCKLIN, with whom he visited Brussels and Antwerp (1847) before moving on to Paris (1848). In 1851 he set up a studio in his father's brewery, buying animals to paint and reselling them. He visited Paris every year or so, and was particularly influenced by TROYON and BRETON. There are works in Basle (Kunstmuseum), Berne, Geneva (Rath) and Neuchâtel.
Lit. A. Frey: *Der Tiermaler R. Koller* (1928); M. Fischer: *R. Koller, 1828–1905* (1951)

Kossak Julius Fortunat von, b. Wisnicz 1824, d. Cracow 1899. Popular and prolific Polish watercolourist and painter of battle scenes, rural genre and horses. He recorded Poland's victories over Napoleon, presenting a picturesque view of the trappings of war, gay uniforms and dashing cavalry. He studied at Lvov University, at the St Petersburg Academy (1851–2) and in Warsaw (1852). He travelled to Vienna and through Hungary (1853) and visited Paris several times between 1856 and 1862, studying there under BONNAT and VERNET. On his return to Warsaw (1862) he taught, provided illustrations for a weekly newspaper and illustrated Polish legends, poems and fairy tales. He visited Munich in 1869 and worked briefly in the studio of ADAM before moving to Cracow (1870), where he became a popular figure in artistic circles. He was the first of a line of Polish rural genre painters with a strong streak of nationalism, which notably includes Josef Brandt, CHEŁMÓNSKI and KOWALSKI-WIERUSZ. There are works in all the main Polish museums.
Lit. S. Witkiewicz: *J. Kossak* (1912)

Kowalski-Wierusz Alfred von (also Wierusz-Kowalski), b. Suwalk 1849, d. Munich 1915. Polish painter of landscapes, peasants and scenes from rural life in Russia, Galicia and Poland. His penchant for drama and movement – a sledge drawn by galloping

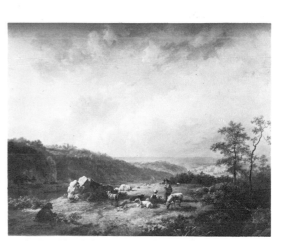
B. C. Koekkoek *Mountainous Landscape*

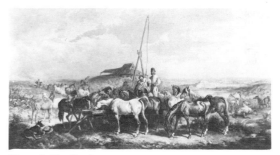
Kossak *The Stud*

horses, a sudden attack by wolves – is interpreted with careful finish and cool palette. After studying in Warsaw, Dresden and Prague, he settled in Munich (1876), working under Wagner and Brandt. He became a professor at the Munich Academy; his work was highly regarded in Germany and he enjoyed an international reputation. There are works in Amsterdam, Boston, Wrocław, Elberfeld, Frankfurt/M., Kaliningrad, Łodz, Montreal, Munich (N. Pin.), New York (Brooklyn), Poznań and Warsaw (Nat. Mus.).

Krafft Johann Peter, b. Hanau 1780, d. Vienna 1856. Austrian history, genre and portrait painter. In his monumental paintings of contemporary life he provided a link between the NEOCLASSICISM of DAVID and Austrian BIEDERMEIER genre; he was considered a pioneer of REALIST painting in Austria. He studied at Hanau drawing school and at the Vienna Academy with FÜGER (1799) before moving on to Paris (1801), where he studied under David and was profoundly influenced by the heroic contemporary scenes depicted by David, GÉRARD and GROS. He spent 1805–7 in Vienna and 1808–9 in Rome, where he painted several portraits of French generals. On his return to Vienna, he worked for the next few years mainly as a portraitist. In 1813 he scored a major success with *A Militiaman's Farewell*, a lifesize contemporary scene realistically painted, and he followed this with a series of Napoleonic battle paintings. In 1815 he became a member of the Vienna Academy, in 1823 professor, and in 1818 was co-founder of the Vienna KUNSTVEREIN. Director of the Imperial Gallery in Belvedere in 1828, he executed (1826–33) three monumental wall paintings, his seminal masterpieces, for the imperial chancellery, depicting scenes from the life of Kaiser Franz I with intimate Realism. These were pioneering works in the history of Austrian Biedermeier; he later returned to painting scenes from classical history and popular literature as well as portraits. There are works in Budapest, Chantilly, Vienna (Belvedere) and Weimar.

Kramskoi Ivan Nikolaievich, b. Novaya Ssotnia 1837, d. St Petersburg 1887. Russian religious painter and portraitist, more important as the leader of the secessionist PEREDVIZHNIKI group than as an artist in his

own right. Apprenticed in 1852 to an icon-painter, he also worked as a retoucher with a travelling photographer, and entered the St Petersburg Academy in 1856. In 1863 he led the protest of thirteen students against the academy and in 1869 organized the launch of the Peredvizhniki travelling exhibitions which aimed to bring art directly to the Russian people. Ivanov's *Christ Appearing to the People* inspired his lifelong effort to develop a specifically Russian interpretation of the life of Christ. Most famous are his *Temptation of Christ* (1872) and the unfinished *Mocking of Christ*. There are works in Leningrad (Russian Mus.) and Moscow (Pushkin, Tretiakov).
Lit. N. Ssobko: *Illustrated Catalogue of Paintings, Drawings and Prints by the late I. N. Kramskoi* (1887, in Russian); W. Stassoff: *I. N. Kramskoi* (1888, in Russian)

Krieghoff Cornelius, b. Amsterdam 1815, d. Chicago 1872. Painter of Canadian landscape and early settler life. Of Dutch parentage, he spent much of his youth in Düsseldorf where he is presumed to have received his first artistic instruction. He moved to New York in 1837 but finally settled in Canada. There are works in Fredericton (New Brunswick), Montreal, Ottawa, Quebec, Toronto and Winnipeg.
Lit. C. M. Barbeau: *C. Krieghoff: Pioneer Painter of North America* (1934); A. H. Robson: *C. Krieghoff* (1937); H. de Jouvancourt: *C. Krieghoff* (1973)

Krohg Christian, b. Aker (nr Oslo) 1852, d. Oslo 1925. REALIST painter influenced in his subject matter by Zola and stylistically by MANET. His paintings of the lower depths of society caused violent controversy in Norwegian artistic circles; there was a parallel movement in Norwegian literature, to which he contributed with his novel on prostitution, *Albertine* (1886), and his large painting of the same title showed a police doctor's waiting-room with prostitutes on their compulsory visit. He also painted interiors and genre scenes of simple fishermen and fjord life. After studying law, he took up painting in 1873 and followed GUDE to Karlsruhe where he studied under GUSSOW before moving to Berlin (1875); there he became a friend of KLINGER. He visited Paris (1880–1) with a state grant and exhibited

there and in Oslo from 1882. In 1884 he settled in Oslo, where he became leader of the *avant-garde*. There are works in Bergen and Oslo (NG).

Krøyer Peter Severin, b. Stavanger 1851, d. Skagen 1909. One of the first Danish artists to study abroad in the 1870s, he played a crucial part in transmitting French REALIST and IMPRESSIONIST ideas to his countrymen. He painted fishermen, landscapes and many portraits, and was the pivot of the Skagen group of *plein air* painters. He studied at the Copenhagen Academy (1864–70) and in Paris with BONNAT (1877), and also paid student visits to Belgium, Holland, Italy and Spain, where he copied Velasquez. *Italian Village Hatmaker*, exhibited in Paris (1881) and Copenhagen (1882), introduced Realist painting to Denmark, with similar impact to that achieved by COURBET with his *Stonebreakers* in France. In protest against the conservatism of the Copenhagen Academy, he founded a private school with Tuxen, Schwartz and ZAHRTMANN in 1855, but he later became a member of the academy (1887) and also of the Stockholm Academy (1894). His earliest works echo the ECKERSBERG school; after visiting Paris, he painted with a dark-toned Realism showing the influence of Velasquez. In the 1890s he adopted the bright palette of the Impressionists, but introduced an increasing narrative-poetic element into his works. His wife Martha Mathilde (née Triepcke) was also a painter. There are works in Aarhus, Berlin, Copenhagen (National, Hirschsprung), Düsseldorf, Frederiksborg, Göteborg, Lübeck, Munich, Nivagaard, Odense, Oslo (NG), Paris, Prague and Stockholm.
Lit. H. C. Christensen: *P. S. Krøyer* (1923)

Krüger Franz, b. Gross-Badegast (Anhalt-Dessau) 1797, d. Berlin 1857. The leading portrait, military and horse painter of BIEDERMEIER Berlin. His most famous works are the large parade pictures of 1829, 1839 and 1849; the first, *Parade on the Opernplatz, Berlin*, was commissioned by Grand Duke Nicholas of Russia. The slightly wooden grandeur of the composition is compensated by relaxed and finely observed portrait groups among the bystanders. He was a largely self-taught artist whose strength lay in fine draughtsmanship and carefully finished form;

he believed that 'given a sense of colour, from a solid grounding in drawing and modelling colour follows of itself'. After entering the Berlin Academy in 1812, he shared a studio with Zimmermann and Kloeber. He made studies in the royal stables and his first exhibition of military and sporting pictures at the Berlin Academy (1818) brought him immediate patronage and commissions. His first parade picture, commissioned in 1824, took him five years to complete. He became a professor and member of the Berlin Academy, received commissions from many German royal houses and from Tsar Nicholas I, and visited St Petersburg in 1836, 1845, 1847 and 1850-1. There are works in Berlin, Braunschweig, Danzig, Dresden, Hamburg, Leningrad, Riga, Schwerin and Vienna.
Lit. M. Osborn: *F. Krüger* (1910); W. Weidmann: *F. Krüger – der Mann und das Werk* (1927)

Kruseman Family of Artists. The Dutch family of Kruseman produced three influential painters in the course of the 19C. **Cornelis** (b. Amsterdam 1797, d. Lisse 1857) was a painter of history, biblical subjects and Italian peasant scenes. His idealized religious works proved popular at a time when the defeat of Napoleon had brought the re-establishment of Calvinism in Holland. His work was highly regarded in court circles. He studied with Hodges and Ravelli and at the Amsterdam Academy under the history painter Daiwaille. In 1821 he visited Paris, travelling on to Italy where he was much influenced by ROBERT and SCHNETZ. He returned to Holland in 1824 and had considerable success with scenes from national history in the early 1830s, following the liberation. **Jan Adam** (b. Haarlem 1804, d. Haarlem 1862) was a nephew and pupil of Cornelis and became a popular history and portrait painter. He studied with DAVID and NAVEZ in Brussels (1822-4) and spent 1825 in Paris. His historical works show the influence of David and, more especially, of INGRES. His portraits brought him fame and favour at court and he was director of the Amsterdam Academy (1830-50). **Frederik Marianus** (b. Haarlem 1817, d. *c.* 1860), another nephew of Cornelis and cousin of Jan Adam, was a landscapist in the KOEKKOEK tradition. There are works by Cornelis in Amsterdam (Rijksmuseum), The Hague

Krafft *Emperor Franz I Driving Out after a Serious Illness* 1833

Krøyer *Duet* 1887

Krüger *Parade on the Opernplatz, 1837* 1839

Kramskoi *Temptation of Christ* 1872

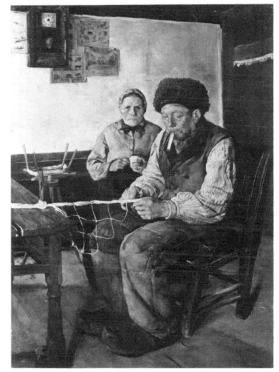
Krohg *The Net-Maker* 1879

(Communal) and Leiden; by Jan Adam in Amsterdam (Rijksmuseum), Haarlem, The Hague (Communal, Teyler) and Leipzig.

Kunstverein (art union). An important German institution responsible for spreading art appreciation among the new industrial middle classes and encouraging them to collect paintings. It provided an outlet for genre, landscape and still-life painters when court patronage was directed towards history and allegory in the grand manner. The Kunstverein in Berlin was founded in 1814,

in Karlsruhe in 1818, in Hamburg in 1822, in Munich in 1824, in Dresden in 1828 and the Kunstverein für die Rheinlande und Westfalen in Düsseldorf in 1829. Activities included the organization of regular exhibitions, the purchase of paintings to be raffled among union members, the distribution of prints made after exhibited paintings, the organization of lectures, and so on. Unions usually had close links with the local academy. The highly successful AMERICAN ART-UNION was founded in 1844 in emulation of a German Kunstverein.

L

La Farge John, b. New York 1835, d. Providence (R.I.) 1910. Exponent of the late-century upsurge of idealist art, with strong links to the ARTS AND CRAFTS movement. His most important work was the mural decoration of churches and public buildings with scenes from the Bible and from Greek and Roman mythology and history. Assistants helped with his murals and he ran a workshop of artists and artisans who produced sculpture and furnishings as well as paintings; he also developed new techniques for the production of stained glass. Of French origin, he studied law and architecture and visited Europe in 1856. In Paris he met CHASSÉRIAU and studied briefly with COUTURE; in England he was impressed by the PRE-RAPHAELITES and MORRIS. He returned to America to enter a law firm, but was persuaded by W. M. HUNT, whose pupil he became, to take up art professionally (c. 1860). He began by painting landscapes, flowers and still lifes in naturalistic vein. In 1876 he received his first major fresco commission for Trinity Church, Boston, and many further commissions followed. He helped to introduce Japanese prints to America and travelled to Japan and Samoa in later life. He was accorded the Legion of Honour in 1889. There are works in Boston, Buffalo, Cambridge Mass. (Fogg), Cincinnati, Detroit, New York (Brooklyn), St Louis, Washington (NG, Corcoran) and Williamstown Mass. (Clark).
Lit. C. Waern: *J. La Farge, Artist and Writer*

(1896); R. Cortizzoz: *J. La Farge, a Memoir and a Study* (1911); J. La Farge: *Reminiscences of the South Sea* (1911)

Lambert Louis Eugène, b. Paris 1825, d. Paris 1900. Animal painter dubbed 'the Raphael of cats'. He studied under DELACROIX and DELAROCHE and his success was launched by his *Cat and Parrot* in the SALON of 1857. He achieved an international reputation and received the Legion of Honour in 1874. There are works in Amsterdam, Angoulême, Baltimore (Walters), Bar-le-Duc, Carpentras, Cincinnati, Clamecy, Dijon, Le Havre, Ixelles, London (BM), Nantes and Paris (Petit Palais).
Lit. G. de Cherville: *Les Chiens et les chats d'E. Lambert* (1888)

Lami Eugène Louis, b. Paris 1800, d. Paris 1890. Watercolourist, lithographer and occasional painter in oils who recorded aristocratic life under the Restoration and the Second Empire. With J. B. ISABEY and GRANET, he was an official court painter to Louis-Philippe. He studied with C. VERNET (1815) and GROS (1817), and was a friend of BONINGTON, who introduced him to the English watercolour style and with whom he visited England in 1826; he paid a second visit in 1848-52. He began by painting military scenes under the influence of H. VERNET and his friend RAFFET. Later he combined grandiose records of official occasions (*Visit of Queen Victoria to*

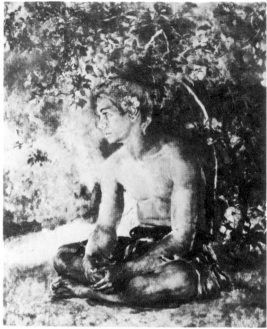
La Farge *Maus, Our Boatman* 1891

Lami *Visit of Queen Victoria to Versailles* 1855

Versailles 1855) with relaxed views of court, café and society life treated with a sparkling daintiness and attention to detail reminiscent of the French 18C. There are works in Alais, Béziers, Cambridge Mass. (Fogg), Chantilly, Lille, London (V&A, Wallace), Paris (Louvre), Philadelphia, Reims and Versailles. *Lit.* P. A. Lemoisne: *E. Lami* (1912); P. A. Lemoisne: *L'Oeuvre d'E. Lami, essai d'un catalogue raisonné* (1914)

Lampi Family of Artists. Austrian family of painters of Italian origin who worked extensively in Russia and Poland, exerting an important influence on early 19C painting in these two countries. **Johann Baptist the Elder** (b. Romeno 1751, d. Vienna 1830) was a portraitist in the baroque tradition, though he made some concessions to NEO-CLASSICISM in his later work. He worked in Salzburg, Verona, Trento and Innsbruck, arriving in Vienna in 1783 with an already established reputation. He lived in Poland (1788–91) and St Petersburg (1791–7). He returned to Vienna in 1797 where he received a knighthood ('von') in 1798 and taught at the academy. **Johann Baptist the Younger** (b. Trento 1775, d. Vienna 1837) was his son. He was also a portraitist and worked in a style close to that of his father, though considerably influenced by LAWRENCE when he came to Vienna for the Congress. He worked in St Petersburg (*c.* 1795–1805) and became an honorary member of the St Petersburg Academy in 1797. He then returned to Vienna where he became a member of the academy in 1813. **Frans Xaver** (b. Klagenfurt 1782, d. Warsaw 1852) was the second son of Johann Baptist the Elder, best known as a battle painter and portraitist. He studied in Vienna with FÜGER and others but lived from 1815 in Warsaw. He also painted some landscapes and genre scenes. There are works by J. B. Lampi the Elder in Baden, Bonn, Budapest, Chantilly, Darmstadt, Florence, Graz, Innsbruck, Cracow, Leningrad (Hermitage), Moscow, Nuremberg, Odessa, Paris (Louvre), Pawlowsk, Poznań, Trento, Vienna (Belvedere) and Warsaw (Nat. Mus.); by J. B. Lampi the Younger in Budapest, Leningrad and Vienna.

Landseer Sir Edwin Henry, b. London 1802, d. London 1873. The most famous and successful animal painter of the 19C. Cheap engravings spread a knowledge of his work throughout Europe. His paintings of wild stretches of Scotland, in which a noble stag becomes the vehicle for a morality lesson (*Monarch of the Glen, Stag at Bay*) appealed to the Victorian taste for the exotic, while his humorous works in which animals are imbued with human psychology (*High Life, Low Life, Dignity and Impudence*) had a simple appeal to the most unexacting taste. He had a reputation for effortless facility which is borne out by his relaxed landscape sketches. Queen Victoria was his great admirer and friend; he painted her portrait several times as well as painting her dogs. The son of an engraver, John Landseer, he learnt to draw from his father, making many studies of animals as a child and exhibiting *Portrait of a Mule* and *Pointer Bitch and Puppy* at the ROYAL ACADEMY in 1815 at the age of only thirteen. He studied with HAYDON and at the Royal Academy Schools from 1816; under the influence of Haydon's anatomical interests he spent much time dissecting animals and his sound anatomical knowledge is reflected in his later work. In 1824 he paid his first visit to Scotland with the genre painter LESLIE. ARA in 1826, RA in 1831, he was offered the presidency in 1866 but refused it. He was knighted (1850) and accorded a gold medal at the Paris EXPOSITION UNIVERSELLE (1855). The bronze lions that he modelled for Trafalgar Square were unveiled in 1867. There are works in Cambridge Mass. (Fogg), Chicago, Cincinnati, Dublin, Edinburgh, Hamburg, Liverpool, London (NG, NPG, V&A, Tate, Wallace), Manchester, Preston, Sheffield, Sunderland, Sydney, Victoria and Washington (Corcoran).
Lit. A. Graves: *Catalogue of the Works of the Late Sir E. Landseer* (1876); F. G. Stephens: *Life and Works of Sir E. Landseer* (1881); L. Scott: *Sir E. Landseer* (1904); A. Chester: *The Art of E. Landseer* (1920); C. Lennie: *Landseer* (1976)

Lane Fitz Hugh, b. Gloucester (Mass.) 1804, d. Gloucester 1865. Marine painter whose careful detail of ships and rigging was achieved with the aid of photography. Little known in his lifetime, he is now considered an important exponent of American LUMINISM. His harbour and bay scenes combine enormous skies, low horizons and frozen ripples on still, light-reflecting water (*New*

J. B. Lampi the Elder *Two Children of Count Thomatis c.* 1790

Landseer *Dignity and Impudence* 1839

York Harbour 1850, *Off Mount Desert Island* 1856). A cripple, he was largely self-taught as a painter; he worked for several lithographers in Gloucester and Boston, ran his own Boston lithographic firm (1845-7) and settled again in Gloucester in 1849, continuing to earn his living from lithographic views of the old port. He made some sea trips down the coast of Maine in the 1850s. He worked on long extended panoramic sketches, of which sections only were used for his finished works. There are works in Boston, Cambridge Mass. (Fogg), Cincinnati, Gloucester, New York (Brooklyn) and Washington (Corcoran).
Lit. J. Wilmerding: *Fitz Hugh Lane 1804-1865, American Marine Painter* (1964); J. Wilmerding: *Fitz Hugh Lane* (1971)

Langer Johann Peter, b. Calcum 1756, d. Munich 1824. NEOCLASSICAL history and portrait painter, and the first director of the Munich Academy when it was founded in 1808. He laid the basis of formal art instruction in Munich, but his classicism tended to alienate the younger generation of painters. He studied in Düsseldorf, where he had a baroque training with classical overtones; he learnt a full-blooded classicism from the French. He became professor and then director (1790) at the Düsseldorf Academy. His son Robert (1783-1846) was a classicist influenced by Mengs and DAVID, and was also an influential teacher and administrator in Munich. There are works in Munich.

Langko Johann Diederich Christian, b. Hamburg 1819, d. Munich 1896. Munich landscapist, a close friend of SPITZWEG and SCHLEICH; much influenced by the BARBIZON SCHOOL, he spread knowledge of their work in Munich. He studied in Hamburg with Gensler and at the Munich Academy (*c.* 1840). After his early success with classically composed landscapes, he adopted a poetic treatment close to that of Schleich; both were influenced in the 1850s by the Barbizon School, and together they copied the *Women Bathing at Dieppe* of E. ISABEY. After the 1860s he fell wholly under the influence of T. ROUSSEAU and concentrated on painting forest interiors. There are works in Hamburg, Lübeck, Munich, Prague and Vienna.

Larsson Carl Olaf, b. Stockholm 1853, d. Sundborn (nr Falun) 1919. Swedish painter and illustrator whose fame rests particularly on his idyllic scenes of family life and intimate rural scenes (*Carl Larsson and Brita* 1895, *Shelling Peas* 1912); his work was a Swedish development of Barbizon *plein air* painting. He worked as a photographic retoucher, illustrator and caricaturist in his early years; he studied at the Stockholm Academy and visited Paris in 1876 and 1880. He taught drawing and painting at Göteborg art school (1886-91) and in his later years executed some monumental fresco commissions (*Birth of Drama* in Stockholm Theatre, six scenes from Swedish artistic history in the Nationalmuseum, Stockholm). There are works in Göteborg and Stockholm (Nat. Mus.).
Lit. C. O. Larsson: *Das Haus in der Sonne* (1921)

Larsson Simon Marcus, b. Örsätter 1825, d. London 1864. Swedish landscape and marine painter. A Düsseldorf REALIST by training, he concentrated on Nordic scenery and seascape which he preferred to catch in dramatic mood with waterfalls, moonlight, storms and shipwreck (*Burning Steamship by Night* 1858, *Waterfall at Sunset* 1857). He studied at the Stockholm Academy and under V. Melbye in Copenhagen. He moved to Düsseldorf under A. ACHENBACH in 1852 and spent 1855-7 in Paris. He visited Russia (1861), becoming an associate of the St Petersburg Academy, before moving to London where he had some initial success but died in poverty. There are works in Göteborg, Helsingør, Stockholm (Nat. Mus.) and Stuttgart.

Laurens Jean-Paul, b. Fourquevaux (Haute Garonne) 1838, d. Paris 1921. History painter who was among the last artists of the 19C to achieve high honours in this field. His conscientious researches to ensure historical accuracy and naturalistic rendering of detail place him among the ACADEMIC REALISTS. He generally selected from history scenes of terror or catastrophe; the Inquisition was a repeated theme (*Excommunication of Robert the Pious* 1875, *The Inquisition Tribunal* 1889, *Deliverance of the Immured of Carcassonne*). He executed murals for many important buildings, including the Panthéon (*Death of St Genoveva*), the Palais de la Légion d'Honneur, the Hôtels de Ville of Paris and Tours (*The Burning of Joan of Arc*) and the law courts in Baltimore. Of humble origins, he studied at Toulouse and in Paris with L. COGNIET and Bida (1860). He first exhibited at the Paris SALON of 1863. Chevalier of the Legion of Honour in 1874, he became successively officer (1878), commander (1900) and grand officer (1919). He was elected to the INSTITUT in 1891. His sons Paul Albert and Jean Pierre were also artists. In addition to his murals, there are works in Paris (Louvre) and many French provincial museums, and in Brussels, Bucharest, Florence (Pitti), Moscow (Tretiakov), New York (Brooklyn) and Philadelphia.
Lit. F. Fabre: *J. P. Laurens* (1895)

Lautrec *see* TOULOUSE-LAUTREC

Lavery Sir John, b. Belfast 1856, d. Kilkenny 1941. Portrait, genre and landscape painter. He was one of the original GLASGOW BOYS, but moved to London in the 1890s to pursue a successful career as a society portraitist. Associate of the Royal Scottish Academy (1892) and academician (1896), he was an ARA (1911) and an RA (1921). He was knighted in 1918. There are works in Berlin, Birmingham, Bradford, Brussels, Dublin, Edinburgh, Glasgow and Munich.
Lit. W. S. Sparrow: *J. Lavery and his Work* (1911); J. Lavery: *The Life of a Painter* (1940)

Lawrence Sir Thomas, b. Bristol 1769, d. London 1830. The heir of Reynolds and Gainsborough, carrying the English portrait tradition into the 19C. His composition tended to the theatrical but, at its best, represents a high point in ROMANTIC portraiture and can be compared to the work of GROS in France. His backgrounds were more sketchy and approximate than those of his predecessors, concentrating attention on the sitter. His fluent and approximative use of paint was admired by DELACROIX and contributed to the influence of the English school on the French Romantics. Success came to him early; he received his first royal commission in 1789 (*Queen Charlotte*) at the age of twenty and was soon London's most sought-after portraitist. The Waterloo Gallery, a series of portraits commissioned by the Prince Regent of European leaders who had contributed to Napoleon's downfall, took him to Aix, Vienna and Rome and established his reputation as the first portraitist in Europe. The promise of

his early full-lengths (*Queen Charlotte* 1790, *Miss Farren* 1790, *Lord Granville Leveson-Gower* 1795–8), with carefully selected settings in the 18C manner, was not fully sustained; in the early 1800s he painted some half-length male portraits of solid and considered depth as well as many potboilers, but the historic challenge of the Waterloo series brought his art to a high point (*Prince Blücher on the Battlefield* 1814, *Pope Pius VII* 1819). A child prodigy, he helped to support his family with portrait drawings when they settled in Oxford (1779) and in Bath (1782–6). In London (1786) he began to work in oils, attended the ROYAL ACADEMY Schools for a few months and attracted the support of Reynolds. ARA in 1791 and RA in 1794, he succeeded Reynolds as painter-in-ordinary to the King in 1792. The Waterloo series was commissioned in 1814 and he was knighted the following year. He spent 1818–20 in Vienna and Rome. His *Duc de Richelieu* (1819) was exhibited at the famous Paris SALON of 1824 and in 1825 he travelled to France to paint Charles X and the Dauphin. He succeeded WEST as president of the Royal Academy in 1820. The most important collection of his work is in the Waterloo Gallery at Windsor Castle, but he is represented in virtually all the world's major museums.
Lit. D. E. Williams: *Life and Correspondence of Sir T. Lawrence* (1831); K. Garlick: *Sir T. Lawrence* (1954)

Lear Edward, b. Holloway 1812, d. San Remo 1888. English landscape painter, better known for his illustrated nonsense poems. In 1831 he was employed by the London Zoological Society on a series of drawings of parrots; he worked also for the zoologist John Gould and for Lord Derby on drawings of his private menagerie. It was for the Derby children that he prepared his first *Book of Nonsense* (1846). From 1835 he turned to topographical painting. Avoiding the English climate for the sake of his health, he travelled constantly in Italy, Greece, the Middle East, India and Ceylon. There are works in Cambridge (Fitzwm), Cambridge Mass. (Fogg), Chantilly (Condé), Chicago, Glasgow, London (BM, Tate, V&A) and New York (Met.). *Lit.* A. Davidson: *E. Lear* (1938); P. Hofer: *E. Lear as a Landscape Draughtsman* (1967); V. Noakes: *E. Lear: The Life of a Wanderer* (1968); J. Lehmann: *Lear and his World* (1977)

Lane *Owl's Head, Penobscot Bay, Maine* 1862

Laurens *Excommunication of Robert the Pious* 1875

Lawrence *Miss Farren* 1790

Lavery *Kevin O'Higgins*

Lear *The Pyramids* 1854

Lecomte de Noüy Jean Jules Antoine, b. Paris 1842, d. Paris 1923. History, portrait and landscape painter whose carefully detailed manner is closely related to that of GÉRÔME and the NÉO-GRECQUES. He studied under GLEYRE (1861), Signol and Gérôme, whose favourite pupil he became. He won the second Rome prize in 1872, and also travelled extensively in the Middle East, returning with archaeological drawings and paintings that were much admired. He was a sensitive portraitist and painted, among others, the king and queen of Rumania, which in turn earned him several mural commissions for churches there. He first exhibited in the SALON of 1863, and received the Legion of Honour in 1876. There are works in Arras, Cette, Florence (Uffizi), Lille, Paris (Louvre), Reims, Tours and Valence.

Lecoq de Boisbaudran Horace, b. Paris 1802, d. Paris 1897. Painter of portraits and religious themes, but most important as a teacher. In the 1850s he ran a small school in which he emphasized painting from nature and from memory. He 'went so far as to have [his pupils] observe dressed or undressed models moving freely in a forest or field, in order to study natural attitudes' (Rewald). His pupils were urged to steep themselves in a scene so that they could paint it from memory. His book, *Education de la memoire pittoresque*, was published in 1862, and an English translation in 1911. FANTIN-LATOUR, LEGROS and LHERMITTE were among his pupils.

Lefebvre Jules Joseph, b. Tournan 1836, d. Paris 1912. French painter of myth, allegory and history; he was also a successful portraitist. The female nude was his special preoccupation, for which he used history and allegory as a vehicle (*Bacchus and Nymph* 1866, *Truth* 1870, *Diana Surprised in her Bath* 1879). In seeking an ideal beauty in his female figures he owed a debt to INGRES, but they were painted with a REALISM typical of his time. He had an outstandingly successful career. Having studied under L. COGNIET from 1852, he won the first Rome prize in 1861. He sent his first painting to the SALON from Rome in 1864 (*Caritas Romana*), returning to France in 1867. *Truth* of 1870 launched his fame. He became a chevalier of the Legion of Honour in 1870, and a commander in 1898; he was also a member

of the INSTITUT (1891). He received several commissions for decorations, including a ceiling for the Paris Hôtel de Ville. There are works in Amiens, Auxerre, Budapest, Buenos Aires, Cincinnati, Copenhagen, Ghent, Lyons, Minneapolis, Melun, New York (Met.), Paris (Louvre), Rouen and St Louis.

Lega Silvestro, b. Modigliana (Forli) 1826, d. Florence 1895. Lyrical painter of naturalistic landscapes and intimate genre scenes, a close associate of the MACCHIAIOLI. He studied in Florence with Pollastrini and MUSSINI, fought with Mazzini's troops in 1848, and then continued his studies with Ciseri, treating religious and historical subjects in a style related to PURISMO. He painted some military scenes from 1859 but his full conversion to REALISM came in 1861, when he joined SIGNORINI, BORRANI and the SCHOOL OF PERGENTINA painting in the Tuscan countryside. In 1865 he followed Borrani, by whom he was greatly influenced, to live a withdrawn life in the country (*The Pergola* 1868, *The Visit* 1868). After the 1870s his brushwork became progressively broader and more summary. There are works in Florence (Mod. Art), Milan (Mod. Art, Brera, Grassi), Rome (Mod. Art) and Turin (Mod. Art).
Lit. T. Signorini: *Per S. Lega* (1896); M. Valsecchi: *Lega* (1950); M. Giardelli: *S. Lega* (1965)

Legros Alphonse, b. Dijon 1837, d. Watford 1911. A close friend of WHISTLER and one of the most influential links between England and French *avant-garde* painting. The youngest child of a penurious family, he worked with an interior decorator in Dijon and with the Paris scene painter C. A. Cambon. He studied in the atelier of LECOQ DE BOISBAUDRAN and at the ECOLE DES BEAUX-ARTS until 1855, and first exhibited at the SALON of 1857. He joined the circle round COURBET (*c.* 1859), developing friendships with FANTIN-LATOUR, MANET, WHISTLER and Seymour Hayden and took part in the first Salon des Refusés in 1863. Lack of success decided him to settle in London (1863). His oil paintings are mainly portraits (*My Father* 1857), landscapes and studies of the poor painted with serious REALISM. In his graphic work he combined lyrical landscapes with grotesquely imaginative works which owed a debt to

medieval German masters (*The Triumph of Death*). Appointed Slade Professor of Fine Art at South Kensington in 1876, he exerted an important influence on English art, especially in the graphic field. There are works in Cologne (Wallraf-Richartz), Dijon, London (Tate) and Tours.
Lit. L. Bénédite: *A. Legros* (1900) and *L'Oeuvre gravé et lithographique d'A. Legros* (1904); M. Salaman: *A. Legros* (1926)

Lehmann Karl Ernest Rudolph Heinrich Salem (Henri), b. Kiel 1814, d. Paris 1882. History painter and portraitist, one of the most successful pupils of INGRES. His dedication to the classical tradition was lastingly embodied in his establishment of the Henri Lehmann Prize, awarded for outstanding academic painting in the Paris SALON. One of the most renowned decorators of his day, he painted *The Evolution of Culture* in fifty-six scenes for the Paris Hôtel de Ville (destroyed by fire in 1871). He studied in Hamburg until 1831 when he entered Ingres's studio in Paris, and first exhibited at the Salon of 1835. After returning to Germany in 1837, he spent 1838–49 largely in Rome. He became a naturalized Frenchman in 1847 and a member of the INSTITUT in 1864. His father Leo and brother Rudolf were also artists. There are works in Angers, Bayonne, Carcassonne, Florence (Uffizi), Hamburg, Lille, Lyons, Montpellier, Nantes, Orleans and Versailles.
Lit. M. Boulanger: *Notice sur H. Lehmann* (1883); R. Lehmann: *Erinnerungen eines Künstlers* (1896)

Leibl Wilhelm Maria Hubertus, b. Cologne 1844, d. Würzburg 1900. REALIST painter whose stature within the German school is equivalent to that of COURBET in France. He concentrated on figure painting, his simple compositions seldom containing more than three people. His striving towards simple but powerful form and harmony of tone or colour values revolutionized Munich painting in the 1870s but met critical opposition. Turning his back on Munich and worldly success, he painted peasant life in the villages of southern Germany. After some study in Cologne he entered the Munich Academy in 1864 under Anschütz, VON RAMBERG and PILOTY. His gifts soon made him the pivot of a realistically inclined group of students, including ALT, du

his early full-lengths (*Queen Charlotte* 1790, *Miss Farren* 1790, *Lord Granville Leveson-Gower* 1795–8), with carefully selected settings in the 18C manner, was not fully sustained; in the early 1800s he painted some half-length male portraits of solid and considered depth as well as many potboilers, but the historic challenge of the Waterloo series brought his art to a high point (*Prince Blücher on the Battlefield* 1814, *Pope Pius VII* 1819). A child prodigy, he helped to support his family with portrait drawings when they settled in Oxford (1779) and in Bath (1782–6). In London (1786) he began to work in oils, attended the ROYAL ACADEMY Schools for a few months and attracted the support of Reynolds. ARA in 1791 and RA in 1794, he succeeded Reynolds as painter-in-ordinary to the King in 1792. The Waterloo series was commissioned in 1814 and he was knighted the following year. He spent 1818–20 in Vienna and Rome. His *Duc de Richelieu* (1819) was exhibited at the famous Paris SALON of 1824 and in 1825 he travelled to France to paint Charles X and the Dauphin. He succeeded WEST as president of the Royal Academy in 1820. The most important collection of his work is in the Waterloo Gallery at Windsor Castle, but he is represented in virtually all the world's major museums.
Lit. D. E. Williams: *Life and Correspondence of Sir T. Lawrence* (1831); K. Garlick: *Sir T. Lawrence* (1954)

Lear Edward, b. Holloway 1812, d. San Remo 1888. English landscape painter, better known for his illustrated nonsense poems. In 1831 he was employed by the London Zoological Society on a series of drawings of parrots; he worked also for the zoologist John Gould and for Lord Derby on drawings of his private menagerie. It was for the Derby children that he prepared his first *Book of Nonsense* (1846). From 1835 he turned to topographical painting. Avoiding the English climate for the sake of his health, he travelled constantly in Italy, Greece, the Middle East, India and Ceylon. There are works in Cambridge (Fitzwm), Cambridge Mass. (Fogg), Chantilly (Condé), Chicago, Glasgow, London (BM, Tate, V&A) and New York (Met.).
Lit. A. Davidson: *E. Lear* (1938); P. Hofer: *E. Lear as a Landscape Draughtsman* (1967); V. Noakes: *E. Lear: The Life of a Wanderer* (1968); J. Lehmann: *Lear and his World* (1977)

Lane *Owl's Head, Penobscot Bay, Maine* 1862

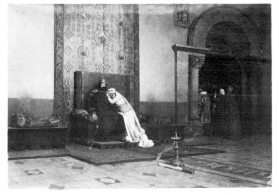
Laurens *Excommunication of Robert the Pious* 1875

Lavery *Kevin O'Higgins*

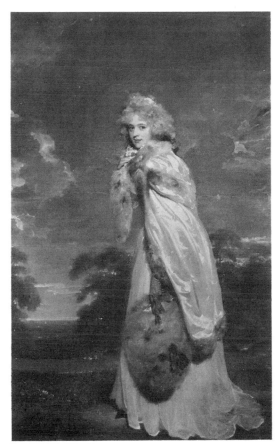
Lawrence *Miss Farren* 1790

Lear *The Pyramids* 1854

Lecomte de Noüy Jean Jules Antoine, b. Paris 1842, d. Paris 1923. History, portrait and landscape painter whose carefully detailed manner is closely related to that of GÉRÔME and the NÉO-GRECQUES. He studied under GLEYRE (1861), Signol and Gérôme, whose favourite pupil he became. He won the second Rome prize in 1872, and also travelled extensively in the Middle East, returning with archaeological drawings and paintings that were much admired. He was a sensitive portraitist and painted, among others, the king and queen of Rumania, which in turn earned him several mural commissions for churches there. He first exhibited in the SALON of 1863, and received the Legion of Honour in 1876. There are works in Arras, Cette, Florence (Uffizi), Lille, Paris (Louvre), Reims, Tours and Valence.

Lecoq de Boisbaudran Horace, b. Paris 1802, d. Paris 1897. Painter of portraits and religious themes, but most important as a teacher. In the 1850s he ran a small school in which he emphasized painting from nature and from memory. He 'went so far as to have [his pupils] observe dressed or undressed models moving freely in a forest or field, in order to study natural attitudes' (Rewald). His pupils were urged to steep themselves in a scene so that they could paint it from memory. His book, *Education de la memoire pittoresque*, was published in 1862, and an English translation in 1911. FANTIN-LATOUR, LEGROS and LHERMITTE were among his pupils.

Lefebvre Jules Joseph, b. Tournan 1836, d. Paris 1912. French painter of myth, allegory and history; he was also a successful portraitist. The female nude was his special preoccupation, for which he used history and allegory as a vehicle (*Bacchus and Nymph* 1866, *Truth* 1870, *Diana Surprised in her Bath* 1879). In seeking an ideal beauty in his female figures he owed a debt to INGRES, but they were painted with a REALISM typical of his time. He had an outstandingly successful career. Having studied under L. COGNIET from 1852, he won the first Rome prize in 1861. He sent his first painting to the SALON from Rome in 1864 (*Caritas Romana*), returning to France in 1867. *Truth* of 1870 launched his fame. He became a chevalier of the Legion of Honour in 1870, and a commander in 1898; he was also a member

of the INSTITUT (1891). He received several commissions for decorations, including a ceiling for the Paris Hôtel de Ville. There are works in Amiens, Auxerre, Budapest, Buenos Aires, Cincinnati, Copenhagen, Ghent, Lyons, Minneapolis, Melun, New York (Met.), Paris (Louvre), Rouen and St Louis.

Lega Silvestro, b. Modigliana (Forli) 1826, d. Florence 1895. Lyrical painter of naturalistic landscapes and intimate genre scenes, a close associate of the MACCHIAIOLI. He studied in Florence with Pollastrini and MUSSINI, fought with Mazzini's troops in 1848, and then continued his studies with Ciseri, treating religious and historical subjects in a style related to PURISMO. He painted some military scenes from 1859 but his full conversion to REALISM came in 1861, when he joined SIGNORINI, BORRANI and the SCHOOL OF PERGENTINA painting in the Tuscan countryside. In 1865 he followed Borrani, by whom he was greatly influenced, to live a withdrawn life in the country (*The Pergola* 1868, *The Visit* 1868). After the 1870s his brushwork became progressively broader and more summary. There are works in Florence (Mod. Art), Milan (Mod. Art, Brera, Grassi), Rome (Mod. Art) and Turin (Mod. Art).
Lit. T. Signorini: *Per S. Lega* (1896); M. Valsecchi: *Lega* (1950); M. Giardelli: *S. Lega* (1965)

Legros Alphonse, b. Dijon 1837, d. Watford 1911. A close friend of WHISTLER and one of the most influential links between England and French *avant-garde* painting. The youngest child of a penurious family, he worked with an interior decorator in Dijon and with the Paris scene painter C. A. Cambon. He studied in the atelier of LECOQ DE BOISBAUDRAN and at the ECOLE DES BEAUX-ARTS until 1855, and first exhibited at the SALON of 1857. He joined the circle round COURBET (*c.* 1859), developing friendships with FANTIN-LATOUR, MANET, WHISTLER and Seymour Hayden and took part in the first Salon des Refusés in 1863. Lack of success decided him to settle in London (1863). His oil paintings are mainly portraits (*My Father* 1857), landscapes and studies of the poor painted with serious REALISM. In his graphic work he combined lyrical landscapes with grotesquely imaginative works which owed a debt to

medieval German masters (*The Triumph of Death*). Appointed Slade Professor of Fine Art at South Kensington in 1876, he exerted an important influence on English art, especially in the graphic field. There are works in Cologne (Wallraf-Richartz), Dijon, London (Tate) and Tours.
Lit. L. Bénédite: *A. Legros* (1900) and *L'Oeuvre gravé et lithographique d'A. Legros* (1904); M. Salaman: *A. Legros* (1926)

Lehmann Karl Ernest Rudolph Heinrich Salem (Henri), b. Kiel 1814, d. Paris 1882. History painter and portraitist, one of the most successful pupils of INGRES. His dedication to the classical tradition was lastingly embodied in his establishment of the Henri Lehmann Prize, awarded for outstanding academic painting in the Paris SALON. One of the most renowned decorators of his day, he painted *The Evolution of Culture* in fifty-six scenes for the Paris Hôtel de Ville (destroyed by fire in 1871). He studied in Hamburg until 1831 when he entered Ingres's studio in Paris, and first exhibited at the Salon of 1835. After returning to Germany in 1837, he spent 1838–49 largely in Rome. He became a naturalized Frenchman in 1847 and a member of the INSTITUT in 1864. His father Leo and brother Rudolf were also artists. There are works in Angers, Bayonne, Carcassonne, Florence (Uffizi), Hamburg, Lille, Lyons, Montpellier, Nantes, Orleans and Versailles.
Lit. M. Boulanger: *Notice sur H. Lehmann* (1883); R. Lehmann: *Erinnerungen eines Künstlers* (1896)

Leibl Wilhelm Maria Hubertus, b. Cologne 1844, d. Würzburg 1900. REALIST painter whose stature within the German school is equivalent to that of COURBET in France. He concentrated on figure painting, his simple compositions seldom containing more than three people. His striving towards simple but powerful form and harmony of tone or colour values revolutionized Munich painting in the 1870s but met critical opposition. Turning his back on Munich and worldly success, he painted peasant life in the villages of southern Germany. After some study in Cologne he entered the Munich Academy in 1864 under Anschütz, VON RAMBERG and PILOTY. His gifts soon made him the pivot of a realistically inclined group of students, including ALT, du

Fresnes and SPERL. He became a close friend of Courbet when he met him at the 1869 Munich INTERNATIONAL EXHIBITION, where his *Portrait of Frau Gedon* established his reputation; he won a gold medal for it at the 1870 SALON in Paris, where he settled in 1869 on Courbet's advice. Driven back to Germany by the war, he settled in Munich (1870–3), mainly painting portraits. In Grasslfing and Unterschondorf (1873–8) he developed a new highly finished style derived, at least partially, from his admiration for Holbein; his most famous picture, *Three Women in Church* (1882), was a high point in this vein. In later years he turned to a looser, more impressionistic style. There are works in Berlin, Bremen, Cologne, Frankfurt, Hamburg, Leipzig, Munich (N. Pin.) and Stuttgart. (*see colour illustration 22*)
Lit. E. Waldman: *W. Leibl* (1914); G. J. Wolf: *Leibl und sein Kreis* (1923); E. Waldmann: *W. Leibl als Zeichner* (1942); A. Langer: *W. Leibl* (1961); M. Petzet (ed.): *W. Leibl und Sein Kreis* (1974)

Leickert Charles, b. Brussels 1818, d. Mainz 1907. Dutch landscapist whose work is in the tradition of the great 17C Dutch masters, though he used a brighter palette and more summary brushwork. The quality of his prolific work varies greatly, but at his best he is among the most distinguished of the Dutch ROMANTIC school. He studied with HOVE, NUYEN and SCHELFHOUT, with whose work his own is closely related. He worked in The Hague until 1863, when he moved to Amsterdam (1883), Nieuwer-Amstel and later Mainz. There are works in Amsterdam (Rijksmuseum), Brussels, Danzig, Groningen, Hamburg, Riga, Rotterdam and Szczecin. He left the contents of his studio to the museum at Mainz.

Leighton Frederic (Baron of Stretton), b. Scarborough 1830, d. London 1896. Much fêted leader of the late 19C return to classicism in England. As president of the ROYAL ACADEMY, he was the pivot of the English art establishment during the last twenty years of the century. He painted scenes from classical Greek mythology and history, combining grandeur of form with an idealized treatment of the human figure that echoes NEOCLASSICISM. The son of a doctor, he travelled constantly as a child and retained

Lega *The Pergola* 1868

Legros *Calvary* 1874

Lehmann *Franz Liszt* 1839

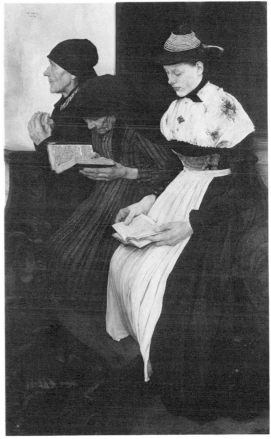

Leibl *Three Women in Church* 1882

Leighton *Garden of the Hesperides* 1892

Lenbach *Emperor Wilhelm I* 1888

a cosmopolitan outlook. He entered the Florence Academy in 1844 under BEZZUOLI and Segnolini, studied in Frankfurt with Becker (1846–8), in Brussels (1848) and in Paris (1849). He returned to Frankfurt to work with STEINLE, the most respected friend and master of his early years, whose NAZARENE influence is evident in his early medieval and Renaissance subject paintings. In 1852 he moved to Rome, where he became the friend of many leading literary and artistic figures (Thackeray, Browning, GÉRÔME, BOUGUEREAU and especially COSTA). *Cimabue*, his first exhibit at the Royal Academy (1855), was purchased by Queen Victoria. He settled in London in 1860, becoming an ARA in 1864 and RA in 1868, and turning to Greek subjects under the influence of the Elgin Marbles and his friend G. F. WATTS. He was knighted and elected president of the Royal Academy (1878), became a baronet in 1886 and baron in 1896. He was an honorary member of the academies of Antwerp, Berlin, Brussels, Florence, Genoa, Perugia, Rome, Turin and Vienna, and a commander of the Legion of Honour. There are works in Aberdeen, Birmingham, Boston, Florence, Frankfurt/M., Hamburg, Leeds, Leicester, Liverpool, London (NPG, Tate, V&A), Manchester, New York (Met.) and Sydney.
Lit. Mrs R. Barrington: *Life and Works of F. Leighton* (1906); E. Staley: *Lord Leighton* (1906); A. L. Baldry: *Leighton* (1908); W. Gaunt: *Victorian Olympus* (1952); L. and R. Ormond: *Lord Leighton* (1975)

Lenbach Franz Seraph von, b. Schrobenhausen 1836, d. Munich 1904. A leading German portraitist, his popularity paralleled that of BONNAT in France; he is also seen as a forerunner of the Munich REALISTS with his famous *Shepherd Boy* (1860). The success of his portraits – he painted Bismarck eighty times – lay in their psychological Realism. His usual method was to concentrate on the head and particularly the eyes, touching in the rest of the painting in summary fashion. Largely self-taught until 1857, he entered the Munich Academy under PILOTY, with whom he went to Rome (1858–9). He was given a teaching post at Weimar at the same time as BÖCKLIN and BEGAS. When the Munich connoisseur Count Schack commissioned him to make a large series of copies of Old Masters, he returned to Rome (1863)

where he shared a studio with Böcklin and VON HAGN. His copies kept him busy until 1866, but a portrait of von Hagn dating from this period provides the first example of his mature style. He returned to Munich in 1868 and from 1871 divided his time between Munich, Vienna and Berlin, enjoying a close friendship with Bismarck from 1878. After 1880 he devoted himself exclusively to portraits, painting all the leading figures of Germany and many from abroad. He was a member of the Munich, Berlin and Antwerp Academies. There are works in Aachen, Baltimore (Walters), Bergamo, Berlin, Berne, Bremen, Wrocław, Brussels (Musées Royaux), Cologne, Darmstadt, Düsseldorf, Edinburgh, Frankfurt/M., Leipzig, Madrid, Magdeburg, Munich (N. Pin.), Bratislava, Stockholm, Stuttgart, Vienna (Kunsthistorisches Mus.) and Weimar.
Lit. A. Rosenberg: *Lenbach* (1898); H. Kehrer: *F. von Lenbach* (1937); H. Behr: *Der Malerfürst F. von Lenbach und seine Zeit* (1960); S. Wichmann: *F. von Lenbach und seine Zeit* (1973)

Le Sidaner Henri Eugène, b. Port Louis (Mauritius) 1862, d. Versailles 1939. French painter who added a poetic and literary element to landscapes, interior and flower pieces painted in the IMPRESSIONIST manner. He passed through a brief SYMBOLIST period *c.* 1896–1900 (*La Ronde au Clair de Lune* 1896). He studied with CABANEL and at the ECOLE DES BEAUX-ARTS from 1880, but abandoned academic instruction in 1882 to settle at Etaples and devote himself to landscape painting. He exhibited at the SALON from 1887 and at the SOCIÉTÉ NATIONALE DES BEAUX-ARTS from 1894, becoming an officer of the Legion of Honour and a member of the INSTITUT in 1930. There are works in Boston, Chalons-sur-Marne, Chicago, Douai, Dublin, Dunkirk, Nantes, Paris (Mod. Art), Philadelphia, Pittsburgh and Rome (Mod. Art).
Lit. C. Mauclair: *H. Le Sidaner* (1928)

Leslie Charles Robert, b. London 1794, d. London 1859. English genre and history painter who spent his early life in America. His small, bright paintings, achieved with fluent summary brushwork, are usually humorous illustrations of well-known works of literature by writers such as Cervantes,

Shakespeare or Molière (*Sancho Panza in the Apartments of the Duchess* 1824, *Le Malade imaginaire* 1843). He was a close friend of CONSTABLE and published his *Memoirs of Constable* in 1845. His parents moved to Philadelphia (1800), where he studied with SULLY, but he left America for England in 1811. He studied at the ROYAL ACADEMY Schools under WEST and ALLSTON and at first turned his hand to history and portraits. He took up genre painting *c.* 1817, modelling his style on WILKIE and MULREADY. He became a friend of Sir Walter Scott, painting several pictures based on scenes from his novels. ARA (1825) and RA (1826), he painted *Queen Victoria Receiving the Sacraments* and *Christening of the Princess Royal* for the Queen. Like TURNER, he was patronized by Lord Egremont and stayed frequently at Petworth. His sons George and Robert were also painters. There are works in Boston, Chicago, Dublin, London (V&A, Tate), Manchester, Melbourne, New York (Met.) and Nottingham.
Lit. C. R. Leslie: *Autobiographical Recollections* (1860); J. Dafforne: *Pictures by Leslie* (1875); J. Constable: *The Letters of J. Constable and C. R. Leslie* (1931)

Lesrel Adolphe Alexandre, b. Genets (Manche) 1839, d. Genets (?) 1921. Prolific painter of historical genre much influenced by MEISSONIER. The 17C with its cavaliers and fine ladies was his favourite setting, but he also painted cardinals. Member of the SOCIÉTÉ DES ARTISTES FRANÇAIS from 1885, he became an associate of the SOCIÉTÉ NATIONALE DES BEAUX-ARTS from its foundation in 1890. Under Meissonier's influence, he painted with minute detail the textures of dress, furnishings and accessories. He exhibited regularly in England and is last recorded sending works from his Genets home in 1921. There are works in Baltimore (Mus. of Art), Digne, Nantes, New York (Pub. Lib.), Rouen, Saint-Lô and Sydney.

Lessing Karl Friedrich, b. Breslau 1808, d. Karlsruhe 1880. History and landscape painter, one of the early Romantics of the DÜSSELDORF SCHOOL. He became the leader of the liberal reaction among Düsseldorf artists to Prussian repression and academic orthodoxy. *Sorrowing Royal Pair* (1830) established his reputation and inaugurated

the mood of sorrowful resignation in Düsseldorf history painting. With *Robber on the Mountain Height* (1832) he entered the political arena, the heroic figure of the robber suggesting the nobility of his battle for the common people against the government of the day. His series of paintings of the Hussite Rebellion (*Hussite Prayer* 1836, *Hus in Kostnitz* 1842, *Hus at the Stake* 1850) reflected his identification with a historic rebellion against political and religious repression and met a stormy reception. He was also a pioneer of Düsseldorf landscape painting, standing on the frontier between late ROMANTICISM and REALISM. The formative influences on his early landscapes were Ruysdael and SCHINKEL; he painted broad panoramic views with corridors of trees to link foreground and distance. In 1832 he discovered in the Eifel district a wild, untamed landscape that exactly suited his taste; thereafter his views are careful studies of nature for which he even researched geological formations. He attended the Berlin Academy and was one of the artists who moved to Düsseldorf with SCHADOW when he was appointed academy director in 1826. In 1827 he founded with SCHIRMER an Association for Landscape Composition. He turned to historical landscape painting under Schadow's influence and established one of the greatest reputations in Germany in the 1830s. The political unrest that foreshadowed 1848 led to the division of Düsseldorf artists into two parties, the liberals following Lessing, the conservatives Schadow, and after his Hussite paintings he lost his position at the academy. In 1858 he left to become gallery director at Karlsruhe. In 1867 he was offered the directorship of the Düsseldorf Academy but refused it. There are works in Basle (Kunstmuseum), Berlin, Cincinnati, Cologne, Dresden, Düsseldorf, Frankfurt/M., Hamburg, Hanover, Karlsruhe, Stuttgart and Vienna.
Lit. A. Buchholz: *Die Geschichte der Familie Lessing* (1909)

Leutze Emanuel Gottlieb, b. Württemberg (Bavaria) 1816, d. Washington D.C. 1868. Historical painter, one of the leaders, with LESSING, of the DÜSSELDORF SCHOOL and the most honoured of the many Düsseldorf-trained Americans after his return to America in 1859. His patriotic *Washington Crossing*

Leslie *Sancho Panza in the Apartments of the Duchess* 1824

Lessing *Hussite Prayer* 1836

Leutze *Washington Crossing the Delaware* 1851

the Delaware was one of the sensational successes of the century and is still familiar to American schoolchildren. His technical skill and high finish are typical of Düsseldorf, while his subject matter and composition reflect the influence of prints after WEST AND COPLEY, to be found in the American homes of his childhood, and perhaps popular prints after DELAROCHE. The son of a radical who fled persecution to America, he studied at Philadelphia with J. A. Smith and was painting portraits by 1836. Local patronage sent him to Düsseldorf (1840), where he studied with Lessing. In 1841 he became famous for two paintings from the life of Columbus, one of which was bought by SCHADOW for the Düsseldorf KUNSTVEREIN and the other by the AMERICAN ART-UNION. After spending 1842 in Munich and 1843-5 in Italy, he lived in Düsseldorf (1845-59), where his studio was the pivot of the American colony. He helped all visiting artists and allowed the most distinguished (WHITTREDGE, JOHNSON) to share his studio. For the first version of *Washington Crossing the Delaware* (1850) Whittredge posed for Washington. Among the founders of the revolutionary artists' club, Malkasten (1848), he also shared in the street fighting; *Washington* was conceived as democratic propaganda. On his return to America (1859) he was commissioned to paint *Westward the Course of Empire Takes Its Way* for the Capitol. He also painted scenes from European history. There are works in Baltimore (Walters), Cincinnati, Düsseldorf, Gmünd, Hamburg, New York (Met., Hist. Soc.), Philadelphia and Stuttgart.
Lit. A. H. Hutton: *Portrait of Patriotism* (1959)

Levitan Isaac Ilyich, b. Kibarty (nr Wirballen) 1860, d. Moscow 1900. The leading Russian landscapist of the 1880s and 1890s. His discovery of MONET and the BARBIZON SCHOOL broke the dominant influence of the DÜSSELDORF SCHOOL on Russian landscape painting of the mid-century. He painted melancholy autumn and sunset scenes, old Russian monasteries by winding rivers with the steppes stretching endlessly into the distance. After studying at the St Petersburg Academy under Savrasov and Polyenov, he visited Paris (1889) where he was profoundly influenced by the works of the Barbizon School, in particular those of COROT and DAUBIGNY, at the EXPOSITION UNIVERSELLE, and took some lessons from DUPRÉ. He exhibited with the PEREDVIZHNIKI from 1884 and later with the MIR ISKUSSTVA, as well as working on theatre décor in the Abramtzsevo artist community. His Volga landscapes of 1887-91 established his fame (*After the Rain near Pless* 1889, *The Quiet Convent* 1891). He taught at the Moscow School of Art (1898-1900) and was a friend of Tchekov. There are works in Leningrad (Russian Mus.) and Moscow (Tretiakov).
Lit. S. Glagol, I. Grabar: *I. I. Levitan, his Life and Work* (1912, in Russian); B. V. Ioganson: *I. I. Levitan* (1963, in Russian); K. Paustowski: *I. I. Levitan* (1965)

Lewis John Frederick, b. London 1805, d. Walton-on-Thames 1876. Best known for his scenes of Spain and the Orient, usually figure subjects painted with brilliant colour and sparkle of light. His meticulous but unlaboured detail led Ruskin to hail him as a leading PRE-RAPHAELITE, although he had no direct links with the movement. The son of a painter, he studied with LANDSEER as a boy and first exhibited at the ROYAL ACADEMY in 1821; his animal paintings achieved royal patronage. He took up watercolours in 1825. In 1827 he visited Switzerland and Italy, and spent 1832-4 in Spain, earning the name of 'Spanish Lewis'. From 1838 to 1841 he was in Rome and Greece, but settled in Cairo from 1841 to 1850, during which period he did not exhibit. In 1850 his watercolour *The Harem* caused a sensation, winning Ruskin's enthusiastic praise, and he followed it by a series of Oriental scenes. President of the Royal Watercolour Society from 1855 until his resignation in 1858, he became an ARA (1859) and RA (1865). There are works in Birmingham, Blackburn, Cambridge, Dublin, Edinburgh, London (Tate, V&A), Manchester, Oxford (Ashmolean), Preston and Warrington.

Leys Baron Hendrik, b. Antwerp 1815, d. Antwerp 1869. History painter whose careful reconstructions of life in the 16C and 17C represent the first important Belgian contribution to REALISM. He painted scenes of ordinary life, taking great pains with the authenticity of costume, architecture and accessories and laying special stress on psychological truth; his paintings are smoothly finished and display a still-life painter's enjoyment of textures and surfaces. He was accorded every honour in Belgium and his influence was felt throughout Europe. He studied at the Antwerp Academy and with his brother-in-law F. DE BRAEKELEER. WAPPERS was the only important early influence on his work and he began by painting dramatic historical scenes (*Spanish Fury in Amsterdam* (1834-44). In 1835 he was in Paris and a frequent visitor to the studio of DELACROIX. Around 1839 he turned away from ROMANTICISM to more truthful historical scenes influenced by Rembrandt, Terborch and de Hooch (*Seventeenth Century Wedding* 1839, *Burgomaster Six with Rembrandt* 1850). The 1850s saw the full development of his new Realist approach, while a visit to Germany in 1852 brought him into contact with the work of Dürer, Cranach and Holbein and fired his interest in the 16C, to which most of his later paintings were devoted (*Mass of Berthal de Haze* 1854, *New Year in Flanders* 1853-4). The frescoes for Antwerp Town Hall (1863-9) depicting episodes from Flemish history are among his most important works; there are easel replicas in Brussels. He won medals in Paris and London, was made chevalier of the Order of Leopold in 1840, officer in 1856 and commander in 1867, the year he was created Baron. There are works in Amsterdam, Antwerp, Baltimore (Walters), Berlin, Brussels (Musées Royaux), Lille, London (Wallace), New York (Brooklyn), Philadelphia and Washington (Corcoran).
Lit. J. de Bosschère: *Le Style de Leys* (1905); G. Vanzype: *H. Leys* (1935)

Lhermitte Leon Augustin, b. Mont-Saint-Père (Aisne) 1844, d. Paris 1925. Painter of peasant scenes who combined the subject matter of MILLET with the palette of the IMPRESSIONISTS and added a picturesque charm which brought him resounding success, substantially helped by Millet's belated international fame. He studied with LECOQ DE BOISBAUDRAN and first exhibited at the SALON of 1864, with immediate success. He became a chevalier of the Legion of Honour (1884), an officer (1894) and a commander (1911), and a member of the INSTITUT (1905). One of the founders, with MEISSONIER, of

the SOCIÉTÉ NATIONALE DES BEAUX-ARTS (1890), he later became its vice-president. Though he kept a Paris studio, most of his working life was spent in the village of his birth. There are works in Albany (Hist. and Art Soc.), Amiens, Boston, Buffalo, Carcassonne, Château-Thierry, Chicago, Florence (Uffizi), Ghent, Montreal, Moscow (Tretiakov), New York (Met.), Paris, Reims, St Louis, Saint-Quentin and Washington (Corcoran).

Liebermann Max, b. Berlin 1847, d. Berlin 1935. Berlin's leading painter at the turn of the century. Through his work, *avant-garde* French painting, first the BARBIZON SCHOOL and then the IMPRESSIONISTS, became a dominant influence in Germany. While he was particularly susceptible to the influence of other artists, the strength of his draughts-manship and his psychological insight give his work a special individuality. He studied with Steffeck (1866–8) in Berlin and at the Weimar Art School (1868–72) under Thumann and Pauwels, and was particularly influenced by a meeting with MUNKÁCSY in Düsseldorf. *Women Plucking Geese* (1872), with its debts to LEIBL and Munkácsy, was violently criticized and like other REALISTS he was dubbed 'the apostle of ugliness'. He followed Munkácsy to Paris in 1872 and spent the summer of 1873 in Barbizon, where he was profoundly influenced by the subject matter of MILLET and COURBET and the colour of COROT, TROYON and DAUBIGNY. After 1874 he spent part of each summer in Holland; the influence of J. ISRAËLS and his own copies from Frans Hals left a lasting mark on his art. The success of *Conserve Factory*, exhibited in Antwerp in 1873, led to flattering offers from French and Belgian dealers. He settled in Paris (1873–8) and exhibited with A. STEVENS, BASTIEN-LEPAGE and others, a group calling themselves the Cercle des XV, at the Galerie Petit; in Munich (1878) he developed signifi-cantly his power of draughtsmanship under the influence of Leibl and painted fresh brightly coloured genre and landscape. In 1884 he moved to Berlin, where until 1890 he painted mainly peasant scenes in the silver-grey tones of Israëls. During the 1890s he developed his mature, brightly coloured Impressionist style with strong impasto, combining the influence of the French with that of MENZEL (*Polo Players* 1902). He be-came president of the Berlin SECESSION in

Leys *Faust and Marguerite* 1856

Levitan *Spring Waters* 1897

Lhermitte *Harvest* exhibited 1874

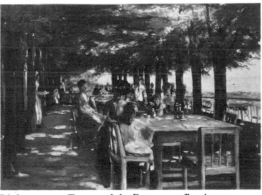
Liebermann *Terrace of the Restaurant Jacob* 1902

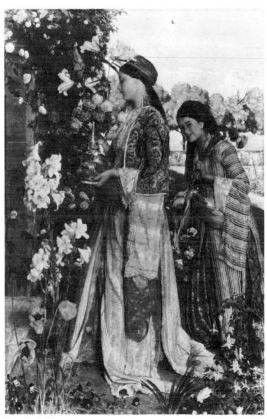
Lewis *Lilium Auratum* 1871

Lier *The Theresienwiese, Munich* 1882

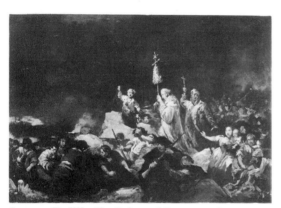

Lucas y Padilla *The Defence of Saragossa* 1850–5

Löfftz *Hall in Hildesheim*

1899. During the last thirty years of his life he painted mainly portraits and views of his garden at Wannsee. There are works in Berlin, Hamburg and most German provincial museums, and in Danzig, The Hague, Prague (NG), Vienna (Kunsthistorisches Mus.), Washington (Corcoran) and Zurich. *Lit.* Cassirer (ed.): *M. Liebermann als Schriftsteller* (1922); G. Schiefler: *M. Liebermann: Sein graphisches Werk* (1923); M. J. Friedländer: *M. Liebermann* (1924); K. Scheffler: *M. Liebermann* (4th ed. 1953); F. Stuttman: *M. Liebermann* (1961)

Lier Adolf Heinrich, b. Herrnhut 1826, d. Wahren (Brixen) 1882. Munich landscapist, one of the founders of STIMMUNGSLANDSCHAFT. He adapted the style of the Barbizon painters to Bavarian landscape, but added a more pronounced note of poetry and mood – tints of autumn, hurrying evening clouds reflected in the still waters of a flooded field. After studying architecture he turned to painting (c. 1849), working in Munich with Zimmerman. He visited Paris (1861, 1864–5), where he came into contact with the BARBIZON SCHOOL and painted from nature in L'Isle-Adam with DUPRÉ. In 1865 he visited England, and in 1863 founded a private school of landscape painting in Munich. He travelled to Holland in 1873. A member of the Dresden and Munich Academies (1868 and 1877), he became a professor at the Munich Academy in 1881. There are works in Berlin, Bremen, Dresden, Elberfeld, Frankfurt/M., Karlsruhe, Leipzig, Munich, Oldenburg, Stuttgart and Wiesbaden. *Lit.* T. Mannacher: *A. Lier und sein Werk* (1928)

Linnell John (the Elder), b. London 1792, d. Redhill (Surrey) 1882. Prolific landscape painter whose best works are touched with a religious vision of the mystery of nature, reflecting his contact with BLAKE and PALMER. He entered the ROYAL ACADEMY Schools under WEST (1805), studied with VARLEY and enjoyed a close early friendship with MULREADY. He exhibited at the Royal Academy from 1807 to 1811 and with the Society of Painters in Oils and Watercolours until 1820, returning to the academy in 1821. His portrait of the *Duke of Argyll* (1817) launched him as a fashionable portrait-painter and miniaturist; his aim was to make enough money from his portraits to be able to devote himself to landscape, and he achieved this c. 1847. He settled in Redhill (1852), and most of his later landscapes are of Surrey (*Reapers, Noonday Rest* 1865). He deeply admired Blake, whom he met in 1818, and financed the publication of the *Illustrations to the Book of Job* (1826). His friendship with Palmer became strained after Palmer's marriage to his daughter Hannah. When he died, he left an estate of over £200,000; he had three painter sons, John (Jr), James Thomas and William. There are works in Birmingham, Glasgow, Liverpool (Walker), London (Tate, V&A, NPG) and Melbourne. *Lit.* A. T. Story: *Life of John Linnell* (1892)

Löfftz Ludwig von, b. Darmstadt 1845, d. Munich 1910. History, genre and landscape painter of the Munich school. He belonged to the REALIST generation but drew extensively on the example of early masters, notably Quentin Matsys, Holbein and van Dyck. He was an influential teacher. He studied at Nuremberg (1869) with Kreling and Raupp, and from 1870 at the Munich Academy with DIEZ. He became professor (1874) and director (1893–9) of the Munich Academy. There are works in Darmstadt, Elberfeld, Frankfurt/M., Karlsruhe, Munich, Prague and Stuttgart.

Lopez y Portana Don Vicente, b. Valencia 1772, d. Madrid 1850. The successor of GOYA as official portraitist to the Spanish court, he also painted historical and allegorical subjects, following the baroque tradition but painting with careful detail. After studying under Villanueva and at the Valencia Academy, he won a grant to study at the Madrid Academy (1789–92). He became director of the Valencia Academy (1801), royal *pintor de camara* (1802), *primer pintor de camara* (1815) and director of the Madrid Academy (1817). He executed frescoes for Charles III's drawing-room in the royal palace in Madrid, as well as for churches and other public buildings. There are works in Madrid (Prado, S. Fernando), Rome, Rouen, Toledo and Valencia. *Lit.* V. Lopez y Portana: *V. Lopez* (1925)

Lucas y Padilla Eugenio, b. Alcala de Henares 1824, d. Madrid 1870. A noted colourist profoundly influenced by GOYA,

following him in both subject matter and style. He studied at the Madrid Academy, but was more influenced by Goya and Velasquez than by his teachers there. He painted many scenes of war, revolution, execution and inquisition, as well as bullfights and dream sequences, and executed frescoes for the Madrid Opera House. There are works in Brussels, Budapest, Cologne, Frankfurt/M., Lille, Madrid and New York (Hist. Soc.).
Lit. J. A. Gaya Nuño: *E. Lucas* (1948)

Luce Maximilien, b. Paris 1858, d. Paris 1941. French painter who studied at the Académie Suisse and worked in London as an illustrator for the *Graphic*. A meeting with SIGNAC changed the course of his career; he adopted the POINTILLIST technique and became one of the NEO-IMPRESSIONIST group, first exhibiting at the SALON DES INDÉPENDANTS in 1887. Townscapes and industrial scenes are characteristic of his work. He exhibited with LES VINGT in Brussels in 1889 and 1892, and worked in the POINTILLIST technique for many years, though he finally returned to a more conventional IMPRESSIONIST brushwork. He became president of the Société des Artistes Indépendants in 1935.
Lit. A. Tabarant: *M. Luce* (1928)

Lugardon Jean Léonard, b. Geneva 1801, d. Geneva 1884. History and genre painter. A pupil of GROS in Paris and a friend of INGRES, he specialized in painting scenes from Swiss history, the reproductions of which became very popular in Switzerland. He spent a considerable period in Paris and Italy and was, for seven years, director of the Geneva School of Art. He visited Algeria in 1845. Illness prevented him from painting during the last twenty-seven years of his life. There are works in Geneva (Ariana, Rath), Neuchâtel and Versailles.

Luminism (Luminist). A recently coined term used to describe a mode in American painting that flowered *c.* 1845–60. Its characteristics are a crystalline clarity of light, an almost mathematical ordering of planes in space, simplicity, serenity and a concentration on the essence of inanimate nature. *Fur Traders Descending the Missouri* (BINGHAM) and *Eel Spearing* (MOUNT) are among the most famous of Luminist images. LANE and HEADE are considered characteristically Luminist painters and several landscapes by KENSETT are painted in this mode. Baur introduced the concept in his essay *American Luminism* and it is further developed by Barbara Novak. Elements of Luminism recur throughout the history of American painting

from *Portrait of Paul Revere* (COPLEY) to Photo-Realism; it appears to be a characteristically American way of seeing. Its slightly naïve simplicity is related to folk art; the formal ordering of planes in space reflects the disciplines of printmaking in which many artists were trained; in the matter of painterly realization there is a debt to the Dutch 17C, especially van de Velde. The term is used variously by different authors and it is sometimes considered an offshoot of the HUDSON RIVER SCHOOL.
Lit. J. I. H. Baur: *American Luminism* (in *Perspectives U.S.A.* No. 9, 1954); B. Novak: *American Painting in the Nineteenth Century* (1969)

Lundbye Johan Thomas, b. Kallundborg 1818, d. Bedsted (Schleswig) 1848. Danish naturalistic landscape and animal painter. Influenced by ECKERSBERG and his contemporary KØBKE, he studied extensively from nature and belongs essentially to the ROMANTIC generation. A scholarship took him to Italy (1845–6); he travelled via Germany and returned through Belgium and Holland. He died as a volunteer in the Danish army in 1848. There are works in Copenhagen (State, Hirschsprung) and Stockholm.
Lit. K. Madsen: *J. T. Lundbye* (1895); T. Oppermann: *Lundbyes danske Landskabstegninger* (1919)

M

Macchiaioli. Italian REALIST movement centred on Florence and dedicated to painting from nature with an emphasis on effect derived from chiaroscuro, the arrangement of emphatic masses of light and shadow. *Macchia* in Italian can mean patch, sketch or blob; it seems to have been used by the artists themselves to refer to contrasting patches of light and shadow, though they were criticized by contemporaries for creating mere sketches rather than finished pictures. Like their French contemporaries, they aimed particularly at the communication of poetic mood and emotion. The movement started in 1855 when DE TIVOLI ('father of the *macchia*')

brought the germ of the new style back from the EXPOSITION UNIVERSELLE in Paris where he had, according to SIGNORINI, been inspired by DECAMPS, TROYON and BONHEUR. The technique of *macchia*, 'violent with chiaroscuro' (Signorini), was applied equally to historical and contemporary subjects; public taste was converted to the *macchia* at the 1861 Florence National Exhibition primarily through the historical canvases of MORELLI. The term has, however, come to be used of the whole Realist movement in Italian landscape painting, which drove artists to paint directly in the countryside and exchange the old convention of contours and modelling for quick

brushstrokes of contrasting colour, attempting a closer approximation to natural phenomena. The political upheavals of 1848 led artists from all over Italy to seek asylum in Florence. From 1850 the Caffé Michelangelo became the meeting-place where the new approach to art was hotly discussed. SIGNORINI, BORRANI and FATTORI formed the original nucleus of the group; they were joined by Altamura from Naples, COSTA from Rome and many others for shorter and longer periods; most notable was the conversion of LEGA in 1861. The school is well documented by Signorini himself, the sculptor Andrea Cecioni and the critic and

Maclise *The Marriage of the Princess Aoife of Leinster with Richard de Clare, Earl of Pembroke (Strongbow) c. 1854*

Madou *The Feast at the Château* 1851

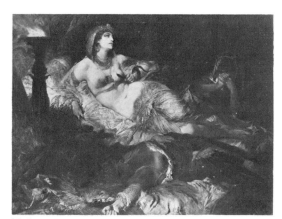

Makart *Death of Cleopatra* 1874–5

collector Diego Martelli, who was a patron and supporter of the movement. It has been claimed that the Macchiaioli invented IMPRESSIONISM before the Impressionists, but their approaches differed in many important particulars.

Lit. A. Franchi: *I Macchiaioli Toscani* (1945); G. Einaudi: *Lettere dei Macchiaioli* (1953); M. Giardelli: *I Macchiaioli e l'epoca loro* (1958); R. de Grada: *I Macchiaioli* (1966)

Maclise Daniel, b. Cork 1806, d. London 1870. The most successful English historical painter of the 19C. Much of his mature working life was taken up with frescoes for the Houses of Parliament, notably his two late masterpieces *The Meeting of Wellington and Blücher* and *The Death of Nelson*. He was influenced by both DELAROCHE and the German NAZARENES (*The Spirit of Chivalry* 1847); his paintings of fairies and illustrations of fairy tales also lean on German precedent. His figures, however, are painted without Continental idealization; their robust REALISM owes a debt to WILKIE. He was a close friend of Dickens and Disraeli and very popular with Queen Victoria and Prince Albert. From 1822 he attended the school of art in the old Apollo theatre, Cork, and from 1826 had some success with portrait drawings in Dublin; his illustrations for Crofton Croker's *Fairy Legends* date from this period. He moved to London in 1827, supporting himself by portrait drawings, and entered the ROYAL ACADEMY Schools in 1828, first exhibiting at the Royal Academy in 1829. In 1830 he visited Paris and in 1831 won the Royal Academy gold medal for history painting with *The Choice of Hercules*; he became an ARA in 1835 and an RA in 1840. In 1843 he painted a fresco of *Comus* for the Garden Pavilion, Buckingham Palace, and the following year in Paris saw Delaroche's *Hemicycle*, which had an important influence on his mural paintings, at the ECOLE DES BEAUX-ARTS. The years 1845–65 were mainly devoted to frescoes for the Houses of Parliament. He declined to be a candidate for the presidency of the Royal Academy in 1866. There are works in Cardiff, Dublin, Edinburgh, Glasgow, Hamburg, Leeds, Liverpool, London (NPG, Tate, V&A, House of Lords), Manchester, Newcastle, Oxford, Preston, Sheffield, Toledo Ohio and Victoria.

Lit. J. Dafforne: *Pictures by D. Maclise* (n.d.); J. Dafforne: *Leslie and Maclise* (n.d.); W. J. O'Driscoll: *Memoir of D. Maclise* (1871)

Madarász Victor, b. Csetnek 1830, d. Budapest 1917. A historical painter with revolutionary sympathies, he painted episodes from Hungarian history with an accent on Habsburg persecution, and portraits of many revolutionary leaders with whom he was in close contact, particularly Kossuth. His patriotic, radical family background led him to join the revolutionary forces in 1848; he escaped after their defeat and went to Vienna where he first studied law and then painting with WALDMÜLLER. He moved on to Paris (1856–70) where he studied with L. COGNIET. He began by painting portrait studies but had his first success in 1861 with *Lament for Laszlo Hunyadi*, which won a SALON medal and much praise from Gautier. He maintained his political stance in other works, attempting to emphasize the tragic and universal aspects of his nation's history. On his return to Hungary in 1870, he largely gave up painting, taking over his father's factory in 1873. His dramatic themes and presentation influenced MUNKÁCSY and he had many imitators. There are works in Budapest.

Madou Jean Baptiste, b. Brussels 1796, d. Brussels 1877. Genre painter who worked in the spirit of Teniers, painting tavern scenes and country festivals generally set in the 18C. Like LEYS, he belongs to the generation of Belgian historical genre painters whose accent on realistic presentation opened the way for A. STEVENS, DE GROUX and the painters of contemporary life. 'He unquestionably stands at the head of the genre painters of Belgium,' stated the London *Art Journal* in 1866. After studying with P. J. C. François, he turned to business (1814–18) and then worked with the map section of the Belgian army (1818–20). He next turned to lithography, working with Jobard in Brussels and after 1830 publishing several series of his own lithographs, including *Souvenirs of Brussels* and *Military Costumes*. He took up painting again *c.* 1840, with notable success; he won the French Legion of Honour and the Order of Leopold of Belgium, and was a member of the Brussels and Antwerp Academies. He became professor of drawing

at the Military School of Brussels. There are works in Amsterdam (Stedelijk), Antwerp, Bremen, Brussels (Musées Royaux), Szczecin and Verviers

Madrazo y Kuntz Don Federigo de, b. Rome 1815, d. Madrid 1894. Spain's leading portraitist of the mid-century. He was a pupil and follower of INGRES, though his religious works were NAZARENE-influenced. He received his first instruction from his father José, a NEOCLASSICAL painter, and became a member of the Madrid Academy at sixteen. In Paris (1832) he studied with Ingres. His early works include large battle scenes and religious-historical compositions (*Choice of Gottfried von Bouillon as King of Jerusalem* 1839). He lived in Madrid (1836) and in Paris (1837–41) before visiting Rome (1841) where he fell under the influence of OVERBECK, subsequently painting many religious works (*The Three Maries at the Grave*, decorations for the Palace of Congress, Madrid). He achieved all the honours possible in his lifetime: he was accorded the Legion of Honour, was a correspondent member of the French INSTITUT, Spanish court painter and, like his father, director of the Prado and director of the S. Fernando Academy, Madrid. Two of his sons, Raimondo and Luis, became painters, while his daughter married FORTUNY. There are works in Bayonne, Berlin (NG), Madrid (Prado, S. Fernando) and Versailles.
Lit. M. de Madrazo: *F. de Madrazo* (1923); B. de Pantorba: *Los Madrazos: ensayo biografico y critica* (1947)

Makart Hans, b. Salzburg 1840, d. Vienna 1884. Painter of history, myth and allegory, a powerful colourist who based his style closely on Rubens. Ignoring the contemporary fashion for historical accuracy, he painted history and allegory as a tapestry of female flesh, rich stuffs, jewels, birds and flowers, 'studies of still life out of which human figures rise to the surface' (Muther). He was sensationally successful in his day and became a pivot of Viennese society in the 1870s. His studio was the venue for elaborate parties at which Sarah Bernhardt and Richard Wagner were favourite guests. His 'style' was an inspiration to modistes, decorators and the applied arts throughout Germany and Austria. He studied at the

Vienna Academy for a few months in 1858, but moved to Munich in 1859, entering the academy in 1860. He became a special friend and protégé of PILOTY, who found him commissions and lent him money for an Italian visit in 1862. Two triptychs exhibited in 1868 established his European fame, *Modern Amoretti* and *Pest in Florence* (also known as *The Seven Deadly Sins*). Vienna, jealous of Munich's position as a capital of art, invited him to return in 1869, offering him commissions, a free home and studio. His sudden fame brought wild art market speculation in his paintings. He spent 1874 in Italy, 1875–6 in Egypt and 1877 in Spain and Morocco. He was appointed professor at the Vienna Academy in 1879 and given charge of the celebrations for the Emperor's silver wedding. There are works in Amiens, Berlin, Béziers, Bielefeld, Bucharest, Darmstadt, Dresden, Graz, Hamburg, Hanover, Innsbruck, Karlsruhe, Kassel, Linz, Munich, Nuremberg, Regensburg, Salzburg, Schweinfurt, Trieste and Vienna (Belvedere). (*see colour illustration 27*)
Lit. R. Stiassny: *H. Makart und seine bleibende Bedeutung* (1886); F. Pollak: *H. Makart* (1905); E. Pirchan: *H. Makart: Leben, Werk und Zeit* (1942)

Makovsky (Makowskij), Vladimir Yegorovich, b. Moscow 1846, d. Petrograd 1920. Genre painter, an early member of the PEREDVIZHNIKI group. His subjects were domestic dramas of Russian farmers and the *petit-bourgeois*. He studied at the St Petersburg Academy, where he won a gold medal in 1869, became an academician in 1878 and a professor in 1894. He exhibited in Vienna and Berlin (1873–93) as well as in Russia. His anecdotic paintings lost much of their satire and reforming zeal in his later life. There are works in Leningrad (Russian Mus.), Moscow (Pushkin, Tretiakov) and St Louis.
Lit. L. Tarasov: *V. E. Makovsky* (1955)

Mancini Antonio, b. Rome 1852, d. Rome 1930. Genre and portrait painter who developed a style close to Caravaggio, Velasquez and the great Neapolitan painters of the 17C, combining their intimate vision of everyday life with a powerful Post-Impressionist impasto. The lovingly painted still-life elements are a notable feature of his work. He studied

Makovsky *In the Doctor's Waiting Room* 1870

Mancini *Return from Piedigrotta*

at the Naples Academy with MORELLI and PALIZZI from 1864, painting some early Caravaggesque works before falling under the spell of the rich colourism of FORTUNY. He moved to Paris in 1875, on Fortuny's advice, but had to return on account of his mental illness in 1883. He settled in Rome, where he developed his own individual style, but travelled widely, particularly to England, Germany, Belgium and Holland. There are works in Florence (Uffizi), Milan (Mod. Art) and Trieste (Revoltella).

Lit. F. Bellonzi: *A. Mancini* (1962); D. Cecchi: *A. Mancini* (1967)

Mánes Josef, b. Prague 1820, d. Prague 1871. A Czech patriot, he studied the traditional peasant way of life, its characteristic costumes, architecture, landscape and legends. He treated all these subjects in paintings of careful REALISM, as well as in book illustrations and lithographs, and is seen as the founder of Czech national art. He was trained by his father, a Prague landscapist, and attended the Prague Academy (1835–44). His early works are conventional history paintings, though intensely ROMANTIC in mood (*Death of Lucas van Leyden* 1843); he also painted many portraits. He visited Dresden (1843) and Munich (1844–6), where he was much influenced by CORNELIUS, GENELLI and SCHWIND. On his return he travelled through Slovakia, making studies of traditional rural life. Extensive magazine and book illustration, particularly the illustrations of Czech folk songs (1856–62), helped to evolve his mature style. The twelve scenes of Czech life (1865–6) painted for the month plates of Prague Town Hall's new clock are among his most important work. He visited Moscow and St Petersburg in 1867 and Rome in 1870, and enjoyed considerable influence and popularity. There are works in Brno and Prague (State, Mod.).

Lit. A. Matějček: *Mánesovy ilustrace* (1952, in Czech); J. Loriš: *Mánesovy padobizny* (1954, in Czech)

Manet Edouard, b. Paris 1832, d. Paris 1883. Manet was one of the most controversial innovators of his time, not only in his dedication to REALISM, to painting life as he saw and knew it (which led him in *Déjeuner sur l'herbe* to paint a Giorgionesque

fête champêtre in modern dress), but also in his rejection of conventional modelling in half-tones, for which he substituted the direct opposition of light and shadow, using a restricted palette in which black was dominant. He often borrowed his compositions from other masters (Giorgione, Titian, Velasquez, Frans Hals, GOYA), his own interest lying primarily in the pictorial unity of the painted surface and its visual immediacy. Slightly older than RENOIR, MONET and the other IMPRESSIONISTS, he powerfully influenced their early work, but later lightened his own palette and adopted their method of juxtaposing contrasting colours. He was a close friend of DEGAS and, at the Café Guérbois, presided over the Impressionists' seminal discussions of their new approach to art. With his extensive study of Old Masters he was, nevertheless, something of a traditionalist; he never exhibited at the Impressionist Group Shows, resented references to the younger innovators as 'Manet's gang', and longed for conventional success through the SALON to which he constantly submitted, meeting with constant rejections. He came of the *haute bourgeoisie*, and was destined by his parents for the navy. He studied in the atelier of COUTURE (1850–6), at the same time studying Old Masters in the Louvre and travelling round Europe. In 1859 his first submission to the Salon, *Absinthe Drinker*, was rejected but in 1861 his *Portrait of the Artist's Parents* and *Guitarrero* were accepted and well received. In 1863 his *Déjeuner sur l'herbe*, rejected by the official Salon, was hung in the Salon des Refusés and proved a *succès de scandale*; its classical allusions were lost on the public who saw only fully dressed men and naked ladies carousing in a wood. Its contemporary Realism and innovatory treatment of colour rallied the younger artists to him. *Olympia* (1863), exhibited at the 1865 Salon, roused another storm of abuse. In the same year he visited Spain and his *Fifer* (rejected from the 1866 Salon) reflected his renewed interest in Velasquez. In 1867 he set up a pavilion outside the EXPOSITION UNIVERSELLE, beside that of COURBET, where he exhibited fifty canvases. In 1868 he met the painter BERTHE MORISOT, who was to marry his brother in 1874; he used her frequently as a model (*The Balcony* 1868) and she in turn did much to convert him to *plein air* painting. He served

in the National Guard in the 1870 war and in 1872 visited Holland; the influence of Frans Hals is reflected in his *Bon Bock* of 1873. He spent some time at Argenteuil in 1874, painting from nature with Monet and Renoir (*The Monet Family in their Garden*). It was only in the 1880s that his work began to gain public acceptance; his portrait of *Proust* was well received at the 1880 Salon. In 1882 *Bar at the Folies-Bergère* brought him the Legion of Honour (with some help from Proust). In 1884, the year after his death, a retrospective exhibition of his work was organized at the ECOLE DES BEAUX-ARTS. There are works in most museums of modern art. (*see colour illustration 23*)

Lit. E. Moreau-Nélaton: *Manet raconté par lui-même* (1926); A. Tabarant: *Manet, histoire catalographique* (1931); Jamot, Wildenstein, Bataille: *Manet* (1932); G. Jedlicka: *Manet* (1941); G. H. Hamilton: *Manet and his Critics* (1954); N. G. Sandblad: *Manet – Three Studies in Artistic Conception* (1954); A. de Leiris: *The Drawings of E. Manet* (1969); E. J. Harris: *E. Manet – Graphic Works* (1970); D. Ronart, D. Wildenstein: *Manet. Catalogue raisonné* (1975); A. C. Hanson: *Manet and the Modern Tradition* (1976)

Marées Johann Hans Reinhard von, b. Elberfeld 1837, d. Rome 1887. With FEUERBACH and BÖCKLIN, one of the German Romans who turned back to idealism, or the painting of ideas, at a period when REALISM was the dominant mode in Germany. His mature art is based on an analytic approach to pictorial problems; he sought monumentality, placing nude human figures in landscape settings which he used organically to link their statuesque isolation. He entered the Berlin Academy in 1853, studying with Steffeck from 1854, and in 1857 moved to Munich where he worked from nature with LIER, LANGKO and LENBACH. In 1864 he left for Italy with Lenbach, both having been commissioned to paint copies of Old Masters for the Munich connoisseur Count Schack. His analytical approach to pictorial problems began to take shape while working on these copies and was encouraged by his meeting with Konrad Fiedler, the art theorist, in 1866. In 1869 they travelled together to Spain, France and Holland. It was in his vast frescoes for the Stazione Zoologica in Naples

(1873) that his style reached maturity (*Friends of the Artist in a Pergola*). He finally settled in Rome where his monumental mythological art was fully developed (*Garden of the Hesperides* 1884-5). He was a close associate of the sculptor Adolf von Hildebrandt in Italy, as well as of Feuerbach and Böcklin. There are works in Berlin, Bremen, Dresden, Hamburg, Hanover, Munich (N. Pin.), Vienna (Kunsthistorisches Mus.) and several other German museums.

Lit. K. Fiedler: *H. von Marées* (1874); H. Meier-Graefe: *H. von Marées, sein Leben und sein Werk* (1910); H. von Marées: *Briefe* (1920); B. Degenhart: *H. von Marées, Die Fresken in Neapel* (1959); H. Faensen: *Die bildnerische Form: die Kunstauffassungen Konrad Fiedlers, Adolf von Hildebrandt und H. von Marées* (1965); K. Liebmann: *H. von Marées* (1972)

Marilhat Prosper Georges Antoine, b. Vertaizon (Puy-de-Dôme) 1811, d. Thiers 1847. The third of the great French Orientalists, following in the footsteps of DELACROIX and DECAMPS. His preoccupation was with landscape and the play of light, which he also put to good use in his few French landscapes. He studied with Roqueplan, and painted in a traditional NEOCLASSICAL vein until he made an extensive tour of Greece, Asia Minor and Egypt (1831-5); the Oriental scenes that he painted on his return to Paris brought him immediate success. His career was cut short by mental illness. There are works in Baltimore (Mus. of Art, Walters), Bernay, Béziers, Blois, Carpentras, Chantilly, Le Mans, Leipzig, Le Puy, Lille, London (Wallace), Lyons, Minneapolis, Montpellier, Moscow (Pushkin), Nantes, Paris (Louvre), Philadelphia, Strasbourg and Versailles.

Lit. H. Gomot: *Marilhat et son œuvre* (1884)

Maris Family of Artists. The Maris brothers, Jacob, Matthijs and Willem, were leading figures of the HAGUE SCHOOL, together with ISRAËLS, MAUVE and BOSBOOM. **Jacob Hendrikus** (b. The Hague 1837, d. Karlsbad 1899) excelled in country scenes set in his native Holland, in townscapes and in harbour views. His atmospheric paintings are built up from contrasting tones, using generally a limited palette with a dominant note of pearl-grey or golden-brown. He studied with Stroebel, Berg and H. van Hove at The

Manet *Bar at the Folies-Bergère* 1882

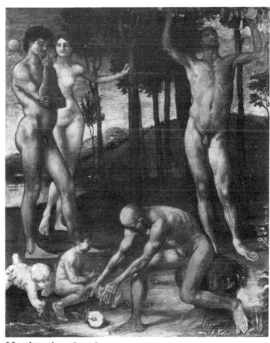

Marées *Age* 1873-8

Marilhat *The Erechtheum at Athens* 1841

J. H. Maris *Three Windmills* 1880

Hague, moving to Antwerp in 1853 but returning to The Hague in 1857. His early works are mainly figure subjects treated in the old Dutch style with a strong debt to Pieter de Hooch (*Feeding the Hens* 1866). In Paris (1865–71), he studied with HÉBERT but also worked at Fontainebleau, coming under the influence of the BARBIZON SCHOOL, particularly COROT and JONGKIND. From this period dates his conversion to landscape painting. He settled in The Hague in 1871, devoting himself to the depiction of Dutch scenery (*The Old House* 1883, *Evening on the Shore* 1890). There are works in Amsterdam (Rijksmuseum, Stedelijk), Boston, Dordrecht, Edinburgh, Glasgow, The Hague, New York (Met., Brooklyn) and Philadelphia. **Matthijs** (b. The Hague 1839, d. London 1917) was the visionary and dreamer of the family; Jacob considered him a genius and was much influenced by him in their student years. He painted landscapes, intimate scenes of family life, history and fairy stories (*Souvenir of Amsterdam, Bride of the Church*), often in watercolour with the figures emerging from a soft haze of wash. He studied at The Hague drawing school and with the marine painter Louis Meijer. He followed Jacob to the Antwerp Academy (1855–8) and in 1860 went with him to Germany, where an exhibition of German ROMANTICS (SCHWIND, KAULBACH, RETHEL) importantly influenced his work. In Paris (1867–72) he fought for the Commune, before settling in London (1877), where he led a retired life and turned to the depiction of medieval myth and fairy story under the influence of BURNE-JONES and the PRE-RAPHAELITES. There are works in Amsterdam (Rijksmuseum, Stedelijk), Boston, Dordrecht, The Hague, London (NG), New York (Met.), Philadelphia and Rotterdam. **Willem** (b. The Hague 1844, d. The Hague 1910) was a painter of domestic landscapes, cows in a corner of a field, ditches bright with weeds, or ducks on a pond. His early works are carefully drawn (*Warm Day* 1868) and bright in colour, but his brushwork became progressively looser and he turned to softer, more subtle tones. He had no formal training but was taught by his brothers from an early age; MAUVE met him sketching at the age of eleven and was amazed by his powers. He first exhibited at The Hague in 1863 and in 1865–6 visited Germany with B. J. Blommers.

He lived in The Hague from 1869. There are works in Amsterdam (Rijksmuseum, Stedelijk), Dordrecht, Edinburgh, The Hague, Hamburg, Philadelphia and Stuttgart.
Lit. D. C. Thompson: *The Maris Brothers* (1907); E. D. Friedlander: *M. Maris* (1922); H. E. van Gelder: *M. Maris* (1945); M. H. W. E. Maris: *De Geschiedenis van een Schildersgeschlacht* (1947)

Márko Károly (Carlo) (the Elder), b. Löcse 1791, d. Florence 1860. Landscape painter of Hungarian extraction, who spent most of his life in Italy. He worked mainly in Florence, where he gained an international reputation and had considerable influence on contemporary Italian landscape painting. He painted in the classical tradition, his warm golden-toned countryside peopled with mythological or biblical figures. He studied in Vienna (1822–30) before returning to Hungary, where he made landscape sketches in the Gömör and Kismarton districts and painted some portraits. With the help of a Viennese patron he moved to Italy in 1832. He maintained strong links with Hungary, keeping open house for compatriot artists and influencing many Hungarian landscapists. His sons, Károly the Younger (1822–91), András, also known as Andrea (1824–95), and Ferenc (1832–74), were also landscape painters, much influenced by their father. András became an influential teacher in Florence. There are works in Arezzo, Budapest (NG), Chambery, Copenhagen (Thorwaldsen), Dresden, Florence, Genoa, Graz, Innsbruck, Karlsruhe, Leipzig, Mannheim, Munich (N. Pin.), Prague, Szombathely and Vienna.
Lit. G. Keleti: *Idösb K. Márko* (1871); T. Szana: *Márko Károly és a tájfestészet* (1899)

Marshall Benjamin, b. Leicestershire 1768, d. London 1835. Sporting painter, the most able follower of Stubbs. He was a portraitist until he established himself at Newmarket, where he had a good clientele for paintings of horses, jockeys and trainers. There are works in Baltimore (Mus. of Art), Leicester, London (Tate), San Marino and Toronto.

Marstrand Vilhelm Nicolai, b. Copenhagen 1810, d. Copenhagen 1873. Satirical genre

painter, an adept in the humorous depiction of *petit-bourgeois* life (*English Travellers in Venice* 1854). He also followed the contemporary fashion for painting scenes from literature, particularly from Holberg's comedies and *Don Quixote*. His many Italian oil sketches are notable for their naturalism and freedom of brushwork. He studied with ECKERSBERG at the Copenhagen Academy and spent 1836–9 in Italy, visiting Munich and Paris in 1840. He returned to Copenhagen in 1841 but later spent long periods in Italy. He became a member of the Copenhagen Academy in 1843, a professor in 1848 and the director in 1853. In his later years he executed some religious paintings and large historical frescoes (Roskilde Cathedral, Copenhagen University). There are works in Copenhagen (State, Hirschsprung), Hamburg and Stockholm.
Lit. K. Madsen: *V. Marstrand* (1905); T. Oppermann: *V. Marstrand* (1920)

Martin Elias, b. Stockholm 1739. d. Stockholm 1818. Landscape and portrait painter; after a long stay in London he carried the influence of the English school to Sweden. He is best known for his ROMANTIC but carefully detailed views of London and Stockholm. He came from a family of artists, studied under Schultz (1763) and in Paris under J. Vernet (1766). He moved to London in 1768, becoming an ARA in 1771 and an RA in 1781. He was particularly influenced by Gainsborough, Wilson, Hogarth and the watercolourist Paul Sandby. On his return to Sweden (1780) he became a member of the Stockholm Academy, and after a further stay in London (1788–91) was recalled by royal command to Sweden. There are works in Göteborg, Helsinki (Athenaeum), London (BM, V&A) and Stockholm (Nat. Mus.).
Lit. H. Fröhlich: *Bröderna Elias och Johan Frederik Martins gravyer* (1939)

Martin Henri, b. Toulouse 1860, d. Paris 1943. French painter and decorator. His early works were devoted to poetic and allegorical themes but *c.* 1900 he turned almost exclusively to landscape. His favourite poets were Dante (*Paolo and Francesca in Hell* 1883), de Musset (*Night in May* 1882) and Baudelaire (*Flower of Evil* 1890). Around 1889 he adopted a POINTILLIST technique

under the influence of SEURAT and SIGNAC; he was an associate of the SYMBOLISTS and exhibited at the first SALON DE LA ROSE+ CROIX. He received several commissions for large mural decorations and was considered the heir of PUVIS DE CHAVANNES, painting the same sylvan glades with classical figures (Hôtel de Ville, Paris; Capitole, Toulouse). He entered the studio of LAURENS in 1879, exhibiting at the SALON from 1880. A visit to Italy in 1885 brought a new lyrical freedom to his work and was shortly followed by his conversion to Pointillism. Chevalier of the Legion of Honour (1896) and commander (1914), he became a member of the INSTITUT in 1918. There are works in Bayonne (Bonnat), Béziers, Bordeaux, Buffalo, Dijon, Lille, Montpellier, Nice, Paris (Petit Palais), Philadelphia and Toulouse.
Lit. J. Martin-Ferrières: *H. Martin 1860–1943* (1967)

Martin John, b. Haydon Bridge (Northumb.) 1789, d. Douglas 1854. ROMANTIC painter of history and landscape. His paintings rely on a theatrical grandeur of scale, vast mountains, monumental architectural complexes and lowering clouds purposely dwarfing his small figures. He favoured dark bituminous paintwork enlivened by bright transparent colours. He was immensely successful in his lifetime and his work became widely known through his engravings. He was apprenticed to a coach painter in Newcastle, and then to Boniface Musso, an Italian artist who introduced him to prints after Salvator Rosa, Claude Lorrain and Stefano della Bella. He moved to London in 1806 and worked first as a decorator of glass and porcelain. He exhibited at the ROYAL ACADEMY from 1811 and at the British Institution, achieving fame with his *Joshua Commanding the Sun to Stand Still* (1816) and *Belshazzar's Feast* (1821), which had to be railed off from the crowds flocking to see it. He was appointed Historical Landscape Painter to Prince Leopold and Princess Charlotte; after Leopold became king of Belgium, he exhibited *The Fall of Nineveh* in Brussels (1833), becoming a member of the Brussels Academy and receiving the Order of Leopold. His work was also admired in France. An eccentric, he was nearly ruined in the 1830s by his projects to improve London's water and sewerage system;

M. Maris *The Infant Princess*

J. Martin *The Bard* 1817

W. Maris *Ducks Alighting on a Pool*

Márko the Elder *Italian Landscape with Harvesters* 1859

Matejko *Stephen Batory at Pskov* 1872

Mauve *Scheveningen* 1874

Max *The Jury of Apes c.* 1835

his vast *Coronation of Queen Victoria* marked the restoration of his fortunes. His three *Judgment* pictures, first exhibited the year after his death, toured England and America for twenty years. His prints were an important influence on COLE in America. He was also a watercolourist and engraver. There are works in Glasgow, Liverpool, London (Tate, V&A), Manchester, Nottingham and Stratford.
Lit. M. L. Pendered: *J. Martin, Painter* (1923); T. Balston: *J. Martin 1789–1854: His Life and Works* (1947); J. Seznec: *J. Martin en France* (1964); W. Feaver: *The Art of J. Martin* (1975)

Matejko Jan, b. Cracow 1838, d. Cracow 1893. Poland's most acclaimed 19C painter. His vast historical canvases owe a debt to Rubens in their rich use of colour; they are mainly sumptuous and crowded dramas, the accessories painted with careful historical accuracy. He also painted portraits notable for their psychological insight, sometimes dressing the sitter in period costume. His work expressed the national pride of partition-torn Poland by evoking its glorious past (*Rejtan at the Diet of Warsaw* 1866, *Stephen Batory at Pskov* 1872, *Battle of Grünwald* 1878). He was immensely popular in his lifetime and his home was made into a national museum at his death. Apart from studies in Munich under Anschütz (1858–9) and in Vienna (1859–60), he spent his life in Cracow, where he studied (1852–8) and later taught in the School of Fine Arts, becoming its director in 1873. He was awarded a medal at the Paris EXPOSITION UNIVERSELLE of 1867 and the Legion of Honour in 1870. A member of many foreign academies, he was offered the directorship of the Prague School of Fine Arts. He was an ardent patriot who believed that art had a social mission, and inspired several followers and imitators. There are works in Wrocław, Budapest (Fine Arts), Cracow, Graz, Łódź, Lublin, Lvov, Poznań, Rome (Vatican), Vienna, Warsaw (Nat. Mus.) and Zagreb. (*see colour illustration 12*)
Lit. M. Treter: *Matejko* (1939); S. Serafinska: *J. Matejko: wspomnienia rodzinne* (1955); J. Starzynski: *J. Matejko* (1962)

Mauve Anton, b. Zaandam 1838, d. Arnheim 1888. One of the leading artists of the HAGUE SCHOOL, a poetic interpreter of peasant life in soft tones of silver and grey. He was a pupil of P. F. VAN OS and the Wouvermans follower, W. Verschuur. He worked with W. MARIS and J. W. Bilders in Oosterbeek (1856–9), and in Amsterdam, Haarlem, The Hague and Laren. He was profoundly influenced by MILLET, and to a lesser extent by COROT and DAUBIGNY. The work of the Dutch period of VAN GOGH is often close to Mauve, who was his cousin and helped him in the early 1880s. A highly prolific artist, he won medals at exhibitions throughout Europe and was very popular in the U.S. There are works in Amsterdam (Rijksmuseum, Stedelijk), Baltimore (Mus. of Art, Walters), Boston, Chicago, Dordrecht, Edinburgh, Glasgow, Haarlem (Teyler), Hamburg, The Hague (Mesdag), Montreal, Munich, New York (Brooklyn, Met.), Pittsburgh, Rotterdam and St Louis.
Lit. H. P. Baard: *A. Mauve* (c. 1945); E. Engel: *A. Mauve* (1967)

Max Gabriel Cornelius von, b. Prague 1840, d. Munich 1915. Highly regarded Czech-born artist who worked in Munich; with LENBACH and MAKART, he was nicknamed a 'Malerfürst', or prince of painting. His subjects reflect a tragic preoccupation, a 'bitter-sweet, half-torturing, half-ensnaring tone' (Muther). A fine draughtsman, he endeavoured to paint with psychological REALISM, treating both history and contemporary life. He was caught up in the fashion for spiritualism and psychic investigation; he is known to have painted from a hypnotized model. He studied with E. Engerth in Prague (1855–8) until in 1859 he won an imperial scholarship to study in Vienna. He returned briefly to Prague in 1863 before leaving for Munich, where he studied with PILOTY (1864–7). He was much influenced by DELAROCHE. He illustrated poems by Goethe and Uhland, as well as fairy and folk stories, and in 1867 had his first major success with the painting, *Girl Martyr on the Cross.* He lived a retired life devoted to his art and the study of anthropology and psychology, though from 1879 to 1883 he was professor of history painting at the Munich Academy. There are works in Berlin, Munich (N. Pin.) and most German provincial museums, and in Baltimore (Walters), Copenhagen, Minneapolis, Moscow,

New York (Met., Brooklyn), Philadelphia, Prague and Vienna.
Lit. N. Mann: *G. Max' Kunst und seine Werke* (1888)

Meissonier Jean Louis Ernest, b. Lyons 1815, d. Paris 1891. Painter of historical genre and military life. His style derived from the study of Dutch 17C painters, but he worked primarily on a small scale with a miniature painter's attention to detail, using clear bright colours. He is one of the leading exponents of ACADEMIC REALISM; his scenes of daily life in the 17C and 18C are realistically treated anecdotes, and he took extraordinary pains with the historical accuracy and authenticity of costumes and accessories, even to the point of picketing horses in the snow and rain before painting them in his Napoleonic scenes. His systematic study of the horse in motion was an influence on DEGAS. He was sensationally successful in his lifetime and had many followers and imitators. He studied with L. COGNIET in Paris, though he preferred copying Dutch and Flemish paintings in the Louvre. His father, appreciating his talent, sent him on a visit to Italy. He first exhibited at the SALON of 1834, and earned his way with illustrations. He had his first important success in 1841 with *The Chess Party* (17 × 11 cm) and by 1849 Charles Blanc was complaining that the state could not purchase his work because it was bought off the easel by private collectors, notably Sir Richard Wallace. In 1855 *The Brawl* won him the EXPOSITION UNIVERSELLE grand medal of honour; it was purchased by Napoleon III and presented to Queen Victoria. In 1859 he followed the Emperor on his Italian campaign which turned him towards military painting; he painted *Napoleon III at Solferino* (1863) on a larger scale than usual (43 × 76 cm) and subsequently turned to the campaigns of Napoleon I (*Campaign in France 1814* 1864, *1807: Friedland* 1875). Chevalier of the Legion of Honour (1846), officer (1856), commander (1867), grand officer (1878) and grand cross (1889), he was also a member of the INSTITUT (1861). President of the 1889 Exposition Universelle jury, he was chief organizer and first president of the SOCIÉTÉ NATIONALE DES BEAUX-ARTS (1890). He is best represented in Paris (Louvre) and London (Wallace), but his work is also to be found in Amsterdam

(Stedelijk), Baltimore (Mus. of Art, Walters), Bayonne (Bonnat), Boston, Cambridge Mass. (Fogg), Chantilly, Chicago, Hamburg, Leningrad (Tretiakov), Lille, Lyons, Melbourne, New York (Met.), Philadelphia, Reims, Rouen, Valenciennes, Versailles, Washington (Corcoran) and Williamstown Mass. (Clark). (*see colour illustration 14*)
Lit. M. O. Gréard: *J. L. E. Meissonier, ses souvenirs, ses entretiens* (1897); C. Formentin: *E. Meissonier, sa vie, son œuvre* (1901); L. Bénédite: *Meissonier* (1911)

Mellery Xavier, b. Laeken (Brussels) 1845, d. Laeken 1921. A forerunner of SYMBOLISM in Belgium. His art was based in the REALIST generation of DE GROUX, but he sought 'to endow objects with soul'; he combined 'small intimate drawings full of hidden significance' (Focillon) and grand flights of imagination conceived as large-scale murals. Figures in flowing draperies seeming to hang in space are a special feature of his art. He studied at the Brussels Academy and won a Rome prize in 1870; he exhibited with LES VINGT in Brussels and at the last SALON DE LA ROSE+CROIX in 1896. He taught at the Brussels Academy, including KHNOPFF among his pupils. After 1900 he lived a retired life at Laeken. There are works in Antwerp, Brussels (Musées Royaux) and Ixelles.
Lit. J. Potvin: *X. Mellery* (1925); A. Goffin: *X. Mellery* (1925); F. Hellens: *X. Mellery* (1932)

Menn Barthélémy, b. Geneva 1815, d. Geneva 1893. Landscape and portrait painter. A friend of the BARBIZON SCHOOL painters and of DELACROIX, he was the pioneer of *paysage intime* in Switzerland. His early landscapes are mostly of lakes and rivers, the later ones of trees and pastures. He studied in Geneva with LUGARDON, on whose advice he went to Paris to study with INGRES; he followed Ingres to Rome (1834-8) and on his return to Paris (1838-43) became a friend of the Barbizon painters. As director of Geneva Art School he was a very influential teacher, including HODLER among his pupils. In 1852 he organized an exhibition of works by COROT, DAUBIGNY, DIAZ, COURBET and Delacroix in Geneva, but it aroused little interest. Recognition came to him only gradually. There are works in Basle (Kunstmuseum),

Meissonier *In the Shade of the Arbours Sings a Young Poet* exhibited 1853

Mellery *Autumn*

Menzel *Sunday in the Tuileries* 1867

Meryon *The Ghoul* 1853

Berne, Geneva (Ariana, Rath), Neuchâtel, Winterthur and Zurich.
Lit. A. Lanicca: *B. Menn* (1911); J. Brüschweiler: *B. Menn, 1815–1893; étude critique et biographique* (1960)

Menzel Adolf Friedrich Erdmann von, b. Breslau 1815, d. Berlin 1905. German painter and illustrator. He was one of the most important German exponents of REALISM and highly regarded in his lifetime. He successfully took over his late father's Berlin lithography business (1832), developing a line in illustrations which led to a commission for four hundred wood engravings to illustrate Kugler's *Life of Frederick the Great* (1840–2). This work established his fame. He made the most careful historical researches to ensure the accuracy of his portraits, of details of dress and accessories, and at the same time sketched extensively from life to bring reality and psychological truth into his recreation of the earlier period. This success led to further major commissions for illustrations but he also turned to painting scenes from Frederick's life and period in oils (a series of eight large scenes at Sanssouci including *The Round Table* 1850, *Flute Recital* 1850–2). While teaching himself oil painting in the 1840s, he painted with summary brushwork a number of simple scenes from his own daily life (*Room with a Balcony* 1845, *Artist's Sister with a Candle* 1847); their treatment of light and simple domestic subject matter led a later generation to claim these works as forerunners of IMPRESSIONISM. His small scenes of daily life in the 18C had much in common with the work of MEISSONIER, though his brushwork was always lighter and more summary; his visits to Paris in 1855, 1867 and 1868 cemented a firm friendship between the two artists and also brought him into contact with COURBET. From the 1860s he turned to painting contemporary life, depicting the glittering interiors of Wilhelm I's court in Berlin (*The Ball Supper* 1878). He also painted outdoor views with milling crowds, experimenting with viewpoints, groupings and perspective (*Sunday in the Tuileries* 1867, *Departure of Wilhelm I* 1871) and some industrial scenes (*Rolling Mill* 1875). He left a large number of oil sketches and studies. Most of his work is still in Berlin but he is also represented in Wrocław, Cambridge Mass. (Fogg), Munich (N. Pin.), Moscow (Tretiakov), Stuttgart, Vienna and Weimar. (*see colour illustration 24*)
Lit. J. Meier-Graefe: *Der Junge Menzel* (1906); E. Bock: *A. Menzel: Verzeichnis seines graphischen Werkes* (1923); E. Waldmann: *Der Maler A. Menzel* (1941); K. Kaiser: *A. Menzel: der Maler* (1965); W. Hütt: *A. Menzel* (1965)

Merson Luc Olivier, b. Paris 1846, d. Paris 1920. Academic painter of history and classical mythology, one of the last fêted 19C mural painters (Panthéon, Palais de Justice). The son of Charles-Olivier Merson, painter and art critic, he studied with Chassevent and PILS. He first exhibited in the 1867 SALON and won the first Rome prize in 1869. He became a chevalier of the Legion of Honour (1881), an officer (1900) and a commander (1920), and was a member of the INSTITUT (1892). Appointed professor at the ECOLE DES BEAUX-ARTS in 1894, he later resigned in protest against the modern movement in art. He was the official designer of French banknotes for thirty years. There are works in Chantilly, Lille, Mulhouse, Nantes, Roubaix, Rouen and Troyes.

Meryon Charles, b. Paris 1821, d. Charenton Asylum 1868. One of the greatest etchers and engravers of the mid-19C, he is among the more individual figures of the French ROMANTIC movement. The illegitimate son of an English doctor and a French ballerina, he went to sea at an early age, and his exotic travels were an important influence on his later artistic inspiration. He gave up the navy in 1847 to become a painter, but abandoned painting (perhaps because he was colour blind) in favour of graphic work, learning his trade from the engraver Eugène Bléry and from copying such masters as Loutherbourg and Salvator Rosa. Although his working life was punctuated by bouts of madness (he spent a year in Charenton Asylum in 1858 and again in 1866) he executed a masterful series of Paris views and many smaller works. There are works in most museum print rooms.
Lit. P. Burty: *C. Meryon, Sailor, Engraver and Etcher: A Memoir and Complete Descriptive Catalogue of His Work* (1879); G. Geffroy: *C. Meryon* (1926); L. Delteil: *C. Meryon* (1927)

Meunier Constantin Emile, b. Etterbeck 1831, d. Ixelles 1905. Belgian REALIST painter and sculptor. Fame came to him late in life, in the mid-1880s, with his monumental paintings and sculptures celebrating the pain and dignity of working class life, particularly that of the miners of the Borinage district. His *Monument to Work* of the 1890s was the major achievement in this vein, comprising four sculptural reliefs and four single figures. He grew up under the shadow of his elder brother Jean Baptiste (1821-1900), a genre painter and engraver, and studied with Fraikin at the Brussels Academy, exhibiting his first sculpture in 1851. He then turned to painting, studying with NAVEZ and coming under the influence of DE GROUX, with whom he later collaborated. Powerfully affected by a visit to a Trappist monastery, from 1857 to 1869 he painted only religious subjects (*St Francis in Ecstasy*). From 1870 there is more variety in his work: historical subjects, genre, portraits and intimate scenes of family life. In 1882 he visited Spain, an experience which added new authority to his work and brightness to his palette (*Tobacco Factory at Seville c.* 1882). He now turned definitively to industrial subjects (*Industry* 1884, *The Port* 1885); in 1885 he began again to exhibit sculpture (*The Stevedore*) which was to be his primary interest in the following years. The Musée Constantin Meunier in Brussels contains a wide range of his work and there are also works in Antwerp, Brussels (Musées Royaux), Courtrai, Dresden, Düsseldorf, Ghent, Ixelles, Leipzig, Louvain and Paris. *Lit.* C. Lemonnier: *C. Meunier* (1904); M. Devigne: *C. Meunier* (1919); L. Christophe: *C. Meunier* (1947)

Meyerheim Friedrich Eduard, b. Danzig 1808, d. Berlin 1879. Berlin genre painter, a popular delineator of peasant life. His small-scale paintings depict happy scenes of everyday life, often including children; they are painted with careful REALISM and detailed finish. He studied with his father Karl Friedrich and J. A. Breysig, moving to Berlin in 1830. He started to specialize in peasant scenes c. 1833. He was a member of the Berlin Academy (1837) and the Dresden Academy (1850). His brothers Wilhelm Alexander, Hermann and Eduard Franz were also artists. There are works in Berlin,

Wrocław, Danzig, Düsseldorf, Leipzig and Munich.
Lit. E. Meyerheim: *Selbstbiographie* (1880)

Michallon Achille Etna, b. Paris 1796, d. Paris 1822. Historical landscapist of the school of VALENCIENNES; his brilliant career (in terms of contemporary esteem) was compressed into eleven short years from the age of fifteen to his early death at twenty-six. The son of a sculptor, Claude Michallon, he studied with BERTIN, Valenciennes and DAVID. At fifteen his precocious talent won him the enthusiastic patronage of the Russian Prince Issoupoff. The following year (1812) he began to exhibit at the SALON, and in 1817 was the first artist to win the newly established Rome prize for historical landscape. He was the friend and first instructor of COROT, whom he advised: 'Look well at nature, reproduce it naïvely and with the greatest care.' His own application of these principles is better seen in his studies than in his finished paintings. There are works in Baltimore (Mus. of Art), Barnard Castle (Bowes), Chantilly, Clamecy, Le Puy, Montpellier, Mulhouse, Orleans, Paris (Louvre), Perpignan and Rochefort.

Michalowski Piotr, b. Cracow 1800, d. Krzyztoforzyce (Cracow) 1855. Poland's 'European ROMANTIC', his art is closely linked to DAUMIER and COURBET, his contemporaries, and to GÉRICAULT whom he greatly admired. His main *œuvre* comprises watercolours and oil sketches; as an amateur with no need to sell his work he never aimed at finish. His dark-toned REALISM has a solid, primitive strength. The horses and Napoleonic battle scenes which dominate his early work (*Napoleon Reviewing his Troops*) were followed by portraits, particularly of Jews and Polish peasants (*Portrait of an Old Peasant*). Shortly before his death he became fascinated by the theme of *Don Quixote*. His palette and composition owe a marked debt to GOYA, Velasquez and the Spanish school. He took drawing lessons from BRODOWSKI and F. LAMPI, and studied at Göttingen (1821-32), also travelling to Vienna, Italy and England. After the failure of the 1831 Polish rising, for which he organized the manufacture of arms, he went to study in Paris under CHARLET and RAFFET;

Meunier *The Return of the Miners* 1905

Michallon *The Forum at Pompeii*

Michalowski *The Battle of Somo Sierra c.* 1848

here he copied some of Géricault's work. He returned to Poland in 1835 but continued to visit Paris frequently. Little regarded during his lifetime, his high reputation has been forged in the 20C. The main body of his work is in the National Museum, Cracow, though there are also works in Wrocław, Bytom, Danzig, Łódź, Lublin, Poznań, Toruń, Warsaw (Nat. Mus.) and Wiedeń.
Lit. H. d'Abancourt: *P. Michalowski* (1931); M. Sterling: *P. Michalowski* (1932); J. Sienkiewicz: *P. Michalowski* (1964)

Michel Georges, b. Paris 1763, d. Paris 1843. A naturalistic landscapist, he was known as 'the Ruysdael of Montmartre'. He followed in the footsteps of the Dutch masters, and was a forerunner of the BARBIZON SCHOOL, though his work was discovered and admired by the Barbizon painters only in the 1860s. He made a modest living by imitating the style of the Dutch and Flemish landscapists much in fashion at court in the pre-Revolution days. In his later work, he broadened his brushwork, seeking a mode of expression for his own passionate response to nature, though remaining faithful to the muted browns and greys of his preceptors. He opened his own teaching atelier (1808–9) and had a brief success in the SALON *c.* 1810, but for the rest of his life he preferred to live and paint quietly in the country, selling virtually all his work to a single patron, the Baron d'Ivry. He was rediscovered by Thoré and Sensier, the first biographer of MILLET, in the mid-century. He collaborated occasionally with Taunay, Swebach and de Marne, minor Dutch-influenced artists. There are works in Amiens, Baltimore (Mus. of Art, Walters), Bayeux, Bayonne, Berlin, Béziers, Boston, Brest, Carpentras, Chicago, Cincinnati, Dublin, Edinburgh, Hanover, The Hague (Mesdag), London (NG), Montreal, Nantes, New York (Met.), Paris (Louvre, Carnavalet), Philadelphia, Pontoise, Stockholm and Strasbourg.
Lit. A. Sensier: *Etude sur G. Michel* (1873); L. Larguier: *G. Michel* (1927)

Michetti Francesco Paolo, b. Tocco di Casauria (Chieti) 1851, d. Francavilla al Mare 1929. A faithful son of the Abbruzzi, his art belongs with the late-century revival of ROMANTICISM. He depicted the landscape, people and customs of the Abbruzzi, first as a Realist under the influence of his Neapolitan teachers MORELLI and PALIZZI and then in the glittering colouristic technique of FORTUNY, under whose influence he fell *c.* 1875 in the wake of his contemporaries (*Wedding in the Abbruzzi*); in the 1880s he was infected with the contemporary zeal for social reform and concentrated on the hardships of the poor, turning in a final phase to religious mysticism and pagan myth (*The Cripples* and *The Serpents*, exhibited 1900). He was a close friend of the poet Gabriele d'Annunzio. There are works in Florence (Mod. Art), Francavilla (Civico), Milan (Grassi, Mod. Art), Naples (San Martino), Pescara (Civico), Rome (Mod. Art), Trieste (Revoltella) and Turin (Mod. Art).
Lit. T. Sillani: *F. P. Michetti* (1932); E. Jacobitti: *F. P. Michetti* (1935); R. de Longu: *Per un profilo di Michetti* (1966)

Millais Sir John Everett, b. Southampton 1829, d. London 1896. One of the founder members of the PRE-RAPHAELITE Brotherhood, Millais was in worldly terms the most successful. From his earliest years he displayed an extraordinary technical facility, though he was not perhaps as inventive as his friends. His Pre-Raphaelite works represent the high point of his artistic achievement but show him strongly influenced by the medievalizing poetry of ROSSETTI on the one hand (*Mariana* 1851), and the religious symbolism of W. H. HUNT on the other (*Christ in the House of his Parents* 1850). He made much of the Pre-Raphaelite approach to landscape with the careful delineation of every weed and flower (*Ophelia* 1852, *The Blind Girl* 1856), while he brought a refined poetry to everyday life with *Autumn Leaves* (1856). After 1855, when he married Ruskin's divorced wife Effie and had to support a family, he turned to more broadly painted, somewhat sentimental anecdotes (*The First Sermon*, *Bubbles*, *Cherry Ripe*, *The Yeoman of the Guard*) and society portraits (*Gladstone, Tennyson, Mrs Bischoffsheim*). Less demanding in time and application, these works brought him immense popularity and, by the 1880s, an income of around £30,000 a year. He also illustrated a number of books and contributed to *Once a Week*, *Good Words* and other periodicals. He was brought up in Jersey and Brittany, moving to London in 1838. He studied at Henry Sass's school and from 1840 at the ROYAL ACADEMY. He first exhibited there in 1847 and in 1848 took part in the formation of the Pre-Raphaelite Brotherhood with Rossetti, Hunt and other student friends. In 1853 he became an ARA and visited Scotland with Ruskin and his wife, an association which was to end in their marriage. He was made a baronet in 1885 and was elected president of the Royal Academy a few months before his death in 1896. There are works in Aberdeen, Baltimore (Walters), Cambridge (Fitzwm), Cambridge Mass. (Fogg), Glasgow, Hamburg, London (Tate, V&A, Guildhall), Manchester, Melbourne, Minneapolis, New York (Met.), Oxford, Port Sunlight, Sheffield, Stratford and Sydney.
Lit. J. G. Millais: *Life and Letters of Sir J. E. Millais* (1899); M. Lutyens: *Millais and the Ruskins* (1967); G. H. Fleming: *That Ne'er Shall Meet Again: Rossetti, Millais, Hunt* (1971)

Millet Jean François, b. Gruchy (nr Cherbourg) 1814, d. Barbizon 1875. French painter of peasant life. From 1849 to his death he lived in Barbizon; while a close friend of T. ROUSSEAU and the BARBIZON SCHOOL landscapists, his interest lay primarily in figure painting, in the relationship of country people to the land they till and the timeless nobility of their toil. 'It is the human, the frankly human side that moves me most in art,' he wrote. He was a lifelong admirer of Poussin and there is a carefully conceived classical order to his composition; he did not work directly from nature but absorbed the Barbizon painters' new approach to brushwork, colour and tone. The son of a Normandy peasant, he studied with Bon Dumoucel and J. C. Langlois in Cherbourg (1834–6) until in 1837 Cherbourg granted him a scholarship to study in Paris, where he entered the studio of DELAROCHE; the history painter apparently held him in high regard. His early works comprise nudes and mythological scenes, influenced by DIAZ and Fragonard (*Offering to Pan* 1845, *Oedipus Taken from the Tree* 1847); he also painted some one hundred portraits (*Antoinette Hébert, Officer of Marine*). He first exhibited at the SALON of 1840 but it was in 1848 that he exhibited his first peasant subject, *The Winnower*, showing the influence of DAUMIER

and COURBET. In 1849 a cholera epidemic drove him to move with Catherine Lemaire (whom he married in 1853) and their children to a cottage in Barbizon, where he spent the rest of his life. He continued with his peasant scenes; *The Sowers* and *The Binders*, exhibited in 1850, caused critics to accuse him of socialism, a charge he angrily refuted. Among the best known of the works that followed are *The Gleaners* (1857), *Angelus* and *Death and the Woodcutter* (1858–9) and *Man with a Hoe* (1863). He lived in extreme poverty until 1860 when he was first taken up by dealers; recognition began with the exhibition of nine paintings at the 1867 EXPOSITION UNIVERSELLE. His work influenced artists throughout Europe, notably VAN GOGH, the HAGUE SCHOOL (especially J. ISRAËLS) and SEGANTINI in Italy. His work is best represented in Paris (Louvre) and Boston (Mus. of Fine Arts), but examples are to be found in most museums with 19C collections, especially in America and France. (*see colour illustration 20*)

Lit. A. Sensier: *La Vie et l'œuvre de Millet* (1881); E. Moreau-Nélaton: *Millet raconté par lui-même* (3 vols 1921); L. Lepoittevin: *J. F. Millet, portraitiste: essai de catalogue* (1971) and *J. F. Millet* (1973); J. Bacon: *Millet. One Hundred Drawings* (1975)

Minardi Tommaso, b. Faenza 1787, d. Rome 1871. Leading painter, teacher and theorist of the PURISMO movement. He studied in Faenza with Giuseppe Zauli, moving to Rome *c*. 1803 where he entered the Academy of St Luke under CAMUCCINI. A devoted student of Old Masters, he imitated many styles before he found his own. His 1807 *Self-portrait* in a student garret was painted under the influence of Caravaggio and the northern Caravaggisti; he copied Michelangelo's *Last Judgment* for the printmaker Longhi (1814–25). He was a professor at the Perugia Academy (1817–21), and from 1821 professor at the Rome Academy of St Luke. A devout Catholic, he sought in his art the 'basis for a religious programme in the spirit of the Catholic tradition' (Faldi); this brought him into contact with the NAZARENES, under whose influence he painted his *Apparition of the Virgin to St Stanilas Kostka* (1825). He signed the Manifesto of Purismo drawn up in 1849. Most Roman religious painting of the 19C was influenced

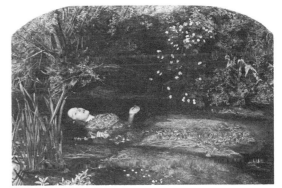

Millais *Ophelia* 1852

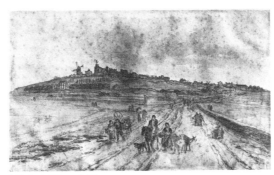

Michel *View of Montmartre*

Minardi *The Rosary Around the Neck of the Lamb* 1840

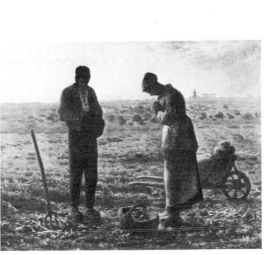

Millet *Angelus* 1859

either directly by his teaching or indirectly by his writing on art theory, to which he turned increasingly in later years. There are frescoes and altar panels in many Roman churches (S. Andrea al Quirinale, S. Maria in Monticelli, S. Andrea del Novigiato) and elsewhere (Spoleto Cathedral, S. Antonio in Anzio). There are oil paintings in Bologna, Faenza, Florence (Pitti) and Rome (Acad. of St Luke).

Lit. G. de Sanctis: *T. Minardi e i suoi tempi* (1900); E. Ovidi: *T. Minardi e la sua scuola* (1902); I. Faldi: *Il Purismo e Tommaso Minardi* (in *Commentari* I, 1950)

Mir Iskusstva (The World of Art). Late 19C and early 20C Russian artistic movement, whose collaborators organized exhibitions and launched a magazine; the group was led by Alexander Benois and Serge Diaghilev, and included Bakst, Korovin, SEROV, Roerich, LEVITAN, VASNETSOV and VRUBEL. Reacting against both the PEREDVIZHNIKI and the ACADEMICIANS, the group believed in a completely decorative art, 'art for art's sake'. They aimed to make Russian art more international while reviving its historic and folklore heritage. The impetus for this came from the pioneering work of the Abramtsevo artistic community, whose patron, Savva Mamontov, helped provide funds to launch the magazine *Mir Iskusstva* (1898-1904). The group brought Russia up to date with world art movements (ART NOUVEAU, French POST-IMPRESSIONISM) and educated opinion on Russian art, past and present. The exhibitions started under Diaghilev's organization in 1897; the first truly international exhibition ever held in Russia followed in 1899. Further exhibitions in 1906 and 1913 included work by Larionov and Goncharova. Pioneering printing techniques, book illustration and theatre décor were important aspects of their work; Diaghilev's Russian ballets were their greatest international triumph.

Moll Carl, b. Vienna 1861, d. Vienna 1945. Landscape painter of the IMPRESSIONIST generation. He was co-founder with KLIMT of the Vienna SECESSION movement and influenced by him towards stylization of composition and a play on colour contrasts. He studied at the Vienna Academy (1880-1),

and was importantly influenced by E. J. SCHINDLER, with whom he worked extensively and whose widow he married. There are works in Dresden, Munich and Vienna (Belvedere).

Monet Claude Oscar, b. Paris 1840, d. Giverny (Seine) 1926. One of the chief founders of IMPRESSIONISM. His central aim was to translate a visual sensation immediately into paint on canvas; he worked directly from nature, often out of doors. This was the main innovation of Impressionism and Monet remained faithful to it throughout his life. CÉZANNE is said to have described him as 'only an eye, but my God what an eye!' He spent his youth in Le Havre where he made a local reputation with caricatures; they attracted the attention of BOUDIN (*c.* 1858), who introduced him to painting sea and landscape out of doors. In Paris (1859-60), he was impressed by the work of DAUBIGNY and TROYON and worked at the Académie Suisse where he met PISSARRO. After two years military service in Algeria he returned to Le Havre in 1862, where he worked along the coast with Boudin and JONGKIND. Back in Paris (1862-3) he entered the studio of GLEYRE, where he met RENOIR, SISLEY and BAZILLE. The group quarrelled with their master and retired to paint from nature in the forest of Fontainebleau. There he painted his first major work, *The Picnic* or *Déjeuner sur l'herbe* (1865-6), much influenced by MANET and COURBET. He exhibited at the SALON of 1865 but most of his subsequent entries were refused by the jury. His financial situation was desperate in the following years and he attempted suicide but was saved by the more prosperous Bazille. He spent 1870-1 in London, avoiding the Franco-Prussian War (*Westminster Bridge*). From 1872-6 he lived at Argenteuil where Renoir and Manet visited him. At the first Group Exhibition of 1874 his *Impression - Sunrise* (1872) led a malicious critic to dub the group 'Impressionists', a name they happily adopted. In 1876 he began a series of paintings of the Gare Saint-Lazare and in 1880-3 spent much time on the coast (*Cliffs at Etretat* 1883). In 1883 he settled at Giverny where he was to make his famous water garden. From 1890 onwards he concentrated on paintings in series, changing from canvas to canvas at different times of

day. Among the famous series subjects are *Poplars* (1890-1), *Haystacks* (1891), *Rouen Cathedral* (1894), *The Seine* (1896-7), *The Thames* (1899-1904), *Venice* (1908) and his last great series of *Waterlilies* on which he was working at his death. The vast *Waterlilies*, painted for the state and now in the Orangerie, with their shimmering pools of colour, are claimed as an important influence on abstract art. He is represented particularly well in Paris (Musée de l'Impressionisme) and Boston but there are works in almost every major museum.

Lit. G. Geffroy: *C. Monet, sa vie, son temps, son œuvre* (1922); M. de Fels: *La Vie de C. Monet* (1929); W. C. Seitz: *C. Monet* (1960); J. Isaacson: *Monet: Le Déjeuner sur l'herbe* (1972); D. Rouart: *Monet Nymphéas; ou, les miroirs du temps* (1972); D. Wildenstein: *C. Monet. Biographie et catalogue raisonné* (1974); C. Joyes: *Monet à Giverny* (1975); S. Z. Levine: *Monet and his Critics* (1976)

Monticelli Adolphe Joseph Thomas, b. Marseilles 1824, d. Marseilles 1886. ROMANTIC artist who used colours of violent intensity, building up his subject in swirling impasto. He painted portraits (*Madame René* 1871), still lifes (*Pomegranates c.* 1880), nudes, *fêtes galantes* and contemporary scenes (*Itinerant Players* 1875-7). His work was an important influence on VAN GOGH and on the GLASGOW BOYS. He studied in Marseilles and under DELAROCHE in Paris (1847-9), where he copied assiduously in the Louvre, especially from the work of Rembrandt, Veronese and Giorgione. At this time he became a close friend of both DELACROIX and DIAZ, who importantly influenced his work. He returned to Marseilles in 1849, but was back in Paris from 1863 to 1870. This period brought him resounding success and an international market (the Coates of Glasgow collected his work). After the Paris siege of 1870 he returned to Marseilles, living in great simplicity and drawing inspiration from opera, Italian pantomime and music. With no interest in official success, he painted for himself and sold his work through dealers. His highly personal style has lent itself to innumerable forgeries. There are works in Paris (Louvre) and many French provincial museums, and in Amsterdam (Rijksmuseum), Antwerp, Baltimore (Mus. of Art, Walters),

Brussels, Bucharest (Muzeul Toma-Stelian), Buffalo, Cardiff, Edinburgh, Frankfurt/M., Glasgow, The Hague, London (NG), Manchester, Milan, Montreal, Minneapolis, New York (Met.), Philadelphia, St Louis and Stockholm.
Lit. A. d'Agrel, E. Isnard: *Monticelli, sa vie et son œuvre* (1926); G. Isnard: *Monticelli dans sa legende* (1967); A. M. Alauzen: *Monticelli, sa vie et son œuvre* (1969)

Moore Albert Joseph, b. York 1841, d. London 1893. English painter, mainly of classical subjects. His compositions were simple, usually of single figures or groups in flowing classical drapery with titles such as *The Dreamers*, *Beads*, *The Sofa*, etc. His central interest lay in the interplay of colours and delicate colour harmonies; he frequently repeated the same composition in different tones. An eccentric who shunned the public eye, he was greatly admired by WHISTLER and an influence on the AESTHETIC MOVEMENT. He studied with his father William, a portrait painter, and at the ROYAL ACADEMY Schools. He exhibited at the Royal Academy from 1857, working first under the influence of the PRE-RAPHAELITES but turning to classical subjects in the 1860s. His brother Henry was a successful marine painter. There are works in Birmingham, Glasgow, Liverpool and London (Tate, V&A).
Lit. A. Baldry: *A. Moore, his Life and Works* (1894)

Moran Thomas, b. Bolton (Lancs.) 1837, d. Santa Barbara (Ca.) 1926. English-born American landscapist who achieved fame with his panoramic views of the Far West, Yellowstone Valley and the Grand Canyon. He revelled in extraordinary natural effects which he painted with flamboyant colour. After going to the U.S. in 1844, he first revisited England in 1862, falling under the spell of TURNER. He was also influenced by the HUDSON RIVER SCHOOL, and was the last American painter to capitalize on panoramic views of untamed nature, which he often improvised in the studio. Immensely popular in his day, he is considered, with BIERSTADT and CHURCH, a leading exponent of the Rocky Mountain School. There are works in Baltimore (Mus. of Art), Minneapolis, Phila-

Monet *Le Déjeuner c.* 1873

Moll *View of Vienna from Eichelhof in Nussdorf c.* 1910

Monticelli *Don Quixote and Sancho Panza c.* 1865

Moore *A Summer Night* 1890

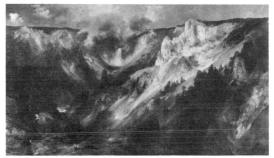
Moran *Grand Canyon of the Yellowstone* 1893–1901

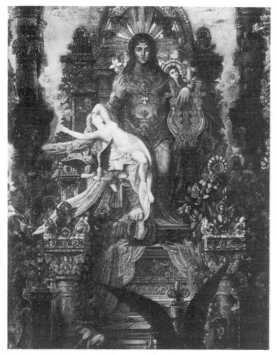

Moreau *Jupiter and Semele* (detail) 1896

Morelli *Temptation of St Anthony* 1878

delphia, Pittsburgh and Washington (Smithsonian).
Lit. F. M. Frywell: *T. Moran, Explorer in Search of Beauty – A Biographical Sketch* (1958); T. Wilkins: *T. Moran, Artist of the Mountains* (1966); T. Morgan: *Home Thoughts from Afar: Letters of T. Moran to Mary N. Moran* (1967)

Morbelli Angelo, b. Alessandria 1853, d. Milan 1919. Pioneer Italian DIVISIONIST painter and writer. He painted landscape, townscape and genre using the Divisionist technique from *c.* 1887, simply as an extension of REALIST painting with no SYMBOLIST overtones. He studied and lived in Milan but exhibited with success and honours in France, Germany and America as well as Italy. There are works in the galleries of modern art of Milan, Rome, Turin and Venice.
Lit. U. Nebbia: *A. Morbelli* (1949); M. P. Tominetti: *A. Morbelli: il primo Divisionismo etc.* (1971)

Moreau Gustave, b. Paris 1826, d. Paris 1898. Painter of mythological and biblical subjects, combining exotic, even fantastic, detail with a sumptuous richness of paint. Both oils and watercolours convey the impression of jewelled dreams, slightly sinister, with a preference for such subjects as *Salome*, *Orpheus*, etc. J. K. Huysmans discovered his paintings at the 1876 SALON (described at length in *A Rebours*) and he was adopted by the SYMBOLISTS as their most admired painter. The son of a Paris architect, he entered the ECOLE DES BEAUX-ARTS in 1846 under PICOT. He met CHASSÉRIAU in 1848 and became his close disciple and friend, sharing with him a profound admiration for DELACROIX. He spent 1857-9 in Italy, where he copied work by Carpaccio, Gozzoli and Mantegna, and struck up student friendships in Rome with DEGAS, PUVIS DE CHAVANNES and DELAUNAY. He first exhibited at the Salon in 1852 and had his first major success in 1864-6 (*Oedipus and the Sphinx* 1864, *Jason* 1865, *Orpheus* 1866). Angered by criticism in 1869 he withdrew from the Salon until 1876; his work was well represented at the EXPOSITION UNIVERSELLE of 1878 but from 1880 he ceased to exhibit publicly, apart from some watercolours shown at the Goupil Gallery in 1886. Chevalier of the Legion of Honour in 1875, he became an officer in 1883, a member of the INSTITUT in 1889 and professor at the Ecole des Beaux-Arts in 1892. He was an influential teacher, including Rouault, Matisse and Marquet among his pupils. His work was much admired by André Breton and the Surrealists. He left his Paris home, the present Musée Gustave Moreau, and a large proportion of his work to the state. There are a few works in the Louvre, and also in Cambridge Mass. (Fogg), Chicago and New York (Met.). *(see colour illustration 29)*
Lit. R. von Holten: *L'Art fantastique de Gustave Moreau* (1960); J. Paladilhe, J. Pierre: *G. Moreau* (1972); B. Wright: *G. Moreau et E. Fromentin: documents inédits* (1972)

Morelli Domenico, b. Naples 1823, d. Naples 1901. A pioneer of REALISM in Italy. His subjects, which were generally taken from history, romantic literature or the Bible, were painted realistically and often selected to parallel contemporary events or thoughts, giving the painting reality on a second level. His declared aim was to 'represent figures and happenings, not seen, but imagined and real at one time'. His influence was felt not only in Naples but throughout Italy, especially among the MACCHIAIOLI in Florence; the jury of the 1880 national exhibition at Turin conferred on him a diploma of recognition as the foremost artist in Italy. He studied with C. Guerra and C. Angelini at the Naples Academy but, powerfully influenced by the naturalistic painting of the brothers PALIZZI, he rebelled against academic instruction. He was involved in the revolutionary activities of 1848 and in 1855 visited Germany and France, seeing the EXPOSITION UNIVERSELLE in Paris. There he met DELAROCHE and developed a particular admiration for MEISSONIER. Next he visited Florence, where he was enthusiastically received by the Macchiaioli. In Milan (1860-1) he became friendly with INDUNO and the Milanese ROMANTICS. In 1868 he became a professor at the Naples Academy. From *c.* 1870 he concentrated on biblical subjects painted with everyday realism in southern sunlight. His style became increasingly summary and impressionistic. There are works in Bari, Florence (Mod. Art), Milan (Grassi, Mod. Art), Naples (Capodimonte), Palermo

(Mod. Art), Rome (Mod. Art), Trieste (Revoltella), Turin (Mod. Art) and Venice (Mod. Art).
Lit. P. Levi: *D. Morelli* (1906); V. Sinazzola: *D. Morelli* (1925); A. Conti: *D. Morelli* (1927)

Moret Henri, b. Cherbourg 1856, d. Paris 1913. Second generation IMPRESSIONIST marine and landscape painter. He studied in Paris with Carolles and LAURENS and exhibited at the SALON in 1880. He then abandoned an official artistic career to paint freely in the countryside, and became one of the group round GAUGUIN at Pont-Aven. His views, largely limited to Brittany, were strongly influenced by MONET. There are works in Boston, Cambridge Mass. (Fogg), Detroit, Reims and Washington (NG).

Morgenstern Christian Ernst Bernhard, b. Hamburg 1805, d. Munich 1867. Pioneer of naturalistic landscape painting in Germany, with DAHL and GURLITT, his student companions in Hamburg. He settled in Munich, where his practice of working directly from nature and his fine observation of light, air and colour had an influential impact on the landscape school. The son of a miniature painter, he worked first with the panorama painters Christoph and Cornelius Suhr before beginning his formal study (1824) with BENDIXEN in Hamburg. In 1827 his move to the Copenhagen Academy and study expeditions to Sweden and Norway brought a sudden flowering of his talent for landscape. He returned to Hamburg in 1828 but settled in Munich in 1829 and spent the rest of his life there. His small paintings of c. 1830 were painted with considerable freedom and directly inspired by nature; his later work, influenced by ROTTMANN and the DÜSSELDORF SCHOOL, tends to a more conventional ROMANTICISM. His son Carl was also a painter. There are works in Wrocław, Karlsruhe, Darmstadt, Frankfurt/ M., Hamburg, Hanover, Karlsruhe, Kiel, Leipzig, Munich (Schack), Prague, Stuttgart and Zurich.

Morisot Berthe Marie Pauline, b. Bourges 1841, d. Paris 1895. French painter of the IMPRESSIONIST school; she exhibited at all but one (1879) of the Impressionist Group Shows and married the younger brother of MANET in 1874. The daughter of a government official, she took early to painting and came to Paris with her sister Edna to pursue her studies. She worked with COROT (1862–8) who was the main influence on her early work, especially the delicate landscapes (*Port of Lorient* 1869). She first exhibited at the SALON in 1865. In 1868 she met Manet, who influenced her in a new direction (*Woman with a Mirror* 1875); she became one of his favourite models and, after joining forces with the Impressionists, was partly responsible for his adopting open air painting and replacing his characteristic blacks with their pure bright colours. She concentrated mainly on portraits and interior scenes (*The Cradle* 1873), combining an intimate flavour with a subtle harmony of tones. She also worked extensively in watercolour and pastel. Mallarmé, DEGAS, MONET and RENOIR were among her close friends. There are works in most galleries of modern art, including Boston, London (Tate), Paris (Musée de l'Impressionisme) and Washington (NG).
Lit. D. Rouart: *Correspondance de B. Morisot* (1950); M. L. Bataille, G. Wildenstein: *B. Morisot: Catalogue des peintures, pastelles et aquarelles* (1961); E. Mongan and others: *B. Morisot: Drawings, Pastels, Watercolours, Paintings* (1961)

Morris William, b. Walthamstow 1834, d. Hammersmith 1896. A close friend and associate of BURNE-JONES from Oxford days, he briefly tried his hand at painting in the 1850s, collaborating with ROSSETTI on the Oxford Union frescoes (1857). His fame, however, rests on his anti-industrialist efforts to revive hand-craftsmanship. The firm of Morris, Marshall, Faulkner and Co., 'Fine Art Workmen in Painting, Carving, Furniture and the Metals', was founded in 1861. Morris's own basically floral wallpaper and chintz designs, deriving from medieval illuminations, have had a lasting popularity. In 1891 he founded the Kelmscott Press, which did much to raise standards of book design and printing. He was also an ardent socialist and poet. His work is well represented in London (V&A, Tate, Walthamstow).
Lit. A. Briggs (ed.): *W. Morris: Selected Writings and Designs* (1962); P. Henderson: *W. Morris: His Life, Work and Friends*

Morgenstern *Waterfall in Oberbayern* 1830

Morisot *The Cradle* 1873

(1967); R. Watkinson: *W. Morris as Designer* (1967)

Morse Samuel Finley Breese, b. Charlestown (Mass.) 1791, d. New York 1872. American painter and inventor of the telegraph (Morse code). Intellectually committed to history painting, he made a living from portraits and occasionally dabbled in Poussinesque landscape. 'I cannot be happy unless I am pursuing the intellectual branch of the art. Portraits have none of it; landscape has some of it; but history has it wholly,' he wrote from London. He studied at Yale but in 1811 left with ALLSTON for London, where he shared lodgings with LESLIE and studied with WEST who, with Allston, fired his ambitions as a history painter (*Dying Hercules* 1813). However, he was forced to take up portrait painting for financial reasons, and on his return to America (1815) worked as a portraitist in Boston and in New York (1823). His historical showpiece, *The House of Representatives* (1822), included eighty-five portraits of careful accuracy. He was a co-founder and first president of the NATIONAL ACADEMY OF DESIGN (1826-45 and 1861-2) but, disenchanted by his failure to receive commissions for frescoes in the Capitol, he turned from painting to invention (*c.* 1838). There are works in Boston, Cambridge Mass. (Fogg), Chicago, Cincinnati, Detroit, New York (Met., Brooklyn, Hist. Soc., Nat. Acad.), Washington (Corcoran, NG) and Worcester.
Lit. E. L. Morse: *Life, Letters and Journals of S. F. B. Morse* (1914); C. Mabee: *The American Leonardo* (1943); O. W. Larking: *S. F. B. Morse and American Democratic Art* (1954)

Mount William Sydney, b. Setauket, Long Island (N.Y.) 1807, d. Setauket 1868. Genre painter and portraitist. His happy temperament overflowed into rural scenes of Long Island; whites and blacks alike are depicted in their workclothes, dancing, music-making and resting, though seldom at work (*Eel Spearing at Setauket* 1845, *Banjo Player* 1858). His style is simple and realistic, using bright clear colours. He worked with his sign-painter brother Henry from 1824 to 1826 before studying at the NATIONAL ACADEMY OF DESIGN (1826-7), where he first exhibited in

1828. He lived in New York from *c.* 1829 to 1836, but spent the rest of his life on the family farm at Stony Brook, Long Island. His genre scenes achieved a wide popularity through the AMERICAN ART-UNION and several were reproduced as lithographs or engravings; he painted portraits when short of money and in the 1850s showed an increasing interest in landscape (*Fence on the Hill* 1850). He became a member of the National Academy of Design in 1832. There are works in Boston, Cambridge Mass. (Fogg), Chicago, New York (Met., Brooklyn, Hist. Soc., Pub. Lib.), Stony Brook and Washington (NG, Corcoran, Smithsonian).
Lit. B. Cowdrey, H. W. Williams: *W. S. Mount, an American Painter* (1944); B. Cowdrey: *The Three Mount Brothers* (1947)

Mucha Alfons Marie, b. Ivancice 1860, d. Prague 1939. Czech painter, designer and decorator, one of the leading exponents of ART NOUVEAU. He designed many posters, particularly for Sarah Bernhardt, carrying the decorative 'whiplash' line to its furthest limits with twisting tendrils of flowers and bizarre undulations of hair. He studied at the Prague and Munich Academies before moving to Paris (1887), where he worked with LAURENS and at the ACADÉMIE JULIAN, and soon became the pivot of the Art Nouveau movement. Between 1904 and 1913 he paid several extended visits to the U.S. After *c.* 1910, Prague became his base and he turned to patriotic paintings in the academic manner (*Epic of the Slavic People* 1910-28). There are works in Baltimore (Mus. of Art), London (V&A), New York, Paris (Carnavalet) and Prague (NG).
Lit. B. Reade: *Art Nouveau and A. Mucha* (1963); J. Mucha: *A. Mucha, his Life and Art* (1966); J. Mucha, M. Henderson, A. Scharf: *A. Mucha: Posters and Photographs* (1971)

Müller Victor, b. Frankfurt/M. 1829, d. Munich 1871. Painter mainly of mythological and literary subjects (Shakespeare, Goethe, etc.). He was considered in his time a revolutionary for he approached these subjects with a REALISM that he had learnt from COURBET in Paris; his strong use of colour led critics to compare his work with that of DELACROIX. He studied in Frankfurt/

M. with STEINLE, in Antwerp, and with COUTURE in Paris. As a colourist he was influenced by his fellow student FEUERBACH and as a Realist by Courbet. He worked in Frankfurt (1858-64) where he had his first success with a realistically painted *Hero and Leander*. In 1864 he settled in Munich where he became the leader of the Realist-oriented group that included LEIBL, THOMA and HAIDER. His major series of Shakespearian paintings date from the Munich years. There are works in Berlin, Frankfurt/M. and Munich.

Muller Leopold Karl, b. Dresden 1834, d. Vienna 1892. Austrian naturalistic painter of Oriental life. He studied at the Vienna Academy with C. Blaas and C. Ruben, and was a friend of PETTENKOFEN, by whom he was much influenced. On a visit to Egypt (1875-6) with MAKART, LENBACH and a group of other artists, he discovered the world which he was to paint for the rest of his life. He was a professor at the Vienna Academy from 1877. There are works in Graz, Munich and Vienna (Belvedere).

Müller William James, b. Bristol 1812, d. Bristol 1845. English landscape painter, son of the German-born curator of the Bristol Museum. His English views have a fresh naturalism that reflects the influence of CONSTABLE and COX; he is better known for his paintings of Venice and the Middle East. Romantically conceived, freely painted and rich in colour they owe a debt to TURNER. He first exhibited at the ROYAL ACADEMY in 1833. In 1834-5 he visited Germany, Switzerland and Italy, in 1838-9 Greece, Egypt, Malta and Naples, and in 1843-4 was in Turkey. His work is best represented in Bristol but there are also paintings and watercolours in London (Tate, V&A, BM).
Lit. N. N. Solly: *Memoir of the Life of W. J. Muller* (1875)

Mulready William, b. Ennis (Ireland) 1786, d. London 1863. With WILKIE, a founding father of Victorian genre painting. His careful and delicate execution was enhanced by the use of luminous colours; for these qualities, he has been dubbed a forerunner of the PRE-RAPHAELITES. Many of his paintings illustrate popular classics, such as Cervantes,

Shakespeare, Goldsmith and Molière, but his anecdotal country scenes were also admired (*Sonnet c.* 1839, *Shooting a Cherry* 1848). He left home as a boy, entering the ROYAL ACADEMY Schools in 1800 when only fourteen. He first painted history and landscape, but in 1807 turned to genre under the influence of Wilkie and Dutch 17C paintings. He had his first major success with *The Fight Interrupted* in 1816. An ARA in 1815, he became an RA in 1816, and continued to exhibit successfully until 1862, developing a technique of painting in thin layers of colour on a white ground. His sons John, Michael and William Jr were also artists. There are works in Dublin, Edinburgh, Leeds, London (Tate, V&A, NPG), Manchester and Paris (Louvre).
Lit. F. G. Stephens: *Memorials of W. Mulready* (1867); J. Dafforne: *Pictures and Biographical Sketch of W. Mulready* (1872)

Munch Edvard, b. Løten (Hedmark) 1863, d. Oslo 1944. Norwegian painter and graphic artist; he is considered a SYMBOLIST and also a forerunner of German Expressionism. He sought in his work to give expression to the dark turmoil of his soul, returning repeatedly to themes of love and death. He was closely associated with the Berlin SECESSION; the suppression of his exhibits from the 1892 Berlin Exhibition was a seminal influence on the formation of the group. The son of a doctor, his childhood was studded with tragedies, including the deaths of his mother and sister. He took up painting in 1880, studying in Oslo with Heyerdahl and KROHG, and visited Paris in 1885, returning 'the first and only Impressionist of Norway' (Krohg). *The Sick Child* (1886) and *Spring* (1889) are important works of this period. On his return to Paris (1889) he studied briefly with BONNAT and found in the work of VAN GOGH and GAUGUIN the chief inspiration for his mature style. Panic-stricken works such as *Karl Johans Gate* (1892) and *The Cry* (1893) followed. It was at this period that he conceived the plan of grouping his paintings together as a *Frieze of Life*, the whole thus becoming an outward expression of his inner conception of the world; he exhibited his work under this title at the Paris Galerie Art Nouveau in 1896 and at the SALON DES INDÉPENDANTS in 1897. In the 1890s, he began to turn his favourite themes into etchings

Morse *Exhibition Gallery of the Louvre* 1832

Mount *Eel Spearing at Setauket* 1845

Mulready *Crossing the Ford* exhibited 1842

Mucha *Gismonda* 1894

Munkácsy

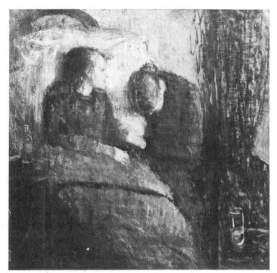

Munch *The Sick Child* 1886 version

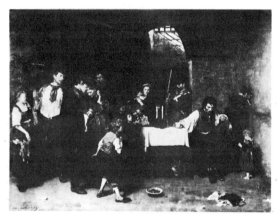

Munkácsy *Last Day of a Condemned Man* 1870

and lithographs of great power. He lived in Berlin (1892–5), in Paris (1895–7) and then mainly in Germany until 1908. In 1909 he returned to Norway after a nervous breakdown; his later work is rich in colour but in a calmer, more naturalistic vein. There is a Munch Museum in Oslo and there are works in most museums of modern art. *(see colour illustration 32)*
Lit. O. Benesch: *E. Munch* (1960); J. H. Langaard, R. Revold: *E. Munch: The University Murals, Graphic Art and Paintings* (1960); O. Sarvig: *E. Munch: Graphik* (1965); J. P. Hodin: *E. Munch* (1972); R. Heller: *E. Munch: The Scream* (1973)

Munkácsy Mihaly von (born Lieb), b. Munkacs 1844, d. Endenuch (nr Bonn) 1909. Hungarian REALIST painter, influenced both by the DÜSSELDORF SCHOOL genre painters (KNAUS, VAUTIER) and by COURBET. His early work is mostly genre, including many Hungarian scenes, and showing a serious concern for the struggles of the poor. In Paris (1872–96) he established an important international reputation with religious and historical paintings (*Milton Dictating Paradise Lost to his Daughters* 1878, *Christ before Pilate* 1881) although continuing to paint some genre scenes and landscape. His family name was Lieb but he adopted the name Munkácsy after his birthplace in 1863. He studied in Budapest (1863), in Vienna with RAHL (1864) and in Munich with F. ADAM (1866); he first visited Paris in 1867, and studied in Düsseldorf with Knaus (1868–72). *Last Day of a Condemned Man*, painted in Düsseldorf, won him a SALON gold medal in Paris in 1870. He moved in 1872 to Paris, where his darktoned Realism was importantly influenced by Courbet; he worked in Barbizon in 1873–4. *Milton* (1878) made him famous and from 1879 to 1890 he withdrew from the Salon, exhibiting a series of religious paintings in his own studio. He received a Hungarian knighthood ('von') in 1878 and in 1896 returned to Hungary, where his success stimulated a new surge of national artistic endeavour. His work was an important early influence on LIEBERMANN. There are works in Baltimore (Walters), Budapest (Fine Arts, NG), Berlin (NG), Cincinnati, Detroit, Dordrecht, Dresden, Düsseldorf, The Hague, Hamburg, Moscow (Tretiakov), Munich (N.

Pin.), New York (Brooklyn), Paris and Stockholm.
Lit. L. Végvári: *Katalog der Gemälde und Zeichnungen Mihály Munkácsys* (1959)

Munthe Gerhard Peter Frantz Vilhelm, b. Elverum (Osterdal) 1849, d. Oslo 1929. Norwegian painter and watercolourist. He moved through REALISM – landscapes in the Barbizon manner – to IMPRESSIONISM, to illustration of Norwegian folk history and myth for which he is accounted a Norwegian SYMBOLIST. He worked in many media, fresco, oil, watercolour and engraving, and also created designs for stained glass, carpets, furniture, ironwork and ceramics. He studied in Oslo with J. F. Eckersberg and M. Müller from 1870, in Düsseldorf (1874–7) and in Munich (1877–82). He also visited Paris, where he was influenced by the Impressionists. His mature style with bright palette, sure colour sense and rhythmic decorative line powerfully influenced a younger generation of Norwegian artists. There are works in Bucharest, Copenhagen, Göteborg, Helsinki (Athenaeum), Krefeld, St Louis and Stockholm.
Lit. H. Bakken: *G. Munthes dekorative Kunst* (1946); H. Bakken: *G. Munthe: en biografisk studie* (1952)

Mussini Luigi, b. Berlin 1813, d. Siena 1888. Leading Tuscan exponent of PURISMO. Personally scorning the work of OVERBECK and the NAZARENES as plagiarism, his Purismo was based on personal studies of 15C paintings in the chapels and churches of Florence and was influenced by his friendship with INGRES. Sufficient classicism remained in his style for Paris critics to label his *Eudoro and Cimodocea* (1854–5) as 'Davidian' in 1857. Not a prolific painter, his role in the rediscovery and re-evaluation of the Italian primitives was greater as a teacher, writer and administrator. He studied with his brother Cesare and at the Florence Academy under BENVENUTI and BEZZUOLI, but he became antagonized by academic teaching and sought inspiration in 15C painting. He won a pension for study in Rome (1840–4), where he began an association with Ingres and the French Academy. In 1848 he enrolled in the Tuscan volunteers, and the following year went to

156

Paris, where he received commissions from the French government and remained until in 1851 he became director of the Siena Academy. He was a correspondent member of the French INSTITUT (1859) and an active member of the Belle Arti Commission for the restoration and conservation of Tuscany's historic monuments from its inception in 1866. There are works in Avranches, Bourg, Faenza, Florence (Mod. Art), Paris (Louvre) and Rome (Mod. Art).
Lit. L. Mussini: *Epistolario artistico, colla vita di lui scritta* (1893); L. Anzoletti: *Vita di L. Mussini* (1893)

N

Nabis. A group of French artists, *c.* 1889–99, interested in SYNTHETISM as developed by BERNARD and GAUGUIN and preached in Paris by SERUSIER, who brought them together. BONNARD, VUILLARD, DENIS, Ranson, the sculptor Maillol, VALLOTTON and RIPPL-RÓNAI all belonged to the group. They had close contacts with the SYMBOLIST poets and were interested in theatre design, book illustrations, posters and stained glass as well as painting. In addition to Gauguin, PUVIS DE CHAVANNES, REDON, primitive sculpture and Japanese prints were important influences on their work.
Lit. A. Humbert: *Les Nabis et leur époque 1888–1900* (1954); F. Hermann: *Die Revue Blanche und die Nabis* (1959); C. Chasse: *The Nabis and their Period* (1969)

National Academy of Design, New York. This was an institution founded by native artists who felt that their interests were not served by the Europe-oriented AMERICAN ACADEMY OF FINE ARTS. Led by Inman and MORSE, the artists formed a drawing association (1825) which was self-governing. The National Academy was founded in 1826 with Morse as president; a drawing school was started and an annual exhibition instituted whose gate money initially supported the whole venture. Only modern American paintings, not previously exhibited, were accepted; membership was restricted to artists from the New York area until 1862. DURAND followed Morse as president (1846–61). Having fostered the emergence of the native school of genre and landscape, the academy became temporarily overshadowed by the powerful AMERICAN ART-UNION. By 1877 its administration had become reactionary and the Society of American Artists was founded as an alternative exhibiting society by the new generation of REALIST- and IMPRESSIONIST-oriented artists.

Naturalism (Naturalist) *see* REALISM

Navez François Joseph, b. Charleroi 1787, d. Brussels 1869. NEOCLASSICAL painter and figurehead of the Brussels art establishment from *c.* 1830 until his death. A pupil of DAVID, he was faithful to strict classical tenets in his teaching, though a modicum of REALISM found its way into his work, especially the portraits (*Hemptinne Family* 1816), which show the influence of his friendship with INGRES, SCHNETZ and ROBERT. After studying with P. J. François in Brussels and with David in Paris, he spent 1817–22 in Rome, where he greatly admired Raphael. In 1833 he became director of the Brussels Academy, and was in charge of the jury for the Brussels INTERNATIONAL EXHIBITION of 1851. He became a knight of the Order of Leopold of Belgium and of the Lion of the Netherlands, received the Legion of Honour and was a correspondent member of the INSTITUT, as well as an associate of several foreign academies. There are works in Amsterdam, Antwerp, Brussels (Musées Royaux), Berlin and Munich.
Lit. A. Alvin: *F. J. Navez, sa vie, ses œuvres et sa correspondance* (1870); F. Maret: *F. J. Navez* (1962)

Nazarenes. A group of German artists working in Rome in the early 19C, dedicated to a rejuvenation of German art in the Christian spirit of the Middle Ages. They rediscovered and emulated the work of 15C artists before Raphael in conscious opposition to their contemporaries who looked to the

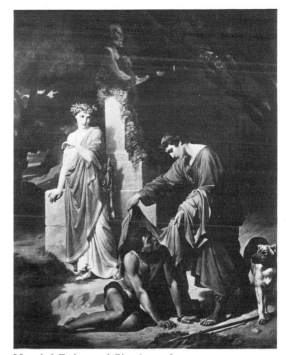
Mussini *Eudoro and Cimodocea* 1854-5

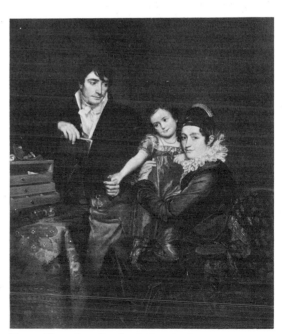
Navez *Hemptinne Family* 1816

Neoclassicism

Renaissance classicists (Raphael, Michelangelo and the Carracci) as models of perfection in painting. In their later works the distinction tends to become academic since they too fell under the spell of Raphael. The founder figures were OVERBECK and PFORR; as students they rediscovered the older masters and adopted their style in reaction against the classical teaching of the Vienna Academy. They founded the BROTHERHOOD OF ST LUKE (1809) with L. Vogel, J. K. Hottinger, J. Wintergerst and J. Sutter. In 1810 Overbeck, Pforr, Vogel and Hottinger left Vienna for Rome, where they established themselves in the monastery of S. Isidoro and led a monastic life in emulation of Fra Angelico, calling themselves the Fratelli di S. Isidoro. On leaving the monastery they called themselves the Düreristen, but it is their nickname of 'Nazarenes', inspired by their long hair and long cloaks, that has survived. In Rome many visiting artists joined the circle for shorter or longer periods, notably CORNELIUS, SCHADOW, VEIT, FÜHRICH, FRIEDRICH, OLIVIER, SCHNORR VON CAROLSFELD and STEINLE. Cornelius became the leading spirit after Pforr's death in 1812 and inspired the group's interest in communal fresco painting (Casa Bartholdy frescoes 1815–17, Casino Massimo frescoes 1817–27). Nazarenism was re-exported to Germany with its disciples as directors of many leading academies, notably Cornelius in Munich. It inspired PURISMO in Italy, influenced the PRE-RAPHAELITES in Britain, and had a second belated impact throughout Europe with the publication in 1860 of Schnorr von Carolsfeld's illustrations to the Bible. While there appears to have been little contact between the French and German artists working in Rome, the religious paintings of INGRES are said to show the influence of the Nazarenes.

Lit. P. F. Schmidt: *Die Lukasbrüder* (1924); C. G. Heise: *Overbeck und sein Kreis* (1928); K. Andrews: *The Nazarenes* (1964)

Neoclassicism (Neoclassical). A product of the Age of Enlightenment and an idealistic reaction to the superficiality of rococo. Artists aimed at 'noble simplicity and calm grandeur'; composition was often derived from classical reliefs and vase painting, figures idealized as in antique sculpture, while colour was considered less important than line and modelling. The style dominated the late 18C and early 19C, originating in Rome and spreading throughout Europe. DAVID was its greatest exponent in the field of painting (*Oath of the Horatii* 1784, *Intervention of the Sabine Women* 1799) and CANOVA in sculpture, but Vien in France, Mengs in Germany (*Parnassus* 1760-1), Piranesi in Italy, WEST (*Agrippina with the Ashes of Germanicus* 1768) and FLAXMAN in England were also among the pioneers. The movement coincided with a strong renewal of interest in antiquity, stimulated in part by the discovery of the buried cities of Herculaneum and Pompeii. But it was more than a historical revival; it was an idealistic attempt to distil the principles of great art for all time and all peoples. The idea that there was only *one* 'true style', irrespective of the artist who practised it, was a central feature of Neoclassical theory. Writers of the period derived the principles of 'true style' by reference to antiquity, in architecture, in sculpture and, with slightly more difficulty, in painting. The absence of antique example in painting led to the virtual reclassification of Raphael, Michelangelo, Poussin and Claude as classical artists. These theoretical writings were of major importance to the movement; its original impetus stemmed from the influence of art historian-theorist J. J. Winckelmann over artists working in Rome (Mengs, West, David); his *History of Ancient Art* was published in 1764 and translated into English by FUSELI. The principal features of Neoclassical theory were: a belief that great art should be ennobling, hence the depiction of noble deeds from history (Homer, Ossian and the Bible being the most favoured sources of subject matter); the striving after Ideal Beauty in composition, figures and landscape – this required the close study of nature and the selection from it of the most perfect example of each of its features (the difficulty of this selection could be eased by reference to that already achieved by great artists of the past); the striving after Truth, which made artists suspicious of colour as an emotive artifice while particularly admiring the purity of outline drawing (the outline drawings of Flaxman and Carstens were long a compositional source for other artists).

While these ideas have their philosophic base in the Enlightenment, the style came to maturity at the beginning of the ROMANTIC period; there are Romantic elements in the work of all the major Neoclassical artists: in the intense REALISM of David's portraits, in the patriotic pomp and colour of his Napoleonic paintings, in West's depictions of contemporary and medieval history, in Fuseli's weird illustrations to Shakespeare.

David dominated the French artistic hierarchy of the Revolutionary and Empire periods and artists flocked to his studio from all over Europe. Through his pupils ECKERSBERG and KRAFFT his Realism, as well as his clear outline and modelling, were a formative influence on the BIEDERMEIER style. In the 1820s and 1830s his pupils gained a dominant position in the French Académie and, stressing the importance of noble subject matter, line and finish, fought a rearguard action against the Romantic colourists and the Realists. Thus Neoclassicism was transmuted into academic classicism and retained its hold throughout the century through INGRES, FLANDRIN, GLEYRE, COUTURE, BOUGUEREAU, CABANEL and PUVIS DE CHAVANNES. The 19C passion for history painting also had its roots in the work of Benjamin West and J. L. David.

Portrait and landscape were considered inferior branches of art in the Neoclassical period, but there were nevertheless superlative achievements in the portraits of David and Ingres and a flourishing school of historical landscape. The proper approach to landscape painting was codified by VALENCIENNES in his *Elements de la perspective practique*, published in 1800. Poussin and Claude should be followed, particularly in the matter of composition; 'truth' was to be assured by sketches from nature which should take at most two hours on account of changing light; landscape should be used to illustrate a classical theme which required the study of Greek and Roman literature. Broadly speaking these were also the principles followed by KOCH, who exerted a dominant influence on landscape painting in the German-speaking world late into the 19C.

Neoclassicism, which was a fully international movement, also profoundly influenced architecture (SCHINKEL, Adam, Ledoux), interior design, all the applied arts (furniture, silver, etc.) and even fashions in dress.

Lit. see Bibliography

Paris, where he received commissions from the French government and remained until in 1851 he became director of the Siena Academy. He was a correspondent member of the French INSTITUT (1859) and an active member of the Belle Arti Commission for the restoration and conservation of Tuscany's

historic monuments from its inception in 1866. There are works in Avranches, Bourg, Faenza, Florence (Mod. Art), Paris (Louvre) and Rome (Mod. Art).
Lit. L. Mussini: *Epistolario artistico, colla vita di lui scritta* (1893); L. Anzoletti: *Vita di L. Mussini* (1893)

N

Nabis. A group of French artists, *c.* 1889-99, interested in SYNTHETISM as developed by BERNARD and GAUGUIN and preached in Paris by SERUSIER, who brought them together. BONNARD, VUILLARD, DENIS, Ranson, the sculptor Maillol, VALLOTTON and RIPPL-RÓNAI all belonged to the group. They had close contacts with the SYMBOLIST poets and were interested in theatre design, book illustrations, posters and stained glass as well as painting. In addition to Gauguin, PUVIS DE CHAVANNES, REDON, primitive sculpture and Japanese prints were important influences on their work.
Lit. A. Humbert: *Les Nabis et leur époque 1888-1900* (1954); F. Hermann: *Die Revue Blanche und die Nabis* (1959); C. Chasse: *The Nabis and their Period* (1969)

National Academy of Design, New York. This was an institution founded by native artists who felt that their interests were not served by the Europe-oriented AMERICAN ACADEMY OF FINE ARTS. Led by Inman and MORSE, the artists formed a drawing association (1825) which was self-governing. The National Academy was founded in 1826 with Morse as president; a drawing school was started and an annual exhibition instituted whose gate money initially supported the whole venture. Only modern American paintings, not previously exhibited, were accepted; membership was restricted to artists from the New York area until 1862. DURAND followed Morse as president (1846-61). Having fostered the emergence of the native school of genre and landscape, the academy became temporarily overshadowed by the powerful AMERICAN ART-UNION. By 1877 its administration had become reactionary and the Society of American Artists was

founded as an alternative exhibiting society by the new generation of REALIST- and IMPRESSIONIST-oriented artists.

Naturalism (Naturalist) *see* REALISM

Navez François Joseph, b. Charleroi 1787, d. Brussels 1869. NEOCLASSICAL painter and figurehead of the Brussels art establishment from *c.* 1830 until his death. A pupil of DAVID, he was faithful to strict classical tenets in his teaching, though a modicum of REALISM found its way into his work, especially the portraits (*Hemptinne Family* 1816), which show the influence of his friendship with INGRES, SCHNETZ and ROBERT. After studying with P. J. François in Brussels and with David in Paris, he spent 1817-22 in Rome, where he greatly admired Raphael. In 1833 he became director of the Brussels Academy, and was in charge of the jury for the Brussels INTERNATIONAL EXHIBITION of 1851. He became a knight of the Order of Leopold of Belgium and of the Lion of the Netherlands, received the Legion of Honour and was a correspondent member of the INSTITUT, as well as an associate of several foreign academies. There are works in Amsterdam, Antwerp, Brussels (Musées Royaux), Berlin and Munich.
Lit. A. Alvin: *F. J. Navez, sa vie, ses œuvres et sa correspondance* (1870); F. Maret: *F. J. Navez* (1962)

Nazarenes. A group of German artists working in Rome in the early 19C, dedicated to a rejuvenation of German art in the Christian spirit of the Middle Ages. They rediscovered and emulated the work of 15C artists before Raphael in conscious opposition to their contemporaries who looked to the

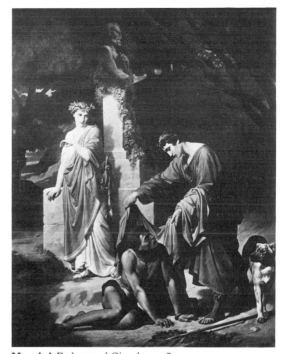

Mussini *Eudoro and Cimodocea* 1854-5

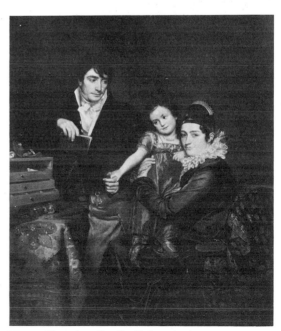

Navez *Hemptinne Family* 1816

Renaissance classicists (Raphael, Michelangelo and the Carracci) as models of perfection in painting. In their later works the distinction tends to become academic since they too fell under the spell of Raphael. The founder figures were OVERBECK and PFORR; as students they rediscovered the older masters and adopted their style in reaction against the classical teaching of the Vienna Academy. They founded the BROTHERHOOD OF ST LUKE (1809) with L. Vogel, J. K. Hottinger, J. Wintergerst and J. Sutter. In 1810 Overbeck, Pforr, Vogel and Hottinger left Vienna for Rome, where they established themselves in the monastery of S. Isidoro and led a monastic life in emulation of Fra Angelico, calling themselves the Fratelli di S. Isidoro. On leaving the monastery they called themselves the Düreristen, but it is their nickname of 'Nazarenes', inspired by their long hair and long cloaks, that has survived. In Rome many visiting artists joined the circle for shorter or longer periods, notably CORNELIUS, SCHADOW, VEIT, FÜHRICH, FRIEDRICH, OLIVIER, SCHNORR VON CAROLSFELD and STEINLE. Cornelius became the leading spirit after Pforr's death in 1812 and inspired the group's interest in communal fresco painting (Casa Bartholdy frescoes 1815–17, Casino Massimo frescoes 1817–27). Nazarenism was re-exported to Germany with its disciples as directors of many leading academies, notably Cornelius in Munich. It inspired PURISMO in Italy, influenced the PRE-RAPHAELITES in Britain, and had a second belated impact throughout Europe with the publication in 1860 of Schnorr von Carolsfeld's illustrations to the Bible. While there appears to have been little contact between the French and German artists working in Rome, the religious paintings of INGRES are said to show the influence of the Nazarenes.
Lit. P. F. Schmidt: Die Lukasbrüder (1924); C. G. Heise: Overbeck und sein Kreis (1928); K. Andrews: The Nazarenes (1964)

Neoclassicism (Neoclassical). A product of the Age of Enlightenment and an idealistic reaction to the superficiality of rococo. Artists aimed at 'noble simplicity and calm grandeur'; composition was often derived from classical reliefs and vase painting, figures idealized as in antique sculpture, while colour was considered less important than line and modelling. The style dominated the late 18C and early 19C, originating in Rome and spreading throughout Europe. DAVID was its greatest exponent in the field of painting (Oath of the Horatii 1784, Intervention of the Sabine Women 1799) and CANOVA in sculpture, but Vien in France, Mengs in Germany (Parnassus 1760–1), Piranesi in Italy, WEST (Agrippina with the Ashes of Germanicus 1768) and FLAXMAN in England were also among the pioneers. The movement coincided with a strong renewal of interest in antiquity, stimulated in part by the discovery of the buried cities of Herculaneum and Pompeii. But it was more than a historical revival; it was an idealistic attempt to distil the principles of great art for all time and all peoples. The idea that there was only *one* 'true style', irrespective of the artist who practised it, was a central feature of Neoclassical theory. Writers of the period derived the principles of 'true style' by reference to antiquity, in architecture, in sculpture and, with slightly more difficulty, in painting. The absence of antique example in painting led to the virtual reclassification of Raphael, Michelangelo, Poussin and Claude as classical artists. These theoretical writings were of major importance to the movement; its original impetus stemmed from the influence of art historian-theorist J. J. Winckelmann over artists working in Rome (Mengs, West, David); his *History of Ancient Art* was published in 1764 and translated into English by FUSELI. The principal features of Neoclassical theory were: a belief that great art should be ennobling, hence the depiction of noble deeds from history (Homer, Ossian and the Bible being the most favoured sources of subject matter); the striving after Ideal Beauty in composition, figures and landscape – this required the close study of nature and the selection from it of the most perfect example of each of its features (the difficulty of this selection could be eased by reference to that already achieved by great artists of the past); the striving after Truth, which made artists suspicious of colour as an emotive artifice while particularly admiring the purity of outline drawing (the outline drawings of Flaxman and Carstens were long a compositional source for other artists).
While these ideas have their philosophic base in the Enlightenment, the style came to maturity at the beginning of the ROMANTIC period; there are Romantic elements in the work of all the major Neoclassical artists: in the intense REALISM of David's portraits, in the patriotic pomp and colour of his Napoleonic paintings, in West's depictions of contemporary and medieval history, in Fuseli's weird illustrations to Shakespeare.

David dominated the French artistic hierarchy of the Revolutionary and Empire periods and artists flocked to his studio from all over Europe. Through his pupils ECKERSBERG and KRAFFT his Realism, as well as his clear outline and modelling, were a formative influence on the BIEDERMEIER style. In the 1820s and 1830s his pupils gained a dominant position in the French Académie and, stressing the importance of noble subject matter, line and finish, fought a rearguard action against the Romantic colourists and the Realists. Thus Neoclassicism was transmuted into academic classicism and retained its hold throughout the century through INGRES, FLANDRIN, GLEYRE, COUTURE, BOUGUEREAU, CABANEL and PUVIS DE CHAVANNES. The 19C passion for history painting also had its roots in the work of Benjamin West and J. L. David.

Portrait and landscape were considered inferior branches of art in the Neoclassical period, but there were nevertheless superlative achievements in the portraits of David and Ingres and a flourishing school of historical landscape. The proper approach to landscape painting was codified by VALENCIENNES in his *Elements de la perspective practique*, published in 1800. Poussin and Claude should be followed, particularly in the matter of composition; 'truth' was to be assured by sketches from nature which should take at most two hours on account of changing light; landscape should be used to illustrate a classical theme which required the study of Greek and Roman literature. Broadly speaking these were also the principles followed by KOCH, who exerted a dominant influence on landscape painting in the German-speaking world late into the 19C.

Neoclassicism, which was a fully international movement, also profoundly influenced architecture (SCHINKEL, Adam, Ledoux), interior design, all the applied arts (furniture, silver, etc.) and even fashions in dress.
Lit. see Bibliography

Néo-Grecques. A group of young French artists, also known as the Pompéistes and led by GÉRÔME, who in the late 1840s and 1850s achieved a wide popularity with genre scenes set in classical antiquity. They were mainly students of GLEYRE, whose monumental scenes of classical history and allegory were a major influence on the new style; the younger artists added grace, eroticism and wit. The enthusiastic reception accorded to Gérôme's *Cock Fight* in the 1847 SALON was the basic stimulus that encouraged the young artists to develop this type of painting. The group included Boulanger, Hamon, Picou and Aubert.

Neo-Impressionism (Neo-Impressionist) *see* DIVISIONISM

Neuville Alphonse Marie de, b. Saint-Omer 1835, d. Paris 1885. Military painter and illustrator who enjoyed an important reputation following the 1870 Franco-Prussian War. He studied under PICOT and DELACROIX, and his preference for military subjects was shown in his first SALON exhibit *The Siege of Sebastopol* (1859). His paintings of the 1870 war were widely reproduced as engravings, thus establishing his popularity. The painterly *bravura* with which he evoked powder-smoke, destruction and the fury of a fusillade shows him to be a true pupil of Delacroix. He became a chevalier of the Legion of Honour in 1873 and an officer in 1881. There are works in Baltimore (Walters), Chantilly, Dijon, Grenoble, Lille, Moscow (Tretiakov), New York (Met.), Paris (Petit Palais), Philadelphia, Saint-Omer, Versailles, Washington (Corcoran) and Williamstown Mass. (Clark).

New English Art Club. Founded in 1886, the club was a rallying point for English artists who had felt the influence of the BARBIZON SCHOOL and IMPRESSIONISM. The painters tended to concentrate on landscape and realistic depiction of contemporary life and were much influenced by WHISTLER. 'The "New English", at its start, was a varied mob of painters, chiefly young, complaining and proclaiming at the gates of the [ROYAL] ACADEMY over its constitution, its exclusions and tardy recognitions, its antiquated School,' wrote D. S. MacColl, an early member and influential critic. STEER was a central figure;

SICKERT joined in 1888; SARGENT was a regular exhibitor. Contacts with the GLASGOW BOYS were severed after the work of one of them was not hung. The years 1890–1914 saw the club's most important contribution to the course of English art.

Newton Gilbert Stuart, b. Halifax (Nova Scotia) 1794, d. London 1835. American painter of humorous literary genre and portraits. He was a nephew of STUART, with whom he initially studied but later quarrelled. He visited Italy in 1817, meeting LESLIE there and returning with him to London to study at the ROYAL ACADEMY. He painted comic scenes from Shakespeare and the classics in Leslie's company, and became an ARA in 1828 and an RA in 1832. His artistic career was cut short by mental illness. There are works in Baltimore (Mus. of Art), Boston, Cambridge Mass. (Fogg), Dublin, Glasgow, Liverpool, London (V&A, Wallace, Tate) and New York (Met.).

Nittis Giuseppe de, b. Barletta (Bari) 1846, d. Paris 1884. His early landscapes, painted with crystalline clarity under a bright sun, are among the most distinguished products of REALIST painting in Naples; after moving to Paris he adopted a broader brushwork under the influence of the IMPRESSIONISTS and turned to the depiction of high society, townscape and city life. His work became fashionable and he won several SALON honours. He entered the Naples Academy in 1861 under Mancinelli and Smargiassi; having been expelled for indiscipline, he turned to *plein air* painting, forming the SCHOOL OF RESÍNA with Rossano, DE GREGORIO and other like-minded artists. In 1866 he visited Florence, where he was enthusiastically welcomed by the MACCHIAIOLI; in Paris (1867–70) he exhibited as a pupil of GÉRÔME. He left on account of the Franco-Prussian War, but returned to settle permanently in Paris in 1872. He exhibited at the first Impressionist Group Show in 1874, the year of his first major success at the Salon. He also visited London; his views of London and Paris, busy with elegant life, are among his most successful works. He received the Legion of Honour in 1878. He worked extensively in pastel during his last years and also executed a number of etchings. There are works in Bari (Civico), Barletta (de Nittis), Florence

Neuville *The Cemetery of Saint-Privat* 1881

Newton *Yorick and the Grisette* exhibited 1830

Nittis *Landscape* 1866

(Mod. Art), Milan (Grassi, Mod. Art), Naples (Capodimonte, San Martino), Paris (Carnavalet, Petit Palais), Philadelphia, Rome (Mod. Art), Trieste (Revoltella), Turin (Mod. Art) and Venice (Mod. Art).
Lit. E. Piceni: *G. de Nittis* (1934) and *G. de Nittis* (1965); E. Piceni, M. Pittaluga: *G. de Nittis* (1968)

Norblin de la Gourdaine Jean Pierre, b. Misy-Fault-Yonne 1745, d. Paris 1830. French painter who spent most of his life in Poland and was a formative influence on the Polish 19C school. His early works were mainly *fêtes galantes* in the manner of Watteau. After settling in Poland he received decorative commissions (Arkadia Castle ceiling 1783-5), but also turned to scenes of everyday life, particularly Polish street and market scenes. During the wars and uprisings of the 1790s he turned to battle scenes (*Warsaw Uprising* 1794) which were later to influence both ORLOWSKI and MICHALOWSKI. He studied in Paris with Vien, and in Dresden, and was invited to Poland in 1774 by Prince Adam Czartoryski; he also worked for the Radziwills and King Stanislaus Augustus. On his return to Paris (1804) he published a book of engravings of Polish costumes (1807) and painted some well-observed Paris scenes (*Social Diversions in the Tuileries Gardens* 1807). There are works in Brussels, Compiègne, Cracow (Czartory-ski), Lille, Orleans, Paris (Carnavalet), Poznań and Warsaw (Nat. Mus.).
Lit. W. Franke: *Das radierte Werke des J. P. Norblin de la Gourdaines* (1895); F. Hille-macher: *Catalogue des estampes de J. P. Norblin de la Gourdaine*; Z. Batowski: *Norblin* (1911, in Polish)

Normann Eilert Adelsteen, b. Bodö 1848, d. Oslo 1918. Highly successful Norwegian landscapist whose Düsseldorf technique dramatized native themes of majestic fjords and towering cliffs. He studied in Düsseldorf (1869-73) and settled in Berlin in 1883. He exhibited in Berlin, Düsseldorf, London, Munich, Paris and Vienna. There are works in Bergen, Wrocław, Karl-Marx-Stadt, Cin-cinnati, Cologne, Dresden, Düsseldorf, Gör-litz, Leeds, Liverpool, Mainz, Rostock, Stockholm and Sydney.

Norwich School. Early 19C school of landscape painting with a strong debt to Hobbema and the Dutch 17C. The greatest master and effective founder of the school was CROME, who was ably abetted by COTMAN.

In 1803 Crome started a club of painters and drawing-masters, the Norwich Society of Artists, who had a house of their own where they held exhibitions. Other members of the school include Crome's son John Berney, Cotman's two sons Miles Edmund and John Joseph, STARK, G. Vincent and H. Bright. The school flourished until the mid-century.
Lit. W. F. Dickes: *The Norwich School of Painting* (1905); D. Clifford: *Watercolours of the Norwich School* (1965)

Nuyen Wijnand Jan Joseph, b. The Hague 1813, d. The Hague 1839. Landscape and townscape painter. A short-lived but influ-ential ROMANTIC artist, he was a pioneer in the modernization of the Dutch landscape tradition. He had a fascination with Gothic architecture and painted many church in-teriors; his realistic but summary treatment of the figures that people his scenes holds an echo of BONINGTON. A pupil and son-in-law of SCHELFHOUT, he became a member of The Hague and Antwerp Academies. There are works in Amsterdam (Rijksmuseum), Brus-sels, Dordrecht, The Hague (Communal), London (Wallace) and Rotterdam.
Lit. L. Bogaert: *Note biographique sur W. J. J. Nuyen, peintre hollandais* (1839)

O

Oberländer Adolf, b. Regensburg 1845, d. Munich 1923. Caricaturist for the Munich *Fliegende Blätter* from 1863 to his death, and from 1869 for the *Münchner Bilderbogen*. After BUSCH, he was the most distinguished German humorist of the second half of the 19C. He used a delicate flowing line and achieved his effects by finely calculated over-emphasis. His oil paintings were exe-cuted during his early years or after 1904. There are works in Bremen, Dresden, Frank-furt/M., Hamburg, Munich and Szczecin.
Lit. H. Esswein: *A. Oberländer* (1905)

Oehme Ernst Ferdinand, b. Dresden 1797, d. Dresden 1855. ROMANTIC landscapist. He studied at the Dresden Academy (1819) and was a private pupil of DAHL. For many years

he was one of the closest, most poetic fol-lowers of Dahl's friend FRIEDRICH. He was in Italy from 1819 to 1825, and in the 1830s turned to BIEDERMEIER REALISM in his land-scapes, which are often close in their happy spirit to those of his friend RICHTER. There are works in Berlin, Dresden and Hamburg.

Olivier Ferdinand, b. Dessau 1785, d. Munich 1841. ROMANTIC landscapist, influ-enced in his student years by FRIEDRICH and later by the Alpine landscapes of KOCH; he shared the religious reverence of the NAZARENES for medieval art. His best land-scapes (*c.* 1817-30), depicting the mountains and villages around Salzburg, combine these influences, breathing a religious intensity

into every detail of the Alpine scenery (*Landscape with Pilgrims* 1817, *View from the Mönchsberg* 1824, *Capuchin Monastery near Salzburg* 1826); his pencil studies of this scenery are considered among the greatest graphic achievements of the period. He studied in Dessau and then in Dresden (1804-6) where he met Friedrich. He was in Paris from 1807 to 1810. In 1811 he moved with his brother Friedrich to Vienna and met KOCH; here he experienced a religious awaken-ing under the influence of St Clemens Hofbauer (canonized 1909) and his house be-came a meeting-place for Protestant artists. He first discovered the Salzburg landscape in 1815 and under his influence many artists worked there in the following years (including his brother Friedrich, VEIT and SCHNORR VON

CAROLSFELD). The Nazarenes recognized the affinity of his aims with their own by making him a member of the Brotherhood in 1816, although he never visited Rome. In 1830 he moved to Munich, where CORNELIUS appointed him general secretary of the academy and professor of art history; administrative duties kept him from painting for some years and his later works are mainly classical landscapes in the manner of Poussin. His brother **Friedrich** (1791–1859) worked closely with him and there are strong similarities of style. He visited Rome (1818–23) and later assisted Schnorr von Carolsfeld with his Munich frescoes; he also painted Bavarian landscapes which have often been attributed to Ferdinand. Another brother, Heinrich (1783–1848), was also an artist. There are works by Ferdinand in Basle (Kunstmuseum), Berlin (NG), Bremen, Cambridge Mass. (Fogg), Dessau, Dresden, Elberfeld, Essen (Folkwang), Frankfurt/M., Hamburg, Leipzig, Munich (N. Pin.), Poznań, Prague and Vienna. Friedrich's work is also represented in most of these museums.
Lit. L. Grote: *Die Brüder Olivier und die deutsche Romantik* (1938); F. Novotny: *F. Oliviers Landschaftszeichnungen von Wien und Umgebung* (1971)

Ommeganck Balthasar Paul, b. Antwerp 1755, d. Antwerp 1826. Animal and landscape painter, whose work has a smooth high finish and shows a strong debt to Potter and the Dutch 17C. He was highly successful in his day and his influence was carried late into the 19C by his pupil VERBOECKHOVEN. He studied with H. J. Antonissen from 1767. Already influential, he fought for the reopening of the Antwerp Academy in 1796 and became a professor of painting there. He was popular with the Empress Josephine and was made a correspondent member of the INSTITUT (1809). He was a member of the academies of Amsterdam, Brussels, Ghent, Munich and Vienna, and of the delegation to recover Belgian art works ceded to France (1814). There are works in Aix, Amiens, Amsterdam (Rijksmuseum, Stedelijk), Antwerp, Brussels (Musées Royaux), Kassel, Cherbourg, Dijon, Dulwich, Dunkirk, Leipzig, Le Puy, Lille, Lyons, Narbonne, New York (Met.), Nice, Paris (Louvre) and Rotterdam.

O'Neil Henry Nelson, b. St Petersburg 1817, d. London 1880. English genre painter. His works mainly depict scenes from history or literature (*The Last Moments of Raphael* 1866) but in the 1850s he turned under the influence of the PRE-RAPHAELITES to scenes of contemporary life. Most successful were his *Eastward Ho!* of 1858 (the departure of troops to put down the Sepoy Mutiny) and *Home Again* of 1859. He visited Italy with his artist friend Alfred Elmore, entered the ROYAL ACADEMY Schools in 1836 and was one of the founder members of THE CLIQUE. He became an ARA in 1879. There are works in Aberdeen, Birmingham, Bristol, Liverpool, Nottingham and Sheffield.

Orchardson Sir William Quiller, b. Edinburgh 1832, d. London 1910. Scottish genre painter. In his early work he favoured costume genre with scenes from Shakespeare and Scott, as well as drawingroom scenes of the Regency period. Later he turned to scenes from contemporary high life (*Mariage de Convenance* 1883, *First Cloud* 1887) with muted palette and sketch finish. He moved from Edinburgh to London in 1862, became an ARA in 1868 and an RA in 1877. There are works in Edinburgh, Glasgow, Hamburg, London (Tate), Sheffield and Victoria.
Lit. W. Armstrong: *The Art of W. Q. Orchardson* (1895); Hilda Orchardson Gray: *The Life of Sir W. Q. Orchardson* (1930)

Orlowski Aleksander Ossipovich, b. Warsaw 1777, d. St Petersburg 1832. Polish painter of battle scenes, portraits and contemporary genre, frequently with a satirical bite. He worked extensively in watercolour and pastel as well as oil, and achieved some reputation with caricatures. He studied under NORBLIN in Warsaw (1793–1801), painting many scenes from the 1794 uprising in which he took part. He went to the St Petersburg Academy in 1802 and became court painter to the Grand Duke Constantine, also working for the Tsars Alexander and Nicholas. A member of the St Petersburg Academy in 1809, he was the first artist in Russia to experiment with lithography. Although he has been called 'more Russian than Polish', his early work with its contemporary subject matter influenced the development of Polish 19C painting. There are works in Berlin,

Ferdinand Olivier *Quarry near Matleindorf c. 1814–16*

Friedrich Olivier *Foothills of the Alps c. 1840*

Orchardson *First Cloud 1887*

Orlowski *Battle Scene*

Overbeck *Joseph Sold by his Brothers 1816–17*

G. J. J. van Os *Still Life with Fruit and Flowers 1822*

Bremen, Cracow (Czartoryski), Leningrad (Hermitage, Russian Mus.), Moscow (Pushkin), Poznań and Warsaw (Nat. Mus.).
Lit. W. Tatarkiewicz: *A. Orlowski* (1926); H. Blumowna: *A. Orlowski* (1953); H. Crkalska-Zborowska: *A. Orlowski* (1962)

Os Family of Artists. Dutch family of painters primarily associated with still lifes of flowers and fruit, richly decorative and smoothly painted compositions in the 17C tradition. **Jan** (b. Middelharnis 1744, d. The Hague 1808) founded the family's still-life tradition as well as painting some marine views. **Georgius Johannes Jacobus** (b. The Hague 1782, d. Paris 1861) was his son and is accounted the family's finest flower painter. He worked with his father in Amsterdam (1816–20) before moving to Paris where he worked for the Sèvres porcelain factory, paying summer visits to Haarlem. **Maria Margaritha** (b. The Hague 1780, d. The Hague 1862) was the daughter of Jan and also a flower painter. **Pieter Gerardus** (b. The Hague 1776, d. The Hague 1839) was Jan's eldest son. He was a landscapist in the Paul Potter tradition but showed his originality in the use of unusual perspective and a loose approximative brushwork. **Pieter Frederik** (b. Amsterdam 1808, d. Haarlem 1860) was the son of Pieter Gerardus and a landscapist close to his father in style. He counted MAUVE among his pupils. There are works by Jan in Amsterdam (Rijksmuseum), Augsburg, Budapest, Cambridge (Fitzwm), Darmstadt, Emden, Frankfurt/M., Geneva (Rath), Gotha, The Hague, Innsbruck, Leningrad, London (NG), Paris (Louvre), Prague, Riga, Schleissheim and Solothurn; by Georgius Johannes Jacobus in Amsterdam (Rijksmuseum, Stedelijk), Berlin (NG), Brussels, Haarlem (Teyler), The Hague, London (NG) and Vienna (Czernin); by Maria Margaritha in Amsterdam (Rijksmuseum), Brussels and The Hague; by Pieter Gerardus in Amsterdam (Rijksmuseum), Wrocław, Brussels, The Hague, Nancy, Riga, Vienna (Albertina) and Würzburg; by Pieter Frederik in Brussels, Haarlem (Teyler) and The Hague.
Lit. P. Mitchell: *J. van Os, 1744–1808* (1968)

Overbeck Friedrich, b. Lübeck 1789, d. Rome 1869. One of the founders of the German NAZARENE movement. His paintings are almost all of religious subjects with an occasional departure into portraiture; spending most of his life in Rome he influenced artists from all over Europe and set the course of devotional painting for the entire century. He used clear outline, bright colours and a consciously archaic composition based on the example of Italian and German 15C painters, particularly Perugino and the early Raphael. He was much influenced by his wife's religious fanaticism in later years; his religious symbolism became complex and difficult to read while his debt to Raphael was accentuated. He attended the Vienna Academy from 1806. Dissatisfied with its conventional classicism he began, with his fellow student PFORR, to seek out the medieval and early Renaissance paintings in Viennese collections. In 1809 they formed the BROTHERHOOD OF ST LUKE with like-minded artists, dedicated to a rejuvenation of religious painting in the spirit of the 15C. Dismissed from the academy, the friends left Vienna for Rome (1810), where they settled in the deserted monastery of S. Isidoro and lived with monastic dedication to art and religion. Pforr's death in 1812 was a harsh blow; their friendship is symbolized in the painting *Germania and Italia* (1811–28). The arrival of CORNELIUS in Rome turned the Brotherhood towards fresco painting; Overbeck contributed *Joseph Sold by his Brothers* to the Casa Bartholdy group frescoes (1816–17) and scenes from *Gerusalemme Liberata* to the Casino Massimo frescoes (1817–27). In 1813 he was converted to Catholicism and in 1818 married Anna Schiffbauer-Hartl from Vienna. His freshest and most original work dates from the early years of the Nazarene movement: *Christ's Entry into Jerusalem* (1811–24, destroyed 1942), *Adoration of the Magi* (1811–13), *Family Portrait* (1820). His most ambitious later work was the *Triumph of Religion in the Arts* (1840), painted for Frankfurt. There are works in Antwerp, Basle (Kunstmuseum), Berlin (NG), Bremen, Cologne, Copenhagen (Thorwaldsen), Dublin (NG), Frankfurt/M., Hamburg, Moscow, Munich (N. Pin.), Vienna (Belvedere) and Zurich.
Lit. M. Howitt: *F. Overbeck, sein Leben und sein Schaffen* (1886); P. Hagen: *F. Overbecks handschriftlicher Nachlass* (1926); C. G. Heise, K. K. Eberlein: *Overbeck und sein Kreis* (1928); J. C. Jensen: *F. Overbeck* (1963)

P

Page William, b. Albany (N.Y.) 1811, d. Staten Island (N.Y.) 1885. Portraitist and history painter. Largely self-taught as a painter, he was fired by descriptions of the work of Titian and, deciding to be a colourist, developed a free treatment of paint quite unlike his contemporaries. He was converted to Swedenborgianism in later life and there tends to be an element of mysticism in his subject paintings (*Cupid and Psyche* 1843). He studied briefly with MORSE and at the NATIONAL ACADEMY OF DESIGN from 1826. He settled in Boston in 1843 and spent 1850–60 in Italy (portraits of Robert and Elizabeth Barrett Browning). He was president of the National Academy (1871–3). There are works in Boston, Cambridge Mass. (Fogg), Cleveland, Detroit and New York (Met.).
Lit. J. C. Taylor: *W. Page, the American Titian* (1957)

Palizzi Filippo, b. Vasto (Chieti) 1818, d. Naples 1899. Naturalistic painter of landscape and animals, one of the pioneers of REALISM in Italy. He painted directly in colour, suppressing the classical accent on outline, and exploring the effects of light and colour in nature; his unfinished studies from nature are often preferred to his finished studio pictures. He joined his elder brother Giuseppe at the Naples Academy in 1837 under Guerra and Angelini. The SCHOOL OF POSILLIPO, devoted to *plein air* painting, was already active with GIGANTE at its head; it quickly attracted him away from the academy. He devoted his life to painting from nature, remaining in contact with French ideas through his brother Giuseppe in Paris. He was already exhibiting Realist landscapes by 1845. In 1855 he visited Holland, Belgium and France, meeting the Barbizon painters in Paris, and returned via Florence and Rome. In 1878 he became director of the Naples Academy, from which he retired in 1880, disliking its bureaucratic establishment, though he was reappointed in 1891. He was an important influence on younger landscapists, notably DE NITTIS. His brother **Giuseppe** (1812–88) attended the Naples Academy from 1835 and worked with the School of Posillipo. He settled in Paris in 1844 and painted landscapes in the Barbizon idiom under the influence of TROYON, DUPRÉ and T. ROUSSEAU. Two other brothers, Nicola (1820–70) and Francesco Paolo (1825–71) were also artists. Filippo presented most of his oil sketches from nature to the Rome Gallery of Modern Art in 1892. There are also works in Florence (Mod. Art), Milan (Mod. Art, Grassi), Naples (Capodimonte), Trieste (Revoltella), Turin (Mod. Art) and Vasto (Civico).
Lit. P. Ricci: *I fratelli Palizzi* (1960)

Palmer Samuel, b. Walworth (London) 1805, d. Redhill (Surrey) 1881. Painter of pastoral landscapes imbued with mystic and religious vision, the greatest follower of BLAKE. He worked largely in sepia and watercolour. Plagued by misfortune, his unique vision only found a happy and spontaneous outlet in his Shoreham years (*c.* 1827–32) and, in muted form, in his etchings of the 1870s. His father instilled in him a love of poetry, especially of Virgil and Milton, and encouraged his artistic inclination. In 1819 he exhibited landscapes at the British Institution and the ROYAL ACADEMY. In 1822 he met LINNELL, who helped him in his search for an art beyond conventional landscape by introducing him to the work of Dürer, Brueghel and Lucas van Leyden and by presenting him in 1824 to his friend Blake. Palmer's admiration for Blake verged on hero-worship; with his friends he formed the group of Blake disciples calling themselves THE ANCIENTS. In 1827 he moved with his father to Shoreham, where Blake and the Ancients were frequent visitors. This was a period of intense creativity but lasted only until the early 1830s. In 1837 he married John Linnell's daughter Hannah; they spent a two-year honeymoon in Italy and returned to England where he painted conventional landscape watercolours and

F. Palizzi *Landscape at Sunset* 1854

G. Palizzi *Forest of Fontainebleau* 1874

Palmer *The Magic Apple Tree c.* 1830

C. W. Peale *The Artist in his Museum* 1822

Raphaelle Peale *Lemons and Sugar c.* 1822

made a poor living from teaching. He was plagued by the criticisms of his father-in-law and former friend, and shattered by the death of two children. His reputation was only established with the publication of Binyon's *Followers of Blake* in 1925 and a 1926 exhibition of his work at the Victoria and Albert Museum. There are works in Cambridge (Fitzwm), Cambridge Mass. (Fogg), London (V&A, Tate) and Oxford (Ashmolean).

Lit. A. H. Palmer: *S. Palmer, a Memoir* (1882); A. H. Palmer: *Life and Letters of S. Palmer* (1892); G. Grigson: *S. Palmer, the Visionary Years* (1947); R. Melville: *S. Palmer* (1956); G. Grigson: *S. Palmer's Valley of Vision* (1960); D. Cecil: *Visionary and Dreamer* (1969); R. Lister: *S. Palmer and his Etchings* (1969); R. Lister: *S. Palmer, a Biography* (1974); R. Lister (ed.): *The Letters of S. Palmer* (1976)

Paterson James, b. Glasgow 1854, d. Edinburgh 1932. Landscape painter and watercolourist, one of the GLASGOW BOYS. He studied in Paris and his quiet pastoral landscapes were clearly influenced by COROT and DAUBIGNY. There are works in Glasgow, Leipzig and Victoria.

Paton Sir Joseph Noel, b. Dunfermline 1821, d. Edinburgh 1901. Scottish painter of religious, historical and literary subjects, including fairy pictures such as *The Reconciliation of Oberon and Titania* (1847) and *The Fairy Raid* (1867). He painted with careful detail and smooth finish, owing a debt to both the PRE-RAPHAELITES and the NAZARENES. He studied at the ROYAL ACADEMY Schools (1843), where he met MILLAIS, a lifelong friend, but lived and worked in Scotland, from 1870 turning largely to religious painting in a manner close to that of the Nazarenes. An associate of the Royal Academy of Scotland in 1847 and full member in 1850, he was appointed Her Majesty's Limner for Scotland in 1866. He was knighted in 1867. There are works in Edinburgh, Glasgow, Melbourne, Montreal and Sheffield.

Peale Family of Artists. American family of painters of the late 18C and early 19C. They worked mainly in Philadelphia and contributed to its early importance as an artistic centre. **Charles Wilson** (b. Queen Anne's County (Md.) 1741, d. Philadelphia (Pa.) 1827) was the pioneer and founder of the dynasty. He had many trades (schoolteacher, saddler, watchmender) before taking up portrait painting. He had some instruction from COPLEY in Boston (1865) and spent 1867-9 in London, where he studied with WEST. Returning to America he worked as a portraitist and fought in the War of Independence (1775-8). In the following years he became deeply interested in the educational role of museums; he opened a portrait gallery of the heroes of Independence in 1782, and then turned to designing elaborate natural history and science displays (his excavation of two almost complete mastodon skeletons aroused international interest). He painted the earliest portrait of *Washington* (1772) while his famous *Staircase Group* (1795), with two of his sons on a stair that seems to continue out of the picture, was an experiment with *trompe l'œil*. He was a co-founder of the American Academy of Fine Arts, Philadelphia, in 1795, and of the Pennsylvania Academy of Fine Arts in 1805. He had seventeen children, several of whom became artists (Raphaelle, Rembrandt, Rubens, Titian), while his brother James was a miniaturist and still-life painter. **Raphaelle** (b. Annapolis (Md.) 1774, d. Philadelphia (Pa.) 1825) was primarily a still-life painter. He followed the Dutch 17C tradition but painted simple groups of flowers and fruit with an individual solid clarity. He studied with his father, helped to run the Peale museum in Philadelphia and attempted to run a museum in Baltimore with his brother Rembrandt (1797-1800). His only financial success came from profile-cutting (1803-5), while *After the Bath* (1795) is his most famous painting. **Rembrandt** (b. Bucks County (Pa.) 1778, d. Philadelphia (Pa.) 1860) painted portraits, miniatures and the occasional subject picture and landscape. He was a pupil and assistant of his father and studied with WEST in London where he adopted a looser brushwork under the influence of LAWRENCE and STUART. He also visited Paris to paint French statesmen for his father's gallery. His most famous work is the *Porthole Portrait of Washington* (first version 1795), of which he made some eighty replicas. His large moralizing canvas, *The Court of Death* (1820), toured the country

when itinerant exhibitions were in fashion. He was president of the AMERICAN ACADEMY OF FINE ARTS in New York and a founder of the NATIONAL ACADEMY OF DESIGN in 1826. He helped to pioneer lithography in America. There are works by members of the Peale family in many American museums, including Baltimore (Mus. of Art), Boston, New York (Met.), Philadelphia and Washington (NG).
Lit. R. Peale: *Portfolio of an Artist* (1839); C. C. Sellers: *The Artist of the Revolution: The Early Life of C. W. Peale* (1939), *C. W. Peale: Later Life* (1947) and *Portraits and Miniatures by C. W. Peale* (1952)

Pellizza da Volpedo Giuseppe, b. Volpedo (Alessandria) 1868, d. Volpedo 1907. Italian painter who adopted the DIVISIONIST technique (c. 1892), using it to heighten the poetry of his landscapes. He combined idealist and REALIST tendencies, treating the dignity of labour in his famous *Fourth Estate* and in other works pursuing an idealized lyricism (*Flowery Meadow* 1900-2). He studied with the Realist Tallone in Bergamo and at the Florence Academy (1893-5). He was a profound admirer of SEGANTINI and a friend of MORBELLI. He committed suicide on the death of his wife in 1907. There are works in Milan (Grassi, Mod. Art), Naples (Capodimonte), Rome (Mod. Art) and Turin (Mod. Art).
Lit. F. Sapori: *G. Pellizza* (1902); P. L. Occhini: *G. Pellizza* (1909); F. Bellonzi: *Omaggio a Pellizza* (1968)

Peredvizhniki (The Travellers). A group of thirteen artists and one sculptor seceded from the St Petersburg Academy in 1863, the final year of their studies, in revolt against the subject chosen for the gold medal competition (the Russian equivalent of the Rome prize). The academy had selected *The Banquet of the Gods in Valhalla*, to which the artists objected on the grounds that it was neither Russian nor of social significance. This revolt over subject matter, rather than over technique, was led by KRAMSKOI. The group was determined to found a national art which was socially edifying. The Artist's Co-operative Society (Artel Khudozhnikov) was formed; its success in exhibiting led to the formation in 1869 of the Society for Travelling Art Exhibitions, and the group

became known as the Peredvizhniki (Travellers). They were greatly helped by P. M. Tretiakov, who gave his large collection, formed mainly of their works, to the city of Moscow (1892). As a direct result, art reached a wider audience in Russia than ever before, with almost all the important Russian contemporary painters contributing to the exhibitions. The artists were united by their dedication to social reform within Russia rather than by style. All painted portraits; religious painting was best represented by GAY, Kramskoi, Nesterov, Polyenon and VASNETZOV, history painting by REPIN, SURIKOV and VERESCHAGIN, genre by MAKOVSKY and PEROV, landscape by AIVAZOVSKY and Kuindchi.
Lit. A. Novitski: *Peredvizhniki i vliyanie ikh na Russkoe Iskusstvo* (1897, in Russian); L. R. Varshawski: *Peredvizhniki* (1937, in Russian)

Pergentina, School of. A group of Italian painters who worked together at the village of Pergentina in Tuscany (c. 1862). They included SIGNORINI, LEGA, BORRANI, FATTORI, Sernesi, Cabianca, Abbati and Banti. All had belonged to the REALIST MACCHIAIOLI group and were looking for something beyond Realism to inform their art. They took their inspiration from the lyrical naturalism of 15C artists such as Lippi, Benozzo Gozzoli and Carpaccio. Their goal was described by Signorini as 'the sincerity of sentiment and love for the whole of nature with which the art of the Quattrocento childishly caressed every form'. Their subject matter was 'nature, countryside, family, ambience, local character' (Somaré).
Lit. see MACCHIAIOLI

Perov Vassili Grigorevich, b. Tobolsk 1833, d. Kusminsk 1882. Leading genre painter of the PEREDVIZHNIKI group. A REALIST painter, influenced in Paris by both MEISSONIER and COURBET, his paintings reflect his commitment to political and social reform in Russia; they treat scenes of daily life, emphasizing the sufferings of the people. He painted an important series of pictures satirizing the drunkenness and gluttony of the clergy (*Easter Procession* 1860, *Monastic Refectory* 1865-75). He was a careful draughtsman and used a generally muted palette. He was also a distinguished portraitist (*Portrait of the*

Rembrandt Peale *The Court of Death* 1820

Pellizza da Volpedo *Memory of Sorrow*

Perov *The Drowned Woman* 1867

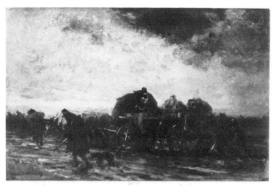

Pettenkofen *Austrian Infantry Crossing a Ford* 1851

Petter *Rabbits and a Fox in a Cornfield*

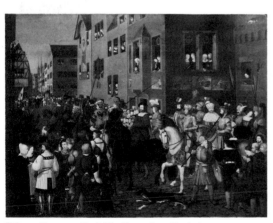

Pforr *Emperor Rudolf's Entry into Basle in 1273*
1808–10

Dramatist A. N. Ostrowski 1871). He studied in the provincial art school at Arsamass and at the Moscow School of Fine Art (1858–60). Having won a travel scholarship, he visited Berlin, Dresden and Paris (1862–4). Most of his major paintings date from the following decade. He was a co-founder of the Peredvizhniki exhibiting society in 1869 and became a professor at the Moscow Art School in 1870. His later work is free from political orientation, more conventional and poetic; he painted a few historical canvases. There are works in Leningrad (Hermitage) and Moscow (Pushkin, Tretiakov).
Lit. N. P. Sobko: *V. G. Perov, his Life and Work* (1892, in Russian)

Pettenkofen August von, b. Vienna 1822, d. Vienna 1889. Painter of landscapes and genre, one of the most distinguished of the country's Barbizon-orientated REALIST painters. He studied at the Vienna Academy (1834–40) under L. Kupelweiser. His early works show the influence of the BIEDERMEIER genre painters C. SCHINDLER and F. Eybl. He painted a series of scenes from army life *c.* 1848, and in 1851 paid his first visit to Szolnok in Hungary, whose colourful peasant and gipsy life he constantly depicted. In Paris (1852) he was influenced by the BARBIZON SCHOOL painters, especially TROYON and DECAMPS, as well as by the work of A. STEVENS and MEISSONIER. Though based in Vienna he paid frequent visits to Italy and Paris, where he made contact with the IMPRESSIONISTS in the 1870s. In 1866 he became a member of the Vienna Academy, in 1872 a member of the Munich Academy. He was knighted ('von') in 1874. There are works in Berlin, Moscow (Tretiakov), Munich and Vienna (Belvedere).
Lit. A. Weixlgärtner: *A. von Pettenkofen* (1916)

Petter Franz Xavier, b. Vienna 1791, d. Vienna 1866. Flower painter, the chief exponent of this art during the BIEDERMEIER period. He attended the Vienna Academy under J. Drechsler and S. Wegmayr. From 1814 he taught flower painting at the academy, becoming a professor (1832) and director (1835) of the industrial drawing section. His son Theodor (1822–72) was a flower painter and portraitist. There are works in Berne and Vienna (Belvedere).

Pforr Franz, b. Frankfurt 1788, d. Albano 1812. Co-founder with OVERBECK of the NAZARENE movement. Like Overbeck, his aim was a renewal of German art in the Christian spirit, following the example of early masters; his interest, however, lay primarily in the northern (as opposed to the Italian) tradition, in Dürer and the early northern printmakers, in mystery and pageantry. As a draughtsman he laid particular emphasis on outline and as a painter on strong local colours. He studied with his father Johann Georg, an animal and landscape painter, and with his uncle J. H. TISCHBEIN in Kassel (1801–5). He attended the Vienna Academy (1805–9), where his friendship with Overbeck led to the formation of the BROTHERHOOD OF ST LUKE in 1809. In 1810 he travelled with his friends to Rome, where they established themselves first in the Villa Malta, then in the deserted monastery of S. Isidoro; three years later he died in Albano, leaving only a small number of completed paintings, notably *Emperor Rudolf's Entry into Basle in 1273* (1808–10). There are works (mainly drawings) in Berlin, Dresden, Frankfurt/M., Munich, Vienna and Weimar.
Lit. F. H. Lehr: *Die Blütezeit Romantischer Bildkunst: F. Pforr der Meister des Lukasbundes* (1924)

Philipsen Theodor Esbern, b. Copenhagen 1840, d. Copenhagen 1920. Danish follower of IMPRESSIONISM. He treated a wide range of subjects but Danish landscapes with cattle and sheep are his most typical works, reflecting the continuing influence of LUNDBYE and the Danish landscape tradition. He gave up farming for painting, studying at the Copenhagen Academy until 1869. He visited Paris (1874–5) and Italy (1877–8), but his full adoption of Impressionist brushwork and colour dates from the time he spent in France, Spain and Italy between 1882 and 1884. He was a founder member (1891) of Den Frie Udstilling (Free Exhibition), an *avant-garde* grouping of REALIST and SYMBOLIST painters, the Danish parallel to the various SECESSION movements. His sight was impaired after 1906 and his painting suffered. There are works in Copenhagen (Ny Carlsberg Glyptotek, State).
Lit. K. Madsen: *Malern T. Philipsen* (1912)

Phillip John, b. Aberdeen 1817, d. London 1867. Scottish genre painter who attended the ROYAL ACADEMY Schools and was a member of THE CLIQUE. He painted Scottish village scenes in the manner of WILKIE until visiting Spain (1851, 1856 and 1860) when he began to specialize in ROMANTIC Spanish genre scenes, earning the nickname 'Spanish Phillip'. He was an ARA in 1857 and an RA in 1859. There are works in Edinburgh, Glasgow, Hamburg, Leicester, Liverpool, London (Tate, V&A), Nottingham, Preston and Sheffield.
Lit. J. Dafforne: *Pictures by John Phillip* (1877)

Picot François Edouard, b. Paris 1786, d. Paris 1868. Painter of history, classical myth and legend, one of the last powerful defenders of NEOCLASSICISM against ROMANTICISM. He studied under Vincent and DAVID, won the second Rome prize in 1812, and first exhibited at the SALON in 1819. Chevalier of the Legion of Honour in 1825 and officer in 1852, he was elected a member of the INSTITUT in 1836. He received extensive fresco commissions for Paris churches, Saint-Sulpice, Saint-Merry, Saint-Clothilde and Notre-Dame-de-Lorette, and collaborated with FLANDRIN on the interior decoration of Saint-Vincent-de-Paul. He also executed ceiling paintings for the Louvre and contributed to the History Gallery at Versailles. He ran an influential teaching atelier which particularly emphasized the importance of the sketch; the enlightened influence of this practice can be traced in the work of his pupils, PILS, NEUVILLE and MOREAU. There are works in Amiens, Auxerre, Brussels, Calais, Dieppe, Paris (Louvre), Sémur and Versailles.

Pieneman Jan Willem, b. Abcoude 1779, d. Amsterdam 1853. Dutch history painter and portraitist who also painted some landscapes. His work was highly regarded in court circles, particularly his vast historical canvases emphasizing Holland's role in the Napoleonic campaigns. In preparation for his most famous work, *Waterloo* (1824), he visited London three times, staying with the Duke of Wellington. He was largely self-taught as a painter; he had been destined for a commercial career but began work in a factory making painted hangings. He was a drawing-master at the School of Artillery and Engineering at Amersfoort (1805–16) and became the first director of the Royal Academy of Fine Arts in Amsterdam (1820). He taught J. ISRAËLS who regarded his talents highly. His son Nicolaas (b. Amersfoort 1809, d. Amsterdam 1860) was a popular court portraitist and also painted history and genre pieces. There are works by Jan Willem in Amsterdam (Rijksmuseum), Brussels, Haarlem (Teyler), The Hague and Stuttgart; and by Nicolaas in Amsterdam (Stedelijk, Rijksmuseum), Dordrecht, The Hague (Communal) and Rotterdam (Boymans).

Piloty Karl Theodor von, b. Munich 1826, d. Ambach 1886. Founder of the mid-century Munich school of history painting, the 'Pilotyschule', and an influential teacher. The Munich school had long concentrated on fresco painting and the preparation of cartoons; Piloty, who was influenced by the BELGIAN COLOURISTS and DELAROCHE, helped bring Munich easel painting back to a high standard of technical competence. His painterly technique owed much to study of Rubens and the Venetians, his carefully researched REALIST reconstructions of times past to Delaroche and the Belgians. As professor at the Munich Academy from 1856 and director from 1874, he had a wide influence. Working with his father on reproductory lithographs of Old Masters gave him an early knowledge of the 17C colourists. He entered the Munich Academy in 1840, studying with SCHNORR VON CAROLSFELD. The exhibition of the *Abdication of Charles V* by GALLAIT and the *Treaty of the Nobles* by BIÈFVE in Munich (1842) opened his eyes to the new Belgian school; he copied Gallait's work in 1848. A visit to Paris and Antwerp (1852) brought him further under the influence of Delaroche and the Belgians. His early works included genre pieces and portraits, but the major success of his *Seni Before the Dead Wallenstein* in 1855 turned him almost exclusively to history painting; he preferred tragic episodes for subject matter (*Galileo in Prison* 1861, *Death of Caesar* 1865). He visited Italy in 1847 and 1858 and was knighted ('von') in 1860. There are works in Berlin, Budapest, Cologne, Düsseldorf, Hanover, Munich (Schack), Stuttgart and Trieste.
Lit. K. Stieler: *Die Pilotyschule* (1881)

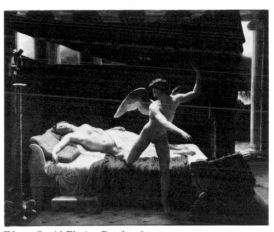

Picot *Cupid Fleeing Psyche* 1817

Piloty *Thusnelda in the Triumphal Procession of Germanicus* 1868–73

Pils *Rouget de l'Isle Singing the Marseillaise at the House of Dietrich, Mayor of Strasbourg* 1849

Pinelli *The Mandoline Player in the Campagna* 1830

Pissarro *Approach to the Village of Voisins* 1872

Pils Isidore Alexandre Auguste, b. Paris 1813, d. Douarnenez 1875. His fame was founded on his military paintings, though he also illustrated religious, historical and mythological themes. As a member of the INSTITUT he was, with GÉRÔME and CABANEL, one of the staunchest enemies of the *avant-garde*. He studied under Lethière and PICOT, winning a Rome prize in 1838. His participation in the Crimean War led him to military painting. Chevalier of the Legion of Honour in 1857 and officer in 1867, he was elected a member of the Institut in 1868. He was also influential as a professor at the ECOLE DES BEAUX-ARTS from 1863. There are works in Ajaccio, Algiers, Amiens, Bordeaux, Brest, Castres, Chantilly, Laval, Le Havre, Le Mans, Lille, London (Wallace), Marseilles, Mulhouse, Paris (Carnavalet, Louvre), Sydney, Toulouse and Versailles.

Pinelli Bartolomeo, b. Rome 1781, d. Rome 1835. Draughtsman, watercolourist and printmaker who applied the NEOCLASSICAL style to the field of popular illustration. His special forte lay in depicting the everyday affairs of the peasants and brigands of the Roman Campagna, conferring on them the dignity of Ancient Romans with his flowing classical outlines. Immensely prolific, he published engravings of peasant costumes, themes from ancient history and contemporary literature. There are examples of his work in most major collections of prints and drawings.
Lit. O. Raggi: *B. Pinelli* (1835); V. Mariani: *B. Pinelli* (1948)

Pinheiro Columbano Bordallo, b. Cacilhas (nr Lisbon) 1857, d. Lisbon 1929. Portrait, genre and landscape painter who gave impetus to a late-19C artistic revival in Portugal. He was essentially a REALIST, though his small genre and still-life paintings owe a debt to the Dutch 17C. After studying with his father and at the Lisbon School of Fine Arts, he went to Paris on a royal grant; his first work exhibited there (1882) was regarded as revolutionary in style and content (*Amateurs' Concert*). On his return to Portugal, he was commissioned to paint many portraits and decorate important public and private buildings, among them the National Theatre, the Palace of Congress, the Palace of Belem and Lisbon Town Hall. He was awarded a gold medal at the Paris EXPOSITION UNIVERSELLE of 1900 and became professor of painting at Lisbon School of Fine Arts. There is a Pinheiro Museum in Lisbon.

Pissarro Camille Jacob, b. St Thomas (W. Indies) 1831, d. Paris 1903. IMPRESSIONIST painter, mainly interested in landscape and rural life, which he painted directly from nature at Louveciennes, Pontoise and Eragny. He also painted some fine portraits and a few still lifes. In his last years, when he was forced by eye trouble to work behind a window, he painted a major series of town views (Paris, Dieppe, Rouen, London). He was educated in Paris but returned to the West Indies to work in his father's store until, determined to become a painter, he escaped to Venezuela in 1852 with the Danish artist F. Melbye. Finally receiving his father's support, he left for Paris in 1855, where his first master was COROT, whose influence is long apparent in his work. In 1857 he met MONET. He exhibited at the SALON in 1859 and in 1863 at the Salon des Refusés, and met MANET in 1866. He fled the Prussian invasion in 1870, spending some time in London, but exhibited in the Impressionist Group Show of 1874 and all subsequent Impressionist exhibitions. He met and befriended CÉZANNE in 1873 and GAUGUIN in 1883, introducing them to the Impressionist circle. Powerfully impressed by SEURAT, whom he met in 1884, he adopted the POINTILLIST technique. The trouble with his eyes forced him to paint indoors from 1895. His work falls into four periods: dark-toned landscapes under the influence of Corot (1855–65); bright outdoor landscapes, influenced by Manet (1865–84); Pointillism, influenced by Seurat (1884–92); freely painted landscape and town scenes, using muted grey tones (1892–1903). He suffered extreme poverty but was always a generous and loyal friend to his fellow Impressionists. His son Lucien was also a painter. There are works in most galleries of modern art.
Lit. A. Tabarant: *Pissarro* (1924); L. R. Pissarro, L. Venturi: *C. Pissarro, son art, son œuvre* (1939); J. Rewald (ed.): *C. Pissarro: Letters to his son Lucien* (1943); J. Leymarie, M. Melot: *Les Gravures des Impressionistes* (1971)

Pitloo *View of Ischia*

Pollard *Highgate Tunnel 1830-5*

Portaels *A Box at the Pesth Theatre* 1869

Pitloo Antonio Sminck van, b. Arnheim 1790, d. Naples 1837. Dutch landscapist, the founding father of the SCHOOL OF POSILLIPO. He combined the tradition of the Dutch 17C with elements of the bright free brushwork of the 18C Venetian view painters. After *c.* 1825 he turned increasingly to studies from nature under the influence of visiting foreigners, notably TURNER, BONINGTON and COROT. He studied in Paris (1808) and Rome (1811) before moving to Naples (1814), where in 1816 he won the competition organized by CAMUCCINI for the professorship of landscape painting at the Naples Academy. There are works in Amsterdam (Rijksmuseum), Nantes, Naples (Capodimonte, San Martino), Solothurn and Vienna.
Lit. A. Consiglio: *A. van Pitloo* (1932); R. Causa: *Pitloo* (1956)

Pointillism (Pointillist) *see* DIVISIONISM

Pollard James, b. London 1792, d. Chelsea (London) 1867. Sporting artist, best known for his coaching scenes. He occasionally exhibited at the ROYAL ACADEMY, but worked largely for dealers or private collectors.
Lit. N. C. Selway: *J. Pollard* (1965)

Pont-Aven, School of. Pont-Aven is a small picturesque town in Brittany where GAUGUIN worked extensively between 1886 and 1890. It was there that he and BERNARD developed CLOISONNISM and SYNTHETISM, which inspired SERUSIER and through him the NABIS in Paris. Young artists of all nationalities visited and found inspiration at Pont-Aven, among them MORET, M. Maufra, Cuno Amiet, ANQUETIN and M. de Haan.
Lit. W. Jaworska: *Gauguin and the Pont-Aven School* (1972)

Portaels Jan Frans, b. Vilvoorde 1818, d. Brussels 1895. Belgian painter of historical and religious subjects and portraits. He painted several murals and was closely involved in the state's attempt in the 1850s to launch a Belgian fresco school, following the German example. Particularly influential as a teacher, he provided a strong technical grounding but left his pupils free to find their own style. He studied at the Brussels Academy under NAVEZ, whose daughter he married, and in Paris under DELAROCHE. After winning the Antwerp Academy Rome prize, he spent 1844-7 in Italy. He also visited the Middle East and painted many Oriental scenes, close in style to those of H. VERNET. He was director of the Ghent Academy (1847-50) and professor at the Brussels Academy (1863-5), and subsequently opened a private studio which attracted many pupils from abroad as well as from Belgium. In 1878 he became director of the Brussels Academy. There are works in Antwerp, Brussels (Musées Royaux), Liège, Prague, Stockholm, Stuttgart and Sydney.
Lit. P. D'Hondt: *J. F. Portaels* (1895)

Posillipo, School of. A school of landscape painters founded by PITLOO; they worked in the countryside round Naples *c.* 1825-45, and inherited the traditions of Hackert and the itinerant view painters of the 18C, earning a livelihood by selling views to visitors. They had constant contacts with visiting foreign artists, notably TURNER, BONINGTON and COROT, and were an important influence on the development of ROMANTIC and REALIST landscape painting in Italy, first with GIGANTE and then with PALIZZI. Vincenzo Altamura carried their influence to the MACCHIAIOLI school of Florence.
Lit. R. Causa: *La Scuola di Posillipo* (1967)

Post-Impressionism (Post-Impressionist). A loose term applied to the work of CÉZANNE, GAUGUIN, VAN GOGH and SEURAT, and in general to the art that developed out of IMPRESSIONISM in the late 19C and early 20C. It applies to the generation of artists who found the Impressionists' pursuit of optical REALISM initially stimulating but inadequate as a central aim for their art. They turned on one hand towards a more formal conception of art (Cézanne, Seurat), on the other towards a subjective interpretation of the artist's emotional reaction to subject matter (van Gogh, MUNCH). The term gained currency in England with Roger Fry's 1910-11 exhibition titled 'Manet and the Post-Impressionists'.
Lit. J. Rewald: *Post-Impressionism: From van Gogh to Gauguin* (1962)

Poynter Sir Edward John, b. Paris 1836, d. London 1919. English painter of both monumental and intimate scenes set in classical antiquity (Greece, Rome and Egypt). He attracted many honours, though he was

overshadowed by LEIGHTON whom he succeeded as president of the ROYAL ACADEMY after the brief interregnum of MILLAIS. Son of the architect Ambrose Poynter, he studied in London from 1854 with J. M. Leigh and W. C. T. Dobson. In 1856–9 he studied with GLEYRE, absorbing the French classical tradition, and lived with the 'Paris gang', du Maurier, Armstrong, Lamont and Whistler. He returned to London in 1860 and exhibited at the Royal Academy from 1861, having his first major success with *Israel in Egypt* (1867). In 1866 he married Agnes Macdonald, sister-in-law of BURNE-JONES. An ARA in 1869 and an RA in 1876, he became Slade professor and later director of art at South Kensington, was director of the National Gallery (1894–1906) and president of the Royal Academy (1896–1918). He received a baronetcy in 1902. In addition to painting, he illustrated books and designed medals, tiles, stained glass and decorations. There are works in Liverpool, London (Tate, V&A), Manchester, Montreal and Sydney.
Lit. A. Margaux: *The Art of E. J. Poynter* (1905); M. Bell: *The Drawings of E. J. Poynter* (1906)

Pradilla y Ortiz Francisco, b. Villanueva de Gállego 1848, d. Madrid 1921. Spanish history, genre, landscape and portrait painter. His large historical canvases packed with tragic drama, which have been compared with those of LAURENS, brought him sensational fame in Spain and considerable acclaim in Paris, Germany and Austria. He studied with Pescador in Madrid and later in Rome. He was director of the Spanish Academy in Rome (1881–3), and became director of the Prado Museum in 1897. He received the Legion of Honour, was a member of the Berlin Academy and a correspondent member of the French INSTITUT. There are works in Wrocław, Cologne, Madrid (S. Fernando Acad.), Philadelphia and Saragossa.

Preller Ernst Christian Johann Friedrich, b. Eisenach 1804, d. Weimar 1878. German landscape and history painter. He continued the tradition of classical landscape late into the 19C, forming a link between the early practitioners (KOCH) and the late German Romans (FEUERBACH, BÖCKLIN). The northern landscapes he painted *c.* 1840 were more relaxed, with an instinctive feel for atmosphere and wild nature; under the influence of Goethe, and later that of Koch and GENELLI, however, his main endeavour was shaped by classical idealism. His two cycles of monumental landscape frescoes illustrating scenes from Homer's *Odyssey* (seven scenes for Dr Härtel's 'Roman House' in Leipzig 1832–4, sixteen scenes for the Weimar Museum 1865–8) were his major achievement, and were followed by the publication of thirty woodcut illustrations of the *Odyssey* in 1872. He studied with H. Meyer in Weimar and then in Dresden, Antwerp and Milan; in Rome (1828–31) he was profoundly influenced by Koch's landscape and Genelli's figure painting. He took over the direction of the Weimar Drawing School in 1832. He visited northern Europe and Scandinavia in 1837, 1839 and 1840 and frequently revisited Italy. There are works in Antwerp, Berlin, Wrocław, Dresden, Düsseldorf, Erfurt, Essen, Halle, Hamburg, Hanover, Karlsruhe, Leipzig, Munich (Schack), Vienna and Weimar.
Lit. M. Jordan: *Peellers Figuren-Fries zur Odyssee* (1875); J. Gensel: *F. Preller* (1904)

Pre-Raphaelite Movement. This was a turning point in English 19C art, and influenced both Continental painting (notably in France and Italy) and the development of the decorative arts (ART NOUVEAU). Several separate phases in the development of the movement must be distinguished: its first flowering in REALIST historical and religious paintings by ROSSETTI, MILLAIS and W.H.HUNT; the extension in the 1850s of their pursuit of 'truth to nature' into both contemporary scenes and landscape of almost surreal detail; the fascination of Rossetti and his disciples, MORRIS and BURNE-JONES, with the Middle Ages which led to a fashion for paintings of Arthurian legend, Dante and medieval themes, borrowing also medieval stylization. It was in this latter form that Pre-Raphaelitism affected Continental painting and the decorative arts. It was by no means a coherent movement. In 1848 the Pre-Raphaelite Brotherhood, a student group, was formed by Millais, W. H. Hunt and Rossetti, together with James Collinson (painter), Thomas Woolner (sculptor), F. G. Stephens (painter and critic) and W. M. Rossetti (art critic and historian). Reacting against the artificiality of academic painting (which they associated with the influence of Raphael) they determined to paint always directly from nature and never at secondhand. This dominant aim of 'truth to nature' was combined with a strong literary bias (particularly in Rossetti), religious fervour (particularly in Hunt) and a shared admiration for what they knew of early Italian painting; engravings of the Campo Santo frescoes in Pisa and Madox BROWN's account of the NAZARENE movement were important. The practice of placing the initials PRB after their signatures was initiated by Rossetti in 1849 with his first exhibited picture, *Girlhood of Mary Virgin*; it was later used by all the group and led to a storm of criticism. However, their work was then championed by Ruskin and quickly gained public acceptance. In the 1850s they turned to contemporary scenes with strong social or moral content (Hunt's *Awakening Conscience*) and to landscape, showing their reverence for nature in the careful delineation of every detail (Millais's *The Blind Girl*). The artistic coherence of the group lasted less than ten years, only Hunt remaining true to the PRB's original aims. Rossetti was the first to abandon the tenets of the Brotherhood, turning to a poetic dream world of the Middle Ages (*The Wedding of St George and Princess Sabra* 1857) which, through its influence on Morris, Burne-Jones and others, became an iconography of international importance, reappearing in the work of SYMBOLIST artists such as BESNARD and SEGANTINI.
Lit. D. S. R. Welland: *The Pre-Raphaelites in Literature and Art* (1953); W. E. Fredeman: *Pre-Raphaelitism: A Bibliocritical Study* (1965); R. Watkinson: *Pre-Raphaelite Art and Design* (1970); J. Nicoll: *The Pre-Raphaelites* (1970); T. Hilton: *The Pre-Raphaelites* (1970); A. Staley: *The Pre-Raphaelite Landscape* (1973)

Previati Gaetano, b. Ferrara 1852, d. Lavagna (Genoa) 1920. Italian SYMBOLIST painter. His style came to full maturity after his introduction to the DIVISIONIST technique by GRUBICY in 1889; using a rich palette dominated by gold, silver, blue and green tones he composed religious and symbolic works with echoes of the English PRE-RAPHAELITES (*Maternity, Sun King, Voyage in the Blue*). He studied in Ferrara, Florence, and from 1877 at the Brera Academy in Milan under Bertini. MORELLI, FARUFFINI

and the SCAPIGLIATURA movement were influences on his early paintings of historic, religious and patriotic themes. He was the author of important treatises on Divisionism (*La tecnica della pittura* 1905, *I principi scientifici del Divisionismo* 1906, *Della pittura tecnica e arte* 1913). There are works in Brussels, Florence, Milan (Grassi, Mod. Art), Novara, Naples (Capodimonte), Rome (Mod. Art) and Turin (Mod. Art).
Lit. V. Pica: *G. Previati* (1912); N. Barbantini: *G. Previati* (1919); V. Constantini: *G. Previati* (1931)

Protais Alexandre, b. Paris 1826, d. Paris 1890. Painter of military scenes and lithographer, popular in the period when MEISSONIER, DETAILLE and NEUVILLE had made this genre fashionable in France. A pupil of Desmoulins, he fought in the Crimean War. His first major success came with the two related paintings, *The Morning before the Attack* and *The Evening after the Battle* (1863). He became a chevalier of the Legion of Honour in 1865 and an officer in 1877. There are works in Bayeux, Chantilly, Grenoble, Limoges, Louviers, Marseilles, Orleans, Paris, Rouen, Toulon, Toulouse and Versailles.

Prud'hon Pierre Paul, b. Cluny 1758, d. Paris 1823. French painter, highly regarded at the court of Napoleon and under the Restoration. His work belongs to the NEO-CLASSICAL school but is softened by a languorous sensuality and a hazy, slightly mysterious chiaroscuro; he was a draughtsman of genius. He began his studies in Dijon and worked for engravers in Paris; in 1784 he won the Rome prize offered by the States of Burgundy. The three years (1785-8) he spent in Italy determined the course of his art; he was deeply impressed by the work of Raphael, Correggio and Leonardo. He became a close friend of the sculptor CANOVA and discovered the languid grace of Alexandrine sculpture. On his return to France, for some years he made a poor living from engravings and portraits, and also became involved in politics. His brilliant career began with the new century and the patronage of Napoleon, including romantic court portraits such as *The Empress Josephine* (1805) and classical allegory (*Justice and Divine Vengeance Pursuing Crime*, *Rape of*

Poynter *Israel in Egypt* 1867

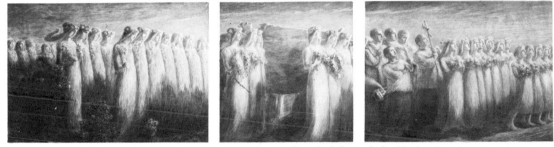

Previati *Funeral of a Virgin* triptych 1914

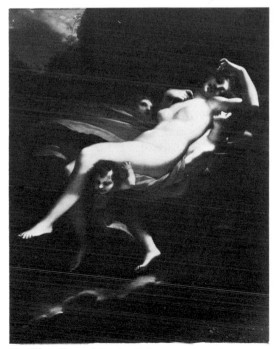

Prud'hon *Rape of Psyche* 1808

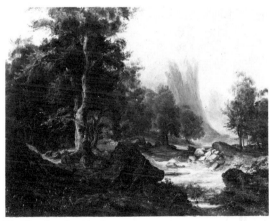

Preller *Landscape* 1827

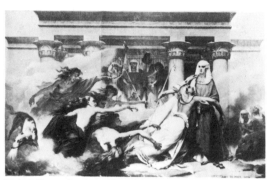

Pujol *Egypt Saved by Joseph* 1827

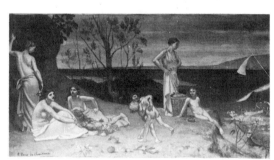

Puvis de Chavannes *Pleasant Land* 1882
(small version)

Psyche, both 1808). His melting effects of light earned him a reputation as 'the French Correggio'. He also designed furniture and decorations for the court, including the whole of Empress Marie Louise's bridal suite. The suicide of his pupil and mistress Constance Mayer in 1821 was a shattering blow that led quickly to his own death. There are works in Paris (Louvre, Carnavalet, Jacquemart-André) and many French provincial museums, and also in Amsterdam (Rijksmuseum), London (Wallace), New York (Met.) and St Louis.
Lit. E. de Goncourt: *Catalogue raisonné de l'œuvre de Prud'hon* (1876); J. Guiffrey: *L'œuvre de P. P. Prud'hon* (1924); E. Bricon: *Prud'hon* (n.d.); G. Grappe: *Prud'hon* (1958)

Pujol Alexandre Denis Abel de, b. Valenciennes 1787, d. Paris 1861. NEOCLASSICAL painter, a favourite pupil of DAVID and much influenced by GROS. He studied in Valenciennes and with David in Paris, winning the first Rome prize in 1811, though he spent only one year in Italy. He exhibited regularly at the SALON from 1808 to 1855, received the Legion of Honour in 1822, and succeeded Gros as a member of the INSTITUT (1835), where he proved a powerful enemy of the ROMANTICS. He executed murals for many public buildings (Louvre, Luxembourg, Versailles, the Bourse, Saint-Sulpice). There are works in Amiens, Auxerre, Cahors, Château-Gontier, Dijon, Douai, La Rochelle, Lille, Saumur, Sens, Troyes, Vervins and Valenciennes.
Lit. G. Rouget: *Notice sur Abel de Pujol* (1861); M. A. Couder: *A. D. A. de Pujol* (1862)

Purismo. An artistic movement in Italy which was inspired by, and closely paralleled, that of the German NAZARENES. Their aim was a renewal of devotional painting, recapturing the simplicity and sincerity of Italian painting in the 15C. While Purismo is linked with a general revival of interest in painting before the time of Raphael, emulation of Raphael himself was encouraged and INGRES, long resident in Rome, was considered a leading Purist. MINARDI, the main exponent of the school in Rome, was closely linked to the Nazarenes, while MUSSINI in Tuscany developed a separate brand of Purismo based on 15C Tuscan painting and the example of Ingres. A manifesto of Purismo was signed in 1849 by Minardi, OVERBECK and Tenerani.

Puvis de Chavannes Pierre, b. Lyons 1824, d. Paris 1898. French painter, much admired by the SYMBOLISTS, who was entrusted with many major mural commissions, and brought new life to this art form in the latter part of the century. He combined classical composition and themes with flat pale colour and simplified forms. His work influenced GAUGUIN and the NABIS, and was enthusiastically admired by Symbolist writers. To Huysmans he was 'a painter of the half-light, his paintings like ancient frescoes eaten away by the light of the moon and drowned in floods of rain'. He studied with SCHEFFER and for brief periods with DELACROIX and COUTURE, but it was in the melancholy dream world of CHASSÉRIAU that he found his true master. He exhibited at the SALON in 1850, but his work was then consistently refused by the jury until 1859. His first success came in 1861 with the large paintings, *Bellum* and *Concordia*, which were purchased by the state for the museum at Amiens. His mural work was painted on canvas and subsequently attached to the wall; important cycles of paintings were commissioned for Amiens, Lyons, the Paris Panthéon (*St Genevieve* 1874-8), the Sorbonne (*Sacred Wood* 1887), and the Boston Public Library (*Inspiring Muses* 1894-8). He became a chevalier of the Legion of Honour in 1867, an officer in 1877 and a commander in 1889. Co-founder with MEISSONIER of the SOCIÉTÉ NATIONALE DES BEAUX-ARTS (1889), he succeeded him as president in 1891. There are works in Amiens, Angers, Baltimore (Walters), Bayonne, Chicago, Dresden, Frankfurt/M., Geneva, Helsinki (Athenaeum), Lille, London (NG), Lyons, Melbourne, Moscow, New York (Met.), Paris (Louvre, Petit Palais) and Rouen.
Lit. L. Worth: *P. de Chavannes* (1926); A. Declairieux: *P. de Chavannes et ses œuvres* (1928); C. Mauclair: *P. de Chavannes* (1928); R. J. Wattenmaker: *P. de Chavannes and the Modern Tradition* (1975)

Q

Quaglio Domenico (the Younger), b. Munich 1787, d. Hohenschwangau 1837. Munich architectural painter. He worked as a scene-painter, like his father, before taking up oil painting in 1819. The influence of the Italian school, especially Canaletto, is evident in his use of contrasting bright light and shade. His figures and overall composition are slightly naïve and rigid. He recorded for Ludwig I the course of the rebuilding of Munich, and in 1823 was a co-founder of the Munich KUNSTVEREIN with P. Hess and F. von Gärtner. In 1832 he was commissioned by Crown Prince Maximilian to rebuild and restore the castle of Hohenschwangau. He was one of the first artists to experiment with lithography. There are works in Berlin, Kassel, Frankfurt/M., Hanover, Leipzig and Munich (N. Pin.).
Lit. B. Trost: *Domenico Quaglio 1787–1837* (1973)

Quidor John, b. Tappau (N.Y.) 1801, d. Jersey City (N.Y.) 1881. One of America's first genre painters. An eccentric with a romantic temperament, he combined caricature with wild, eery drama in themes mainly culled from writers such as W. Irving and J. F. Cooper (*Ichabod Crane Pursued by the Headless Horseman* 1828, *The Money Diggers* 1832). He was apprenticed to the portrait painter J. W. Jarvis. He quarrelled with the NATIONAL ACADEMY OF DESIGN and was unmoved by authors who sought him out as an illustrator, earning his keep by painting decorative panels for fire-engines and commercial signs. He had a considerable reputation among his contemporaries. In later works he experimented with transparent glazes which time has rendered almost opaque. There are works in Boston, Cleveland, Detroit, New York (Brooklyn), Yale (Univ.) and Washington (NG).

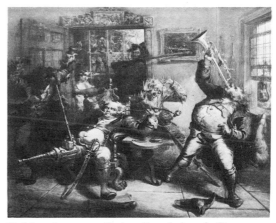

Quidor *Antony van Corlear Brought into the Presence of Peter Stuyvesant* 1839

R

Raeburn Sir Henry, b. Stockbridge (nr Edinburgh) 1756, d. Edinburgh 1823. A portrait painter who worked largely in Scotland, where he achieved a reputation parallel to that of REYNOLDS in England. He was largely self-taught and his early work betrays his lack of formal training (*George Chalmers* 1776). In the 1780s he visited London, where he was much influenced by Reynolds, and paid an extended visit to Italy. By the 1790s he had achieved a broad, assured style (*Sir John Sinclair* 1794-5, *The Macnab* 1803-13). The romantically conceived, somewhat elaborate backgrounds to these works gave way to sternly simplified portraits concentrating on the head of the sitter and using vigorous, square brushstrokes (*Lord Newton* 1806-11). He became an ARA in 1812 and an RA in 1815; he was knighted in 1822 and appointed His Majesty's Limner for Scotland in 1823. Many of his portraits are still owned by the sitters' families but there are works in the London and Edinburgh National Portrait Galleries and several American museums, including Baltimore (Mus. of Art), Boston, New York (Met.) and Washington (NG).
Lit. W. Armstrong: *Sir H. Raeburn* (1901); T. Brotchie: *H. Raeburn* (1924); E. R. Dibdin: *Raeburn* (1925)

Raffaëlli Jean François, b. Paris 1850, d. Paris 1924. Painter of the life and landscape of the Paris suburbs. Though an associate of the IMPRESSIONISTS, he retained (until late in life) the dark-toned palette of the previous generation and a brushwork closer to the BARBIZON SCHOOL. As a friend of DEGAS, he

Raeburn *Lieutenant-Colonel Bryce McMurdo*

Raffaëlli *Guests Waiting for the Wedding*

Raffet *The Retreat from Russia* 1856

Rahl *Persecution of the Christians in the Roman Catacombs* 1844

exhibited at the 1880 and 1881 Impressionist Group Shows, but his presence was a bone of contention. After working as an actor, he spent three months studying under GÉRÔME and first exhibited at the SALON of 1870. *Guests Waiting for the Wedding* won enthusiastic praise from NATURALIST writers. He was also a notable graphic artist. He became a chevalier of the Legion of Honour in 1889 and an officer in 1906. The last decade of the century saw his reputation at its height; it was thoroughly eclipsed by the time of his death. There are works in Paris (Louvre) and many French provincial museums, and also in Boston, Brussels, Buffalo, Cambridge Mass. (Fogg), Chicago, Copenhagen (Ny Carlsberg Glyptotek), New York (Met., Brooklyn), Oslo (NG), Philadelphia, Stockholm and Washington (NG, Corcoran).
Lit. A. Alexandre: *J. F. Raffaëlli* (1909); G. Lecomte: *Raffaëlli* (1927)

Raffet Denis Auguste Marie, b. Paris 1804, d. Genoa 1860. Delineator of the Napoleonic epic, and one of the most gifted and original lithographers of the ROMANTIC movement. He added a REALIST dimension to Napoleonic painting, contrasting the sufferings of the army with its military pomp. In lithography his forte was suggestion; vast armies are implied by galloping waves of shading. He worked with a cabinetmaker and as a decorator of porcelain before entering the studio of CHARLET in 1824. He became a pupil of GROS in 1829, but his early works are mainly Napoleonic scenes conceived in the style of Charlet and VERNET. After failing to win the Rome prize in 1831, he turned almost exclusively to drawing and lithography, illustrating various works on Napoleonic history. In 1837 a trip with Prince Anatole Demidoff through eastern Europe resulted in a masterly series of watercolours and his published *Voyage en Crimée*. He followed the French army's campaigns in Italy and travelled extensively, often with Prince Demidoff. There are works in Bayonne, Cambridge Mass. (Fogg), Chicago, Edinburgh, Haarlem (Teyler), Lille, Montpellier, Munich, New York (Met.), Paris (Louvre), Poitiers, Pontoise, Rouen and Versailles.
Lit. A. Dayot: *Raffet et son œuvre* (1892); A. Curtis: *A. Raffet* (1903); P. Ladoué: *Un Peintre de l'épopée française* (1946)

Rahl Carl, b. Vienna 1812, d. Vienna 1865. History painter and portraitist. He was a keen student of Old Masters, and his dramatic and elaborate compositions combine many disparate influences; his self-declared aim was 'Roman form and Venetian colour'. He was a direct forerunner of MAKART and an influential teacher. After studying at the Vienna Academy, in Munich and in Stuttgart, he lived mainly in Rome (1836–50), finally returning to settle in Vienna. He received fresco commissions for many of the new buildings then under construction in Vienna (Arsenal, Heinrichshof, Palais Todesco) and ran a highly successful private school; CANON, ROMAKO, MUNKÁCSY and GENELLI were among his pupils. He also taught briefly at the Vienna Academy, from 1850–1 and again in 1863. There are works in Berlin, Wrocław, Budapest (Fine Arts), Frankfurt/M., Hamburg, Hanover, Heidelberg, Munich (Schack), Oldenburg and Vienna (Belvedere).
Lit. A. George-Mayer: *Erinnerungen an Rahl* (1882); A. Rössler: *C. Rahl, Briefe mit einem Vorwort* (1922)

Ramberg Arthur Georg, Freiherr von, b. Vienna 1819, d. Munich 1875. Munich genre painter, especially noted as the teacher of LEIBL and many of the Munich REALISTS. His atelier acted as a counter-balance to the powerful history school of PILOTY. An aristocrat and dandy, he studied with his great uncle J. H. Ramberg and with J. Hübner in Dresden. He painted some romantic legends and fairy scenes under the influence of SCHWIND and RICHTER before he went to Munich in 1849, where he took up contemporary genre. He taught at Weimar (1860–6) before becoming a professor at the Munich Academy. There are works in Berlin, Munich, New York (Met.), Weimar and Wiesbaden.

Ramboux Johann Anton, b. Trier 1790, d. Cologne 1866. An associate of the NAZARENES, his fame rests on his delicate watercolour copies of Italian masters of the 14-16C, which were important in spreading Nazarene influence within Germany; a collection of 248 of them was donated to the Düsseldorf Academy by Friedrich Wilhelm IV in 1840. His few original oil paintings and landscape watercolours are of great delicacy, with a Nazarene accent on line reminiscent of SCHNORR VON CAROLSFELD or

FOHR. In Paris (1807–12) he was a pupil of DAVID, whose influence can be traced in his portraits. In 1815 he entered the Munich Academy and from 1816 to 1827 he was in Rome with the Nazarenes. He spent 1827 to 1829 at Trier and was back in Rome from 1832 to 1840. From 1843 he was curator of the Wallraf Collection, Cologne, later the Wallraf-Richartz Museum. There are works in Berlin, Cologne, Darmstadt, Frankfurt/M. and Magdeburg.

Ranzoni Daniele, b. Intra (Novara) 1843, d. Intra 1889. A leading artist of the Milanese SCAPIGLIATURA school, he is also considered as the first of the Italian DIVISIONISTS. He was particularly successful with his female portraits; in these and in his subject pictures quick dabs of bright colour dissolve into romantically suggestive compositions which show the influence of Leonardo and the 18C Venetians (Tiepolo). He studied at the Academia Albertina, Turin, and under Bertini at the Brera in Milan, where he became a close friend of CREMONA. In 1887 he entered an insane asylum. There are works in Milan (Grassi, Mod. Art), Novara and Udine (Marangoni).
Lit. F. Furlani: *Disegni di D. Ranzoni* (1934); F. Tosi: *Disegni di D. Ranzoni* (1934); M. Sarfatti: *D. Ranzoni* (1935) ·

Rayski Louis Ferdinand von, b. Pegau (Saxony) 1806, d. Dresden 1890. Dresden portraitist and occasional history, genre and landscape painter, who combined the direct REALISM of BIEDERMEIER painting with a flowing brushwork which reflects the influence of the French ROMANTICS (especially GÉRICAULT) and the English portrait school. He studied at the Dresden Academy (1823–5) and in Paris (1834–5). His most important work belongs to the 1840–60 period (*Graf Haubold von Einsiedel* 1855, *Graf Zech* 1841), but the distinction of his work only gained full recognition with the 1906 Berlin centenary exhibition. There are works in Berlin, Bremen, Karl-Marx-Stadt, Cologne, Dresden, Elberfeld, Hamburg, Kiel, Leipzig, Magdeburg, Mannheim, Munich (N. Pin.), Nuremberg, Prague, Szczecin, Stuttgart and Weimar.
Lit. O. Grautoff: *F. von Rayski* (1923); M. Goeritz: *F. von Rayski und die Kunst des 19 Jhr.* (1942); M. Walter: *F. von Rayski: sein Leben und sein Werk* (1943); H. Menz:

F. von Rayski (1954); M. Walter: *F. von Rayski* (1968)

Realism (Realist). Realism was bred by the positivist and scientific attitudes of the 19C, gaining ground from 1850 onwards. The term has never been strictly defined and its application tends to vary from author to author. In its narrowest sense it is applied to the French Réalistes of the school generated and publicized by COURBET; he rejected all idealization in art and spurned literary or exotic subject matter, believing that an artist should only paint what he had actually experienced – landscape, still life, portraits and scenes of ordinary life. Courbet's approach had strong political overtones; his large canvases of peasant life (*Funeral at Ornans*, *The Stonebreakers*) reflect his sympathy with the revolutionary currents of 1848. In its wider sense Realism grew up semi-autonomously in Europe and America; artists sought to render the exact appearance of the world about them as accurately as possible, making use of new scientific studies – of natural phenomena (for landscape), of archaeology (for accurate historical reconstruction), of psychology and sociology (for portrait and genre). The landscapes of CONSTABLE in England, F. PALIZZI in Naples, WALDMÜLLER in Vienna and COLE in America, as well as the BARBIZON SCHOOL in France, all aimed at objective representation of what they saw; for Waldmüller and Cole this meant the careful delineation of detail, for the others a rendering of atmosphere through approximative brushstrokes. With genre painting the distinction between quaint storytelling and a Realist 'slice of life' is often debatable, but WILKIE in England, SPITZWEG in Munich, HASENCLEVER in Düsseldorf and MOUNT in America were all Realists to the extent that they aimed at a faithful representation of a familiar social setting. Waldmüller and Spitzweg, along with similar minded contemporaries in Austria, Germany and Scandinavia (KØBKE), are often referred to as BIEDERMEIER Realists.

The achievement of Courbet and the Barbizon School was, however, a watershed for all of Europe and America; the next generation of Realists drew freely on their example (vigorous approximative brushwork, the rejection of selection and composition in landscape, the interest in rendering light

Ranzoni *Countess Arrivabene* 1880

Rayski *Graf Haubold von Einsiedel* 1855

Redon *Orpheus* after 1913

H. A. G. Régnault *General Prim* 1869

and atmosphere, the sympathetic attention to the struggles of poor peasants and workers). This applies notably to the HAGUE SCHOOL, the Munich school (LEIBL, LENBACH, SCHLEICH) and the MACCHIAIOLI in Italy. In France successful academic painters such as BASTIEN-LEPAGE and LHERMITTE bought popularity by imitating the Barbizon School, while the new optical approach of IMPRESSIONISM developed from the same source. The successful SALON painter A. STEVENS had an international impact almost parallel to Courbet when he pioneered the daily life of the elegant middle-class lady as a subject for Realist genre.

Indeed, Realist attitudes were by no means the prerogative of the *avant-garde*; in academic painting the depiction of great historical events gave way to careful historical reconstructions of everyday life in earlier times in the work of such artists as MEISSONIER, MENZEL, LEYS and MORELLI, mainly painted with high finish and attention to detail. Other Academic Realists turned their attention to the objective delineation of the Orient (GÉRÔME) and military life (DETAILLE, DE NEUVILLE). The Realist depiction of contemporary life became increasingly accepted from *c.* 1860 onwards, though it was approached from many different directions: as a means of highlighting social injustice (the PEREDVIZHNIKI in Russia, DE GROUX and MEUNIER in Belgium), in moralizing vein (in the early work of the PRE-RAPHAELITES and many English artists), as a vehicle for entertaining characters and situations (KNAUS in Germany, FRITH in England, INDUNO in Italy, FORTUNY in Spain and Italy), or simply as an objective study of the human situation (EAKINS in America, SICKERT in England, Menzel in Germany, the French Impressionists). These late-century delineators of contemporary life are sometimes referred to as Naturalists, an extension of the term Naturalism in literature associated with Zola, de Maupassant and other writers after 1870, who represented everyday life with an unswerving emphasis on objectivity.
Lit. see Bibliography

Rebell Joseph, b. Vienna 1787, d. Vienna 1828. Austrian landscape painter who spent most of his working life in Italy, where he painted classical landscapes under the influence of KOCH and some more intimate views which look forward to REALISM. He was highly regarded in Italy and Austria. He studied at the Vienna Academy, began his career with architectural drawings and then took up landscape under the influence of Michael Wutky. In 1810 he went to Italy, working for Eugène Beauharnais in Milan and for Murat in Naples (1812-15). In Rome (1815-24) he became an honorary member of the Academy of St Luke (1819) and was 'discovered' by Kaiser Franz I, who invited him to follow FÜGER as director of the Imperial Gallery (1824). He was also a professor at the Vienna Academy. There are works in Berlin, Berne, Chantilly, Hamburg, Innsbruck, Copenhagen (Thorwaldsen), Munich (N. Pin.), Parma, Vienna (Belvedere, Czernin) and Warsaw.
Lit. H. Lischke: *J. Rebell* (PhD Innsbruck 1956)

Redgrave Richard, b. London 1804, d. London 1888. English painter. He began with costume genre set in the 18C, then in the 1840s helped to pioneer contemporary genre painting with overtones of social comment. He took to landscape painting in his later years, under the influence of the PRE-RAPHAELITES. He was also an influential teacher, administrator and author (*A Century of Painting*, written with his brother Samuel, 1866). He became an ARA in 1840 and an RA in 1851. There are works in Blackburn, Hamburg and London (V&A, NPG).

Redon Odilon, b. Bordeaux 1840, d. Paris 1916. SYMBOLIST painter and graphic artist. Until *c.* 1890 he worked exclusively in black and white (charcoal drawings, etchings, lithographs), creating nightmare images of phantom creatures and landscapes, the products of a highly wrought imagination fascinated by magic and mystery. His fame was grounded on his lithographs (*The Dream* 1879, *The Apocalypse of St John* 1883, *Night* 1886). The paintings and pastels to which he turned increasingly after 1890 use a rich IMPRESSIONIST palette and include many flower pieces, as well as figure subjects with a more gentle atmosphere of dream and magic (*With Closed Eyes* 1890, *Cyclops* 1895-1900, *Birth of Venus* 1912, *Violette Heymann* 1909-10). He studied with GÉRÔME but was more influenced by the engraver BRESDIN with whom he worked *c.* 1863-5. His first highly personal works are the charcoal

drawings of the 1870s. He was a friend of Mallarmé and much admired by the Symbolist writers. In 1884 he was asked to preside over the Société des Indépendants; he exhibited at the last Impressionist Group Show in 1886. There are works in Paris (Louvre, Petit Palais), most major American museums and many European museums of modern art.

Lit. O. Redon: *Autobiographie* (1909) and *A soi-même, journal 1867–1915* (1922); K. Berger: *O. Redon, Fantasy and Colour* (1965); J. Selz: *O. Redon* (1971); J. Cassou: *O. Redon* (1972)

Régnault Henri Alexandre Georges, b. Paris 1843, d. Buzenval 1871. Considered by his contemporaries the heir of DELACROIX, this short-lived artist entranced the public with the *bravura* of his colour; his reputation was enhanced by his heroic death in battle. His father was director of the Sèvres porcelain factory and he entered the ECOLE DES BEAUX-ARTS in 1860, studying with Lamothe and CABANEL. He won the first Rome prize in 1866, but after two years in Rome moved to Madrid, falling under the spell of GOYA and Velasquez; his equestrian portrait of *General Prim*, reminiscent of GÉRICAULT, won him paeans of praise in 1869. Moving to Morocco, he found full satisfaction for his passion for colour (*Salome, The Moorish Herdsman*). He returned to France to fight in the Franco–Prussian War and died in the battle of Buzenval. His memory was honoured by a retrospective exhibition of his work at the EXPOSITION UNIVERSELLE in 1878. There are works in Algiers, Boston, Calais, Cambridge Mass. (Fogg), Chicago, Marseilles, Mulhouse, New York (Met.), Paris (Louvre, Carnavalet), Philadelphia and Washington (Corcoran).

Lit. A. Duparc: *Correspondance de H. Régnault, annotée et receuillie, suivi du catalogue complet de l'œuvre* (1872); M. Brey Mariño: *Viaje a España del pintor H. Régnault* (1949)

Regnault Baron Jean-Baptiste, b. Paris 1754, d. Paris 1829. NEOCLASSICAL painter of myth, allegory, history and portrait. His work combines the influence of the 17C Bolognese school with a conventional imitation of antique sculpture. In the early years of the 19C he was the chief rival of DAVID as a teacher and executed a series of vast Napoleonic allegories (*Triumphal March of Napoleon I to the Temple of Immortality*). At the age of fourteen he visited Rome with his teacher Bardin and met the Neoclassical painters round Mengs. He returned to Paris in 1773, worked under Vien and won the first Rome prize in 1776. He was made an associate of the Académie in 1782 and a full academician in 1783; he was named a member of the INSTITUT in 1795 and taught at the ECOLE DES BEAUX-ARTS. There are works in Paris (Louvre), Versailles and many French provincial museums, and also in Chicago, Düsseldorf, Hamburg, Leningrad (Hermitage) and Moscow.

Reinhart Johann Christian, b. Hof (Saale) 1761, d. Rome 1847. Landscapist, second in importance only to KOCH among the German-Roman group of classical landscape painters. He studied with Oeser in Leipzig and Klengel in Dresden; the landscapes of his German period are freshly and realistically painted with a debt to the Dutch school. From 1789 he was in Rome; profoundly influenced by Koch and Carstens, he adapted his landscape style to carefully structured heroic or idyllic views. He is credited with coining the sarcastic nickname NAZARENES for the BROTHERHOOD OF ST LUKE. There are works in Berlin, Cologne, Copenhagen (Thorwaldsen), Essen, Gotha, Leipzig, Montpellier, Munich (N. Pin.), Nuremberg, Riga, Szczecin and Stuttgart.

Lit. O. Baisch: *J. C. Reinhart und seine Kreise* (1882)

Renoir Pierre Auguste, b. Limoges 1841, d. Cagnes 1919. One of the greatest of the French IMPRESSIONISTS; he worked closely with MONET in the late 1860s and 1870s, developing with him the new optical approach to light and atmosphere which is displayed in such works as *Monet in his Garden* (1873), *La Loge* (1874) and *Paris Boulevards* (1875). However, he sought more in his art than the purely visual aspects of Impressionism; he studied Old Masters, admired INGRES, aimed at a classical structure in his composition and developed a very personal palette dominated by warm reds, pinks and yellows. As a student he had admired the sensuous figure painting of Boucher and Fragonard, as well as COURBET's later nudes; female nudes (often bathing scenes) are a recurrent feature of his work, especially in the later years. He worked

J. B. Regnault *The Three Graces c.* 1799

Renoir *La Loge (The Box)* 1874

Repin *They did not Expect Him* 1883

Rethel *Another Dance of Death* 1848-9, plate 2

as a porcelain painter before entering the studio of GLEYRE (1861), where he met Monet, BAZILLE and SISLEY. In the following years he spent much time in the Louvre, and painted landscapes in Barbizon; his figure painting was influenced by Courbet. In the late 1860s he worked closely with Monet in Paris and Bougival (*La Grenouillère* 1869), his colour becoming lighter and in a higher key. After the Franco-Prussian War they again worked frequently together, particularly at Argenteuil, developing the full range of the Impressionist approach. He exhibited at the first four Impressionist Group Shows but from 1877 his portraits were being accepted by the SALON (*Mme Charpentier and her Daughters* 1878) and he was unwilling to risk his reputation by exhibiting with his friends. In 1881-2 he visited Algeria, Guernsey and Italy (influence of Raphael) and worked with CÉZANNE at L'Estaque. He later travelled widely and began to modify his style; the early 1880s were marked by a classical emphasis on line as opposed to brushwork (*The Umbrellas* 1884). By the early 1890s the characteristics of his late style were beginning to appear, the warm tonality, a concentration on nudes (*Bather with a Hat* 1904, *Judgment of Paris* 1914) and a loose approximative brushwork. He settled at Cagnes-sur-Mer in 1905 suffering from arthritis; the brush had finally to be tied to his gnarled hands. In his last years he turned to sculptures which were modelled in clay by assistants under his direction. He painted more than six thousand pictures and there are examples in all the world's major museums, notably Paris (Musée de l'Impressionisme). *(see colour illustration 25)*
Lit. O. Mirbeau: *Renoir* (1913); A. Vollard: *Renoir* (1918); G. Rivière: *Renoir et ses amis* (1921); A. Vollard: *Tableaux, pastels et dessins de P. A. Renoir* (1921); J. Renoir: *Renoir, My Father* (1962); J. Leymarie, M. Melot: *Les Gravures des Impressionistes – œuvres complet* (1971); F. Daulte: *A. Renoir – catalogue raisonné de l'œuvre peint* (Vol. I 1971); L. Hanson: *Renoir, the Man, the Painter and his World* (1972); F. Daulte: *A. Renoir* (1972); J. G. Stella: *The Graphic Work of Renoir. Catalogue Raisonné* (1975)

Repin (Riepin, Rjepin) Ilya Efimovich, b. Tschuguev 1844, d. Kuokkala (Finland) 1930. REALIST painter of history and genre whose work is characterized by its rich colour, vigorous brushwork and reformist concern with the social problems of Russia. He is one of the most distinguished of the PEREDVIZHNIKI group. He studied at the St Petersburg Academy from 1864, winning a travel scholarship in 1871 which took him to Vienna, Rome and Paris. His reputation was founded with *Volga Boatmen* (1873), depicting a team of men harnessed like packhorses to draw a barge. He painted some powerful portraits of the great figures of his day and colourful scenes of Cossack life (*Cossacks' Jeering Reply to the Sultan* 1891), and also successful historical canvases (*Ivan the Terrible with the Dead Body of his Son* 1881-3). *They did not Expect Him* (1883), depicting the return of a political prisoner to his family, had great success. The influence of IMPRESSIONIST colour and brushwork is apparent in his work after a second visit to Paris in 1883. Elected a member of the St Petersburg Academy in 1876, he taught history painting there from 1893 to 1907, becoming its director in 1898. From 1917 he lived in Finland. SEROV and VRUBEL were among his pupils, while his powerful use of colour was an influence on 20C Russian art. There are works in Cincinnati, Helsinki (Athenaeum), Leningrad (Russian Mus.), Moscow (Pushkin, Tretiakov), New York (Met.), Rome and Stockholm.
Lit. I. Grabar: *Repin* (1937, in Russian); V. N. Moskvinov: *Repin* (1954, in Russian)

Resína, School of. Italian REALIST school centred on DE NITTIS. Expelled from the Naples Academy in 1863, de Nittis settled in Portici il Cecioni (Resína) until 1867, devoting himself to painting landscapes and everyday life directly from nature. He was joined by DE GREGORIO, F. Rossano and the sculptor, painter and critic A. Cecioni.

Rethel Alfred, b. Diepenbend (nr Aachen) 1816, d. Düsseldorf 1859. German ROMANTIC painter and graphic artist whose macabre vision continued the tradition of Dürer and Holbein. Primarily a draughtsman, he developed a symbolic style of history painting, dominated by his obsession with death. He left few paintings, his career being cut short by madness. He studied with J. B. J. Bastiné in Aachen and then at the Düsseldorf Academy under SCHADOW (1829-36),

where he was a friend of A. ACHENBACH. He completed his studies in Frankfurt with VEIT, settling there from 1836 to 1847. He visited Italy in 1844-5 and 1852-3. He had his first success during his Düsseldorf years with *Bonifazius* (1832-6), but his mature style developed in Frankfurt. His most famous paintings are the Aachen town hall frescoes from the life of Charlemagne; he began them in 1847, but completed only four, the rest being executed by J. Kehren from his cartoons. His famous series of woodcuts, *Another Dance of Death* (1849), the pessimism of which was criticized by the Düsseldorf socialists, shows Death as the embodiment of anarchy. There are works in Aachen, Berlin, Dresden, Düsseldorf, Frankfurt/M., Hamburg, Leipzig and Stuttgart.
Lit. W. Franke: *A. Rethels Zeichnungen* (1921); J. Ponten: *Studien über A. Rethel* (1922); K. Zoege von Manteuffel: *A. Rethel, Radierungen und Holzschnitten* (1926); K. Koetschau: *Rethels Kunst vor dem Hintergrund der Historienmalerei seiner Zeit* (1929)

Ribot Théodule Augustin, b. S. Nicolas d'Attez (Eure) 1823, d. Colombes 1891. REALIST painter who depicted the daily life of the humblest class of Parisian with whom he mixed. Simple kitchen interiors are his most characteristic works, though he also painted some religious subjects (*St Sebastian* 1865, *Christ among the Doctors* 1866), portraits and still lifes. He was much influenced by the Spanish school, especially Ribera, while his contemporaries compared his still-life painting to Chardin. His paintings, mostly of small dimensions, are dark in tone, usually with a single source of light. He pursued many humble trades before taking to painting at the age of forty. He studied with Glaize and first exhibited at the SALON in 1861 with four kitchen interiors. In the mid-1860s he turned to religious subjects, employing the same simple Realism, and in later years concentrated on single figure studies of old people. Chevalier of the Legion of Honour in 1878, he became an officer in 1887. He was one of the founder members of the SOCIÉTÉ NATIONALE DES BEAUX-ARTS in 1889. There are works in Paris (Louvre, Petit Palais) and many French provincial museums, and also in Amsterdam (Rijksmuseum), Baltimore (Walters), Boston, Bucharest,

Chicago, Cleveland, Geneva, Philadelphia, Stockholm, Vienna (Kunsthistorisches Mus.) and Washington (NG, Corcoran).
Lit. L. de Fourcaud: *T. Ribot* (1885)

Richter Adrian Ludwig, b. Dresden 1803, d. Loschwitz (nr Dresden) 1884. Late ROMANTIC painter and illustrator. His landscapes (often peopled with children at play or young lovers) have an appealing naïvety; flowering meadows and woodlands are painted with careful detail and a hard smooth finish. His lasting fame rests on his graphic work; his illustrations to folk-tales and children's books have delighted generations of German children (*German Fairy Tales* 1842, *The Spinning Room* 1860). He was the son and pupil of Carl August, engraver and professor at the Dresden Academy, with whom he published a hundred etched plates, *Mahlerische An- und Aussichten* (1820). The publisher Christoph Arnold financed his three-year visit to Rome (1823-6), where he painted classical landscapes in the manner of KOCH. He spent 1828-35 teaching drawing at the Meissen porcelain factory, and from 1835 to 1876 was a professor at the Dresden Academy. He turned to the delineation of German landscape and with the Leipzig publisher Georg Wiegand embarked on a prolific career as an illustrator. He made over two thousand illustrations and changed the course of German wood engraving. His work is closely related to that of SCHWIND, his contemporary and friend. There are works in Bremen, Dresden, Düsseldorf, Essen, Frankfurt/M., Hamburg, Hanover, Mannheim, Munich (N. Pin.) and Vienna. *(see colour illustration 8)*
Lit. L. Richter: *Lebenserinnerungen eines deutschen Malers* (autobiography 1885, new ed. 1950); K. J. Friedrich: *L. Richter und sein Schülerkreis* (1956); A. W. Stubbe: *Das L. Richter Album: Sämtliche Holzschnitte* (1968); H. J. Neidhart: *L. Richter* (1969)

Riedel Johann Friedrich Ludwig Heinrich August, b. Bayreuth 1799, d. Rome 1883. German follower of ROBERT. His idealized paintings of Italian peasant life achieved immense popularity in Germany *c.* 1830-60 but he outlived his fame. He was considered a notable colourist, an unusual achievement for a German in the era of NAZARENE ascendancy: 'You have fully attained what I have avoided with the greatest effort during

Ribot *The Seamstress*

Richter *Genoveva* 1839-41

Rimmer *Flight and Pursuit* 1872

Rippl-Rónai *When One Lives on Memories* 1904

Robert *Arrival of the Harvesters in the Pontine Marshes* 1831

Robert-Fleury *Galileo Before the Holy Office* 1847

the course of my whole life,' said CORNELIUS. He studied at the Munich Academy (1820-8) with LANGER. From 1832 he lived in Rome, with occasional visits to Germany. He became a professor as well as a member of the Rome Academy of St Luke, and a member of the Berlin, Munich, Vienna and St Petersburg Academies. There are works in Augsburg, Bayreuth, Berlin, Braunschweig, Copenhagen (Thorwaldsen), Frankfurt/M., Hanover, Munich, Stuttgart and Würzburg.

Rimmer William, b. Liverpool 1816, d. South Milford (Mass.) 1879. American painter of fanciful historical scenes. *Flight and Pursuit* (1872) is perhaps the most successful imaginative painting executed in America in the mid-19C. His family moved to America when he was two years old; his father believed himself the Dauphin of France and brought up his son in a world of romantic fantasy combined with intense poverty. He worked as a typesetter, soap-maker and cobbler, dissected corpses and taught himself medicine. Applying his anatomical knowledge to sculpture, he achieved recognition and earned a living by teaching 'art anatomy' to young Boston ladies. He painted for his own pleasure, allowing his imagination free rein – winged naked figures dropping from the sky, gladiators, knights in the lists. His paintings, virtually unknown in his lifetime, were only appreciated after his death. There are works in Boston, Cambridge Mass. (Fogg), Detroit and Washington (NG, Corcoran).
Lit. W. Rimmer: *Art Anatomy* (1877); T. H. Bartlett: *The Art Life of W. Rimmer* (1882)

Rippl-Rónai Jozsef, b. Kaposvar 1861, d. Kaposvar 1927. Hungarian painter who lived in Paris from 1884 to 1902, was a friend of Maillol, DENIS, BONNARD and VUILLARD, and a distinguished member of the NABIS group. In this early period he worked in flat planes and contours, generally concentrating on tones of black and grey; in his later work he turned to a richly coloured mosaic effect. He studied in Munich and then in Paris, where he worked in the studio of MUNKÁCSY and supported himself by copying his paintings. He lived in Neuilly from 1892 to 1902, when he returned to Hungary. Like his contemporaries in Paris he designed posters and

became involved in the decorative arts as well as painting genre scenes (*When One Lives on Memories* 1904) and portraits. His work was an important influence on the Hungarian school. There are works in most Hungarian museums.
Lit. I. Genthon: *Rippl-Rónai, the Hungarian 'Nabi'* (1958)

Riviere Briton, b. London 1840, d. London 1920. Animal, genre and history painter. Like LANDSEER, he tended to imbue his animals with para-human character; they appear even in his genre and history pieces, lions, dogs, birds and domestic pets being among those most frequently depicted. His pictures achieved a wide popularity through engravings. He studied with J. Pettie and ORCHARDSON, learning from them to use the textured brushwork of the Scottish school. He was made an ARA in 1878 and an RA in 1880. *Beyond Man's Footsteps* was bought by the CHANTREY BEQUEST in 1894. There are works in Birmingham, Hamburg, Liverpool, London (Tate, V&A), Manchester, Melbourne, Nottingham, Oxford and Sydney.
Lit. W. Armstrong: *B. Riviere, his Life and Work* (1891)

Robert Louis Léopold, b. Les Eplatures (Neuchâtel) 1794, d. Venice 1835. Swiss NEOCLASSICAL painter who acquired an international reputation with his scenes of Italian peasant life, brigands and fishermen. His figures are idealized in the classical manner and his pictures carefully composed with clear outlines; his sensitive observation of Nature (its 'nobility and beauty') was considered by his contemporaries to place his work in a more serious category of art than that of the conventional genre or 'costume' painter. He had many followers, especially among French and German artists. He studied engraving in Paris with his compatriot GIRARDET, but also worked with DAVID and briefly, after David's departure, with GROS. He first visited Rome in 1818 and was to remain in Italy for the rest of his life. In Rome he turned seriously to oil painting and *c.* 1822 painted his first Italian genre scenes, which he sent to the Paris SALON. His first major success came in 1827 with the *Return from the Pilgrimage to the Madonna of Arco*, and this was followed by the *Arrival of the*

Harvesters in the Pontine Marshes (1831). He was made an honorary member of the Berlin Academy in 1825 and received the Legion of Honour in 1831. He committed suicide in 1835 at the height of his success. There are works in Avignon, Basle (Kunstmuseum), Berne, Besançon, Chantilly, Copenhagen (Thorwaldsen), Dresden, Genoa, Geneva (Ariana, Rath), Leipzig, Lille, London (Wallace), Montpellier, Munich (N. Pin.), Nantes, Neuchâtel, Paris (Louvre), Poznań and Rome (Napoleon).
Lit. L. Florentin: *L. Robert* (1934); D. Berthoud: *La vie du peintre L. Robert* (1935)

Robert-Fleury Joseph Nicolas, b. Cologne 1797, d. Paris 1890. One of the leading French history painters of the mid-century. He selected events from history which had a clear message for his own time, frequently returning to the issue of religious tolerance (*Colloquy of Poissy* 1840). Like other REALIST history painters, he carried out careful research to ensure the historical accuracy of his reconstructions. He studied under VERNET, GIRODET and GROS and first exhibited at the SALON in 1824. Chevalier of the Legion of Honour in 1846, he became an officer in 1849 and a commander in 1867. A professor at the ECOLE DES BEAUX-ARTS from 1855, he was appointed its director in 1863. He became a member of the INSTITUT in 1850 and director of the French Academy in Rome in 1865. His son Tony (1837–1912) was a history and genre painter who also achieved the rank of commander of the Legion of Honour and was an influential teacher at the ACADÉMIE JULIAN. There are works in Amsterdam (Stedelijk), Antwerp, Bayeux, Bayonne (Bonnat), Bucharest, Chantilly, Compiègne, Dunkirk, Florence (Uffizi), London (Wallace), Lyons, Montpellier, Nantes, Neufchâtel, New York (Met.), Paris (Louvre), Périgueux, Rome, Toulouse and Versailles.
Lit. E. Montrosier: *Peintres modernes: Ingres, Flandrin, Robert-Fleury* (1882); H. Jouin: *Robert-Fleury* (1890); M. Français: *Notice sur M. Robert-Fleury* (1891)

Roberts David, b. Stockbridge (Edinburgh) 1796, d. London 1864. Painter and water-colourist who began life as a scene-painter but achieved a high reputation as a topo-graphical landscapist with particular skill in rendering architectural features. He travelled widely, spending much time in Spain, Italy and the Middle East. An ARA in 1838, he became an RA in 1841. There are works in Amiens, Cardiff, Dublin, Edinburgh, Glasgow, Leicester, Liverpool, London (Tate, V&A, Wallace), Manchester, Preston, Sheffield and Sydney.
Lit. J. Ballantine: *The Life of D. Roberts, R.A.* (1866); J. Quigley: *Prout and Roberts* (1926)

Rochegrosse Georges Antoine, b. Versailles 1859, d. Paris 1938. History painter, one of the most fashionable SALON artists during the last two decades of the 19C. He was a keen archaeologist and his paintings were mainly reconstructions of life in the ancient world; he contributed several vast paintings of carnage to the Salon (*Andromaque* 1883) and also scenes from the daily life of women in classical times (*Les Courtisanes* 1908). His pictures are rich in colour, broadly and sensuously painted. He paid extended visits to Egypt and North Africa and settled at the end of his life in Algeria, painting Eastern beauties seductively posed in rich settings. He studied under Dehodencq, BOULANGER and LEFEBVRE. He became a chevalier of the Legion of Honour in 1892 and an officer in 1910. His work was much admired by Conan Doyle, and Sherlock Holmes was made to express the same sentiments. There are works in Algiers, Amiens, Grenoble, Leipzig, Lille, Montpellier, Moulins, Mulhouse, Paris (Mus. V. Hugo, Petit Palais) and Rouen.

Rochussen Charles, b. Kralingen 1814, d. Rotterdam 1894. Illustrator, genre and landscape painter. He was Holland's most distinguished 19C book illustrator and painted scenes from contemporary life, usually on a small scale, with a freedom, humour and panache that prefigure the NATURALIST painters of the following generation. He was a pupil of NUYEN and A. Waldorp in The Hague before moving to Amsterdam (1849–69) and then to Rotterdam. His early work concentrated on landscape and scenes from Dutch history, from which developed his illustrative career and, in turn, his interest in contemporary genre. There are works in Amsterdam (Rijksmuseum, Stedelijk), Dordrecht (Modern, Mesdag) and Rotterdam.
Lit. Franken, Obreen: *L'Oeuvre de C. Rochussen, essai d'un catalogue raisonné de ses tableaux* (1894)

Rodakowski Henryk Hipolit, b. Lvov 1823, d. Cracow 1894. Portrait and history painter who achieved a high reputation both in France, where he lived for many years, and in Poland. In his portraits he aimed at a monumental simplicity and a faithful reflection of the character of the sitter; he used a dark-toned palette and broad brushwork. His history paintings are dramatically composed, showing an affinity with his compatriot MATEJKO, though individual figures are painted with the same REALISM as his portraits. He studied in Vienna from 1843 with DANNHAUSER, Eybl and AMERLING. He lived in Paris from 1848 to 1867 and studied with COGNIET (1848–50). His reputation was established with his portrait of *General Dembinski* (1852) and he subsequently exhibited a series of portraits, that of his *Mother* (1853) winning the praise of both DELACROIX and Gautier. Determined to establish himself also as a history painter he exhibited *Papal and Imperial Ambassadors Imploring John III Sobieski to Come to the Aid of Vienna* in 1861, winning the Legion of Honour; his famous *Confirmation of the Nobles' Privileges* followed in 1872. From 1867 he divided his life between Poland, France and Italy and was named director of the Cracow Art School the year before his death. There are works in Wrocław, Bytom, Cracow, Łódź, Lvov, Paris (Louvre), Poznań, Versailles and Warsaw (Nat. Mus.).
Lit. W. Kozicki: *H. Rodakowski* (1937, in Polish); A. Ryszkiewicz: *H. Rodakowski* (1958, in Polish)

Rodin Auguste, b. Paris 1840, d. Meudon 1917. Sculptor whose battle for recognition paralleled that of the IMPRESSIONISTS. His method of treating a fragment as a finished work (a head, a trunk, a pair of hands) was revolutionary; he also imitated Michelangelo in leaving parts of the marble block uncarved to increase the expressive power of the image (*The Kiss* 1886). With his first SALON exhibit, *Bronze Age* (1877), he was accused of having cast the figure from a live model. He worked on a bronze door for the Ecole des Arts Décoratifs from 1880 until his death; the theme was *The Gate of Hell* and many of its features are repeated in independent statues

and groups in bronze and marble. Other famous sculptures include *The Burghers of Calais* (1884-6), *Victor Hugo* (1893) and *Balzac* (1897). He left his estate to the French nation; there is a Rodin Museum in Paris, at Meudon and in Philadelphia; his work is represented in most museums of modern art. *Lit.* J. Cladel: *Rodin* (1937); A. Elsen: *Rodin* (1963); B. Champignuelle: *Rodin* (1967); R. Descharnes, J. F. Chabrun: *A. Rodin* (1967)

Roed Jørgen Pedersen, b. Ringsted 1808, d. Copenhagen 1888. BIEDERMEIER genre, landscape and architectural painter. He studied at the Copenhagen Academy with H. Hansen and ECKERSBERG. He was in Italy from 1837 to 1842 and again in 1861-2. He painted at Frederiksborg with KØBKE and in Italy with HANSEN, a close friend. His early works are now the most highly regarded. He was a member of the Copenhagen Academy from 1844, and taught there from 1862 to 1887. There are works in Aarhus, Copenhagen (State, Hirschsprung, Ny Carlsberg Glyptotek, Thorwaldsen), Frederiksborg, Nivaagaard and Stockholm.

Rohden Johann Martin von, b. Kassel 1778, d. Rome 1868. German landscapist who lived in Rome from 1795 and painted wide vistas of Italian countryside, often including peasants, with the most extreme attention to detail under a bright hard light. He was in Kassel in 1802, 1812 and again in 1827-31. His early landscapes were influenced by KOCH, but he rejected Koch's classicism in favour of a personal type of REALISM which he interpreted as careful attention to detail. From 1831 he received an annual stipend from Kurfürst Wilhelm II of Hessen in return for one painting every two years. He was converted to Catholicism in 1815 when he married an Italian girl; his fellow artists nicknamed him St Munchausen and many anecdotes grew up round his eccentric personality. Long forgotten, his work was rediscovered at the Berlin Centennial Exhibition of 1906. There are works in Berlin, Hanover, Hamburg, Kassel and Vienna (Kunsthistorisches Mus.). *Lit.* R. I. Pinnau: *J. M. von Rohden, 1778-1868: Leben und Werk* (1965)

Roll Alfred Philippe, b. Paris 1846, d. Paris 1919. Painter of peasant life and the struggles of the working classes, sometimes in crowded busy scenes, sometimes quiet studies. He owed a strong stylistic debt to COURBET and MANET but enjoyed a highly successful career. He studied under GÉRÔME, BONNAT and HARPIGNIES, first exhibiting at the SALON in 1870. He became a chevalier of the Legion of Honour in 1883, an officer in 1889, a commander in 1900, and a grand officer in 1913. He was one of the co-founders of the SOCIÉTÉ NATIONALE DES BEAUX-ARTS, and became its president in 1905. There are works in Avignon, Béziers, Bordeaux, Buenos Aires, Cognac, Dieppe, Dijon, Geneva, Le Havre, Lille, Paris (Louvre, Mus. de la Ville, Jacq.-André), Pau, Rouen, Saverne, Valenciennes and Versailles. *Lit.* L. de Fourcaud: *L'Oeuvre de A. P. Roll* (1896); Roger-Milès: *A. Roll* (1904); F. Hérold: *A. Roll* (1924)

Romako Anton, b. Atzgersdorf 1832, d. Vienna 1889. Austrian painter of landscape, genre, history and portraits; he was sensitive to every influence and painted in many different styles. His best work combines IMPRESSIONIST brushwork with psychologically sensitive anecdote. Completely outshone by MAKART in his own day, he is now considered 'the foremost Austrian painter of the second half of the century' (Novotny). He studied from 1847 at the Vienna Academy under WALDMÜLLER and RAHL, leaving the academy with the latter in 1851 and attending his private school. He also studied history painting with KAULBACH in Munich and watercolour with K. Werner in Venice. He spent the years 1859-74 in Rome; his landscapes and genre scenes from Roman life were much admired and his house became the centre of the German artistic colony. In 1874 he moved back to Vienna, where he painted his finest works, also paying short visits to Geneva, Paris and Rome. There are works in Frankfurt/M., Graz and Vienna (Belvedere). *Lit.* F. Novotny: *Der Maler A. Romako* (1954)

Romanticism (Romantic). The Age of Enlightenment was succeeded by the Romantic era in philosophy, literature and art. The most fundamental difference between the two streams of thought and creativity lies in the Enlightenment's reverence for that which is of universal and timeless significance, and Romanticism's delight in diversity and individuality. In its broadest definition, the Romantic era stretches from the late 18C to the present day. With reference to painting and sculpture, however, Romanticism is generally considered the characteristic artistic movement of *c.* 1770-1850. While it is convenient to identify NEOCLASSICISM as the last artistic movement fostered by the Enlightenment and Romanticism with the new art that developed out of and away from it, the finest achievements of Neoclassical art belong to the Romantic age and all the major artists of the period were affected by its new ideas (DAVID, BLAKE, RUNGE).

Romantic art was by its very nature diverse; with the high valuation now set on originality, artists delved into their imaginations and sought to express their own subjective feelings in paint. The landscapes of FRIEDRICH are informed with an intense religious response to nature, those of TURNER with glory in the poetry of colour and light, while CONSTABLE, the BARBIZON SCHOOL painters and even the HUDSON RIVER SCHOOL in America seek a particularized fidelity to observed landscape; indeed, REALISM must be considered a part of Romanticism.

Other characteristic features of the period were: an immense multiplication of modes of painting, with the standard classifications of history, portrait, landscape, still life and genre developing a multiplicity of subdivisions (and spawning the French terms *fantaisiste, ethnographe, orientaliste, paysanneries*, etc.); intense nationalism, fostered by Napoleon's conquests, which turned the attention of artists to the history, legend and folklore of their own countries; a glorification of the imperfect, the grotesque and the deviant; the imaginative reconstruction of distant cultures (in time or geography) extended beyond mere appearances to the inner feelings of the people depicted.

In France GÉRICAULT and DELACROIX are considered the greatest artists of the Romantic movement: Géricault's exploration of the link between madness and physiognomy, his combination of dramatic composition and Realist detail in the *Raft of the Medusa*, Delacroix's fascination with the Orient, and his emotive reinterpretation of classical, medieval and contemporary history. The

fact that Delacroix found the technical tradition of Rubens and the colourists best suited to the interpretation of feelings on canvas led to an identification of Romanticism with colour and classicism with line, crystallized in his battles with INGRES and the French Académie. With the perspective of history this appears as no more than an administrative battle between artists all grounded in the classical tradition and all affected (though in different ways) by Romanticism.

Indeed, Ingres's accent on line and modelling, his devotion to Raphael and his paintings of medieval history give the work a significant affinity with that of the NAZARENES, who were the most characteristic exponents of Romanticism in Germany. The parallel Italian school (PURISMO) acknowledged the twin influence of Ingres and the Nazarenes.

There were close links between art and literature in the Romantic period. History painters recreated scenes from Shakespeare, Dante, Ossian, Goethe and Sir Walter Scott, while genre painters turned their attention to Goldsmith, Molière, etc.
Lit. see Bibliography

Rops Félicien Joseph Victor, b. Namur 1833, d. Essonnes 1898. Belgian painter, draughtsman and engraver whose fame rests essentially on his prints and illustrations, which appealed particularly to the SYMBOLISTS. They are often erotic; women of the streets were a favourite subject. Already in 1868 the Goncourts wrote, 'Rops is truly eloquent in depicting the cruel aspect of contemporary women,' and Huysmans commented in *Certains*: 'He has penetrated Satanism.' His paintings and drawings followed similar subjects. He played an important role in the early anti-academic reaction in Belgium. Largely self-taught, he discovered his aptitude through illustrations for the student magazine *Crocodile* (1853–6), and with his friends DE GROUX, MEUNIER and others he founded the Atelier Saint-Luc, a shared studio where students drew without formal instruction. In parallel (1856), they started the anti-establishment magazine *Uylenspiegel* for which Rops provided quantities of caricatures and illustrations. Although he settled in Paris in 1874, he was a founder member of LES VINGT in Brussels (1883). He illustrated works by Baudelaire, Péladan and

Rodin *Nude Study of a Crouching Woman*

Rohden *Waterfall near Tivoli* 1800–10

Romako *Admiral Tegethoff on the Bridge c.* 1880

Rops *The Hanged Man c.* 1865

Mallarmé. There are paintings in Brussels (Musées Royaux), The Hague and Moscow.
Lit. Péladan: *F. Rops* (1885); M. Exsteens: *L'œuvre gravé et lithographié de F. Rops* (1928); C. Brison: *Pornocrates: An Introduction to the Life and Works of F. Rops* (1969); J. P. Babut du Marès: *F. Rops* (1971)

Rørbye Martinus Christian Wesseltoff, b. Drammen (Norway) 1803, d. Copenhagen 1848. BIEDERMEIER genre and landscape painter. He studied at the Copenhagen Academy (1820-6) under C. A. Lorentzen and ECKERSBERG. His passion for travel resulted in paintings of characteristic life and landscape of many European and Eastern countries; between 1834 and 1837 he visited Paris, Italy, Greece and Turkey, and from 1839 to 1842 he was in Italy. In 1838 he became a member of the Copenhagen Academy, receiving a teaching post in 1844. There are works in Aarhus, Copenhagen (State, Hirschsprung, Ny Carlsberg Glyptotek, Thorwaldsen), Frederiksborg, Nivaagaard, Skagen and Sorø.
Lit. M. Krohn: *M. Rørbyes Arbejder...* (1905)

Rosales Martínez Eduardo, b. Madrid 1836, d. Madrid 1873. Spanish history, genre and portrait painter who achieved a high reputation for his scenes from history in the ROMANTIC–REALIST style of the DELAROCHE school. He studied at Madrid with L. Ferrant and DE MADRAZO, and from 1855 in Rome. He spent most of his working life in Rome, where he was director of the Spanish Academy. He received the Legion of Honour in 1867. There are works in Madrid.
Lit. B. Pantorba: *E. Rosales: ensayo biográfico e critico* (1937)

Rose + Croix, Salon de la. In the 1880s there was a widespread revival of interest in religious mysticism and the occult. Joséphin Péladan, art critic and novelist, revived the ancient Rosicrucian order and changed his name to 'Le Sâr Médrodack Joséphin Péladan'. From 1892 to 1897 his Ordre de la Rose + Croix Catholique du Temple et du Graal organized annual Salons in which paintings of contemporary life, rustic scenes, seascapes, flowers and fruit were banned. He favoured 'the Catholic dogma and Italian

subjects from Margharitone to Andrea Sacchi; the interpretation of Oriental theologies with the exception of those of the yellow races; expressive or decorative allegories; the nude exalted in the style of Primaticcio, of Correggio, or expressive heads like those by Leonardo and Michelangelo'. Among the exhibitors were BERNARD, VALLOTTON, KHNOPFF, HODLER, TOOROP and the sculptor Bourdelle. Péladan was greatly admired in Belgium where DELVILLE established a parallel Salon d'Art Idéaliste. His Salons attracted wide publicity and popular interest; they were an important feature of the SYMBOLIST era.

Rossetti Gabriel Charles (called Dante Gabriel), b. London 1828, d. Birchington-on-Sea 1882. Poet and painter, a founding member of the PRE-RAPHAELITE Brotherhood, whose most successful work was inspired by the Middle Ages, especially the worlds of Dante and Malory's *Morte d'Arthur*. His stylized but magical watercolours of the early years were a formative influence on BURNE-JONES and W. MORRIS, while his large sensuous oil paintings of the 1870s influenced the development of SYMBOLISM as well as of ART NOUVEAU design. He combined poetic sensitivity, flamboyant Bohemian humour and Southern sensuality. The son of an Italian emigré Professor of Languages at King's College, London, and a brother of the poet Christina Rossetti, he entered the ROYAL ACADEMY Schools in 1845, but quickly tired of the academic grind and went to work with Madox BROWN. In 1848 he formed the Pre-Raphaelite Brotherhood with MILLAIS and W. H. HUNT; their aims were 'truth to nature' and a return to the purity of painting 'before Raphael'. *Girlhood of Mary Virgin* (1849) and *Ecce Ancilla Domini* (1850), exhibited at the Royal Academy, were heavily criticized and he never exhibited in public again. The year 1855 saw the start of a close friendship with Burne-Jones and Morris; in 1857 he executed frescoes for the Oxford Union with their help. He met Elizabeth Siddal (*c.* 1850) who became his model, mistress and finally his wife; his paintings were obsessed with her image and he did many fine portrait drawings. He was shattered by her death in 1862, but his creative force revived in the late 1860s with his passion for Jane Morris, William's wife. He

lived with the Morrises at Kelmscott Manor (1871-4). In his final years persecution mania made him an almost total recluse. He was a close friend of Swinburne, Meredith and other poets; he published translations from Dante and several books of his own poetry. There are works in Birmingham, Boston, Edinburgh, Hamburg (Kunsthalle), Liverpool, London (Tate, NPG, V&A), Manchester and New York (Met.).
Lit. W. M. Rossetti: *D. G. Rossetti, His Family Letters* (1895); V. Surtees: *The Paintings and Drawings of D. G. Rossetti, a catalogue raisonné* (1970); M. Henderson: *D. G. Rossetti* (1973); A. I. Grieve: *The Art of D. G. Rossetti* (1973); J. Nicoll: *D. G. Rossetti* (1975)

Rottmann Carl, b. Handschuhsheim 1797, d. Munich 1850. Landscape painter who enjoyed the patronage of Ludwig I of Bavaria. While his small intimate views look forward to the REALIST generation, his main artistic endeavour was concentrated on the preparation of monumental landscape frescoes for the Hofgarten arcades in Munich. In these broad panoramas of Italy and Greece he aimed to distil the spirit of classical history. He studied with his father Friedrich and Johann Xellers but the major influences on his early work were FOHR, G. A. Wallis and the classical landscapes of KOCH. He settled in Munich in 1822. After visiting Italy (1826-7), he exhibited views of *Rome* and *Palermo* (1828) which led to Ludwig's fresco commissions. The first series of frescoes depicting twenty-eight Italian views was completed in 1833; he spent 1828-9 working on preparatory studies in Italy. In Greece (1834-5) he prepared for a second series of Greek views which had also been projected for the Hofgarten, but a new building plan intervened and they were subsequently painted on large movable sheets of slate. He was appointed court painter in 1841. There are works in Berlin, Cologne, Frankfurt/M., Hamburg, Hanover, Munich (N. Pin., Schack), Vienna (Kunsthistorisches Mus.) and other German and eastern European museums.
Lit. L. Lange: *Die griechische Landschaftsgemälde von C. Rottmann* (1854); A. Bayersdorfer: *C. Rottmann* (1871); F. Krauss: *C. Rottmann* (1930); H. Decker: *C. Rottmann* (1957)

Rousseau Henri Julien Felix (called Le Douanier), b. Laval 1844, d. Paris 1910. An amateur or 'Sunday' painter, he painted scenes of the imagination with intense colour and naïve hard-edged vision. Among his most remarkable works are his jungle paintings based on studies in the Paris Jardin des Plantes (*Virgin Forest at Sunset* 1907). After serving in the army he entered the Paris Customs service in 1871 (hence Le Douanier), and began to paint *c.* 1880, though he did not resign from the Customs service until 1893. He exhibited at the SALON DES INDÉPENDANTS from 1886 and gained the friendship of such artists as SIGNAC, PISSARRO, REDON and TOULOUSE-LAUTREC. In 1908 Picasso organized a banquet in his studio in Rousseau's honour. There are works in London (Tate, Courtauld), New York (Mod. Art, Met.), Paris (Louvre), Zurich and many museums of modern art.
Lit. J. Bouret: *H. Rousseau* (1961); D. Vallier: *H. Rousseau* (1964)

Rousseau Philippe, b. Paris 1816, d. Acquigny 1887. A minor master of the French ROMANTIC generation who specialized in animal and still-life painting. After studying under GROS and J. V. BERTIN, he first exhibited at the SALON in 1834 and became a chevalier of the Legion of Honour in 1852. There are works in Amiens, Amsterdam (Rijksmuseum), Bagnères, Baltimore (Mus. of Art), Bordeaux, Carcassonne, Chartres, Dieppe, La Rochelle, Le Mans, Lille, Louviers, Lyons, Moscow (Pushkin), Nantes, Paris (Louvre), Philadelphia, Rouen, Utrecht and Valenciennes.

Rousseau Pierre Etienne Théodore, b. Paris 1812, d. Barbizon 1867. The leader and most important painter of the BARBIZON SCHOOL. His work is grounded in the example of Hobbema, Ruysdael and the Dutch, but he also worked directly from nature in many parts of France, though predominantly in Barbizon. He developed a method of using small brushstrokes of colour to catch fleeting effects of light and atmosphere, working mainly in dark tones. Woodland scenes with old gnarled trees are his most characteristic works. He studied with the NEOCLASSICAL painters Rémond and Lethière (1827–9), but more important to him were his studies of the Dutch 17C masters. The summer of

Rossetti *The Bower Meadow* 1872

Rottmann *Taormina and Aetna* 1828

Rousseau (Le Douanier) *The Sleeping Gypsy* 1897

P. Rousseau *Still Life: Game* before 1875

T. Rousseau *The Forest of Fontainebleau at Sunset* exhibited 1855

185

Runge *Morning* 1808–9

Ryder *The Race Track, or Death on a Pale Horse*
c. 1890–1910

1830 spent in the Auvergne crystallized his personal style, and he first exhibited at the SALON in 1831 with *Valley among the Cantal Mountains*. Deeply impressed by the work of CONSTABLE and BONINGTON, he visited Brittany in 1832 to work from scenes already treated by Bonington. In 1836 *Descent of the Cattle from Pasture in the Jura* was turned down by the Salon jury; he was also rejected from the three following Salons and did not again send pictures for consideration until the reform of the jury in 1849. After his first visit to Barbizon in 1833, he went there increasingly often until in the 1840s he settled there permanently. Between 1840 and 1850 he spent much of his time with fellow landscapist DUPRÉ, who urged him towards more careful composition of his work. His return to the Salon in 1849 was crowned with a first-class medal; his reputation was further enhanced by the exhibition of thirteen works at the 1855 EXPOSITION UNIVERSELLE. He became a chevalier of the Legion of Honour in 1852 and was promoted to officer in 1867. Dupré, DIAZ and SCHEFFER were special friends during his early years of struggle and poverty; MILLET, who settled in Barbizon in 1849, was the intimate friend of his last years. There are works in almost every public collection where the 19C is represented, especially in America and France. *(see colour illustration 10)*
Lit. A. Sensier: *Souvenirs sur T. Rousseau* (1872); E. Chesnau: *T. Rousseau* (1880); W. Gensel: *Millet and Rousseau* (1902); P. Dorbec: *T. Rousseau* (1910); A. Terasse: *L'univers de T. Rousseau* (1976)

Roussel Ker-Xavier, b. Lorry-les-Metz 1867, d. L'Etang-la-Ville 1944. An associate of the NABIS, he painted INTIMISTE scenes of daily life and landscapes round Paris in a flat decorative technique much influenced by GAUGUIN and VUILLARD. He entered the ACADÉMIE JULIAN in 1888 with Vuillard, his friend and future brother-in-law. After 1900 he turned to mythological landscapes peopled by fauns and nymphs. There are works in Bremen, Copenhagen (Ny Carlsberg Glyptotek), Helsinki (Athenaeum), Moscow, Paris (Mod. Art, Petit Palais) and Winterthur.
Lit. L. Werth: *K. X. Roussel* (1930)

Royal Academy London. Founded by George III in 1768, it has, since its foundation, run an art school and an annual exhibition for which artists of any nationality may submit work. At any one time forty artists have the title of Royal Academician and there have usually been between thirty and thirty-five associates. In the 19C the Royal Academicians were generally representative of the best in British art, although the academy took an unconscionable time over electing CONSTABLE. Young painters grouped themselves from time to time in protest against the conservatism of the academy – the CLIQUE, the PRE-RAPHAELITES and the NEW ENGLISH ART CLUB, for instance – but unlike in France there were no long sustained battles; the best of the rebels were generally received within the academy in the shorter or longer term. Lonely geniuses like BLAKE or PALMER are the exception rather than the rule. During the 19C its presidents were WEST, WYATT, LAWRENCE, SHEE, EASTLAKE, GRANT (LANDSEER and MACLISE having refused the office), LEIGHTON, MILLAIS and POYNTER.
Lit. S. Hutchinson: *History of the Royal Academy 1768–1968* (1968)

Roybet Ferdinand, b. Uzes 1840, d. Paris 1920. Painter of genre scenes, usually set in the 16C and 17C; his elaborate costumes and accessories are treated with a still-life painter's attention to detail and textures. He studied under VIBERT, first exhibiting at the SALON in 1864. His work was very popular with contemporary collectors, and he became a chevalier of the Legion of Honour in 1893. There are works in Amiens, Avignon, Bagnols, Bordeaux, Boston, Bucharest, Cologne, Dunkirk, Grenoble, Montpellier, Montreal, Moscow (Tretiakov), Mulhouse, New York (Met.), Paris (Louvre), Reims and Rouen.

Runge Philipp Otto, b. Wolgast 1777, d. Hamburg 1810. German ROMANTIC painter and mystic, he sought to depict the forces of nature through allegory; the result was a small number of naïvely painted allegorical landscapes (*Morning* 1808–9, a baby in a flower-bedecked landscape) and a series of carefully structured outline drawings that owe a debt to FLAXMAN and parallel the mystic symbolism of BLAKE. He also painted a number of distinguished portraits (*Hülsenbeck Children* 1805–6). His ambitious scheme for allegorical murals depicting the *Four Phases of the Day*, to which his last years were

devoted, never got beyond the preparatory stages. He studied in Hamburg and then (1799-1801) at the Copenhagen Academy with Jens Juel. In Dresden (1801) he met FRIEDRICH, the Romantic writer L. Tieck, the philosopher F. von Schlegel and Goethe, who was interested by his colour theories. After 1803 he lived in Hamburg. He elaborated a symbolic theory of colour which is outlined in his two books, *Farbenkugel* and the unfinished *Farbenlehre*. His work was forgotten after his death and it is only in the 20C that he has come to be considered as one of the most important early German Romantics. He is best represented in the Hamburg Kunsthalle, but there are also works in Berlin, Szczecin and Vienna (Kunsthistorisches Mus.).
Lit. P. O. Runge: *Hinterlassene Schriften* (1840-1, new ed. 1965); P. F. Schmidt: *P. O. Runge, sein Leben und sein Werk* (1956); R. M. Bisanz: *German Romanticism and P. O. Runge* (1970); H. Matile: *Die Farbenlehre P. O. Runges* (1973); J. Traeger: *P. O. Runge und sein Werk* (1975)

Ryder Albert Pinkham, b. New Bedford (Mass.) 1847, d. Elmshurst (N.Y.) 1917. Visionary painter of moonlit seas, scenes from Shakespeare, Wagner and the Romantic poets, and landscapes: small, simple compositions in thick layers of paint and repaint that reflect the lyrical mystery of his inner world. His paintings, of which about 165 are known, have suffered chemical deterioration; with his immense popularity in the 20C, 'there came later to be ten times as many forgeries as originals' (Richardson). He studied with W. E. Marshall and at the NATIONAL ACADEMY OF DESIGN from 1871, first exhibiting there in 1873. He was a co-founder of the Society of American Artists in 1877. He painted mainly landscapes and pastoral scenes in the 1870s, turning to literary subjects *c.* 1880. He visited England in 1877 and France, Holland, Italy, Spain and Tangier in 1882; he sailed twice to England and back for the sake of the voyage. His cluttered, dusty studio with a path from door to easel has become a legend; he painted and reworked his canvases over many years, generally refusing to part with them. There are works in many American museums including Brooklyn, Chicago, Cleveland, Detroit, New York (Met.), St Louis, Toledo, Washington (NG) and Worcester.
Lit. F. F. Sherman: *A. P. Ryder* (1920); L. Goodrich: *A. P. Ryder* (1959)

Rysselberghe Théodore van, b. Ghent 1862, d. Saint-Clair (Var) 1926. Belgian POINTILLIST, an enthusiastic follower and friend of SEURAT and SIGNAC. His scenes of women bathing in the sea are particularly characteristic, but he also executed notable Pointillist portraits. He studied at the Ghent Academy and at the Brussels Academy under PORTAELS. In 1884 he was a founder member of the *avant-garde* group, LES VINGT, in Brussels. He travelled extensively and settled in Paris in 1898. In later years he abandoned POINTILLISM for a straightforward IMPRESSIONIST technique. There are works in Amsterdam (Rijksmuseum), Brussels (Musées Royaux), Essen (Folkwang), Ghent, Helsinki (Athenaeum), Paris (Jeu de Paume), Rotterdam (Boymans) and Weimar.
Lit. P. Fierens: *T. van Rysselberghe* (1937); G. Pogu: *T. van Rysselberghe : sa vie dans le cadre des recherches techniques et psychosociales des causes de l'art* (1963)

Rysselberghe *Madame Monnom* 1900

S

Sabatelli Luigi, b. Florence 1772, d. Milan 1850. NEOCLASSICAL painter, an influential teacher at the Accademia Brera in Milan for almost half a century. A draughtsman of great distinction, he was influenced by 16C Tuscan painting and his rather mannered classicism is often reminiscent of INGRES. He painted some fine portraits but is best remembered as a fresco painter; his most famous work is the *Hall of the Iliad* in the Pitti Palace, Florence (1822-5). He also painted scenes from medieval history and is sometimes

Sabatelli *Assembly of the Gods*

considered a forerunner of the Milanese ROMANTIC school. He studied in Florence and Rome where he shared a studio with CAMUCCINI and BENVENUTI. From 1808 to his death he was professor of painting in Milan, though HAYEZ briefly substituted for him from 1822 to 1825. He was a member of the academies of Florence, Carrara, Rome (S. Luca) and Genoa. His sons Francesco, Giuseppe, Gaetano and Luigi the Younger were also painters. There are frescoes in several churches and palaces in both Milan and Florence, a famous *David and Abigail* in Arezzo Cathedral, and a self-portrait in the Uffizi.

St John's Wood Clique. A group of English genre and narrative painters formed in the 1890s and led by P. H. Calderon. Other members were J. E. Hodgson, G. D. Leslie, H. Stacy Marks, G. A. Storey, F. WALKER, D. W. Wynfield and W. F. Yeames, all well-known artists at the time and prominent exhibitors at the ROYAL ACADEMY.

St Luke Brotherhood of *see* NAZARENES

Salinas Juan Pablo, b. Madrid 1871, d. Rome 1946. Genre painter who carried the FORTUNY tradition of rococo costume genre painting into the 20C. Having trained in Spain he spent the later part of his life in Rome where his work had a wide popular appeal; in the 1930s the cost of commissioned paintings is said to have been calculated at 1,000 lire per figure. There are works in Karl-Marx-Stadt, Madrid (Mod. Art) and Oldenburg.

Salon *see* FRENCH ART ESTABLISHMENT

Sandreuter Hans, b. Basle 1850, d. Basle 1901. Swiss landscape painter, the principal pupil of BÖCKLIN, with whom he worked 1874–7 and 1880–4. He also studied at the Naples and Munich Academies and had his own studio in Paris (1877–80). His early work strongly reflects the influence of Böcklin, but his later landscapes are more directly IMPRESSIONIST. There are works in Basle (Kunstmuseum), Berne, Geneva (Rath) and Neuchâtel.

Sargent John Singer, b. Florence 1856, d. London 1925. American portrait painter who made an outstandingly successful career

in Europe. His brushwork owed a strong debt to the IMPRESSIONISTS but he developed a technical *bravura* which was highly personal. This was combined with sensitive psychological insight and an abhorrence of flattery; the outrage caused by his unflattering *Mme. Gautreau* (a society beauty) decided his removal from Paris to London in 1884. He studied in Paris with CAROLUS-DURAN from 1874–9 and shared his master's interest in Velasquez. He first exhibited at the SALON in 1877 (*Miss Frances Watts*) and in the following years visited both Italy (*Señor Subercaseaux in a Gondola* 1880) and Spain (*El Jaleo* 1882). In London he bought WHISTLER's Chelsea studio and his reputation climbed steadily (*Carnation, Lily, Lily, Rose* 1887, *Lady Agnew* 1893). In 1910 at the height of his fame he decided to give up portrait painting and the following summer saw a brilliant series of landscape watercolours (Brooklyn). He executed a series of murals for Boston Public Library (1890–1919) and also decorated the rotunda of Boston Museum and the Widener Library at Harvard. Chevalier of the Legion of Honour in 1889 and officer in 1897, he became an associate of the New York NATIONAL ACADEMY OF DESIGN in 1891 and academician in 1897, an ARA in 1894 and an RA in 1897. He is best represented in Boston, London (Tate, NPG) and New York (Met.) but there are examples of his work in most major American museums and many European ones.
Lit. C. M. Mount: *J. S. Sargent, a Biography* (1955)

Scapigliatura (Scapigliati). The Scapigliati, literally 'the dishevelled', were a group of Bohemian artists and writers in Milan *c.* 1865–75. They painted figures and landscape out of a mist of quick brightly coloured brushstrokes. The exploration of effects of light and colour by FARUFFINI provided their initial impetus. The movement was led by CREMONA, RANZONI and the sculptor G. Grandi.
Lit. S. Pagani: *La Pittura Lombarda della Scapigliatura* (1955); G. Predaval: *Pittura Lombarda del Romanticismo alla Scapigliatura* (1967)

Schadow Friedrich Wilhelm von, b. Berlin 1788, d. Düsseldorf 1862. NAZARENE painter,

the influential director of the Düsseldorf Academy from 1826 to 1859. He was a painter mainly of biblical scenes and religious allegory but his work is distinguished from that of OVERBECK and the other Nazarenes by its accent on naturalism and strong use of colour, learnt partly from his French contemporaries in Rome. This emerges particularly in his portraits (*Group Portrait of Thorwaldsen, Wilhelm and Rudolf Schadow* 1815–18). He believed that a painting should be 'a poem in form and colour'; the academic idealism of his work was a profound influence on the DÜSSELDORF SCHOOL but alienated the subsequent generation of REALIST painters. He was the son of the Berlin sculptor Gottfried Schadow and a student of G. Weitsch. In 1811 he went to Rome, where he became a member of the BROTHERHOOD OF ST LUKE in 1813 and was converted to Catholicism in 1814. He collaborated with CORNELIUS, Overbeck and VEIT on the Bartholdy frescoes. In 1819 he was appointed a professor at the Berlin Academy and his popularity was such that a large group of students accompanied him to Düsseldorf on his appointment as academy director in 1826 (SOHN, LESSING, HILDEBRANDT, etc.). He revisited Rome in 1830–1 and 1839–40, and was knighted ('von') in 1845. There are works in Antwerp, Berlin, Düsseldorf, Frankfurt/M., Hamburg, Munich (N. Pin.) and Poznań.
Lit. W. Schadow: *Der moderne Vasari, Erinnerungen aus dem Künstlerleben* (1854); J. Hübner: *Schadow und seine Schule* (1869)

Scheffer Ary, b. Dordrecht 1795, d. Argenteuil 1858. Dutch artist who made his career in France and was considered in the early 1830s one of the leaders of the ROMANTIC movement. He worked mainly in muted colours while his figures tended to classical idealization and were carefully finished; his Romanticism was displayed in subject and composition. He studied with PRUD'HON (1810) and GUÉRIN (1811), first exhibiting at the SALON of 1812. His reputation was established in the 1820s with a series of tearfully sentimental little family scenes (*The Young Widow* 1822, *Sick Child* 1824) though he also, like DELACROIX, painted scenes from the Greek war of independence (*Souliote Women* 1827). From 1821 he was drawing master to the children of the future

king, Louis-Philippe; he was a friend of many of the leading intellectuals and politicians of his time, whose appearance he recorded in a series of outstanding portraits. Around 1830 he turned almost exclusively to the illustration of literary themes, taken from Dante, Shakespeare, Scott, Byron, Schiller and above all from Goethe (*Faust in his Study, Margaret at the Spinning Wheel* both 1831). A close friend of the Orléans family, his career went into eclipse with the 1848 revolution; he turned to religious painting in his last years. His brother Henri was also a painter. There are works in Baltimore (Walters), Boston, Cambridge Mass. (Fogg), Chicago, Dordrecht (Mus. Ary Scheffer), London (Wallace), Paris (Louvre), Venice (Correr), Versailles and Washington (Corcoran).
Lit. L. Viter: *L'Oeuvre de A. Scheffer* (1860); Hofstede de Groot: *A. Scheffer, ein Charakterbild* (1870); L. Wellisz: *Les Amis Romantiques: A. Scheffer et ses amis polonais* (1933); M. Kolb: *A. Scheffer et son temps* (1937)

Schelfhout Andreas, b. The Hague 1787, d. The Hague 1870. Landscape painter, most characteristically of winter scenes, and one of the founders of REALISM in Holland. His use of bright naturalistic colours was a significant departure from early 19C practice, as was his loose, atmospheric brushwork. His teaching was an important influence on JONGKIND, who in his turn exerted a formative influence on IMPRESSIONISM. He studied with J. H. Breckenheimer, and his finest landscapes belong to his early exploratory years; his style, once developed, changed little in the course of a long life. He was a member of the academies of Amsterdam, Brussels and Ghent. There are works in Amsterdam (Rijksmuseum), Brussels, Cambridge (Fitzwm), Cheltenham, Dordrecht, Frankfurt/M., Ghent, The Hague, Haarlem, Leeuwarden, London (Wallace), Poznań and Würzburg.

Schick Christian Gottlieb, b. Stuttgart 1776, d. Stuttgart 1812. German NEO-CLASSICAL painter who studied with DAVID in Paris and was much influenced by the monumental drawings of Carstens. Stylistically his work lies on the frontier between 18C classicism and the ROMANTIC sensitivity of the NAZARENES. His portraits are classically

Sargent *W. Graham Robertson* 1894

Schelfhout *On the Banks of the Maas*

Schadow *Portrait of a Woman* 1832

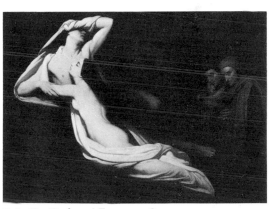

Scheffer *Paolo and Francesca* 1854

Schick *Apollo with the Shepherds* 1808

Schinkel *Gothic Church by the Water* 1813-14

Schirmer *The Melbtai, near Bonn c.* 1850

Schleich *Lake Starnberg c.* 1861

posed but painted with a fresh realism (*Frau Dannecker, Frau von Cotta* both 1802) and were highly regarded by his contemporaries in Rome, as were his mythological and biblical paintings (*Apollo with the Shepherds* 1808); these too place realistically painted figures in graceful classical settings. He studied in Stuttgart with G. F. Hetsch and the sculptor J. H. Dannecker (1787-94), and in Paris with David (1798-1802). He arrived in Rome in 1802 and in 1806 married Emily Wallis, daughter of the Scottish painter George Augustus Wallis, whose influence can be detected in his free handling of landscape. He returned to Germany shortly before his death. There are works in Berlin (NG), Cologne (Wallraf-Richartz), Mannheim and Stuttgart.
Lit. K. Simon: *G. Schick, ein Beitrag zur Geschichte der deutschen Malerei um 1800* (1914)

Schindler Carl, b. Vienna 1821, d. Laab am Walde 1842. Short-lived BIEDERMEIER genre painter and watercolourist, known as 'Soldatenschindler' on account of his scenes from military life. The son of the painter Johann Josef Schindler, he studied at the Vienna Academy (1836-7). FENDI was his most important guide and teacher but his watercolours, full of movement and colour, also demonstrate the influence of lithographs by CHARLET, LAMI and RAFFET. His influence was in turn felt by PETTENKOFEN. There are works in Nuremberg and Vienna.
Lit. F. M. Haberditzl, H. Schwarz: *C. Schindler, sein Leben und sein Werk* (1930)

Schindler Emil Jakob, b. Vienna 1842, d. Westerland auf Sylt 1892. Landscape painter, strongly influenced by the Dutch 17C and the BARBIZON SCHOOL. He studied at the Vienna Academy under A. Zimmerman and worked mainly in Austria, visiting Holland (1875), Paris (1881) and Dalmatia (1888). He was a member of the Vienna Academy. There are works in Berlin, Wrocław, Leipzig, Munich and Vienna (Belvedere).
Lit. C. Moll: *E. J. Schindler* (1930); H. Fuchs: *E. J. Schindler* (1970)

Schinkel Karl Friedrich, b. Neuruppin 1781, d. Berlin 1841. Prussian architect, one of the most important exponents of ROMANTIC classicism; he also worked briefly as a land-

scape painter. He was self-taught as a painter, developing his talent during a visit to Italy (1803-5). After the Napoleonic defeat of Prussia (1806) there was little work for an architect and he turned almost exclusively to painting. He executed several panoramas and dioramas and between 1816 and 1832 designed forty-two productions for the Royal Theatre. His paintings were generally wide vistas of town or country with romantically heightened effects of light. After 1816 his success as an architect tended to keep him from painting. There are works in Berlin and Munich (N. Pin.).
Lit. P. O. Rave: *K. F. Schinkel* (1935); K. F. Schinkel: *K. F. Schinkel: aus Tagebüchern und Briefen* (1967)

Schirmer Johann Wilhelm, b. Jülich 1807, d. Karlsruhe 1863. German landscape painter. In his student years he went on many sketching expeditions to different parts of Germany, to Normandy with LESSING, and to Italy; these expeditions resulted in freshly realistic landscape studies. His visit to Italy in 1839-40, however, opened his eyes to the glories of southern landscape and to the achievements of its most noted delineators, Claude, Poussin and KOCH. His mature style combines formal classical composition, learnt from these masters, with an abiding element of REALISM. He studied at the Düsseldorf Academy from 1825 under SCHADOW and Kolbe, and was importantly influenced by the landscapes of Lessing. He taught at the Düsseldorf Academy from 1839-54; his example was a formative influence on the ACHENBACH brothers but it was during the period 1854-63, when he was director of the art school at Karlsruhe, that he fostered an identifiable 'Schirmer school' of landscape painting. BÖCKLIN and THOMA were among his pupils. In his last years he abandoned the classical formula and moved towards a free, almost IMPRESSIONIST handling. There are works in most German museums, in Cincinnati and in Minneapolis.
Lit. K. Zimmermann: *J. W. Schirmer* (1920); H. Curjel: *Landschaftsstudien J. W. Schirmers* (1925); J. W. Schirmer: *Lebenserinnerungen* (P. Kauhausen (ed.) 1956)

Schleich Eduard (the Elder), b. Haarbach 1812, d. Munich 1874. Munich landscape painter, one of the pioneers of STIMMUNGS-

LANDSCHAFT. He painted wide vistas of the Bavarian landscape with a combination of REALISM and lyrical sensitivity to light, atmosphere and mood. He entered the Munich Academy in 1827 but left to teach himself landscape painting; he was influenced by ROTTMANN and MORGENSTERN. He visited Italy with Morgenstern in 1831. RAHL, whom he met in 1848, introduced him to his new colour theories and advised him to study Rubens' landscapes, while in 1851 with SPITZWEG he paid an influential visit to Paris, where he first came into contact with the work of the BARBIZON SCHOOL. His work achieved recognition c. 1860 and its popularity continued to grow after his death, exerting an important influence on the Munich school. His son Eduard Schleich the Younger (1853–93) was also a landscape painter. There are works in Berlin, Bremen, Wrocław, Darmstadt, Dresden, Hamburg, Leipzig, London (V&A), Munich (Schack) and Stuttgart.
Lit. S. Wichman: *E. Schleich der Ältere* (1951)

Schnetz Jean Victor, b. Versailles 1787, d. Paris 1870. French painter who studied with DAVID and REGNAULT and adapted the NEO-CLASSICAL style to scenes of Italian peasant life, closely related to those of his friend ROBERT (*Old Woman and Young Girl Praying before a Madonna* 1827–8). He first exhibited at the SALON in 1808 (*Valour of a French Soldier*), studied with Regnault (1810), David (1812) and briefly with GROS and GÉRARD. He left for Italy in 1817 and the religious paintings he sent back to the Paris Salon brought him his first success (*The Good Samaritan* 1819). His Italian genre scenes, often touched with ROMANTIC sentiment or drama (*Murdered Woman* 1824), were very successful in the 1820s. He returned to Paris in 1832, was elected to the INSTITUT in 1837 and ran the ECOLE DES BEAUX-ARTS from 1837 to 1841. He was director of the French Academy in Rome (1841–7 and 1853–66) and was an important influence on academic teaching. There are works in Arras, Douai, Le Havre, Nantes, Paris (Louvre), Reims, Rouen, Sémur, Strasbourg, Toulouse, Valenciennes and Versailles.

Schnorr von Carolsfeld Julius, b. Leipzig 1794, d. Dresden 1872. An associate of the

NAZARENES in Rome, he adapted their fresco style to themes of medieval history and legend in his later Munich murals. While his main artistic endeavour was devoted to these frescoes, he was also an outstanding draughtsman and notable landscape painter. His early landscape drawings in Austria and Italy, influenced by his friend FERDINAND OLIVIER, share the latter's delicacy of line and spirituality. In Rome (*c.* 1820) he conceived the grandiose idea of illustrating the Bible; the series of 240 drawings, completed and published only in 1860, were enthusiastically received throughout Europe, prolonging the influence of the Nazarenes on devotional art. The son of a painter and engraver, Johann Veit Schnorr, he entered the Vienna Academy in 1811 but the formative influences on his art were the landscapes of KOCH and Olivier, with whom he lived from 1814 to 1817 (*Battle of Lipidusa* 1816, *St Rochus Giving Alms* 1817). In Rome (1818) he joined the circle of the Nazarenes, collaborating with them on the Casino Massimo frescoes (Ariosto Room 1820–6) and executing a series of fine pencil drawings of his fellow artists. In 1827 he settled in Munich to execute fresco commissions for Ludwig I (Nibelungen frescoes for the Königsbau 1827–67, completed by pupils, and scenes from the life of Charlemagne, Frederick Barbarossa and Rudolf von Habsburg for the Residenz, executed by assistants from his cartoons). In 1846 he was appointed director of the Dresden Art Gallery and a professor at its academy. His brothers Ludwig and Eduard were also painters. There are works in Basle (Kunstmuseum), Berlin, Bremen, Cambridge (Fitzwm), Cologne, Dresden, Frankfurt/M., Leipzig, Munich, Poznań, Rome (Villa Massimo) and Stuttgart.
Lit. J. Schnorr von Carolsfeld: *Briefe aus Italien* (1886); A. Schahl: *Die Geschichte der Bilderbibel von J. Schnorr von Carolsfeld* (1936); H. Hutter, W. Lhotsky: *J. Schnorr von Carolsfeld* (1973)

Schuch Carl, b. Vienna 1846, d. Vienna 1903. He combined the Viennese tradition of decorative painting with the influence of LEIBL and COURBET to develop a REALIST style of still-life painting with a rich harmony of tones. His large still lifes painted in Paris between 1882 and 1894 are considered his most important works. His landscapes also

Schnorr von Carolsfeld *Flight into Egypt* 1828

Schuch *Still Life with Apples c.* 1870–75

Schwind *The Rose* 1847

Segantini *Angel of Life* 1894

belong to the Realist school. After studying at the Vienna Academy (1864-7) with the landscapist Halauska, he visited Italy (1868-70) and Munich (1870-2), where he became a friend of Leibl and TRÜBNER. He lived in Venice (1876-82) and Paris (1882-94) before returning to Vienna. Mental illness cut short his career in 1891. He is said to have sold only one painting during his lifetime, but his reputation was established by the Berlin retrospective exhibition of 19C art in 1906. There are works in Aachen, Berlin, Bremen, Wrocław, Cologne, Dresden, Düsseldorf, Halle, Hamburg, Hanover, Krefeld, Leipzig, Magdeburg, Mannheim, Munich (N. Pin.), Nuremberg, Poznań, Szczecin, Stuttgart, Vienna (Belvedere), Wuppertal-Eberfeld and Zurich. *Lit.* K. Hagemeister: *K. Schuch, sein Leben und seine Werke* (1913); H. Roessler (ed.): *K. Schuch: Briefe* (1922)

Schwind Moritz von, b. Vienna 1804, d. Niederpöcking (nr Munich) 1871. Austrian ROMANTIC painter and illustrator. He was essentially a storyteller, a painter of fairy tale and medieval legend. His work places a strong accent on outline, uses clear bright colours and is smoothly finished; his poetic sensitivity to nature and landscape breathes a magical reality into his best work, foreshadowing BÖCKLIN and the *fin de siècle* Romantics. His gentle humour gives freshness to his occasional genre pieces. He studied in Vienna with SCHNORR VON CAROLSFELD and KRAFFT; his early years were mainly devoted to commercial engravings and illustrations. Under the influence of CORNELIUS he moved to Munich in 1828 and became involved with fresco painting (Residenz, Hohenschwangau). He visited Italy in 1835, moved to Karlsruhe in 1840 and in 1844 to Frankfurt/M., where he painted his famous *Itinerant Artists* (1847). In 1847 he returned to Munich, where he was appointed a professor at the academy. A set of four oil paintings of scenes from *Cinderella*, completed in 1854, established his fame; two other fairy tale cycles followed, fifteen watercolour scenes from *The Seven Ravens* (1857-8) and eleven watercolour scenes from *Melusina* completed just before his death. His *Reisebilder*, forty or so small oils painted mainly for his own pleasure in the 1850s and 1860s and treating his favourite legendary themes, are now regarded as among his finest work. There are works in

Berlin, Frankfurt/M., Karlsruhe, Munich (N. Pin., Schack), Vienna (Belvedere) and many German museums.
Lit. L. R. von Führich: *M. von Schwind* (1871); O. Weigmann: *M. von Schwind* (1906); M. von Schwind: *Briefe* (O. Stoessl (ed.) 1924); E. Kalkschmidt: *M. von Schwind, der Mann – das Werk* (1943); H. Busch: *M. von Schwind* (1949)

Secession (Munich, Berlin, Vienna). The Secession movements grouped *avant-garde* artists mainly of REALIST, IMPRESSIONIST or SYMBOLIST leanings. The Munich Secession was founded in 1892 by VON STUCK, TRÜBNER and VON UHDE. BÖCKLIN, COURBET and the BARBIZON SCHOOL painters were featured in its exhibitions, as was LIEBERMANN, the first president of the Berlin Secession founded in 1899. The Berlin Secession grew out of protest over the works MUNCH was forced to withdraw from the KUNSTVEREIN exhibition of 1892. His group of supporters included Julius Meier-Graefe, whose reassessment of 19C art history is the cornerstone of 20C attitudes to the period. The Vienna Secession of 1897 was dominated by KLIMT, its first president, and was particularly important for the applied arts. Parallel movements sprang up in many northern countries, including the Danish Free Exhibition group and the Stzuka group in Poland.

Segantini Giovanni, b. Arco 1858, d. Schafberg 1899. Italy's leading DIVISIONIST and SYMBOLIST artist, his work was exhibited all over Europe, winning great critical acclaim. The dominant influence on his art was MILLET; he painted peasant life but heightened its poetry with compositional devices borrowed from the PRE-RAPHAELITES and Japanese prints. From 1886 he used a Divisionist technique. He entered the Accademia di Brera in Milan in 1874, and was influenced by CREMONA and the SCAPIGLIATURA movement. His friendship with Vittore GRUBICY, art dealer, critic and artist, dates from *c.* 1880; Grubicy's knowledge of international artistic developments brought Segantini into contact with the work of the HAGUE SCHOOL (especially MAUVE), the PRE-RAPHAELITES and French Divisionism. As an art dealer, Grubicy was also responsible for making Segantini's work known throughout Europe. After 1881 he lived a retired life in the countryside, in

Brianza (1881-6), Savognino in Switzerland (1886-94) and Engadina (1894-9): 'I went out only at the hour of sunset, to see and feel its impressions, which I then transferred to the canvas during the day.' There are works in Amsterdam, Basle, Berlin, Berne, Brussels, Hamburg, The Hague (Mesdag), Leipzig, Liverpool, Milan (Grassi, Mod. Art), Munich, Rome (Mod. Art), Saint-Moritz, Vienna (Kunsthistorisches Mus.) and Zurich.
Lit. G. Segantini: *Autobiograffia, scritti, lettere, memorie* (1910); L. Budigna: *G. Segantini* (1962); F. Arcangeli: *L'opera completa di Segantini* (1973)

Sequeira Domingos António de, b. Ajuda (Belem) 1768, d. Rome 1837. NEOCLASSICAL painter mainly of religious and historical subjects, a fine colourist and the most illustrious artist of his generation in Portugal. He studied at the Lisbon School of Drawing (1781-8) before going to Rome on a state grant. Two scenes from the life of Christ (1791 and 1794) brought him fame and he returned to Portugal in 1796. In 1802 he was appointed first painter to the court; he executed mural decorations for the Royal Palace at Ajuda. His involvement in the 1820-2 revolution forced him to leave Portugal for Paris (1824-6) and Rome, where he finally settled. His ease in composing and balancing masses is best shown in his final works for the Casa de Palmela (1836-7), *The Adoration of the Magi, Descent from the Cross, Ascension* and *Last Judgment*. There are works in Belem, Braga, Lisbon (Nat. Mus.), Parma and Porto.
Lit. J. M. Teixeira de Carvalho: *D. A. de Sequeira em Italia* (1922); L. Xavier da Costa: *A obra litográfica de D. A. de Sequeira* (1925); D. de Macedo: *D. Sequeira* (1956)

Serov (Sjeroff), Valentin Alexandrovich, b. St Petersburg 1865, d. Moscow 1911. The most fashionable Russian portraitist of the turn of the 19C. His work has been compared to that of RENOIR and SARGENT, but the decisive influences on it were in fact BASTIEN-LEPAGE and ZORN. His first IMPRESSIONIST technique changed to a decorative linear style under Zorn's influence (*Ida Rubinstein*). The son of a composer, he was brought up in a cosmopolitan and creative circle; he studied in Munich with Köppings (1873-4) and in Paris with REPIN (1874), with whom he

worked at the Abramtsevo artistic community (1878-80). He attended the St Petersburg Academy (1880-4) and discovered Bastien-Lepage's paintings in the Hermitage. After beginning his career as a landscape painter, he later turned to portraits, including among his sitters the imperial family, many members of the nobility, artists, ballerinas and composers (*Princess Yussupov, Vera Mamontova*). He taught at the Moscow Art School (1900-9), was a member of the MIR ISKUSSTVA group and took part in their exhibitions. He was a friend of Bakst and VRUBEL, and an influential teacher. There are works in Leningrad (Russian Mus.) and Moscow (Pushkin, Tretiakov).
Lit. I. Grabar: *Serov: His Life and Work* (1913, in Russian); N. Sokolova: *V. A. Serov* (1935, in Russian)

Serusier Paul, b. Paris 1863, d. Morlaix (Finistère) 1927. Artist much influenced by GAUGUIN and the theory of SYNTHETISM. He studied at the ACADÉMIE JULIAN under LEFEBVRE, BOULANGER and Doucet, and it was during this period that he met Gauguin at Pont-Aven (1888); he painted a landscape panel (*Bois d'Amour*) in the course of a morning under his instruction. This panel sparked his fellow students' interest in Gauguin; they included DENIS, BONNARD, VUILLARD and VALLOTTON, who were to form the NABIS group (*c.* 1889-99) with Serusier as their theorist. In 1897 he was introduced to the school of religious painting at the Benedictine Abbey of Beuron; its teaching, based on the 'sacred proportions', obsessed him for the rest of his life. In 1921 he published an *ABC de la peinture*. There are works in London (Tate), Ottawa, Paris (Mod. Art) and Stuttgart.
Lit. M. Denis: *Serusier, sa vie, son œuvre* (1943)

Seurat Georges, b. Paris 1859, d. Paris 1891. Painter whose monumental style was based on intensive scientific studies. His main achievement was the invention of DIVISIONISM. He entered the ECOLE DES BEAUX-ARTS in 1878, studying with LEHMANN. At the same time he was a voracious reader of scientific treatises, finding special inspiration in Chevreul's law of simultaneous colour contrasts; he spent much time in the Louvre where he checked his findings against the

Sequeira *Allegory of the Virtues of João VI* 1810

Serov *Dostoyevsky*

Serusier *The Tapestry*

Seurat *Bathing at Asnières* 1833-4

Sickert *Café des Tribunaux*

work of great colourists (Veronese, DELA-CROIX) as well as copying works by INGRES, Raphael, Holbein and Poussin. During 1881-2 he worked exclusively in black and white, developing a style of drawing which balanced dark and light masses without the use of line. In 1883-4 he worked on his first major Divisionist composition, *Bathing at Asnières*, for which he prepared quantities of outdoor sketches and studio studies. It was refused for the 1884 SALON but exhibited at the SALON DES INDÉPENDANTS which he helped to found, immediately influencing SIGNAC and PISSARRO. *Sunday Afternoon on the Island of La Grande Jatte*, his second major composition, occupied him from 1884 to 1886; he used a palette based on Chevreul's colour disc and applied small spots of pure colour, light being broken into local colour and reflections, with complementaries for shadow. It was exhibited in 1886 at the last IMPRESSIONIST Group Show in a room also containing Divisionist works by Signac and C. and L. Pissarro. It was treated with derision by the critics but received a better reception at the Brussels LES VINGT exhibition the following year. He painted five more major compositions: *Les Poseuses* (1887), *The Parade* (1887), *Le Chahut* (1889-90), *Young Woman Powdering Herself* (1889-90) and *The Circus* (1890). During the summers of 1885-90 he painted a number of pure landscapes in Divisionist technique. After 1884 he worked closely with Signac, who later recorded his ideas in print. There are major works in Baltimore (Mus. of Art), Chicago, London (Tate, Courtauld), Merion Pa. (Barnes), Munich (N. Pin.), New York (Mod. Art), Otterloo (Kröller-Müller) and Paris (Louvre); there are also works in Brussels (Musées Royaux), Edinburgh, Glasgow, Indianapolis, Liverpool and Prague (NG).
Lit. D. C. Rich: *Seurat and the Evolution of La Grande Jatte* (1935); J. Rewald: *G. Seurat* (1943); J. Rewald and H. Dorra: *Seurat: L'Oeuvre peint, biographie, et catalogue critique* (1959); R. L. Herbet: *Seurat's Drawings* (1962); W. I. Homer: *Seurat and the Science of Painting* (1964); J. Russell: *Seurat* (1965); P. Courthion: *G. Seurat* (1969); A. Chastel (ed.): *Seurat. Tout l'œuvre peint* (1973)

Shayer William, b. Southampton 1788, d. Shirley (nr Southampton) 1879. Prolific painter of rustic genre, woodland views and coastal scenes. He exhibited mostly at the Society of British Artists, Suffolk Street. The New Forest with its gypsies and peasants remained his main theme throughout life. There are works in Brooklyn, Leicester, London (Guildhall, V&A), New Orleans, Sunderland, Worcester and York.

Shee Sir Martin Archer, b. Dublin 1769, d. Brighton 1850. English portrait painter. His portraits of actors and actresses in famous roles first brought him to the public's notice (*c.* 1790). He studied in Dublin and at the ROYAL ACADEMY Schools and was befriended by Reynolds. He became an ARA in 1798 and an RA in 1800. In 1830 he succeeded LAWRENCE as president of the Royal Academy and received a knighthood. There are works in Baltimore (Mus. of Art), Chicago, Dublin, Glasgow, Liverpool, London (NG, NPG), New York (Met.) and Salford.
Lit. M. A. Shee Jr: *The Life of Sir M. Archer Shee* (1860)

Sickert Walter Richard, b. Munich 1860, d. Bathampton 1942. Painter of landscape, townscape and intimate glimpses of daily life. He was a friend of DEGAS and his work provides one of the few links between England and IMPRESSIONISM. He worked generally in dark tones, exploiting the glitter of occasional bright splashes of light. After studying at the Slade art school, he worked under WHISTLER (1882-3). In 1883 he took Whistler's painting of *The Artist's Mother* for exhibition in France, where he met Degas. He was a member of the NEW ENGLISH ART CLUB, but only achieved fame in the 20C. There are works in Dieppe, Liverpool, London (Tate, Courtauld), Melbourne, New York (Mod. Art), Ottawa, Rouen, Sydney and Toledo Ohio.
Lit. Sir J. Rothenstein: *W. R. Sickert* (1961); M. Lilly: *Sickert: The Painter and his Circle* (1971); W. Baron: *Sickert* (1973); D. Sutton: *W. Sickert, a Biography* (1976)

Signac Paul, b. Paris 1863, d. Paris 1935. SEURAT's collaborator and propagandist in the development of a 'science' of painting, of which the most influential feature was POINTILLISM. He first exhibited in 1884 at the SALON DES INDÉPENDANTS, where he met Seurat who was exhibiting *Baignade*. Signac

influenced Seurat, who brightened his palette, while Seurat expounded his scientific theory of colour. Together with C. and L. PISSARRO, they exhibited Pointillist paintings in the last Impressionist group exhibition of 1886, provoking a storm of criticism. In the late 1880s Signac and Seurat worked closely with Charles Henry on his theories of expressive line founded on geometry. Signac travelled widely, often recording in watercolour his impression of scenes visited, and showing a particular attachment to rivers and harbours. In 1899 he published *D'Eugène Delacroix au neo-impressionisme*, expounding the theories of the Pointillists. There are works in Baltimore (Mus. of Art), Berlin, Cambridge Mass. (Fogg), Chicago, Detroit, Essen, Grenoble, Krefeld, Lyons, Minneapolis, New York (Met., Brooklyn) and Paris (Louvre, Mod. Art).
Lit. G. Besson: *P. Signac* (1935); G. Besson: *P. Signac: Dessin* (1950); F. Cachin: *P. Signac* (1970); E. W. Kornfeld, P. A. Wick: *Catalogue raisonné de l'œuvre gravé et lithografié de P. Signac* (1974)

Signorini Telemaco, b. Florence 1835, d. Florence 1901. Artist and writer, the leader and chief propagandist of the MACCHIAIOLI. He painted landscape, scenes of war, and scenes of contemporary life which he approached in a reformist spirit (*Insane Ward* 1865); like COURBET, he was influenced by the ideas of the socialist philosopher Proudhon. He briefly attended the Florence Academy and painted some conventional historical canvases. He was quick to appreciate the new REALIST ideas brought back from Paris in 1855 by MORELLI, Altamura and DE TIVOLI, the rejection of outline and finish in favour of colour and chiaroscuro, and was a member of the group of Macchiaioli who met at the Caffè Michelangelo to discuss the new approach to painting. He joined the freedom fighters in 1859 and painted several pictures of their campaigns. In 1861 he visited Paris, meeting COROT and TROYON. During the 1860s, painting outdoors along the banks of the Arno with BORRANI, Cabianca, de Tivoli and others (the SCHOOL OF PERGENTINA), he developed a luminous and freshly observed landscape style. In 1867 he founded a magazine with Diego Martelli, the *Gazettino delle arti del disegno*, and during 1870-2 worked with DE NITTIS in Rome and Naples.

In the following years he visited Paris several times, making the acquaintance of DEGAS, and was also in London and Scotland. He worked extensively in watercolour as well as in oil. There are works in the galleries of modern art of Florence, Milan, Naples (Capodimonte), Rome, Turin and Venice.
Lit. U. Ojetti: *T. Signorini* (1930); F. Somaré: *T. Signorini* (1931)

Sisley Alfred, b. Paris 1839, d. Moret-sur-Loing 1899. IMPRESSIONIST landscape painter. He was a close friend of MONET, by whom he was strongly influenced, although he retained an individual vision, both poetic and intimate. His central aim, to interpret the mood and character of the scene he painted, was never subordinated to the interests of visual experiment. He moved from dark-toned landscapes to airy sunlit views, and finally built his pictures as a tapestry of bright short brushstrokes. He was particularly successful in his treatment of water and snow. Destined for commerce by his English parents, he was sent to England in 1857 but returned to Paris to study art. He worked under GLEYRE (1860-3) with Monet, RENOIR and BAZILLE, becoming their close associate. His early work was strongly influenced by COROT and DAUBIGNY; he exhibited at the SALON (1866-70) as a pupil of Corot. In 1870 his family was financially ruined and he fled to London to avoid the Franco-Prussian War. He exhibited in the first three Impressionist Group Shows (1874, 1876, 1877) and again in 1882. The landscapes of 1872-80, painted in the countryside round Paris under Monet's influence, are generally considered his finest work. After 1870 he lived in extreme poverty. There are works in most galleries of modern art, including Aberdeen, Boston, London (Tate, Courtauld), Paris (Louvre) and Washington (NG).
Lit. G. Geffroy: *Sisley* (1927); F. Daulte: *Sisley, catalogue raisonné de l'œuvre peint* (1959) and *Les Paysages de Sisley* (1961); J. Leymarie, M. Melot: *Les Gravures des Impressionists: Oeuvre complet* (1971); F. Daulte: *A. Sisley* (1972)

Sketching Society. The name is used to refer to three successive and closely linked British clubs that operated from 1799 to 1851. The members met one evening a week in the house of one of their number, the president for the evening, and each sketched

Signac *Banks of the Seine at Herblay* 1889

Signorini *Insane Ward* 1865

Sisley *Wooden Bridge at Argenteuil* 1872

a given subject, ending the evening with 'simple fare' and ale; the drawings became the property of the president. The first society called themselves 'The Brothers' and included Thomas Girtin and Louis Francia; their aim was to establish a 'School of Historic Landscape', and descriptive passages from famous poets were taken as subjects. The origin of the second society is obscure but it was in existence in 1802, became known as 'Cotman's Drawing Society', and included among its members COTMAN, P. S. and W. Munn, W. F. and J. VARLEY and J. Cristall. In 1808 it took its third and definitive form, 'The Society for the Study of Epic and Pastoral Design', founded by J. J. and A. E. Chalon, which later became known as the 'Bread and Cheese Society' and 'The Chalon Sketching Society'. There were to be at most eight members and one visitor (later two) would be invited each week; they met every Wednesday from November to May. The early landscape orientation shifted towards historical figure subjects taken generally from classical literature, Milton, Shakespeare or the Bible. LESLIE and STAN-FIELD were both long-standing members, while the many visitors included TURNER, CONSTABLE, MACLISE and LANDSEER.

Skovgaard Peter Christian Thamsen, b. Hofe Hammershus (Ringsted) 1817, d. Copenhagen 1875. Landscape painter who continued the tradition of his short-lived friends KØBKE and LUNDBYE, becoming Denmark's leading landscapist in the 1850s and 1860s. He was a REALIST, and his paintings are characterized by cool clarity and architectural composition. He studied with Lund and at the Copenhagen Academy, and visited Italy in 1854-5 and 1869. From 1847 he lived in the park outside the old ramparts of Copenhagen, which he constantly painted. His sons Joakim and Niels were also successful painters. There are works in Copenhagen (Hirschsprung, Ny Carlsberg Glyptotek, State).
Lit. K. Madsen: *P. C. Skovgaard og hans Sonner* (1918); H. Bramsen: *Malerier af P. C. Skovgaard* (1938)

Slevogt Max, b. Landshut 1868, d. Neukastel 1932. One of the leading German IMPRESSIONISTS, with LIEBERMANN and CORINTH.

His early work was much influenced by LEIBL and BÖCKLIN, the latter's influence showing particularly in his historical paintings (*The Angel Appearing to Joseph*, *Salome* 1895). He turned fully to Impressionist colour and brushwork *c.* 1900, principally under the influence of MANET (*Portrait of the Singer d'Andrade* 1902). Like the French Impressionists he painted portraits, landscape and scenes from contemporary life, but even after 1900 he frequently returned to poetic or narrative themes. He received several fresco commissions in these years, the most important being his *Golgotha* in the Friedenskirche at Ludwigshafen. He studied at the Munich Academy under DIEZ, worked at the ACADÉMIE JULIAN in Paris in 1889 and visited Italy in 1889-90. His Impressionist style came to maturity during the ten years he lived in Munich (1890-1900); he also contributed illustrations to *Jugend* and *Simplizissmus*. He moved to Berlin in 1901, joining the SECESSION movement. He received his first fresco commission in 1912 and was appointed a professor at the Berlin Academy in 1917. He travelled widely, visiting Egypt in 1913-14. There are works in Berlin, Munich and most German provincial museums, and also in Amsterdam, The Hague, Paris and Vienna (Kunsthistorisches Mus.).
Lit. E. Waldmann: *M. Slevogt* (1923); W. von Alten: *M. Slevogt* (1926); H. J. Imiela: *M. Slevogt* (1968)

Slewinski Wladyslaw, b. Bialynin-on-Pilica 1854, d. nr Paris 1918. Polish painter of seascapes, flower pieces, peasant life and portraits in a style greatly influenced by GAUGUIN and the PONT-AVEN SCHOOL. He began to paint seriously late in life, after meeting Gauguin on a visit to Paris in 1888; he spent his summers from 1890 to 1895 in Le Pouldu, Brittany, and settled there in 1896. On his return to Poland, he taught at the Warsaw School of Fine Arts (1905-9). His masterpiece is *Woman Combing her Hair* (1904). There are works in Bromberg, Cracow, Katowice, Poznań and Warsaw (Nat. Mus.).
Lit. W. Jaworska: *Gauguin, Slewinski, Makovski* (1957)

Société des Artistes Français see FRENCH ART ESTABLISHMENT

Société Nationale des Beaux-Arts see FRENCH ART ESTABLISHMENT

Sohn Carl Friedrich, b. Berlin 1805, d. Cologne 1867. Düsseldorf portraitist and history painter, taking his themes most often from Tasso and other Italian poets. He employed clear bright colours and careful finish; his composition owed a debt to the theatre while his figures were graceful and idealized. A technically accomplished artist, he was also an influential teacher. He studied at the Berlin Academy with SCHADOW, moved with him to Düsseldorf in 1826, and visited Italy with him in 1830. His popularity as a portraitist was at its height between 1840 and 1860. He taught at the Düsseldorf Academy 1832-55 and 1859-67; FEUERBACH was among his pupils. There are works in Aachen, Berlin, Bonn, Bremen, Cologne, Düsseldorf, Frankfurt/M., Karlsruhe, Leipzig, Mannheim, Oslo (NG) and Poznań.

Sperl Johann, b. Buch (nr Fürth) 1840, d. Aibling 1914. Landscapist, the constant companion of LEIBL after he retired from Munich to work in the Bavarian countryside. His landscapes are painted with simple REALISM, the brushwork becoming progressively looser and more IMPRESSIONIST. After studying at the Nuremberg Art School (1860-3), he worked under Anschütz and von Ramberg at the Munich Academy (from 1865), where he first met Leibl. His first paintings were peasant genre scenes; the work of COURBET and the BARBIZON SCHOOL shown at the 1869 Munich International Exhibition led him to take up landscape, mainly small paintings sketched freely from nature. He lived with Leibl in Unterschondorf (1875), Berbling (1878), Aibling (1881) and Kutterling (1892); Leibl painted figures in several of his landscapes. There are works in Berlin, Bremen, Cologne, Frankfurt/M., Halle, Hamburg, Hanover, Leipzig, Munich, Nuremberg, Stuttgart, Venice and Wuppertal.
Lit. E. Diem: *J. Sperl* (1955)

Spitzweg Carl, b. Munich 1808, d. Munich 1885. Humorous genre and landscape painter whose scenes of middle-class life are painted with carefully observed realism; his loose brushwork and mastery of colour place him among the REALIST forerunners of IMPRES-

SIONISM. He is also claimed as one of the greatest German BIEDERMEIER painters The son of a prosperous merchant, he came late to painting after visiting Bad Sulz for his health in 1833 and meeting a group of artists with whom he made his first painterly experiments. The encouragement of C. H. Hannson determined him to become a painter, and he taught himself by copying 17C Dutch masters with advice from his friends Hannson, MORGENSTERN, LANGKO and SCHLEICH. In 1844 he began to contribute illustrations to the *Fliegende Blätter*; he painted small genre scenes with clear outline and careful finish, described by Uhde-Bernays as 'painted drawings', notably *The Poor Poet* (1839). In 1850 he visited Venice and in 1851 Paris, London and Belgium. The crucial influence of DELACROIX and the BARBIZON SCHOOL, especially DIAZ, on his technique as a colourist dates from this period. The focus of his art shifted from storytelling to a faithful visual rendering of impressions. He left over a thousand pictures, often painting several versions of a popular composition. While his small genre scenes were popular during his lifetime, his serious reputation as a colourist came with the 20C. There are works in Aachen, Berlin, Berne, Bremen, Wrocław, Karl-Marx-Stadt, Darmstadt, Dresden, Frankfurt/M., Freiburg, Halle, Hamburg, Hanover, Heidelberg, Leipzig, Magdeburg, Mannheim, Munich (N. Pin., Schack), Nuremberg, Prague, Riga, Stuttgart, Ulm, Vienna (Kunsthistorisches Mus.), Wuppertal and Zurich *(see colour illustration 17)*
Lit. H. Uhde-Bernays: *C. Spitzweg, des Meisters Leben und Werk* (1935); A. Elsen: *C. Spitzweg* (1948); G. Roennefahrt: *C. Spitzweg, Beschreibendes Verzeichnis seiner Gemälde, Ölstudien und Aquarelle* (1960); S. Wichmann: *C. Spitzweg – Der Maler, der Zeichner* (1968); H. Weiss: *C. Spitzweg* (1972)

Sporting School, English. The life style of English country gentlemen with their interest in hunting, racing and other outdoor sports brought into existence a school of sporting painters. They would immortalize a gentleman's favourite hunters and race-horses in paint, as well as depicting them in the field and on the course. The school began life in the early 18C with some pleasantly naïve painters such as James Seymour,

Skovgaard *Landscape near Kongens Møller* 1844

Spitzweg *The Departure*

Slevogt *The Victor (Prizes of War)* 1912

Sohn *Girl with a Rose c.* 1860

Stanfield *Off the Dogger Bank* 1846

Steinle *Adam and Eve* 1867

produced one outstanding genius in George Stubbs, and flourished in the 19C with several families specializing in the genre, making it, as it were, into a family business – notably the FERNELEYS, Alkens, HERRINGS and POLLARDS. MARSHALL was another distinguished exponent of the school. The popularity of sporting prints made after their paintings made this a lucrative branch of art.
Lit. W. S. Sparrow: *British Sporting Artists* (1922); S. H. Pavière: *Dictionary of British Sporting Painters* (1965)

Springer Cornelis, b. Amsterdam 1817, d. Hilversum 1891. Painter of architectural and town views in the traditional Dutch manner. A pupil of H. G. van der Stok and H. G. ten Kate, he became a member of the Rotterdam Academy and knight of the Belgian Order of Leopold. There are works in Amsterdam (Rijksmuseum, Stedelijk), Bremen, Brussels, Cheltenham, Cologne, Dordrecht, Haarlem (Teyler), Leeuwarden, Rotterdam (Boymans) and Vienna.

Stäbli Adolf, b. Winterthur 1842, d. Munich 1901. Swiss landscape painter, one of the pioneers of STIMMUNGSLANDSCHAFT in Munich, where he made his home. The son of a drawing teacher and engraver, Diethelm Stäbli, he studied in Zurich with R. KOLLER (1859-62) and with SCHIRMER in Karlsruhe (1862-3), where he formed a close friendship with THOMA. In Paris (1866-7) his style was definitively influenced by the BARBIZON SCHOOL, especially DAUBIGNY. In 1868 he settled in Munich, where he was a friend of LIER. There are works in Aarau, Hanover, Munich (N. Pin.), Winterthur and Zurich.
Lit. H. Graber: *A. Stäbli* (1916)

Stanfield William Clarkson, b. Sunderland 1793, d. London 1867. Marine painter and landscapist. Both inhibited and inspired by the towering genius of his contemporary TURNER, he was nevertheless highly regarded by his contemporaries and won a gold medal at the 1855 EXPOSITION UNIVERSELLE. After spending his early years at sea, he came to easel painting via theatrical scene-painting, often in collaboration with his lifelong friend ROBERTS. An ARA in 1832, he became an RA in 1835. There are works in Cambridge, Dublin, Hamburg, Leicester, London (Tate,

V&A, Wallace), Manchester, Melbourne, Preston, Sheffield and Sunderland.
Lit. J. Dafforne: *C. Stanfield* (1873)

Stanislawski Jan Grzegorz, b. Olszana (Ukraine) 1860, d. Kiev 1907. Polish painter of small bright landscapes, mostly of Poland, the Ukraine and Italy, with a strong debt to MONET. He studied in Warsaw, Cracow and Paris under CAROLUS-DURAN (1885-8). He helped found the Stzuka ('Art') movement, the Cracow Secessionist group, in 1897. He was a professor at the Cracow Academy from 1897 and an influential teacher. There are works in Cracow, Lvov, Warsaw and Vienna.

Stark James, b. Norwich 1794, d. London 1859. Landscape painter and watercolourist of the NORWICH SCHOOL. He studied with CROME (1811-14) and entered the ROYAL ACADEMY Schools in 1817. He divided his working life mainly between Norwich, Yarmouth and London. His son Arthur James was also a landscape painter. There are works in Edinburgh, Glasgow, London (V&A, Tate), Manchester, Montreal (Learmont), New York (Met.), Nottingham and Sheffield.

Steer Philip Wilson, b. Birkenhead 1860, d. London 1942. With SICKERT, one of the first 'English Impressionists', providing a link between British and French painting. He painted landscape, genre and portraits which owe a debt to the English tradition of CONSTABLE, TURNER and Gainsborough as well as to IMPRESSIONISM. He studied at Gloucester Art School, and in Paris at the ACADÉMIE JULIAN and the ECOLE DES BEAUX-ARTS (1882-4). He was a founder member of the NEW ENGLISH ART CLUB in 1885 and contributed to the London Impressionists exhibition at the Goupil Gallery in 1889. He turned increasingly to landscape after 1900 and taught at the Slade for forty years. There are works in Aberdeen, Bradford, Cambridge (Fitzwm), Leeds, Liverpool, London (Tate), Manchester, Ottawa and Southampton.
Lit. R. Ironside: *W. Steer* (1943); D. S. MacColl: *Life, Work and Setting of P. W. Steer* (1945); B. Laughton: *P. W. Steer* (1971)

Steffan Johann Gottfried, b. Wädenswil (Zurich) 1815, d. Munich 1905. Swiss

painter who settled in Munich and made a reputation with his picturesque Alpine landscapes; he has been called the 'German CALAME'. He studied lithography in Wädenswil and entered a Munich lithographic firm while he studied painting with Zimmerman and RAMBERG; he turned wholly to landscape painting c. 1840. His work was influenced by the classical landscapes of ROTTMANN. He visited Italy in 1845 and Paris in 1855. FRÖHLICHER studied with him, as did BÖCKLIN for a short time. There are works in Basle (Kunstmuseum), Berlin, Berne, Bremen, Dresden, Leipzig and Munich.

Steinle Edward Jakob von, b. Vienna 1810, d. Frankfurt 1886. Known as the 'last NAZARENE', he carried their fresco tradition and medieval style of religious painting into a new generation; his reputation as a teacher and sensitive draughtsman persuaded the young LEIGHTON to study in Frankfurt. Under the influence of SCHWIND he executed some charming fairy-story illustrations. After studying at the Vienna Academy with V. G. Kininger, he went to Rome (1828) where he became the pupil and assistant of OVERBECK. He returned to Vienna in 1833 and moved in 1838 to Munich, where he worked on frescoes with CORNELIUS. In Frankfurt (1841) he was given a studio at the Städelische Institut by VEIT and became professor of history painting there in 1850. He was knighted ('von') in 1879. There are works in Basle (Kunstmuseum), Berlin, Cologne, Düsseldorf, Frankfurt/M., Hamburg, Innsbruck, Mannheim, Munich (Schack), Szczecin, Vienna, Weimar and Worms.
Lit. A. M. von Steinle: *E. Steinles Briefwechsel mit seinen Freunden* (1897); J. Popp: *E. von Steinle* (1906)

Stevens Alfred Emile Léopold, b. Brussels 1823, d. Paris 1906. Belgian artist who painted the Parisian ladies of his time about their daily occupations, with fine observation and wholly objective REALISM. His work was distinguished by a technical mastery of colour and a still-life painter's delight in rendering dress and accessories, all the appurtenances of *le chic*. His work was immensely popular, particularly in the 1860s and 1870s, while in 1900 he was the first living artist to be accorded a retrospective

exhibition at the ECOLE DES BEAUX-ARTS, including 180 paintings. He pioneered scenes of elegant middle-class life as a subject for art and was a close friend and supporter of MANET. With WHISTLER and BRACQUEMOND he was one of the first Parisian enthusiasts for Japanese art. In the late 1870s and 1880s he moved towards a free, almost IMPRESSIONIST brushwork; this is particularly marked in his little seascapes painted after 1880. He studied with NAVEZ at the Brussels Academy; the influence of the BELGIAN COLOURISTS as well as the carefully observed history paintings of LEYS can be detected in his work. In 1844 he moved to Paris and entered the Ecole des Beaux-Arts. From 1849 he shared a studio with WILLEMS. He exhibited history paintings at the SALON from 1853 but in 1855 showed his first painting of contemporary life (*What is Called Vagrancy*). Famous works such as *Tous les Bonheurs* (1861) and *La Dame en Rose* (1866) followed. He became a chevalier of the Legion of Honour in 1863, an officer in 1867 and a commander in 1878. His younger brother Arthur was an influential art critic and dealer, advising King Leopold of Belgium on his collection. There are works in Amsterdam, Antwerp, Baltimore (Mus. of Art, Walters), Boston, Brussels (Musées Royaux), Cambridge (Fitzwm), Cardiff, Chicago, Cincinnati, Cologne, Ghent, The Hague, Leningrad, Munich, New York (Met.), Philadelphia, Stockholm and Washington (NG). *(see colour illustration 26)*
Lit. C. Lemonnier: *A. Stevens et son œuvre* (1906); G. van Zype: *Les Frères Stevens* (1936); J. L. Broeck: *A. Stevens en zijn 'Impressions sur la peinture'* (1943)

Stevens Joseph Edouard, b. Brussels 1819, d. Brussels 1892. Genre and animal painter, the elder brother of A. STEVENS. He was a technically accomplished REALIST but devoted his best energies to the depiction of animals, particularly dogs, cats, monkeys and horses. *Dog's Work*, which shows dogs as working animals struggling with a heavy load of sand, has something of the reformist zeal which COURBET applied to his paintings of peasants and workers. He studied with L. Robbe and divided his working life between Paris and Brussels. In his own day his work was as famous as that of his brother Alfred. He received the Legion of Honour in

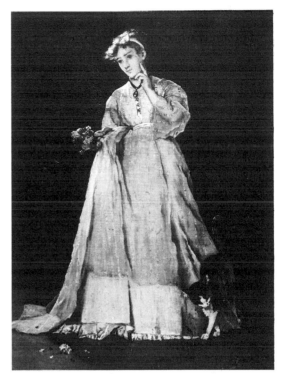

A. E. L. Stevens *Ophelia*

J. E. Stevens *The Dog at the Mirror*

Stieler *Amalie von Schintling* 1831

Stuart *George Washington* 1796

1861, and the Order of Leopold of Belgium in 1863. There are works in Antwerp, Brussels (Musées Royaux), Hamburg, Marseilles, New York (Met.), Rouen, Stuttgart and Tournai.
Lit. A. d'Inghuen: *J. Stevens* (1905); G. van Zype: *Les Frères Stevens* (1936)

Stieler Josef Karl, b. Mainz 1781, d. Munich 1858. German portrait painter whose style derived from the example of GÉRARD, with whom he studied in Paris: strong outline and modelling, clear colours and smooth finish. He tended to idealize his sitters, romantically accentuating beauty. His most famous work was the *Schönheitsgalerie*, a series of portraits painted for Ludwig I of women selected by the King for their exceptional beauty. He started his career as a miniaturist, studying at Vienna with FÜGER (1800) before working with Gérard in Paris (1807–8), and spending 1811–12 in Rome. He worked for Maximilian I in Munich (1812–16) and returned to settle there in 1820 after spending a few years in Vienna. He was appointed court painter by Ludwig I and was a co-founder of the Munich KUNSTVEREIN in 1824. His portrait style was a formative influence on WINTERHALTER. There are works in Augsburg, Berlin, Copenhagen (Thorwaldsen), Hamburg, Heidelberg, Munich (N. Pin., Residenz), Stuttgart and Vienna.
Lit. H. A. Thies: *König Ludwig I und die Schönheiten seiner Galerie* (1954); V. von Hase: *J. Stieler, 1781–1858: sein Leben und sein Werk* (1971)

Stifter Adalbert, b. Oberplan (Bohmerwald) 1805, d. Linz 1868. Austrian poet, art critic and self-taught painter. He was in close sympathy with the BIEDERMEIER painters' concentration on 'the greatness of little things', but his painterly achievement was strictly individual. During his stay in Vienna (1826–48), he painted brightly coloured sketches of landscape and townscape which are often compared with the early naturalistic sketches of WASMANN, DAHL and MENZEL. In Linz, where he settled from 1849, he painted romantic-symbolic landscapes entitled *Movement, Rest, Solemnity*, etc. There are works in Linz, Prague and Vienna (Belvedere).
Lit. F. Novotny: *A. Stifter als Maler* (1941)

Stimmungslandschaft. This term, literally 'landscape of mood', describes the school of landscape painting which developed in Germany under the influence of the French BARBIZON SCHOOL. Though the technical debt to France is clear, the German painters were not content to paint nature as it is; they looked for its poetry, music, 'mood'. Munich was the centre of the movement; SCHLEICH and LIER (who had great influence as a teacher) were among the pioneers. THOMA, who has been called the father of Stimmungslandschaft, although his poetic vision was also applied to portraits, genre and still life, influenced the Swiss painters FRÖHLICHER and STÄBLI. Two other distinguished painters, TRÜBNER and HAIDER, had strong links with the school, and its influence was felt in America, Russia and most of northern Europe. There are strong parallels between the Munich school and the GLASGOW BOYS, who were enthusiastically welcomed when they exhibited in Munich in 1890.

Stone Marcus, b. London 1840, d. London 1921. Genre painter much admired at the turn of the century. Most of his paintings depict the trials of young lovers (*Rejected, A Stolen Kiss*); full of narrative sentiment, they are generally dressed in the style of the rococo or Directoire periods. He was an ARA in 1876 and an RA in 1886. *Il y a toujours un autre* was bought by the CHANTREY BEQUEST in 1882. There are works in Blackburn, Glasgow, Liverpool, London (Tate, Guildhall), Manchester, Nottingham, Sheffield, Sydney and York.

Stuart Gilbert, b. North Kingstown (R.I.) 1755, d. Boston (Mass.) 1828. America's most celebrated portraitist at the turn of the 18C. His early portraits are realistic, linear and slightly naïve, depicting the sitter in unpretentious surroundings in the colonial manner. In London the example of the English school (Reynolds, Gainsborough *et al.*) taught him a free fluent brushwork and colouristic *bravura*; he avoided elaborate backgrounds, concentrating on catching an animated and lifelike image of his sitter. His unfinished head of *George Washington* (1796) is probably the best-known image of America's first president; he made over seventy copies. He also executed half-length (1795) and full-length (1796) Washington portraits. His first teacher was Cosmo Alexander, an

painter who settled in Munich and made a reputation with his picturesque Alpine landscapes; he has been called the 'German CALAME'. He studied lithography in Wädenswil and entered a Munich lithographic firm while he studied painting with Zimmerman and RAMBERG; he turned wholly to landscape painting *c.* 1840. His work was influenced by the classical landscapes of ROTTMANN. He visited Italy in 1845 and Paris in 1855. FRÖHLICHER studied with him, as did BÖCKLIN for a short time. There are works in Basle (Kunstmuseum), Berlin, Berne, Bremen, Dresden, Leipzig and Munich.

Steinle Edward Jakob von, b. Vienna 1810, d. Frankfurt 1886. Known as the 'last NAZARENE', he carried their fresco tradition and medieval style of religious painting into a new generation; his reputation as a teacher and sensitive draughtsman persuaded the young LEIGHTON to study in Frankfurt. Under the influence of SCHWIND he executed some charming fairy-story illustrations. After studying at the Vienna Academy with V. G. Kininger, he went to Rome (1828) where he became the pupil and assistant of OVERBECK. He returned to Vienna in 1833 and moved in 1838 to Munich, where he worked on frescoes with CORNELIUS. In Frankfurt (1841) he was given a studio at the Städelische Institut by VEIT and became professor of history painting there in 1850. He was knighted ('von') in 1879. There are works in Basle (Kunstmuseum), Berlin, Cologne, Düsseldorf, Frankfurt/M., Hamburg, Innsbruck, Mannheim, Munich (Schack), Szczecin, Vienna, Weimar and Worms.
Lit. A. M. von Steinle: *E. Steinles Briefwechsel mit seinen Freunden* (1897); J. Popp: *E. von Steinle* (1906)

Stevens Alfred Emile Léopold, b. Brussels 1823, d. Paris 1906. Belgian artist who painted the Parisian ladies of his time about their daily occupations, with fine observation and wholly objective REALISM. His work was distinguished by a technical mastery of colour and a still-life painter's delight in rendering dress and accessories, all the appurtenances of *le chic*. His work was immensely popular, particularly in the 1860s and 1870s, while in 1900 he was the first living artist to be accorded a retrospective

exhibition at the ECOLE DES BEAUX-ARTS, including 180 paintings. He pioneered scenes of elegant middle-class life as a subject for art and was a close friend and supporter of MANET. With WHISTLER and BRACQUEMOND he was one of the first Parisian enthusiasts for Japanese art. In the late 1870s and 1880s he moved towards a free, almost IMPRESSIONIST brushwork; this is particularly marked in his little seascapes painted after 1880. He studied with NAVEZ at the Brussels Academy; the influence of the BELGIAN COLOURISTS as well as the carefully observed history paintings of LEYS can be detected in his work. In 1844 he moved to Paris and entered the Ecole des Beaux-Arts. From 1849 he shared a studio with WILLEMS. He exhibited history paintings at the SALON from 1853 but in 1855 showed his first painting of contemporary life (*What is Called Vagrancy*). Famous works such as *Tous les Bonheurs* (1861) and *La Dame en Rose* (1866) followed. He became a chevalier of the Legion of Honour in 1863, an officer in 1867 and a commander in 1878. His younger brother Arthur was an influential art critic and dealer, advising King Leopold of Belgium on his collection. There are works in Amsterdam, Antwerp, Baltimore (Mus. of Art, Walters), Boston, Brussels (Musées Royaux), Cambridge (Fitzwm), Cardiff, Chicago, Cincinnati, Cologne, Ghent, The Hague, Leningrad, Munich, New York (Met.), Philadelphia, Stockholm and Washington (NG). *(see colour illustration 26)*
Lit. C. Lemonnier: *A. Stevens et son œuvre* (1906); G. van Zype: *Les Frères Stevens* (1936); J. L. Broeck: *A. Stevens en zijn 'Impressions sur la peinture'* (1943)

Stevens Joseph Edouard, b. Brussels 1819, d. Brussels 1892. Genre and animal painter, the elder brother of A. STEVENS. He was a technically accomplished REALIST but devoted his best energies to the depiction of animals, particularly dogs, cats, monkeys and horses. *Dog's Work*, which shows dogs as working animals struggling with a heavy load of sand, has something of the reformist zeal which COURBET applied to his paintings of peasants and workers. He studied with L. Robbe and divided his working life between Paris and Brussels. In his own day his work was as famous as that of his brother Alfred. He received the Legion of Honour in

A. E. L. Stevens *Ophelia*

J. E. Stevens *The Dog at the Mirror*

Stieler *Amalie von Schintling* 1831

Stuart *George Washington* 1796

1861, and the Order of Leopold of Belgium in 1863. There are works in Antwerp, Brussels (Musées Royaux), Hamburg, Marseilles, New York (Met.), Rouen, Stuttgart and Tournai.
Lit. A. d'Inghuen: *J. Stevens* (1905); G. van Zype: *Les Frères Stevens* (1936)

Stieler Josef Karl, b. Mainz 1781, d. Munich 1858. German portrait painter whose style derived from the example of GÉRARD, with whom he studied in Paris: strong outline and modelling, clear colours and smooth finish. He tended to idealize his sitters, romantically accentuating beauty. His most famous work was the *Schönheitsgalerie*, a series of portraits painted for Ludwig I of women selected by the King for their exceptional beauty. He started his career as a miniaturist, studying at Vienna with FÜGER (1800) before working with Gérard in Paris (1807–8), and spending 1811–12 in Rome. He worked for Maximilian I in Munich (1812–16) and returned to settle there in 1820 after spending a few years in Vienna. He was appointed court painter by Ludwig I and was a co-founder of the Munich KUNSTVEREIN in 1824. His portrait style was a formative influence on WINTERHALTER. There are works in Augsburg, Berlin, Copenhagen (Thorwaldsen), Hamburg, Heidelberg, Munich (N. Pin., Residenz), Stuttgart and Vienna.
Lit. H. A. Thies: *König Ludwig I und die Schönheiten seiner Galerie* (1954); V. von Hase: *J. Stieler, 1781–1858 : sein Leben und sein Werk* (1971)

Stifter Adalbert, b. Oberplan (Bohmerwald) 1805, d. Linz 1868. Austrian poet, art critic and self-taught painter. He was in close sympathy with the BIEDERMEIER painters' concentration on 'the greatness of little things', but his painterly achievement was strictly individual. During his stay in Vienna (1826–48), he painted brightly coloured sketches of landscape and townscape which are often compared with the early naturalistic sketches of WASMANN, DAHL and MENZEL. In Linz, where he settled from 1849, he painted romantic-symbolic landscapes entitled *Movement, Rest, Solemnity*, etc. There are works in Linz, Prague and Vienna (Belvedere).
Lit. F. Novotny: *A. Stifter als Maler* (1941)

Stimmungslandschaft. This term, literally 'landscape of mood', describes the school of landscape painting which developed in Germany under the influence of the French BARBIZON SCHOOL. Though the technical debt to France is clear, the German painters were not content to paint nature as it is; they looked for its poetry, music, 'mood'. Munich was the centre of the movement; SCHLEICH and LIER (who had great influence as a teacher) were among the pioneers. THOMA, who has been called the father of Stimmungslandschaft, although his poetic vision was also applied to portraits, genre and still life, influenced the Swiss painters FRÖHLICHER and STÄBLI. Two other distinguished painters, TRÜBNER and HAIDER, had strong links with the school, and its influence was felt in America, Russia and most of northern Europe. There are strong parallels between the Munich school and the GLASGOW BOYS, who were enthusiastically welcomed when they exhibited in Munich in 1890.

Stone Marcus, b. London 1840, d. London 1921. Genre painter much admired at the turn of the century. Most of his paintings depict the trials of young lovers (*Rejected, A Stolen Kiss*); full of narrative sentiment, they are generally dressed in the style of the rococo or Directoire periods. He was an ARA in 1876 and an RA in 1886. *Il y a toujours un autre* was bought by the CHANTREY BEQUEST in 1882. There are works in Blackburn, Glasgow, Liverpool, London (Tate, Guildhall), Manchester, Nottingham, Sheffield, Sydney and York.

Stuart Gilbert, b. North Kingstown (R.I.) 1755, d. Boston (Mass.) 1828. America's most celebrated portraitist at the turn of the 18C. His early portraits are realistic, linear and slightly naïve, depicting the sitter in unpretentious surroundings in the colonial manner. In London the example of the English school (Reynolds, Gainsborough *et al.*) taught him a free fluent brushwork and colouristic *bravura*; he avoided elaborate backgrounds, concentrating on catching an animated and lifelike image of his sitter. His unfinished head of *George Washington* (1796) is probably the best-known image of America's first president; he made over seventy copies. He also executed half-length (1795) and full-length (1796) Washington portraits. His first teacher was Cosmo Alexander, an

itinerant Scottish painter with whom he visited Scotland in 1771-2. On his return to America (1773) he began to make a living from his portraits. In England (from 1775) lack of work and alcoholism led him into severe financial difficulties, from which he was rescued by WEST with whom he studied 1777-82. He ran a successful London studio (1782-7) but debts forced his removal to Dublin (1787-92) and his return to America (1793), where he set up a studio in New York. He subsequently worked in Philadelphia (1794-6), Washington (1803-5) and Boston (1805-28). His fame spread throughout the country and students flocked to his studio. His son Charles Gilbert was also a painter. There are works in many American museums, including Baltimore (Mus. of Art), Boston, New York (Met.) and Washington (NG, Corcoran), and in London (Tate, NPG).
Lit. J. H. Morgan: *G. Stuart and his Pupils* (1939); J. T. Flexner: *G. Stuart* (1955); C. M. Mount: *G. Stuart, a Biography* (1964)

Stuck Franz von, b. Tettenweis 1863, d. Tetschen 1928. German SYMBOLIST painter, one of the most fêted Munich artists of the turn of the 19C. His work was heavily influenced by the mythological scenes of BÖCKLIN, but contained a *fin de siècle* tone of mystery and evil (*Battle of the Fauns* 1889, *Medusa* 1903, *Bacchanal* 1905). His study of the applied arts gave him a strong sense of decorative effect, and he was an outstanding draughtsman. After attending the Munich School for the Applied Arts (1882-4), he turned to painting and studied under Lindenschmit at the academy (1885), where he paid scant attention to his formal studies but was strongly influenced by DIEZ, Böcklin and LENBACH. He first earned his living with humorous illustrations and engravings, having his first major success with *Warder of Paradise* in 1889. A founder member of the Munich SECESSION, he later became its president; he became a professor at the Munich Academy (1895), was knighted ('von') (1906) and was an honorary member of the academies of Berlin, Dresden, Vienna, Milan and Stockholm. There are works in many German museums and in Brussels, Lucerne, Rome, Trieste, Venice and Zurich.
Lit. F. von Ostini (ed.): *Das Gesamtwerk F. von Stucks* (1909); G. Nicodemi: *F. von Stuck* (1936); H. Voss: *F. von Stuck* (1973)

Sully Thomas, b. Horncastle (Lincs.) 1783, d. Philadelphia (Pa.) 1872. Portraitist who was strongly influenced by STUART and LAWRENCE, developing a fine fluent brushwork that made him the most popular portrait painter in America; he also painted some genre and historical pieces. His English parents settled in Charleston, S. Carolina, and he later (1801) joined his elder brother Lawrence, a miniature painter, in Virginia and began his professional career as a portraitist. In New York (1806) he studied with Jarvis and TRUMBULL before moving to Boston (1807) where he studied with Stuart. He worked with WEST in London (1809-10) and was greatly influenced by Lawrence. He settled in Philadelphia in 1810. The fashion for itinerant exhibitions led him (c. 1821) to make a large-scale copy of the *Capuchin Chapel* of GRANET, which then toured the country. He visited London in 1838 to paint the portrait of *Queen Victoria*. He left over 2,500 portraits. There are works in Albany, Baltimore (Mus. of Art), Boston, Chicago, Cincinnati, Concord Mass., Detroit, Kansas City, London (NPG, Wallace), New York (Brooklyn, Met., City Hall), Philadelphia, Toledo, Washington (NG, Corcoran) and West Point.
Lit. E. Biddle, M. Fielding: *Life and Works of T. Sully* (1921)

Surikov Vassili Ivanovich, b. Krassnojarsk 1848, d. Moscow 1916. Russian historical painter and portraitist, a member of the PEREDVIZHNIKI from 1881. He was the pioneer of nationalistic history painting, combining mysticism and REALISM in dramatically composed paintings; A. N. Benois compared his work with that of Dostoevski. He studied at the St Petersburg Academy (1870-5) and visited Germany, Italy and France in the early 1880s. His two most famous paintings are *Boyarinya Morosova on the Sledge* (1887) and *Morning of the Execution of the Streltsi* (1881-3). He worked with the Abramtsevo artistic community and became a member of the St Petersburg Academy in 1895. He fathered a school of Slavophile history painters. There are works in Leningrad (Russian Mus.) and Moscow (Tretiakov).
Lit. N. Shchekotov: *The Pictures of V. Surikov* (1944, in Russian); S. Gor, V. Petrov:

Stuck *The Sphinx* 1904

Sully *Lady with a Harp: Eliza Ridgely* 1818

Surikov *Boyarinya Morosova on the Sledge* 1887

Szinyei-Merse *The Picnic* 1873

V. Surikov (1935, in Russian); M. Deac: *Surikov* (1958)

Symbolism (Symbolist). A French literary movement of *c.* 1885–95, seeking (in reaction against NATURALISM) 'to clothe the idea in a sensitive form'. The Symbolist poets were disciples of Mallarmé and Verlaine and considered Baudelaire their precursor; the term Symbolism came to be used of the painters they admired (MOREAU, PUVIS DE CHAVANNES, REDON) and those with whom they collaborated (GAUGUIN, the SYNTHETISTS, the NABIS). In fact, from the 1860s there was a dichotomy in European art, with the REALISTS on one side aiming at a purely objective rendering of appearances, while other artists delved into the soul and imagination, seeking to give visual form to myth, dream, music and poetry. Their contemporaries distinguished the two camps as 'realists' and 'idealists'; the term idealism has now fallen into disuse and Symbolism has come to be used in its place. In this sense it comprises a broad international movement: the poetic medievalizing of ROSSETTI and BURNE-JONES, as well as G. F. WATTS, WHISTLER and MOORE, in England; the mysterious mythological landscapes of BÖCKLIN and his followers in Germany, notably VON STUCK in Munich; KLIMT in Vienna; ROPS, KHNOPFF and DELVILLE in Belgium; TOOROP in Holland; MUNCH in Norway; SEGANTINI in Italy.

Huysmans' *A Rebours* is considered the most important Symbolist novel, underlining the decadent overtones of the movement which found an influential visual parallel in the drawings of BEARDSLEY. The religious mysticism of the Sâr Péladan is another curious offshoot, artistically of considerable significance through his SALON DE LA ROSE + CROIX. The term Neo-Romanticism is also sometimes used to describe these developments in 19C art, emphasizing the continuity of imaginative painting throughout the century.

Lit. A. G. Lehmann: *The Symbolist Aesthetic in France 1885–1895* (1950); J. Milner: *Symbolists and Decadents* (1971); E. Lucie-Smith: *Symbolist Art* (1972)

Synthetism (Synthetist). Developed by GAUGUIN and BERNARD in Brittany in the late 1880s. It grew out of their experiments with CLOISONNISM; this style drew its inspiration from stained glass and *cloisonné* enamels, imitating on canvas the decorative effect achieved by areas of pure colour divided by dark arabesque outlines. They first painted peasant scenes in this manner; Synthetism describes the second phase in the evolution of the style, when they rejected realistic representation and drew instead on the pictorial memory in the attempt to present an 'idea' on the canvas.

Lit. H. R. Rookmaaker: *Synthetist Art Theories* (1959)

Szinyei-Merse Pál, b. Szinye-Ujfalu 1845, d. Jernye 1920. Hungarian artist whose most famous painting, *The Picnic* (1873), tackles the optical problems of *plein air* figure painting which concurrently preoccupied the IMPRESSIONISTS in France; he used clear bright colours and informal composition. The work was exhibited in Munich but the attacks of Hungarian critics caused him to retire to his country estate at Jernye and he did not exhibit again until 1894–5. He studied in Munich under DIEZ (1864) and PILOTY (1868). When he emerged from his seclusion in the 1890s he was taken up as the leader of the Hungarian modern (Nagybanya) school. In 1905 he was appointed director of the Budapest Academy. There are works in Budapest (Fine Arts, NG).

Lit. M. Rajnai: *Szinyei-Merse Pál* (1953); D. Pataky: *Pál Szinyei Merse* (1965)

T

Thoma Hans, b. Bernau (Black Forest) 1839, d. Karlsruhe 1924. German painter who achieved outstanding popularity in the late 19C and early 20C. The formative influences on his art were COURBET, MANET and the BARBIZON SCHOOL; in the 1860s and 1870s he painted landscapes, which combined intense REALISM with an echo of ROMANTIC storytelling, showing the influence of FRIEDRICH, SCHWIND and RICHTER. For this reason he has been called the father of STIMMUNGS-LANDSCHAFT (*Black Forest Landscape* 1867, *The Rhine near Laufenburg* 1870, *Singing Children* 1875). He also painted peasant scenes, still lifes and portraits. In his later work, which includes frescoes, oils, watercolours, lithographs and engravings, the Romantic element is dominant; he painted mythological landscapes in the manner of BÖCKLIN, fairy stories, idylls and Wagnerian themes, and it was this later manner that made him the most popular painter in Germany. He studied at the Karlsruhe Academy (1860–6) under SCHIRMER, moving to Düsseldorf in 1866. On a visit to Paris in 1868 he got to know the work of Courbet, COROT, Manet and the Barbizon painters. In 1870 he moved to Munich, where he was a friend of LEIBL, Böcklin and TRÜBNER. From 1876 to 1899 he lived in Frankfurt, though he had his first highly successful exhibition in Munich in 1890 and was a member of the Munich SECESSION. In 1899 he was appointed director of the Karlsruhe Academy. During the following years he was showered with honours and there were repeated exhibitions of his work throughout Germany. There are works in most German museums, and also in Basle (Kunstmuseum), Cambridge Mass. (Fogg), New York (Met.), Prague and Vienna (Kunsthistorisches Mus.).
Lit. H. Thode: *H. Thoma* (1909); H. Thoma: *Im Herbste des Lebens* (1909) and *Im Winter des Lebens* (1919); H. E. Busse: *H. Thoma: Leben und Werk* (1935)

Thorwaldsen Bertel, b. Copenhagen 1768, d. Copenhagen 1844. With CANOVA, one of the leading sculptors of the NEOCLASSICAL period. He studied at the Copenhagen Academy from 1781, winning a scholarship to study in Rome in 1796. He remained in Rome until 1838, except for a brief but triumphant visit to Denmark in 1819. His work was much in demand and he employed many assistants. Among his more famous works are *Venus with the Apple* (1813–16), *The Shepherd Boy* (1817), *The Lion of Lucerne* (1819–21), and *The Tomb of Pope Pius VII* (1824–31). The Thorwaldsen Museum in Copenhagen has a large collection of original sculptures, casts and copies and there are also works in Lucerne, Minneapolis, Naples and Rome (Accad. di San Luca, St Peter's).
Lit. P. O. Rave: *Thorwaldsen* (1944)

Tidemand Adolf Claudius, b. Mandel 1814, d. Oslo 1876. Norwegian painter of peasant genre scenes who dwelt with loving attention on the picturesque rustic details of fishermen's homes and ceremonies, in the highly finished style of the DÜSSELDORF SCHOOL. He studied under Lund at the Copenhagen Academy (1832–7) and in Düsseldorf until 1841. In 1842 he was awarded a grant to study in Italy for a year; he returned to Oslo for three years before settling in Düsseldorf in 1846, spending his summers in Norway. He was an associate of the Amsterdam, Berlin, Copenhagen, Dresden, Oslo, Stockholm and Vienna Academies. A prolific painter, he had considerable influence in Norway. There are works in Amsterdam, Bergen, Düsseldorf, Göteborg, Karlsruhe, Leipzig, Oslo (NG), Stockholm and Trondheim.
Lit. S. T. Madsen: *Den ukjente Tidemand* (1963)

Tischbein Johann Heinrich Wilhelm, b. Haina 1751, d. Eutin 1829. Known as Goethe-Tischbein or 'Neapolitan Tischbein', his major success was founded on portraits, notably *Goethe in the Campagna* (1786–8). His early work belongs to the rococo tradition; in the 1780s he was strongly influenced by NEOCLASSICISM, while after his return to

Thoma *The Rhine near Laufenburg* 1870

Tischbein *Goethe in the Campagna* 1786–8

Tissot *The Picnic* 1875

Toma *Rain of Ashes from Vesuvius* 1880

Toorop *Faith in Decline* 1894

Germany in 1800 he became involved with the younger generation of ROMANTICS. He worked at many German courts and was director of the Naples Academy from 1789 to 1799. He came of a large Hessian family of artists; his cousin, Johann Friedrich August Tischbein (1750-1812), known as the 'Leipzig Tischbein', was also a portraitist who travelled widely. While influenced by DAVID, Mengs and FÜGER, his style is closest to the English school. He was director of the Leipzig Academy from 1800 to 1812. There are works by both artists in most German museums, and in Baltimore (Walters) and Cambridge Mass. (Fogg).
Lit. J. H. W. Tischbein: *Aus meinem Leben* (1861); A. Stoll: *Der Maler J. F. A. Tischbein und seine Familie* (1923); J. W. von Goethe: *W. Tischbeins Idyllen* (new ed. 1970)

Tissot James Jacques Joseph, b. Nantes 1836, d. Buillon (Doubs) 1902. French genre painter who made his career in England from *c.* 1870. His paintings of elegant society life (*Ball on Shipboard, The Concert*) are closely linked to REALIST painting in France. He studied with L. Lamothe and FLANDRIN in Paris and began by painting historical genre influenced by LEYS before turning to scenes of contemporary life with a debt to MANET, STEVENS and WHISTLER. Shattered by the death of his mistress, Kathleen Newton, in 1882, he turned to biblical paintings and illustrations and spent ten years in the Holy Land. His 865 New Testament illustrations were published in 1896 (*La Vie de Notre Seigneur*); he was working on an Old Testament series at his death. There are works in Antwerp, Baltimore (Walters), Cardiff, Compiègne, Leeds, London (Tate, NPG, Guildhall), New York (Brooklyn), Oxford, Paris (Louvre) and Reims.
Lit. J. Laver: *Vulgar Society – The Romantic Career of J. Tissot* (1936)

Tivoli Serafino de, b. Livorno 1826, d. Florence 1892. Landscapist and one of the pioneers of the MACCHIAIOLI school, described by SIGNORINI as 'the father of the *macchia*'. After visiting the Paris EXPOSITION UNIVERSELLE in 1855, he explained the theories of the French REALISTS to his friends, who enthusiastically followed his lead; according to Signorini, he particularly admired DECAMPS, TROYON and ROSA BONHEUR. He studied with Markó and fought in the

patriotic campaigns of 1848-9 before working with the Macchiaioli in Florence during the 1850s. He left Florence for London in 1864 and later settled in Paris, only returning to Florence in 1890. His brother Felice, also a landscapist, settled in London. There are works in Florence (Mod. Art), Livorno (Fattori), Milan (Mod. Art) and Turin (Mod. Art).

Toma Gioacchino, b. Galatina 1836, d. Naples 1891. Self-taught REALIST painter, a 'poet of interiors and intimate domesticity' (Maltese) and one of the most important Italian painters of his generation. His simple compositions were painted with muted tones, predominantly in a luminous grey. He spent his early years in Naples, was imprisoned in 1857 for political conspiracy and fought with Garibaldi (1859-60). Though he had painted and exhibited earlier, he devoted the 1860s to serious study and emerged with a powerful mature style showing the influence of both PALIZZI and the MACCHIAIOLI. He was given a teaching post at the Naples Academy. There are works in Bari, Florence (Uffizi, Mod. Art), Lecce (Civico), Milan (Grassi, Mod. Art), Naples (San Martino, Belle Arti), Palermo (Mod. Art), Rome (Mod. Art) and Turin (Mod. Art).
Lit. G. Toma: *Ricordi d'un orfano* (1898); S. Ortolani: *G. Toma* (1934); A. de Rinaldis: *G. Toma* (1934)

Toorop Johannes Theodoor (Jan), b. Poerworedjo (Java) 1858, d. The Hague 1928. Holland's most important SYMBOLIST painter. After experimenting with POINTILLISM in the 1880s, he became a fully fledged Symbolist in the 1890s. He concentrated largely on figures, and his drawings are a pattern of rhythmic curves with a debt to BEARDSLEY. He studied at the Amsterdam Academy (1880-1) and at the Brussels Academy (1882-5). A friend of ENSOR and the Belgian *avant-garde* artists and poets, he exhibited with LES VINGT in Brussels. There are works in Amsterdam (Rijksmuseum, Stedelijk), Brussels (Musées Royaux), Bremen, Dordrecht, Essen, The Hague (Mesdag, Modern), Haarlem (Bisschoppelijk), Mainz, Otterloo (Kröller-Müller), Rotterdam (Boymans), Utrecht, Wiesbaden and Zurich.
Lit. A. Plasschaert: *J. Toorop* (1925); M. Janssen: *Herinneringen aan J. Toorop* (1933); J. B. Knipping: *J. Toorop* (*c.* 1945)

Töpffer Wolfgang Adam, b. Geneva 1766, d. Morillon (Geneva) 1847. Swiss genre and landscape painter and caricaturist. His paintings of the peasant life and mountainous landscapes of Switzerland are strongly influenced by his friend the Flemish painter Demarne and the Dutch 17C school. Now seen as a forerunner of REALIST painting in Switzerland, he was also highly regarded by his contemporaries. After training as an engraver, he visited Paris (1889 and 1891), where he studied with Suvée and became a close friend of Demarne. On his return to Geneva he studied landscape with P. L. de la Rive and taught drawing. Every year he undertook a sketching expedition through the country, sometimes with de la Rive, once with AGASSE and later with his son Rodolphe. He made several visits to Paris, where he attracted Napoleon's attention and was briefly employed as drawing master to the Empress Josephine. He visited England in 1816 and Italy in 1824. His son Rodolphe achieved fame as a caricaturist and novelist. There are works in Basle (Kunstmuseum), Geneva (Ariana, Rath), Lyons, Narbonne and Zurich.

Toulouse-Lautrec Henri de, b. Albi 1864, d. Château de Malromé 1901. POST-IMPRESSIONIST painter and graphic artist who recorded the life of music-halls, cafés and brothels in Paris. A brilliant draughtsman and lithographer, he worked more often in watercolour and pastel than in oils. His primary interest was in form and movement; the confident use of line and the flat planes of colour in his lithographs owe a clear debt to Japanese prints. The technique is echoed in his oils, where he used thin paint and purposely left much of the board unpainted. The son of a sporting count of ancient lineage, he was crippled when a child and began drawing during his convalescence. He studied with BONNAT (1883) and with Cormon (1884), when he met VAN GOGH. In 1884 he established a studio in Montmartre and plunged into nightlife, sketchbook in hand; he taught himself but was considerably influenced by DEGAS. He exhibited in Brussels with LES VINGT from 1887 and at the SALON DES INDÉPENDANTS from 1889. In the early 1890s he took up lithography, producing some superb posters, notably for Aristide Bruant's cabaret, and working for various publications.

In 1895 he made the first of several visits to London, where he knew Wilde and BEARDSLEY. He was highly sensitive to jibes at his stunted growth, and drank heavily; in 1899 his health collapsed and he retired to a nursing home. From this period dates his series of circus pictures. After recovering, he lived mainly in Bordeaux, working industriously, but he died two years later. Not greatly appreciated during his lifetime, his work began to gain international renown after the retrospective exhibition at the Goupil Galleries in 1914. There are works in most museums of modern art, and a particularly notable collection at Albi, his birthplace.
Lit. D. Cooper: *H. de Toulouse-Lautrec* (1956); P. Huisman: *Lautrec par Lautrec* (1964); J. Bouret: *Toulouse-Lautrec* (1964); A. Fermigier: *Toulouse-Lautrec* (1969); M. G. Dortu: *Toulouse-Lautrec et son œuvre* (1971)

Troyon Constant, b. Sèvres 1810, d. Paris 1865. Leading landscape and animal painter of the BARBIZON SCHOOL. His early landscapes were received with criticism and hostility, but by the end of his life he had won an international reputation and was plied with commissions. He taught himself landscape painting from nature and exhibited three views in conventional classical style at the 1833 SALON. Camille Roqueplan, whom he met while sketching, introduced him to the Barbizon painters, thus changing the course of his art. He met T. ROUSSEAU in 1843 and went to work in Barbizon; DUPRÉ became a close friend. He continued to exhibit landscapes in the Salons with increasing success, winning a first class medal in 1846. A visit to Holland and Belgium in 1847 crystallized the nature of his art; he discovered Paul Potter and Albert Cuyp and under their influence animals became the focus of his landscapes. The animal paintings on which his reputation is founded date from the years 1848-65. In 1847 he was elected a member of the Amsterdam Academy and received the Belgian Cross of Leopold, while in 1849 he became a chevalier of the Legion of Honour. A large posthumous exhibition of his work was held at the EXPOSITION UNIVERSELLE of 1867. There are works in Amiens, Amsterdam (Rijksmuseum), Baltimore (Mus. of Art, Walters), Bayonne (Bonnat), Bordeaux, Boston,

Töpffer *Girl with Bowed Head*

Toulouse-Lautrec *In the Salon of the Rue des Moulins* 1894

Troyon *Morning* 1855

Trübner *Young Girl with Folded Hands* 1878

Trumbull *The Battle of Bunker's Hill* 1786

Brussels, Kassel, Chartres, Clamecy, Cologne, Detroit, Dijon, Edinburgh, Frankfurt, Glasgow, Hamburg, The Hague (Mesdag), Le Havre, Leipzig, Le Mans, Limoges, London (Wallace), Lyons, Marseilles, Montpellier, Montreal, Moscow (Tretiakov), Mulhouse, New York (Met.), Paris (Louvre), Reims, Rouen and Vienna (Kunsthistorisches Mus.). *Lit.* H. Dumesnil: *Troyons, souvenirs intimes* (1888); A. Hustin: *C. Troyon* (1893); W. Gensel: *Corot und Troyon* (1906)

Trübner Heinrich Wilhelm, b. Heidelberg 1851, d. Karlsruhe 1917. Three distinct phases can be distinguished in his work: until *c.* 1876 he was closely involved with LEIBL, SCHUCH and the Munich REALISTS, painting landscapes and portraits which use vigorous brushstrokes and muted colours and aim above all at a harmony of tone; in a second period, until *c.* 1890, he turned to literary themes, including centaurs, Amazons and giants, in a manner related to BÖCKLIN and THOMA (with whom he had shared a studio in 1872); in the third and last period he returned to Realist landscape and portraiture, concentrating particularly on *plein air* painting, simplifying his compositions and using a rich palette under the influence of IMPRESSIONISM. By 1900 he and Thoma were the two most influential artists in southern Germany. He studied at Karlsruhe (1868) before working at the Munich Academy in 1869 under A. Wagner and DIEZ. The works of COURBET and Leibl included in the Munich International Exhibition of 1869 launched his interest in Realist painting. He contributed to several of the Munich SECESSION exhibitions, including the first in 1892. In 1896 he moved to Frankfurt, where he taught at the Städelsches Institut as well as running a private teaching atelier. In 1903 he was appointed director of the Karlsruhe Academy. There are works in most German museums, including Berlin and Munich, and in Basle (Kunstmuseum), Bucharest, Danzig, Milan, New York (Met.) and Vienna (Kunsthistorisches Mus.). *Lit.* G. Fuchs: *W. Trübner und sein Werk* (1908); J. A. Beringer: *W. Trübner* (1917); J. Elias: *W. Trübner, Handzeichnungen* (1921)

Trumbull John, b. Lebanon (Conn.) 1756, d. New York 1843. History and portrait painter. His small paintings of scenes from the American Revolution painted in the studio of WEST (1784–9) are full of dramatic movement and colour which prefigure the work of the French ROMANTICS. He had lost this fresh inspiration by the time he repeated four of these compositions as large-scale frescoes for the Capitol in Washington (*Washington Resigning his Commission, Surrender of Cornwallis, Surrender of Burgoyne, Signing of the Declaration of Independence* 1817–24). As a student he painted in his spare time; after fighting with the Continental Army (1775–7) he painted a full-length portrait of *Washington* (1780). He paid his first visit to London in 1780 and returned to study with West from 1784 to 1789. He mixed business and politics with painting, but also worked as a portraitist in New York (1804–8) and in London (1808–16). Appointed president of the AMERICAN ACADEMY OF FINE ARTS in New York in 1816, a post which he held until 1835, he exerted considerable influence on contemporary American painting, notably by launching the career of COLE. Yale University acquired his personal collection of paintings in 1831; his work is represented in many other American museums, including Boston, New York (Met.) and Washington (NG, Corcoran). *Lit.* J. Trumbull: *Autobiography, Reminiscences and Letters* (1841, new ed. 1953); T. Sizer: *The Works of Col. J. Trumbull, Artist of the American Revolution* (1967); I. B. Jaffé: *Trumbull: The Declaration of Independence* (1976)

Turner Joseph Mallord William, b. London 1775, d. London 1851. ROMANTIC landscape painter and one of the most important landscape artists of the 19C. He began his career as a topographical artist, making careful drawings of well-known buildings and views, but his passionate interest in effects of light brought a progressively more fluid treatment to both his watercolours and oils until, in his final paintings, all figurative elements disappear in a storm of colour. The dependence of his vision on poetry – he appended quotations from Shakespeare, Milton, Byron, Thomson and his own poems *Fallacies of Hope* to many works – ties his painting firmly into the Romantic generation and underlines the difference between his impressionistic work and that of the optically-oriented French IMPRESSIONIST painters. He entered the ROYAL

ACADEMY Schools in 1789 and exhibited his first watercolour the next year at the age of fifteen. He devoted the following years to topographical watercolours, studying with T. Malton and E. Dayes, copying Cozens' drawings at Dr Monro's and making sketching tours with T. Girtin. His first oils exhibited at the Royal Academy (1796-7) show the influence of Dutch marine painting (*Fishermen at Sea* 1796, *Millbank, Moonlight* 1797). This influence was almost immediately succeeded by that of Wilson and Claude; he stipulated in his will that *Sunrise in Mist* (1807) and *Dido Building Carthage* (1815) should be hung next to the Claudes in the National Gallery. ARA in 1799, RA in 1802 and professor of perspective in 1807, he was already considered one of the leading painters of the day. Between 1807 and 1819 he prepared his *Liber Studiorum*, in imitation of Claude's *Liber Veritatis*, comprising seventy-one mezzotint engravings after his paintings to demonstrate his range as a landscape painter and confound his critics. He paid his first visit to the Swiss Alps in 1802, to the Rhine in 1817 and to Italy in 1819, and he returned frequently to the Continent; the dramatic scenery of the Alps and the intensity of southern sunlight and colour both profoundly affected him, reaching a

climax in the Venetian views of 1834-7 and the great Swiss watercolours of 1840-6. In the last decade of his life the clash of the elements and wild effects of light became his overriding preoccupation (*Snowstorm at Sea* 1842, *Rain, Steam and Speed* 1844). An earthy eccentric of uncouth manners, Turner avoided society; he lived with his father until 1829 and never married, though he fathered several children. He died in a Chelsea garrett where he lived with a mistress under the assumed name of Booth. His reputation as an artist had always been high but was further enhanced by the praise lavished on his work by Ruskin in his *Modern Painters*. He left his personal collection of paintings, watercolours and sketches to the British nation and they are now split between the National Gallery, Tate Gallery and British Museum in London. His work is also represented in most major American and English provincial museums. (*see colour illustration* 9)
Lit. J. Ruskin: *Modern Painters* (1843); M. Kitson: *J. M. W. Turner* (1964); Sir J. Rothenstein, M. Butlin: *Turner* (1964); G. Reynolds: *Turner* (1970); G. Wilkinson: *The Sketches of Turner* (1974); L. Herrmann: *Turner: Paintings, Watercolours, Prints and Drawings* (1976)

Turner *Venice: The Dogana, San Giorgio Maggiore, Le Zitelle from the steps of the Europa c.* 1842

U

Uhde Friedrich Karl Hermann (Fritz) von, b. Wolkenburg 1848, d. Munich 1911. REALIST painter best known for his biblical scenes translated into a contemporary German environment; he also painted peasant genre and landscape. A leading figure in the Munich SECESSION movement, he was stylistically much influenced by LIEBERMANN and BASTIEN-LEPAGE. After studying at the Dresden Academy (1866), he spent ten years in the army. In Munich (1877), PILOTY refused him entrance to the academy and instead, on the advice of LENBACH, he studied Dutch Old Masters in the Pinakothek. A meeting with MUNKÁCSY (1879) took him to Paris, where he was much influenced by Munkácsy's religious paintings. Back in Munich (1880), he was encouraged by

Liebermann to brighten his palette and experiment with *plein air* painting, but he was dissatisfied with Realism for its own sake, and in 1884 exhibited his first modern-dress Bible picture, *Suffer Little Children to Come Unto Me*, to a storm of controversy. He was one of the founders of the Munich Secession in 1892, and fifty-three of his paintings were shown at the 1907 Secession exhibition. There are many works in Munich and he is also represented in most German museums as well as in Bucharest (Muzeul Toma-Stelian), New York (Met.), Paris (Louvre), St Louis and Vienna (Kunsthistorisches Mus.).
Lit. F. H. Meissner: *F. von Uhde* (1900); F. von Ostini: *Uhde* (1902); H. Rosenhagen: *F. von Uhde* (1908)

Uhde *Three Models* before 1884

V

Valenciennes Pierre Henri de, b. Toulouse 1750, d. Paris 1819. French NEOCLASSICAL landscape painter and theorist. His *Eléments de la perspective pratique*, published in 1800, helped to establish landscape painting as a serious discipline and indirectly influenced the establishment in 1817 of a Rome prize for historic landscape. He stressed the importance of studies from nature, but at the same time held that the artist must be deeply versed in classical literature, since he believed that genius lay in using landscape elements to illustrate a classical theme. A pupil of G. F. Doyen in Paris, he followed up his studies in Italy and modelled his landscape style on Poussin. He became an academician in 1787 and was appointed professor of perspective at the ECOLE DES BEAUX-ARTS in 1812. His Roman sketches anticipate COROT, while his book provided for GUILLAUMIN a first introduction to landscape painting and was recommended by C. PISSARRO to his son Lucien; the practical insights it provides into landscape technique are not marred by his emphasis on the superiority of composed historic landscape. There are works in Auch, Langres, Nantes, Paris (Louvre), Périgueux, Toulouse and Troyes.

Vallotton Félix, b. Lausanne 1865, d. Paris 1925. Swiss painter who made his career in Paris. He studied at the ACADÉMIE JULIAN (1882) where he met SERUSIER and was drawn into the NABIS group. In 1891 he learned wood engraving, a medium in which he excelled, and in the following years he briefly adopted POINTILLISM (*Waltz* 1893). He worked for the *Revue Blanche* from 1894. His Nabi work shows a strong sense of ornamental design which is brilliantly formalized in his woodcuts in the contrast of dark and light areas. There is always a REALIST element in his treatment of figures and landscape, and this becomes the dominant note in his later work. There are works in Baltimore, Basle (Kunstmuseum), Chicago, Lausanne, Lille, London (Tate),

Lucerne, Lyons, Nantes, Neuchâtel, New York (Mod. Art), Paris (Mod. Art), Strasbourg, Winterthur and Zurich.
Lit. H. Hahnloser: *F. Vallotton et ses amis* (1936); F. Jourdain: *F. Vallotton* (1953); J. Monnier: *F. Vallotton* (1970)

Vanderlyn John, b. Kingston (N.Y.) 1775, d. Kingston 1852. History and portrait painter. He was the only American of his generation to be trained in Paris, where he adopted the idealization and high finish of NEOCLASSICISM. The son of a painter, he studied briefly with STUART before leaving in 1796 for Paris, where he studied with VINCENT. He returned to America in 1801, but two years later the AMERICAN ACADEMY OF FINE ARTS sent him back to Europe to copy Old Masters and buy casts for their collection; *Massacre of Jane McCree* (1804), a work in heroic style, dates from this period. He worked for the next twelve years in Europe, mainly in Paris, though he also spent some time in Rome with ALLSTON (1805-8). *Marius Before the Ruins of Carthage* (1808) won a Paris gold medal and Napoleon's admiration. He returned to New York (1815) with his classical nude *Ariadne on Naxos* and a huge panorama of Versailles, but their exhibition did not bring the success he expected. Financial pressures then forced him to concentrate on portrait painting. In 1837 Congress commissioned him to paint the *Landing of Columbus* for the Capitol. There are works in Cleveland, New York (Met.), St Louis, San Francisco, Washington (Corcoran) and Philadelphia (Acad.).

Varley John, b. London 1778, d. London 1842. Prolific watercolour painter whose views of the English countryside were treated with classic simplicity and naturalism in broad areas of wash. He studied under J. C. Barrow from *c*. 1794 and was patronized by Dr Monro, exhibiting at the ROYAL ACADEMY from 1798 and helping to found the Old Watercolour Society in 1804. He was interested in astrology and a friend of BLAKE; he was

an important teacher, numbering LINNELL and W. H. HUNT among his pupils. His brothers Cornelius and William and sons Albert Fleetwood and Charles Smith were also painters. There are works in Birmingham, Capetown, Cardiff, Dublin, Glasgow, Leeds, Leicester, Liverpool, London (V&A), Manchester and Melbourne.
Lit. A. Bury: *J. Varley of the 'Old Society'* (1946)

Vasnetzov (Vasnetsoff, Wassnezoff) Viktor Mikhailovich, b. Wyatka 1848, d. Moscow 1927. A pioneer in the revival of Russian religious art, deriving from Byzantine mosaics and icons but infused with modern REALISM. His illustrations of Russian folk and fairy tales also inspired many followers and imitators prominent at the turn of the century. After attending the St Petersburg Academy (1868-75), he visited Paris (1876-7); he exhibited with the PEREDVIZHNIKI from 1874. His first paintings were genre scenes, but after 1878 he turned almost exclusively to Russian history and legend. He was the co-founder of the Abramtsevo artistic community, designing a mosaic floor for their church (1882) and the first of the great Russian opera décors for *Snow White* (1883). In 1887 he won the competition for murals in the new Cathedral of St Vladimir, Kiev. He made a preparatory study of early Byzantine art in Italy and Sicily, and worked in the cathedral until 1896; the frescoes were seen as a rejuvenation of national religious art, and achieved considerable fame inside and outside Russia. There are works in Kiev (Cathedral of St Vladimir) and Moscow (Tretiakov).
Lit. N. Morganov: *V. Vasnetzov* (1941, in Russian); V. M. Alpatov: *V. M. Vasnetzov* (1954, in Russian); A. Lebedev: *V. M. Vasnetzov* (1957, in Russian)

Vautier Benjamin (the Elder), b. Morges 1829, d. Düsseldorf 1898. Swiss genre painter who settled in Düsseldorf and achieved, like his contemporaries KNAUS and

DEFREGGER, immense popularity with pictures of village life. His gift was primarily as a draughtsman; he worked through careful preparatory studies to highly finished scenes with a still-life painter's attention to detail; his peasants are almost always festive and happy. He studied with Jules Hébert in Geneva (1847) and with the enamel painter J. L. Lugardon. In 1850, on the advice of A. van Muyden, he went to Düsseldorf, where he was turned away from the academy by SCHADOW but entered Rudolf Jordans' art school. A meeting with K. GIRARDET in Switzerland (1853) determined his dedication to genre painting. He visited Paris in 1856, but returned to settle in Düsseldorf the following year. After his first major success at a Munich exhibition in 1858, a visit with Knaus to the Black Forest crystallized his future subject matter. He became a member of the Berlin, Munich, Antwerp and Amsterdam Academies. His sons Karl and Otto were also painters, as was his grandson Benjamin the Younger. There are works in Aachen, Baltimore (Walters), Basle (Kunstmuseum), Berlin, Berne, Wrocław, Cologne, Dresden, Düsseldorf, Geneva (Ariana, Rath), Graz, Hamburg, Leipzig, Mainz and Munich.
Lit. A. Rosenberg: *Vautier* (1897)

Vedder Elihu, b. New York 1836, d. Rome 1923. American SYMBOLIST painter of myth, landscape and allegory. He studied with T. H. Matteson in Sherbourne, New York, and with PICOT in Paris; on his return to America, the Civil War forced him to undertake illustration and commercial work. He became a member of the NATIONAL ACADEMY OF DESIGN in 1865, and settled in Rome in 1866. His illustrations to the *Rubaiyat of Omar Khayyám* (1884) and his mural decorations for the Library of Congress, Washington (1896–7) are among his best-known works. There are works in Baltimore (Mus. of Art), Boston, Chicago, Cleveland, New York (Met.), Pittsburgh and Washington (Corcoran).
Lit. E. Vedder: *The Digressions of Vedder, Written for his Own Fun and that of his Friends* (1910); R. Soria: *E. Vedder* (1970)

Veit Philipp, b. Berlin 1793, d. Mainz 1877. NAZARENE painter. His early work in Rome was strongly influenced by OVERBECK, with

Valenciennes *Tivoli*

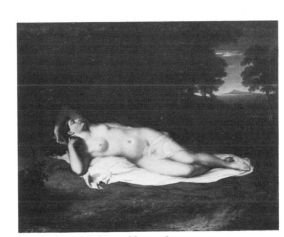

Vanderlyn *Ariadne on Naxos* 1814

Vasnetzov *Russian Knights*

Vautier *Peasants Playing Cards* 1862

Vedder *The Cumaean Sibyl* 1876

Veit *The Introduction of the Arts into Germany by Christianity* 1834-6

Velde *Tropon* 1898

consciously archaicized composition; his later painting leans on the literary ROMANTICISM of the DÜSSELDORF SCHOOL. The stepson of Friedrich Schlegel, the influential philosopher, he studied at the Dresden Academy with F. Mathai and briefly with FRIEDRICH (1809) and was converted to Catholicism in 1810. He continued his studies in Vienna (1811), where he met KOCH, and arrived in Rome in 1815, joining the group of Nazarene artists. He collaborated on the Bartholdy frescoes (*Joseph and Potiphar's Wife, Allegory of the Seven Fat Years* 1816); he took over the commission of CORNELIUS for the Dante room frescoes of the Casino Massimo when he returned to Munich, but after struggling for several years he left their completion to KOCH (1824). He was appointed director of the Städelsches Institut in Frankfurt (1830), for which he painted a vast mural, *The Introduction of the Arts into Germany by Christianity*. He resigned his directorship in 1843 but remained in Frankfurt until 1854, when he was appointed director of the museum in Mainz. There are works in Berlin, Darmstadt, Frankfurt/M., Leipzig, Mainz and Rome.
Lit. M. Spahn: *Philipp Veit* (1901)

Velde Henry Clemens van de, b. Antwerp 1863, d. Zurich 1957. Belgian painter, architect and designer. He studied in Paris with CAROLUS-DURAN (1884) and was an early disciple of SEURAT, adopting the POINTILLIST style; he joined the *avant-garde* exhibiting group LES VINGT in 1889. Around 1890 he gave up painting in favour of the applied arts, becoming one of the most important pioneers of ART NOUVEAU; in 1896 he decorated Samuel Bing's Paris shop, the Maison de l'Art Nouveau, from which the movement takes its name. Appointed artistic adviser to the court of Saxe-Weimar in 1901, he set up the Kunstgewerbeschule, thus preparing the way for the Bauhaus. In 1926 he set up the Institut des Arts Décoratifs de la Cambre in Belgium, which he ran until 1935. His major buildings include the Folkwang Museum at Hagen (1900-2), the library block at Ghent University (1936) and the Kröller-Müller Museum at Otterloo (1937-54).
Lit. H. Teirlinck: *H. van de Velde* (1959); A. Hammacher: *Le monde de H. van de Velde* (1967); K. H. Hüter: *H. van de Velde* (1967)

Venetsianov (Wenezianoff) Alexei Gavrilovich, b. Nieshin 1780, d. Safonkovo 1847. Russia's first genre painter, a delineator of peasant interiors and rural scenes. He spent his early life in Moscow, but moved in 1802 to St Petersburg, where he copied the Dutch Masters in the Hermitage; he also took up engraving and lithography and studied under BOROVIKOVSKY. The exhibition of the *Capuchin Chapel* by GRANET at the Hermitage (1820) changed his life; he moved to a country estate at Safonkovo, where for the rest of his life he devoted himself to painting 'after nature' in emulation of Granet. *Barn* (1824) was bought by the Tsar, thus enabling him to start his own school. In the second half of the 19C several artists turned, under his influence, to the depiction of Russian rural scenes. There are works in Leningrad (Russian Mus.) and Moscow (Pushkin, Tretiakov).
Lit. N. N. Vrangel: *A. G. Venetsianov in Private Collections* (1911, in Russian); T. Alexeyeva: *Artists of the School of Venetsianov* (1958, in Russian)

Verboeckhoven Eugène Joseph, b. Warneton 1799, d. Brussels 1881. Animal painter who depicted domestic animals, particularly sheep and cows, in their natural landscape environment with careful detail and smooth high finish. A leading figure in the Belgian art establishment, he was showered with honours both at home and abroad. Son of the sculptor Barthélemy, he studied with A. Voituron and OMMEGANCK, an animal painter in the same tradition deriving from P. Potter and the Dutch 17C, and first exhibited in Ghent in 1820. He travelled extensively to France (1824 and 1841), England (1824 and 1826), Germany (1828) and Italy (1841). In his studio in Brussels he had many pupils and he collaborated with several Dutch landscapists, painting the animals in their canvases. A chevalier of the Legion of Honour, he was also accorded the Orders of Leopold of Belgium, Michael of Bavaria and Christ of Portugal, and the Iron Cross of Prussia. He was a member of the Antwerp, Brussels and St Petersburg Academies. There are works in Amsterdam, Antwerp, Baltimore (Walters), Berlin, Brussels (Musées Royaux), Frankfurt/M., Graz, Hamburg, Leeds, Liège, Liverpool, London (Wallace), Montreal, Munich, Nottingham,

Oslo (NG), Reading, Stockholm and Sunderland.

Vereschagin (Weretschagin) Vassili Vassilievich, b. Liubez (Novgorod) 1842, d. Port Arthur 1904. Russian REALIST painter best known for his almost photographic representations of the horrors of war. He studied at the St Petersburg Academy (1861-3) and in Paris with GÉRÔME (1865). He travelled constantly, visiting every part of Russia, almost all the countries of Europe, was twice in India, visited Syria and Palestine in 1848 and America and Japan in 1890. He also took part in three separate wars, in Turkestan (1867-70), the Russian–Turkestan War of 1877-8 and the Russian–Japanese War of 1904. The sketches that he made on his travels and at war served him as material for his paintings (*A Sudden Engagement* 1871, *Dervishes in Tashkent* 1870-1) which were also polemical statements of his reformist political, social and religious ideas. *The Apotheosis of War*, a pyramid of skulls, is among his most famous paintings. He exhibited his war paintings and sketches all over Europe, in London, Paris, Vienna, Berlin and Budapest as well as in Russia. There are works in Boston, Leningrad (Russian Mus.), Moscow (Pushkin, Tretiakov), New York (Brooklyn), St Louis and Toledo.
Lit. A. Lebedev, G. Burov: *Correspondence of V. Vereschagin and V. Stasov* (1951, in Russian); A. K. Lebedev: *V. V. Vereschagin: His Life and Work* (1958, in Russian)

Verlat Charles Michel Maria, b. Antwerp 1824, d. Antwerp 1890. Belgian REALIST painter much influenced by COURBET and the brothers STEVENS. Like J. Stevens, he was primarily an animal painter, preferring as subjects wild deer and hunting scenes, though he also painted some historical and religious subjects and Oriental scenes. He was an influential teacher. After studying at the Antwerp Academy with DE KEYSER and WAPPERS, he worked in Paris (1850-68) with A. SCHEFFER, FLANDRIN and COUTURE. In 1869 he was appointed a professor at the Weimar Kunstschule. He travelled to Egypt, Palestine and Syria (1875-7) before becoming a professor at the Antwerp Academy and in 1885 its director. There are works in Amster-

dam, Antwerp, Bremen, Brussels (Musées Royaux), Graz, Liège, Montauban, Toulouse and Weimar.
Lit. V. and C. Verlat: *C. Verlat* (1926)

Vermehren Johann Frederick Nikolai, b. Ringsted 1823, d. Copenhagen 1910. Danish painter primarily of genre scenes, though also of landscapes and portraits. With DALSGAARD and EXNER, he was a leading exponent of the nationalist-oriented genre painting, treating the customs and costumes of the Danish countryside, encouraged by the influential Professor Høyen after the 1848-50 wars. He studied at Sorø with H. Harder and at the Copenhagen Academy under ROED. He visited Italy and Paris in 1855-7, 1862 and 1878, and from 1873 to 1901 was a professor at the Copenhagen Academy. His sons Gustav and Sophus were also painters. There are works in Copenhagen (State).

Vernet Antoine Charles Horace (Carle), b. Bordeaux 1758, d. Paris 1836. French painter popular in the early decades of the 19C. Fascinated by horses, he introduced them into Napoleonic battle scenes, sporting pictures and historical works influenced by DAVID. He was essentially a draughtsman; his paintings tend to rigidity, and his best work lies in his satirical commentaries on contemporary costumes and manners, which were reproduced by leading engravers of the time and in various series of lithographs (*Merveilleuses*, *Incroyables*). He studied with his father Joseph and with Lépicié, and began with history paintings, winning a second Rome prize in 1779 and a first in 1782. He was made an associate of the Académie Royale (1789) for his *Triumph of Aemilius Paullus*. During the Consulate and Empire, he painted battle scenes for Napoleon (*Morning of Austerlitz* 1803, *Marengo* 1804), and was elected a member of the INSTITUT in 1810. After the Restoration he became a friend of the Duc d'Orléans and devoted himself to hunting and racing pictures (*Deer Hunt* 1827). He was the father of H. VERNET. There are works in Amiens, Avignon, Besançon, Chantilly, Chartres, Chicago, Clamecy, Neuchâtel, New York (Met.), Paris (Louvre), Toulouse and Versailles.
Lit. C. Blanc: *Une Famille d'art, les trois Vernet* (1898); A. Dayot: *C. Vernet* (1925);

Venetsianov *Harvesting*

Vereschagin *After the Attack*

A. C. H. Vernet *Deer Hunt* 1827

R. and J. Brunon: *C. Vernet: La Grande Armée de 1812* (1959)

Vernet Emile Jean Horace, b. Paris 1789, d. Paris 1863. Immensely successful artist and special protégé of Louis-Philippe; he gave artistic interpretation to the contemporary ideal, the 'juste milieu', by combining in his compositions ROMANTIC drama and movement with NEOCLASSICAL linearity and careful modelling. For subject matter he preferred battles, but he also painted Oriental scenes of distinguished clarity and a few medieval subjects. The son of Carle and grandson of Joseph Vernet, and father-in-law of DELAROCHE, he studied with his father and VINCENT. His first SALON exhibit, a portrait of *Jerome Bonaparte*, won him a first-class medal in 1812. He fought at the Barrière Clichy in 1814 and was made chevalier of the Legion of Honour by the Emperor (1814), but his Bonapartist sympathies made him unpopular under the Restoration and he went to Rome with his father in 1820. His works, particularly a painting of the *Barrière Clichy*, were rejected by the Salon of 1822 for political reasons, but he remained in high favour with the Duc d'Orléans and his circle. Elected a member of the INSTITUT in 1826, he became director of the French Academy in Rome (1827–35). In 1833 a visit to Algeria to follow the French army in action was the beginning of his fascination with the East (*The Lion Hunt* 1836). Replaced by INGRES at the French Academy in 1835, he returned to Paris to play a leading role in the creation of Louis-Philippe's historical galleries in Versailles (*Napoleon at the Battle of Wagram, Capture of the Smalah of Abd-el-Kader*); the size of his battle canvases was such that a ceiling had to be removed and two floors made into one to accommodate them. In 1836 and 1842–3 he visited St Petersburg, where he was showered with commissions and honours by the Tsar; in 1839 he travelled in Egypt, Syria and Turkey. His reputation was not eclipsed by the 1848 revolution; a whole room was devoted to his work at the 1855 EXPOSITION UNIVERSELLE. He became an officer of the Legion of Honour in 1825, a commander in 1842 and a grand officer in 1862. There are works in Ajaccio, Algiers, Amiens, Amsterdam (Stedelijk), Autun, Avignon, Bagnères, Baltimore (Walters), Bayeux, Bayonne, Berlin, Boston, Caen, Cambridge Mass. (Fogg), Chantilly, Compiègne, Dijon, Genoa, Hamburg, Leipzig, Lille, London (Wallace, NG), Montpellier, Moulins, Nancy, Nantes, Narbonne, Paris (Louvre), Sémur and Versailles.
Lit. H. Delaborde: *H. Vernet, ses œuvres et sa manière* (1863); J. R. Rees: *H. Vernet and P. Delaroche* (1880); C. Blanc: *Une Famille d'art, les trois Vernet* (1898); P. G. Delaroche-Vernet: *H. Vernet, P. Delaroche et leur famille* (1907)

Verwée Alfred Jacques, b. Saint-Josse-ten-Noode 1838, d. Brussels 1895. Animal and landscape painter, a Belgian parallel to TROYON. He was a staunch campaigner for the Belgian REALIST movement in its opposition to the art establishment, and became a member of the Société Libre des Beaux-Arts in 1868. He studied with his father, with VERBOECKHOVEN and with L. Robbe, and first exhibited in Brussels in 1857. During the 1860s he came under the influence of COURBET and the BARBIZON SCHOOL. A knight of the Order of Leopold in 1871, an officer in 1881 and a commander in 1894, he was also accorded the French Legion of Honour in 1881. His father Louis Pierre (1807–77) was a faithful pupil, follower and collaborator of Verboeckhoven, and his smoothly finished paintings of domestic animals in their landscape environment are often confused with Verboeckhoven's. There are works in Antwerp, Brussels (Musées Royaux), Courtrai, Groningen, Ghent, The Hague (Mesdag), Liège and Montreal.
Lit. G. van Zype: *A. Verwée* (1933)

Vibert Jehan Georges (Jean), b. Paris 1840, d. Paris 1902. Painter who launched the craze for satirical paintings of cardinals; he painted humorous anecdotes from the life of the clergy with the loving attention to detail, costume and still-life features of the scene developed by the school of genre painters influenced by MEISSONIER. After studying under Barrias at the ECOLE DES BEAUX-ARTS (1857), he fought and was wounded in the Franco–Prussian War, receiving the cross of chevalier of the Legion of Honour; he became an officer in 1882. He started his career as a painter of costume genre and also painted little scenes of Spain and the East, but it was his paintings of the clergy that brought him great success with collectors. There are works in Baltimore (Walters), Bordeaux, Buffalo, Cambridge Mass. (Fogg), Cincinnati, Glasgow, Melbourne, New York (Met., Brooklyn), Rochefort, St Louis, Troyes and Versailles.

Vigée-Lebrun Marie Louise Elisabeth, b. Paris 1755, d. Paris 1842. Portraitist who achieved an immense reputation throughout Europe in the late 18C and early 19C. Her most successful portraits are of women (*Mlle Porporati* 1792, *Elizabeth Alexeyevna* 1792, *Mme de Staël* 1808). She was the favourite protégée of Marie Antoinette, of whom she painted more than twenty portraits. Her ladies' soft palpitating charm owes much to the French artists of the rococo and especially to Greuze, but she was also influenced by the NEOCLASSICISM of her contemporaries, seeking to imbue her compositions with antique simplicity and purity of style. She studied with her father Louis Vigée and was also helped by J. Vernet and Greuze. Partly through the Queen's influence she was accorded the title of ACADEMICIAN in 1783. In 1789 she took refuge in Italy to escape the Revolution; received with high honours in Rome and Naples, she was appointed a member of the Rome, Parma and Bologna Academies. In 1792 she moved to Vienna where she was held in high regard at court, and in 1795 she travelled via Berlin to St Petersburg. She spent five years in Russia and had an important influence on the Russian portrait school, being named a member of the St Petersburg Academy in 1800. She spent 1801 in Berlin, becoming a member of the academy, and in 1802 returned briefly to Paris before visiting London (1802–5). She then visited Switzerland before returning to settle in France. There are works in Aachen, Angers, Auxerre, Avignon, Baltimore (Mus. of Art), Berne, Bologna, Bordeaux, Boston, Chantilly, Chicago, Cincinnati, Darmstadt, Dieppe, Geneva, Le Havre, Leningrad (Hermitage, Russian Mus.), London (NG), Madrid, Montpellier, Moscow (Pushkin), New York (Met.), Paris (Louvre, Jacquemart), Parma, Rouen, Toulouse, Turin, Versailles, Vienna and Washington (NG, Corcoran).
Lit. Mme Vigée-Lebrun: *Souvenirs* (1835–7); W. H. Helm: *Vigée-Lebrun, her Life, Works*

E. J. H. Vernet *The Arab Tale-Teller* 1833

Vigée-Lebrun *The Artist and her Daughter* 1789

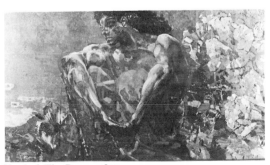

Vrubel *The Demon* 1890

and Friendships (with catalogue 1916); L. Hautecœur: *Mme Vigée-Lebrun* (1917); A. Blum: *Mme Vigée-Lebrun, peintre des grandes dames du 18ᵉ siècle* (1919)

Vingt, Les (Les XX). Belgian *avant-garde* exhibition group founded by the lawyer Octave Maus in 1883 when the official Brussels Salon jury refused the work of twenty promising young artists. He dissolved the group in 1893, believing that no *avant-garde* circle should 'continue too long and pay the penalty of decline or retrogression'. Membership varied considerably but DE GROUX, ENSOR, ROPS and VAN RYSSELBERGHE were at one time members, as were TOOROP, RODIN and SIGNAC. Several Parisian artists were invited to exhibit well before their reputations were established in France, among them VAN GOGH, GAUGUIN, CÉZANNE, REDON, MONET, RENOIR and TOULOUSE-LAUTREC.
Lit. M. O. Maus: *Trente Années de lutte pour l'art* (1926)

Vollon Antoine, b. Lyons 1833, d. Paris 1900. REALIST artist, best known as a still-life painter; in this field he betrays the influence of both Chardin and RIBOT. His preference was for simple groups of a few objects (kitchen utensils, food, flowers) which he caught with vigorous brushstrokes in a rich dark palette. It was, however, with elaborately arranged still lifes that he won popularity; *Curiosités* (1868), commissioned by Nieuwerkerke, the superintendent of the Beaux-Arts, includes old ewers, faiences and various guns leaning against an Aubusson tapestry. In landscape he was a follower of COROT and DAUBIGNY. He attended evening classes at the Lyons art school and in 1859 arrived in Paris, where he studied with Ribot. He first exhibited at the SALON in 1864, winning his first medal the following year. Chevalier of the Legion of Honour in 1870 and officer in 1878, he became a member of the INSTITUT in 1898. There are works in Amiens, Amsterdam (Rijksmuseum), Auxerre, Baltimore (Mus. of Art), Boston, Brussels, Buffalo, Cherbourg, Dieppe, Glasgow, Grenoble, The Hague (Mesdag), Lyons, Melbourne, Moscow (Tretiakov), Munich, Nantes, Paris (Louvre, Carnavalet, Petit Palais), Périgueux, Reims, Rouen and Stockholm.

Vrubel Mikhail Alexandrovich, b. Omsk 1856, d. St Petersburg 1910. Tormented, visionary artist and sculptor, whose experiments in colour and decorative form much influenced the following generation of Russian painters. His obsession with the theme of Lermontov's 'Demon' inspired his greatest and strangest work. His Polish father's career in the Russian army gave him an unsettled, uprooted childhood. He studied philosophy and literature at St Petersburg University from 1874 to 1879, was at the academy from 1880 to 1884, and began his career by restoring the ancient murals of St Cyril in Kiev; to prepare for this he travelled to Venice (1884-5), where he was importantly influenced by Byzantine mosaics and early Venetian painting. He also worked with VASNETZOV on his Kiev Cathedral frescoes (1889). After years of struggle and lack of recognition (1885-9), SEROV introduced him to Mamontov, patron of the Abramtsevo artistic community, whose commissions and encouragement greatly helped his career and involved him in ceramic and theatre design (1890-1902); he also took part in the MIR ISKUSSTVA exhibitions. In 1905 he became insane. There are works in Leningrad (Russian Mus., Acad.) and Moscow (Tretiakov).
Lit. S. Yaremich: *M. A. Vrubel* (1911, in Russian); E. V. Zhuravlev: *M. A. Vrubel* (1958, in Russian)

Vuillard Jean Edouard, b. Cuiseaux 1868, d. La Baule 1940. Member of the NABIS in the last decade of the 19C, but best known for his INTIMISTE paintings which, like those of his friend BONNARD, belong mainly to the 20C. He studied at the ECOLE DES BEAUX-ARTS with GÉRÔME and BOUGUEREAU, and at the ACADÉMIE JULIAN where he met SERUSIER, Bonnard and VALLOTTON, the nucleus of the future Nabi group. Although he joined the Nabis it was more through friendship than conviction; he was only briefly influenced by GAUGUIN (*In Bed* 1891). However, he shared their interest in Japanese prints which were a lasting influence on his work, particularly on his composition. Looking back to MANET and DEGAS, he found his favourite themes in domestic interiors, often treated by artificial light (*Sitting-Room with Three Lamps* 1899). He developed an elaborate mixed media technique, combining oil,

tempera, gouache and pastel to achieve a subtle harmony of muted tones, working frequently on board. In his later years he received a number of major mural commissions (Théâtre des Champs Elysées 1912-13, League of Nations building, Geneva, 1938).

His graphic work included some fine colour lithographs. His work is represented in most galleries of modern art.
Lit. J. Salomon: *Vuillard admiré* (1961); J. Salomon: *Vuillard* (1968); J. Russell: *Vuillard* (1971)

W

Wächter Georg Friedrich Eberhard, b. Balingen 1762, d. Stuttgart 1852. German NEOCLASSICAL painter, much influenced by Carstens, who aimed at a style of monumental figure painting which would express grand and universal ideas (*Job and his Friends* 1797-1808, altered 1824). He was also one of the first German artists to admire and study early Italian painting (Cimabue, Masaccio), an interest which he passed on to the young NAZARENES, OVERBECK and PFORR, in their Vienna student days. He studied in Stuttgart and in Paris (1785-93) with Peyron and REGNAULT, where he also came in contact with the circle round DAVID. In Rome (1794-8) he was a friend of Carstens and KOCH. He spent 1798-1808 in Vienna and lived for the rest of his life in Stuttgart where he was given charge of the royal print room. His work is best represented in Stuttgart.
Lit. P. Koster: *E. Wächter, ein Maler des deutschen Klassizismus* (1968)

Wagenbauer Max Josef, b. Öxing 1774, d. Munich 1829. Early Munich landscapist whose simple naturalistic paintings are among the forerunners of STIMMUNGSLAND-SCHAFT. At the Munich drawing academy (1797-1801), he was much influenced by the Dutch 17C painters, especially Potter. He began by painting landscape watercolours, winning the patronage and encouragement of King Maximilian I, but turned to oil painting *c.* 1810. The high pastures among the Bavarian mountains were his favourite subjects; there are echoes of Potter in these views, but he painted with a personal observation and clear colours. There are works in Augsburg, Braunschweig, Bremen, Danzig, Darmstadt, Frankfurt/M., Munich

(N. Pin.), Riga, Schleissheim, Speyer, Vienna, Wiesbaden, Würzburg and Wuppertal.
Lit. R. Heinemann: *M. J. Wagenbauer* (1924)

Waldmüller Ferdinand Georg, b. Vienna 1793, d. Helmstreitmühle 1865. The leading exponent of BIEDERMEIER REALISM in Austria. He painted portraits with smooth high finish and decorative detail which are often compared to the work of INGRES (*Beethoven* 1823), and landscapes based on careful observation of the scenery of Austria and Italy; these, like the cheerful peasant genre scenes of his later years, are usually set in bright sunlight (*Prater Landscape* 1830, *View of the Halstattersee* 1838). He also painted occasional flower still lifes (*Bouquet with a Silver Ewer c.* 1840). He studied at the Vienna Academy with H. Maurer and LAMPI, but developed his individual talent by copying Old Masters and making studies from nature. He began his career as a miniature painter before turning to theatrical designs and scene painting in Agram, Prague and Brno. On his return to Vienna (1817) he painted his first oil portraits and landscapes with help from J. N. Schödlberger (*c.* 1820) and first exhibited in 1822. He was appointed a professor at the Vienna Academy in 1829, but the publication of essays criticizing academic teaching methods and stressing the observation of nature as the only source of art led to his dismissal in 1857 (reinstated 1864). He began his series of paintings of Austrian peasant scenes *c.* 1840. He also ran a private painting school in Vienna, and visited Italy several times, France in 1830 and England in 1856. His son Ferdinand was a musician and painter. Forgotten after his death, his reputation was re-established by the great 19C

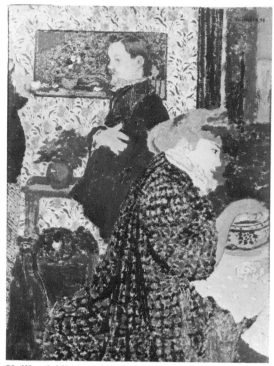

Vuillard *Missia and Valloton* 1894

Waldmüller *View of the Hallstattersee* 1838

retrospective exhibition held in Berlin in 1906. There are works in Belgrade (Nat. Mus.), Berlin, Wrocław, Budapest (Fine Arts), Cologne, Dresden, Düsseldorf, Essen, Frankfurt/M., Graz, Hamburg, Hanover, Kassel, Munich (N. Pin.), Nuremberg, Prague, Salzburg, Szczecin, Stuttgart and Vienna (Belvedere).
Lit. F. G. Waldmüller: *Das Bedürfnis eines Zweckmässigen Unterrichts in der Malerei und plastischen Kunst* (1846); A. Roessler: *F. G. Waldmüller: Sein Leben, sein Werk, und seine Schriften* (1907); G. Pisko: *Waldmüller* (1907); B. Grimschitz: *F. G. Waldmüller* (1957)

Walker Frederick, b. London 1840, d. St Fillans (Perthshire) 1875. English painter of rustic scenes, imbued with a sweet lyrical poetry and occasionally with overtones of social comment. He studied at the ROYAL ACADEMY Schools (1858) and first came to prominence in the 1860s as an illustrator; he contributed to *Once a Week* and the *Cornhill Magazine* and was sought after as a book illustrator. He began to exhibit at the Royal Academy in 1863 and thereafter showed both oils and watercolours (*The Violet Field, Wayfarers, The Old Gate*). He had a powerful influence on his contemporaries. Writing about Walker in the 1890s, R. Muther commented: 'Fifty per cent of the English pictures in every exhibition would perhaps never have been painted if he had not been born. . . . Like bees they suck from reality only its sweets'. He died of consumption at thirty-five. There are works in Birmingham, Liverpool, London (NPG, Tate, V&A), Manchester and Melbourne.
Lit. Sir C. Phillips: *F. Walker* (1894); J. G. Marks: *The Life and Letters of F. Walker* (1896); C. Black: *F. Walker* (1902)

Wappers Baron Egidius Karel Gustav, b. Antwerp 1803, d. Paris 1874. History painter who sprang to sudden prominence with his *Burgomaster van der Werff* (1830). Its patriotic historical theme caught the imagination of the Belgian people who had just rewon their independence; furthermore, he had studied Rubens and his brushwork and colour also broke with the tradition of French classicism which had dominated Belgian painting since the exile of DAVID in Brussels. With this painting and the even more successful *Episode*

from the Belgian Revolution of 1830 (1834), he launched the BELGIAN COLOURISTS. After studying with I. J. van Regemorter and at the Antwerp Academy with VAN BREE and W. Herreyns, he visited Paris (1826 and 1829), where he was much influenced by the new generation of ROMANTIC history painters (DELACROIX, SCHEFFER, DEVÉRIA, BOULANGER). He became a professor at the Antwerp Academy (1832) and its director (1840–53). An officer of the Legion of Honour and commander of the Belgian Order of Leopold, he was created Baron in 1845. In 1853 he settled in Paris. His later work, which includes history, genre and portrait, never matched up to his early success. There are works in Amsterdam, Antwerp, Brussels (Musées Royaux) and Utrecht.
Lit. J. G. A. Luthereau: *Le Baron G. Wappers* (1862); H. Billung: *G. Wappers, ein Kunstlerleben* (1880)

Ward James, b. London 1769, d. Cheshunt 1859. Animal painter who combined themes of animals in wild and dramatic movement (*Fighting Bulls with St Donat's Castle in the Background* 1803, *Fighting Horses* 1806), already pioneered in English painting by Stubbs and Gilpin, with richly textured landscapes in the manner of Rubens, thus making a highly individual contribution to the English ROMANTIC movement; he was among the English artists who influenced GÉRICAULT and DELACROIX in the 1820s. He studied engraving with his brother William and J. R. Smith and took up painting *c.* 1790; his early work is much in the manner of his brother-in-law George Morland. In 1794 he was appointed Painter and Engraver in Mezzotint to the Prince of Wales. He first exhibited at the ROYAL ACADEMY in 1792, becoming an ARA in 1807 and RA in 1811. In 1815 he completed his vast dramatic masterpiece, *Gordale Scar*, and in the following years tried his hand at ambitious works of history and allegory (*Triumph of the Duke of Wellington* 1821, 35 × 22 ft). His power as a painter later declined; he was harassed by financial difficulties and quarrelled with both his family and the Royal Academy. There are works in Bradford, Cambridge (Fitzwm), Cambridge Mass. (Fogg), Dublin, London (Tate, V&A, NPG), Manchester, Melbourne and Nottingham.
Lit. J. Frankau: *W. Ward and J. Ward*

Walker *The Old Gate* exhibited 1869

Wappers *Episode from the Belgian Revolution of 1830* 1834

Ward *Fighting Bulls, with St Donat's Castle in the Background* 1803

Wasmann *Flower Garden, Merano c.* 1840

G. F. Watts *Hope* 1885

216

(1904); C. R. Grundy: *J. Ward, his Life and Works* (1909)

Wasmann Rudolf Friedrich, b. Hamburg 1805, d. Merano 1886. German portrait, genre and landscape painter. He was an associate of the NAZARENES, and his portraits and portrait drawings combine the linear clarity of Nazarene style with penetrating psychological insight. Besides the genre and religious paintings of his later years, he made numerous oil landscape sketches of the landscape round Merano which are now regarded as important pre-IMPRESSIONIST works. After studying at the Dresden Academy with the Nazarene artist G. H. Naeke, he moved to Munich (1829) where he worked with CORNELIUS. In Rome (1832) he came into contact with the Nazarenes, particularly OVERBECK, and was converted to Catholicism in 1835. He spent 1835-9 in Munich and 1839-43 in Merano and Bozen, where he executed many portrait commissions; in Hamburg (1843-6) he was influenced by the BELGIAN COLOURISTS. He settled in Merano in 1846. The 1906 Berlin centenary exhibition brought an important re-evaluation of his achievement. There are works in Bremen, Düsseldorf, Hamburg, Hanover, Innsbruck, Magdeburg, Szczecin and Wuppertal.
Lit. F. Wasmann: *Ein deutsches Künstlerleben, von ihm selbst geschildert* (1896); P. Nathan: *F. Wasmann: Sein Leben und sein Werk* (1954)

Waterhouse John William, b. Rome 1849, d. London 1917. Artist who began his career as a follower of ALMA-TADEMA, painting Greek and Roman themes; in the 1880s he fell under the spell of the later works of ROSSETTI and devoted himself to painting the *femmes fatales* of literature, often placing them in a naturalistic landscape setting. He studied with his painter father and at the ROYAL ACADEMY Schools, becoming an ARA in 1885 and an RA in 1895. There are works in Adelaide, Leeds, Liverpool, London (Tate), Manchester, Melbourne and Sydney.

Watts Frederick Waters, b. ? 1800, d. Hampstead 1870. Prolific landscape painter who lived in Hampstead at the same time as Constable, to whom his paintings owe a profound debt. He exhibited at the ROYAL ACADEMY from 1821 to 1860; during his lifetime his reputation was somewhat overshadowed by Constable, but the 20C has seen a new interest in his work. There are works in Boston, London (Tate, V&A), New York (Met.) and Philadelphia.

Watts George Frederick, b. London 1817, d. London 1904. Painter of allegory, history and portrait, a sculptor and a notable draughtsman. His major allegorical paintings (*Hope, Love and Death, The Spirit of Christianity*) reflect the influence of classical antiquity (particularly the Elgin Marbles) in their simple but monumental composition, and of Titian in their richly textured brushwork full of broken lights. He was essentially a painter of ideas ('the exposition of some weighty principle of spiritual significance') which he clothed in symbolic form; with BURNE-JONES he was one of the English artists most admired by the French SYMBOLISTS and from the 1880s he enjoyed one of the highest reputations in England. He studied with the sculptor William Behnes and first exhibited at the ROYAL ACADEMY in 1837 (*Wounded Heron*). In 1843 his *Caractacus* cartoon won a £300 prize in the Houses of Parliament fresco competition, enabling him to visit Italy. He returned to London in 1847 and in 1850 went to live with the Prinseps at Little Holland House, where he built a small museum open to the public at weekends. He was briefly married to Ellen Terry (1864) and in 1887 married Mary Fraser Tytler, with whom he built Limnerslease at Compton in Surrey, now the Watts Museum. He twice declined the offer of a baronetcy (1885 and 1894). In 1895 he presented a series of portraits of prominent men of his time to the National Portrait Gallery; the subjects were selected by Watts himself for their spiritual qualities and character. He seldom sold his paintings and is best represented at the Watts Museum, and in London at the Tate and NPG, though there are works in several other English and American museums.
Lit. E. R. Dibdin: *G. F. Watts* (1923); R. E. D. Sketchley: *Watts* (1924); R. Chapman: *The Laurel and the Thorn* (1945); W. Blunt: *England's Michelangelo* (1975)

Webster Thomas, b. London 1800, d. Cranbrook 1886. Genre painter who carried

the WILKIE tradition of humorous village scenes into the late 19C. School children at play are among his favourite subjects; engravings of his works were very popular. An ARA in 1840, he was an RA from 1846 until he retired in 1876. He moved in 1856 to Cranbrook, in Kent, where he was a leading light of the CRANBROOK COLONY. There are works in Bury, London (Tate, V&A), Manchester, New York (Met.) and Preston.

Welti Albert, b. Zurich 1862, d. Berne 1912. SYMBOLIST painter profoundly influenced by BÖCKLIN; he peopled his landscapes with figures from northern legend – witches, knights and miraculous beasts. He specialized in small cabinet paintings which are often touched with humour. After studying photography in Lausanne (1880), he attended the Munich Academy (1881–6), aiming to become an illustrator. He visited Venice in 1887 and studied with Böcklin (1888–90). After short visits to Paris and Zurich, he settled in Munich. There are works in Basle (Kunstmuseum), Berne, Geneva and Zurich.
Lit. W. Wartmann: *A. Welti, 1862–1912 . . . Verzeichnis des graphischen Werkes* (1913); H. Hasse: *A. Welti: Gemälde und Radierungen* (1925)

Werenskiold Erik Theodor, b. Kongsvinger 1855, d. Oslo 1938. One of the leaders of Norwegian *avant-garde* painting *c.* 1900, he was a strong supporter of KROHG in his battle for REALISM. His own work combined Realist landscape and peasant scenes with illustrations to folk tales and legends, using clear, strong lines to evoke dreams and fairy fantasies. He also painted many portraits. He studied in Oslo (1872) and in Munich under LÖFFTZ and Lindenschmit (1876–80). In Paris (1881–3, 1885 and 1888–9), he was influenced by the IMPRESSIONISTS. He finally settled in Norway. There are works in Bergen, Copenhagen, Drontheim, Göteborg, Haugesund, Helsinki (Athenaeum), Oslo (NG) and Stockholm (Nat. Mus.).
Lit. T. Svedfelt: *E. Werenskiolds Konst* (1938)

West Benjamin, b. Springfield (Pa.) 1738, d. London 1820. American painter who made his career in England and was a significant influence on European painting. His Quaker soul warmed to the high idealism of the early NEOCLASSICAL theorists and artists in Rome (Winckelmann, Mengs, Hamilton), and his *Agrippina with the Ashes of Germanicus* (1768) is one of the first major subject paintings of the Neoclassical school. This painting won him the warm patronage of George III which enabled him to concentrate on history painting, unlike his English contemporaries who could only find an assured market with portraits. With *The Death of General Wolfe* (1771) and *Penn's Treaty with the Indians* (1771), he pioneered contemporary history as a subject for art and pointed the way for the French Romantic-classical limners of the Napoleonic epic. In a series of paintings of English history commissioned by George III, he also delved into the Middle Ages (*Death of Bayard* 1773, *Battle of Crécy* 1778), thus pioneering the genre of nationalistic history painting which swept Europe in the 19C. Stylistically he remained close to the classical school with formally idealized composition and careful finish. He worked as a portraitist in Philadelphia and New York before leaving for Europe in 1759; he spent the following three years in Italy and arrived in England in 1763. Here he first set up as a portraitist until freed by the success of *Agrippina*; this and his later subject paintings earned him considerable sums through engravings which were popular throughout Europe and America. Co-founder of the ROYAL ACADEMY in 1768, he was its president from 1792 to 1805 and again from 1806 to 1820. In 1802 he visited Paris, where he exhibited the preparatory study for *Death on a Pale Horse*. He was made a member of the INSTITUT in 1803, the Berlin Academy in 1812 and the Rome Accademia di S. Luca in 1816. Visiting American artists (COPLEY, STUART, PEALE, TRUMBULL) flocked to study in his studio, which was also popular with English painters (CONSTABLE, LAWRENCE). Many of his major paintings are still in the English Royal Collections but there are also works in Boston, Chicago, Cincinnati, Cleveland, Glasgow, Kansas City, Liverpool, London (Tate, V&A), Ottawa, Philadelphia, Pittsburgh, Sheffield and Vienna. (*see colour illustration 13*)
Lit. J. Galt: *The Life, Studies and Works of B. West* (1820); G. Evans: *B. West and the Taste of his Times* (1959)

Welti *The King's Daughters* 1901

Werenskiold *Country Funeral* 1883–5

West *Agrippina with the Ashes of Germanicus* 1768

Whistler *Arrangement in Black and Grey No. 1 : The Artist's Mother 1871-2*

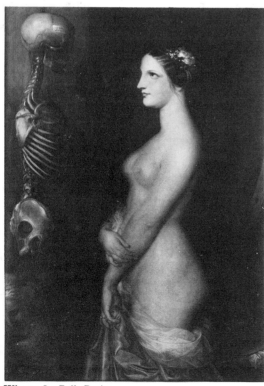

Wiertz *La Belle Rosine*

Whistler James Abbott McNeill, b. Lowell (Mass.) 1834, d. London 1903. American artist who lived most of his life in London and was England's most important link with COURBET, DEGAS, MANET and the French *avant-garde*; he was a major figure in the AESTHETIC MOVEMENT. As a student in Paris he was one of the first enthusiasts for Japanese prints, by which his work was much influenced (*Rose and Silver* 1864). Most typical of his work are his landscapes and portraits, where the emphasis lies on a musical harmony of tone and colour rather than on subject matter; he underlined this aim with his choice of titles (*Arrangement in Black and Gray No. 1 : The Artist's Mother* 1871-2, *Nocturne in Black and Gold: Old Battersea Bridge* 1872-5). He spent most of his childhood in Europe but learnt etching with an American cartographer before arriving in Paris as an art student in 1855. He studied intermittently with GLEYRE, was much influenced by Courbet and became a friend of Degas and FANTIN-LATOUR. He published his first etchings in 1858 (*Twelve Etchings from Nature*) and later won a considerable reputation as a graphic artist, especially with his views of London and Venice. He settled in England in 1859, though he continued to pay frequent visits to Paris. In 1878 he had a celebrated lawsuit with Ruskin, who had described his *Nocturne in Black and Gold* as 'flinging a pot of paint in the public's face'. He became president of the Society of British Artists and of the International Society of Sculptors, Painters and Gravers; chevalier of the Legion of Honour in 1889, he was promoted to officer in 1891. The best collections of his work are in Washington (Freer) and Glasgow University, but he is also represented in London (Tate), Paris (Louvre) and many American museums.
Lit. J. A. M. Whistler: *The Gentle Art of Making Enemies* (1890); D. Sutton: *Nocturne : The Art of J. M. Whistler* (1963) and *J. M. Whistler : Paintings, Etchings, Pastels, and Watercolours* (1966); D. Holden: *Whistler Landscapes and Seascapes* (1969)

Whittredge Worthington, b. Springfield (Ohio) 1820, d. Summit (N.J.) 1910. American landscapist who trained with A. ACHEN-BACH in Düsseldorf but fell under the spell of COLE and DURAND on his return to America.

He adapted the style of the HUDSON RIVER SCHOOL, specializing in broad horizontal views with a few busy figures. After studying at the Western Art-Union in Cincinnati, he travelled to Europe in 1849, financed by his Ohio patrons. He visited Paris, but gravitated to Düsseldorf, where he remained until 1854 when he went to Italy for five years. On his return to America, he was inspired by the work of Cole and Durand, which he saw at the New York Historical Society, and went to live in the Catskills to paint from nature. He visited the Rocky Mountains with KENSETT and GIFFORD in 1865, but found his main inspiration in the landscapes of the coast and plains (*Crossing the River Platte*). There are works in Baltimore (Mus. of Art), Boston, Buffalo, Cincinnati, New York (Met.) and Washington (NG, Corcoran).

Wiertz Antoine Joseph, b. Dinant 1806, d. Brussels 1865. Belgian painter of history and allegory; he turned his paintings into sermons on the evils of contemporary society. Firmly convinced of his own genius, he combined the examples of Michelangelo and Rubens in huge monumental paintings. After studying on a state scholarship at the Antwerp Academy under Herreyns and VAN BREE, he won a Rome prize in 1832; in Rome his *Patroclus* was hailed as a masterpiece, but it received scant attention when exhibited in Paris and Brussels and for the rest of his life he was preoccupied with avenging himself on the establishment. He was nevertheless treated kindly by the state, which built him a huge studio in Brussels and honoured him as a leader of the Belgian school. Filled with canvases he had refused or been unable to sell, it became the Musée Wiertz at his death (*Revolt of Heaven against Hell* 1842, *Thoughts and Visions of a Severed Head* 1853). He painted unsigned portraits to earn his keep. There are works in Antwerp and Liège as well as in the Musée Wiertz in Brussels.
Lit. F. Vanderpyl: *A. Wiertz* (1931); R. Bodart: *A. Wiertz* (1949); H. Colleye: *A. Wiertz* (1957)

Wilkie Sir David, b. Cults (Fifeshire) 1785, d. Mediterranean 1841. The father of 19C genre painting in England and a powerful influence on the Continent, particularly in

Germany; *Opening of the Will* was bought by Ludwig I for the Munich collections in 1826 and brought into existence a school of Munich genre painters, while KNAUS had Wilkie engravings hanging round the hall of his Berlin home. His peasant scenes leant heavily on Teniers, Ostade and the Dutch, but he used free rapid brushstrokes, the hallmark of early 19C England; his paintings are usually humorous and anecdotal. The Spanish pictures of his second period, inspired by Velasquez and Murillo, were acclaimed in the 1830s. Life in the small Scottish village of his childhood provided the main subject matter for his mature paintings. At fourteen he entered the Trustee's Academy, Edinburgh, under the historical painter John Graham. The sale of *Pitlessie Fair* financed his move to London (1805), where he entered the ROYAL ACADEMY Schools and exhibited *Village Politicians* (1806) with instant success. He became an ARA in 1809 and an RA in 1811. In 1814 he visited Paris and Holland, and between 1825 and 1828 Italy, Germany and Switzerland; a visit to Spain during this period heralded his second 'Spanish' style and subjects. He succeeded LAWRENCE as painter-in-ordinary to the King (1830) and six years later was knighted and elected to the INSTITUT. In 1840 he became one of the first British artists to visit the Near East, staying in Constantinople, Smyrna and Jerusalem. He died on the return journey and was buried at sea. With ETTY and Lawrence, he was among the English artists who most impressed GÉRICAULT and DELACROIX. There are works in Berlin, Besançon, Cardiff, Dublin, Edinburgh, Glasgow, Leicester, Lille, London (NG, NPG, Tate, Wallace), Minneapolis, Montreal, Munich, New York (Brooklyn, Met.), Nottingham, Toledo, Victoria, Windsor and Worcester Mass.
Lit. A. Cunningham: *Life of Sir D. Wilkie* (1843); R. S. Gower: *Sir D. Wilkie* (1902); W. Bayne: *Sir D. Wilkie* (1903)

Willems Florent, b. Liège 1823, d. Neuilly-sur-Seine 1905. Belgian painter of historical genre, usually tranquil studies set in the 16C and 17C with careful attention to the texture of satins, velvets, curls and lace. Lemonnier remarked that he 'painted the dress of an epoch but neither its spirit nor

its face'; he nevertheless achieved a wide popularity. After studying at the Malines Academy, he moved to Paris (1844), where he became a close friend of A. STEVENS, with whom he shared a studio. At the SALON of 1855, one of his works was bought by the Emperor and the other by the Empress. A chevalier of the Legion of Honour in 1853, an officer in 1864 and a commander in 1878, he also became a knight of the Order of Leopold in 1851, an officer in 1855, and a commander in 1860. There are works in Amsterdam (Stedelijk), Antwerp, Baltimore (Walters), Brussels (Musées Royaux), Dublin, Hamburg, Liège, New York (Met.), Nice and Vienna (Czernin).

Winterhalter Franz Xavier, b. Menzenschwand 1805, d. Frankfurt 1873. The favourite portraitist of the royal houses of Europe from 1840 to 1870. Queen Victoria acquired over a hundred oils and many drawings and watercolours; Empress Eugénie carried quantities of his work into exile to remind her of happier days. He painted female beauty and the frolics of fashionable *couture* with a smooth enamel finish owing much to STIELER; after he settled in Paris his style became looser and from the 1840s the influence of LAWRENCE and the English 18C portraitists is discernible. After studying at Freiburg from 1818, he won a scholarship to the Munich Academy (1824), where he studied with R. von Langer and earned a living by making prints after Old Masters. In 1828 he moved to Karlsruhe, where he taught drawing to Markgräfin Sophie and painted portraits, becoming court painter in 1834. In Italy (1833–4) he painted some genre scenes in the manner of ROBERT, before moving to Paris (1835), where he became a favourite portraitist at the court of Louis-Philippe. In 1841 he received his first commission from Victoria. Based in Paris until 1870, he fled from the Franco-Prussian War to Interlaken, afterwards settling in Karlsruhe. His work reached a wide public through engravings. In busy years his portraits were often finished by his painter brother Hermann or by his friend and assistant Eduard Magnus. There are works in Ajaccio, Amsterdam, Baltimore (Walters), Calais, Castres, Chantilly, Florence (Uffizi), Karlsruhe, Lille, London (NPG, Wallace),

Wilkie *Opening of the Will* 1820

Willems *The Duchess's Reception* exhibited 1897

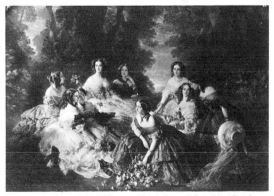
Winterhalter *The Empress Eugénie and her Maids of Honour* 1853

Munich, New York (Met.), Nice, Paris (Louvre), Reims and Versailles.

Woodville Richard Caton, b. Baltimore (Md.) 1825, d. London 1855. The first of the American genre painters to study abroad, he painted humorous views of bourgeois life in America in the highly finished style of the DÜSSELDORF SCHOOL. After studying medicine, he turned seriously to painting in 1845 and worked in Düsseldorf with SOHN until 1850, sending home his paintings for exhibition at the AMERICAN ART-UNION, where they were much admired. He committed suicide in London. There are works in Baltimore (Mus. of Art, Walters), Bristol, Liverpool, New York (Nat. Acad.) and Washington (Corcoran).

Wyspiánski Stanislaw, b. Cracow 1869, d. Cracow 1907. Polish painter, illustrator and designer much influenced by French SYMBOL-ISM and the work of GAUGUIN. He was the leader of Stzuka, the Cracow Secessionist movement, founded in 1897. A pupil of MATEJKO in Cracow, he lived for a time in Paris (1891-4), where he met Gauguin, and travelled widely throughout Europe. In 1894 he returned to Poland, becoming a teacher at Cracow Art School in 1904. He painted frescoes for many Polish churches, designed stained-glass windows, wrote and designed for the theatre, and executed innovative and influential graphics. There are works in Cracow.
Lit. W. E. Skierkowska: *Wyspiánski and the Art of the Book* (1960, in Polish)

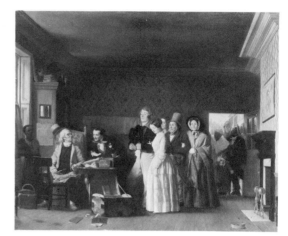

Woodville *The Sailor's Wedding* 1852

Z

Zahrtmann Peder Henrik Kristian, b. Rønne 1843, d. Copenhagen 1917. Danish history painter whose intimate and reflective scenes were painted with a bright palette of pure colours. The life of Eleonora Christina, daughter of Christian IV, and her tragic imprisonment were a recurring theme. His art had no obvious precursor and no true followers, though he was highly influential as teacher of the younger Funen school of Danish IMPRESSIONISTS. He studied at the Copenhagen Academy (1863-4) under MAR-STRAND, and went with a travel scholarship to Italy (1875-8), where he painted many genre scenes. He travelled widely and taught at the anti-academic free school founded by Rohde (1885-1908). There are works in Aarhus, Copenhagen (State, Hirschsprung), Odense, Oslo (NG), Skagen and Stockholm.
Lit. S. Danneskiold-Samsoei: *K. Zahrtmann* (1942)

Zandomeneghi Federico, b. Venice 1841, d. Paris 1917. REALIST landscape and genre painter, an associate of the MACCHIAIOLI. He moved to Paris in 1874 and fell under the spell of the IMPRESSIONISTS, developing a mature style close to the early work of RENOIR. He studied at the Venice Academy under Molmenti and Grigoletti, fought with

Garibaldi in 1861 and the following year settled in Florence, where he turned to *plein air* painting with the Macchiaioli. There are works in Florence (Mod. Art), Milan (Brera, Grassi, Mod. Art), Piacenza (Oddi-Ricci) and Venice (Mod. Art).
Lit. G. Perocco: *Zandomeneghi* (1959); M. Cinotti: *Zandomeneghi* (1960); E. Piceni: *Zandomeneghi* (1967)

Ziem Félix François Georges Philibert, b. Beaune 1821, d. Paris 1911. French painter of the sea and southern ports, especially Venice and Constantinople. Though his early work was strongly influenced by the BARBIZON SCHOOL, he developed an individual style, a misty treatment with a riot of rich colour. His seascapes won him several medals and a large following of collectors. He studied at the Dijon Ecole d'Architecture before moving to Marseilles and in 1841 to Italy. After spending 1842-3 in Russia, he arrived in Paris in 1848 and first exhibited at the SALON the following year. Throughout his life he travelled constantly, particularly to Venice and the Bosphorus. He became a chevalier of the Legion of Honour in 1857, an officer in 1878 and a commander in 1908, and left the contents of his studio to the museum of the city of Paris. There are also

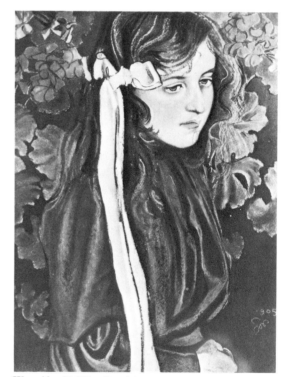

Wyspiánski *Eliza Parénska* 1905

works in Ajaccio, Amsterdam (Rijksmuseum, Stedelijk), Avignon, Baltimore (Walters), Berlin, Bordeaux, Boston, Buenos Aires, Cincinnati, Digne, Dijon, Douai, Frankfurt/M., Hamburg, Kansas, Liège, London (Wallace), Marseilles, Minneapolis, Montpellier, Montreal, Moscow, Mulhouse, Nantes, New York (Met., Brooklyn), Nice, Paris (Louvre, Marine), Philadelphia, Reims, Rouen, San Francisco, Tokyo, Toledo, Toulouse, Utrecht, Valenciennes and Washington (Corcoran).

Lit. L. Fournier: *Un Grand Peintre: F. Ziem* (1898); C. Mauclair: *L'Art de F. Ziem* (1901); L. Roger-Milès: *F. Ziem* (1903)

Zorn Anders Leonard, b. Utmeland (nr Mora) 1860, d. Mora 1920. Swedish portraitist who achieved a wide fashionable success in Paris, London and America as well as in Sweden. He also worked extensively as an engraver, treating portraits and scenes of fashionable life with a dense pattern of rapid lines to achieve a dashing and glamorous effect. In later life he painted many landscapes and village interiors peopled mainly by sturdy nudes. At the Stockholm Academy (1877–81), he trained first to be a sculptor before turning to watercolour, genre and portraits. His visits to London and Paris in 1881 were followed by years of extensive travel in Europe and the Middle East. From 1886 to 1896 he lived in Paris, where his work delighted fashionable society; he was a friend of Proust and a founder member of the SOCIÉTÉ NATIONALE DES BEAUX-ARTS. In 1893 he visited America for the World's Columbian Exposition in Chicago; the popularity of his portraits encouraged him to make several return trips. After 1896 he lived in Sweden, though he frequently made trips abroad. There are works in Berlin, Budapest (Mus. of Fine Arts), Chicago, Cleveland, Copenhagen, Florence, Hamburg, Helsinki (Athenaeum), Leipzig, New York (Met., Brooklyn), Paris, Rome (Mod. Art), St Louis, Stockholm (Nat. Mus.), Trieste (Revoltella), Venice and Washington (NG, Corcoran).

Lit. K. Asplund: *A. L. Zorn, his Life and Work* (1921); G. Boethius: *Zorn: Tecknaren, malaren, etsaren, skulptören* (1949); G. and A. Zorn: *An International Swedish Artist* (1954)

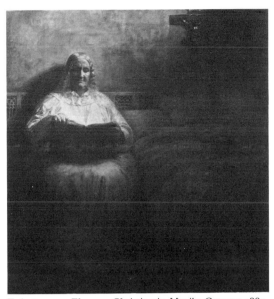

Zahrtmann *Eleonora Christina in Maribo Convent* 1882

Zandomeneghi *Place d'Anvers, Paris* 1886

Ziem *View of an Island in the Lagoon, Venice*

Zorn *Mrs Potter Palmer* 1893

Zügel *Sheep in an Alder Grove* 1875

Zuloaga y Zabaleta *Portrait of a Woman*

Zügel Heinrich von, b. Murrhardt 1850, d. Munich 1941. German animal painter, highly regarded at the turn of the 19C, who painted sheep and cows in their pastures, first with a Barbizon-oriented REALISM typical of the Munich school, and later with a bright, almost IMPRESSIONIST palette. He studied in Stuttgart (1867–9) and in Munich, where he was significantly influenced by BRAITH. A member of the Munich Academy in 1888 and a professor in 1889, he was also a founder member of the Munich SECESSION in 1892. He became a member of the Berlin, Dresden and Antwerp Academies and was knighted ('von') in 1907. There are works in Berlin, Bremen, Wrocław, Cologne, Dresden, Düsseldorf, Frankfurt/M., Hamburg, Leipzig, Mainz, Montreal, Munich (N. Pin.), Stuttgart and Trieste.
Lit. G. Biermann: *H. von Zügel* (1910); E. T. Rohnert: *H. von Zügel, ein Malerleben* (1941)

Zuloaga y Zabaleta Ignacio, b. Eibar 1870, d. Zumaya 1945. Spanish painter who was an associate of the SYMBOLISTS in Paris. He has been called the true follower of GOYA, painting Spanish peasant life, bullfights and witches with a sombre perception of pain and hardship and a technique which echoes MANET and the IMPRESSIONISTS. Born into a family with an important craft tradition in metalwork and ceramics, he was largely self-taught as a painter, copying in the Prado and moving early to Paris. He was a friend of Mallarmé, GAUGUIN, DEGAS and RODIN and divided his life between Spain and France. There are works in most Spanish galleries, and in Berlin (NG), Boston, Brussels (Musées Royaux), Buenos Aires, Bucharest, Chicago, Essen, Ghent, Leipzig, London (Tate), New York (Met.), Paris (Louvre), Poznań, Rome, St Louis, San Diego, Tournai, Trieste and Venice.
Lit. J. López Jimenéz: *I. Zuloaga, ensayo biográfico y critico* (1944); E. Lafuente Ferrari: *La vida y el arte de I. Zuloaga* (1950)

Zünd Robert, b. Lucerne 1827, d. Lucerne 1909. Landscapist who combined REALIST and idealist tendencies; his landscapes, carefully composed in the tradition of Claude and Poussin, are full of the sparkling colour of the *plein air* school. He studied in Geneva with DIDAY and CALAME (1848–50) and from 1851 in Munich, where he copied Old Masters and began a lifelong friendship with KOLLER. In Paris (1852) he met DECAMPS, BUCHSER and ANKER, and studied the work of Claude and Poussin; on later visits (1859, 1861) he became a friend of TROYON and the BARBIZON SCHOOL painters. He lived a withdrawn life in his country house near Lucerne, exhibiting rarely, and received an honorary doctorate from Zurich University in 1896. There are works in Aarau, Basle (Kunstmuseum), Berne, Fribourg, Lucerne and Zurich.
Lit. H. Uhde-Bernays: *R. Zünd* (1934)

Bibliography

Those books on which I have particularly relied are indicated by an asterisk.

Dictionaries

* ★ E. Bénézit: *Dictionnaire des peintres, sculpteurs, dessinateurs et graveurs* (4th ed. 1966)
* ★ A. Bolaffi (ed.): *Catalogo bolaffi della pittura Italiana dell'800* (1970)
* C. Brun: *Schweizerisches Künstler-Lexikon* (4 vols 1905-17)
* M. Bryan: *Dictionary of Painters and Engravers* (1903)
* ★ C. E. Clement, L. Hutton: *Artists of the 19th Century* (1884)
* ★ Encyclopaedia Britannica (ed.): *Encyclopaedia of Art* (1971)
* *Encyclopaedia of World Art* (1967)
* M. Fielding: *Dictionary of American Painters, Sculptors and Engravers* (1945)
* A. Graves: *A Dictionary of Artists 1760-1893* (1884, 1969)
* ★ *Kindlers Malerei Lexikon* (5 vols 1964-8)
* *Lexikon der Kunst* (I 1968, II 1971)
* ★ P. and L. Murray: *Dictionary of Art and Artists* (1959, 1968)
* H. Ottley: *A Biographical and Critical Dictionary* (1866)
* S. H. Pavière: *A Dictionary of Victorian Landscape Painters* (1968)
* S. H. Pavière: *Dictionary of British Sporting Painters* (1965)
* S. Redgrave: *A Dictionary of Artists of the English School* (1878)
* ★ P. Scheen: *Lexicon Nederlaandse Beeldende Kunstenaars 1750-1950* (1969)
* W. G. Strickland: *A Dictionary of Irish Artists* (1913, 1971)
* *Svensk Konstnärs Lexikon* (2 vols 1952)
* ★ U. Thieme, F. Becker: *Allgemeines Lexikon der bildenden Künstler* (37 vols 1907-50)
* A. Wilson: *Dictionary of British Marine Painters* (1967)
* ★ C. Wood: *Dictionary of Victorian Painters* (1971)

19th Century: General

* P. d'Ancona: *La pittura dell'800* (1954)
* F. Antal: *Classicism and Romanticism with other Studies in Art History* (1966)
* Mrs A. Bell: *Representative Painters of the 19th Century* (1899)
* F. Bellonzi: *Romanticismo e socialismo nell'arte dell'800* (1956)
* L. Bénédite: *L'Art du XIXe. siècle* (1905)
* ★ C. Blanc: *Histoires des peintres* (1865)
* E. von Boetticher: *Malerwerke des 19 Jahrhunderts* (1901)
* C. Clement: *Les Artistes célèbres* (1886)
* P. Colin: *La Peinture Européenne au XIXe. siècle* (1935)
* ★ Dubosc de Pesquidoux: *L'Art au 19e. siècle* (1881)
* ★ L. Eitner: *Neo-Classicism and Romanticism 1750-1850. Sources and Documents* (2 vols 1970)
* ★ H. Focillon: *La Peinture au 19e. siècle. Le retour à l'antique – le romantisme* (1927)
* ★ H. Focillon: *La Peinture aux 19e. et 20e. siècles. Du réalisme à nos jours* (1928)
* ★ E. Gilmore Holt: *From the Classicists to the Impressionists. A Documentary History of Art* (1966)
* ★ A. Hauser: *The Social History of Art* (1951)
* C. G. Heise: *Grosse Zeichner des 19 Jahrhunderts* (3rd ed. 1907)
* H. Hildebrandt: *Die Kunst des 19. und 20. Jahrhunderts* (1924)
* W. Hofmann: *The Earthly Paradise. Art in the 19th Century* (1961)
* J. K. Huysmans: *L'Art moderne* (1883)
* E. Lavignino: *L'Arte moderna dai neoclassici ai contemporanei* (2 vols 1961)
* H. Lietzmann (ed.): *Bibliographie zur Kunstgeschichte des 19 Jahrhunderts* (vol 4 of *Studien zur Kunst des 19 Jahrhunderts* 1968)
* D. S. MacColl: *Nineteenth Century Art* (1902)
* ★ J. Meier-Graefe: *Entwicklungsgeschichte der modernen Kunst* (1904)
* G. Moore: *Modern Art* (1893)
* ★ R. Muther: *History of Modern Painting* (4 vols 1893-4, 1907)
* ★ F. Novotny: *Painting and Sculpture in Europe 1780-1880* (1960)
* G. Pauli: *Die Kunst des Klassizismus und der Romantik* (1925)
* F. Pecht: *Künstler des 19 Jahrhunderts* (1881)
* N. Pevsner: *Gemeinschaftsideale unter den bildenden Künstlern des 19 Jahrhunderts* (1931)
* N. Pevsner: *Art and Architecture in Europe 1830-1870* (1957)
* G. and G. Pischel: *Pittura Europea dell'800* (1945)
* ★ E. P. Richardson: *The Way of Western Art 1776-1914* (1939)
* A. Rosenberg: *Geschichte der modernen Malerei* (1888)
* K. Scheffler: *Die europäische Kunst im 19 Jahrhundert* (2 vols 1927)
* E. Scheyer: *Biedermeier in der Literatur- und Kunstgeschichte* (1960)
* T. Sylvestre: *Histoire des artistes vivants français et étrangers* (1857)
* H. C. White, C. White: *Canvases and Careers* (1965)
* D. Wild: *Moderne Malerei* (1950)
* ★ R. Zeitler: *Die Kunst des 19 Jahrhunderts* (1966)

Academies and Institutions

* ★ A. Boime: *The Academy and French Art in the 19th Century* (1971)
* H. Delaborde: *Académie des Beaux-Arts* (1891)
* J. Hasselblatt: *Historischer Ueberblick der Entwicklung der kaiserlich russischen Akademie der Künste in St. Petersburg* (1886)
* S. Hutchinson: *History of the Royal Academy 1768-1968* (1968)
* ★ W. R. M. Lamb: *The Royal Academy* (1935)
* Looström: *Den svenska Konstakademien 1735-1835* (1887)
* ★ N. Pevsner: *Academies of Art* (1940)
* J. L. Roget: *History of the Old Watercolour Society* (1891)
* A. Soubies: *Les Membres de l'Académie des Beaux-Arts* (1909)
* M. Tourneux: *Salons et expositions d'art à Paris 1801-1870* (1919)

Bibliography

R. Wiegmann: *Die königliche Kunstakademie zu Düsseldorf* (1856)

Impressionism and Post-Impressionism

W. Balzer: *Der französische Impressionismus. Die Hauptmeister in der Malerei* (1958)

G. Bazin: *L'Époque impressioniste* (1947)

T. Duret: *Les Peintres impressionistes* (1939)

R. Hamann: *Impressionismus in Leben und Kunst* (1923)

L. and E. Hanson: *Impressionism. Golden Decade 1872-1882* (1961)

G. F. Hartlaub: *Impressionists in France* (1956)

J. Leymarie: *Impressionism* (1955)

P. Mathey: *The Impressionists* (1961)

C. Mauclair: *Les Maîtres de l'impressionisme. Leur histoire, leur esthétique, leurs œuvres* (1923)

P. Pool: *Impressionism* (1967)

* J. Rewald: *The History of Impressionism* (1946)

* J. Rewald: *Post-Impressionism from Van Gogh to Gauguin* (1962)

M. Sérullaz: *Les Peintres impressionistes* (1946)

J. Vandoyer: *Les Impressionistes de Manet à Cézanne* (1948)

L. Venturi: *Les Archives de l'impressionisme* (2 vols 1939)

L. Venturi: *Impressionists and Symbolists* (1950)

Neoclassicism

* 'The Age of Neo-Classicism' (Cat. Arts Council of Great Britain 1972)

F. Benoît: *L'Art français sous la revolution et l'empire* (1897)

U. Christoffel: *Klassizismus in Frankreich um 1800* (1941)

R. Escholier: *La Peinture française. 19e. siècle, de David à Géricault* (1941)

K. Gerstenberg: *Die ideale Landschaftsmalerei. Ihre Begrundung und Vollendung in Rom* (1923)

S. Giedion: *Spätbarocker und romantischer Klassizismus* (1922)

L. Hautecoeur: *Rome et la renaissance de l'antiquité à la fin du 18e. siècle* (1912)

* H. Honour: *Neo-Classicism* (1968)

D. Irwin: *English Neoclassical Art* (1966)

K. Kaiser: *Deutsche Malerei um 1800* (1959)

B. Knauss: *Das Künstlerideal des Klassizismus und der Romantik* (1925)

J. Lindsay: *Death of a Hero. French Painting from David to Delacroix* (1961)

C. von Lorck: *Die Klassik und der Osten Europas. Von Ursprung und Wesen des Klassizismus* (1966)

W. Milton: *The Paintings of the French Revolution* (1938)

G. Nicodemi: *La pittura milanese dell'età neoclassica* (1915)

* A. Ottino della Chiesa: *Il neoclassicismo nella pittura italiana* (1967)

F. G. Pariset: *L'Art Néo-Classique* (1976)

G. Pauli: *Die Kunst des Klassizismus und der Romantik* (1925)

M. Praz: *On Neoclassicism* (1969)

R. Schneider: *L'Art français. 19e. siècle, du classicisme Davidien au romantisme* (1929)

E. von Sydow: *Kultur des deutschen Klassizismus* (1926)

E. Waterhouse: 'The British contribution to the Neo-Classical style in painting' (*Proceedings of the British Academy* vol XL 1954)

R. Zeitler: *Klassizismus und Utopia. Interpretationen zu Werken von David, Canova, Carstens, Thorwaldsen, Koch* (1954)

Realism

F. Bouvier: *La Bataille réaliste 1844-57* (1913)

M. Buchsbaum: *Deutsche Malerei im 19 Jahrhundert. Realismus und Naturalismus* (1967)

A. Cassagne: *La Théorie de l'art pour l'art en France chez les derniers romantiques et les premiers réalistes* (1959)

V. Fiala: *Die russische realistische Malerei des 19 Jahrhunderts* (1953)

R. Hamann, J. Herman: *Naturalismus* (1968)

* C. Maltese: *Realismo e verismo nella pittura italiana dell'800* (1967)

A. McDowell: *Realism, a Study in Art and Thought* (1917)

L. Nochlin: *Realism and Tradition in Art 1848-1900* (1966)

* L. Nochlin: *Realism* (1971)

J. Proudhon: *Du Principe de l'art et de sa destination sociale* (1865)

L. Rosenthal: *Du Romantisme au réalisme, 1830-1948* (1914)

D. Sauvageot: *Le Réalisme et le naturalisme dans la littérature et dans l'art* (1889)

J. Sloane: *French Painting between Past and Present 1848-70* (1951)

* E. Waldmann: *Die Kunst des Realismus und Impressionismus* (1927)

B. Weinberg: *French Realism. The Critical Reaction 1830-70* (1937)

Romanticism

A. Addison: *Romanticism and the Gothic Revival* (1938)

* Arts Council of Great Britain: *The Romantic Movement* (Tate Gallery 1959)

K. Badt: *Wolkenbilder und Wolkengedichte der Romantik* (1960)

C. Baudelaire: *L'Art romantique* (1869)

F. Baudson: 'Le Style troubadour' (Cat. Musée de l'Ain, Bourg-en-Bresse 1971)

R. E. Benz and A. von Schneider: *Die Kunst der deutschen Romantik* (1939)

T. S. R. Boase: 'Shipwrecks in English romantic painting' (*Journal of the Warburg and Courtauld Institutes* XXII nos 3-4 1959)

M. P. Boyé: *La Mêlée romantique* (1946)

G. Briganti: *Pittura fantastica e visionaria dell'800* (1967)

M. Brion: *Romantic Art* (1960)

* M. Brion: *Art of the Romantic Era* (1966)

C. Carrà: *Pittori romantici lombardi* (1932)

C. Caubisens: 'Peinture et préromantisme pendant la revolution française' (*Gazette des Beaux-Arts* LVIII Dec. 1961)

K. Clark: *The Gothic Revival* (1950)

K. Clark: *The Romantic Rebellion* (1975)

R. Cogniat: *Le Romantisme* (*Histoire Générale de la Peinture* 1966)

* P. Colin: *La Peinture européenne au 19e. siècle: le romantisme* (1935)

P. Courthion: *Romanticism* (1961)

A. Dasnoy: *Les Beaux Jours du romantisme belge* (1948)

Detroit Institute of Art and Philadelphia Museum of Art: 'Romantic Art in Britain' (Exhib. Cat. 1968)

W. R. Deusch: *Malerei der deutschen Romantiker und ihrer Zeitgenossen* (1937)

C. L. Eastlake: *A History of the Gothic Revival* (1872)

L. Eitner: 'The open window and the storm-tossed boat: An essay in the iconography of Romanticism' (*Art Bulletin* XXXVII Dec. 1955)

F. Flutre: *Le Romantisme* (1926)

E. H. Gombrich: 'Imagery and art in the Romantic period' (*Burlington Magazine* XCI June 1949)

G. Grigson: 'Painters of the abyss' (*Architectural Review* CVIII Oct. 1950)

G. Grundmann: *Das Riesengebirge in der Malerei der Romantik* (1958)

L. Hautecœur (ed.): *Le Romantisme et l'art* (1928)

G. Hough: *The Last Romantics* (1961)

F. M. Huebner: *Die Kunst der niederländischen Romantik* (1942)

F. Landsberger: *Die Kunst der Goethezeit* (1931)

G. Pauli (ed.): *Arte del clasicismo y del romanticismo* (1948)

J. F. Ratok: *El arte romantico en España* (1954)

L. Réau: *L'Art romantique* (1930)

L. Réau: *L'Ère romantique: les arts plastiques* (1949)

L. Rosenthal: *La Peinture romantique* (1901)

L. Rosenthal: *Du Romantisme au réalisme* (1914)

L. Rosenthal: *L'Art et les artistes romantiques* (1928)

A. von Schneider: *Deutsche Romantiker-Zeichnungen* (1942)

R. Todd: *Tracks in the Snow* (1946)

P. Wescher: *Die Romantik in der schweizer Malerei* (1947)

Symbolism

R. G. Aubrun: *Péladan* (1904)

R. Barilli: *Il simbolismo nella pittura francese dell'800* (1967)

C. Chassé: *Le Mouvement symboliste* (1947)

U. Christoffel: *Malerei und Poesie. Die symbolistische Kunst des 19 Jahrhunderts* (1948)

M. Denis: *Théories 1890-1910. Du symbolisme et de Gauguin vers un nouvel ordre classique* (1920)

P. Julian: *Esthètes et magiciens* (1969)

* P. Julian: *Dreamers of Decadence* (1971)

F.-C. Legrand: *Symbolism in Belgium* (1972)

A. G. Lehmann: *The Symbolist Aesthetic in France 1885-1895* (1968)

J. Lethève: *Impressionistes et symbolistes devant la presse* (1959)

* E. Lucie-Smith: *Symbolist Art* (1972)

A. Mellerio: *The Idealist Movement in Painting* (1896)

* J. Milner: *Symbolists and Decadents* (1971)

J. Péladan: *De la Sensation d'art* (1907)

J. Péladan: *Introduction à l'esthétique* (1907)

J. Péladan: *L'Art idéalistique et mystique* (1909)

B. S. Polak: *Het Fin-de-Siècle in de Nederlandse Schilderkunst* (1955)

B. S. Polak: *Symbolism* (1967)

M. Raymond: *From Baudelaire to Surrealism* (1950)

E. Raynaud: *La Mêlée symboliste* (1918-22)

H. R. Rookmaker: *Synthetist Art Theories* (1958)

B. Ruettenauer: *Symbolische Kunst* (1900)

N. Wallis: *Fin de siècle* (1947)

Austria

O. Benesch: *Kleine Geschichte der Kunst in Österreich* (1950)

W. Buchowiecki: *Geschichte der Malerei in Wien* (1955)

H. Bunemann: *Deutsche Malerei des 19 Jahrhunderts. Deutschland, Österreich, Schweiz* (1960-1)

R. Feuchtmuller, W. Mrazek: *Biedermeier in Österreich* (1963)

R. Feuchtmuller, W. Mrazek: *Kunst in Österreich 1860-1918* (1964)

W. Frodl: *Kunst in Südtirol* (1960)

K. Ginhart (ed.): *Die bildende Kunst in Österreich vom Ausgang des 18 Jahrhunderts bis zur Gegenwart* (1943)

K. Ginhart: *Wiener Kunstgeschichte* (1948)

* B. Grimschitz: *Die altwiener Malerei* (1961)

* B. Grimschitz: *Österreichische Maler vom Biedermeier zur Moderne* (1963)

L. Hevesi: *Österreichische Kunst im 19 Jahrhundert* (1903)

C. Holme (ed.): *The Art Revival in Austria* (1906)

L. Münz: *Österreichische Landschaftsmalerei des 19 Jahrhunderts* (1954)

H. Schwarz: *Salzburg und das Salzkammergut. Die kunstlerische Entdeckung der Stadt und der Landschaft im 19 Jahrhundert* (1958)

H. Tietze: *Das vormärzliche Wien in Wort und Bild* (1925)

E. H. Zimmerman: *Das Alt-Wiener Sittenbild* (1923)

Belgium

P. Colin: *La Peinture belge depuis 1830* (1930)

A. Dasnoy: *Les Beaux Jours du romantisme belge* (1948)

P. Fierens et al.: *L'Art en Belgique* (1938)

P. Fierens: *L'Art flamand* (1946)

A. Fontaine: *L'Art belge* (1925)

H. E. van Gelder: *Kunstgeschichte der Nederlände* (1938)

* H. Hijmans: *Belgische Kunst des 19 Jahrhunderts* (1906)

J. du Jardin: *L'Art flamand* (1897)

P. Lambosse: *Histoire de la peinture et de la sculpture en Belgique 1830-1930* (1930)

* F.-C. Legrand: *Symbolism in Belgium* (1972)

C. Lemonnier: *Histoire de la peinture en Belgique, 50 ans de liberté* (1881)

C. Lemonnier: *Les Peintres de la vie* (1888)

* C. Lemonnier: *L'Ecole belge 1830-1905* (1906)

A. Michels: *Histoire de la peinture flamande depuis ses debuts jusqu'en 1864* (vols IX, X 1865-76)

P. de Mont: *Schilderkunst in Belgium 1830-1920* (1921)

R. Muther: *Die Belgische Malerei im 19 Jahrhundert* (1904)

G. Vanzype: *L'Art belge du 19e. siècle* (2 vols 1923)

A. J. Wauters: *Le Peinture flamande* (1883)

Czechoslovakia

J. Neumann: *Die tschechische klassische Malerei des 19 Jahrhunderts* (1955)

W. Ritter: *La Peinture tcheque, l'art et les artistes* (1912)

Zdensk Wirth: *L'Art tchecoslovaque des origines jusqu'à nos jours* (1926)

Denmark

H. Bramsen: *Landskabmaleriet i Danmark 1750-1875* (1935)

C. A. Breen (ed.): *Danmarks Malerkunst* (1902-3)

E. Hannover: *Danische Kunst des 19 Jahrhunderts* (1907)

C. Hintze: *Kopenhagen und die deutsche Malerei um 1800* (1937)

A. Kamphausen: *Deutsche und Skandinavische Kunst* (1956)

C. Laurin, E. Hannover, J. This: *Scandinavian Art* (1922)

N. T. Mortensen: *Dansk Billedkunst gennem en Menneskealder* (1939)

* V. Poulsen: *Danish Painting and Sculpture* (1955)

V. Poulsen: *Danische Maler* (1961)

S. Schultz: *Dansk Genremaleri* (1928)

Bibliography

V. Thorlacius-Ussing: *Danmarks Billed-huggerkunst fra Oldtid til Nutid* (1947)

E. Zahle: *Danmarks Malerkunst fra Middelalder til Nutid* (1947)

Finland

O. Okkonen: *Die finnische Kunst* (1943)

★ Österreichisches Museum für Angewandte Kunst, Wien: 'Finnland 1900. Finnischer Jugendstil' (Exhib. Cat. 1973)

France

K. Berger: 'Ingrisme et Pre-Raphaelitisme' (*Actes du 19e. Congrès Internationale d'Histoire de l'Art* 1958)

★ C. Blanc: *Les Artistes de mon temps* (1876)

★ A. Boime: *The Academy and French Painting in the 19th Century* (1971)

★ J. Bouret: *The Barbizon School* (1973)

M. P. Boyé: *La Mêlée romantique* (1946)

W. Bürger-Thoré: *Französische Kunst im 19 Jahrhundert* (3 vols 1911)

A. Chatelet, J. Thuillier, J. Leymarie: *French Painting III. 19th Century from David to Seurat* (1962)

U. Christoffel: *Von Poussin zu Ingres und Delacroix: Betrachtungen über die französische Malerei* (1945)

H. Clouzot: *Le Style Louis-Philippe-Napoléon III* (1939)

★ J. P. Crespelle: *Les Maîtres de la Belle Epoque* (1966)

★ 'De David à Delacroix: La peinture française de 1774 à 1830' (exposition 1974-5, Grand Palais, Paris)

L. Dimier: *Histoire de la peinture française au 19e. siècle* (1914)

P. Dorbec: *L'Art du paysage en France. Essai sur son évolution de la fin du 18e. siècle à la fin du Second Empire* (1925)

B. Dorival: *La Peinture française* (1946)

J. C. van Dycke: *Modern French Masters* (1896)

M. Easton: *Artists and Writers in Paris. The Bohemian Idea 1803-1867* (1969)

D. C. Eaton: *Handbook of Modern French Painting* (1909)

F. Flutre: *Le Romantisme* (1926)

A. Fontaines, L. Vauxcelles: *Histoire générale de l'art français de la révolution à nos jours* (1922)

M. T. Forges: *Barbizon* (1962)

F. Fosca: *La Peinture française au 19e. siècle* (1956)

S. Fox: *An Art Student's Reminiscences of Paris in the Eighties* (1909)

W. F. Friedländer: *David to Delacroix* (1952)

R. H. I. Gammel: *The Twilight of Painting* (1946)

G. Gassies: *Le Vieux Barbizon, souvenirs de jeunesse d'un paysagiste* (1911)

E. W. Herbert: *The Artist and Social Reform. France and Belgium 1885-1898* (1961)

R. L. Herbert: *Barbizon Revisited* (1962)

S. Hunter: *Modern French Painting 1855-1956* (1956)

A. Leroy: *Histoire de la peinture française 1800-1933* (1934)

J. Leymarie: *La Peinture française - 19e. siècle* (1962)

P. Miquel: *Le paysage français au XIXe. siècle* (1976)

L. Réau: *L'Art romantique* (1930)

★ S. Rocheblave: *La Peinture française au 19e. siècle* (1936)

L. Rosenthal: *L'Art et les artistes romantiques* (1928)

L. Rosenthal: *Du Romantisme au réalisme* (1914)

★ J. C. Sloane: *French Painting between Past and Present. Artists, Critics and Traditions from 1848-1870* (1951)

C. H. Stranahan: *A History of French Painting* (1897)

T. Sylvestre: *Histoire des artistes vivants* (1856, 1857)

A. Tabarant: *La Vie artistique au temps de Baudelaire* (1963)

R. H. Wilenski: *Modern French Painters I 1863-1903* (1940)

M. Zamacoïs: *Pinceaux et stylos* (1948)

Germany

★ K. Andrews: *The Nazarenes* (1964)

Ausstellung deutscher Kunst aus der Zeit von 1775-1875 in der königlichen National-galerie Berlin 1906. Introduction by H. von Tschudi (2 vols 1906)

J. Beavington-Atkinson: *The Schools of Modern Art in Germany* (1880)

H. Becker: *Deutscher Maler* (1888)

H. Beenken: *Das neunzehnte Jahrhundert in der deutschen Kunst* (1944)

R. E. Benz, A. von Schneider: *Die Kunst der deutschen Romantik* (1939)

W. von Biederman: *Goethe und Dresden* (1875)

R. M. Bisanz: *German Romanticism and Phillip Otto Runge* (1970)

M. von Boehn: *Biedermeier: Deutschland von 1815-1857* (1911)

P. Brieger: *Die deutsche Geschichtsmalerei des 19 Jahrhunderts* (1930)

M. Buchsbaum: *Deutsche Malerei im 19 Jahrhundert. Realismus und Naturalismus* (1967)

H. Bunemann: *Deutsche Malerei des 19 Jahrhunderts. Deutschland, Österreich, Schweiz* (1961)

W. Cohen: *Hundert Jahre rheinische Malerei* (1924)

W. Geismeier: *Deutsche Malerei des 19 Jahrhunderts* (1966)

W. R. Deusch: *Malerei der deutschen Romantiker und ihrer Zeitgenossen* (1937)

H. Geller: *150 Jahre deutsche Landschaftsmalerei. Ihre Entwicklung von 1800 bis zur Gegenwart* (1951)

H. Geller: *Die Bildnisse der deutschen Künstler in Rom 1800-1830* (1952)

G. Grundmann: *Das Riesengebirge in der Malerei der Romantik* (1958)

J. B. C. Grundy: *Tieck and Runge. A Study in the Relationship of Literature and Art in the Romantic Period* (1930)

★ C. Gurlitt: *Die deutsche Kunst seit 1800* (1924)

R. Hamann: *Die deutsche Malerei im 19 Jahrhundert* (1914)

R. Hamann: *Die deutsche Malerei vom Rokoko bis zum Expressionismus* (1925)

Von Hasselt: *L'Art Moderne en Allemagne* (1841)

★ W. Hütt: *Düsseldorfer Malerschule 1819-1869* (1964)

L. Justi: *Von Runge bis Thoma* (1932)

★ H. Karlinger: *München und die Kunst des 19 Jahrhunderts* (1933)

F. Landsberger: *Die Kunst der Goethezeit* (1931)

K. Lankheit: *Das Freundschaftsbild der Romantik* (1952)

I. Markowitz: *Die Düsseldorfer Malerschule* (Kunstmuseum Düsseldorf 1969)

Marquis de la Mazelière: *La Peinture allemande au 19e. siècle* (1900)

F. Noack: *Das Deutschtum in Rom* (1927)

R. Oldenbourg, H. Uhde-Bernays: *Die Münchner Malerei im 19 Jahrhundert* (1922)

G. Pauli: *Die Hamburger Maler der guten alten Zeit* (1925)

F. Pecht: *Deutsche Künstler des 19 Jahrhunderts. Studien und Erinnerungen* (1877–81)

★ Graf A. Raczynski: *Geschichte der neueren deutschen Kunst* (1841)

P. O. Rave: *Deutsche Malerei des 19 Jahrhunderts* (1949)

W. Robson-Scott: *The Literary Background of Gothic Revival in Germany. A Chapter in the History of Taste* (1965)

A. Rosenberg: *Berliner Malerschule* (1879)

A. Rosenberg: *Die Düsseldorfer Schule* (1886)

A. Rosenberg: *Düsseldorfer Malerschule* (1889)

A. Rosenberg: *Geschichte der modernen Kunst* (1889)

F. Schaarschmidt: *Zur Geschichte der Düsseldorfer Kunst* (1902)

K. Scheffler: *Deutsche Maler und Zeichner im 19 Jahrhundert* (1911)

W. Scheidig: *Goethes Preisaufgaben für bildende Künstler 1799-1805* (Schriften der Goethe-Gesellschaft 57, Weimar 1958)

W. Scheidig: *Die Geschichte der Weimarer Malerschule* (1974)

P. F. Schmidt: *Biedermeier Malerei* (1922)

P. F. Schmidt: *Die deutsche Landschaftsmalerei von 1750-1830* (1922)

A. von Schneider: *Deutsche Romantiker-Zeichnungen* (1942)

H. Schrade: *Deutsche Maler der Romantik* (1967)

H. Uhde-Bernays: *Münchener Landschafter im 19 Jahrhundert* (1921)

★ E. Waldmann: *Die Kunst des Realismus und Impressionismus* (1927)

P. Weiglin: *Berliner Biedermeier. Leben, Kunst und Kultur 1815-1848* (1942)

R. Wiegmann: *Die königliche Kunstakademie zu Düsseldorf* (1856)

G. J. Wolf: *Die Entdeckung der Münchener Landschaft* (1921)

★ R. Zeitler: *Die Kunst des 19 Jahrhunderts* (1966)

Holland

H. E. Van Gelder, J. Duverger (eds): *Kunstgeschiedenis der Nedelanden* (2 vols 1954-5)

A. M. Hammacher: *Amsterdamsche Impressionisten en hun Kring* (1941)

F. M. Huebner: *Die Kunst der niederländischen Romantik* (1942)

J. Knoef: *Tussen Rococo en Romantiek* (1943)

J. Knoef: *Van Romantiek tot Realisme* (1947)

★ G. H. Marius; *Dutch painters of the 19th Century* (1908, 1974)

★ M. Rooses: *Dutch Painters of the 19th Century* (1898)

★ P. Scheen: *Lexicon Nederlaandse Beeldende Kunstenaars 1750-1950* (1969)

Hungary

L. von Balás-Piry: *Die ungarische Malerei des XIX und XX Jahrhunderts* (1940)

B. Biró: *Magyar Müvészeti irodalom* (Bibliography of Hungarian Art History) (1954)

G. Divald: *Histoire de l'art hongrois* (1927)

L. Fülep: *A Magyarorszagi Müvészet Törtenete* (1970)

A. Peter: *Histoire de l'art hongrois* (1930)

G. Ö. Pógany: *19th Century Hungarian Painting* (1960)

Italy

F. Bellonzi: *Il divisionismo nella pittura italiana* (1967)

F. Bellonzi: *La pittura di storia dell'800 italiana* (1967)

Borgese, Cevese: *Storia dell'arte italiana* (vol. III 1959)

L. Callari: *Storia dell'arte contemporanea italiana* (1907)

R. Causa: *La Scuola di Posillipo* (1967)

M. P. Cazzullo: *La Scuola Toscana dei Macchiaioli* (n.d.)

E. Cecchi: *Pittura italiana dell'800* (1926, 1966)

E. Cecchi, M. Borgiotti: *Macchiaioli Toscani d'Europa* (1963)

A. Chiesa: *Pittori Lombardi del Secondo Ottocento* (1954)

A. M. Comanducci: *I pittori italiani dell'800* (1935)

G. Delogu: *Pittura italiana dell'800* (1962)

G. Einaudi (ed.): *Lettere dei Macchiaioli* (1953)

I. Faldi: '*Il purismo e Tommaso Minardi*' (*Commentari* I 1950)

R. Franchi: *La pittura italiana dell'800 al 900* (1929)

A. Franchi: *I Macchiaioli Toscani* (1945)

M. Giardelli: *I Macchiaioli e l'epoca loro* (1958)

R. de Grada: *I Macchiaioli* (1967)

V. Guzzi: *Il ritratto nella pittura italiana dell'800* (1967)

F. Hayez: *Le mie memorie* (1890)

I. Köhler: *Die Florentiner Macchiaioli. Ihre Würdigung in der zeitgenössischen und neueren Kunstliteratur* (1956)

E. Lavagnino: *L'arte moderna* (2 vols 1956)

L. Lloyd: *La pittura dell'800 in Italia* (1929)

★ C. Maltese: *Storia dell'arte in Italia 1785-1945* (1960)

G. Mazzariol, T. Pignatti: *Storia dell'arte italiana III* (1957)

D. Morelli, Dalbono: *La Scuola Napoletana di pittura nel secolo XIX* (1915)

F. Napier: *Notes of Modern Painting in Naples* (1855, 1956)

U. Ojetti: *Ritratti d'artisti italiani* (1911)

U. Ojetti: *La pittura italiana dell'800* (1929)

A. Ottino della Chiesa: *Il neoclassicismo nella pittura italiana* (1967)

G. Perocco: *La pittura veneta dell'800* (1967)

G. Predaval: *Pittura lombarda dal romanticismo alla Scapigliatura* (1967)

★ A.-P. Quinsec: *Ottocento Paintings in American Collections* (Columbia Mus. of Art 1973)

R. Rocchieri: *I pittori italiani del decimono* (1962)

A. Soffici: *Scoperte e massacri* (1919)

★ E. Somaré: *Storia dei pittori italiani dell'800* (1928)

E. Somaré: *La pittura italiana dell'800* (1944)

★ W. R. Willard: *History of Modern Italian Art* (1898)

Norway

A. Aubert: *Die nordische Landschaftsmalerei und J. C. C. Dahl* (1947)

A. Aubert: *Die Norwegische Malerei im XIX Jahrhundert* (n.d.)

A. Durham: *Painting in Norway* (1955)

C. G. Lauren *et al.*: *Scandinavian Art* (1922)

J. This: *La peinture norvégienne au 19e. siècle* (Actes du Congrés d'Histoire de l'Art 1921 III)

G. Vidalenc: *L'Art et les artistes norvégiens* (n.d.)

Poland

★ H. Gotlib: *Polish Painting* (1942)

A. Kuhn: *Die Polnische Kunst von 1800* (1930)

Bibliography

'L'Inspiration de l'art Vénitien dans la peinture Polonaise des XIX e. et XX e. siècles' (in 'Venezia e la Polonia nei Secoli da XVII al XIX' Luigi Cini 1965)

* '1,000 years of Art in Poland' (Exhib. Royal Academy, London, 1970)

J. Topass: *L'Art et les artistes en Pologne du romantisme à nos jours* (1928)

M. Treter: *Die neuere Malerei in Polen, das XIX Jahrhundert* (1930)

Portugal

M. Dieulafoy: *Espagne et Portugal* (1913)

E. Lambert: *L'Art en Espagne et au Portugal* (n.d.)

R. dos Santos: *L'Art portugais* (1953)

Rumania

I. Frunzetti: 'Development of Rumanian landscape painting to Grigorescu' (*Studii si cercetări de istoria artei* VIII 1961)

G. Opresco: *La Peinture roumaine de 1800 à nos jours* (n.d.)

Russia

M. Alpatov: *Russian Impact on Art* (1950)

A. Benois: *The Russian School of Painting* (1916)

E. Behrens: *Kunst in Russland* (1969)

R. Biedrzynski: *Die bildende Kunst Russlands* (1964)

C. G. E. Bunt: *Russian Art from Scythes to Soviets* (1946)

A. Eliasberg: *Russische Kunst. Ein Beitrag zur Charakteristik des Russentums* (1915)

O. Fastabend: *Über die russische religiöse Malerei seit 1830* (1940)

V. Fiala: *Die russische realistische Malerei des 19 Jahrhunderts* (1953)

V. Fiala: *Die russische Malerei des 18. und 19. Jahrhunderts* (1956)

T. Gautier: *Trésors d'art de la Russie ancienne et moderne* (1859)

* C. Gray: *The Great Experiment. Russian Art 1863–1922* (1962)

G. H. Hamilton: *The Art and Architecture of Russia* (1954)

R. Hare: *The Art and Artists of Russia* (1965)

J. Hasselblatt: *Historischer Überblick der Entwicklung der kaiserlich russischen Akademie der Künste in St. Petersburg. Ein Beitrag zur Geschichte der Kunst in Russland* (1886)

G. K. Lukomsky: *History of Modern Russian Painting. Russian Painting of the Last Hundred Years 1840–1940* (1945)

V. Marcadé: *Le Renouveau de l'art pictural russe 1863–1914* (1971)

W. Matthey: *Russische Kunst* (1948)

F. Nemitz: *Die Kunst Russlands vom 11. bis 19. Jahrhundert* (1940)

W. A. Nikolsky: *Peinture russe* (1906)

* L. Réau: *L'Art russe de Pierre le Grand à nos jours* (1922)

I. Repin: *Fernes und Nahes. Erinnerungen* (1970)

* Staatliche Kunsthalle, Baden-Baden: 'Russische Realismus 1850–1900' (Cat. 1973)

K. Stählin: *Über Russland, die russische Kunst und den grossen Dichter der russischen Erde* (1913)

T. Talbot Rice: 'Some Reflections on 19th Century Russian Painting' (*Burlington Magazine* 101, 1959)

T. Talbot Rice: *Die Kunst Russlands* (1965)

O. Wulff: *Die neurussische Kunst im Rahmen der Kulturentwicklung Russlands von Peter dem Grossen bis zur Revolution* (1932)

E. Zabel: *Russische Kulturbilder. Erlebnisse und Erinnerungen* (1907)

Spain

O. Y. Bernard: *Galeria biografica a dei artistes espagnoles des siglo 19* (1883–4)

A. de Beruete: *La pintura espagnol en el Secolo XIX* (1926)

G. Diecks: *Moderner Spanischen Maler* (1890)

P. Guinard, J. Baticle: *Histoire de la peinture. Espagnole du C17–C19* (n.d.)

E. Lambert: *L'Art en Espagne et au Portugal* (n.d.)

G. Pauli (ed.): *Arte del clasicismo y del romanticismo* (1948)

J. F. Ratok: *El arte romantico en España* (1954)

F. Tubino: *The Revival of Spanish Art* (1882)

Sweden

H. Cornell: *Den Svenska Konsten Historia* (2 vols 1945–6)

A. Gauffin: 'Les grandes époques de l'art Suedois' (*Gazette des Beaux-Arts* vol. 1 1929)

C. G. Lauren *et al.*: *Scandinavian Art* (1922)

S. L. Millner: *E. Josephson* (1948)

G. Nordensvan: *Schwedische Kunst des 19 Jahrhunderts* (1904)

G. Nordensvan: *Svensk Kunsthistoria* (1914)

Svensk Konstnärs Lexikon (2 vols 1952)

G. Vidalenc: *L'Art suédois* (n.d.)

Switzerland

D. Baud-Bovy: *Peintres genevois* (1903–4)

D. Baud-Bovy: *L'Ancienne Ecole genevoise de peinture* (1924)

A. Bovy: *La Peinture suisse de 1600 à 1900* (1948)

C. W. Bredt: *Die Alpen und ihre Maler* (1911)

C. Brun: *Schweizerisches Künstler-Lexikon* (4 vols 1905–17)

W. Cohen: *Die Entwicklung der Kunst in der Schweiz* (1924)

L. Fromer-im Obersteg: *Die Entwicklung der schweizerischen Landschafts Malerei im 18. und frühen 19. Jahrhundert* (1945)

J. Gantner: *Kunstgeschichte der Schweiz von der Anfangen bis zum Beginn des 20 Jahrhunderts* (1936–56)

P. Ganz: *Malerei in der Schweiz* (1924)

H. Graber: *Schweizer Maler* (1913)

M. von Grellet: *Nos Peintres romands* (1921)

J. R. Heer: *Die schweizerische Malerei des 19 Jahrhunderts* (1906)

F. Heinemann: *Schweizerische Kunstschätze* (1921)

F. Heinemann: *Quelques Peintres suisses* (1921)

* M. Huggler, A. M. Cetto: *Peinture suisse au 19e. siècle* (1943)

W. Kugelshofer: *Schweizer Kleinmeister* (1943)

C. de Mandach: *L'Art en Suisse au 19e. siècle et jusqu'à nos jours* (in A. Michel: *Histoire de l'Art* vol. 8 1926)

A. Neuweiler: *La Peinture à Genève de 1700–1900* (1945)

A. Reinle: *Kunstgeschichte der Schweiz* (vol. 4 1962)

W. Schäfer: *Die moderne Malerei der deutschen Schweiz* (1924)

P. Wescher: *Die Romantik in der schweizer Malerei* (1947)

U.K.

A. Addison: *Romanticism and the Gothic Revival* (1938)

* W. Ames: *Prince Albert and Victorian Taste* (1967)

P. H. Bate: *The English Pre-Raphaelite Painters* (1899)

Q. Bell: *Victorian Artists* (1967)

* T. S. R. Boase: *English Art 1800–1870* (1959)

Sir J. L. Caw: *Scottish Painting 1620–1908* (1908)

E. C. Clayton: *English Female Artists* (1876)

D. Clifford: *Watercolours of the Norwich School* (1965)

H. M. Cundall: *History of British Watercolour Painting* (1908)

C. L. Eastlake: *A History of the Gothic Revival* (1872)

T. Fawcett: *The Rise of English Provincial Art – Artists, Patrons and Institutions outside London 1800–1830* (1976)

W. Fredeman: *Pre-Raphaelitism, a Bibliocritical Study* (1965)

* W. Gaunt: *Victorian Olympus* (1952)

W. Gaunt: *The Pre-Raphaelite Tragedy* (1942)

* W. Gaunt: *The Aesthetic Adventure* (1945)

M. Hardie: *Watercolour Painting in Britain* (3 vols 1967–9)

G. F. Hartlaub: *Die grossen englischen Maler der Blütezeit 1750–1840* (1948)

G. E. Hughes: *Early English Watercolours* (1913, 1950)

S. Hutchinson: *History of the Royal Academy 1768–1968* (1968)

R. Ironside, J. A. Gere: *Pre-Raphaelite Painters* (1948)

D. and F. Irwin: *Scottish Painters at Home and Abroad 1700–1900* (1975)

* W. R. M. Lamb: *The Royal Academy* (1935)

* J. Maas: *Victorian Painters* (1969)

J. Maas: *Gambart, Prince of the Victorian Art World* (1976)

H. C. Marillier: *The Liverpool School of Painters* (1904)

D. Martin: *The Glasgow School of Painting* (1902)

J. J. Mayoux: *English Painting from Hogarth to the Pre-Raphaelites* (1975)

J. Meier-Graefe: *Die grossen Engländer* (1908)

D. Piper (ed.): *Genius of British Painting* (1975)

J. Piper: *British Romantic Artists* (1947)

S. and R. Redgrave: *A Century of British Painters* (1866)

* G. Reynolds: *Victorian Painting* (1966)

G. Reynolds: *Painters of the Victorian Scene* (1953)

J. L. Roget: *History of the Old Watercolour Society* (1891)

J. Ruskin: *Modern Painters* (5 vols 1843–60)

J. Ruskin: *Academy Notes 1855–59* (1875)

W. S. Sparrow: *British Sporting Artists* (1922, 1965)

E. Waldmann: *Englische Malerei* (1927)

G. White: *English Illustration, the Sixties* (1908, 1970)

* C. Wood: *Dictionary of Victorian Painters* (1971)

U.S.A.

M. Baigell: *A History of American Painting* (1971)

V. Barker: *American Painting: History and Interpretation* (1950)

S. G. W. Benjamin: *Art in America. A Critical and Historical Sketch* (1880)

J. Bennett: *A History of American Painting* (1973)

A. Burroughs: *Limners and Likenesses. 3 Centuries of American Painting* (1936)

C. H. Caffin: *The Story of American Painting* (1907)

M. Fielding: *Dictionary of American Painters, Sculptors and Engravers* (1945)

* J. T. Flexner: *The Light of Distant Skies 1760–1835* (1954)

* J. T. Flexner: *That Wilder Image. Cole to Homer* (1962)

G. C. Groce, D. H. Wallace: *The New York Historical Society's Dictionary of Artists in America 1564–1860* (1957)

O. Hagen: *The Birth of the American Tradition in Art* (1940)

S. Hartmann: *A History of American Art* (2 vols 1902)

S. Isham: *The History of American Painting* (1905)

S. La Follette: *Art in America* (1929)

O. W. Larkin: *Art and Life in America* (1949)

J. W. McCoubrey: *American Art 1700–1960. Sources and Documents* (1965)

R. McLanathan: *The American Tradition in the Arts* (1968)

* B. Novak: *American Painting of the 19th Century* (1969)

* E. P. Richardson: *Painting in America from 1502 to the Present* (1956)

E. P. Richardson: *A Short History of Painting in America* (1963)

G. W. Sheldon: *American Painters* (1879)

H. T. Tuckerman: *Book of the Artists* (1867, 1966)

List of Illustrations

*Dimensions are given in inches and centimetres, height before width;
dates are omitted where no reliable information is available*

Colour Plates

1 INGRES, Jean Auguste Dominique (1780–1867)
Odalisque, 1814
Oil on canvas, 33⅞ × 63⅜ (86 × 160.9)
Louvre, Paris

2 DAVID, Jacques Louis (1748–1825)
Mars Disarmed by Venus and the Graces, 1822–4
Oil on canvas, 121¼ × 65 (308 × 265)
Musées Royaux des Beaux-Arts, Brussels

3 FRIEDRICH, Caspar David (1774–1840)
Man and Woman Gazing at the Moon, c. 1830–5
Oil on canvas, 13⅜ × 17⅜ (34 × 44)
Nationalgalerie, Staatliche Museen Preussischer
 Kulturbesitz, Berlin

4 COLE, Thomas (1801–48)
The Savage State or *Commencement of Empire*,
 1833–6
Oil on canvas, 39¼ × 63¼ (99.7 × 160.6)
Courtesy of the New York Historical Society, New
 York City

5 DELACROIX, Ferdinand Victor Eugène (1798–1863)
The Death of Sardanapalus, 1827
Oil on canvas, 155½ × 194⅞ (395 × 495)
Louvre, Paris

6 FUSELI, Henry (1741–1825)
Titania and Bottom, c. 1790
Oil on canvas, 85½ × 108½ (217 × 275.5)
Tate Gallery, London

7 CONSTABLE, John (1776–1837)
The Hay Wain, 1821
Oil on canvas, 51¼ × 72 (130 × 183)
National Gallery, London

8 RICHTER, Adrian Ludwig (1803–84)
The Little Lake, 1839
Oil on canvas, 24¾ × 34¾ (63 × 88)
Nationalgalerie, Staatliche Museen Preussischer
 Kulturbesitz, Berlin

9 TURNER, Joseph Mallord William (1775–1851)
Rain, Steam and Speed – The Great Western Railway,
 1844
Oil on canvas, 35¾ × 48 (91 × 122)
National Gallery, London

10 ROUSSEAU, Pierre Etienne Théodore (1812–67)
Marshy Landscape, 1842
Oil on paper and on canvas, 8¾ × 11½ (22 × 28)
Private collection

11 DELAROCHE, Paul (1797–1856)
The Execution of Lady Jane Grey, 1833
Oil on canvas, 97 × 117 (246 × 297)
National Gallery, London

12 MATEJKO, Jan (1838–93)
Stephen Batory at Pskov, 1872
Oil on canvas, 130¾ × 214⅝ (332 × 545)
Muzeum Narodowe, Warsaw

13 WEST, Benjamin (1738–1820)
Penn's Treaty with the Indians, 1771
Oil on canvas, 75½ × 108¾ (184 × 230)
Pennsylvania Academy of the Fine Arts, Philadelphia

14 MEISSONIER, Jean Louis Ernest (1815–91)
Napoleon III at Solferino, 1863
Oil on canvas, 17⅞ × 29⅞ (44 × 76)
Louvre, Paris
Photo: Giraudon

15 FRITH, William Powell (1819–1909)
Derby Day, 1858
Oil on canvas, 40 × 88 (101.6 × 223.5)
Tate Gallery, London

16 BINGHAM, George Caleb (1811–79)
Fur Traders Descending the Missouri, c. 1845
Oil on canvas, 29 × 36½ (73.6 × 92.7)
Metropolitan Museum of Art, New York, Morris K.
 Jessup Fund, 1933

17 SPITZWEG, Carl (1808–85)
The Hypochondriac, 1866
Oil on canvas, 21¼ × 12⅜ (54 × 31.5)
Schack-Galerie, Munich

18 FEDOTOV, Paul Andreyevich (1815–52)
Little Widow, 1851
District Land Museum, Ivanov

19 COURBET, Gustave (1819–77)
Funeral at Ornans, 1849
Oil on canvas, 123¼ × 261⅝ (313 × 663.9)
Louvre, Paris

20 MILLET, Jean François (1814–75)
The Gleaners, 1857
Oil on canvas, 33⅛ × 43¾ (84 × 111)
Louvre, Paris
Photo: Giraudon

21 KØBKE, Christen Schjellerup (1810–48)
The Landscape Painter Frederik Sødring
Oil on canvas, 15¾ × 14⅛ (40 × 36)
Hirschsprung Collection, Copenhagen
Photo: Ole Woldbye

22 LEIBL, Wilhelm Maria Hubertus (1844–1900)
Three Women in Church, 1882
Oil on mahogany, 44½ × 30¼ (113 × 77)
Kunsthalle, Hamburg

23 MANET, Edouard (1832–83)
Lunch in the Studio, 1869
Oil on canvas, 47 × 60 (118 × 154)
Neue Pinakothek, Munich

24 MENZEL, Adolf Friedrich Erdmann von (1815–1905)
Weekday in Paris, 1869
Oil on canvas, 27 × 27⅞ (68.4 × 69.5)
Kunstmuseum, Düsseldorf

25 RENOIR, Pierre Auguste (1841–1919)
The Umbrellas, 1884
Oil on canvas, 71 × 45¼ (180 × 115)
National Gallery, London

26 STEVENS, Alfred Emile Léopold (1823–1906)
The Visit
Oil on panel, 25⅜ × 18½ (64.5 × 47.1)
Sterling and Francine Clark Art Institute,
 Williamstown, Massachusetts

27 MAKART, Hans (1840–84)
Death of Cleopatra, 1874–5
Oil on canvas, 75¼ × 100⅜ (191 × 255)
Staatliche Kunstsammlungen Kassel, Leihgabe
 der Bundesrepublik Deutschland

28 BURNE-JONES, Sir Edward (1833–98)
The Beguiling of Merlin, 1874
Oil on canvas, 73 × 43½ (185.4 × 110.5)
Courtesy of the Trustees of the Lady Lever Art
 Gallery, Port Sunlight

29 MOREAU, Gustave (1826–98)
Orpheus, 1865
Oil on canvas, 60 × 36 (154 × 99.5)
Louvre, Paris
Photo: Bulloz

30 BÖCKLIN, Arnold (1827–1901)
The War, 1896
Oil on wood, 39⅜ × 27⅜ (100 × 69.5)
Gemäldegalerie Neue Meister, Dresden

31 GOGH, Vincent Willem van (1853–90)
A Cornfield with Cypresses, 1889
Oil on canvas, 28⅜ × 35¾ (72.1 × 90.9)
National Gallery, London

32 MUNCH, Edvard (1863–1944)
The Cry, 1893
Oil on hardboard, 35⅞ × 28⅞ (91 × 73.5)
Nasjonalgalleriet, Oslo

List of Illustrations

BRAEKELEER, Henri de (1840–88)
The Geographer, 1871
Oil on wood, 24 × 31½ (61 × 80)
Musées Royaux des Beaux-Arts, Brussels
Photo: A.C.L.
BRÉE, Mathieu Ignace van (1773–1839)
Regulus Returning to Carthage
Oil on canvas, 27⅞ × 36¾ (69 × 92.5)
Musées Royaux des Beaux-Arts, Brussels
Photo: A.C.L.
BREITNER, Georg Hendrik (1857–1923)
Rokin in the Evening, c. 1900
Oil on cloth, 31½ × 51⅛ (80 × 130)
Gemeentemusea, Amsterdam
BRESDIN, Rodolphe (1822–85)
The Comedy of Death, 1854
Lithograph, first state, 8½ × 5⅞ (21.7 × 15)
Bibliothèque Nationale, Paris
BRETON, Jules Adolphe Aimé Louis (1827–1905)
Calling the Gleaners Home, 1859
Musée d'Arras
Photo: Alinari-Giraudon
BROWN, Ford Madox (1821–93)
Work, 1852–65
Oil on canvas, 53 × 77⅛ (134.5 × 196)
City Art Gallery, Manchester
BRÜLLOV, Karl Pavlovich (1799–1852)
Last Days of Pompeii, 1833
State Russian Museum, Leningrad
Photo: Novosti Press Agency
BUCHSER, Frank (1828–90)
Negro Hut in Charlottesville, 1870
Oil on canvas, 12⅝ × 19⅞ (32.1 × 50.6)
Kunstmuseum, Basle
BÜRKEL, Heinrich (1802–69)
Gang of Robbers in the Abruzzi, c. 1832
Oil on canvas, 21⅞ × 23 (55.5 × 58.5)
Bayerische Staatsgemäldesammlungen, Munich
BURNE-JONES, Sir Edward Coley (1833–98)
Pygmalion and the Image (III), The Godhead Fires, 1878
Oil on canvas, 38¾ × 29½ (98 × 75)
By courtesy of Birmingham Museums and Art Gallery

CABANEL, Alexandre (1823–89)
Birth of Venus, 1862
Oil on canvas, 51¼ × 88⅝ (130 × 225)
Louvre, Paris
Photo: Giraudon
CAILLEBOTTE, Gustave (1848–94)
Paris, A Rainy Day (Intersection of the Rue de Turin and the Rue de Moscou), 1877
Oil on canvas, 83½ × 108¾ (212 × 276.2)
Courtesy of the Art Institute of Chicago
CALAME, Alexandre (1810–64)
The Lake of Thun, 1854
Oil on canvas, 23¼ × 30¾ (59.1 × 78.1)
National Gallery, London
CAMMARANO, Michele (1835–1920)
Battaglia di Dogali (The Battle of Dogali), 1889–93
Oil on canvas, 175⅝ × 294½ (445 × 748)
Galleria Nazionale d'Arte Moderna, Rome
Photo: Mansell-Anderson
CAMUCCINI, Vincenzo (1771–1844)
The Death of Caesar, 1798
Oil on canvas, 157½ × 278⅜ (400 × 707)
Galleria Nazionale di Capodimonte, Naples

Photo: Soprintendenza alle Gallerie, Naples
CANON, Hans (1829–85)
Page, 1870
Oil on canvas, 48⅝ × 33⅝ (123.5 × 85.5)
Kunsthalle, Hamburg
CARNOVALI, Giovanni (1804–73)
Landscape, c. 1844–6
Oil on canvas, 24¾ × 39⅜ (63 × 100)
Galleria d'Arte Moderna, Milan
CAROLUS-DURAN, Emile Auguste (1838–1917)
La Dame au Gant (The Woman with the Glove: Madame Carolus-Duran), 1869
Oil on canvas, 89¾ × 64⅝ (228 × 164)
Louvre, Paris
Photo: Lauros-Giraudon
CARRIÈRE, Eugène (1849–1906)
Motherhood
Oil on canvas
Musée Rodin, Paris
CARUS, Carl Gustav (1789–1869)
Allegory on the Death of Goethe, c. 1832
Oil on canvas, 15¾ × 22 (40 × 56)
Goethe Museum, Frankfurt
CASSATT, Mary (1845–1926)
A Cup of Tea, c. 1880
Oil on canvas, 25½ × 36½ (64.8 × 92.7)
Courtesy Museum of Fine Arts, Boston, Maria Hopkins Fund
CAZIN, Jean Charles (1841–1901)
Hagar and Ishmael, c. 1880
Oil on canvas, 99¼ × 79½ (252 × 202)
Musée des Beaux-Arts, Tours
CÉZANNE, Paul (1839–1906)
Mont Sainte-Victoire with a Large Fir Tree, 1885–7
Oil on canvas, 23½ × 28½ (59.5 × 72.4)
Phillips Collection, Washington D.C.
CHAPLIN, Charles (1825–91)
Loto, 1865
Oil on canvas, 45⅝ × 38¼ (116 × 97)
Musée des Beaux-Arts, Rouen
Photo: Lauros-Giraudon
CHARLET, Nicolas Toussaint (1792–1845)
Retreat from Moscow, 1836
Oil on canvas, 45⅞ × 82⅞ (116.5 × 209.5)
Musée des Beaux-Arts, Lyons
CHASE, William Merritt (1849–1916)
A Friendly Call, 1895
Oil on canvas, 30¼ × 48¼ (77 × 122.5)
National Gallery of Art, Washington D.C., Chester Dale Collection
CHASSÉRIAU, Théodore (1819–56)
Chaste Susanna, 1839
Oil on canvas, 100⅜ × 77⅛ (255 × 196)
Louvre, Paris
Photo: Archives Photographiques
CHEŁMÓNSKI, Josef (1849–1914)
On a Farm, 1875
Oil on canvas, 33½ × 56¼ (85 × 143)
Muzeum Narodowe, Cracow
Photo: Royal Academy of Arts, London
CHÉRET, Jules (1836–1932)
Pantomimes Lumineuses au Musée Grévin, 1892
Poster, 48¾ × 34½ (124 × 87.5)
Musée Chéret, Nice
CHURCH, Frederick Edwin (1826–1900)
The Heart of the Andes, 1859
Oil on canvas, 66⅛ × 119¼ (167.9 × 302.9)

Metropolitan Museum of Art, New York, Bequest of Mrs David Dows, 1909
COGNIET, Léon (1794–1880)
Tintoretto Painting his Dead Daughter, 1845
Oil on canvas, 56¼ × 64⅛ (143 × 163)
Musée des Beaux-Arts, Bordeaux
COLE, Thomas (1801–48)
The Oxbow (The Connecticut River near Northampton), 1846
Oil on canvas, 51½ × 76 (130.8 × 193)
Metropolitan Museum of Art, New York, Gift of Mrs Russell Sage, 1908
CONSTABLE, John (1776–1837)
Dedham Lock and Mill, 1820
Oil on canvas, 21⅛ × 30 (53.7 × 76.2)
Crown Copyright, Victoria and Albert Museum, London
COPLEY, John Singleton (1737–1815)
Watson and the Shark, 1778
Oil on canvas, 71¼ × 90½ (182.3 × 229.9)
National Gallery of Art, Washington D.C., Ferdinand Lammot Belin Fund
CORINTH, Lovis (1858–1925)
Walchensee Panorama, 1924
Oil on canvas, 39⅜ × 78¾ (100 × 200)
Wallraf-Richartz Museum, Cologne
CORNELIUS, Peter (1783–1867)
Wise and Foolish Virgins, 1815–19
Oil on canvas, 44⅞ × 60½ (114 × 153)
Kunstmuseum, Düsseldorf
COROT, Jean Baptiste Camille (1796–1875)
Morning, the Dance of the Nymphs, 1850
Oil on canvas, 38¼ × 51⅛ (97 × 130)
Louvre, Paris
Photo: Bulloz
COSTA, Giovanni (1826–1903)
Women on the Beach at Anzio, 1852
Oil on canvas, 31½ × 47⅛ (80 × 120)
Galleria Nazionale d'Arte Moderna, Rome
Photo: Oscar Savio
COTMAN, John Sell (1782–1842)
Greta Bridge, 1810
Watercolour, 11⅞ × 19¾ (30.2 × 50.2)
Norfolk Museums Service (Norwich Castle Museum)
COURBET, Gustave (1819–77)
Bonjour M. Courbet!, 1854
Oil on canvas, 50¾ × 58⅝ (129 × 149)
Musée Fabré, Montpellier
Photo: Giraudon
COUTURE, Thomas (1815–79)
Romans of the Decadence, 1847
Oil on canvas, 183½ × 305⅝ (466 × 775)
Louvre, Paris
Photo: Bulloz
CREMONA, Tranquillo (1837–78)
The Two Cousins, 1870
Oil on canvas, 25¼ × 33½ (64 × 85)
Galleria Nazionale d'Arte Moderna, Rome
CROME, John (1768–1821)
Back of the New Mills, Norwich, 1810–11
Oil on canvas, 16¼ × 21¼ (41.3 × 54)
Norfolk Museums Service (Norwich Castle Museum)

DADD, Richard (1817–86)
The Fairy Feller's Master Stroke, 1855–64
Oil on canvas, 21¼ × 15½ (54 × 39.4)
Tate Gallery, London

List of Illustrations

List of Illustrations

List of Illustrations